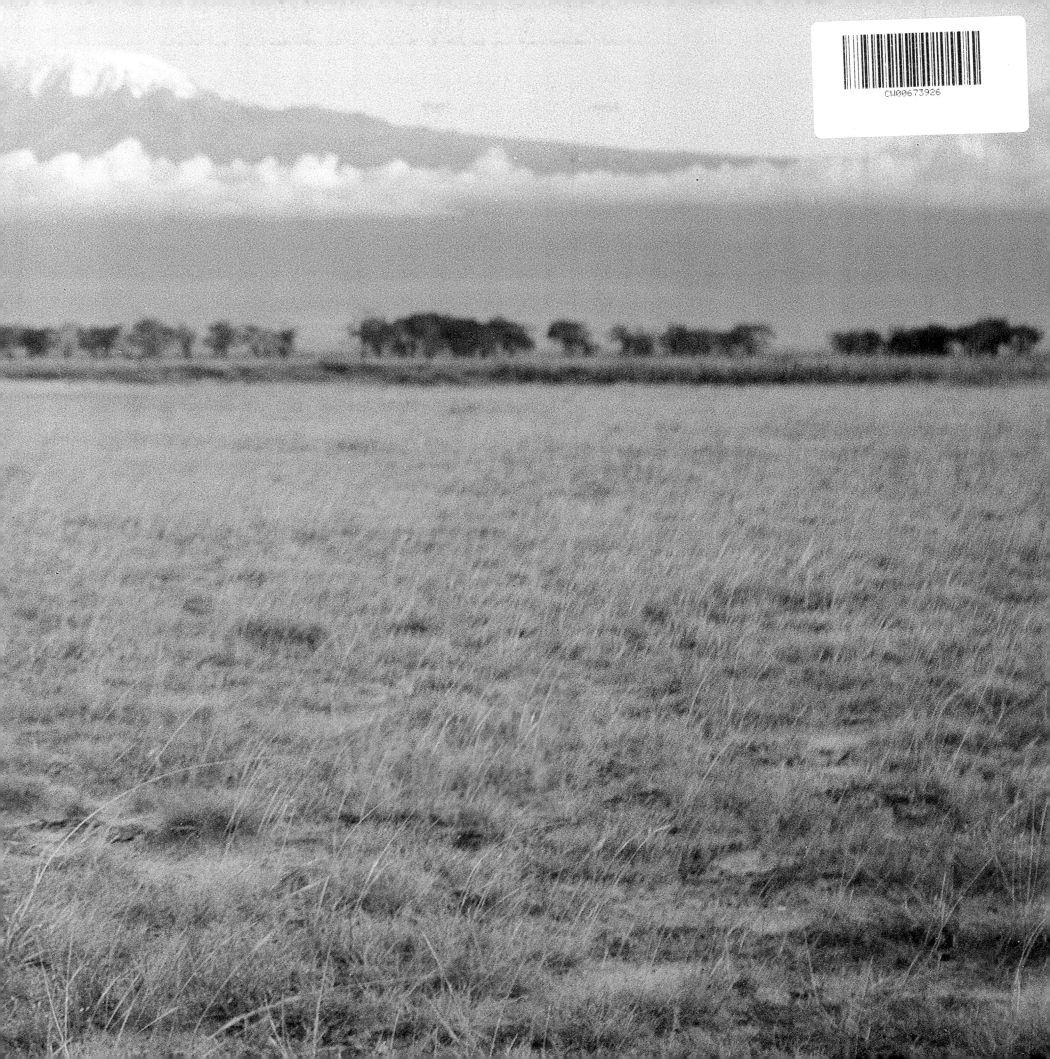

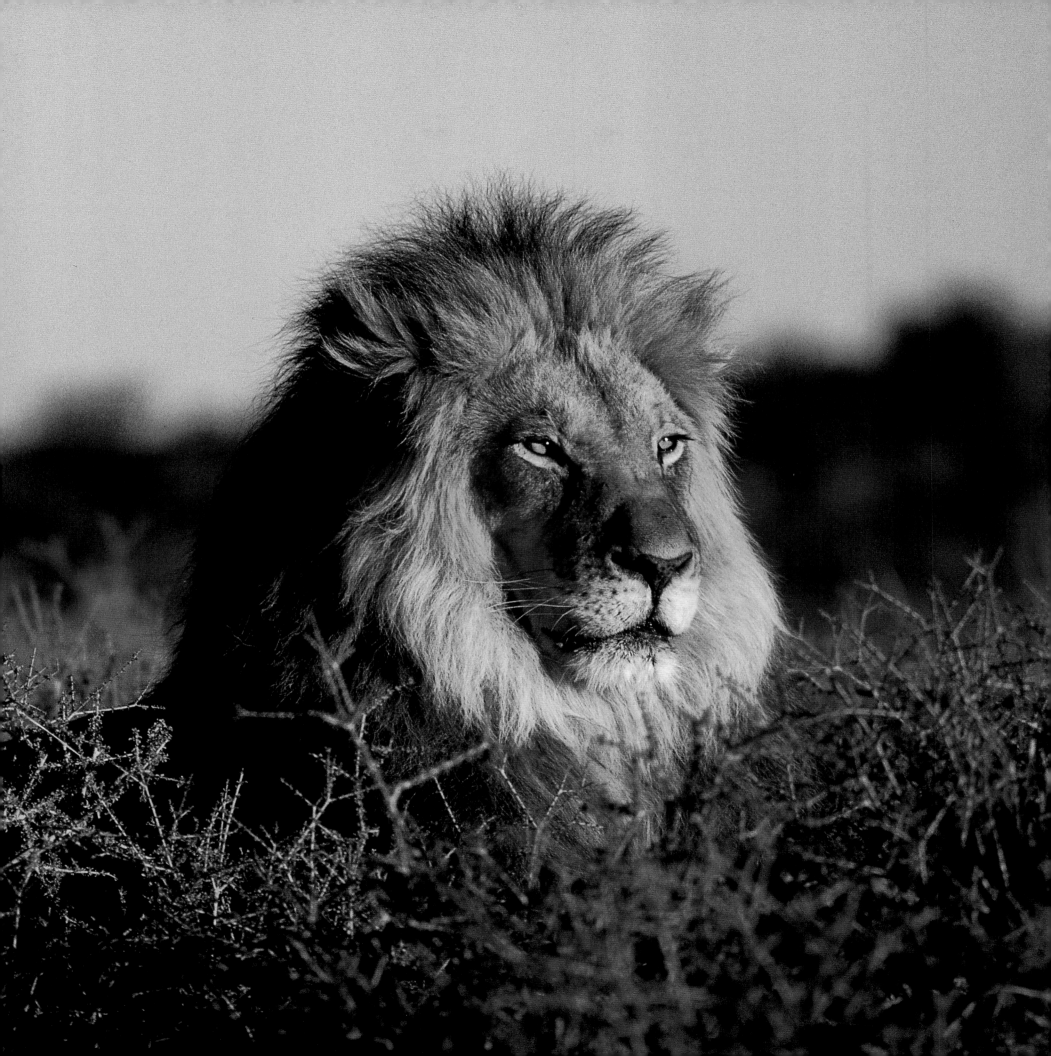

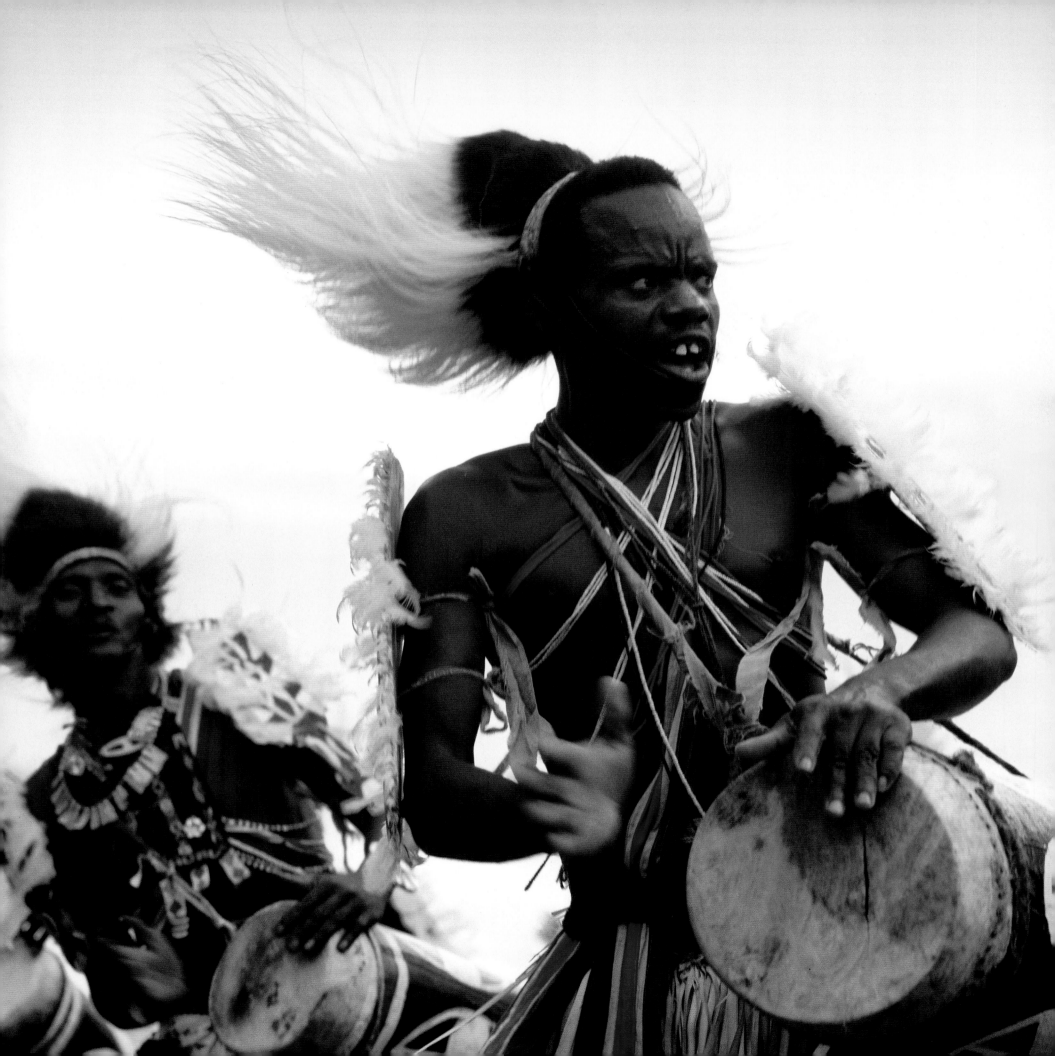

evocative
Africa
Ventures of Discovery

Gerald Cubitt

End papers: A Lion *Panthera leo* at rest on the Amboseli plains with a backdrop of Mount Kilamanjaro in the distance, Kenya.
Frontispiece: The majestic King of the Beasts basks in the late afternoon glow, Kgalakgadi Transfrontier National Park. South Africa.

Cover: The 'Kokerboom' Forest *Aloe dichotama* at sunset, in southern Namibia.
Back Cover: A snarling African leopard *Panthera pardus*.

Left : Chuka dancers, famed for their polyrhythmic percussion music, in the Kenya Highlands.

FOREWORD

"Photography, as a powerful medium of expression and communications, offers an infinite variety of perception, interpretation and execution" Ansel Adams (1902 -1984)

What a privilege and pleasure to write the foreword for a book which I have no doubt is destined to become a "must-have" for anybody who delights in Africa's extraordinary diversity of species, landscapes, people, colours and textures. *Evocative Africa*, the title, says it all.

I have visited and worked in many of the places Gerald Cubitt has portrayed in this book, but my efforts at photography are mundane and prosaic when compared with the artistic inspiration on the pages that follow. Time after time a new picture elicits a gasp of exhilarated astonishment at the way in which Gerald has succeeded in presenting innovative interpretations of subjects photographed many times before, but rarely with such passion for the subject.

It is all too easy to take a quick shot in passing, but this book is far from the quick and easy. Evocative, moody landscapes require hours of observation and positioning to capture the correct light and minute detail which together combine to produce a truly great photograph. Patience is undoubtedly required for all wildlife subjects, but when dealing with people, the ability to work and harmonise with African communities is a rare talent, if the subjects are to relax and appear as congenial individuals, untraumatised by the prying camera lens. To quote again from one of America's most respected photographer/environmentalists, Ansel Adams: *"You don't take a photograph, you make it."*

The talent, of the designer, Benni Hotz, also should not go without mention.

This exquisite book is testament not only to the many hours Gerald Cubitt has spent capturing each image, but also to his unique artistic style and his ability to *make* photographs of this magic continent, which cannot fail to encourage all who see them to visit, or return to, the selected destinations with a fresh appreciation of what each has to offer.

John Hanks

John Hanks
Former CEO WWF-SA & Peace Parks Foundation

ACKNOWLEDGEMENTS

G.C.: First and foremost to my wife, Janet, who has consistently supported and encouraged me in all my photographic endeavours.

My partners in the project, Willi Wighard of Clifton Publications and Thomas Mihal of Positive Imaging.

Benni Hotz for his design of the book and the accompanying text.

Dr John Hanks for contributing the foreword.

March Turnbull for his introduction copy and sleeve text.

Derek Schuurman for his introduction to the Madagascar section and for editing text for the Madagascar images.

Christopher Walton for advice and assistance with the cover design.

Also, to the following:

Dr Franco Andreone (ACSAM) specialist in Madagascar amphibians.

Robert and Julie Beckett. Marius Burger. Pete and Karen Glover.

Bongikaya Gobile and Natasha du Plessis of Positive Imaging.

Grace Galland

MalaMala Game Reserve (photo GC p76/77)

Missouri Botanical Gardens.

Rainbow Tours at W&O Travel (Madagascar Travels).

Liz Westby-Nunn ('The Portfolio Collection').

All images photographed on medium (6 x 6cm) format and with Hasselblad equipment

B.H.: Firstly, I would like to thank the publisher and photographer for entrusting such a prestigious publication to my care. To Willi Wighard, for his fine-tuned eye for detail, which has resulted in a much refined body of work, and Gerald Cubitt for his constant encouragement as we 'battled' along; and for getting to understand my macabre sense of humour.

A few years ago, research for such a publication would have taken many months at libraries and archives, and from my own fairly comprehensive library of flora and fauna books. In today's electronic era I must also extend thanks to those with whom I had no personal contact: *Google*, for its wonderful search engine, browser and for *Google Earth*; and also to *Wikipedia* for its consistently succinct detailed articles (none of which were taken at face value but most were cross-checked with other sources where possible). Among the many web sites I visited, I must single out three: those of Oakland and San Diego zoos in California along with the Minnesota Zoo and for the quote on p171 ©SANParks.org 2004-2010.

Last, but most importantly, I must thank my wife Melanie, firstly for putting up with me and all those countless late, late nights. On top of that, having to live with me with my mind constantly zoned into another world. With her sharply focused eye, she has been my most forthright and helpful critic, both with design issues, and also by checking my writing as it progressed.

Coquerel's sifaka *Propithicus coquereli*, one of the many endangered lemurs of Madagascar.

Overleaf: Reed Cormorants *Phalacrocorax africanus* roost at dusk on the skeletal remains of a drowned forest in Lake Kariba.

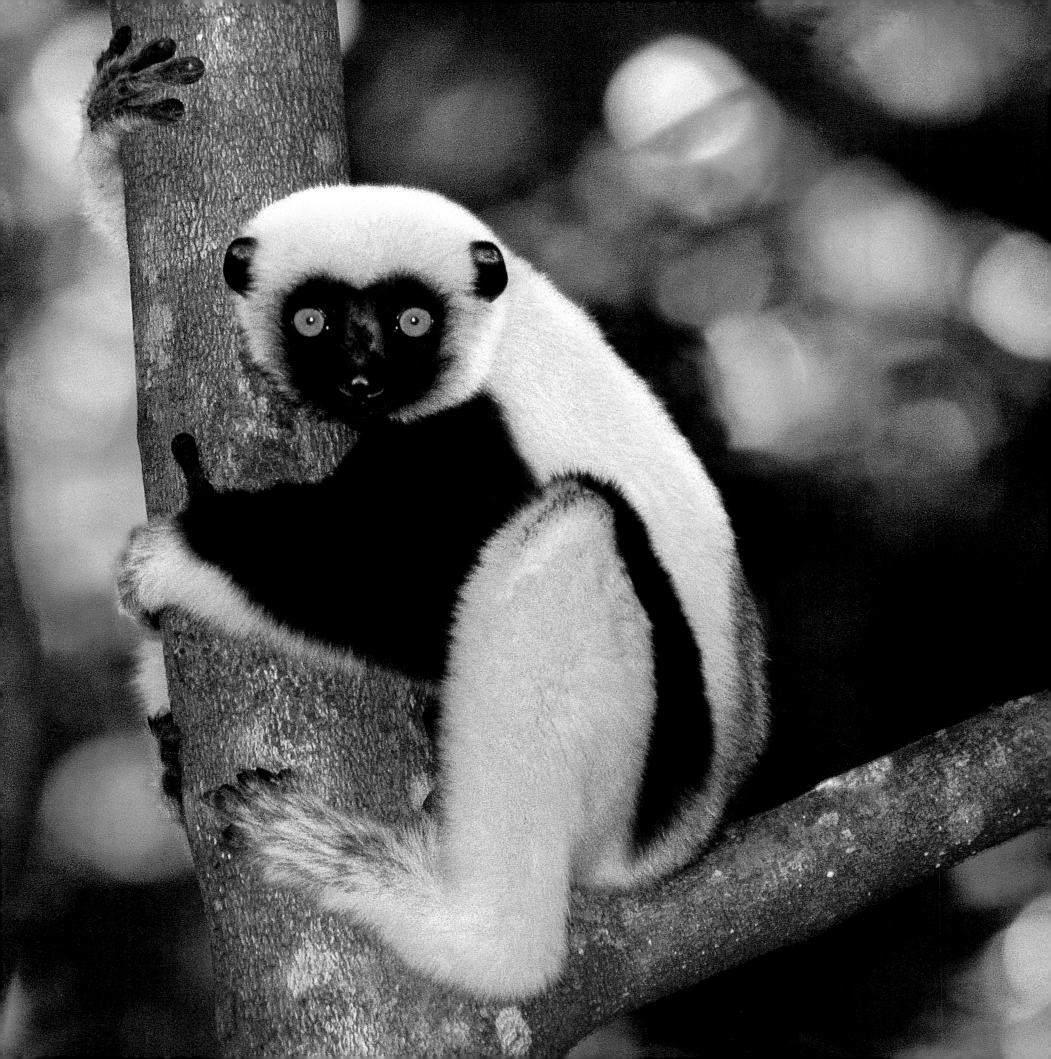

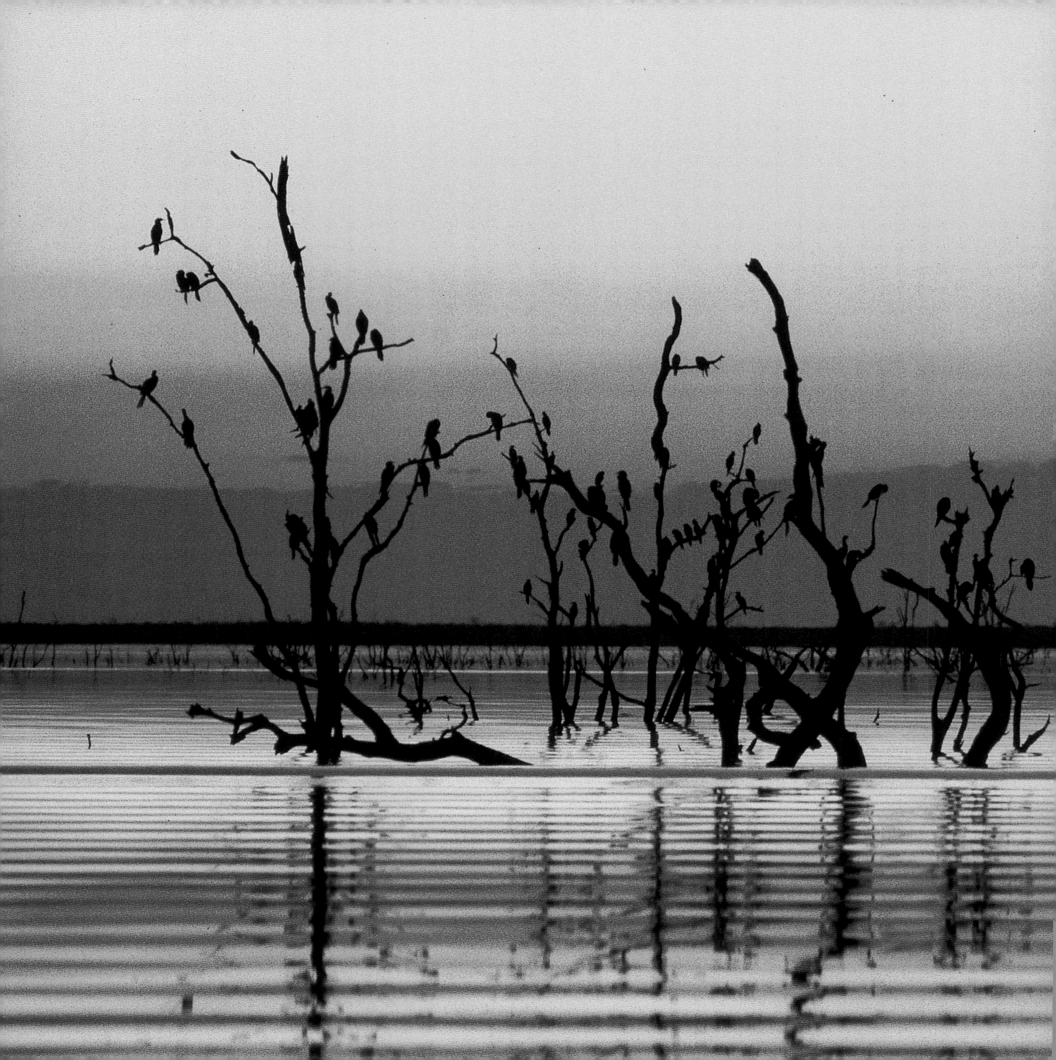

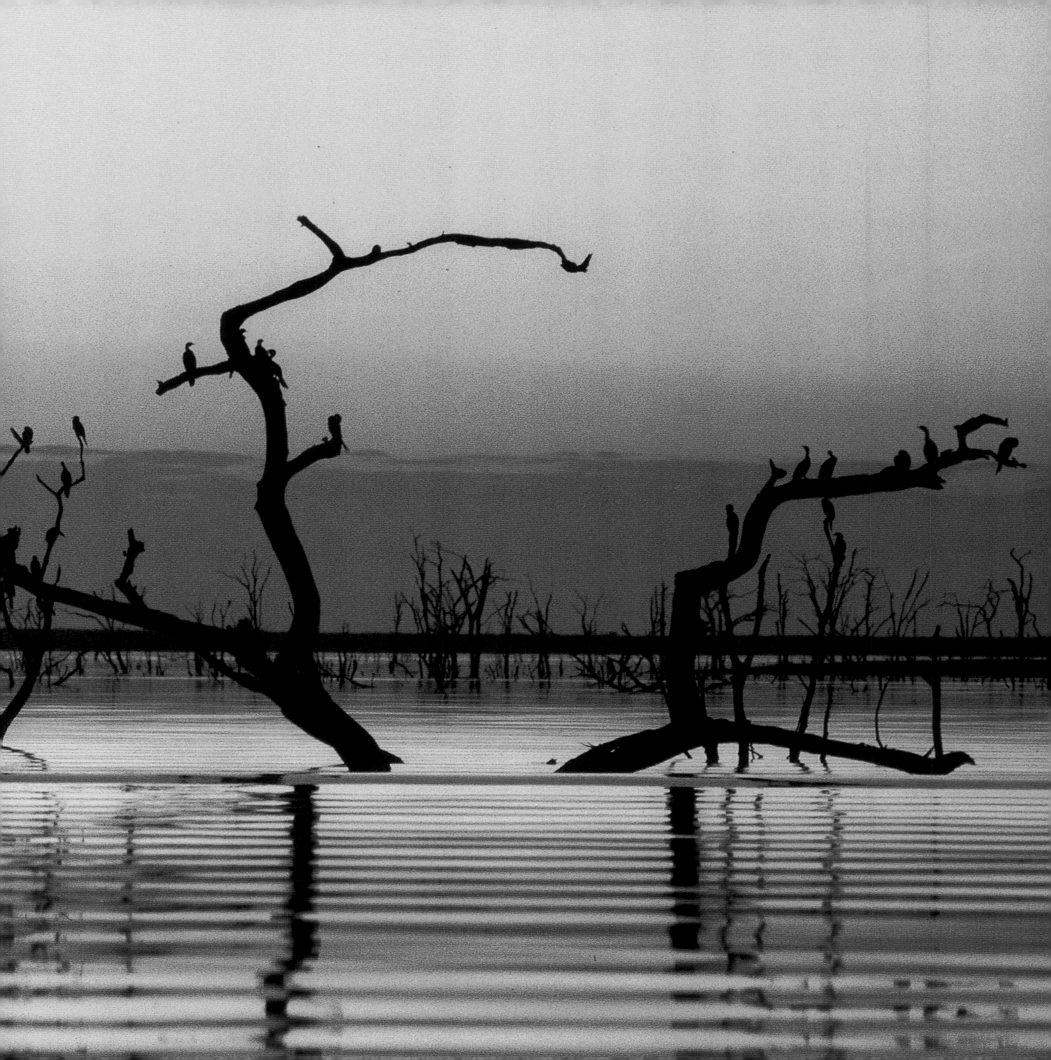

...for my wife, Janet,
who has accompanied me on these travels with
enthusiasm, a keen eye, and a lot of patience.

CONTENTS

Foreword & Acknowledgements		4
Introduction		10
Map		13
1	The South-West Cape, Karoo, Garden Route, Eastern Cape & the Wild Coast	16
2	The Eastern Free State & KwaZulu-Natal	46
3	Northern Regions & the Kruger Park	68
4	Zimbabwe to Mozambique & Malawi	84
5	Madagascar	120
6	Northern Tanzania & Kenya	158
7	Botswana	194
8	Namibia	216
9	Kalahari & the Cape West Coast	266
Index		299

ISBN 978 0 620 50161 3
First edition 2011
Copyright all photographs ©Gerald Cubitt
E-mail: geraldcubitt@telkomsa.net

Designed by benni hotz ©2010; benni@thehotzshop.co.za
Text and captions: ©benni hotz 2010
Scanning & colour retouching: Thomas Mihal
Computer page make-up & additional retouching: benni hotz
Indexing: Leni Martin
Printed and bound by PWGS, China

Published by Clifton Publications, Cape Town
P.O. Box 165, Maitland, Cape Town 7404, South Africa
Tel: +27 21 593 2700, e-mail: info@cliftonproducts.co.za
Web site: evocativeafrica.co.za

Dwarfed by the immensity of an African landscape,
a patrol of ostriches *Struthio camelus* pass behind
a white rhino *Ceratotherium simum* grazing peacefully with her calf
in the Loskop Dam Nature Reserve, Mpumalanga, South Africa.

EVOCATIVE AFRICA

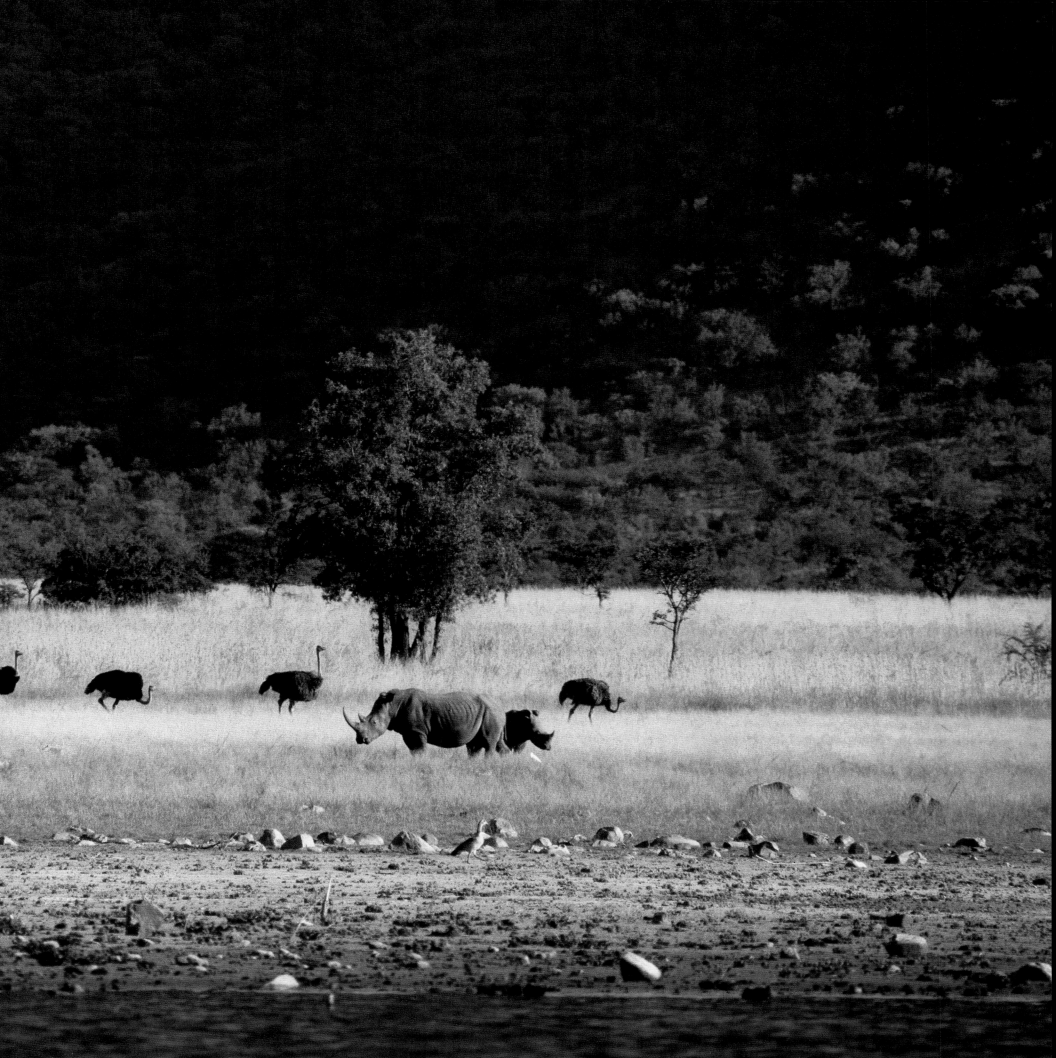

INTRODUCTION

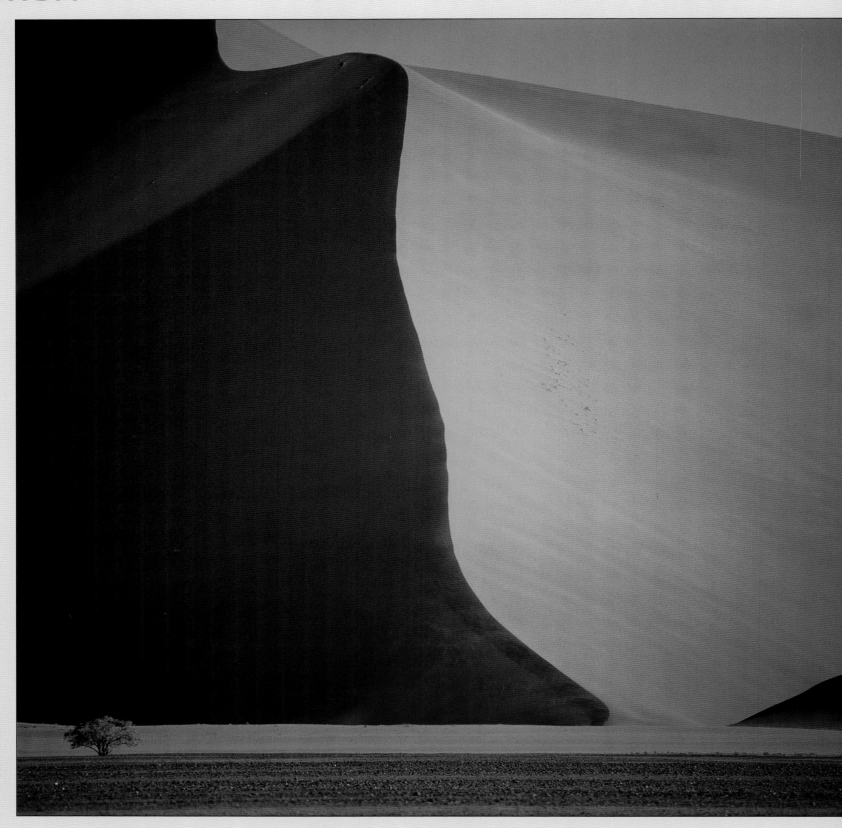

A lone camelthorn acacia stands vigil beside the overwhelming immensity of a desert dune at Sossusvlei in the Namib-Skeleton Coast National Park, Namibia.

We can all take a lucky photograph, one that really captures a person, or a place, or a mood. But it ...es time, experience and extraordinary skill to do it ...nsistently, building portfolios of the necessary breadth ...d quality to illustrate a whole shelf of books, as Gerald ...s done during his career.

...his meander through sub-Saharan Africa is a journey ...once familiar and wonderfully new. He has delib-...tely chosen his images from places squarely in the ...ch of all but the most timid travellers, yet they have ...eshness of perspective that is bound to inspire new ...rneys and breathe life into old ones.

...is his most personal collection to date with glimpses ...ten accessible and rewarding countries. And that is ...e great strength of this album; none of the ...stinations is beyond our reach and all of them are ...rth seeing. It gives him great pleasure to know that ...ny readers will have stood in the same spots as he ...s, recording their own impressions, and if this volume ...npts just one other to travel more widely in Africa, ...e photographer will consider it a success.

...nd travelling is what this book is all about. From the ...oment he bursts through the ordered and achingly ...otogenic vineyards of South Africa's Cape, a mosaic ...African experiences unfolds.

...he journey starts at the south-west edge of the ...ntinent, exploring the astonishing diversity of land-...pe, culture and wildlife that South Africa has to offer. ...aking out of the agricultural fecundity of the Western ...pe, he finds simpler ways of life in the Transkei region ...d rural Zululand. To Cape colonists of the 1800s, the ...nskei was the hinterland, a frontier of rugged land-...pes bitterly fought over by indigenous farmers and ...opean settlers. Highly politicised by their history, ...osa-speaking people of the Transkei, including Nelson ...ndela, were at the forefront of the struggle for ...mocracy in South Africa. Charismatic leadership is not ...w to this rugged region. In 1856 the visions of ...ngqawuse, a teenage medium, persuaded her people ...burn their crops and slaughter their cattle to win ...ine deliverance from oppression. After months of ...nzied destruction, Nongqawuse's people began to ...rve. Within the year, forty thousand had died.

...ts and maize fields still dot the green hills back from the ...ast, and cattle remain a cornerstone of the rural ...onomy, grazing on grassy uplands reaching back to ...e foothills of the formidable Drakensberg ...untains. The dormant grandeur of the region's

highest peaks, scarcely hints at their origins; unimaginable tectonic forces that have shaped the eastern flank to the continent, all the way to the Horn of Africa. Gerald meets that fault line again on the bank of Lake Natron in Tanzania, where he experiences and captures the dramatic eruption of Ol Doinyo Lengai, the country's last remaining active volcano. Across the region, steam rises over bitter Rift Valley lakes, ethereal proof of the geological drama still being played out under this ancient continent.

Before leaving South Africa, Gerald turns his lens east towards the Kruger National Park, one of the greatest wildlife pageants on earth. Again and again on his venture, the photographer is drawn to fabulous, and sometimes fragile, biogeographical islands tenaciously preserving the natural history of the continent. Kruger, known to many South Africans simply as 'the park', extends to over two million hectares with its north-eastern tip marking the legendary intersection of the South African, Mozambican and Zimbabwean borders. This was once the site of the infamous Crooks Corner, the refuge of dubious characters escaping the jurisdiction of one - or all - of the neighbouring coun-tries. It is also the traditional home of the Makuleke people who actually own the northernmost part of the park. Large as it is on its own, the Kruger itself forms part of the Great Limpopo Transfrontier Park and visitors can travel freely between Mozambique and South Africa within this massive 'peace park'.

Across the Zimbabwean border, his images of the fabulous curving walls of Great Zimbabwe remind us that this was once the hub of a thriving trade network, uelled by iron, glass, slaves, ivory and gold. When generations of masons built this city, Arab captains anchored their dhows in the estuaries of Mozambique, one eye on the sky for signs of the seasonal southerly winds that would fill their sails and take them north, and home. While they waited, they sent out trad-ing delegations and haggled with Africans on the river banks. Tales of theirfannual voyages would have reached across Zimbabwe's Rozwi empire to the ancestors of Chief Hwange, after whom Zimbabwe's largest National Park was named. Hwange is the focus of another beautiful photographic portfolio. Even in Victoria Falls, at Mana Pools and across the Zimbabwean border on the photogenic banks of Lake Malawi, hunters would have stockpiled ivory to trade along the arduous route

to the Mozambican coast. The dhows, heeling over under their signature triangles of patched canvas, are little changed when Gerald finds them again in East Africa. Centuries after the influence of Great Zimbabwe began to decline, and its walls to crumble, these robust vessels still ply their trade in Indian Ocean ports, just one of so many legacies left by those early Arab adventurers.

Before his lens points towards East Africa, he crosses the Mozambique Channel to Madagascar, which is as rewarding to him as the mainland was to those early sea captains. This dazzling portfolio is the result of extensive travel on the massive island.

Madagascar is an astonishing place, largely because of its geological history. The island was once attached to mainland Africa, as part of the ancient super-continent of Gondwana. Ceaseless movement of the earth's crust ripped a huge landmass from Africa's eastern flank, land which would fragment further into Madagascar, which remained close to the mainland, and India which was carried away to the north east. Madagascar's forcible sequestration left an evolutionary legacy found nowhere else on earth. The variety of habitats, ranging from virtual desert to humid forest is matched only by its diversity of species. Most of the plants and animals here are found nowhere else on earth. The baobab tree is almost iconic of Africa, yet, of the seven species on the continent, six are endemic to Madagascar.

In fact very little of Madagascar is reminiscent of the mainland. The plants, the animals, the people and their traditions are rooted in lands far away in either time or space. Even the landscapes are other-worldly; in the south, the eerie spiny bush forest is dominated by peculiar euphorbias and populated by creatures whose ecology is still poorly understood.

Madagascar's environment, so extraordinary, so finely balanced, is retreating under an onslaught of apocalyptic proportions. A growing population, and the inevitable attendant pressures of deforestation and overgrazing, is driving the animals that Gerald has photographed, into ever shrinking refuges. All over the island delicate ecological relationships teeter on the edge of sustainability. The elegant division of food between greater bamboo Lemurs, which prefer stems, and the golden bamboo lemur, which take the tips, is only relevant as long as there is bamboo.

After that it is just history. The photographer's love for Madagascar is a highlight of this book, and a timely reminder to travellers and conservationists alike that the time to think about this vulnerable and irreplaceable biodiversity is right now.

Back on the mainland, he heads for East Africa, pausing in the shadow of Kilimanjaro, the tallest mountain in Africa and the tallest free-standing mountain in the world. His images of Kilimanjaro's high altitudeglaciers capture both a moment and an era; global climate change is shrinking the mountain's icecap so rapidly that it will probably be gone completely within fifteen years.

That won't be true of the Swahili culture of East Africa, epitomised by the coastal town of Lamu. Echoes of influences from outside Africa ring in the gorgeous jewellery, architecture and faces of its people. Today Lamu is a popular tourist destination but northern Kenya, plagued until recently with banditry, is less well known.

It is here the photographer celebrates the pastoral peoples of this semi-desert. Names like Gabra, Pokot, Rendille and Samburu evoke impressions of a physical and political self-reliance that sets these communities apart from other Kenyans. Indeed, in custom and language, these herders often have more in common with their Somali and Ethiopian neighbours than the Bantu peoples of the south. Perhaps best known are the Borana and Turkana, nomadic communities of the perennially drought-stricken far north, who continue to measure their wealth largely by the health of their cows, goats and camels, which they move relentlessly to find forage.

Crossing the equator a second time, Gerald's turns south towards Botswana. Once again he is drawn to a great assemblage of wildlife, this time in the spectacular Okavango Delta. Rising in the highlands of Angola, far to the north west, the Okavango River never makes it to the sea, and dies instead in a verdant blaze of glory in the heart of the greatest desert in southern Africa - the Kalahari. On the ground it is difficult to appreciate that this fabulous natural world is so ephemeral, nourished by seasonal rains falling hundreds of kilometres away. So many creatures are anchored to the myriad waterways, trapped in this vast oasis; water adapted antelope like lechwe and sitatunga, raptors like the fish eagle and Pel's fishing owl. Only its fringes hint at the truth; he finds enigmatic salt pans that fill in exceptional years, but too frequently offer little more than false hope and yet remarkable photographs. The Okavango is the exception that proves the rule, for Southern Africa is a dry place. Just north of the inland delta, Namibia's cartographic anomaly, the Caprivi Strip, shares the seasonal bounty that floods the Okavango, but further west, in Namibia proper, desperately little rain falls. This is the sparsely populated home of hardy wildlife and equally resilient peoples.

Some of the most thought provoking images in this album are of Himba men and women, their traditional way of life still very much evident in Kaokoland. Body adornment is tremendously important in traditional dress, laden with both personal style and societal meaning. Copper necklaces, traditional conch shell pendants and extravagant hairstyles abound; a young flute player's pigtail advertises his unmarried status; a sheen of ochre and scented animal fat gives a gorgeous lustre to a woman's skin.

Inching reluctantly southwards through a nation that clearly captivates him, the photographer revels in yet another magnificent, but quite different, national park - Etosha. Every visitor to Etosha soon realises that to see animals you need to find water. Almost featureless landscapes boil into dusty action as thirsty wildebeest canter to water-holes in the late afternoon. It is not unusual to find giraffe, springbok, kudu, zebra, gemsbok and other species sharing the same pools.

At 20° south of the Equator, Namibia's Skeleton Coast lies at the same latitude as central Madagascar, so far away on this photographic journey. But, where the Indian Ocean is warm, the South Atlantic is desperately cold. Named for the skeletons of ships which litter this treacherous coastline, it could equally refer to the bones of the unfortunates who sailed in them; there is almost no fresh water within walking distance of the sea shore, as the aerial pictures graphically illustrate.

Yet, there is abundance. Vast colonies of cape fur seals thrive on plentiful stocks of fish, themselves nourished by the nutrient-rich cold water which 'upwells' just offshore. The seals have been harvested, often controversially, for many years, but the most valuable resource lies under the sand, not on it. Diamonds have drawn speculators to the coast and southern Namib desert since the early 20th century, and today mining companies have exclusive access to tens of thousands of square kilometres of Namibia's coastline.

Drifting inland for the last push into South Africa, Gerald makes a final foray into a great wildlife theatre, the south-western Kalahari. It seems impossible that so many animals can make a living in such a harsh environment, but live they do, and in sufficient numbers that the Kalahari is famed for its predators; a tremendous variety of raptors, including the long-legged secretary bird, the busy meerkats - hunters and hunted - and, of course, the legendary black-maned lions.

With just a few hundred kilometres to go, the photographer's eye sweeps over impossibly vibrant fields of flowers. No-one who has only seen South Africa's west coast out of season can comprehend the splendour that is painted on its drab canvas each spring. Just a few weeks earlier, or later, and the dry, rocky,

inhospitable landscape would have appeared incapabl of inciting the riot of colour captured in these images.

All along the southern coastline the cold, nutrient-rich Benguela Current fuels an astoundingly successfu food chain; a local wealth of plankton feeds insatiable shoalsof pelagic fish which in turn are feasted on by a number of marine predators, including noisy colonies gannets, cormorants and the unlikely African penguin But, as the journey nears it's end, it is clear that the Atlantic is also sharing its bounty further inshore thar does to the north.

Snows fall on the peaks of the Cederberg mountains and the Western Cape farmlands, that Gerald left behind so many thousands of kilometres earlier, reap-pear. His great photographic trek comes to end where began, in the lee of Table Mountain.

In Afrikaans, the word trek implies something more complex than it does in English, something closer to a quest than a simple journey from one place to anothe The photographer's quest is to capture the essence of his subjects and evoke something special - a sight or sound or a taste - that take his images beyond a simp record of these wonderful destinations.

And for all of us who live on this extraordinary continent, there can be nowhere more captivating and evocative than Africa.

March Turnbull.

Map: BENNI HOTZ 07

Bangui

Yaoundé

Libreville

Congo River

Equator 0°

Equator 0°

Kampala

Mt Kenya

Lake
Victoria

Nairobi

Kigali

Mt Kilimanjaro

Brazzaville

Bujumbura

Mombasa

Kinshasa

Lake Tanganyika

Zanzibar

Dar es Salaam

**INDIAN
OCEAN**

Luanda

Lake Nyasa

COMOROS

Pembe

Hlongwe

Lusaka

Lake
Cabora Bassa

Blantyre

Kaokoveld

Livingstone

Okavango
Delta

Lake Kariba

Zambezi River

Harare

Namib

Tsumeb

*Etosha
Pan*

Beira

Antananarivo

Bulawayo

Makgadikgadi

Francistown

Limpopo River

Swakopmund

Windhoek

Tropic of Capricorn

Tropic of Capricorn

Walvis Bay

Gaberone

**ATLANTIC
OCEAN**

MADAGASCAR

Kalahari

Pretoria

Maputo

Lüderitz

Desert

Johannesburg

Orange River

Springbok

Durban

Namaqualand

West Coast

INDIAN OCEAN

Cape Town

Port Elizabeth

Mogadishu

White Nile

Distance Scale

1:12 000 000
Miles 0 100 200 300 400 500

Regions covered
by the Author

Km 0 250 500 750

Height above sea level :

...res 0 200 500 1000 2000 3000 5000 *above sea level*

0 656 1640 3281 6562 9843 16404 *above sea level*

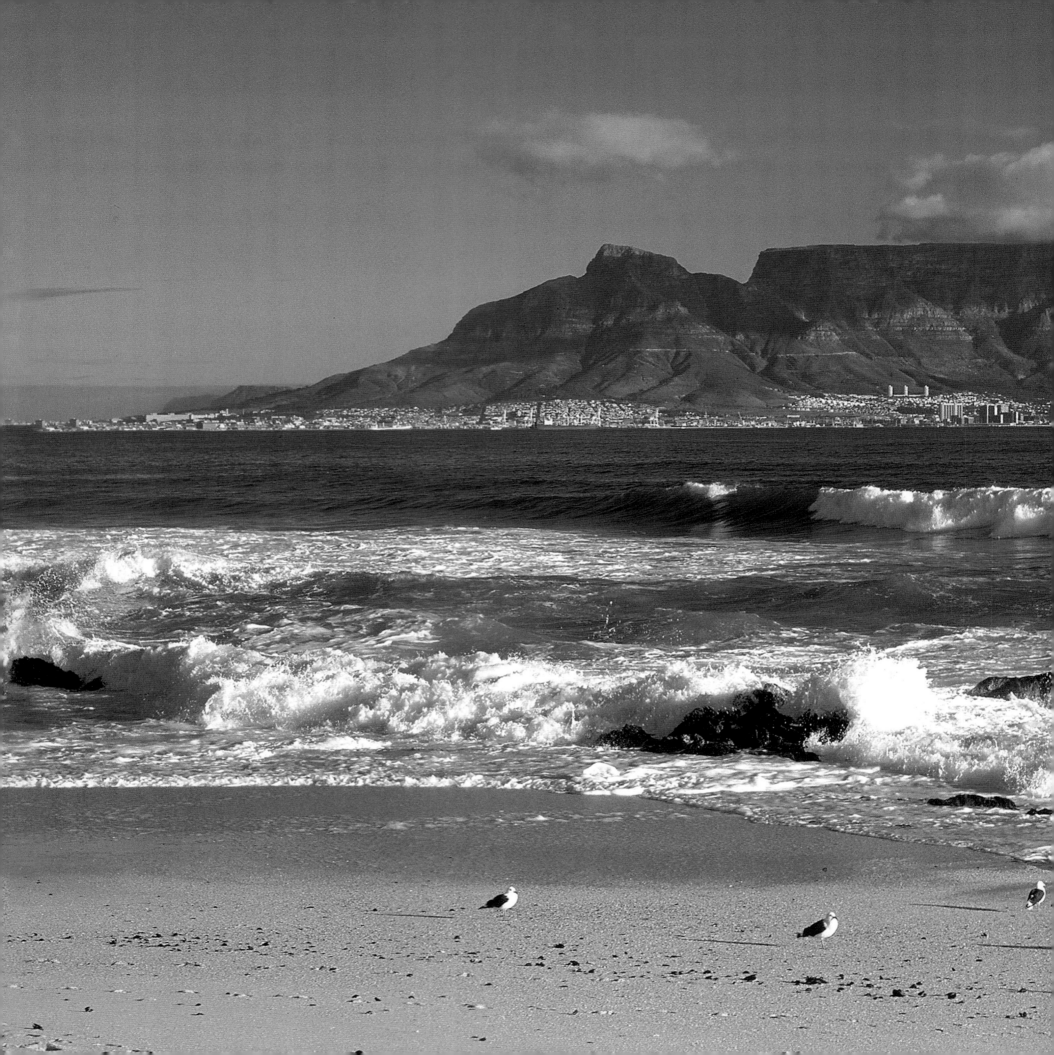

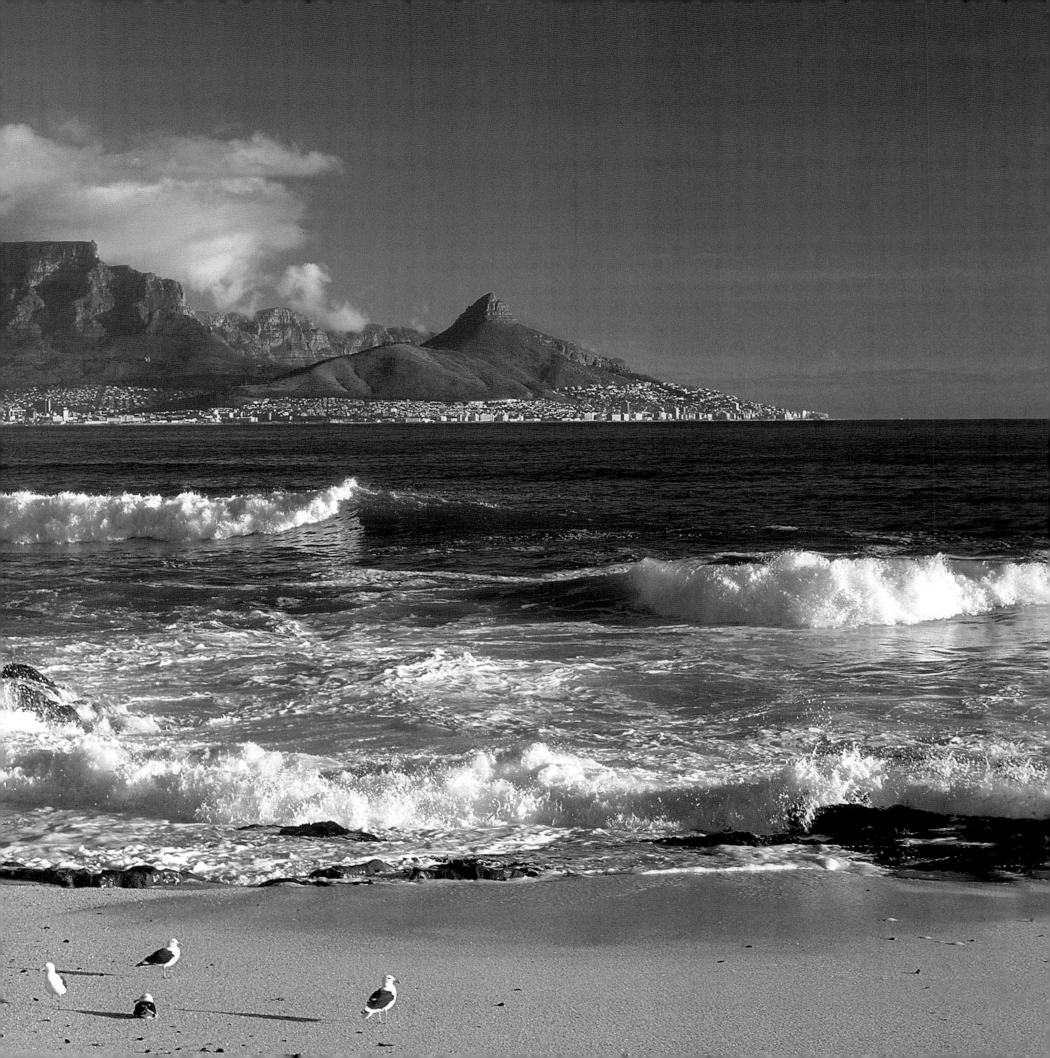

THE SOUTH-WEST CAPE , KAROO, GARDEN ROUTE, EASTERN CAPE & THE WILD COAST

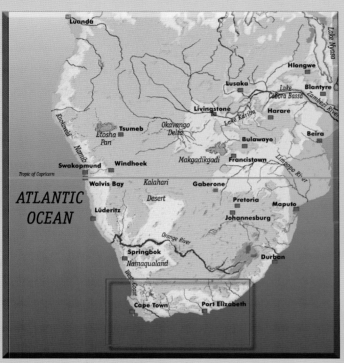

At the southernmost tip of Africa there lies a land rich in contrasts and striking beauty.

Bartholomeu Dias in 1488 was the first seafaring European to round the Cape at the tip of Africa. With good reason he referred to it as the 'Cabo das Tormentas' (Cape of Storms). Subsequently it was renamed by King John II of Portugal as 'Cabo da Boa Esperança' (Cape of Good Hope) due to the optimism generated by the opening of a trading route to the East. Later, in 1580, Sir Francis Drake described the peninsula coastline that confronts the Atlantic Ocean as " ... the fairest Cape we saw in the whole circumference of the earth."

Today the Cape Peninsula is rated as one of the top ten destinations in the world with the iconic Table Mountain (a World Heritage Site) bestowing a spectacular backdrop to the thriving metropolis of Cape Town.

Two great oceans, the Atlantic with its cold Benguela Current, and the Indian Ocean with its warmer current, meet not at Cape Point, but a little eastwards, at Cape Agulhas, the *real* southernmost tip of Africa.

Stretching from coastal cliffs over the hills and mountains, the terrain supports the smallest, yet richest of the world's six described floral kingdoms. Table Mountain alone supports over 2200 species, more than the entire United Kingdom. Of the 9600 species of vascular plants (plants with vessels for bearing sap) found in the Cape Floral Kingdom, about 70% are endemic, occurring nowhere else on earth.

Renowned today for the quality of its wines, The Cape continues a heritage that started over 300 years ago. Throughout the year the vineyards offer a memorable spectacle of the glorious bright greens of summer, so fresh in the early hours and serene and soothing at the approach of dusk; and of the warm russet hues and deep reds of autumn. Latitude 34° S reveals a world of myriad splendours in just one rugged peninsula.

Karoo *kä-roo'*, n. a huge inland pastoral tableland (S. Afr.) etc.

The name is derived from an old Khoi word meaning 'thirstland'. The Little Karoo, located north of the Langeberg and Outeniqua Mountains extends about 320 km from the west at an altitude of 305–610 m. It is separated from the Great Karoo, Western Cape and Eastern Cape by the Swartberg Mountains. A spectacular pass, sometimes snowbound in winter, zigzags up the steep incline of of the mountain with a series of sudden switchbacks, each with breath-taking expansive views.

On the other side: the tranquility of desolation and vast arid plains -
Listen out for the silence -
Watch out for the flowers.

Garden of Eden? Wilderness? Are these still around? Indeed so.

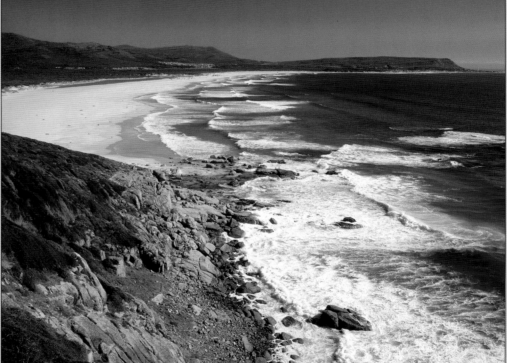

The 'Garden Route' lies between the Outeniqua an Tsitsikamma mountains in north, and the Indian Ocea is a densely vegetated regio a mixture of Cape Fynbos and temperate forest, with the occasional lake and lon stretches of unspoiled whit sandy beaches.

A spectacular coastline, rich in diverse natural beau contrasts dramatically with country's arid interior.

The Eastern Cape and its coast, traditional home o the Xhosa people, is the loc where the original English settlers landed in 1820. The land becomes progressively wetter from west to east as gentle hills eventually form of the mighty Drakensberg.

The landscape is one of ro hills dotted with rondavels, traditional round mud huts with thatched roofs. Subsistence agriculture predominates.

The rugged shores are a fisherman's and scuba diver paradise. Birdlife too, is abundant.

This is a tranquil world— a slow-paced and peaceful world.

Away from the cities, time almost stands still.

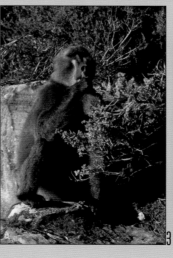

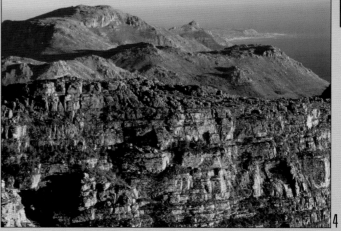

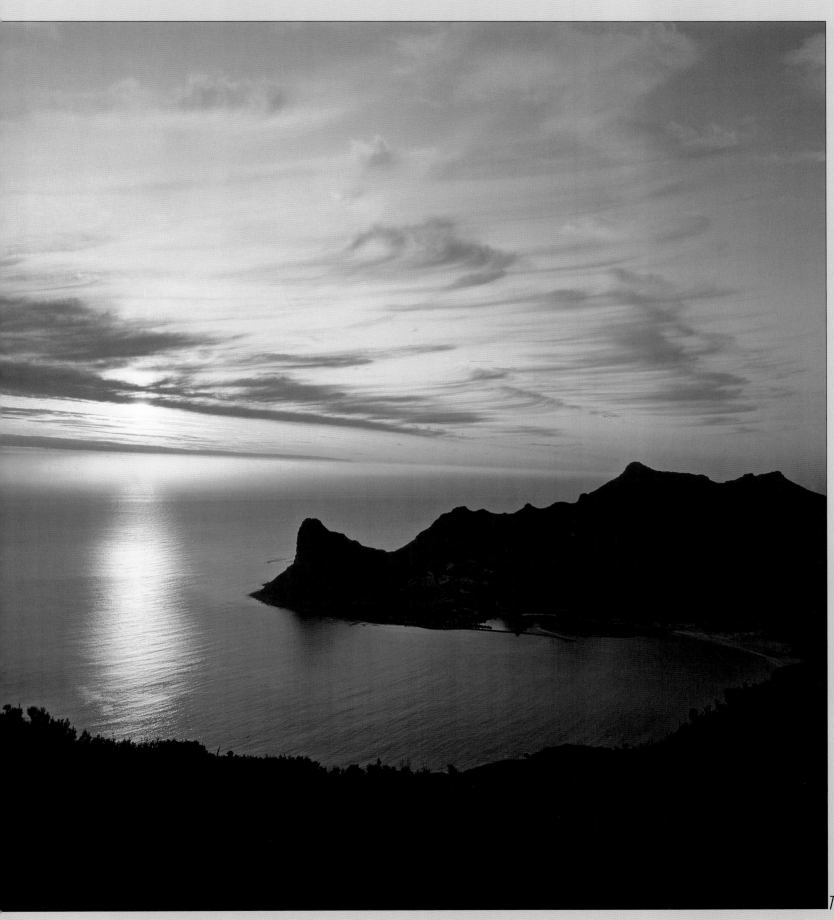

1. Thunberg's stick-insect *Macynia labiata* is widespread in the Western Cape and Eastern Cape. It has a short lifespan of four months.

2. Long Beach, one of the most beautiful beaches in the Peninsula.

3. A Chacma baboon *Papio ursinus* seen feeding on fynbos. The most distinctive feature of the Cape baboon is its long, downward-pointed face. Males have canines as long as 3 cm (longer than a lion's). Usually found in social groups of multiple adult males, females, and offspring, baboons possess a complex group behaviour and communicate by means of body attitude, facial expression, call and touch. Widespread elsewhere, in the confines of the Cape Peninsula the species is listed as Threatened under CITES (Convention on International Trade in Endangered Species) due to habitat loss and conflict with humans.

4. View from the top of Table Mountain to distant Long Beach and Kommetjie.

5. Fynbos in the Cape of Good Hope Nature Reserve.

6. *Polygala bracteolata* on the slopes of Constantiaberg, Cape Peninsula.

7. The sun lingers on the horizon as Sentinel Peak guards the entrance to Hout bay.

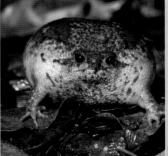

8. A Cape rain frog *Breviceps gibbosus* stands puffed up in defensive posture. It is a vulnerable endemic, mainly due to loss of habitat. It inhabits sandy regions of the Cape Flats, around Table Mountain and the surrounding suburbia.
It can be heard calling when rain starts to fall. Strangely, it never frequents water.

1. An orange-breasted sunbird *Anthobaphes violacea* endemic to the south-western Cape, perches on a sprig of *Erica versicolor* in the Cape Peninsula.

2. A defensive cluster of Cape lappet moth *Pachypasa capensis* caterpillars.

3. The red disa *Disa uniflora* an orchid endemic to Table Mountain, is the floral symbol of the Western Cape.

4. The breeding males of the malachite sunbird *Nectarinia famosa* develop a striking metallic green iridescence.

5. The Cape dwarf chameleon *Bradypodion pumilum* uses its sticky tongue, twice its body length, to catch unsuspecting insect prey.

6. Named the national flower in 1976, the king or giant protea *Protea cynaroides* is the pride of South Africa. It is endemic to the south-western Cape.

7. The Cape robin *Cossypha caffra* is a common garden species in the Peninsula. It is also widespread in forested areas throughout the country.

Not really a robin at all, it is in reality a chat. This misnomer arose in colonial times wherever English people settled. The first bird they looked for was one that resembled the familiar English robin redbreast.

8. A Cape weaver *Ploceus capensis* 'displays' exuberantly to attract a female to its newly constructed nest.

9. A hunting spider, *Palystes* sp., at its nest.

10. The African olive pigeon *Columba arquatrix*. By far the largest of its family, it is conspicuous with its yellow feet and bill.

Far right: 11. A Cape sugarbird *Promerops cafer* perched on one of its favorite plants, the pincushion protea *Leucospermum cordifolium*. This is a specialist nectar feeder which uses its long, sharp beak and brush-tipped tongue to reach the nectar of a variety of protea species.

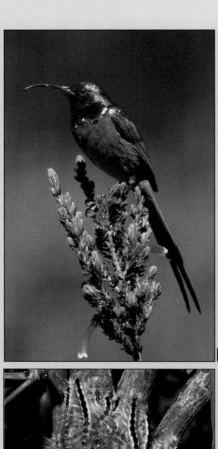

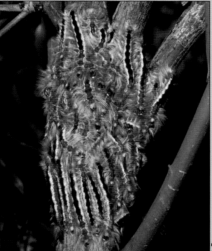

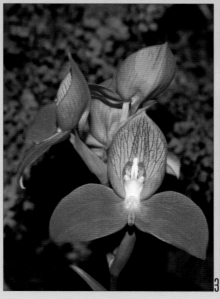

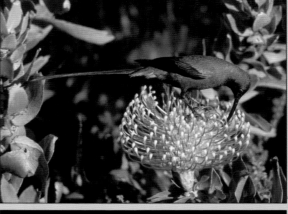

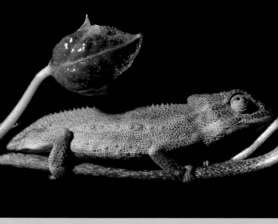

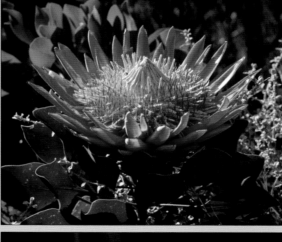

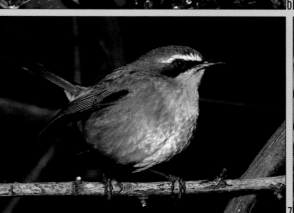

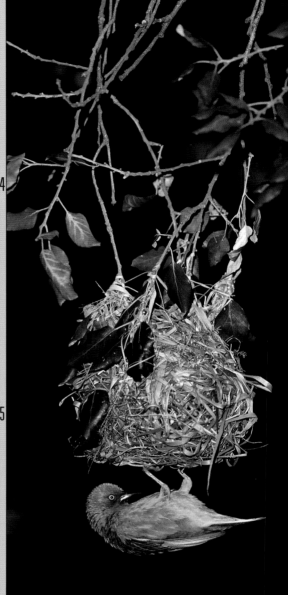

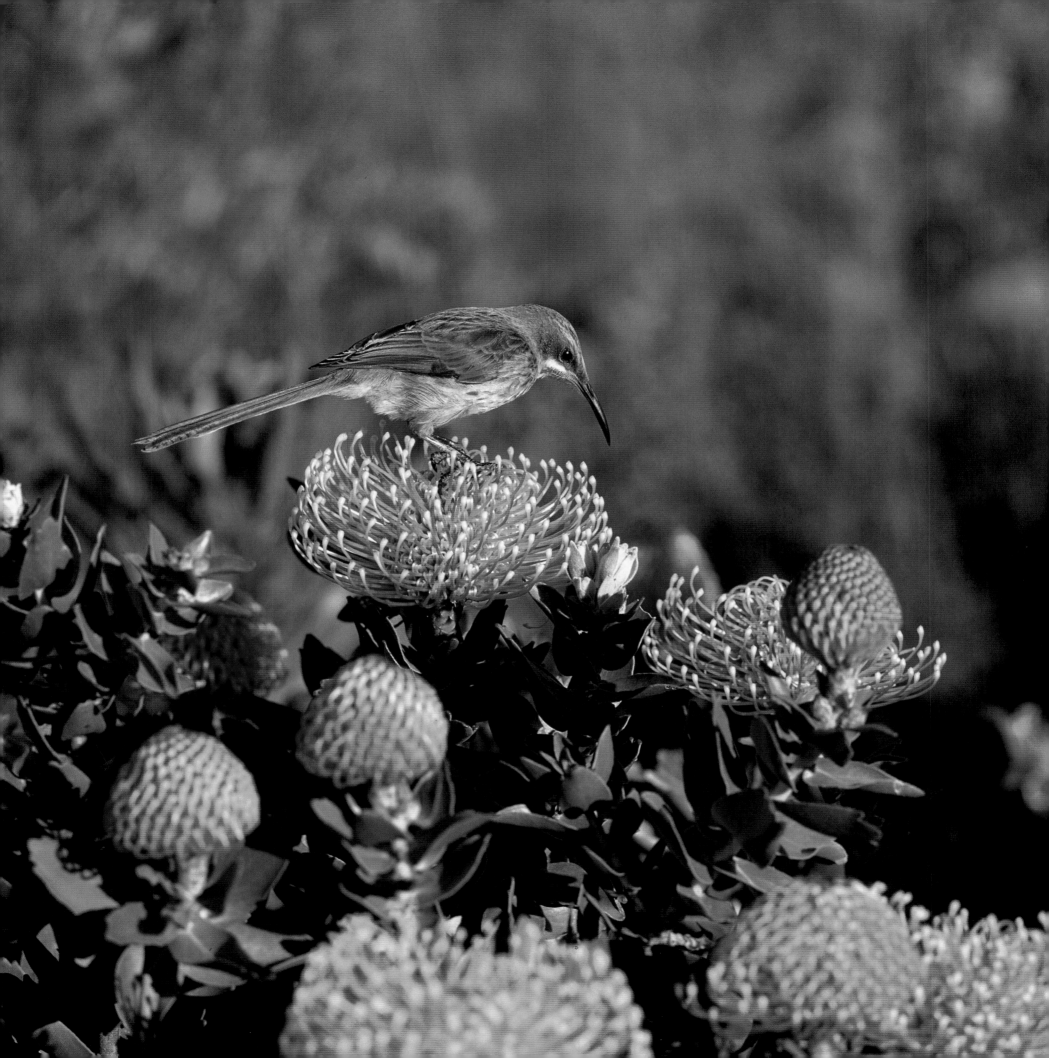

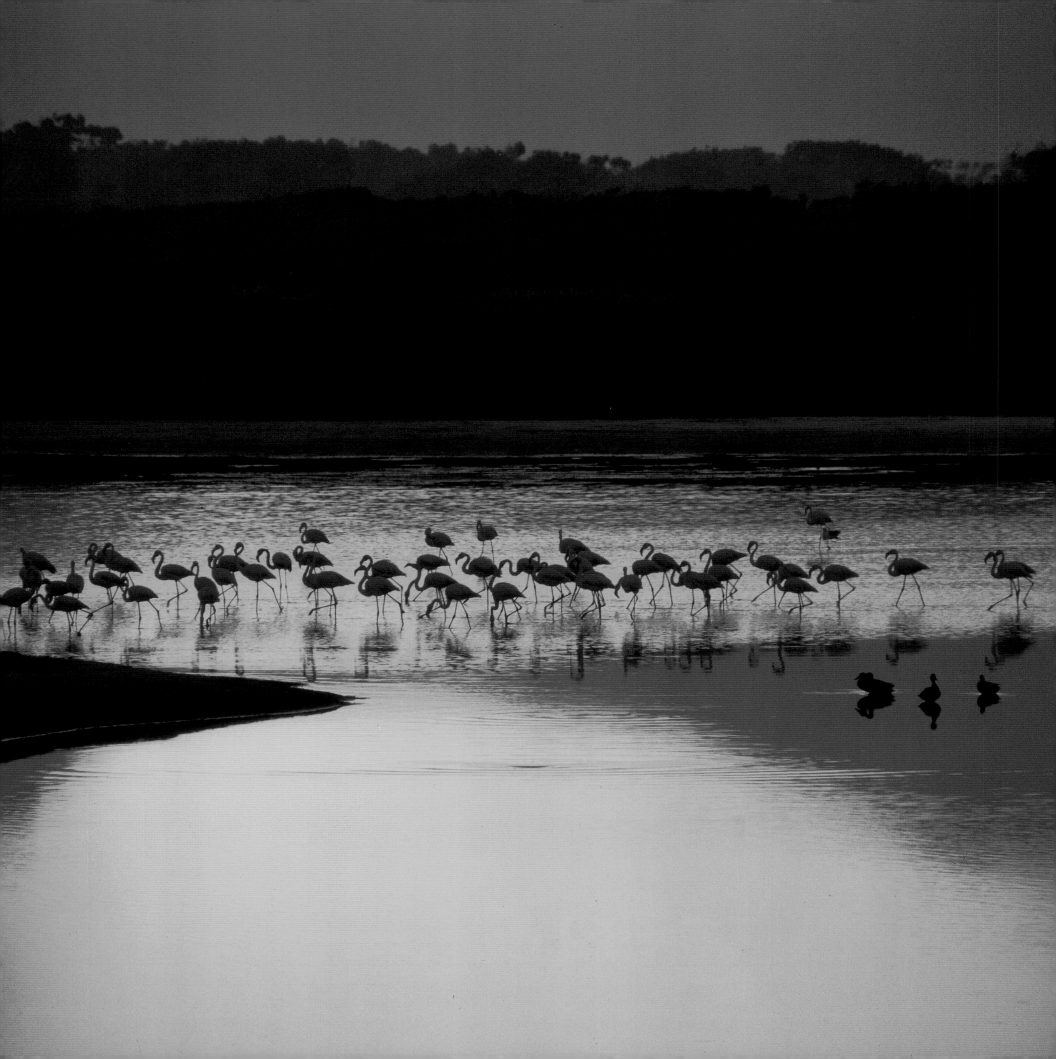

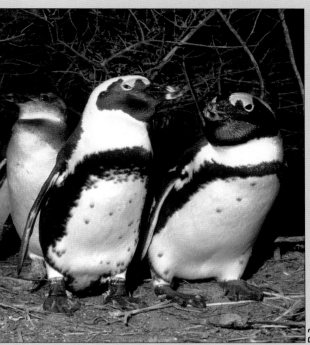

As the day draws to a close the golden rays of the sun reflect across the nutrient-rich waters of Rondevlei Sanctuary on the Cape Flats, where a flock of lesser flamingoes *Phoenicopterus minor* feed peacefully. (***Far left*** 1.)

Flamingoes are gregarious birds, sometimes congregating in huge flocks of many thousands at sites where high alkalinity prevails. Here they feed mainly on spirulina (blue-green algae), diatoms, and small invertebrates which are filtered through their specially adapted beaks.

Despite being the most numerous of the flamingo family, lesser flamingoes are classified as Near-Threatened due to declining populations and the low number of breeding sites. Some of these are seriously threatened by human activities, such as at Kamfers Dam outside Kimberley, where the only breeding population of the species in South Africa is exposed to a poorly planned housing development scheme, as well as water pollution from a nearby dysfunctional sewerage plant.

2. A pair of now Endangered African Penguins *Spheniscus demersus* in defensive posture with their chick. The species is monogamous with an average lifespan of ten years.

3. At Boulder's Beach on the Cape Peninsula the penguins established a breeding colony in the 1980s, probably due to the reduction of predator numbers in recent years. It is now a reserve. This is one of only two mainland colonies, the only other situated in Namibia. Elsewhere the penguins breed at various locations along the south-western coast of Africa, nesting on 24 islands between Namibia and Algoa Bay. Over the past century numbers have plummeted by 90% due to the practice of egg collecting during the earlier years, the removal of guano for fertiliser from their habitual offshore breeding islands (which affected nest burrowing), scarcity of food around colonies due to competition with commercial fisheries for sardines and anchovies (their main food source)—and generally from ever-increasing coastal pollution, especially oil spills from ships rounding the Cape.

One significant incident occurred on 23 June, 2000, when the iron ore carrier MV *Treasure* sank between Robben and Dassen Islands, oiling 19 000 adult penguins at the height of the best breeding season on record. A further 19 500 uncontaminated birds were removed from Dassen Island and other areas before they could become oiled in what has been described as 'the largest animal rescue event in history'.

Current trends are today a serious cause for concern. Overall it has been estimated that numbers have plummeted over 60% since 2004.

Since monitoring started in 1956 on Dyer Island (about 8 km offshore from Gansbaai), one of the principal colonies, the population has nose-dived by 40%. According to the *Dyer Island Conservation Trust* there were then 4000 breeding pairs recorded on the island. In 1979, this increased to 22 655 pairs, representing 55% of the entire Western Cape's penguin population. Since then, there has been a steady decline, and in 2007 only 1513 pairs were counted, a 93% decline in 30 years.

At Boulders Beach the penguins have habituated themselves to the hazards of living in close proximity to humans.

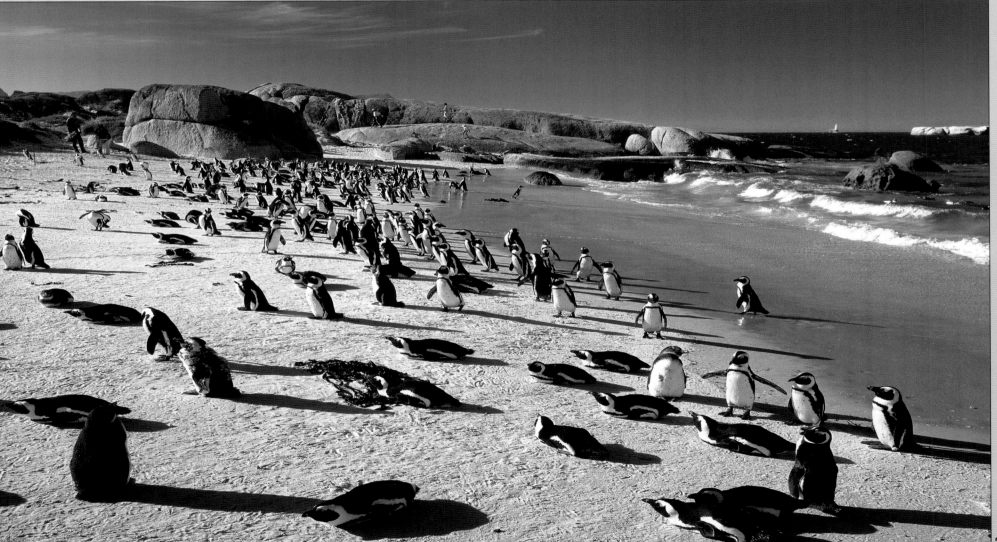

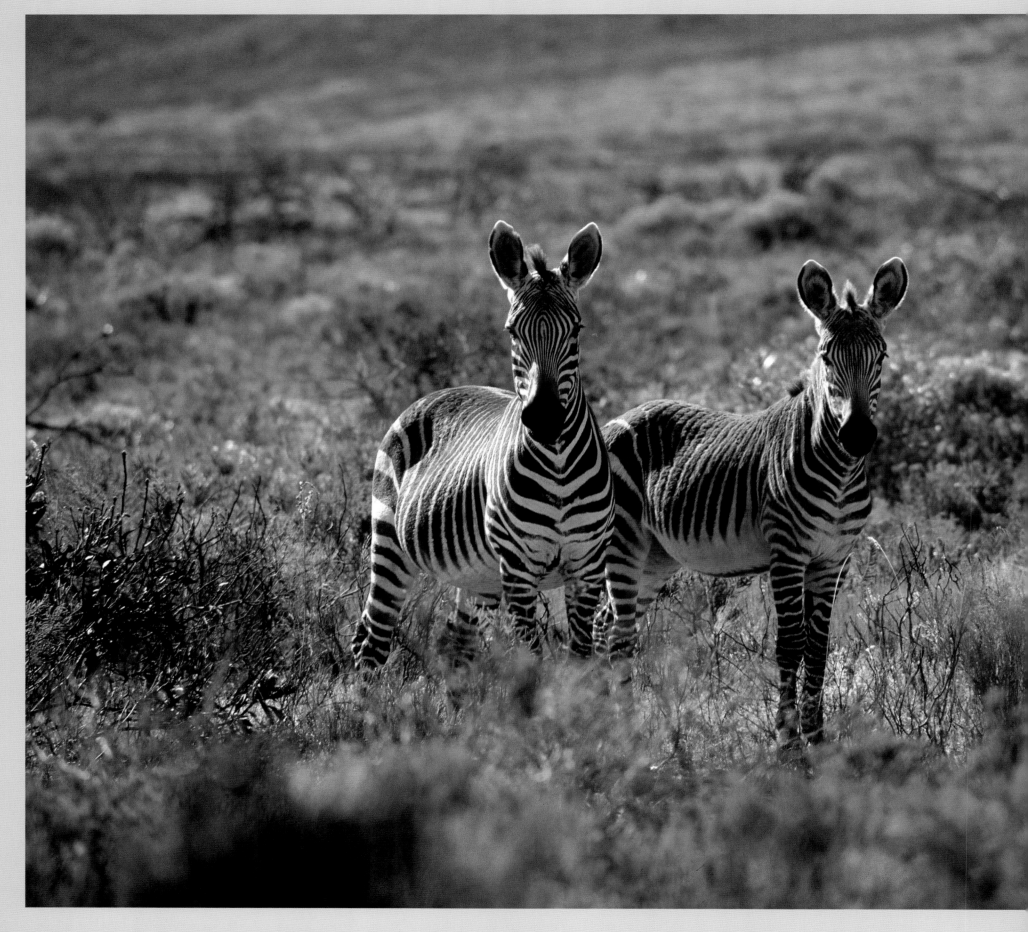

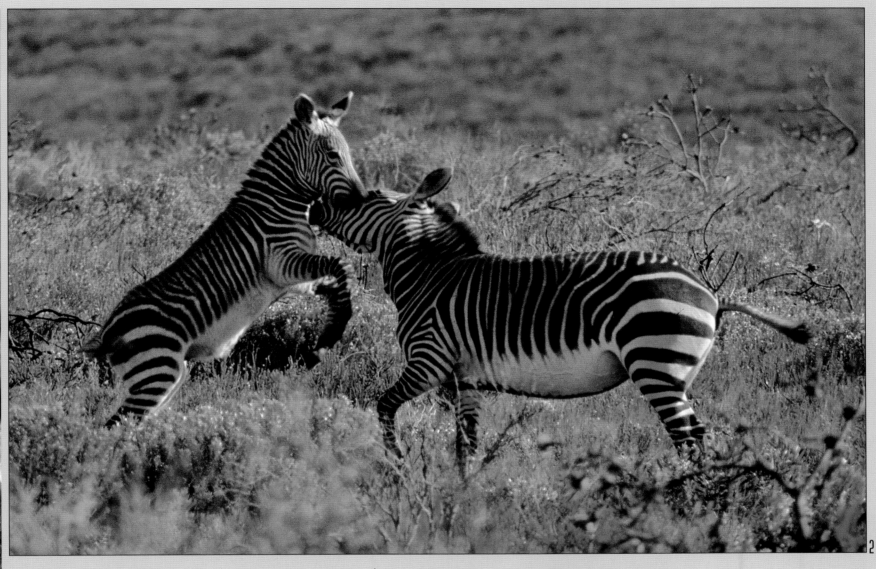

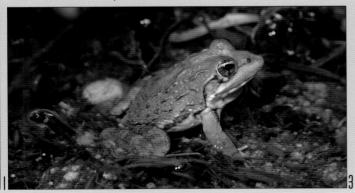

D e Hoop Nature Reserve, some 260 km from Cape Town along the Western Cape shoreline, is one of the largest natural areas managed by *CapeNature* and covers 340 km² of fynbos. Fynbos is a vegetation group confined to nutrient-poor soils in the winter-rainfall areas of the Western Cape. Adapted to fire and drought it is defined by four growth forms: 1) proteas – tall shrubs with large leaves; 2) ericas – heath-like shrubs; 3) restios – wiry, reed-like plants, always present; and 4) geophytes – bulbs that store moisture in fleshy underground organs. It provides the ideal habitat for some of the 86 protected mammal species. Amongst these the rare bontebok and Cape mountain zebra.

1. Cross-lit in the crisp morning light, a pair of Cape mountain zebras *Equus zebra zebra* pose in typical fynbos surrounds.

2. Two stallions spar aggressively with each other. In the wild, their lifespan extends from 20 to 30 years. Mares reach sexual maturity in two to four years. Males however mature after four years. Sparring occurs when gathering females for breeding. Rival stallions compete fiercely by kicking and biting. Once the victor establishes his harem, ownership is rarely disputed unless the male becomes unfit.

This zebra species formerly inhabited all the mountain ranges of the southern Cape Province. By 1922, however, only 400 were believed to survive. To counteract the continued decline, the Mountain Zebra National Park was established in 1937 on acacia veld near Cradock, but its small population became extinct in 1950. Reintroductions from nearby remnant populations subsequently took place. By the late 1960s, the total population was only 140 but this grew to 200 by 1979. By 1984, the numbers were back to 400. Since then a few zebras have been reintroduced to other parks.

3. The Cape river frog *Rana fuscigula* also known as the dusky-throated river frog, prefers large, still bodies of water where it calls from the deep supporting itself on floating vegetation.

4. A male malachite sunbird in breeding plumage. The male has extended central tail feathers whilst the female's tail is square-ended.

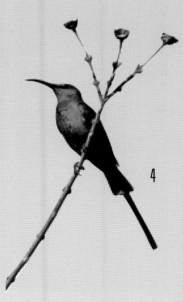

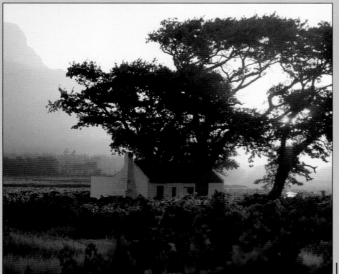

Moving inland the scenery changes. Fynbos growing in the acidic coastal periphery gives way to rich soils on the slopes of the mountain ranges. With a Mediterranean climate, ideal conditions are provided for viticulture and deciduous fruit.

Jan van Riebeek, founder of Cape Town, produced the first wine recorded in South Africa, on the 2nd February 1659. A few years later the historic Constantia estate was established by Simon van der Stel, Governor of the Cape at the time. By 1778, it's then owner Hendrik Cloete had placed Cape wines firmly on the map. His blend became a favourite tipple of European kings and emperors, from Frederick the Great to Napoleon.

The initial settlers of the Cape were primarily Dutch, and they brought with them their distinctive architectural style. Modelled on the townhouses of Amsterdam, these homes developed prominent gables. In the Cape they evolved through U-plan, T-plan and eventually into an H-shaped homestead, all with white-washed walls and thatched roofs.

1. An old Cape Dutch cottage in the Franschhoek district takes on a romantic mood as evening settles over the valley.

2. Vineyards in the Franschhoek region. The Farmhouse is a modern variant on the traditional Dutch architectural style.

3. Unique to the species, the Ground Woodpecker, *Geocolaptes olivaceus*, is as the name implies, a ground dweller. Usually seen in small groups hopping around the terrain, it occasionally alights on sturdy shrubs.

4. 'Still-life': Wine cask with cockerels. Farmers' wives in rural areas often spend time decorating and gardening. Whatever comes to hand, sometimes centuries-old artefacts, are used to create an atmospheric ambiance.

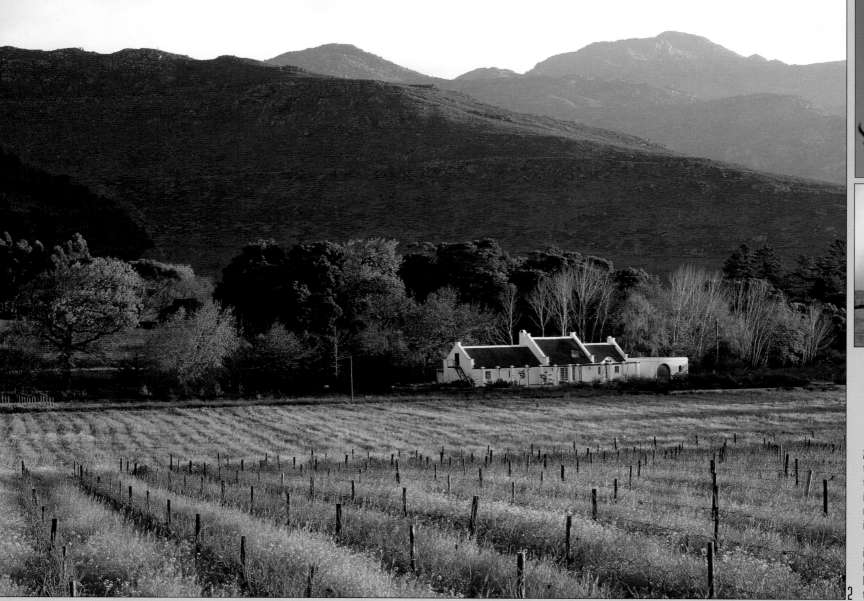

Right: 5. Vineyards show off their glorious autumnal hues the Hex River valley. This valley is dominated by the Hex River mountain range, glinting here in the early morning sun.

The Matroosberg (2249 m) is the highest peak and a familiar sight on the main N1 route travelling north towards the Great Karoo.

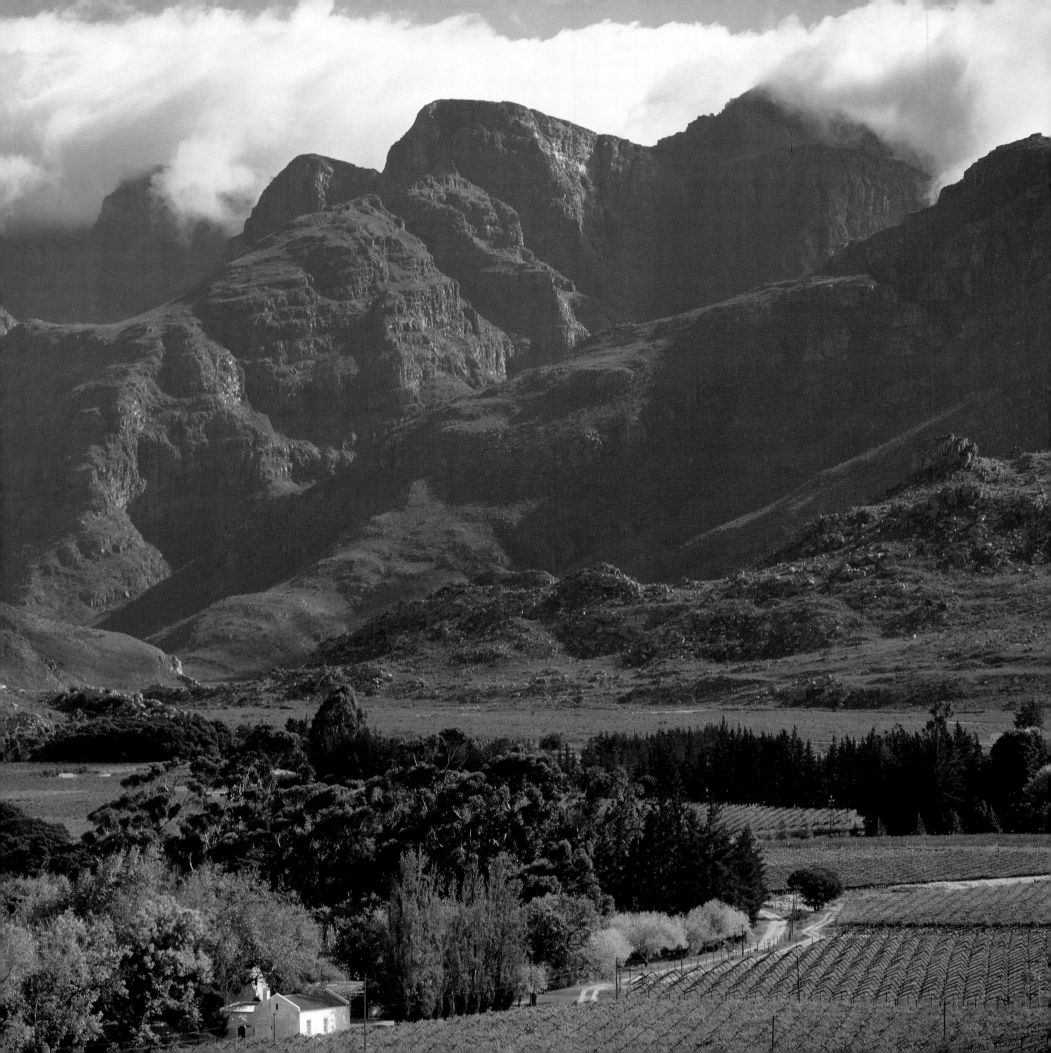

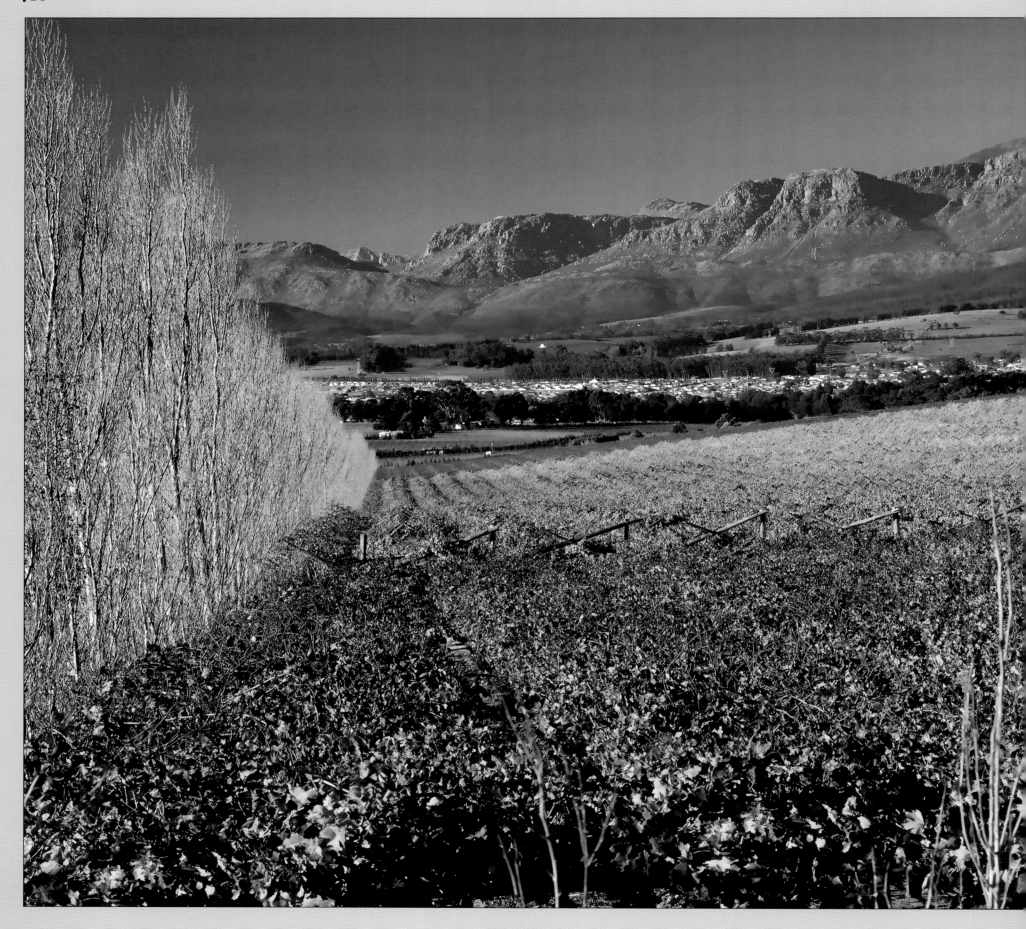

eyards in the Paarl Valley
estle between Paarl
ntain and the towering
bitskloof Mountains.
he Berg River gently flows
ugh the valley, giving
aining waters to the
ards, deciduous fruit
ards and olive groves.
tward lies the 'Overberg'
er the mountain range'),
nging landscape of hills
valleys, flanked to the
by a spine of mountains.
3. Local children in
ton, a 200-year-old
village, that is today a
nal Monument.
heep graze peacefully in
land of wheat, rye and
canola fields. The last, a
ar of rapeseed, is used to
uce edible oil.
ich verdant farmlands in
Caledon district after
rains. Following the
al harvest, the scene
ges dramatically to one of
ureless browns and ochres.

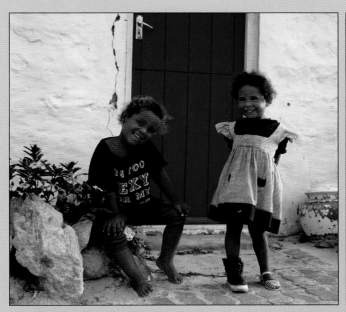

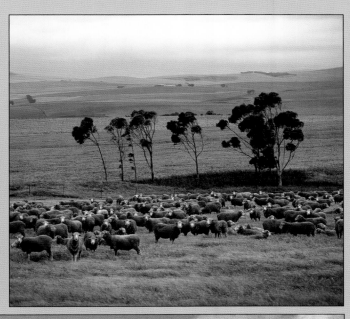

e blue crane *Anthropoides
disea* is South Africa's
nal bird. It is a tall
nd-dwelling species about
metre high. It prefers the
uplands of the region
re it feeds on seeds and
cts.
is crane is an altitudinal
ant, nesting in upper
slands in summer
moving down to
r altitudes in winter.

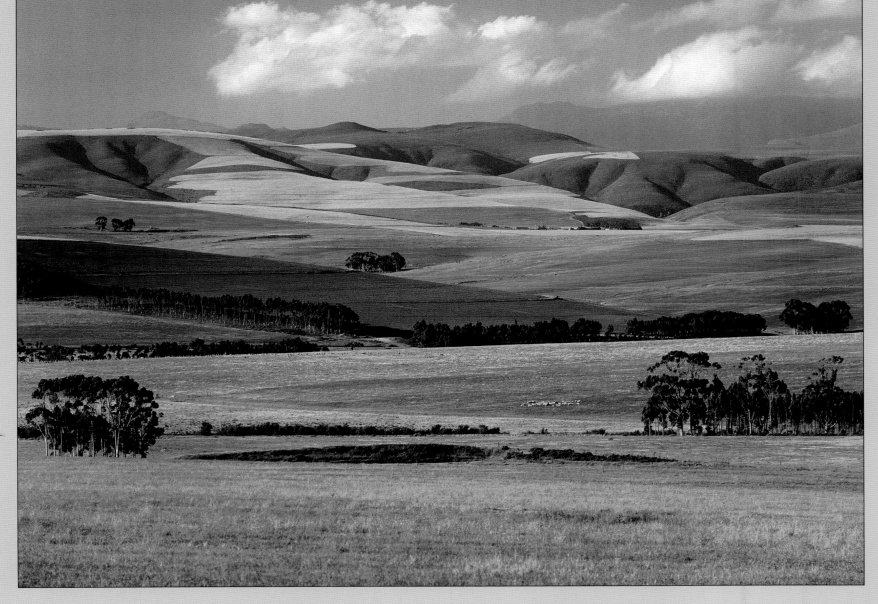

6

1. The swallowtail butterfly *Papilio demodocus*, widely known as the 'citrus' or 'Christmas' butterfly, is a common sight often seen flitting from bush to bush or tree to tree in a garden or hillside,

2. *Oxalis hirta*.

3. The Prince of Wales heath *Erica perspicua* a Cape fynbos species, occurs in damp regions in the Caledon district. Colours vary from pure white through rose to almost purple.

4. Indigenous to the sandveld of the Cape, the 'red Afrikaner' *Homoglossum priorii* flowers in May. Here it is surrounded by the leaves of *Colpoon compressum*, a shrub which flowers erratically throughout the year.

5. This red 'vygie' *Lampranthus roseus*, is a member of a genus of perennial succulents that varies in form from creeping ground-cover to a large rounded bush. The flowers only open in full sunlight.

6. *Erica bauera*, known as bridal or albertinia heath, flowers throughout the year.

7. The bloodroot plant *Dilatris pillansii* is one of four endemic species. It stands on a fan-like base of rigid leaves with the flower head on a stem about 300 mm high. After a fire the plant blooms in abundance.

8. The marsh rose *Orothamnus zeyheri*, the only species of the genus, is a rare gem of the protea family. The name derives from the Greek 'mountain branch'. It is a tall erect shrub, some 2,5 m high, surmounted by droopy flowerheads.

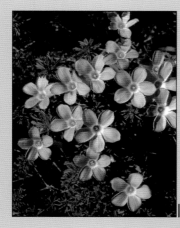

Far right: 9. *Helichrysum vestitum* is a member of a large genus, with many indigenous species in southern Africa. Here, in the Salmonsdam Nature Reserve, it is surrounded by pink everlastings *Phaenocoma prolifera* and yellow daisies of the *Ursinia* genus.

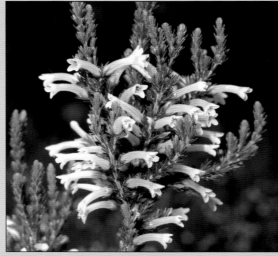

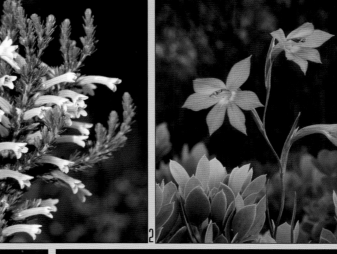

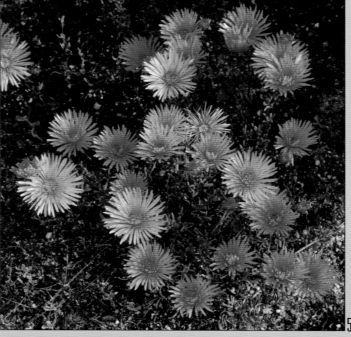

EVOCATIVE AFRICA

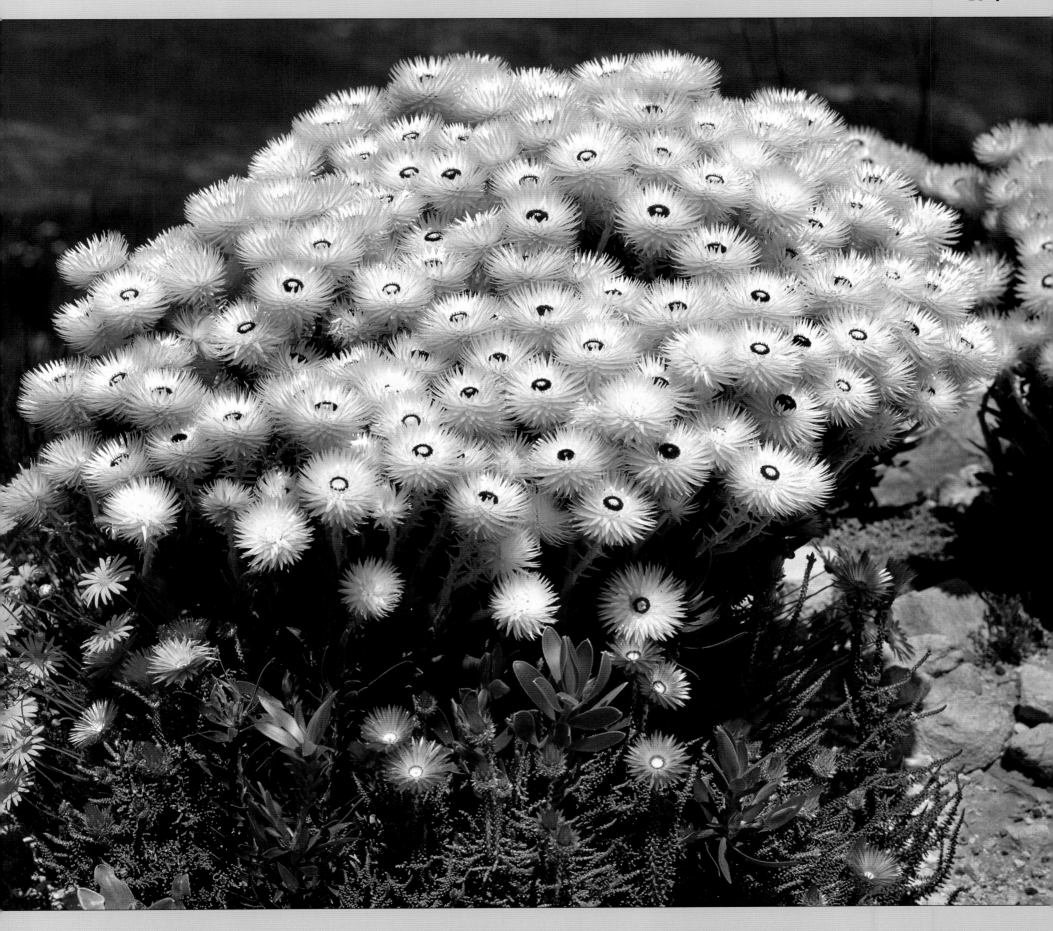

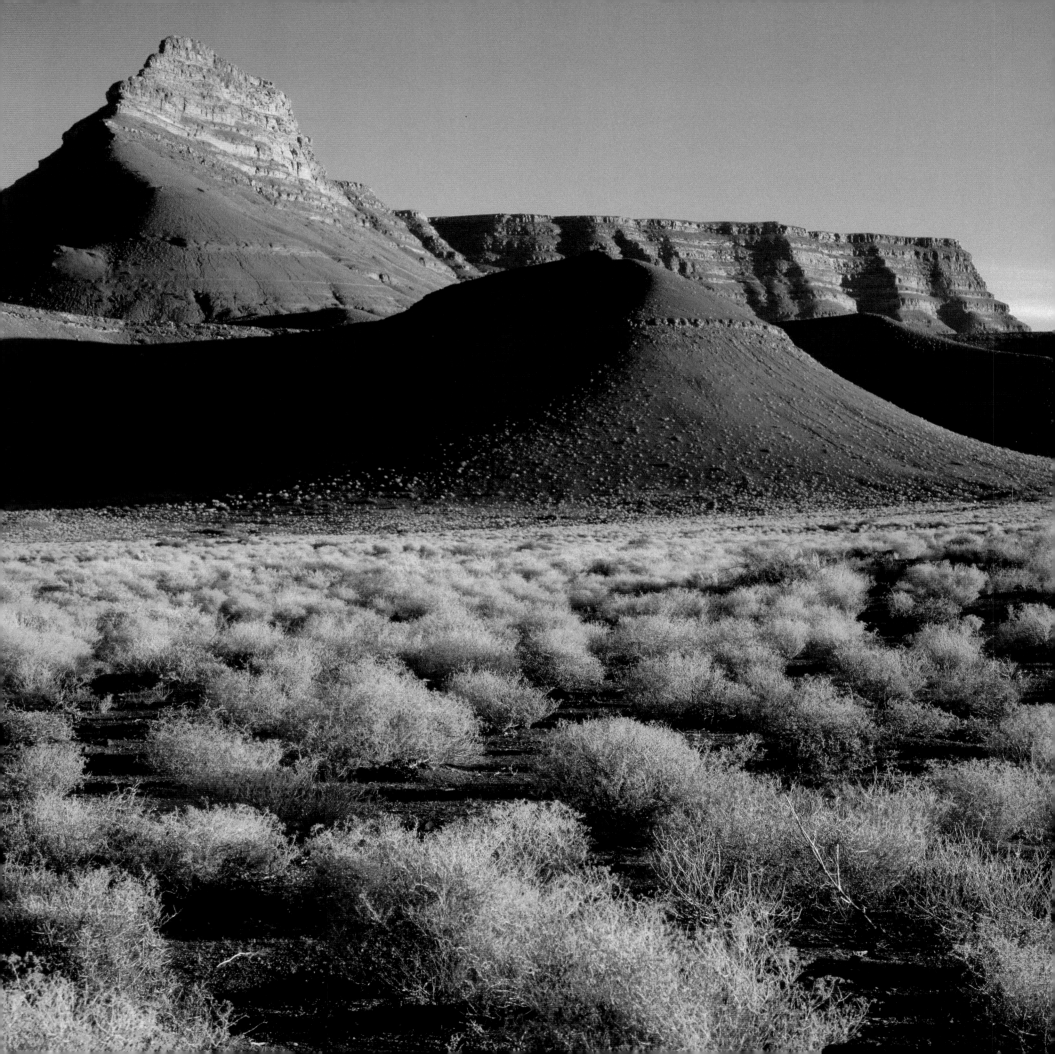

...rossing the mountain spine, moving north inland away from ...the coast, the scene changes dramatically. The fertile coastal ...phery gives way to an arid dry land and bare river beds which ...after occasional flash floods. This is the Great Karoo plateau ...lies between 600 and 900 m in altitude.

...st open vistas can be lonely but they have a haunting beauty ...atmosphere of their own. Endless plains and blue mountains ...rle. The blazing summers juxtapose with icy winters where ...wild winds fade to pure silence.

...this vast inland basin, embracing 400 000 m², volcanic ...vity took place on a titanic scale. At one stage the region was ...ated. At various later periods great inland deltas appeared as ...as seas, lakes and swamps. Huge deposits of coal were laid

down at this time. Yet, as one source says, "Despite this baptism of fire, ancient reptiles and amphibians prospered in the wet forests and their remains have made the Karoo famous amongst paleontologists."

Today the region barely sustains sheep farming, but in days gone by it supported vast herds of springbok, zebra and many other animals. In his book *Karoo*, (published by Howard Timmins), Lawrence Green quotes a first-hand description of the migration of a huge springbok herd. The Bushman guide gave a warning hours before anything was seen or heard, then " At last came a faint drumming... a cloud of dust dense, and enormous... they were in such numbers that Gert found the sight frightening. He could see a front line of buck at least three miles long...Within an hour the

main body of springbok had passed, but that was not the end of the spectacle. Until long after sunset, hundreds upon hundreds of stragglers followed."

Sadly this is no more, but today, just outside Beaufort West, the Karoo National Park has been established. Here, previous indigenous species have been reintroduced. These include black rhino, buffalo, black wildebeest, eland, red hartebeest, kudu, springbok and Cape mountain zebra. The park, moreover, provides sanctuary for sundry lesser creatures including five tortoise species. Twenty breeding pairs of Verreaux's eagles have re-established their territory in the region.

1. This typical Great Karoo landscape shows the water and glacial patterns of eons ago. In the foreground, catching the setting sun and reflecting the peacefulness of the Karoo, the veld is carpeted with kraalbos (also known as 'geelbos' and 'perdebos') *Galenia africana* here seen in winter dormancy. This Karoo vegetation is most common on the western and southern fringes where it is an active invader, often in disturbed and over-grazed lands. *Galenia africana* is used to treat venereal sores, wounds, eye infections and skin diseases, but it also contains still unknown liver toxins that cause 'waterpens', cardiomyopathy (a chronic disease of the heart muscle) and liver fibrosis.

2. A gradually disappearing scene in the Great Karoo: a family's mule cart travels a lonely farm road.

3. Sundry implements stacked against a farmhouse wall portray a typical Karoo cameo.

4. The Karoo after good spring rains. As far as the eye can see purple mesembryanthemums *Ruschia* sp. in full bloom carpet the familiar semi-arid veld.

5. An orb spider *Argiope* sp. spins an almost invisible web. Like most other spiders in southern Africa, it is completely harmless to humans.

6. *Phymateus morbilosus,* a large grasshopper with relatively small, non-functional wings.

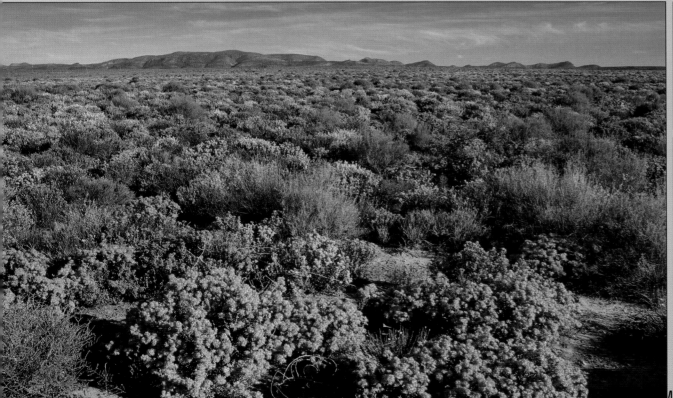
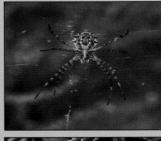

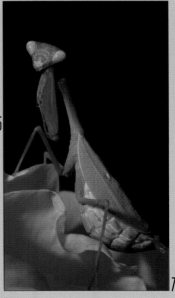

7. The praying mantis *Cilnia humeralis* is a skilled ambush predator. Exclusively carnivorous, it feeds on anything suitable that passes: other invertebrates, spiders, crickets, grasshoppers, butterflies, even small chameleons, lizards, frogs, snakes and mice.

The Karoo takes on many guises, from the harshness of midday sun to the slowly softening palette of pastel shades of pink and blue that deepen as the day draws to a close, setting the wild canvas ablaze with glorious hues of red, orange and yellow.

This is the largest ecosystem in South Africa and, although the most arid, it is home to a fascinating diversity of life. Apart from mammals and birds, there are more than 9 000 plant species in the Great Karoo.

1. The Cape porcupine *Hystrix africaeaustralis* is southern Africa's largest rodent. It can weigh over 30 kg. Contrary to myth, it does not 'shoot' its quills; but when attacked, freezes. If cornered, it will turn vicious and charge backwards, repeatedly stabbing the attacker.

2 Winter Karoo grasses in the Sutherland district.

3 The Rhombic night adder *Causuas rhombeatus* is a venomous viper some 60 cm in length. Mostly docile, it seldom attempts to bite unless severely provoked. Usually found on the ground, it can however climb and swim with ease. Mainly nocturnal, it is occasionally seen basking in the early morning or late afternoon sun.

4. *Drosanthemum bicolor* is a short-lived plant, the leaves of which contain prominent water cells that glisten in the sunlight. The flowers open only on warm, sunny days and close in the evening.

5. Quiescence and tranquillity reign supreme in the Klein Swartberg Mountains. This range exceeds 2000 m throughout, making it the highest in the Western Cape. Geologically it forms part of the Table Mountain group with sandstone strata rock formations. Rock folds in the narrow passes reach for the skies– evidence of dramatic volcanic forces that formed these mountains. The mountains provide a wild habitat for grey rhebuck, klipspringer, baboons, jackals, dassies, and the occasional leopard.

The spectacular Verreaux's eagle and more than 130 bird species have been recorded.

Far Right: 1. Outside Graaff-Reinet lies a unique Karoo landscape and ecosystem that created an oasis in the midst of the aridity of the Karoo. This is the Valley of Desolation, a geological phenomenon formed eons ago. Heat and cold, together with drought and water, made the rocks crumble to form bizarre formations. Sheer cliff faces and columns of dolerite stand guard, teetering precariously 120 m above the valley floor. In 2005 the Valley was included in the Camdeboo National Park.

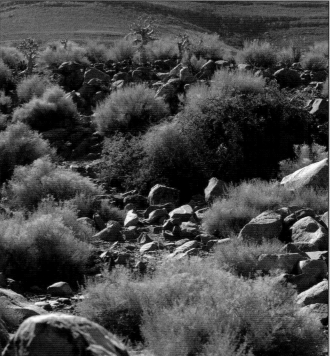

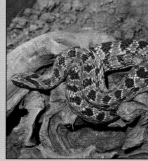

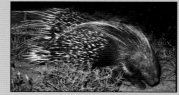

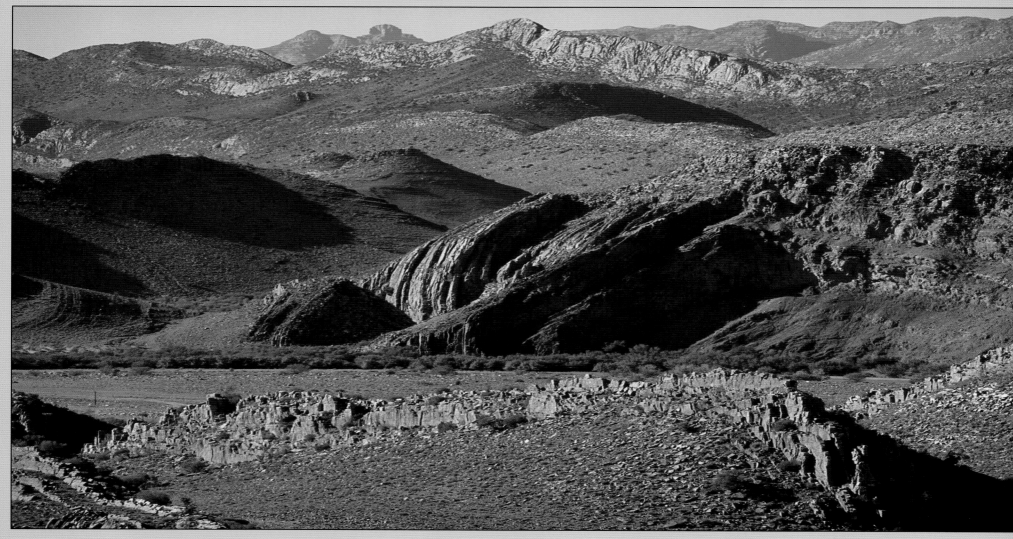

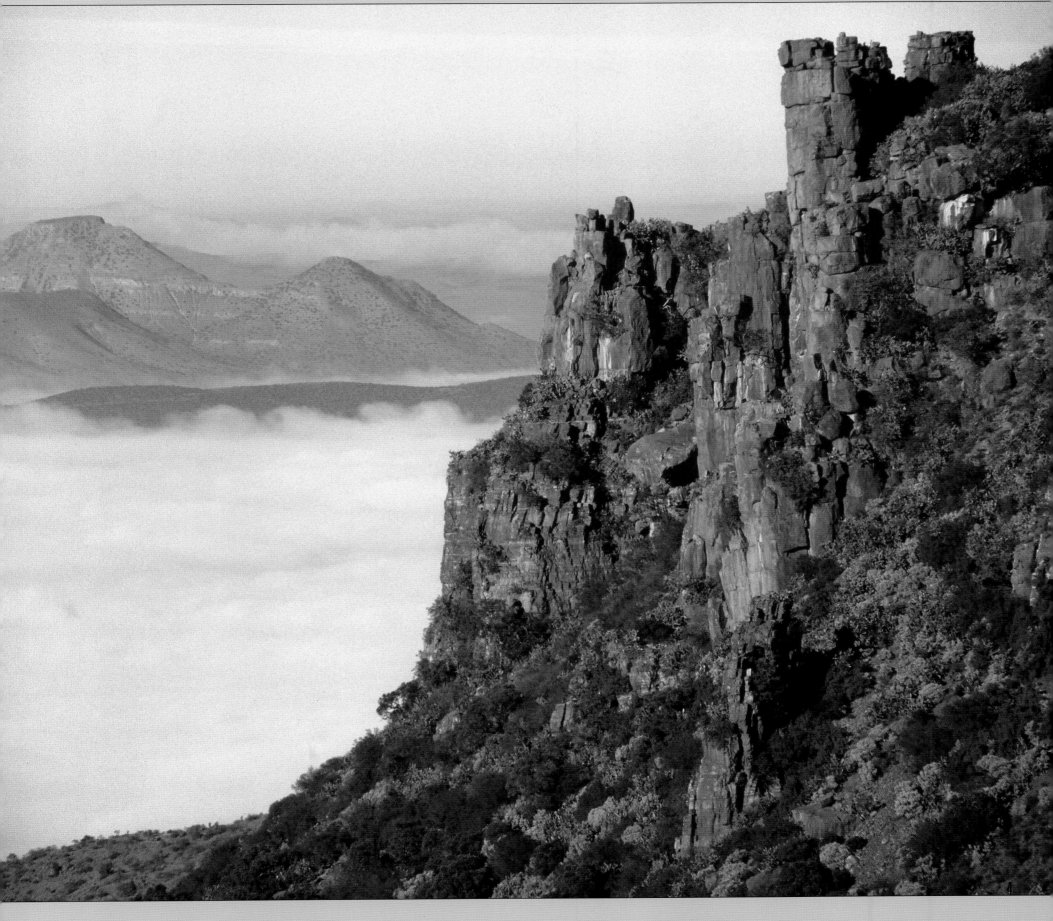

KAROO

A swathe of majestic mountains stretches along the southern Cape coastal belt. Here two distinctive ranges run roughly east–west along the northern edge of the semi-arid region known as the Little Karoo. The Swartberg separates this region from its northern neighbour, the Great Karoo and, in the south, lies the Langeberg. Rivers and tortuous mountain passes dissect the terrain with spectacular effect.

This is prime habitat for the candelabra-shaped *Aloe ferox*, a widespread succulent. This aloe is common on rocky hill slopes where it sometimes occurs in large numbers, creating a stunning winter display. To the south it features in the more grassy coastal fynbos.

Known as bitter aloe or red aloe, the plant is famed for its diverse medicinal uses. The bitter yellow juice found just beneath the skin has been harvested as a renewable resource for over 200 years. It dries to a hard, black and resinous product known as 'aloe lumps', which are renowned for their laxative properties and for alleviating the effects of arthritis. The gel-like flesh from the inside of the leaves provides the white aloe gel used in health drinks and skin-care products. It also contains proven antiseptic qualities.

The Bontebok National Park, proclaimed in 1931, is a peaceful sanctuary for bontebok. At one time down to only 17 animals, this was the rarest and most endangered antelope in the world.

As a result of dedicated conservation management in recent years, the species has now regenerated to a present population of around 3 000.

The park also protects endangered fynbos and coastal renosterveld.

1. *Eugaster longipes,* a bush cricket, belongs to one of four species of armoured ground crickets (family Bradyporidae), found in South Africa.

2. Framed by the distant Langeberg and an expanse of renosterveld, a herd of bontebok *Damaliscus pygargus pygargus* pauses momentarily from grazing.

3. *Aloe ferox* reaches 2–3 m in height. The leaves appear in a rosette with the old ones remaining on the stem after they have dried to give a 'petticoat' effect.

Right: 4. Mountain peaks and ridges of the Outeniqua range. The name is believed to derive from that of a Khoisan tribe that at one time lived in these mountains. It translates as 'they who bear honey'.

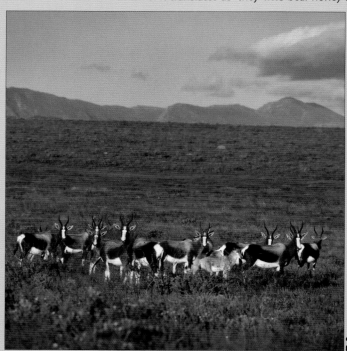

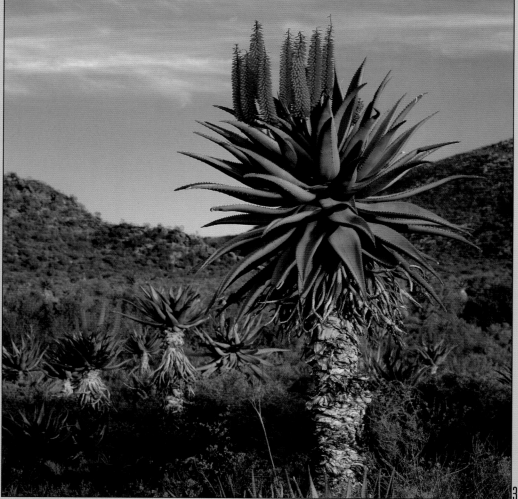

As you cross the Kaaimans River and reach Dolphin Point, the immediate scent of pure ozone is overwhelming. This is the start of South Africa's renowned Garden Route, sandwiched between the Outeniqua Mountains and the Tsitsikamma indigenous forests on the northern side and the Indian Ocean to the south, and stretching 200 km from west to east.

Truly a Garden of Eden, this densely vegetated stretch of stunning western Cape coastline, so rich in diverse natural beauty, contrasts dramatically with the country's arid interior.

A heady mixture of lakes, lagoons, gorges and mountain passes with indigenous temperate forest, pine plantations and thick fragrant fynbos waits to be explored.

The coastline comprises rocky coves and glorious sandy beaches, some stretching for kilometres. Here southern right whales, *Eubalaena australis* come to calve during the winter and spring months. Dolphins frolic year-round.

Between 1785 and 1805 alone, it is estimated that between 12 000 and 25 000 southern right whales were slaughtered in these southern Cape waters. Listed as Endangered by CITES, the population is now gradually recovering.

1. Swartvlei Beach provides great opportunities for whale and dolphin watching, whilst at the same time giving the obs▪ spectacular views of the inland lakes, forests and distant mountains.

2. Ever watchful, a rock hyrax *Procavia capensis* suns itself on rocky perch by the mouth of the Storms River.

3. Bietou Lagoon is an ever-changing feature of Plettenberg Bay.

Right: 4. Approaching storm clouds. Plettenberg Bay.

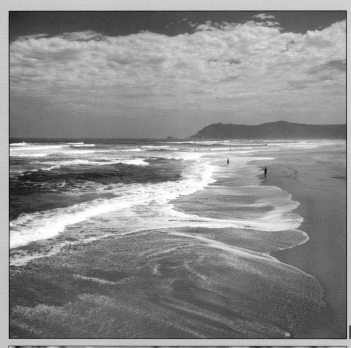

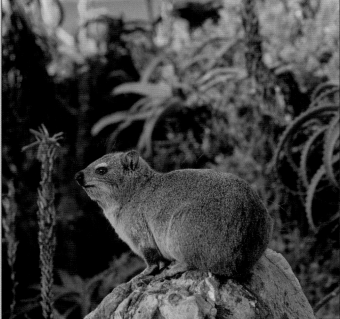

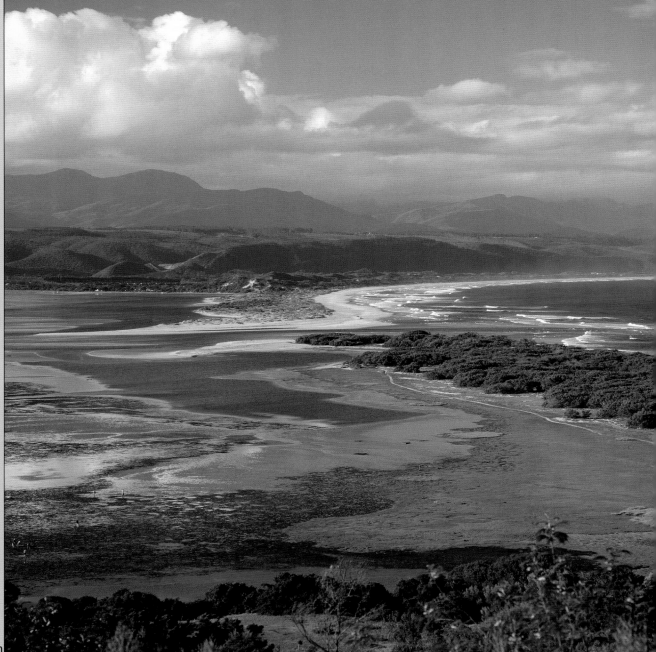

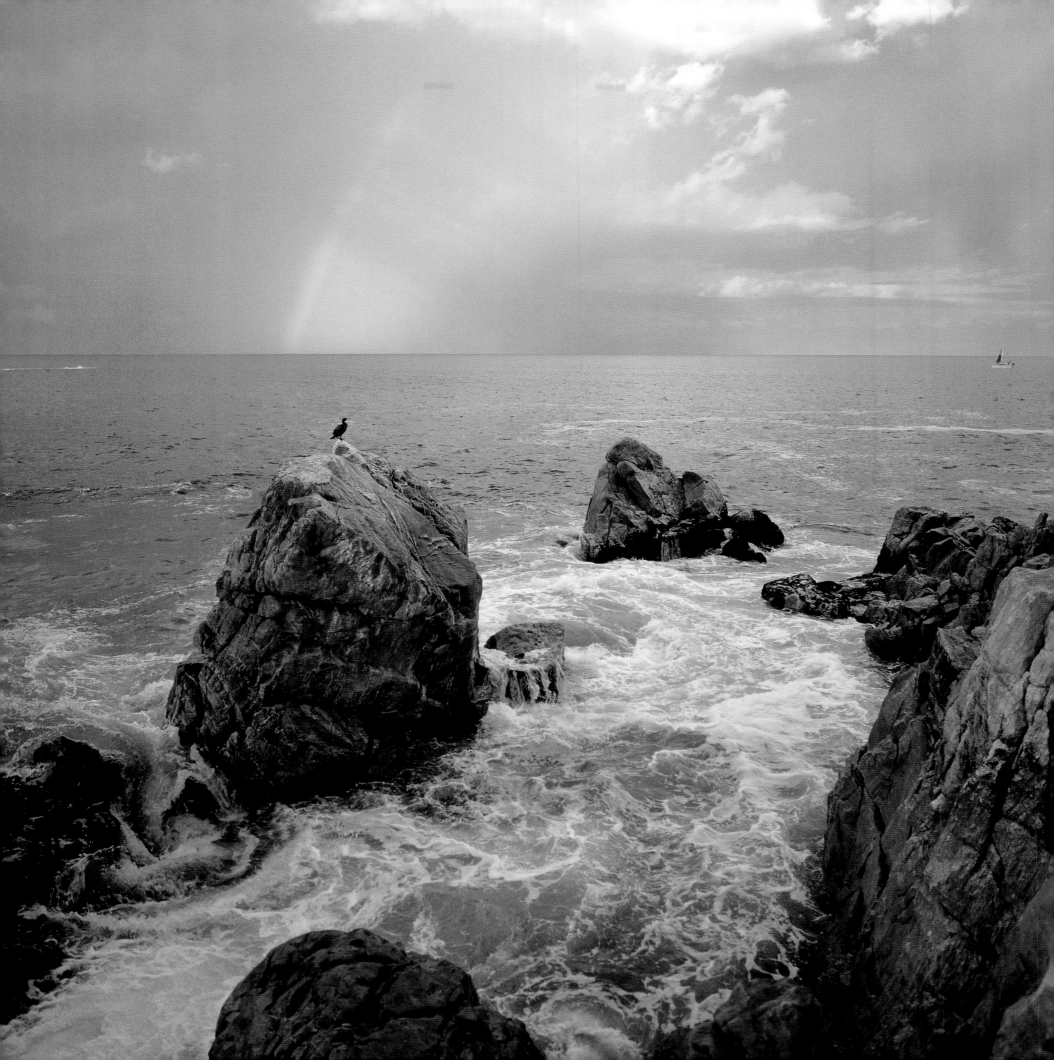

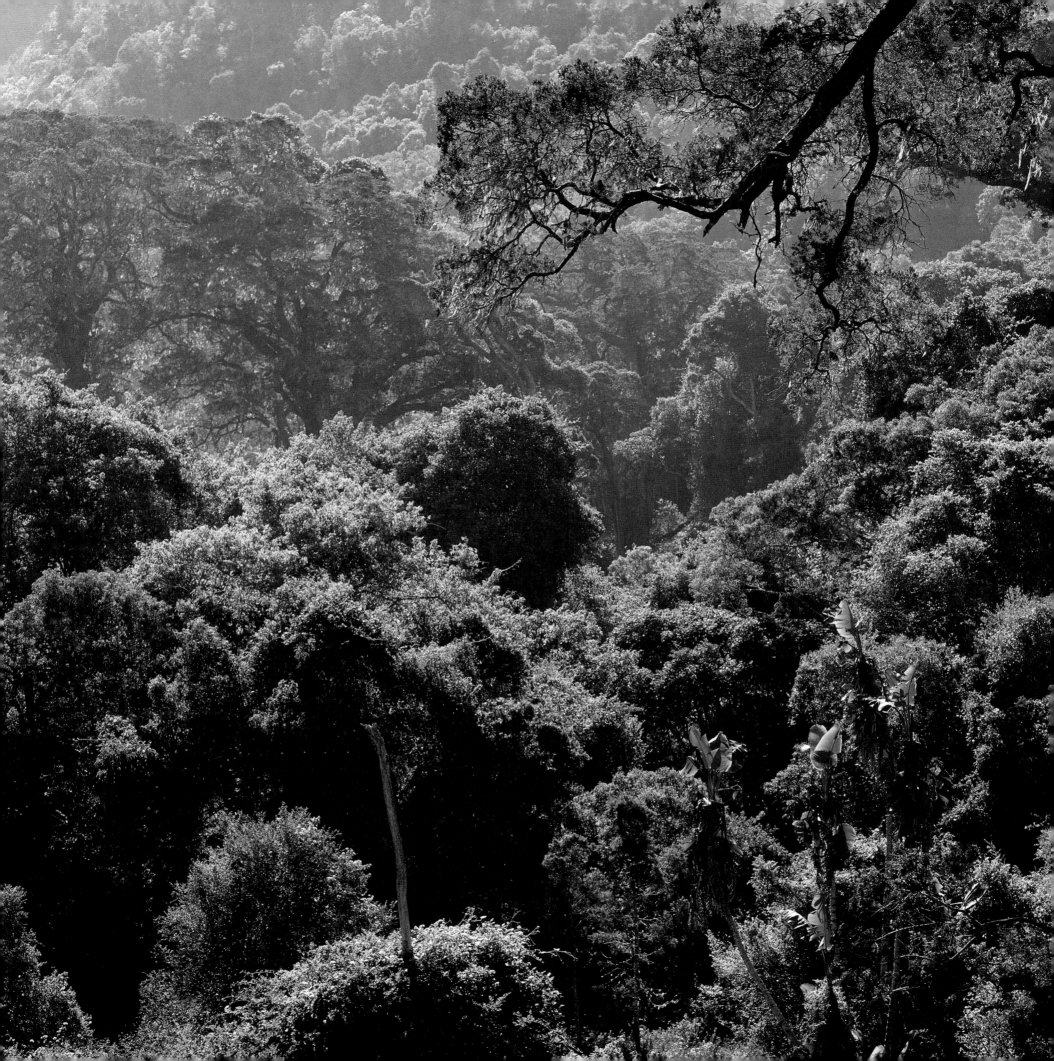

The Tsitsikamma Forest comprises some 800 km² of indigenous subtropical and afro-montane forest. It is the largest complex of closed-canopy forest in southern Africa.

This is the enigmatic habitat of the last surviving, most southerly African elephants. It was thought that there were only three still roaming the forest, but recent research indicates there could well be several more. Magnificent hardwoods abound including stinkwood *Ocotea bullata*, ironwood *Olea capensis*

and the two yellowwoods, Outeniqua yellowwood, *Afrocarpus falcatus*, and South Africa's national tree, the Real Yellowwood *Podocarpus latifolius*. The latter is the wood many of the early settlers used for flooring, ceilings and furniture in their homes.

In the dense forests (but not in the open) these yellowwoods can attain a height of 40 m as they reach for the sunlight.

Far left: 1. Indigenous forest in the Groot Rivier Pass.

2. A spotted eagle-owl *Bubo africanus* surveys the surrounds from its leafy daytime perch, where it roosts until evening. This widely distributed raptor is active at night when it swoops down on its prey of small rodents, bats, roosting birds and insects. The last it persues tenaciously on the ground.

3. The Knysna lourie *Tauraco corythaix* is an agile, all green, forest bird which reveals in flight a flash of spectacular crimson on its primaries.

4. A forest glade catches the late afternoon sun.

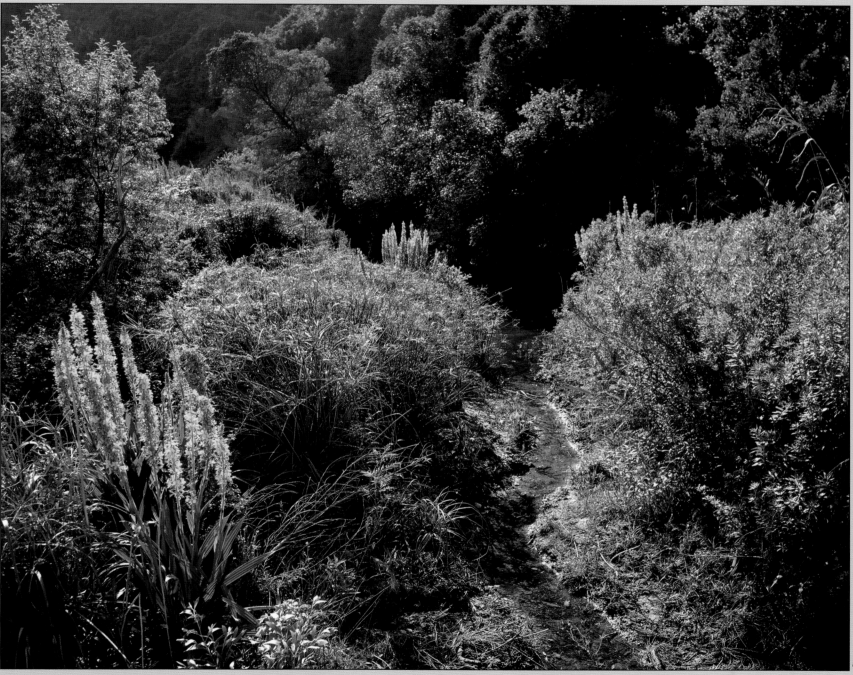

Forming a link between the Outeniqua and Tsitsikamma mountains, the Langkloof is a short mountain range within the Cape Fold Belt. Situated to the north of the Garden Route, it stretches 160 km from Prince Alfred's Pass in the west to just north of Nature's Valley, and to the south of Joubertina, providing a transition into the Eastern Cape.

Named in 1689 by explorer Izaak Schryver, the Langkloof Valley behind the mountain range played a significant historical role in guerilla warfare that took place during the South African War in 1901. Commandant Scheepers and his commandos raided Uniondale and made it their military headquarters for incursions into the southern Cape and Little

Karoo with orders to inflict as much damage as possible on the British forces. Today, this fertile valley is renowned for its deciduous fruit orchards.

The Eastern Cape extends from this region eastwards. It was formed in 1994 out of the 'independent' homelands of Transkei and Ciskei as well as the eastern portion of the old Cape Province.

In 1820 the first British settlers landed in Algoa Bay (Port Elizabeth) and settled throughout the interior.

The Eastern Cape was however also the traditional home of the Xhosa people, and this led to future conflict and warfare.

The mountain ranges in the north include the Sneeuberg, Winterberg and Drakensberg. Lush grasslands, intermittent forest and a region of rolling hills punctuated by deep gorges fill the landscape in the south from East London towards KwaZulu-Natal. At the southern periphery: the rugged

Indian Ocean shoreline is interspersed with beautiful soft sandy beaches.

1. The crowned lapwing *Vanellus coronatus*, is common throughout southern Africa. This courageous little bird is very protective of its nest with eggs or young; screeching loudly, it will swoop aggressively down on intruders.

2. The bushbuck, *Tragelaphus scriptus*, is the most widespread antelope species in sub-Saharan Africa, and also the least social. These mainly solitary, shy forest- dwellers are browsers, found in the wooded regions from Knysna to George, through Kwa-Zulu Natal to the Kruger Park, and further north. The antelope stands around 0.9 m at shoulder height. The male's needle sharp horns are dangerous when the animal is wounded or at bay. When alarmed or on the run, the tail flaps up and down, revealing a distictive white underside.

3. A red stink-horn fungus *Anthurus archeri* adds colour to the forest leaf-litter.

4. The distant Langkloof range viewed from above Plettenberg Bay. Red-hot pokers *Kniphofia uvaria* stand out amongst characteristic mountain fynbos.

Right: 5. A Xhosa girl makes her way home, skilfully balancing her woven basket.

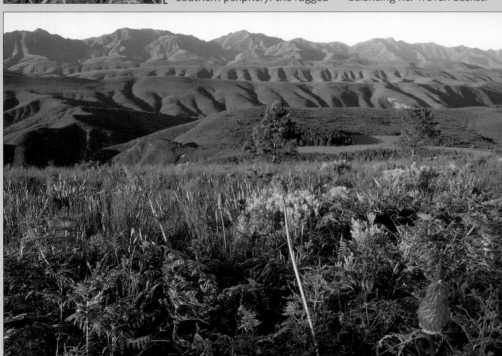

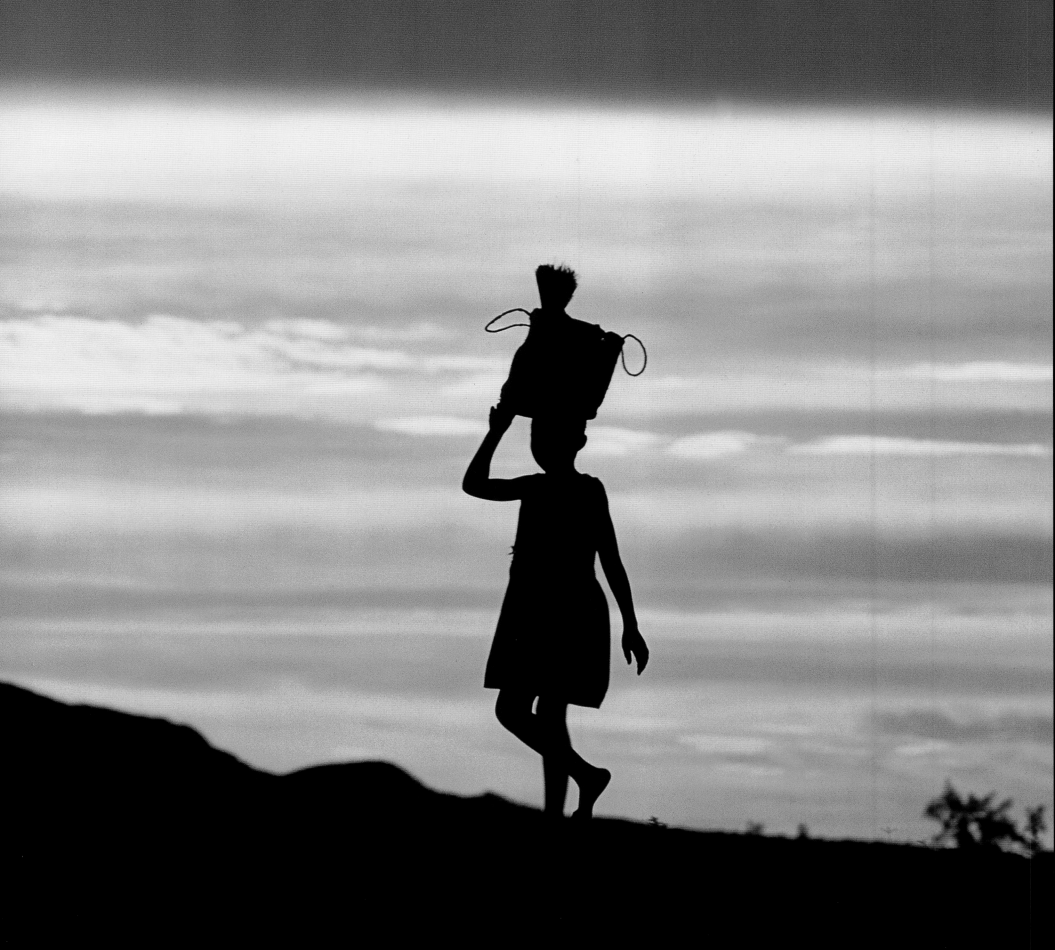

The first Xhosa tribes to reach southern Africa were part of the Nguni migration from the region around the Great Lakes of East Africa. They settled in the 14th century in the region later to be known as the Transkei.

The Xhosa-speaking peoples are divided into several subgroups: the Bhaca, Bomvana, Mfengu, Mpondo, Mpondomise, Xesibe and Thembu. At a later stage some of the clans moved further southwards, meeting up eventually with white settlers at the Fish River in 1788.

The Xhosas like most Nguni people, recognise a supreme spiritual authority, *uThixo*, as well as the presence and power of ancestral spirits. This leads to the attributing of misfortune and illnesses to unworldly supernatural influences. The Xhosa also have 'diviners', usually women, who assist the tribe's people with psychological, physical and mental illnesses.

The *imbongi* (praise singer) is another key figure in Xhosa oral tradition, who accompanies the chief on important occasions. His poetry praises the adventures and actions of both chiefs and ancestors. Such was the case in May 1994 at the inauguration of Nelson Mandela, a member of the Thembu people. Today, approximately eight million Xhosa people are distributed throughout South Africa.

1. Xhosa herdsmen drive their cattle along a rural road. Wealth among the tribes is gauged by the number of cattle a man possesses.

2. The leopard tortoise *Geochelone pardalis* is the largest chelonian in South Africa. Very old tortoises lose their markings and become a uniform dark grey.

3. Spotted dikkop *Burhinus capensis* are common throughout dry regions in southern Africa. Here a bird 'displays' to draw attention away from its nearby nest.

4. A landscape with characteristic dwellings in the Eastern Cape. The Xhosa originally constructed 'beehive' huts, but later adapted the 'rondavel' style of the Sotho and tribes to the north.

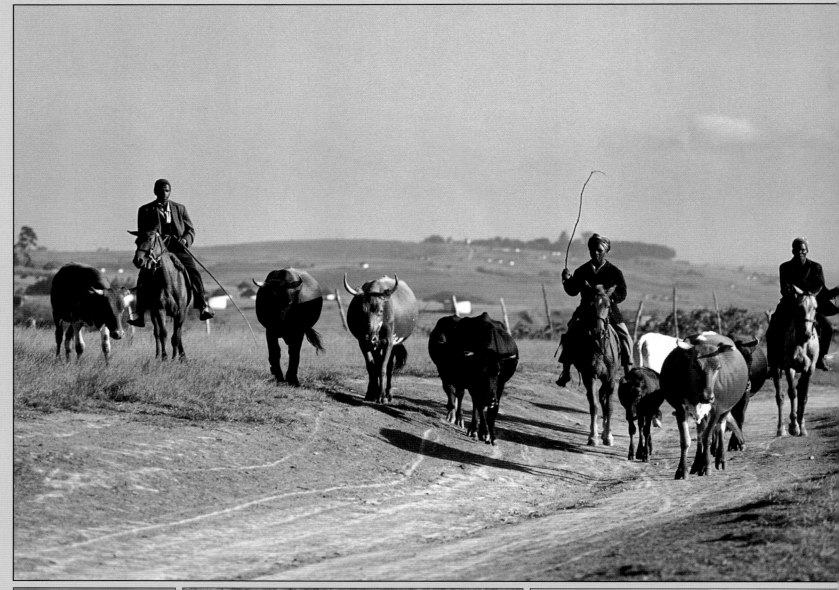

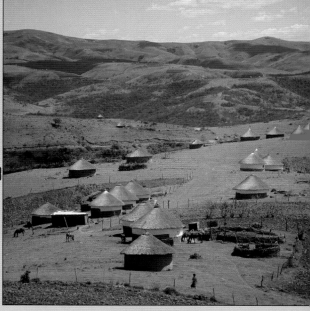

Circular walls formed out of vertical posts are sealed with mud and cow dung. The roof is built from poles tied together and then thatched. Compressed earth is use for flooring.

Right: 5. A Xhosa mother with infant, in the heart of rural Transkei. The Xhosa enjoy physical closeness, with mothers carrying their babies close to their bodies.

Both men and women smoke wooden pipes, *inqawa*, for relaxation. Typically, the long-stemmed pipes are smoked by older married women, who tend to have a high status within the community. The length of this traditional pipe prevents ash from falling onto the breasts or a child on the lap.

Men in contrast smoke short-stemmed and sometimes beaded pipes.

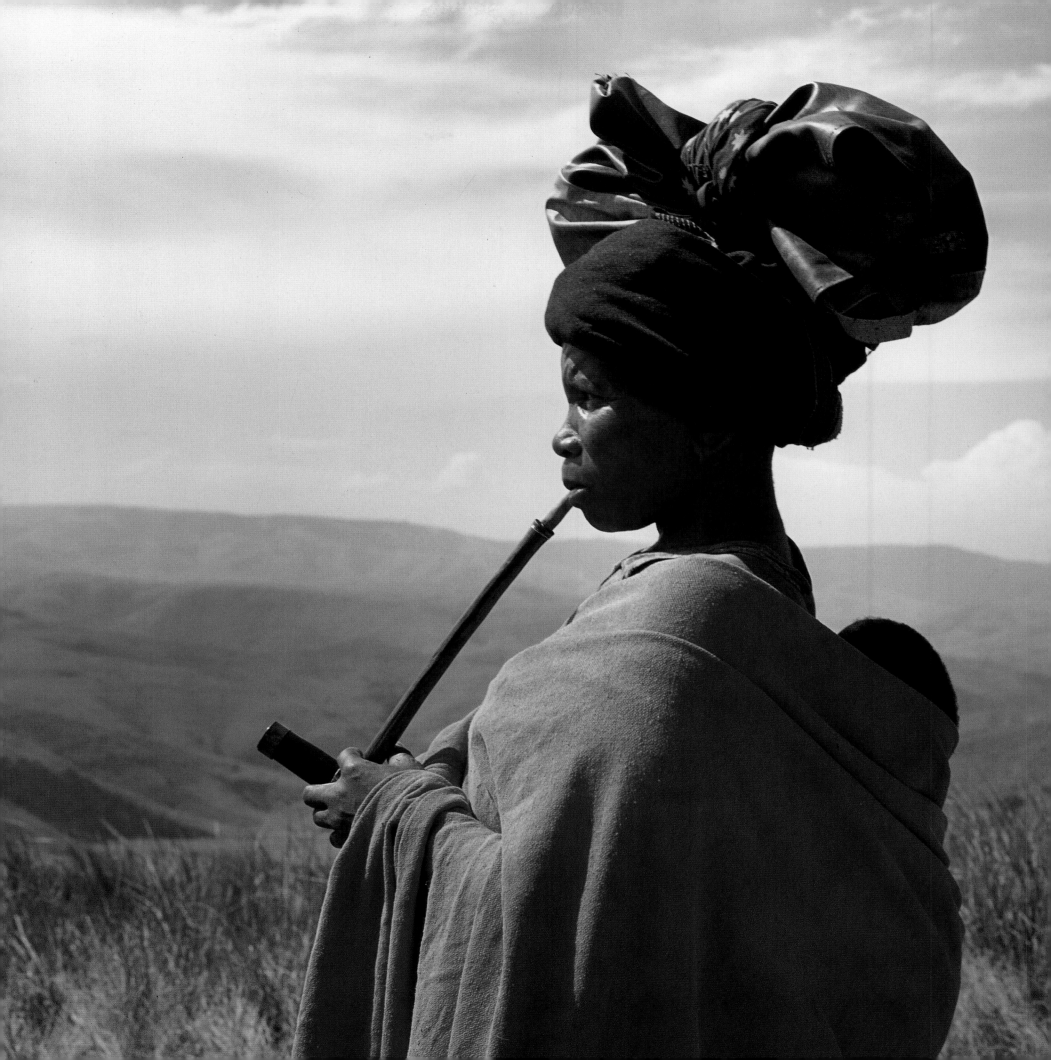

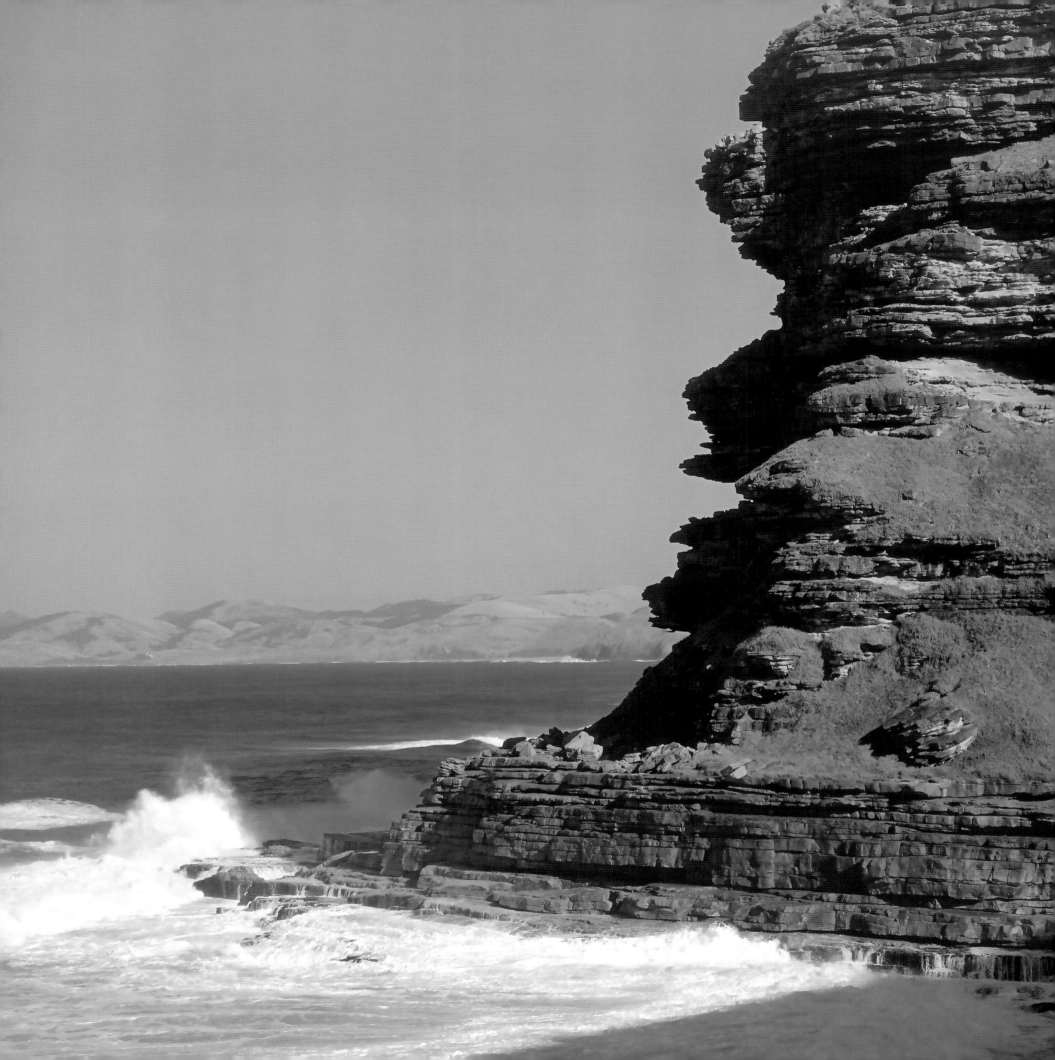

Wild Coast is a relatively
spoiled paradise of
pitous and craggy cliff
, wild and desolate
es, secluded bays and
rolling hills interspersed
deep ravines peppered
groves of aloes and
s. Here, waterfalls tumble
atically into the sea.
coastline is sparsely
lated, with only the
sional rondavel appearing
e verdant hilly landscape.

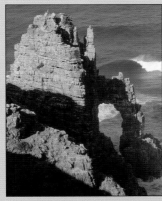

made, but they all face an
uncertain future. Quoting *The
Guardian*, UK, on 18 August 2009
regarding scientific research in the
Mkambathi Nature Reserve
"...scientists surveying a nature
reserve in South Africa have
discovered 18 previously
unrecorded species of
invertebrates, including spiders,
snails, millipedes, earthworms
and centipedes.... [they] warned
that planned developments in the
area could threaten the ecosystem

and deny them the chance to
identify further species. The
region has been earmarked for
titanium mining as well as the
construction of a toll road..."

Far left: 1. The northern stretch
of the Wild Coast, close to
Cathedral Rock.
2. At Waterfall Bluff the
Mzintlava River leaps over
rocky crags and plunges
dramaticaly into the pounding
surf below.

3. The Cape clawless otter
Aonyx capensis has an
adaptable habitat tolerance,
living in permanent streams,
dams or even salty coastal
waters. It feeds mainly on crabs,
but also on amphibians, small
mammals and birds.
4. Cathedral Rock is just
one of many bizarre eroded
formations along this
spectacular coast.
5. A tranquil landscape of
rolling hills and a pristine

beach. The gentle waves
contrast to the 'wildness' that
can so easily churn the sea
into a tumultuous fury at any
moment. Here the coast lives
up to its fearsome reputation for
claiming both lives and ships.

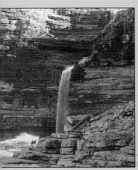

Wild Coast stretches from
Grosvenor' in the north
e mouth of the Great Kei
in the south.
ng these shores many
empty into the sea.
are characterised by wide
plains in the southern part
region where the hills
wer. In the rugged north,
ever, rivers find their
to the sea hindered by
ive cliffs.

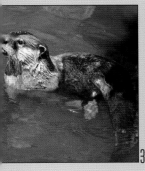

ost half of this coastline
aces indigenous forest.
in these mysterious
ets many new forest
s have in recent times
discovered. Over 900
and grassland species
this region have been
tified as having commercial,
tional or homeopathic
e.
teworthy entomological
overies are also being

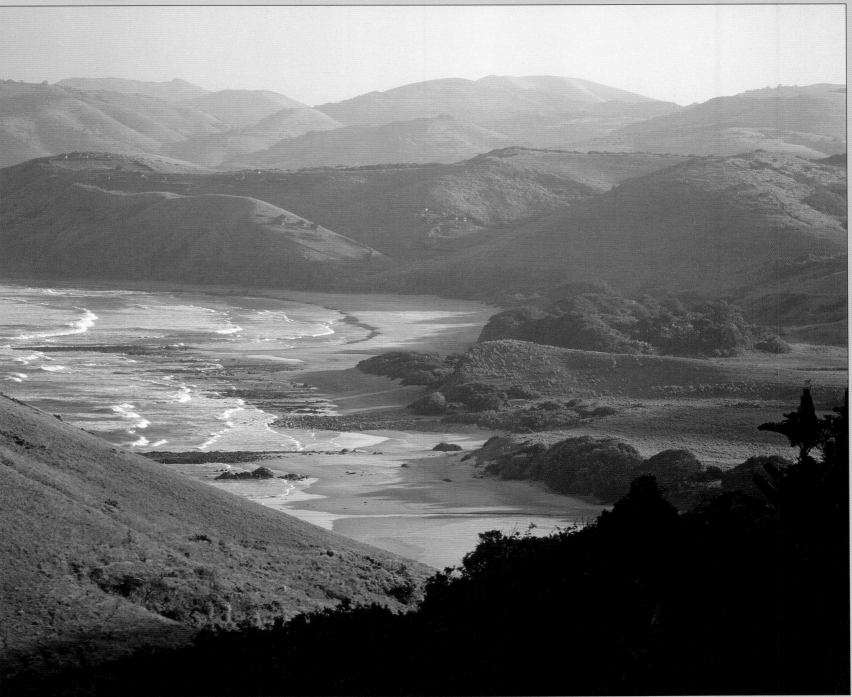

THE EASTERN FREE STATE & KWAZULU-NATAL

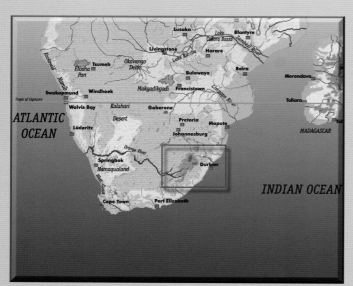

By the 1830s the Zulu kingdom occupied the northern regions. The southern part, between 1839 and 1843, briefly became a Boer republic known as Natalia. In 1843 this became the British Colony of Natal. Zululand remained independent until 1879 when the Zulu armies were finally vanquished by British imperial forces. Their warrior king Cetewayo was taken prisoner at the definitive battle of Ulundi. Natal was later incorporated into the Union of South Africa.

The final change came in 1994 when the province was renamed KwaZulu-Natal.

Geographically the province consists of three distinct divisions: the lowland Indian Ocean coastal region, the central Natal Midlands and the mountains of the Drakensberg and Lebombo.

1. A young white (square-lipped) rhino calf *Ceratotherium simum* pauses from grazing in the Hluhluwe-Umfolozi Game Reserve. This reserve has been instrumental in restoring the

white rhino from the brink of extinction in the 1950s.

2. A characteristic parapet-style Sotho dwelling in the eastern Free State.

3. The Golden Gate National Park provides many tranquil vistas.

4. The Rooiberg is a predominant

feature of the eastern Free State. The russet colours of winter grasslands gave rise to the Afrikaans name Rooiberg (Red Mountains).

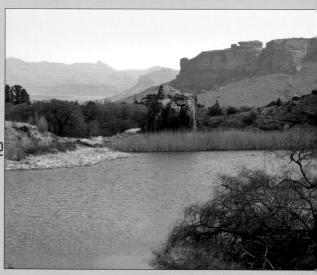

5. A stretch of the undula main road which winds through the countryside connecting Ficksburg and Fouriesburg.

Often referred to as the country's 'bread-basket', the landlocked Free State lies at the heart of South Africa. Bordered by the Kingdom of Lesotho in the south-east, the region is characterised by majestic mountains and flat wide-open spaces interspersed with productive agricultural farming areas. Abundant mineral deposits, especially gold, have ensured worldwide renown.

This was home to semi-nomadic Bantu-speaking peoples such as the Tswana, who preceded the arrival of the first Europeans in the 18th century. The Tswana were subsequently dispersed by Zulu military campaigns early in the 19th century. They were in turn succeeded by Sotho and Griqua peoples. This was the period when itinerant pastoral farmers of Dutch descent ('trekboers') began to settle the area.

The historical Boer 'Orange Free State' became an integral province of the Union of South Africa in 1910. Following 1994 it was renamed the Free State.

Nestling in the rolling foothills of the Maluti Mountains, the Golden Gate Highlands National Park is the jewel of the Free State. Its name is derived

from the brilliant shades of deep golden-yellow cast by the late afternoon sun on the spectacular sandstone cliffs. These formations reveal three distinct rock strata. The red layer owes its origin to ancient swampy river mud-like sediments. The landmass eventually dried up to become a desert, resulting in yellow sandstone deposits. Finally, volcanic activity capped these layers with basalt.

The park encompasses 11,6 km^2 of true highland habitat, providing a home to a variety of mammals: Burchell's zebra, Black wildebeest, eland, blesbok, springbok and oribi. Birdlife includes the rare bearded vulture and the southern bald ibis, which both breed on precipitous ledges set amongst the sandstone cliffs.

In former times Bushmen sheltered in caves which breech the soft sandstone formations, their presence recorded by well preserved rock paintings. In much later times, these secret shelters provided refuge to Afrikaans families during the South African War.

On 25 December 1497, Portuguese explorer Vasco da Gama first set eyes on the verdant shores of KwaZulu-Natal. He named his discovery 'Natal', the Portuguese word for Christmas.

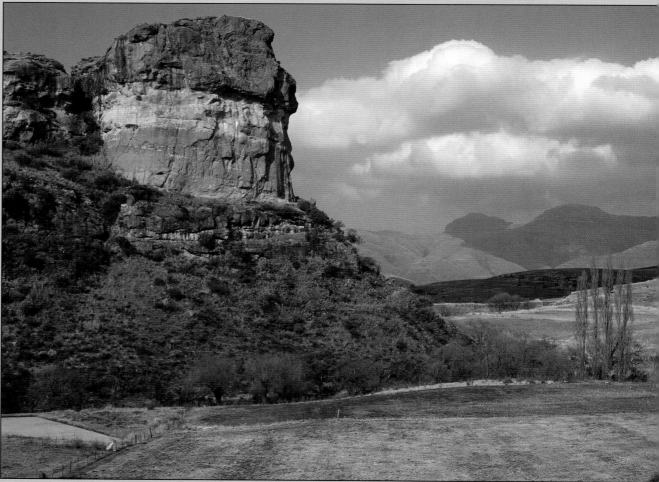

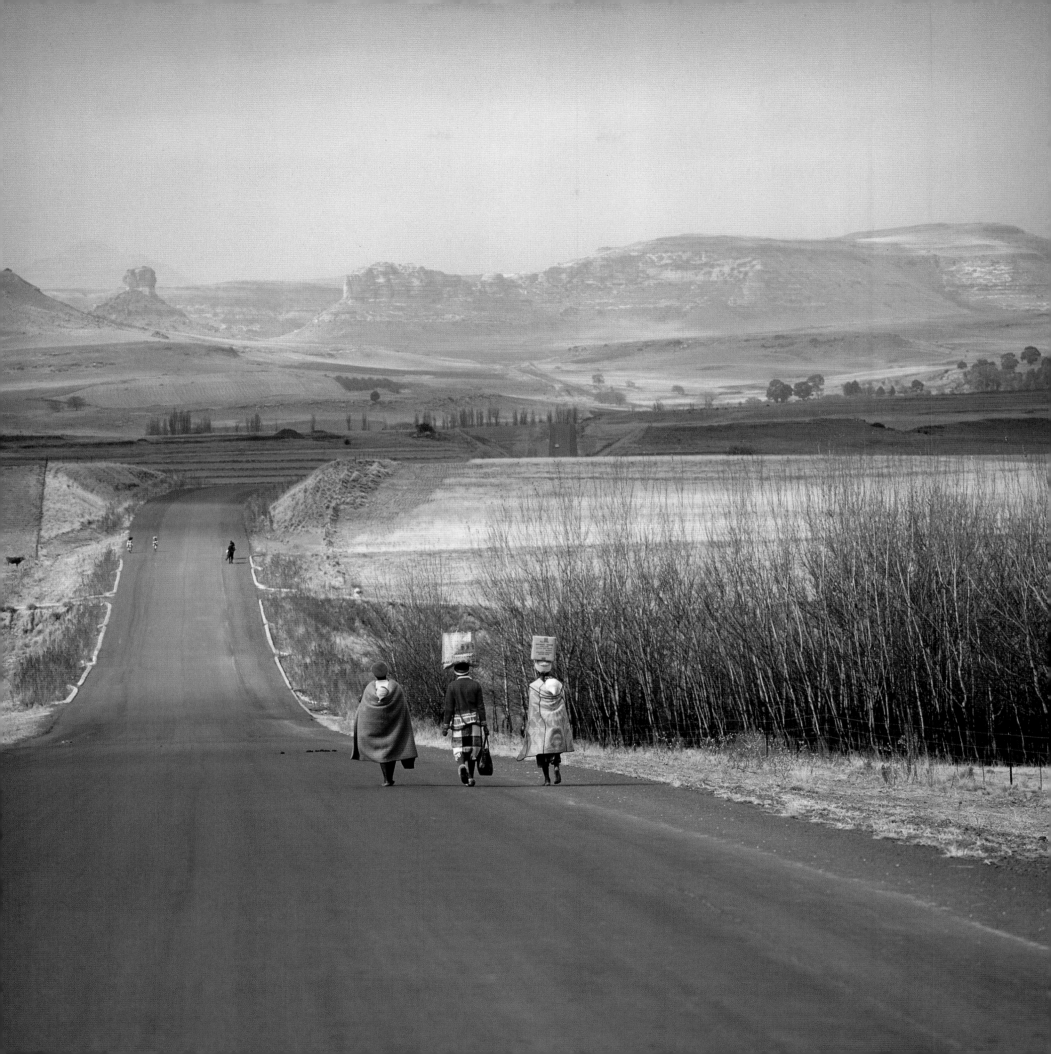

1. *Zonocerus elegans* grasshoppers mating. These are insects of the suborder Caelifera in the order Orthoptera. To distinguish them from bush crickets or katydids, they are occasionally referred to as short-horned grasshoppers. (locusts are the species that change colour and behaviour, swarming at high population densities). As seen here, the females are normally larger than males.

As the name implies, grasshoppers prefer to eat grasses, leaves and cereal crops. Some feed from a single host plant, while others will eat from a variety of sources throughout the day.
2. Alert in the bushveld, a white rhino mother stands beside her young calf.
3. Burchell's zebra *Equus quagga burchellii* is the southern subspecies of the plains zebra.

4. Stripes of a different kind, this time to warn off potential predators. A lily borer caterpillar *Brithys pancratii* busily devastates the beauty of a pink lily.

Far right: 5. Lesser flamingoes, *Phoenicopterus minor* reflect the golden rays of sunrise.

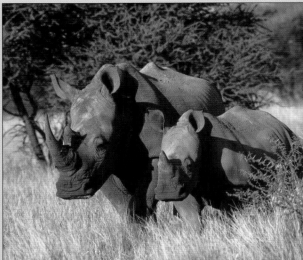

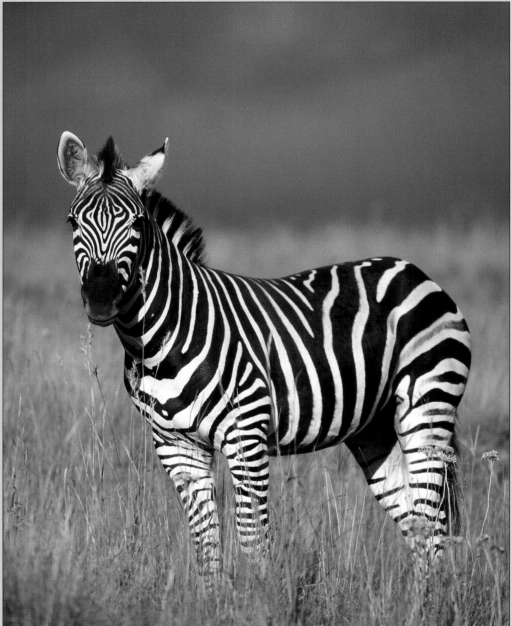

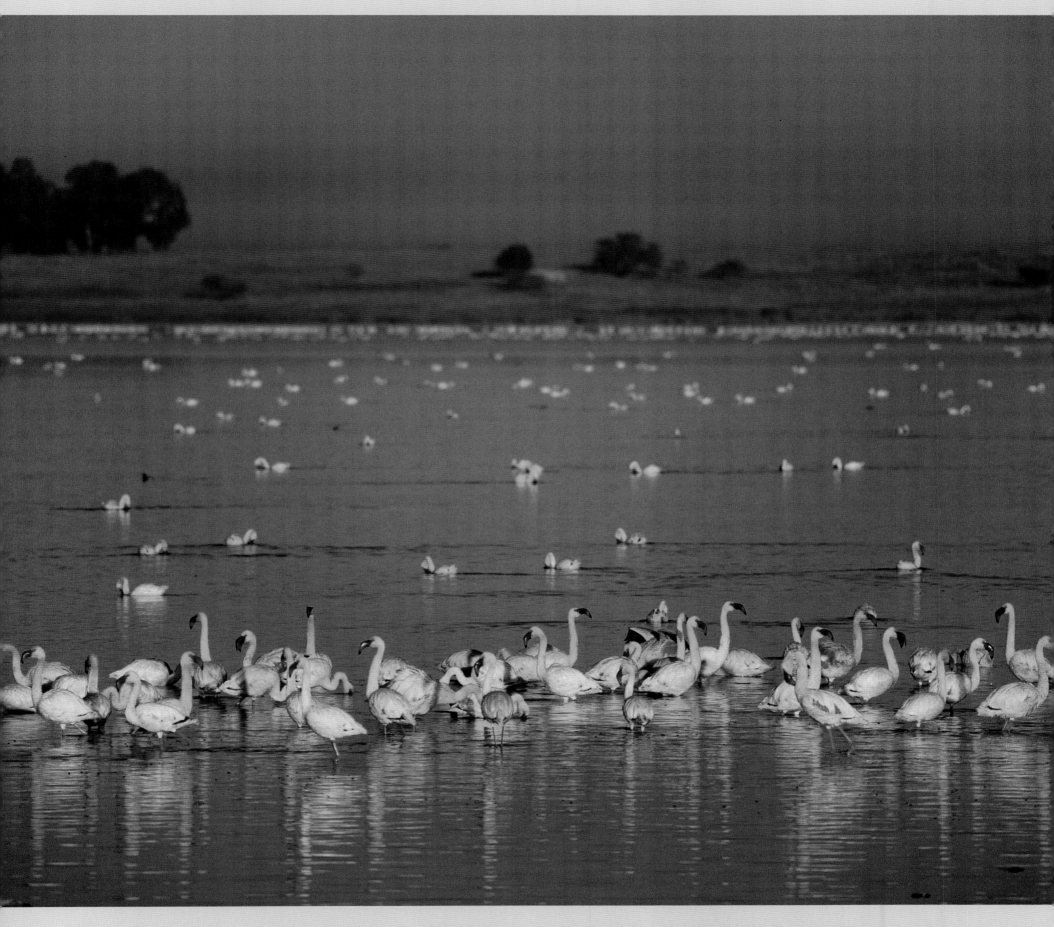

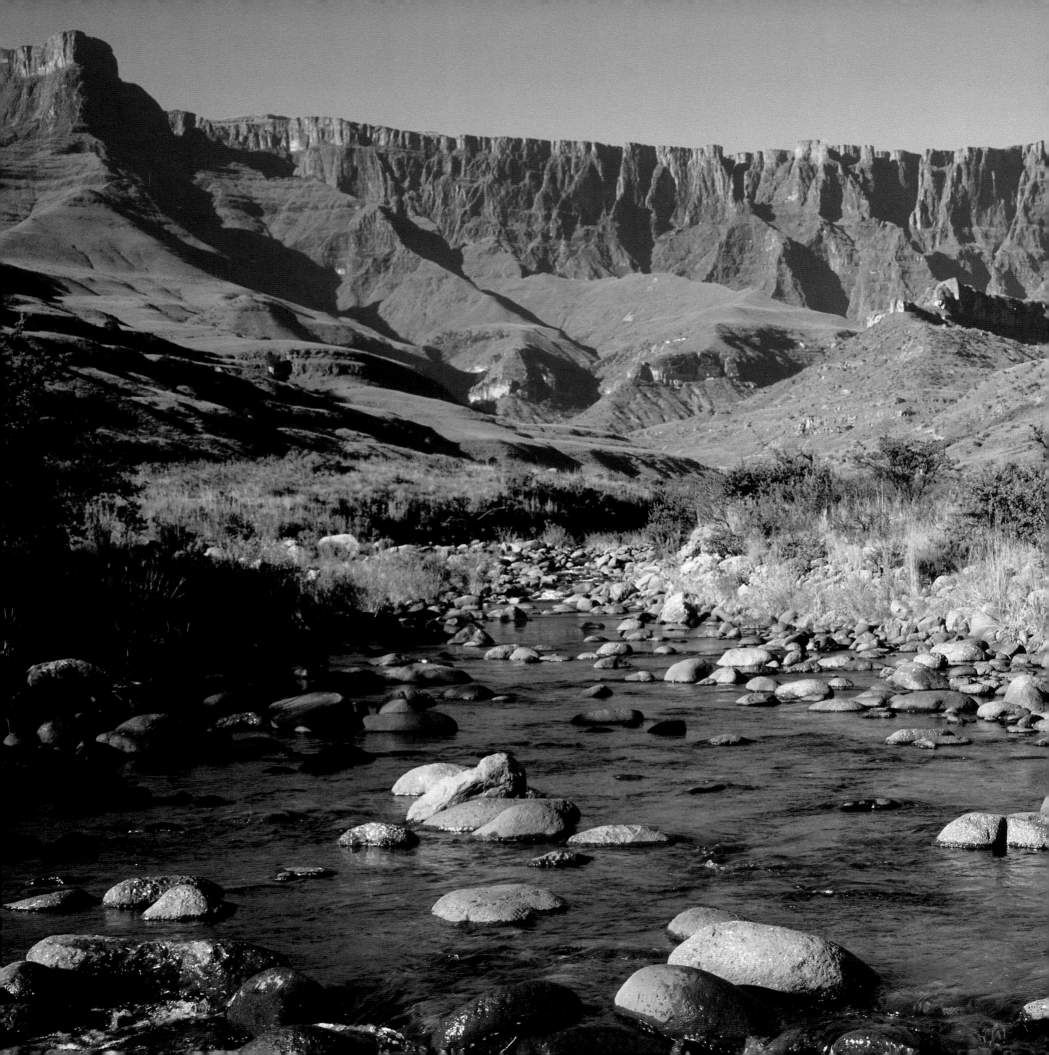

The Royal Natal National Park, proclaimed in 1916, forms part of the uKhahlamba Drakensberg Park World Heritage Site and contains some of the most spectacular scenery in Africa.

The Amphitheatre, the predominant feature, comprises a 5-km-long rock wall rising up to 1000 m, situated between the Sentinel Peak (3165 m) and the Eastern Buttress (3047 m).

A number of domes emerge from the relatively flat summit plateau. French missionaries Arbousset and Daumas, in 1836, named the largest of these domes Mont-aux-Sources – a literal description since this is in fact the source of five rivers. One of these, the Tugela, tumbles over the second highest waterfall in the world, plummeting 948 m over the lip in a series five free-cascading falls.

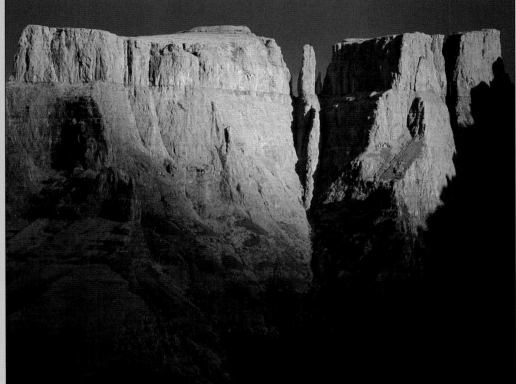

Far left: 1. View from the Tugela River to the spectacular Amphitheatre.
2. The sheer walls of the Eastern Buttress and the Devil's Tooth' pinnacle.
3. *Helichrysum squarrosum*.
4. *Helichrysum adenocarpum*.
5. *Protea subvestita*.
6. *Hesperantha schelpeana*, a rare high-altitude (2700 m) species limited to one locality.
7. *Helichrysum ecklonis*.
8. *Greyia sutherlandii*.

KWAZULU-NATAL

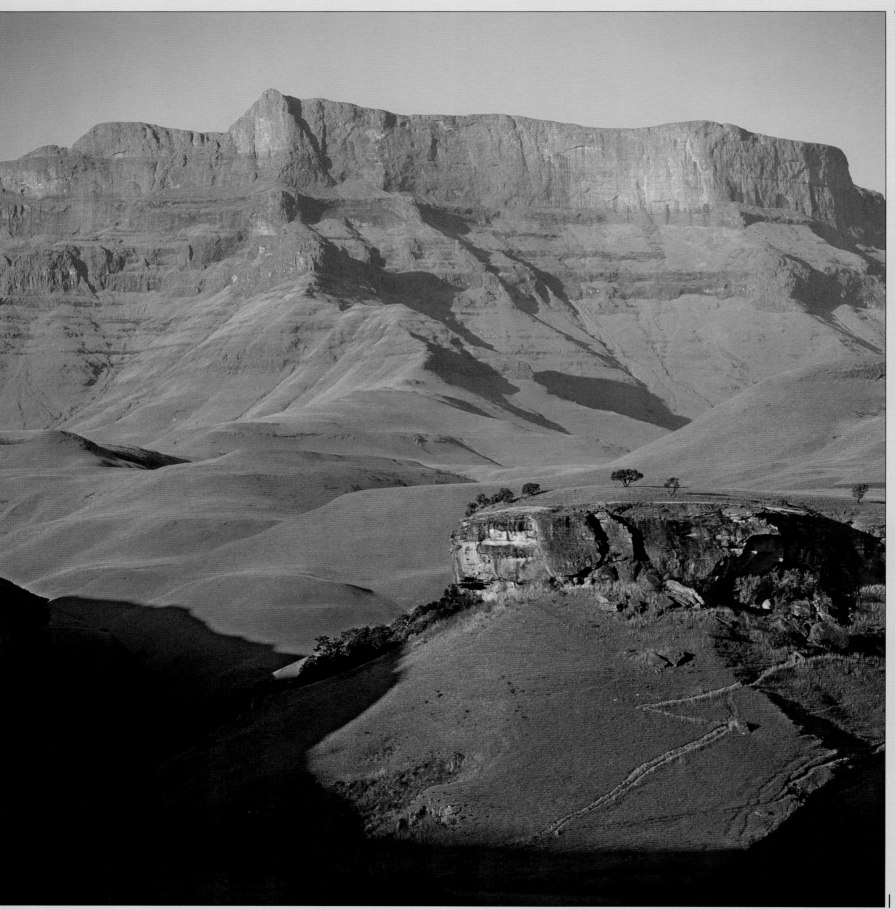

The Drakensberg, (Afrikaans for Dragon's Mountain) is the highest mountain range in sou Africa, rising to 3482 m. To the Zulu it is known as uKhahlamb (barrier of spears),

The mountains are capped by layer of basalt approximately 1400 m thick surmounting sandstone. This results in a combination of awe-inspiring steep-sided blocks and pinnacl

1. Giant's Castle, a dramatic fe of the Drakensberg, with footh shown here brushed with a wi cloak of brown and ochre.

2. A bushman rock painting displays a hunter carrying his s antelope. Soft sandstone cave numerous and contain betwee 35 000 and 40 000 works of bushman art: the world's large collection of rock art.

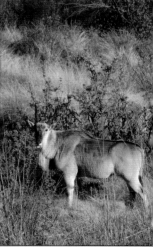

3. An eland *Taurotragus oryx* browses high on the alpine grassland slopes.
4. A natural outline of southe Africa close to the summit of Cathedral Peak.

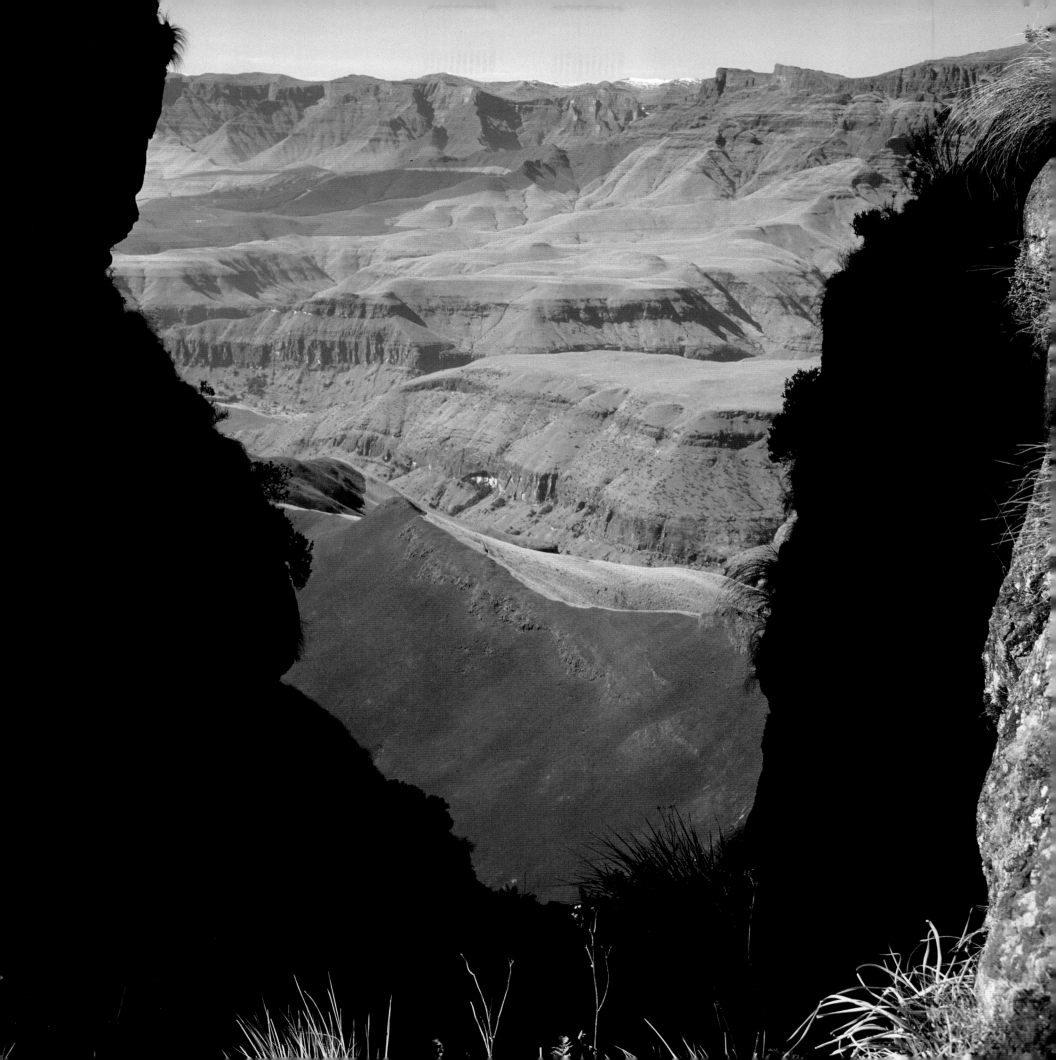

The Drakensberg, ranging for over 1 000 km from south-west to north-east, forms a mighty barrier separating KwaZulu-Natal from the Kingdom of Lesotho.

The mountains are drained on the east and south by a number of rivers, the most prominent being the Tugela, which cascades down from the Amphitheatre in the Royal Natal National Park.

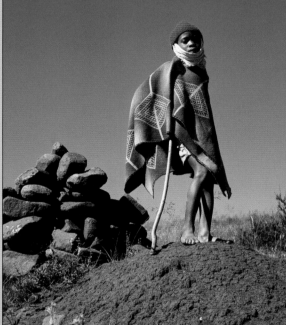

1. A Drakensberg girdled lizard *Pseudocordylus subviridis* spreadeagled and sunning itself.
2. From the high grassy plateau in Sehlabathebe National Park, Lesotho, the mountains display clear geological features: a layer of basalt resulting from continental upheaval and volcanic activity on the exposed mountains, and below, soft lower slopes of sandstone.
3. A young Sotho herdboy in his warm Lesotho blanket.
4. Sotho horsemen descend from Lesotho

through the Drakensberg foothills on sure-footed Basotho ponies.

Descended from the 'Cape Horse', these animals are a hardy species accustomed to rugged terrain and climate. They are used today for transportation, draught work and tourist trekking.

Right: 5. Blanketed in winter snow, Giant's Castle towers over the Bushmans River.

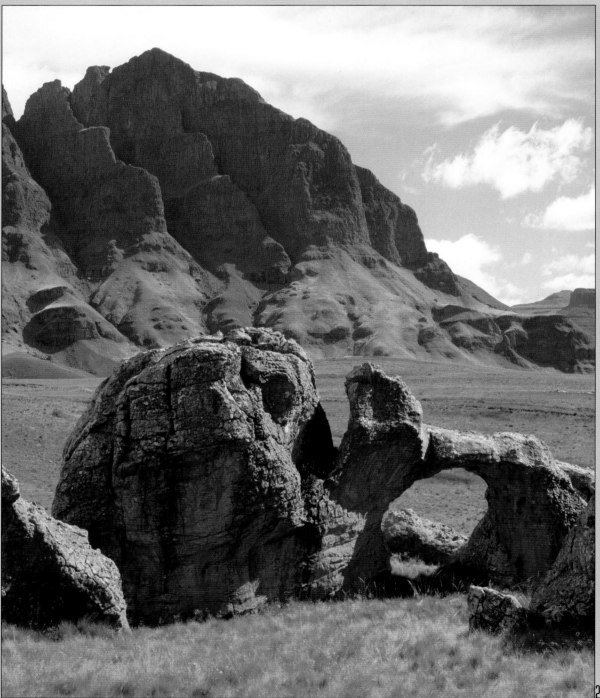

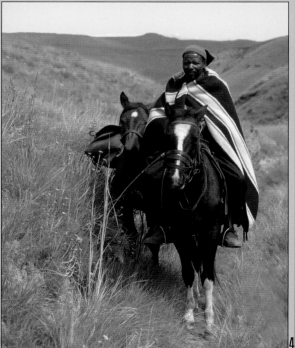

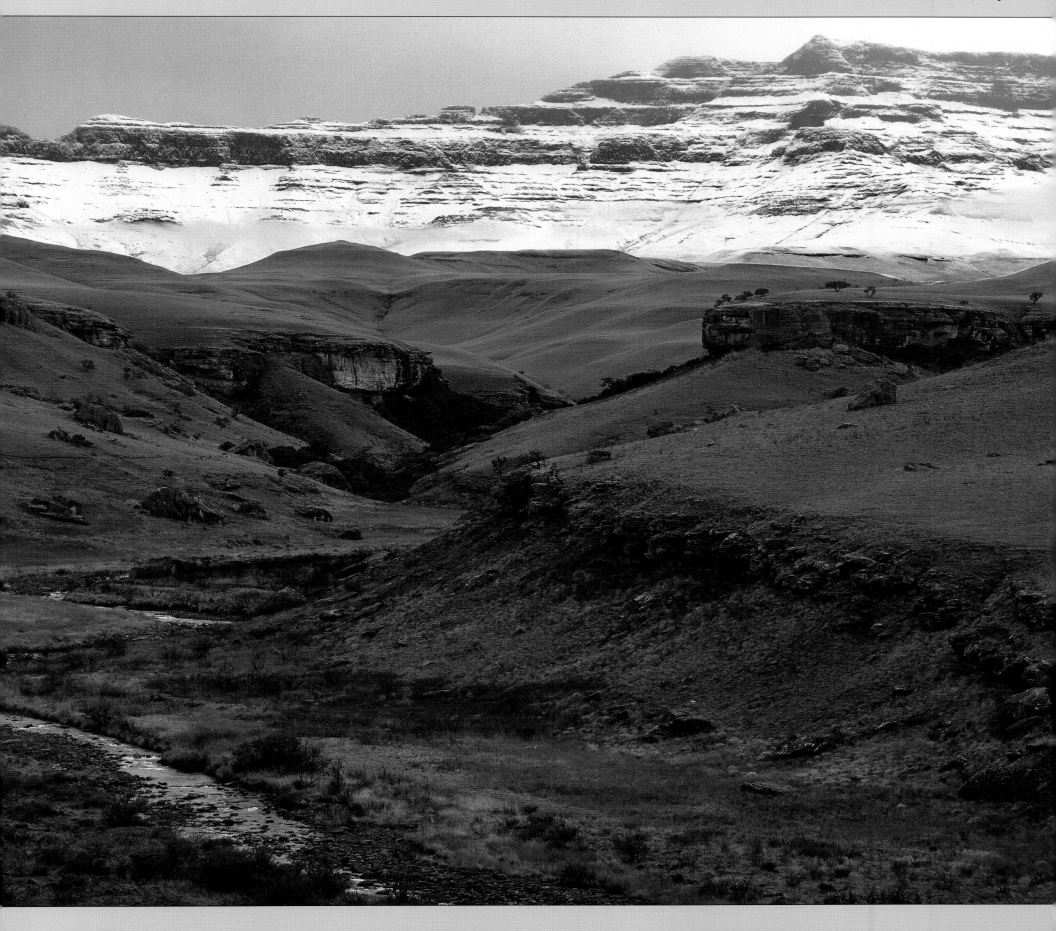

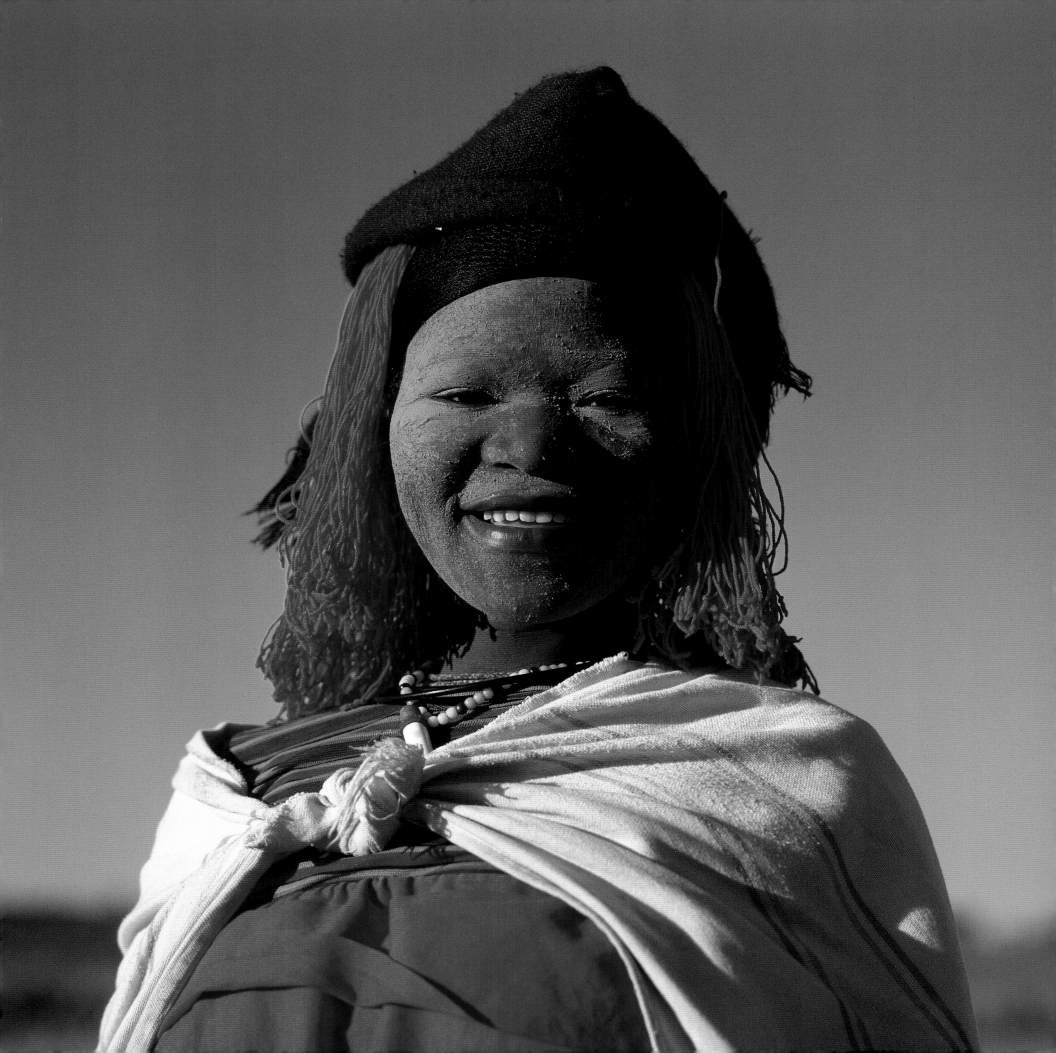

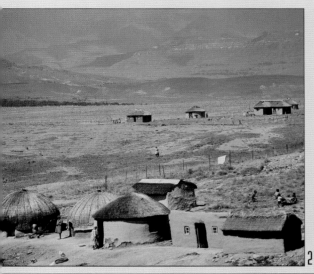

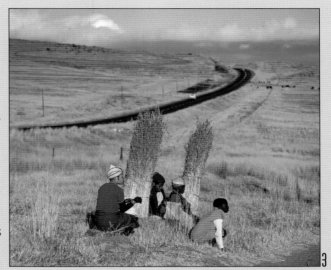

Southern Zululand conjures up multifaceted images of noble culture, magnificent mountain scenery, powerful flowing rivers and peaceful surroundings. This is home to part of the mighty Zulu nation, South Africa's largest ethnic group, estimated to number over 10 million people.

The Zulus are descended from the Nguni people, who according to tribal storytellers lived in a mystical land called Embo supposedly in Central/ East Africa. The main migration south occurred during the 16th and 17th centuries, when small groups settled in the fertile valleys of Zululand. Eventually the great warrior King Shaka forcibly united the many tribes and clans of the amaZulu, forging feuding farmers and cattle herders into a proud and powerful nation. Based on male ancestry, the clan, led by a chieftain, forms the highest social unit among all Nguni tribes.

As they have done for centuries, Zulus bring their herds home from grazing at the end of each day, and drive them into a kraal (a South African term describing an enclosure for cattle and other livestock). This holding pen is surrounded by a palisade mud wall, or other types of fencing, and is roughly circular. The kraal is generally located within the homestead or village.

1. **Far left:** A young Zulu woman in the rural Ixopo region displays the rich heritage of her cultural upbringing.

2. A Zulu kraal beneath the Drakensberg foothills displays the traditional 'beehive' hut together with the rondavel and more modern designs.

3. Zulu women rest after collecting reeds for hut roofing.

4. Rolling hills dotted with huts: a quintessential rural landscape in the Ixopo region of KwaZulu-Natal. Ixopo is most famously described by Alan Paton in the opening lines of *Cry, the Beloved Country*: "There is a lovely road which runs from Ixopo into the hills. These hills are grass covered and rolling, and they are lovely beyond any singing of it."

5. Dragonflies belong to the order Odonata. They are valuable predators since they have a prediliction for mosquitoes. Like all insects they possess six legs, but are incapable of walking.

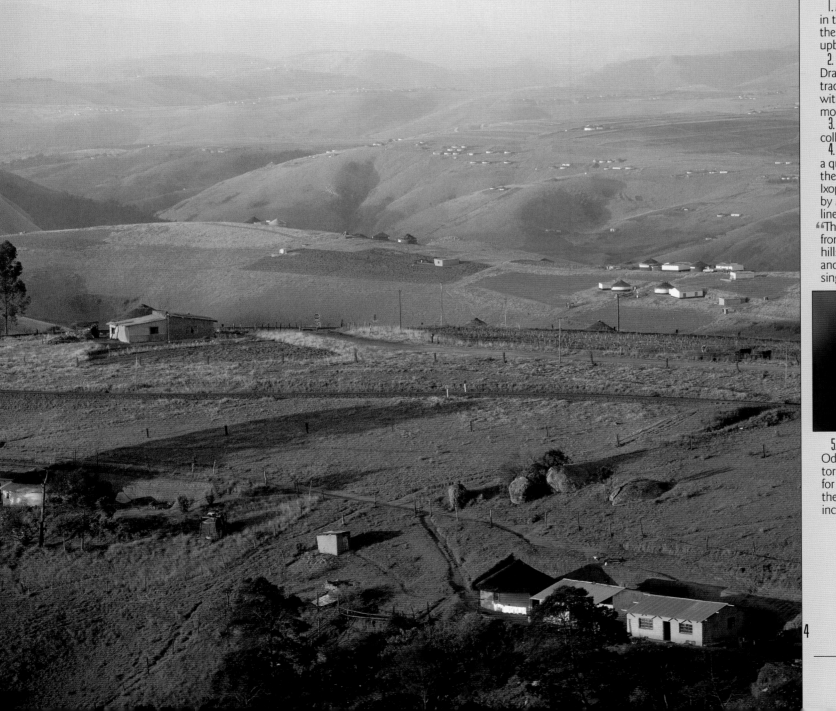

Zulu culture is steeped in rich historical traditions. Although westernized, many of their customary rituals are still practised. For example: Men must always remove their hats when entering a house to show respect to the resident dwellers.

In Zululand animal skins are never discarded. Clansmen use them as ceremonial attire for tribal events as well as for covering their shields and decorating spears.

Women still cover their heads as a symbol of respect.

Like their Xhosa neighbours, Zulus retain strong belief in the spirits of their ancestors. These are venerated in the belief that the departed can influence the living. Sangomas, traditional 'doctors' and interpreters for the departed, are able to foresee problems and heal the sick.

When illness strikes, traditional healers are usually first consulted. Dry bones are tossed to check the cause of sickness. The patient will then be given 'Muthi' (medicine) made from traditional herbs.

For psychological and family issues the Sangoma, in most cases, will imply that ancestors are unhappy and that a goat sacrifice is needed in propitiation. The supplicant is also instructed to visit family graves and plead with the ancestors for their help.

The traditional hats 'Isicholos' worn by Zulu women may appear similar to each other, but are in fact individually distinctive. The wearing indicates married status. These hats are hand woven from cotton, rope or vegetable fiber. They are dyed and then stretched over a basket frame. Today, they are mostly seen worn by married women during ceremonial celebrations.

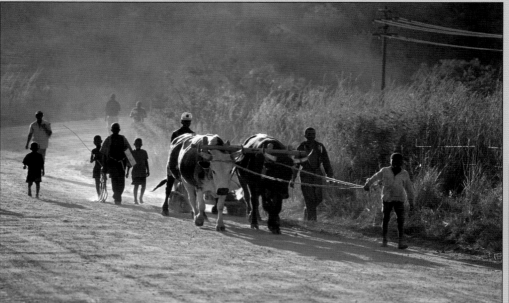

there is a low level of frustra
among teachers in rural sch
teachers in farm schools ha
sense of belonging to a
community; teachers seem
be satisfied with classroom
physical facilities, and
teacher-student ratios.'

Right: 5. Washing clothes the tradional way – in the slow-flowing Tugela river.

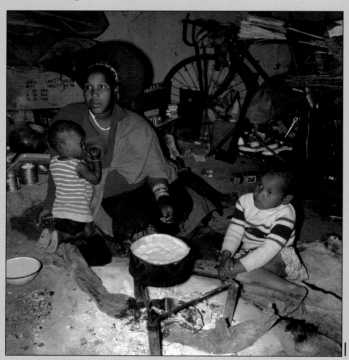

1. A Zulu mother with her two children inside their rural dwelling.
2. An ox sled, still used as a means of transportation in the rural heartland, rounds the bend of a dusty byway.
3. Bush locusts, *Phymateus leprosus,* clasp tightly together in a mating embrace.
4. Open-air primary schools still exist in Zululand. In a study to determine the quality of the work-life of teachers on farm schools in South Africa, Mentz and Kobus delivered a paper at the *Annual Meeting of the American Educational Research Association in Seattle* in 2001: '... Findings (in South Africa) indicate that teachers in rural schools are generally satisfied with their circumstances and enjoy teaching; teachers are proud of their schools and have good relationships with students; teachers are proud to be teachers;

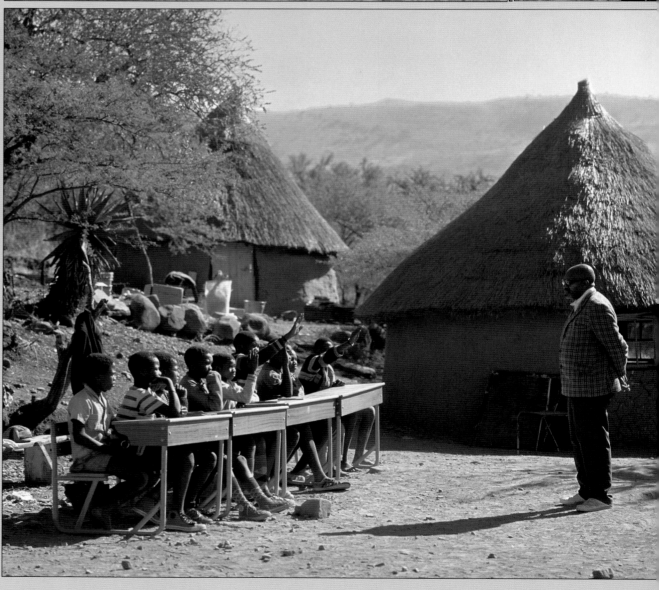

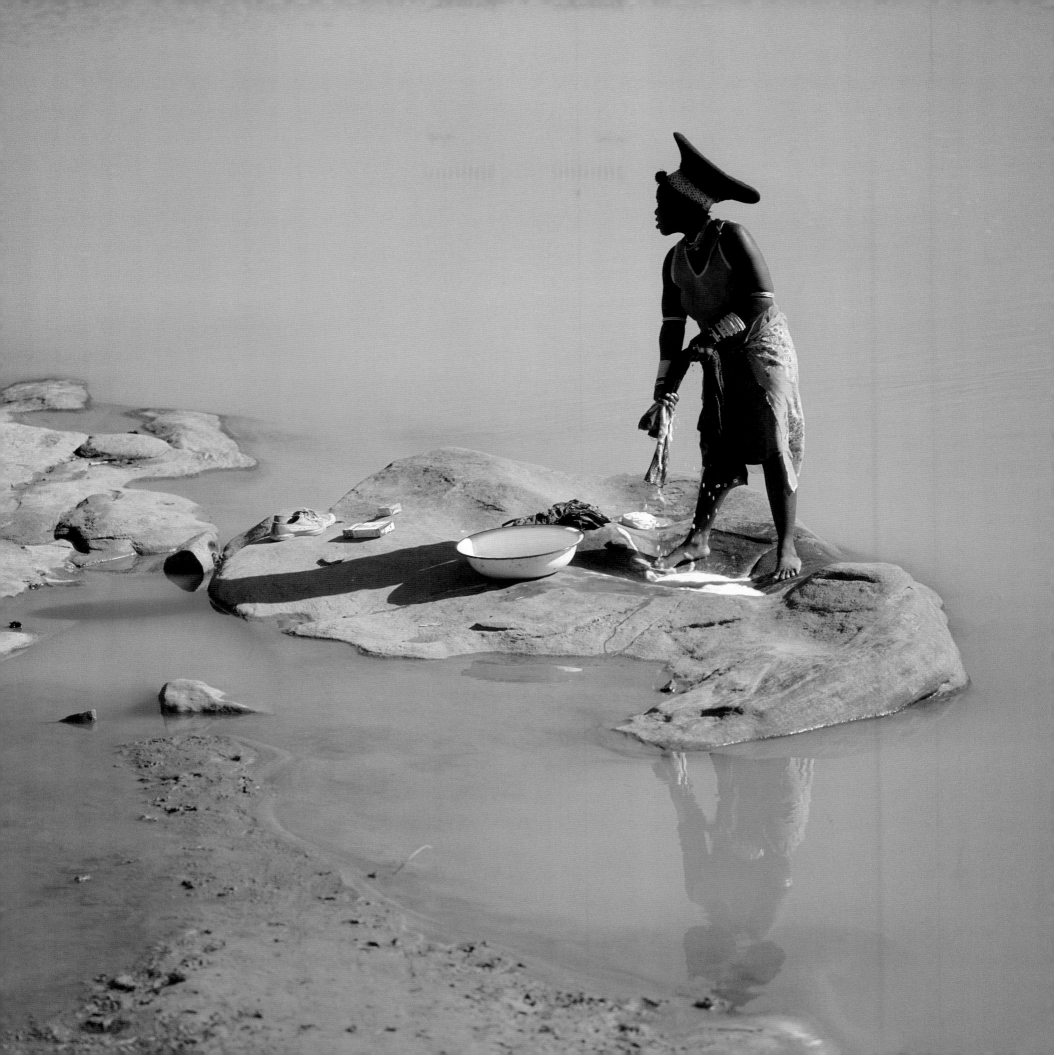

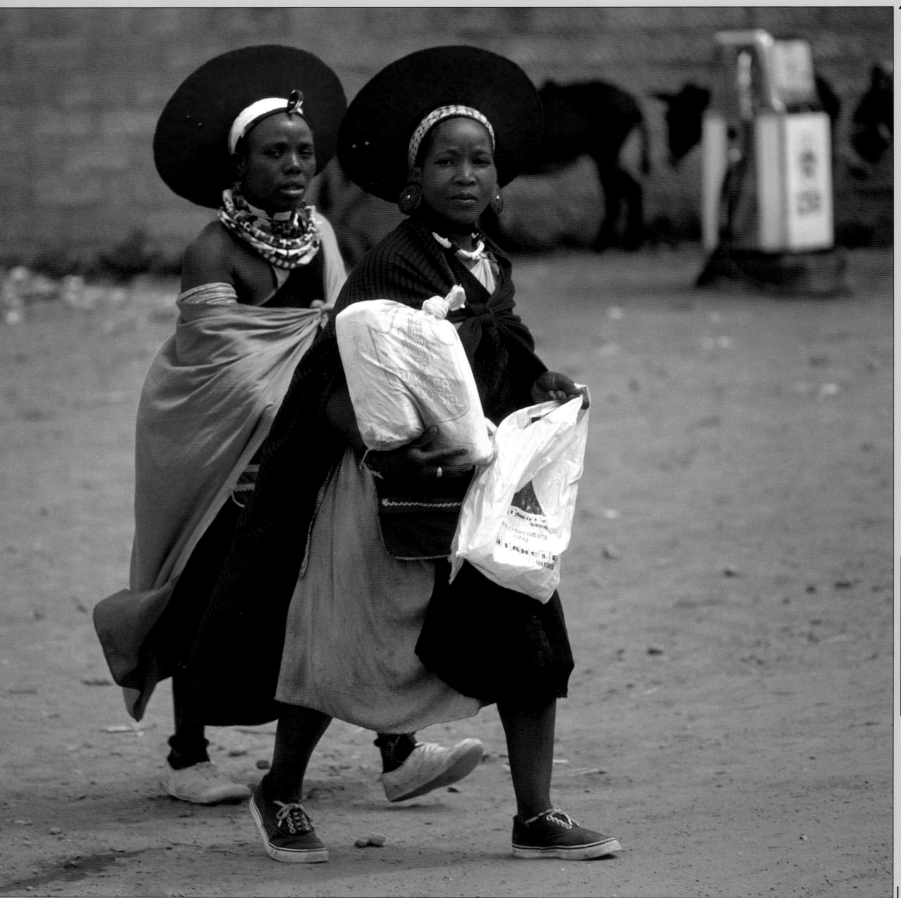

The Zulu king, currently King Goodwill Zwelitini kaBhekuzulu, has no direct political power, but continues to hold considerable sway and influence over the Zulu people.

Each year the renowned annual Reed Dance ceremony takes place in Nongoma, during which the king used to choose an additional wife. The current King has 13 wives, and although he has retained this ceremony, he has foregone the opportunity to select further wives. Instead he uses the occasion to promote abstinence until marriage as a way of preventing the spread of HIV/AIDS and preserving the purity of Zulu culture.

1. Two women depart the trading post at Keate's Drift with their shopping.
2. A young Zulu boy rides bareback on his donkey.
3. Young Zulu women socialise outside the trading post at Keate's Drift in the heart of what were the Anglo-Zulu battlefields. This remote village played a prominent role in a key historical episode following the Zulu war campaigns:

In 1906 Bhambatha, a Zondi tribal chieftain was suspended from his chieftainship. It is alleged that Dinuzulu, a neighbouring chief, encouraged him to resist the authorities that had imposed a poll tax on the

local Zulu community, adding to already numerous grievances borne by the African people against Natal colonial rule. This was the spark for the rebellion instigated by Bhambatha along with other chiefs.

To evade capture and arrest by the colonial authorities, Bhambatha fled to Chief Dinuzulu's Usuthu headquarters capturing his uncle Magwababa, who had been made chief in his

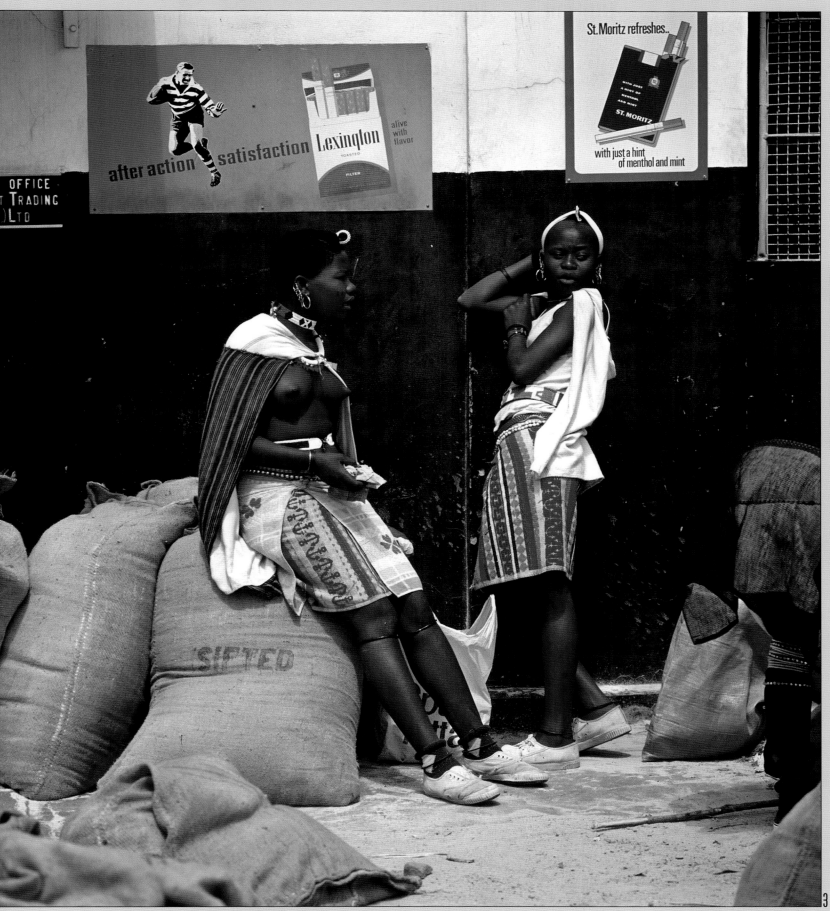

stead. Although his people were generally unenthusiastic, Bhambatha managed to mobilise some 200 men as fellow rebels.

On 3 April 1906, the Greytown magistrate, John Cross, set out with an armed escort along the Keate's Drift road to investigate the situation. The party called in at Marshall's Hotel where, apart from Mr Spencer who ran the hotel, there were three ladies and a young boy present.

Cross and his men then descended into the 'thorns' in search of Magwababa's captors. Here they were fired

on by Bhambhatha's men but with no effect. Cross returned to Marshall's Hotel to urge the ladies and the boy to hide in the bush. Instead they left the hotel and went to the nearby Keate's Drift police station. Shortly afterwards, Bhambhatha's men ransacked the hotel. This was now open insurgency.

A column of police was subsequently dispatched to rescue the women and child. On 4 April, the party returned in the evening along the same road they had arrived on from Keate's Drift: a foolish move as it turned out, since Bhambhatha's men were waiting in ambush. Four policemen, a soldier, a trooper and his dog, were killed at Ambush Rock, on the way to Greytown and safety.

This episode is today considered to be the founding moment of the 'armed struggle' in South Africa.

4 In traditional apparel, a Zulu headman displays the use of animal skins.

Originally a royal hunting ground for the Zulu kingdom, Hluhluwe and the Umfolozi reserves were established primarily to protect the white rhinos. Hluhluwe was proclaimed in 1895, making it the oldest park in Africa. The two reserves were combined in 1989.

Hluhluwe consists of 960 km² of hilly topography in central Zululand and is the birthplace of rhino conservation. White rhinos have been successfully bred back from less than 20 in 1900 to more than 10 000 today. The reserve now contains around 1600 white rhino the largest population of the species in Africa. As a result of the successful breeding programme, Hluhluwe has over the years been able to relocate hundreds of these magnificent animals to game reserves around the world.

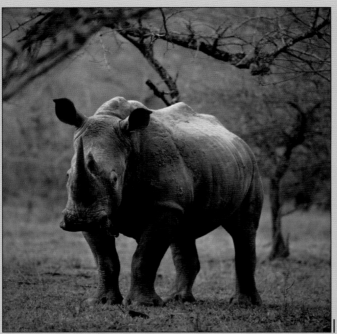

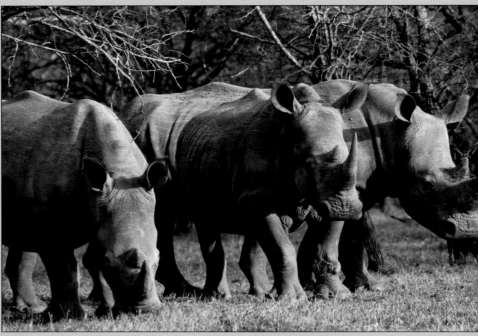

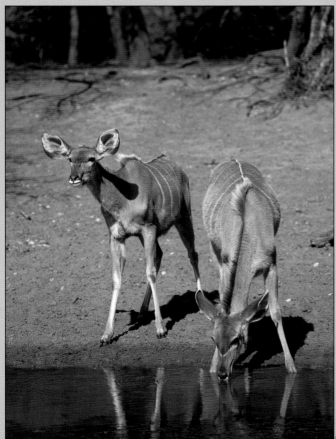

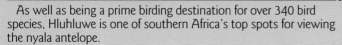

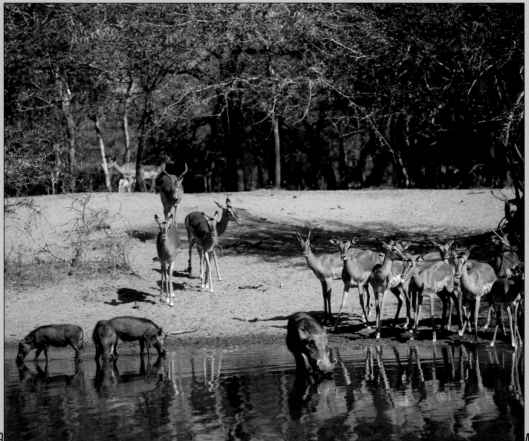

As well as being a prime birding destination for over 340 bird species, Hluhluwe is one of southern Africa's top spots for viewing the nyala antelope.

1 & 2. White rhinos *Ceratotherium simum* in the Hluhluwe-Umfolozi Game Reserve.
3. Kudu cows *Tragelaphus strepsiceros* drink at the Masinga waterhole in Mkuze Game Reserve.

4. A herd of Impala *Aepyceros melampus* approach the Masinga waterhole where warthogs *Phacochoerus aethiopicus* are already drinking their fill.
5. *Euphorbia cooperi*, sometimes known as the lesser candelabra tree, grows in the reserve. It is a succulent tree up to 7 m tall and contains a milky latex highly poisonous to humans and animals.
6. Another resident in the park: a young male nyala *Tragelaphus angasii*. About 1 m at the shoulder, males have horns up to 80 cm long.

Right: 7. A black rhino *Diceros bicornis bicornis* mother and calf meander through the Umfolozi bushveld.

Black rhinos have been poached to the brink of extinction, even in protected reserves, due to demand for

their horn for use in Chines[e] traditional medicine and for *jambiya* dagger handles in Yemen.

It is estimated that in Afr[ica] between 1970 and 1992, around 96% of the black rh[ino] population was lost to poa[ching]

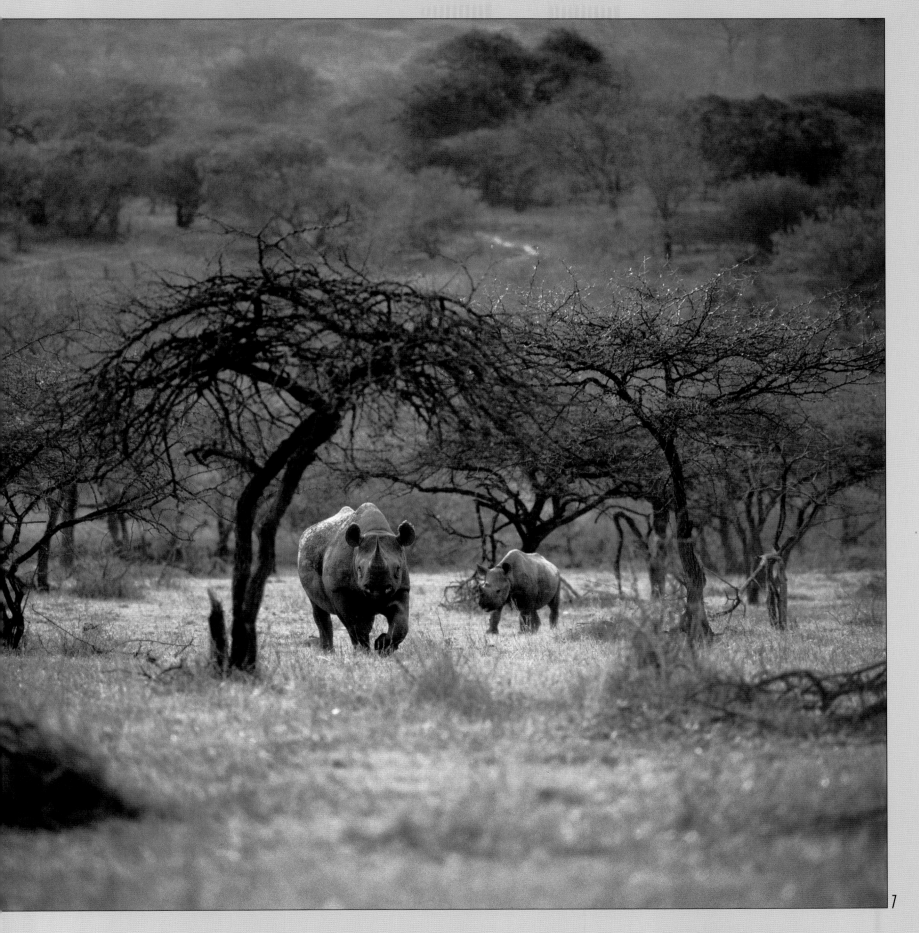

7

KWAZULU-NATAL

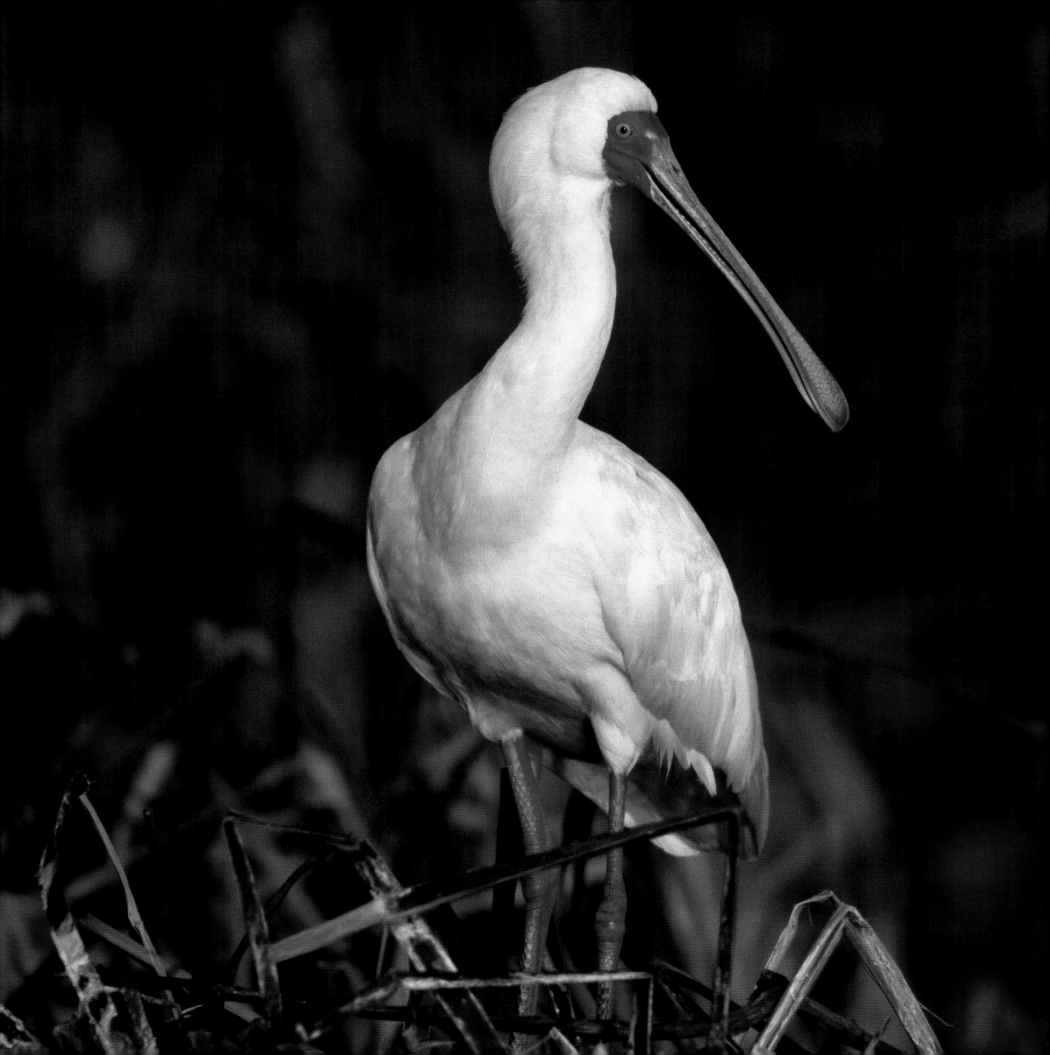

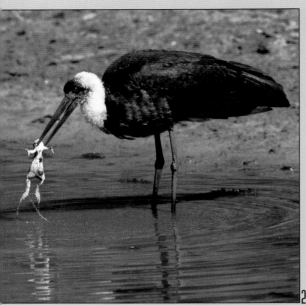

Far Left: l. The African spoonbill *Platalea alba* is a wading bird occurring in marshy wetlands interspersed with shallow open waters. It nests in tree colonies or reedbeds. Here it is shown at its nesting site in the Bluff Reserve, Durban.

The spoonbill hatches with a short beak that gradually develops into a spoon-like shape by the time it is ready to leave the nest. It feeds on various fish, molluscs and amphibians.

2. A Woolly-necked stork *Ciconia episcopus* with a freshly caught frog at the Masinga waterhole in Mkuze Game Reserve. This large wader, typically 85 cm tall with distinctive glossy black plumage and woolly neck, is an uncommon species in Zululand. The bird's diet consists of crabs, molluscs, fish, lizards, grasshoppers and the occasional mantis.

3. The Grey heron *Ardea cinerea* is a large mainly solitary wader. It stands about 1 m tall with a wingspan of up to 2 m. Feeding in shallow water, the heron catches fish, frogs, and insects with its long, dagger-shaped bill. On land it takes small mammals, reptiles and occasionally small birds. Common throughout Africa, it is seen here in the St Lucia wetlands.

4. The striking orange-red to scarlet cones of the female *Encephalartos ferox* contrast with the dark green foliage to make it one of the most spectacular of cycads. It is commonly know as the Zululand cycad, and in Afrikaans as the 'broodboom' (bread tree) due to its use by local people for its starch content. The pith is fermented and then ground into a flour meal. These cycads, often referred to as 'living fossils', are commonly found in shady locations in dune forest margins right up to the beach. The arching leaves, 1–2 m long, are darker and darker. The plant can only be reproduced by seed.

At the Centre of Pharmaceutical Studies at the University of Coimbra in Portugal, doctors seeking plants with neurobiological activity as potential targets for drug discovery, established that this plant is known to contain buphanidrine, an alkaloid pain-killer similar to codeine.

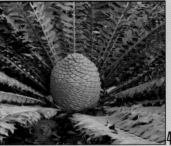

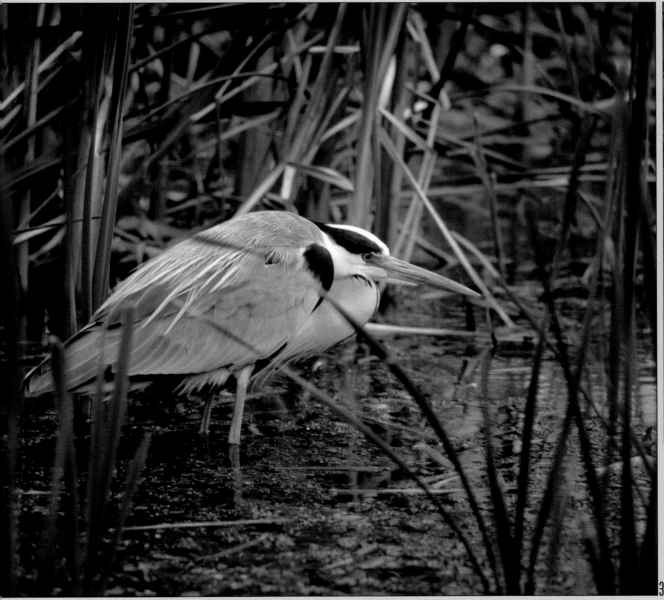

wider than those of any other *Encephalartos* species.

5. The ground lily *Ammocharis coranica* is a member of the Amaryllidaceae family. It grows in sandy or even clay-like soil with some water and lots of sun. The leaves tend to lie on the ground.

The flowers are pink, lasting for up to 20 days, turn gradually

6. The banks of the Nzimane River in the Hluhluwe-Umfolozi Game Reserve are bordered with the characteristic date palm *Phoenix reclinata*. This is one of the main seasonal tributaries of the Hluhluwe River, which flows through the reserve.

Situated at the junction of the Usuthu and Pongola floodplain systems, the Ndumo Game Reserve is a good example of a floodplain ecosystem relatively unaffected by human activities. The Pongola River runs from south to north while the Usuthu forms the northern border as well as the international boundary with Mozambique. The reserve is characterised by beautiful pans, yellow fever trees, extensive wetlands and reed beds, acacia savanna and sand forest. Ndumo, with 430 identified species, is famed for having the highest bird count of any location in South Africa.

iSimangaliso Wetland Park (formally Greater St Lucia Wetland Park), is the third largest conservation area in South Africa and was proclaimed as a World Heritage site in 1999. It incorporates an astonishing variety of habitats ranging from the Ubombo mountains to grasslands, forests, wetlands, mangroves and some of the highest forested dunes in the world. It also boasts magnificent beaches and coral reefs.

The park stretches over 280 km from Kosi Bay in the

north to St Lucia in the south and covers an area of 328 km².

1. The rare Wattled crane *Grus carunculatus* is unmistakable due to its astonishing size (1.2 m). It frequents swamp borders and adjoining grassy veld, and is usually seen in small parties wading in shallow water.

2. A male scarlet-chested sunbird *Nectarinia senegalensis* perches in a fever tree *Acacia xanthophloea*. This striking bird favours *Leonotis*, *Erythrina* and *Aloe* flowers which it pierces at the base for nectar. Its diet also includes insects such as crickets, ants, caterpillars and spiders.

3. The blue duiker *Philantomba monticola* smallest of all the antelope species (30 cm at the shoulder), is a nocturnal forest dweller. It is very territorial by nature and patrols its territory marking the borders; intruders are chased off and their own

offspring are only tolerated until they reach about 18 months. Besides vegetarian preferences, this is the only antelope that includes meat in the diet: rats, birds and carrion.

4. The nile crocodile *Crocodylus niloticus* largest of the three species found in Africa, has a long, broad snout ending in nostrils which close underwater. A third eyelid protects the reptiles whilst underwater. Sociable by habit, crocodiles bask on waterside banks during the cooler hours.

5. The African Rock Python, *Python sebae,* is a widespread non-venomous species. It inhabits savanna grasslands generally close to water.

6. Against the backdrop of a wild fig forest a red duiker, *Cephalophus natalensis* skips along the water's edge in the Ndumo Reserve. This small antelope browses mostly after dark on the leaves, stems and fruits of low-growing shrubs. It is preyed upon by eagles, pythons and other predators.

7. A well-established fig tree *Ficus sycomorus* in the Pongola riverine forest, Ndumo Game Reserve.

Far right: 8. A tranquil setting at the Nyamiti pan in Ndumo.

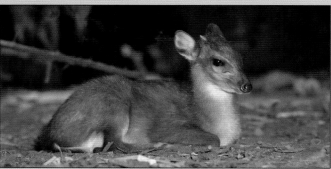

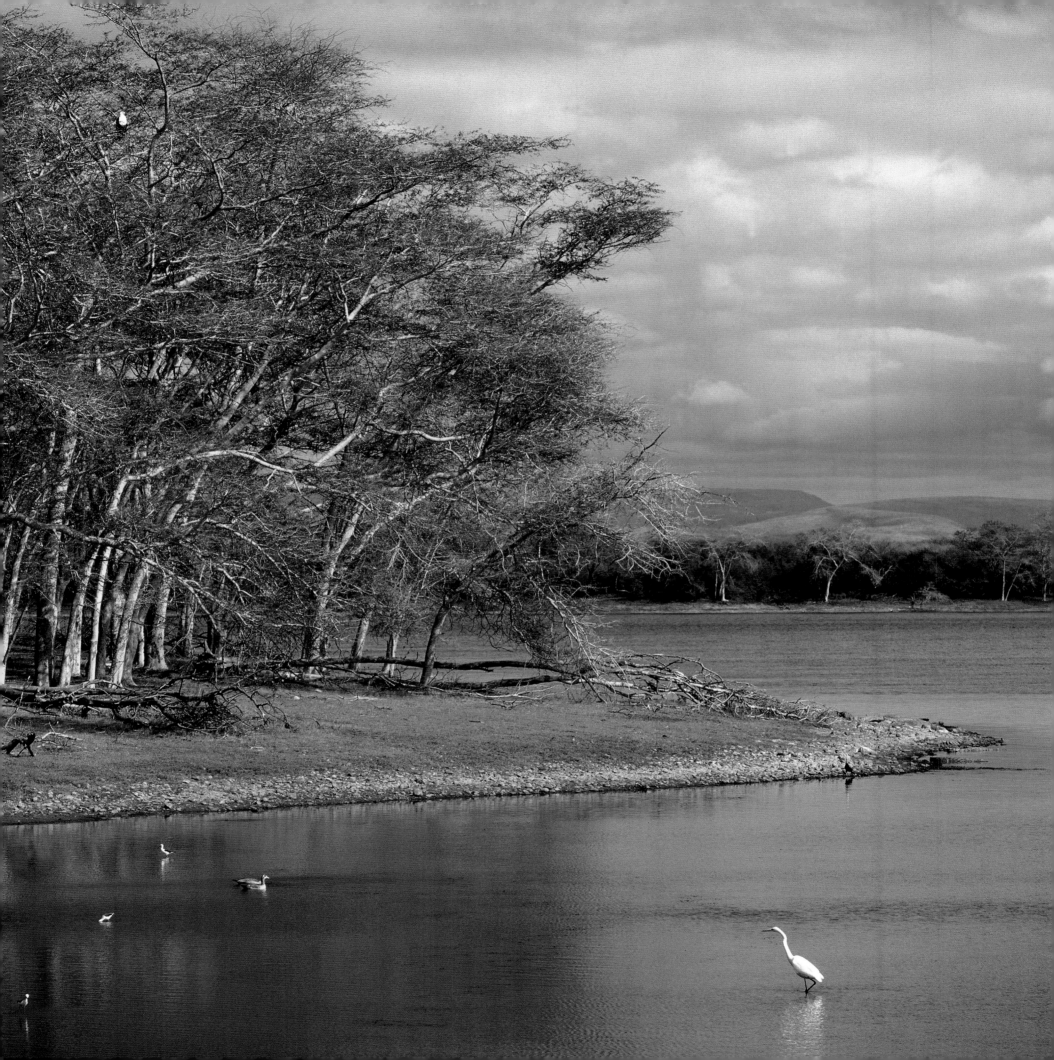

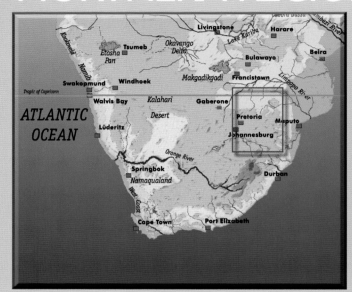

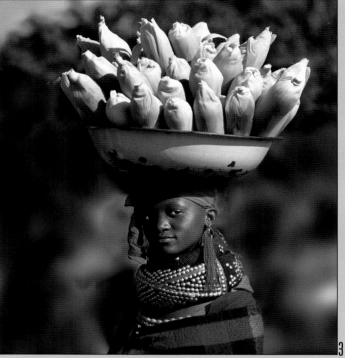

P̲art of the larger Nguni ethnic group, Ndebele people settled in the Limpopo Province in the early 17th century. Many traditions still survive among these people, especially the painting of huts in colourful geometric patterns. Generally this was done by women using muted earth colours made from ground ochre, as well as different natural clays in white, browns, pinks and yellows. When required, black was derived from charcoal. Bright colours are now more popular.

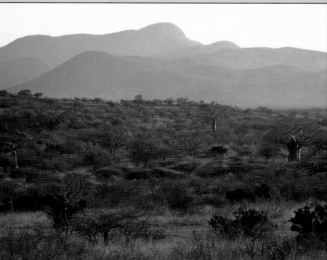

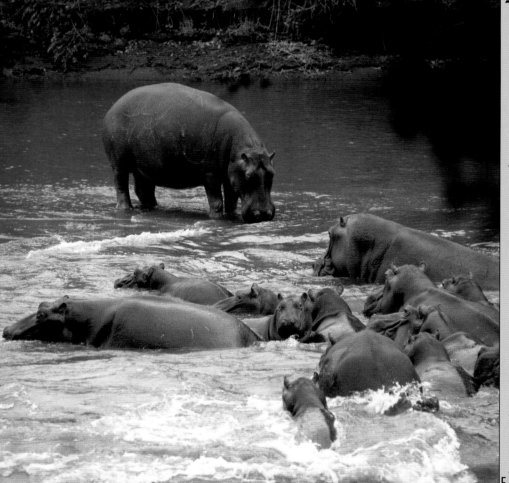

T̲he Kruger National Park is t̲ pre-eminent and largest ga̲ park in southern Africa. Initia̲ created to control hunting an̲ re-establish wildlife resources̲ was officially proclaimed on 26 March 1898 by Paul Kruge̲ president of the Transvaal Republic. James Stevenson-Hamilton was appointed the warden in 1902.

Over the years the park's boundaries were greatly exte̲ Today, with the establishmen̲ transfrontier park with Zimba̲ and Mozambique, it covers a̲ 35 000 km², allowing wildlife̲ roam freely as in the past.

1. With its distinctive style a̲ outline, a Ndebele homestead̲ features brightly in the wintr̲ highveld grasslands.

2. Bushveld wilderness in the̲ Honnet Nature Reserve.

3. A young woman balances̲ a load of *mielies* (corn cobs).

4. A Ndebele child poses shyly beside the brightly geometric-patterned façade of a traditional dwelling.

5. Hippos *Hippopotamus amphibius* restlessly stir up t̲ waters of the Luvuvhu River in Kruger.

Right: 6. Poised and elegant, a young Ndebele woman wears elaborately fashioned traditional neckbands.

The Drakensberg Escarpment divides Mpumalanga ('the place where the sun rises' in the Nguni languages) into two: a westerly half consisting mainly of high-altitude alpine grassland called the Highveld, and the eastern section situated in low-altitude subtropical bushveld known as the Lowveld. The Kruger National Park is situated in this latter region.

The central region of Mpumalanga is mountainous with peaks often exceeding 2000 m whereas the Lowveld is relatively flat with interspersed rocky outcrops.

Some of the oldest rocks on earth are located in the Barberton region. These ancient greenstones and metamorphosed granites form the Crocodile River Mountains in the south-east of the province.

Whereas the Lowveld is underlaid by African Cratonic Basement rocks of ages in excess of two billion years, the Highveld comprises mostly Karoo Sequence sedimentary rocks of a younger age.

Extensive mining occurs in this region. Rich mineral deposits include gold, platinum group metals, silica, chromite, zinc, cobalt, iron, manganese, tin, coal and asbestos.

Mpumalanga accounts for 83% of South Africa's coal production, of which 90% is used for electricity generation and the synthetic fuel industry.

1. The rare southern bald ibis, *Geronticus calvus*.
2. The honey badger (*ratel* in Afrikaans) *Mellivora capensis* is a tenacious small carnivore with an ultra-keen sense of smell.

For its size it has the reputation for being Africa's most fearless animal.

Honey badgers are generalist carnivores with an unusually wide diet. Besides consuming a variety of smaller food items including insect larvae, beetles, scorpions, lizards, rodents and birds, they prey on medium sized mammals and reptiles. Their snake-killing abilities are legendary. Pythons as well as highly venomous adders, cobras and black mambas are skillfully despatched and devoured.

3. Ever curious, a southern giraffe *Giraffa camelopardalis giraffa* stands alert with her attendant offspring in the Nylsvlei Nature Reserve bushveld.

Giraffes are the tallest of all land-living animals and are the largest ruminants. They are uniquely adapted to reach vegetation inaccessible to other herbivores. Their habitat comprises savanna grasslands and open woodlands. Males sometimes penetrate deeper into forest thickets to browse.

Since giraffes only occasionally drink, they can sometimes be seen far from a water source. They are non-

territorial social animals livi[ng] in loose, open, unstable gr[oups] varying in size generally fro[m] two to 10.

4. A Chacma baboon *Pap[io] ursinus* chews on the husk [of] sausage tree fruit.
5. An impala herd *Aepyce[ros] melampus* grazes peacefully [in] the woodlands of the Mala[...] Park Nature Reserve.

Far right: 6. The thick-tailed bushbaby *Otolemur crassicaudatus*, is the larges[t] of the bushbabies. Its eerie call sounds like a human ch[ild] crying. These animals inhab[it] woodland, forested savann[a,] plantations and bamboo thickets. Nocturnal and arboreal, they prefer the up[per] levels of the forest canopy.

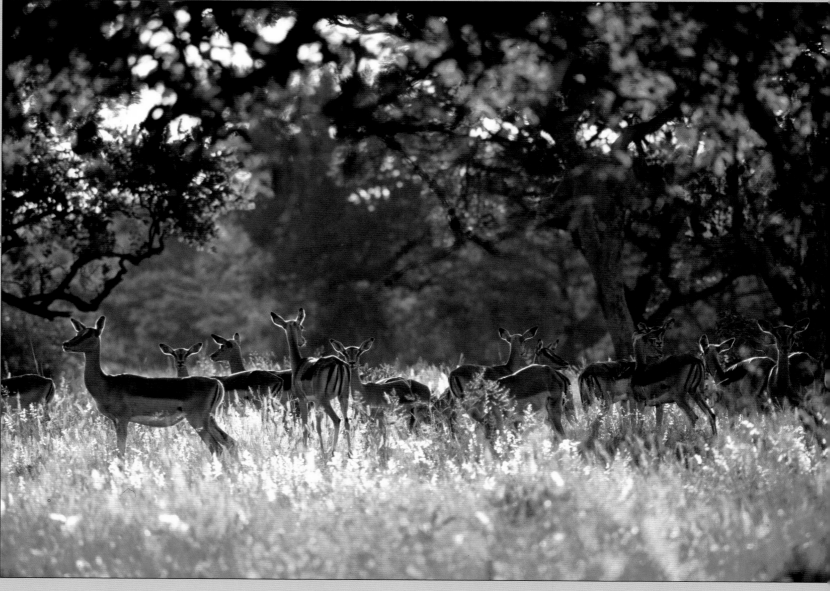

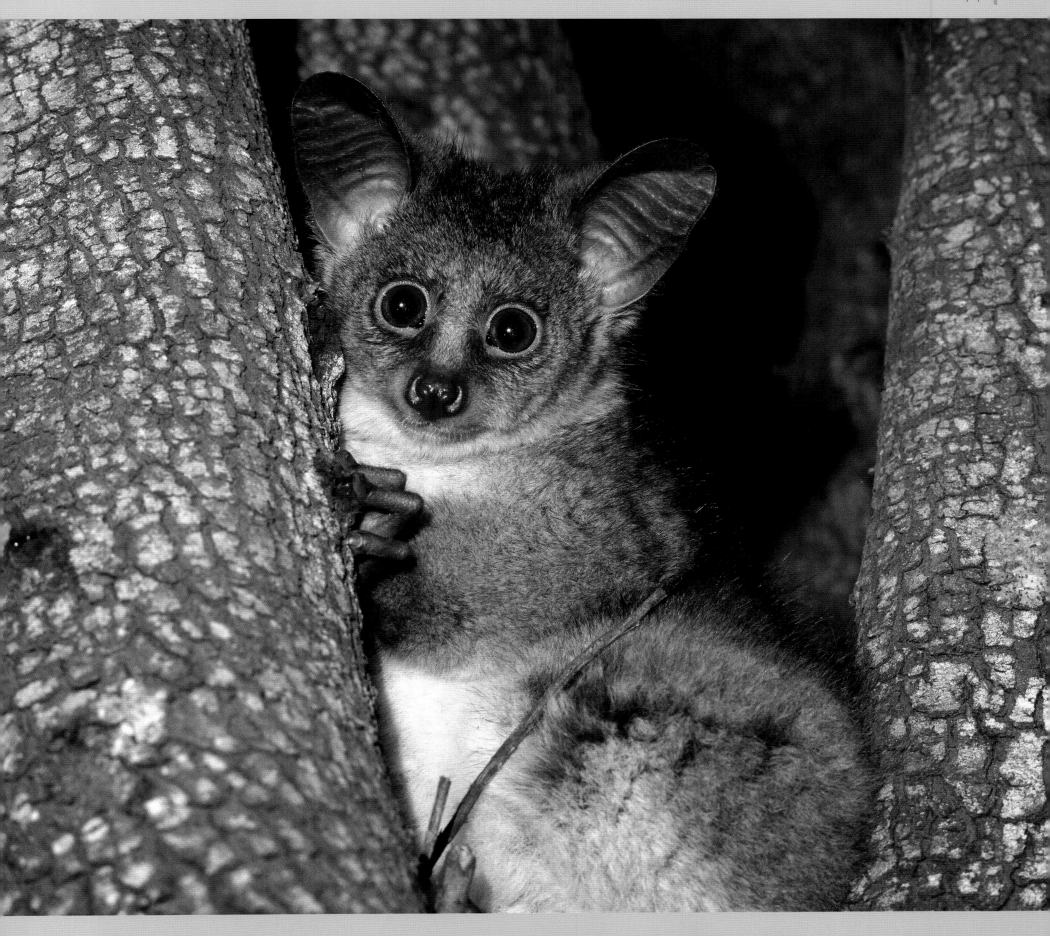

mountains of Limpopo
vince are rugged and
tiful, affording some of the
spectacular mountain
ry in the country.
Wolkberg (cloud
ntain), 2 127 m, is situated
e far northern reaches of
ansvaal Drakensberg.
miniscent in character to
outh American Andes, the
features steep mountain
, dense forests, daunting
es and beautiful valleys.
igh in the mist-shrouded
vaal Drakensberg, a lone
i kraal enjoys a spectacular
ion.

2

mpatiens sylvicola is one
nly three *Impatiens species*
rring naturally in South
a. The specific name is
riptive of its occurrence in
dland habitat. The plant
ow, scrambling, short-
perennial that may form
nies in shady, humid places
ong watercourses. It is
found in forest clearings
open areas.

3

he wild Barberton daisy
bera jamesonii is a perennial
genous to South Africa and
und in this region. It occurs
variety of colours and is
parent plant of the many
urful hybrids grown world-
e in gardens, parks, pots
hothouses.
Wild pineapple *Eucomis*
umnalis and tree ferns

Cyathea dregei embrace the slopes of
the Wolkberg.

5. *Androcymbium striatum* is widely
known as the pyjama flower. It is a
subalpine grassland herb attaining
30 cm in height. Growing in high rocky
places, its bulbs are protected from
excavation by porcupines.

6. *Protea simplex* grows high on the
Wolkberg slopes. This is a grassland
species with isolated populations in
the Drakensberg mist-belt. Like many
proteas it benefits from regular burning.

7. A waterfall close to the summit
of the Wolkberg cascades over
precipitous slopes.

5

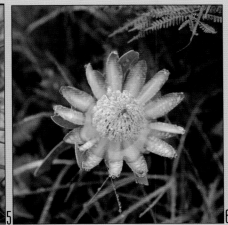

6

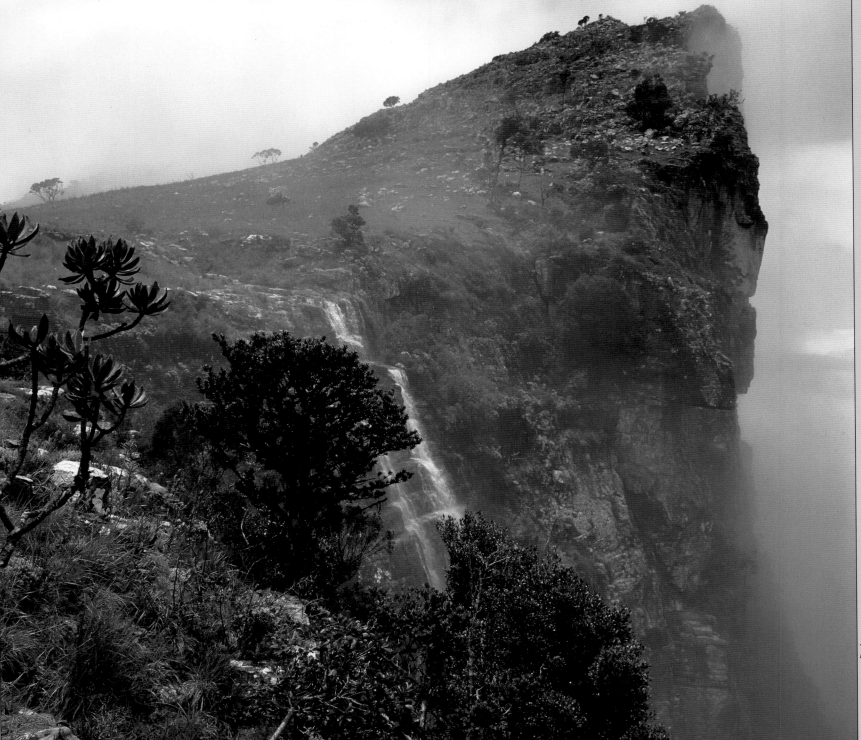

7

4

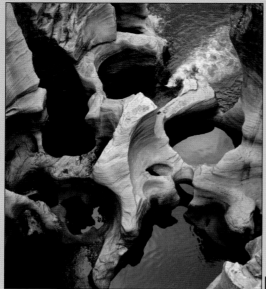

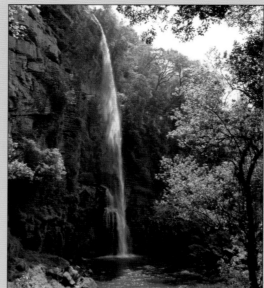

The Blyde River Canyon (recently renamed the Motlatse), is the third deepest in the world and ranks as one of the most spectacular sights in Africa.

The entire canyon extends over 20 km as it cuts deeply through the Transvaal Drakensberg range.

Below the canyon, the Blyde River yields to the unique and critically threatened Lowveld riparian forest, today barely covering 1 km². The river is dammed at the mouth of the canyon to create the tranquil Blyderivierpoort Dam.

The Mpumalanga Drakensberg escarpment has more waterfalls than any other area in South Africa. Numerous rivers and streams flow over the jagged edge of the great plateau and rage through ravines and kloofs before descending to the lowveld floor.

1. At Bourke's Luck Potholes, at the southern end of the canyon, the Treur River plunges into the Blyde River. Over many million years the bedrock has been eroded by the tumultuous flow of rock particles and sand to bring about these huge cylindrical holes.

2. Lone Creek Falls are a feature of the Sabie River where it plunges over a 68-m cliff covered with moss and ferns. It appears most spectacular following heavy rainfall, with spray nurturing a surrounding mini rainforest.

3. A lonely track penetrates the bushveld wilderness in the Langjan Nature Reserve.

4. The tree fuchsia *Schotia brachypetala* also known as weeping boer-bean and African walnut, is a medium to large tree with a wide-spreading, densely branched, rounded crown. The flowers are rich deep red and appear en masse in dense branched heads.

5. *Pavonia burchelli* is from the Malvaceae family (over 4000 species). Pavonias are part of the Hibiscus sub-family.

Right: 6. Where the swift-flowing Blyde River is joined by the Ohrigstad from the west, engineers have built an unobtrusive dam wall in a bottleneck below the confluence. The result is the Blyderivierspoort Dam, the heart of a beautiful nature reserve.

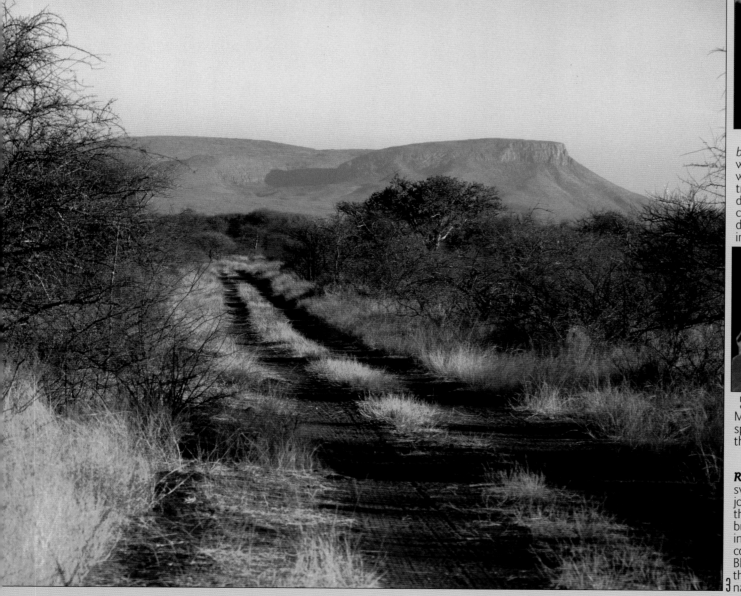

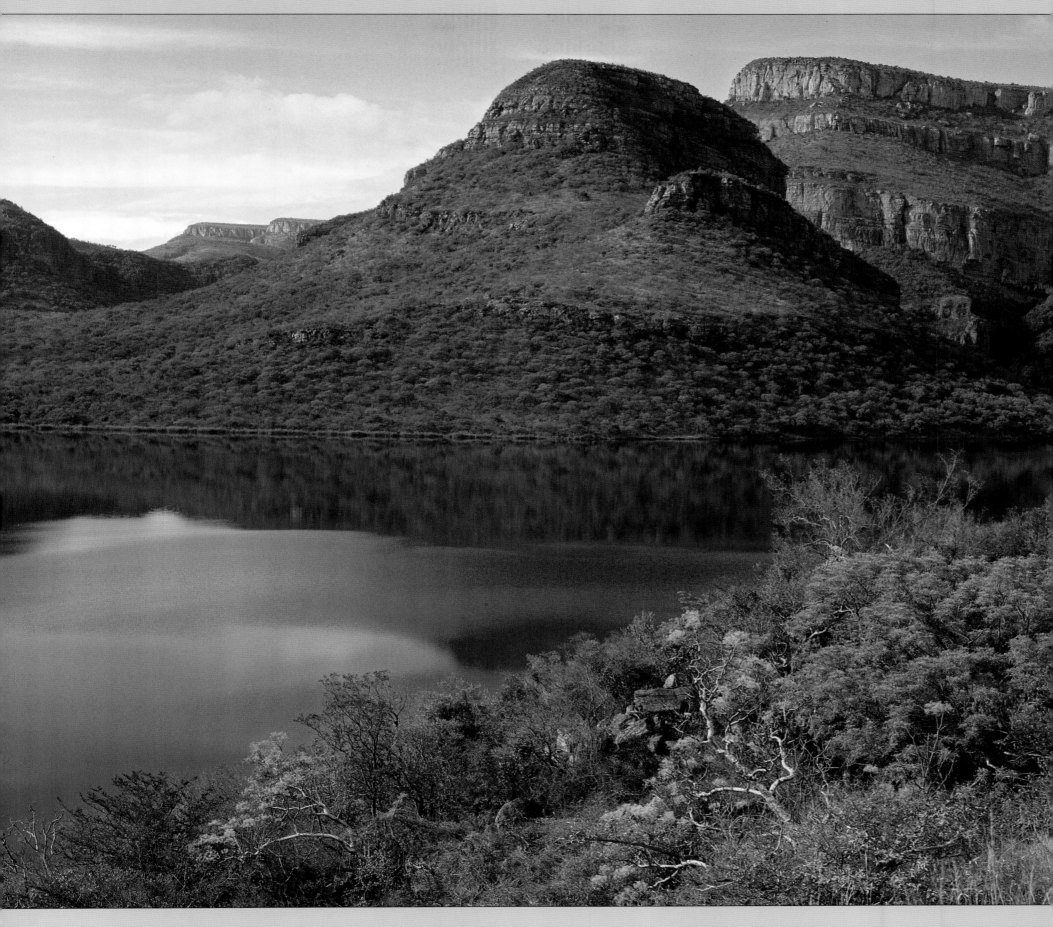

Established in 1956 by like-minded game farmers, Timbavati Private Nature Reserve today comprises 53.4 km² of private land adjoining the Kruger National Park.

It shares an unfenced border with Kruger, allowing unlimited freedom of movement for the Big Five (lion, leopard, rhino, buffalo and elephant) as well as other species.

Currently, over 40 mammal, 360 bird, 79 reptile, 49 fish and 85 listed tree species have been recorded in the reserve.

1. A six-week-old white lion cub, here shown with a normally coloured sibling, displays a rare mutation of the Kruger subspecies *Panthera leo krugeri*. This recessive gene is masked in the appearance of the tawny lion.
2. The same white cub yawning.
3. Most active as a species at night, this lion watches vigilantly over his buffalo kill.

Far right: 4. A lioness with her three suckling cubs.

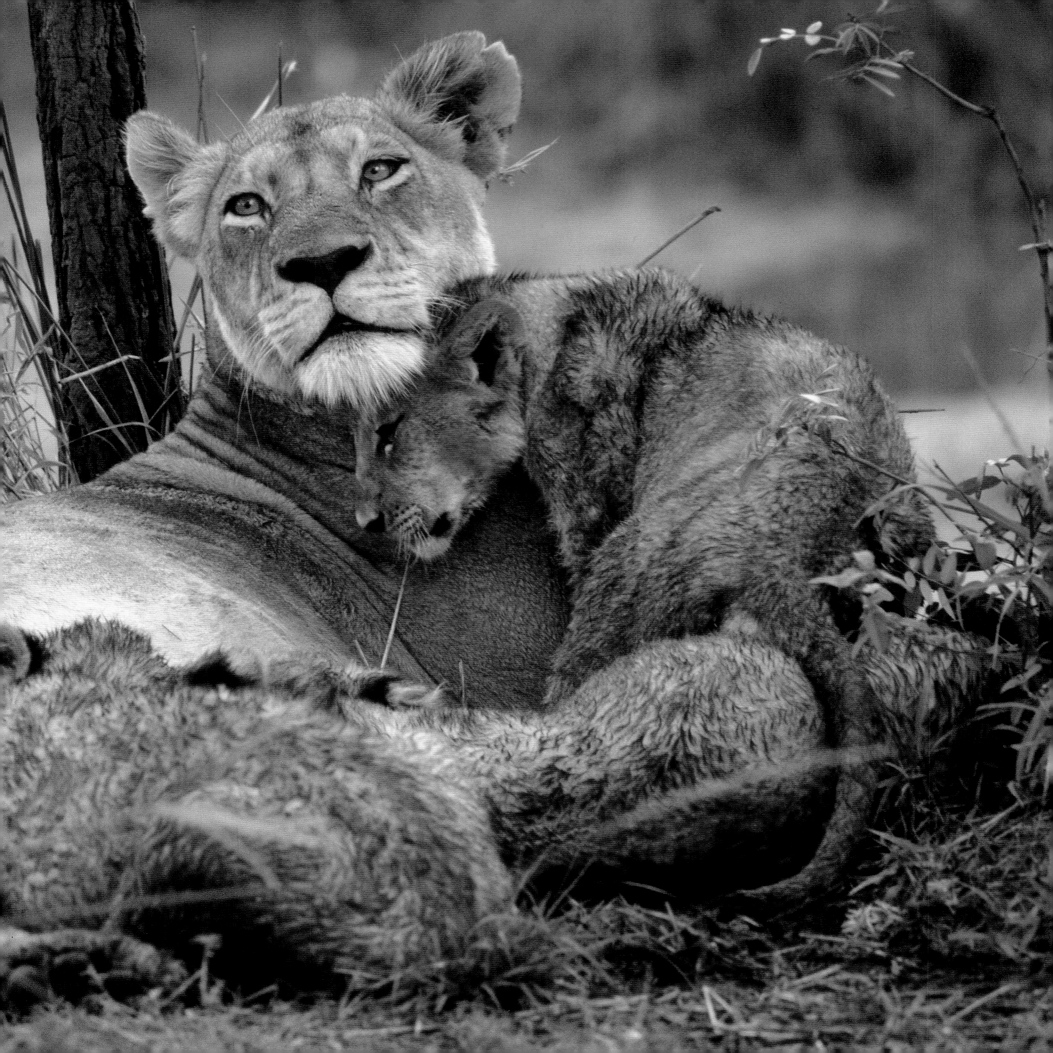

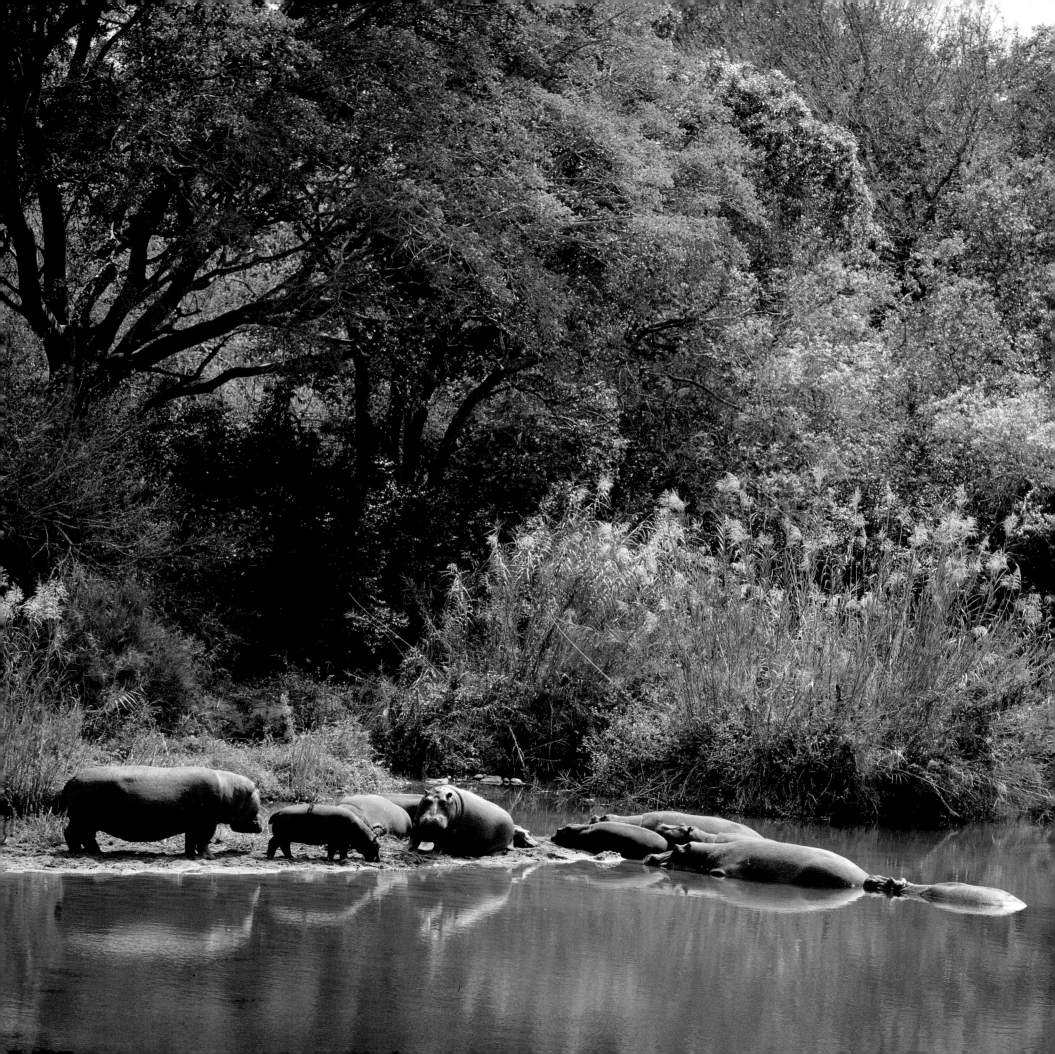

Far left:

l. A pod of hippos *Hippopotamus amphibius* relax beside the Sabie River. These massive amphibious animals prefer deep water with adjacent reed beds and grasslands. While submerged, the eyes and nostrils protrude, allowing the animal to see and breathe.

2. A cheetah *Acinonyx jubatus* charges out from the bush.

3. The Olifants is the largest river flowing through the Kruger National Park. Today it is facing a huge depletion of water content due to irrigation, pollution, abstraction and other uses from outside the park.

4. A Burchell's zebra mother *Equus burchellii* nuzzles her attentive calf.

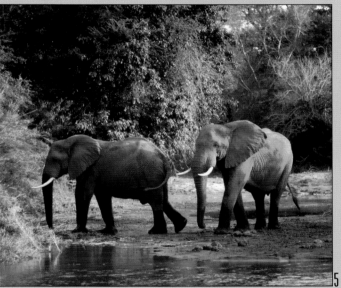

5. Two African elephants *Loxodonta africana* cross the shallow Letaba River. Historically elephants roamed in large herds from south of the Sahara Desert to the southernmost tip of Africa, and from the Atlantic coast in the west to the Indian Ocean in the east. Currently, populations are found in increasingly fragmented habitat throughout much of the same range, often primarily in and near wildlife reserves and protected areas. Poaching and habitat destruction have however wrought devastion during the past few decades.

Elephants frequent a wide variety of terrain including savanna, forest, river valleys, marshes – and even the arid Kaokoveld wilderness on the fringes of the Namib Desert. Their incisor teeth develop into tusks up to 2.5 m long which can each weigh a massive 60 kg.

Non-territorial, elephants live in wandering matriarchal communities. The herd's welfare depends on the guidance and experience of the matriarch and she determines where they will eat, rest, bathe or drink.

6. What the African or Cape buffalo *Syncerus caffer* may lack in beauty is more than made up for by its renowned unpredictable temperament.

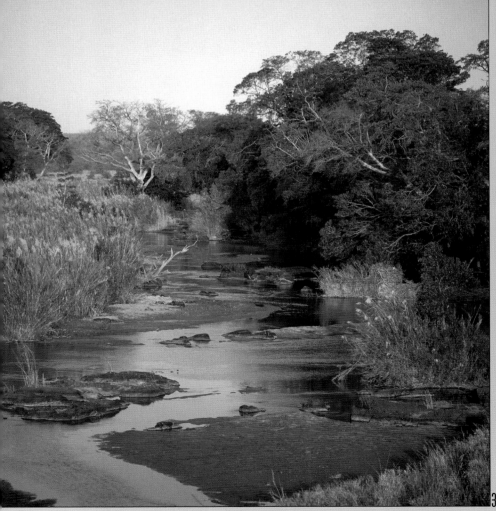

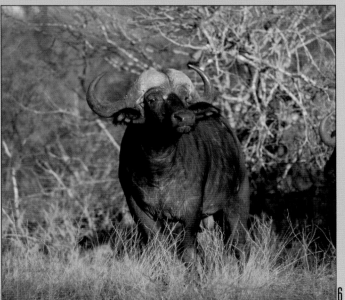

The Kruger National Park is one of the premier game-watching destinations in the world. Over 145 mammal species have been recorded in the park. The terrain is generally flat interspersed with a few gentle hills. Often viewed as being unvaried and dry, the park can in fact be divided into six distinctive ecosystems: baobab sandveld, Lebombo knobthorn-marula bushveld, mixed acacia thicket, combretum-silver clusterleaf, woodland on granite and riverine forest.

The 2009 species count in the park included: 11 672 elephants; 3 000 hippo; 5 114 giraffes; 1 500 lions; 1 000 leopards; 300 eland; 5 798 greater kudus; 9 612 blue wildebeest; 17 797 Burchell's zebras; 5 000 waterbuck; 90 000 impala; 500 bushbuck; 2,000 spotted hyena; and 350 African wild dogs.

1. An immature male roan antelope *Hippotragus equinus*. The species occurs in lightly wooded savanna with medium to tall grass and must have access to water. It is the second largest antelope species.

Its pelage is greyish-brown with a hint of red, and the legs

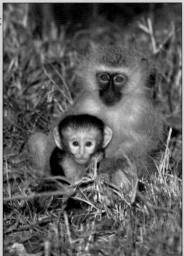

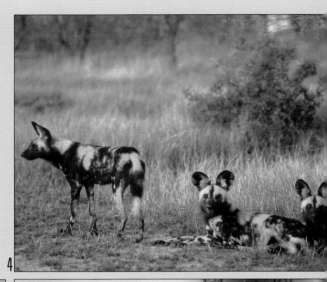

are darker. Both sexes have beautiful scimitar-shaped horns sweeping backwards in an even curve. Mainly active during the cooler parts of the day, roan antelope associate in herds of up to 35 individuals.

2. A vervet monkey mother *Chlorocebus aethiops* with her wide-eyed infant. These primates are highly social, often travelling in small groups in open areas, and are adept at moving along the ground, in preference to trees. Vervets are one of the few species to live in multi-male groups and must drink water daily in the dry season, hence their habitat is limited to the vicinity of a

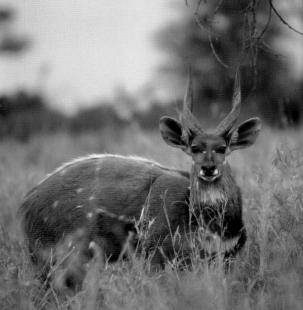

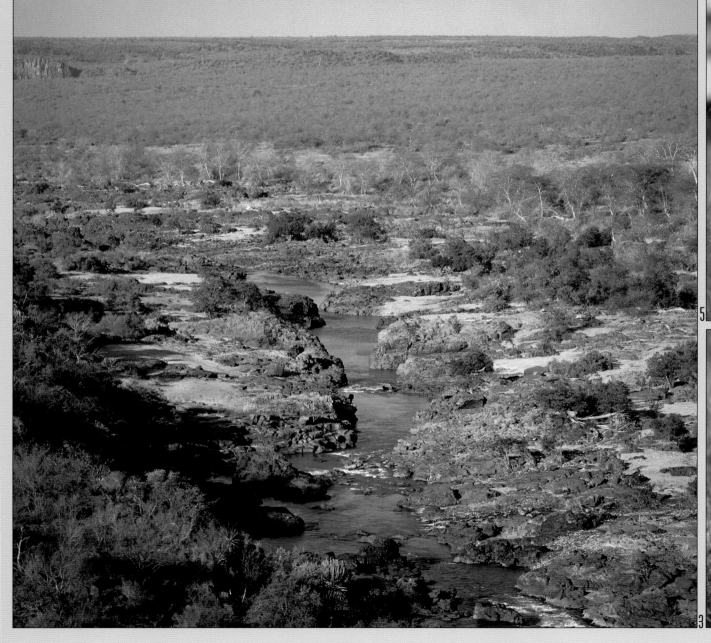

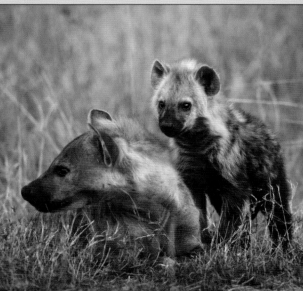

ant water supply.
e Olifants River flows
gh the Kruger bushveld.
rican wild dogs *Lycaon*
 inhabit savanna and
woodlands in East
 outhern Africa. These
ngered animals are
 rious and form packs of up
, each with an alpha male
 male, the dominant pair
 ead the hunt.
 d dogs are cooperative,
 ious hunters, tending to
 on mammals up to twice
 own weight in a long,
 chase. Prey includes small
 ope such as impala and
 r, as well as young, old,

 or injured larger animals,
 ding wildebeest and zebra.
 scientific name describes
 nted wolf,' and this aptly
 eys the colourful coat of
 brown, black and yellow
 nes in a pattern unique to
 animal.
 present trend is to refer

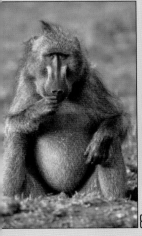

 em as 'Painted Hunting
 s'.
 he bushbuck *Tragelaphus*
 tus is a large antelope that
 s on vegetation for cover. It
 s in most of sub-Saharan
 a, especially in areas where
 is good cover. Males

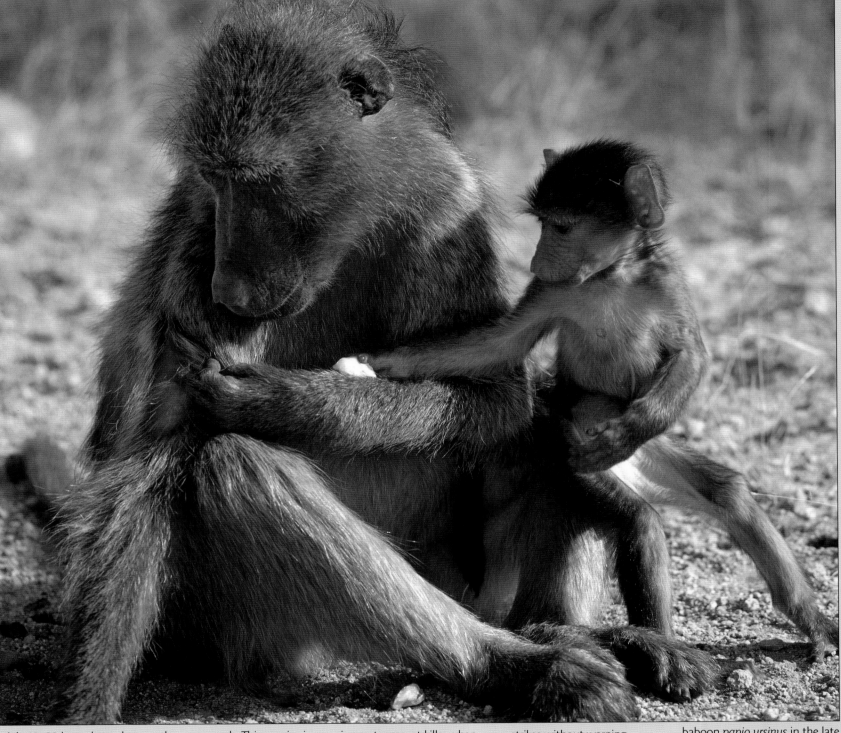

weigh 40–80 kg and stand 70–100 cm tall. The horns, nearly straight, are between 30 and 57 cm long. Bushbuck have both night and day ranges. Primarily nocturnal, they move back to their day range before dawn. They are the only Solitary and non-territorial African antelopes.

6. A spotted hyaena *Crocuta crocuta* mother relaxes with her young cub. This species is common in open dry habitats that include semi-desert, savanna, acacia bush and mountainous forest. Social groups, known as clans, are formed which can consist of between three and 80 members. The smaller clans tend to occur in the desert areas of southern Africa. Members of a clan are only observed together in three circumstances: at kills; when defending their territory; and at a communal den.

Although known primarily as scavengers, they are not exclusively so. A recent study in the Kalahari found that 70% of the diet was composed of direct kills.

7. Well camouflaged in the foliage, the arboreal boomslang *Dispholidus typus* typically strikes without warning. This slim snake (1–1.6 m in length), carries a highly potent haemotoxic venom delivered through large fangs located in the rear of the jaw. Its diet includes chameleons, other arboreal lizards, frogs, and occasionally even small mammals and birds, all of which are swallowed whole.

8. A pot-bellied Chacma baboon *papio ursinus* in the late afternnoon sun.

9. A Chacma baboon mother with her playful infant. This terrestrial primate prefers savanna, open woodland and hilly regions across Africa. Most baboons live in hierarchical troops that can vary between five and up to 250 animals, depending on the time of the year.

1. Common in forested areas, the Narina trogon *Apaloderma narina* (named by 18th-century French naturalist François

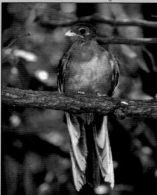

le Vaillant in honour of his Hottentot mistress Narina), is shy and unobtrusive.

Usually found singly or in pairs, the trogon usually perches stock still in an upright, though slightly hunched position. As a result, it is easily overlooked despite its bright colouring.

2. A white-fronted bee-eater *Merops bullockoides* with dragonfly just caught for its young in the adjacent mudbank nesting hole.

3. The southern ground hornbill *Bucorvus leadbeateri* is the largest of the hornbills (90 – 130cm from beak to tip of the tail). It is today a vulnerable species, mainly confined to

parks and reserves where a habitat of open savanna and woodlands is preferred.

These birds live in groups of five to 10 individuals including adults and juveniles. They forage on the ground for reptiles, frogs and insects as well as small mammals up to the size of a hare.

Here a female hornbill is shown being groomed by a male.

4. Displaying a fine pair of corkscrew horns, a greater kudu bull *Tragelaphus strepsiceros* grazes in the mopane bushveld. These spectacular animals carry the

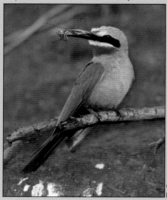

largest horns of the antelope tribe, averaging 1.2m in length.

Greater kudus prefer bush and thicket cover. In the rainy season they keep to deciduous woodlands, wheras during the

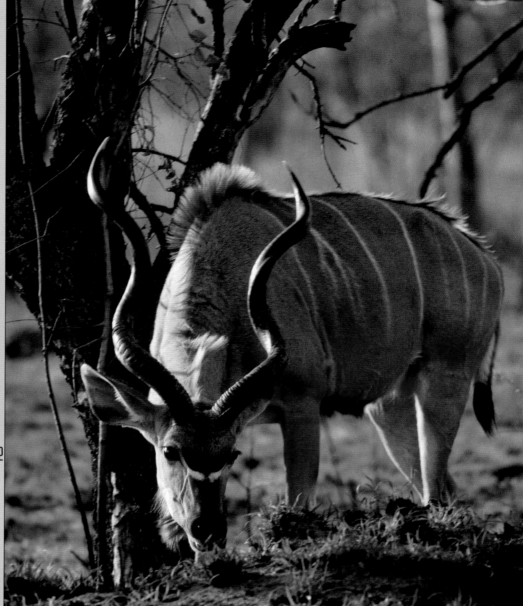

dry season, where conditions allow, they can be found grazing along the vegetated banks of rivers. Males and females live in separate herds, only associating with each other during the mating season.

5. The southern yellow-billed hornbill *Tockus leucomelas* is characterized by a long yellow beak with casque. This is a widespread resident of dry thornveld and broad-leafed woodlands.

Far right: 6. A Kudu bull in the Kruger bushveld silhouetted in the golden glow of dusk.

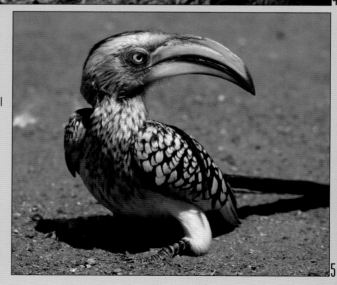

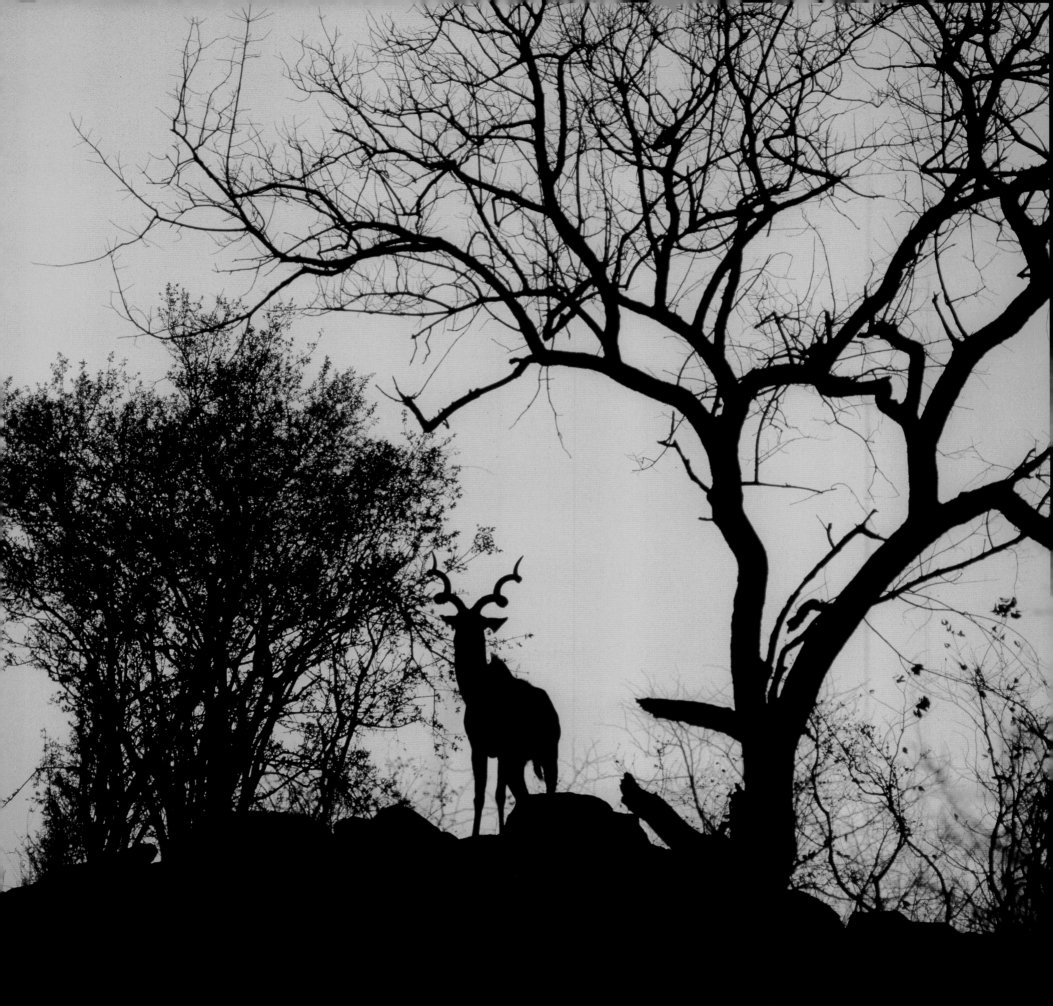

ZIMBABWE TO MOZAMBIQUE & MALAWI

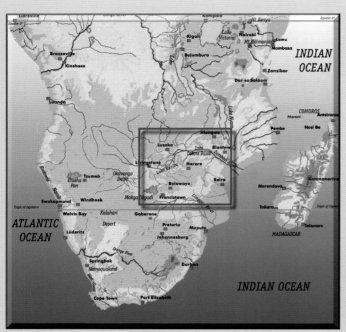

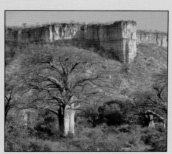
The red sandstone Chilojo Cliffs in Gonarezhou Natinnal Park.

At the northern end of the old Dutch East India Company Gardens in Cape Town stands a statue of Cecil John Rhodes, his left hand outstretched pointing north-east. Inscribed on the pedestal is "Your hinterland lies yonder". Rhodes' own early aspirations were to see in the future a 'red strip' on the geopolitical map of Africa, starting at the southern tip of the continent and stretching across what was to become Rhodesia, all the way to Cairo in North Africa. He envisioned an uninterrupted rail link, which was felt to be the best way to "unify the possessions, facilitate governance, enable the military to move quickly to hot spots or conduct war, help settlement, and foster trade".

Crinum sp.

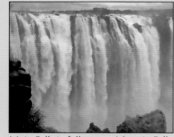
Main Falls in full torrent. Victoria Falls.

Much of Zimbabwe is elevated, with a central plateau that stretches from the south-west to the north-west between 1200 and 1600 m. The east is mountainous, with the highest point, Mt. Nyangani at 2592 m. The southern Lowveld constitutes about 20% of the total landmass.

Zimbabwe is borderd by two rivers: the mighty Zambezi in the north and the Limpopo River in the south. The Zambezi features the spectacular Victoria Falls, and the vast man-made Lake Kariba. Both rivers traverse Mozambique to flow into the Indian Ocean.

The country has a tropical climate, moderated by altitude, with a rainy season that occurs between November and March. Throughout, the vegetation is generally uniform: bushveld (thorny acacia-savanna) and miombo (dry open woodland) cover most of the central and western plateau, while the drier lowlands of the south and south-east are characterised by thorny scrub and baobabs. The varied terrain supports an abundance of wildflowers as well as 30 diverse species of aloe.

The word 'Zimbabwe' is most likely a short form of 'ziimba remabwe' or 'ziimba rebwe' in the Shona dialect of ChiKaranga: a term meaning 'The great house built of stone boulders', or simply 'House of stone'. The ChiKaranga-speaking Shona people live in the vicinity of Great Zimbabwe and have inhabited this region since the building of this mysterious ancient city.

In the ninth century, proto-Shona-speaking societies emerged from the middle Limpopo Valley and settled on the highland plateau. This became the centre of sophisticated Shona trade states. Successive kingdoms eclipsed each other. The original Mapungubwe state existed from about 1250 until 1450 and was then superceded by the kingdom of Zimbabwe which refined and expanded upon Mapungubwe's stone architecture. The famed ruins of its capital, 'Great Zimbabwe', survive to this day. This eclipsing of kingdoms continued until the mid-19th century, when after fleeing from Zulu dominance in the south, the Ndebele arrived and established their own empire, Matabeleland. The vanquished were forced to move northwards and to pay tribute.

Cecil Rhodes' dream began to materialize in 1888 when he obtained a concession for mining rights from the Ndebele King,

A BaTonga woman smoking her traditional pipe.

Lobengula. He presented this to the British Government in return for the granting of a royal charter to his British South Africa Company (BSAC) over Matabeleland and its subject states. This document was used to justify the despatch of a Pioneer Column of white settlers, protected by well-armed British South Africa Police through Matabeleland and into Shona territory to establish Fort Salisbury (now Harare). They went on to defeat the Ndebele in the First Matabele War (1893–4). Rhodes subsequently negotiated similar concessions covering all territory between the Limpopo River and Lake Tanganyika. Colonisation was promoted with British control over the extraction of precious metals and other mineral as well as native labour resources. The BSAC adopted the name Rhodesia in honour of Rhodes. The region south of the Zambezi officially became Southern Rhodesia in 1898 (today Zimbabwe) while the northern region was administered separately as Northern Rhodesia (gaining independence as Zambia in 1964).

A Second Matabele War followed, (1896–7) resulting in both Ndebele and Shona groups becoming subject to Rhodes' administration. This precipitated European settlement, which to a disproportionate land distribution that favoured European displaced the indigenous peoples.

In October 1923 following a referendum, Southern Rhodesia became a self-governing British colony. In 1963 growing Africa nationalism and general dissent persuaded Britain to dissolve Federation of the three colonies (Southern Rhodesia, Northern Rhodesia and Nyasaland) that had been formed in September Colonial rule was coming to an end throughout the continent However, the white-minority government in Southern Rhodes proclaimed a Unilateral Declaration of Independence (UDI) from United Kingdom in November 1965. This effectively repudiate British plan that the country should become a multi-racial democracy. In 1970 a republic was proclaimed which led to civ Over the years guerilla fighting against the UDI government intensified. Finally, Ian Smith opened negotiations with the leaders of the two main resistance fighter groups, ZANU led by Robert Mugabe, and ZAPU, led by Joshua Nkomo. In 1978, Sm

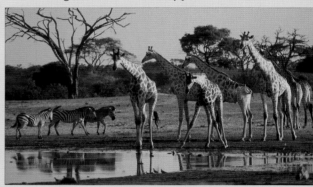
Burchell's zebras and giraffe at the Nyamandlovu waterhole, Hwang

signed an accord with the three African leaders, with safeguard offered to white civilians. Following the Fifth Commonwealth of Government meeting held in Lusaka, Zambia, that year, the British government invited the leaders to discuss and reach agment on the terms of an independence constitution with Briti supervised elections. On 1 December 1979, the Lanca House Agreement was sig officially ending the civil w In subsequent 1980 electi Robert Mugabe and his ZA won a landslide victory.

Two sides of the wildlife saga.

Pearl-spotted owl

The following exerpts are taken from recent studies on the current status of wildlife in Zimbabwe. The Zimbabwe Conservation Task Force (ZCTF) has documented the widespread destruction of wildlife in Zimbabwe in a devastating report: "The ZCTF documents massive deforestation and widespread slaughter of the wildlife... Zimbabwe had 620 private game sanctuaries before the land invasions began. ... Of the 14 conservancies before 2000, only one remains... until this point there was only anecdotal evidence of the widespread slaughter of wildlife in Zimbabwe... This report has shown that up to 90% of the wildlife in Zimbabwe has been destroyed since Mugabe expelled the white farmers... Compounding the disastrous economic policies of Mugabe's Government has been the neglect of national parks such as the world-famous Hwange National Park. Severe neglect has led to watering pans running dry because parks officials claimed there was 'no longer enough fuel to power the pumps'. Massive poaching, often organised by the very conservation officials who are meant to be protecting the wildlife, along with an invasion of poachers from neighbouring countries, has made bushmeat prevalent in the market places."

In a pre-feasibility study for donors and NGOs 'Rebuilding the Wildlife Sector in a New Zimbabwe' Dr Rolf D. Baldus & Dr Graham Child, expressed a positive hope: "Wildlife however, has a great ability to recover within a relatively short period of time, provided the natural habitats remain intact, sound protection and wise management can be reintroduced... Wildlife conservation is not a luxury that may be taken up at a later stage after the most urgent tasks of rehabilitation have been achieved. Zimbabwe's wildlife heritage is the draw card of the country's tourist industry, which is a sector that can quickly be turned around and play an important role in the reconstruction of the country. For the recovery of the wildlife sector, it must be incorporated in economic development and poverty reduction strategies from the start of the reconstruction effort."

Despite its name, the waterbuck ellipsiprymnus is not truly aqua

ring the early 1980s widespread uprisings occurred in [Mata]beleland which were ruthlessly crushed by Mugabe's North [Kore]an-trained Fifth Brigade. The violence ended in 1988 when [t]wo 'warring' parties merged, creating ZANU-PF. During the [follo]wing 20 years political tensions grew, with many divisive [out]breaks of instability. Mugabe, with his dictatorial style of rule [cl]ung on to power ever since, surviving resurgent rivalry and [oppositi]on activity through a canny combination of often question-[able] government, gerrymandering and intimidation.

[Zim]babwe's citizens became increasingly impatient as large-[scale] mismanagement filtered down to the man on the street. In [Jun]e in early 1998, dissatisfaction spilt over into open hostility, [riots] and looting. Anarchy escalated during wide-scale seizures [of wh]ite-owned farmland by squatters in 2000, followed by a [gover]nment-imposed land-acquisition law that dispossessed a [furth]er 3000 white farmers of their land. Resultant production [short]falls led to desperate food shortages, famine and a shattered economy. Precipitous hyperin-flation caused economic ruin and by 2008, inflation skyrocketed to nearly 100 000%, up from 7 000% in 2007. The Zimbabwean dollar became worthless.

In 2008, Zimbabweans, clearly disillusioned, expressed their anger at the polls, and the opposition Movement for Democratic Change won a majority of seats in Parliament. Ten months after these violent [d]isputed elections, a unity government was finally formed [with] Morgan Tsvangirai becoming prime minister and Mugabe [rema]ining as president. Since then, reasonable progress has been [made] to restore some social and political stability, although [signif]icant threats remain that could still derail the reform process. [The] current ethnic breakdown of Zimbabwe stands at: [Shon]a 71%, Ndebele 16%, other African 11%, white 1%, [mixe]d and Asian 1%.

[Min]eral exports, including some of the world's largest platinum [reser]ves, together with agriculture and tourism are the principal [forei]gn currency earners. Agricultural production, however, is [wani]ng. For years Zimbabwe was a major tobacco producer [as we]ll as bread basket for surrounding countries. Today this no [long]er applies due to forced seizure of almost all white-owned [comm]ercial farms, with the stated aim of benefiting landless black [Zimb]abweans. This led to sharp falls in production and precipitated [the c]ollapse of the agriculture-based economy with the country [suffe]ring critical food shortages yearly since 2001.

[Wi]ldlife and cultural tourism have for years proved to be a [signif]icant segment of the economy. The country's magnificent [wildl]ife and game parks embrace a wide diversity of topography [and v]egetation varying from miombo woodlands, thorny acacia, [tree]-studded landscapes to mist-shrouded highlands.

dwellings in the [...]n Highlands.

[H]wange, named after a local Nhanzwa chief, is Zimbabwe's [large]st national park (14 500 km²) and the country's premier [gam]e-viewing sanctuary. It is situated in the west, bordering [Bots]wana. Originally the royal hunting grounds of the Ndebele [warri]or-king Mzilikazi in the early 19th century, it was set aside [and p]roclaimed a National Park in 1929. Hwange today provides [habit]at for the largest variety of animals in the country including [...] bird species.

[In] the north-west lies: **Victoria Falls & Zambezi National** [Park], (560 km²) – and the mighty Zambezi River, which here [form]es the northern border with Zambia for 40 km. The park [comp]rises mist-forest, mopane thickets and savanna. Larger [wildl]ife species include elephant, hippo, lion, buffalo, giraffe, zebra, [sable] (the national animal), bushbuck and other antelope. [Reno]wned for wild flora and fauna. The tranquility and rugged [beau]ty of Chizarira is unequalled.

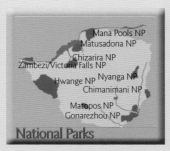

National Parks

Mana Pools NP
Matusadona NP
Chizarira NP
Zambezi/Victoria Falls NP
Nyanga NP
Hwange NP
Chimanimani NP
Matopos NP
Gonarezhou NP

To the north and on the southern shores of Lake Kariba lies **Matusadona**, bordered by the Zambezi Escarpment. This park (1400 km²) provides a combination of flat plains and wild mountain country. Before the lake was created, this was a vast rugged wilderness with limited access. With the lake came ecological changes. The lakeshore now contributes greatly to the increase of large mammal populations in the area. *Panicum repens* found on the shoreline is a rejuvenate grass, needing only fluctuating lake levels to replenish its nutrients. With this ready food source, large herds of elephant and buffalo are supported as well as many fish eagles. The park is also a rich habitat for zebra, kudu, waterbuck, roan antelope, impala, bushbuck, common duiker, grysbok, klipspringer and many lesser species, with the larger predators always attendant in the wings.

Mana Pools lies at the northern tip of the country. The name means 'four' in the local Shona language and applies to four large pools in the floodplain just inland from the river. These are remnants of ox-bow lakes carved out thousands of years ago as the Zambezi changed course northwards. Hippos, crocodiles and a variety of aquatic birds are associated with the pools. The park is a World Heritage Site: wild, remote and unspoiled, supporting over 350 bird species as well as a rich aquatic wildlife. This is one of Zimbabwe's most popular parks and provides habitat for a large variety of game. Formerly it was a successful refuge for the endangered black rhino. From forests growing on Karoo sediments, the vegetation changes to open woodlands (*Faidherbia albida*) on the old river terraces. This vegetation gives a unique look to the area with a surreal light filtering through the trees to give Mana Pools its distinctive cathedral-like atmosphere.

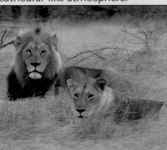

Lion and lioness Panthera leo in the southern bushveld.

Nyanga is situated to the south, in the Eastern Highlands. This national park provides stunning mountain vistas, numerous waterfalls and Zimbabwe's highest mountain, Mt. Nyangani. Nyanga is not a game park, more a hiking and scenic destination. Altitudes vary between 1800 and 2593 m, providing cool weather and fresh mountain air.

Further south and bordering Mozambique, **Chimanimani** a hiking park distinctively devoid of roads with only footpaths and narrow tracks. The Chimanimani mountain range, renowned for its scenic and diverse landscapes of steep sandstone peaks and towers, savanna valleys, rivers and pools, provides the main focal point of this park. The area is rich with orchids, hibiscus, lobelia, heather, aloes and many species of meadow wildflowers. Development has deliberately been limited in order to preserve its natural, pristine beauty and the wilderness landscapes of this mountainous region. Wildlife includes eland, sable, bushbuck, blue duiker, klipspringer - and an occasional leopard. The virgin forest, dense with moist evergreens, is frequented by several butterfly species. Birdlife includes species such as Gurney's and malachite sugarbirds, as well as trumpeter hornbills and eagles.

Gonarezhou lies in the south-east of Zimbabwe. Today it is an extension of The Great Limpopo Transfrontier Park which adjoins South Africa's Kruger National Park in the south and Mozambique's

Following the map clockwise, **Chizarira** National Park is situated at the top of the Zambezi Escarpment in the north-west, overlooking the Zambezi Valley and the upper waters of Lake Kariba. This large remote area (1920 km²) is endowed with magnificent gorges, plateaux, dense wood-lands and floodplains and is

Limpopo National Park. It covers an area of 5000 km² and is set to become one of the finest peace parks in the world dedicated to conservation, biodiversity and the economic development of surrounding local communities. The vast and diverse nature of this mega-park will provide world-class ecotourism and strive to re-establish historical animal migration routes and fragile regional ecosystems. The park's name originates from the Shona language meaning 'abode of elephants'.

Awarded UNESCO World Heritage Status in June 2003, the **Matopos** is situated in the magnificent Matopo (Matobo) Hills, a range of domes, spires and balancing rock formations hewn out of the solid granite plateau through millions of years of erosion and weathering. The majestic and rugged terrain of the park is a hiker's paradise and supports a diversity of vegetation and a wide range of wildlife species. The name Matopos ('bald heads') was chosen by the great Ndebele king, Mzilikazi, who is buried in the hills. This is also the burial site of Cecil Rhodes, whose grave lies on the top of Malindidzimu Mountain (which he had named 'World's View'). The park is renowned for its large concentration of Verreaux's eagles *Aquila verreauxi* often to be seen perched atop the characteristic eroded rock formations or soaring along the cliffs in search of prey.

Vervet monkeys Chlorocebus aethiops grooming.

The Flame Lily Gloriosa Superba Zimbabwe's national flower.

Species found in Zimbabwe, that have a limited distribution elsewhere, include the rare nyala, found only in Gonarezhou and Mana Pools national park, the king cheetah in Gonarezhou, and the samango monkey in the Eastern Highlands. Both white and black rhinos are present, albeit in small numbers and under grave threat from poaching.

The current situation and future for conservation in Zimbabwe and its once magnificent abundance of wildlife remain problematic. The Zimbabwe Conservation Task Force, a registered NGO, endeavours to protect both wildlife and habitat. Its website clearly defines what has happened since the 'land grab' by so-called 'war vets'. Not only agricultural land was targeted: a large percentage of private game ranches and conservancies were also confiscated, leaving wildlife to the mercy of these war vets. Once sanctuary to endangered species, several conservancies are now completely devoid of wildlife. Poachers do not discriminate between endangered and common species.

The website moreover describes evidence of deforestation and destruction of dry river beds, decimation of the fish population in Zimbabwe's rivers and lakes, and shocking graphic evidence of animals caught in snares left to die a painful lingering death. Often enough the perpetrators do not even bother to return to the snares to collect the meat; they merely leave it to rot. Estimates show that Lake Kariba is losing between 10 –15 tons of fish per day to organised poaching operations. Top officials, who purport to be guardians of the environment, are sometimes the actual perpetrators of these crimes. Thousands upon thousands of trees, mostly indigenous, are being felled by the new land settlers. Now vast tracts of barren land exist where once there was lush vegetation.

The Zimbabwe Conservation Task Force released a report in June 2007 estimating that " game ranches have lost between 80% and 90% of wildlife to poachers... Some game ranchers have reported that they *do not have a single animal left* ". The report warns that this loss, combined with widespread deforestation, is potentially disastrous to the tourism industry.

It can only be hoped that the future will bring abouts a more positive and balanced perspective.

"There are some that can live without wild things and some that cannot" Aldo Leopold.

The southern Zimbabwe Lowveld provides a vast and hauntingly beautiful expanse of spectacular landscapes.

1. Framed by the red sandstone Chilojo Cliffs, a giraffe *Giraffa camelopardalis* strides across the dry veld in the Gonarezhou National Park.

2. A large-spotted genet, *genetta tigrina*, at night in the southern lowveld.

3. For many hundreds of years this wild, rocky region was inhabited by nomadic Bushmen,

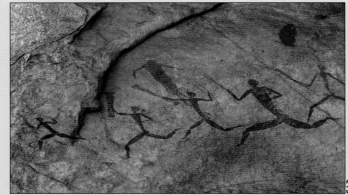

hunter gatherers who left a lasting reference to their presence in numerous cave paintings. These energetic graphic figures reflect the significance of the hunt to a long–gone way of life.

4. Gaunt yet magestic in the dry southern Lowveld, a huge baobab *Adansonia digitata* stands in the Chiredzi region, its branches outstretched like witches' hands:

FIRST WITCH : "When shall we three meet again,

In thunder, lightning, or in rain?"
MACBETH: ACT I SC.I

THIRD APPARITION: " Macbeth shall never vanquished be, until Great Birnham wood to high Dunsinane hill shall come against him.
MACBETH: That will never be: Who can impress the forest; bid the tree Unfix his earth-bound root?"
MACBETH: *ACT IV SC.I W.SHAKESPEARE*

Right: 5. In tranquil mood, the Nyamasakana River meanders through the Lowveld wilderness.

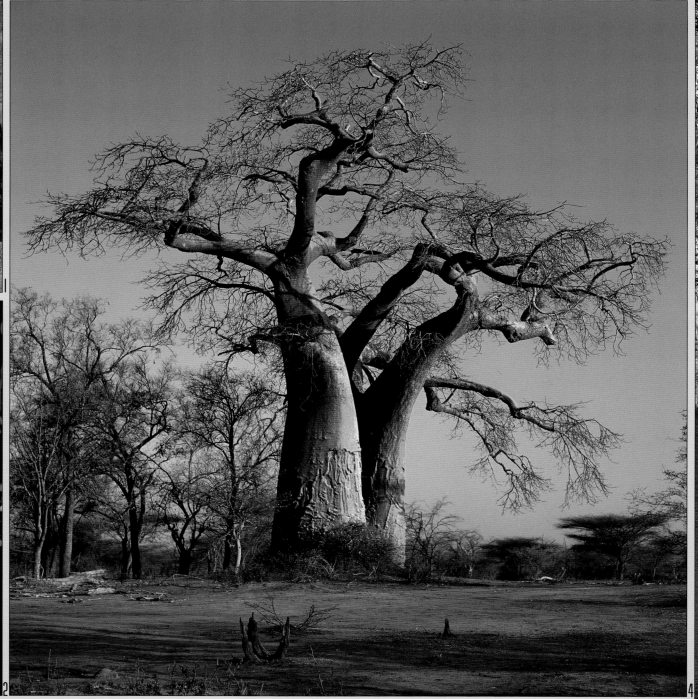

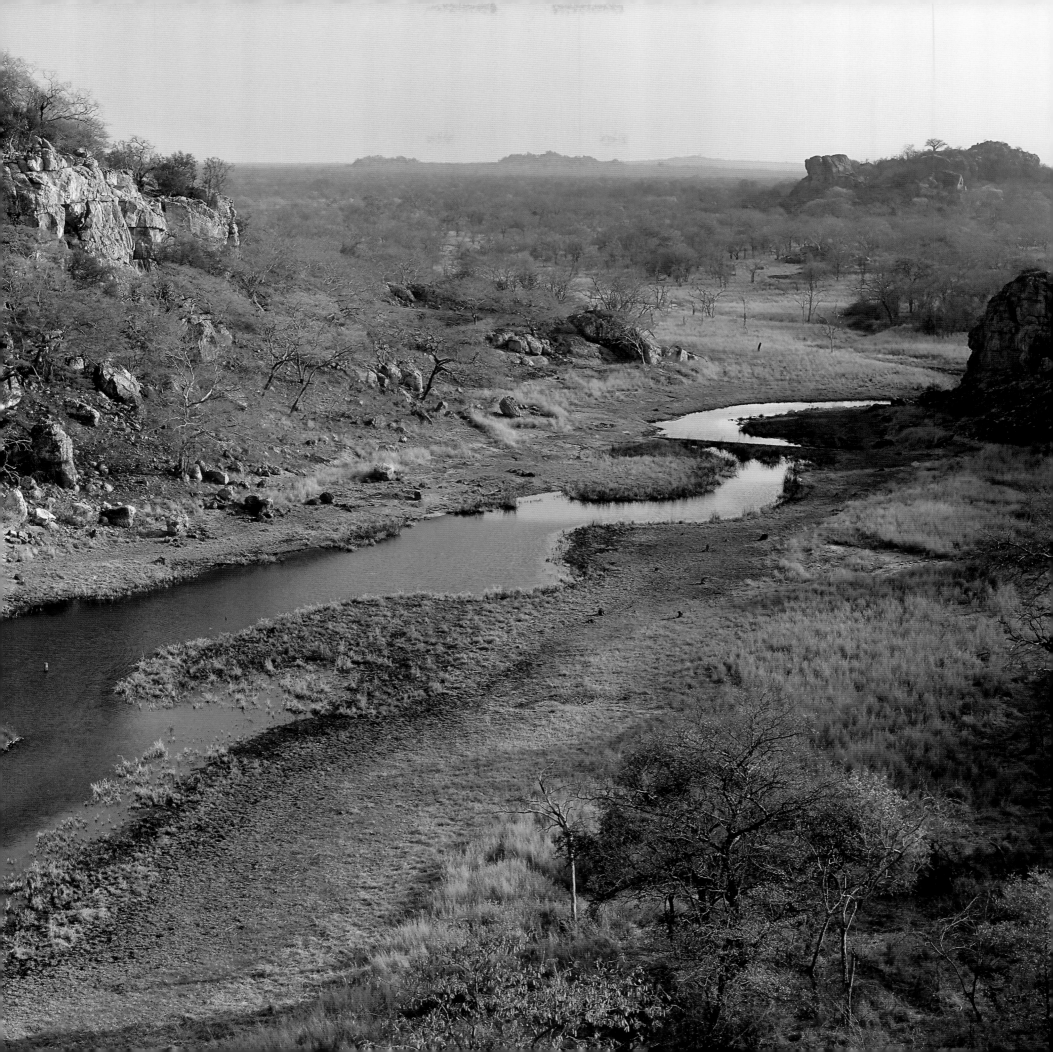

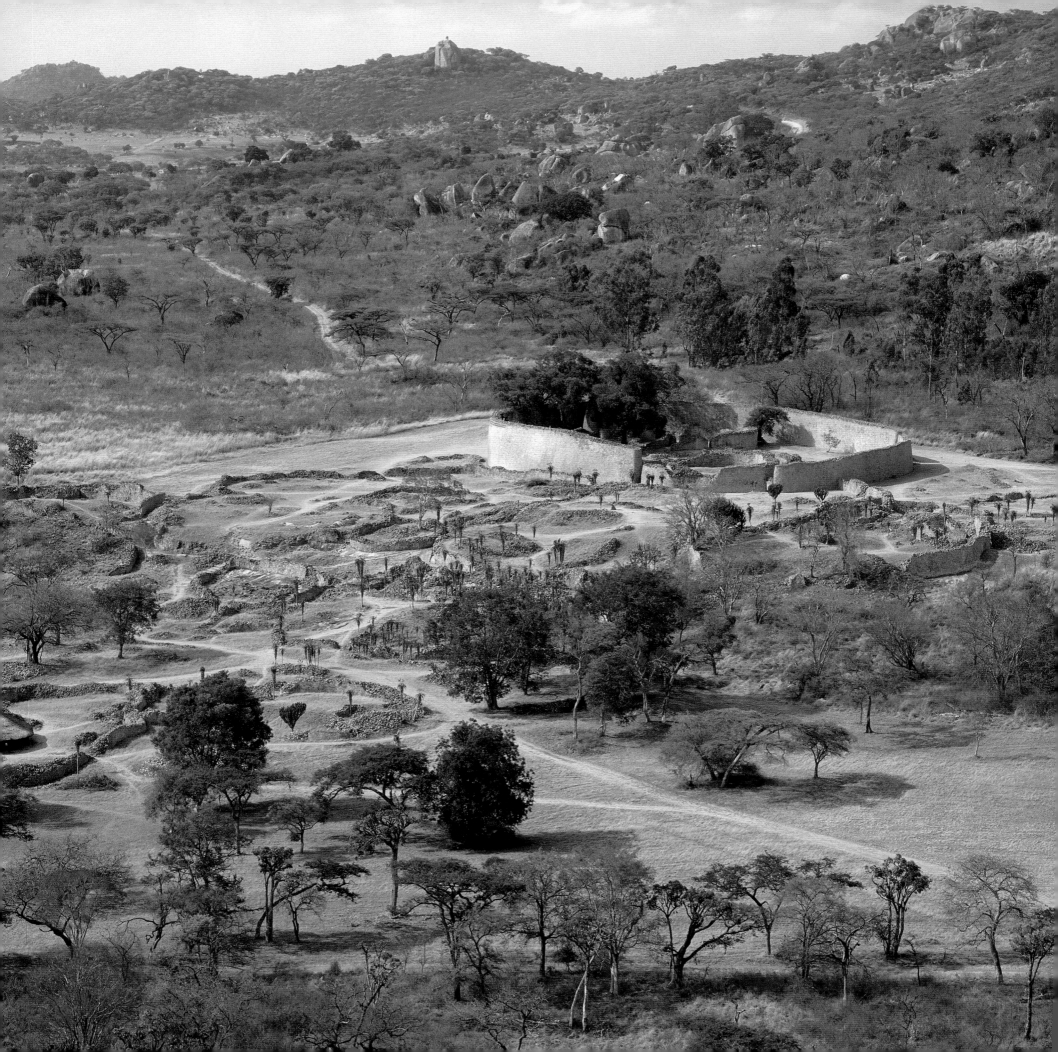

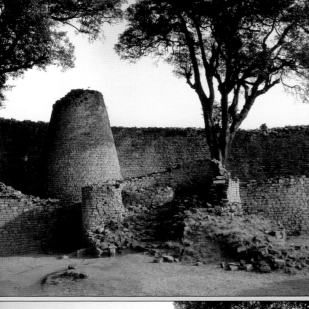

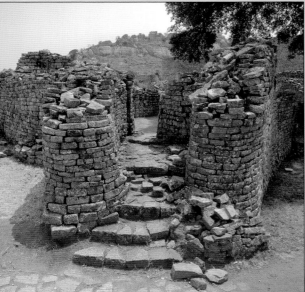

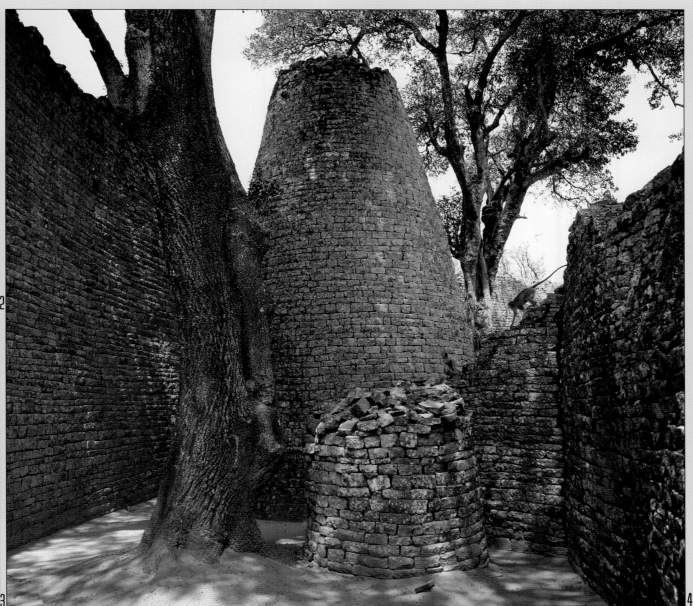

proclaimed a World Heritage Site in 1986, the Great Zimbabwe Ruins, the largest single historic structure in southern Africa, remain an intriguing enigma to this day. Were these ruins built by ancestors of the Venda / Lemba tribes (now dwelling further south) or the resident Karanga people? Were they perhaps constructed by Arabians who sailed here in catamarans using favourable monsoon trade winds?

Whatever their origin, these majestic, awe-inspiring and timeless ruins tell of the rise and fall of a civilisation that left behind no record of a written language. They represent one of the truly lost civilisations of the world, inspiring wild and romantic speculations. The ruins that survive are built entirely from many thousands of stones balanced perfectly one on top of the other without the use of mortar. The complex spreads out over 7.2 km² and covers a radius of 160 to 320 km.

The ruins are broken down into three distinct architectural groups: the Hill Complex, the Valley Complex and the Great Enclosure. The Hill Complex was used as a temple, hence its name 'Acropolis', the Valley Complex was for the citizens, and the Great Enclosure, where over 300 structures have been discovered, was the precinct of the king.

Construction started in the 11th century and continued for over 300 years. Archaeologists generally agree that the builders spoke one of the Shona languages. Some theorise that Great Zimbabwe was the work of the ancient Bantu Gokomere culture, progenitors of the Shona who lived in the area from around 500 AD. Archaeological evidence indicates that this group formed an early phase of the regional culture. However, Great Zimbabwe is also claimed by other Shona-speaking people as well as by the Lemba (a tribe with traditional claims of ancient Jewish descent, substantiated by recent DNA testing). By the 15th century the city had fallen into irreversible decline.

Great Zimbabwe gave modern Zimbabwe both its name and its national emblem, an eagle, probably a bateleur, from a bird stylishly carved out of soapstone found at the ruins.

Far left: 1. A view from The Acropolis to the Great Enclosure. Peter Garlake, in *Early Art and Architecture of Africa* (Oxford University Press 2002) believes this was "almost certainly a royal residence".

2. The Conical Tower from inside the Great Enclosure.

3. The distant Acropolis viewed from crumbling ruins in the Valley complex.

4. A vervet monkey crosses the walls towards the Conical Tower.

5. Detail of the walls surrounding the Great Enclosure shows construction without the use of binding mortar. Carved stone birds feature along the parapet.

Strangely eroded rock formations and granitic domes dominate the valleys and woodlands of the Matopo Hills. Renowned as one of the richest areas in the world for prehistoric rock art, the Matopos National Park is also known for its White rhinos. It is moreover the burial place of Cecil John Rhodes, pioneering founder of the British South Africa Company, which was granted a royal charter in 1889 to develop the region north of the Transvaal.

1. & 5. Curiously eroded granite outcrops some, giving rise to seemingly natural sculptures.

2. A Matopos bushveld landscape showing characteristic granitic koppies.

3. An eastern rock elephant shrew *Elephantulus myuru*, beside its rock sanctuary. This tiny rodent lives mostly among rocky outcroppings of boulders (koppies) in hilly terrain where it only inhabits formations with plenty of cracks and crevices since it neither nests nor burrows.

The shrew is thought to have a lifespan of four to six years in the wild. It is primarily an insectivore feeding on spiders, termites, ants, flies and butterflies.

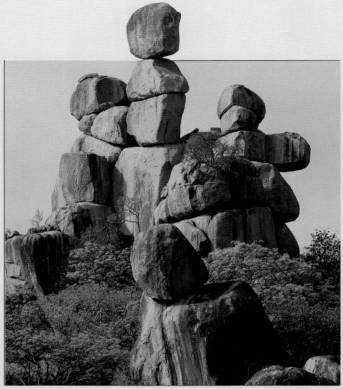

4. A male flat lizard *Platysaurus intermedius rhodesianus* displays its typically gaudy coloration, appearing like something from a fairytale book. Common flat lizards are the most widely distribu *Platysaurus*, a genus of lizards in the Cordylidae family. There are nine subspecies of P. intermedius all living in southern Africa. Ea has its own unique array of colours. Females and juveniles of th species are not as brightly coloured, typically having black scale brown bellies and white stripes on their backs.

These lizards live under weathered rocks, and prefer granite, sandstone and quartzite.

Overleaf: The golden glow of sunset at the Caterpillar Pan in Hwange National Park heralds day's end for a herd of elephants and peacefully grazing buffaloes.

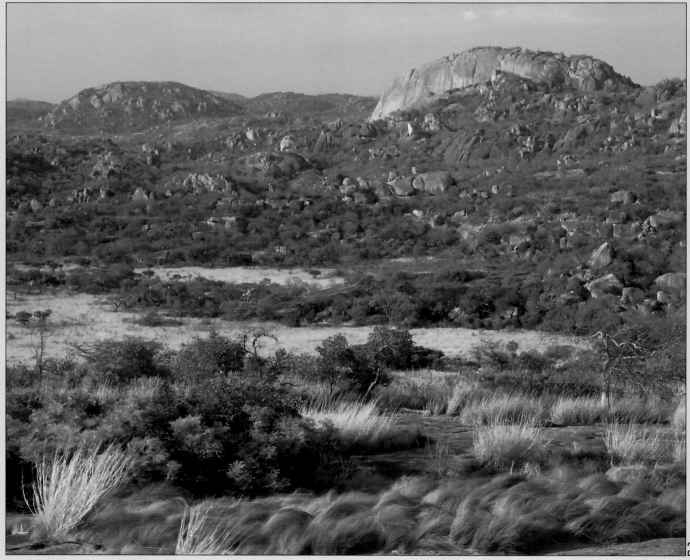

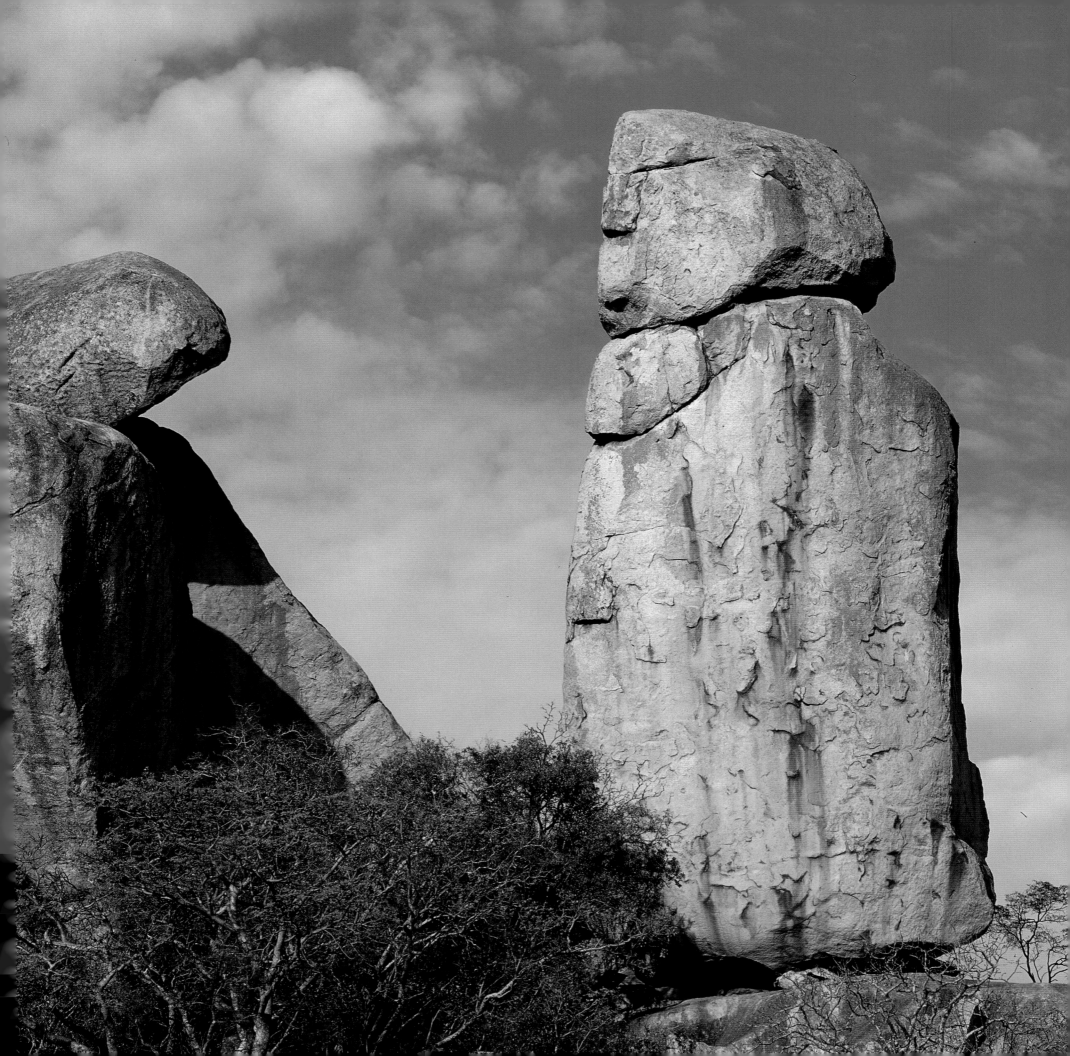

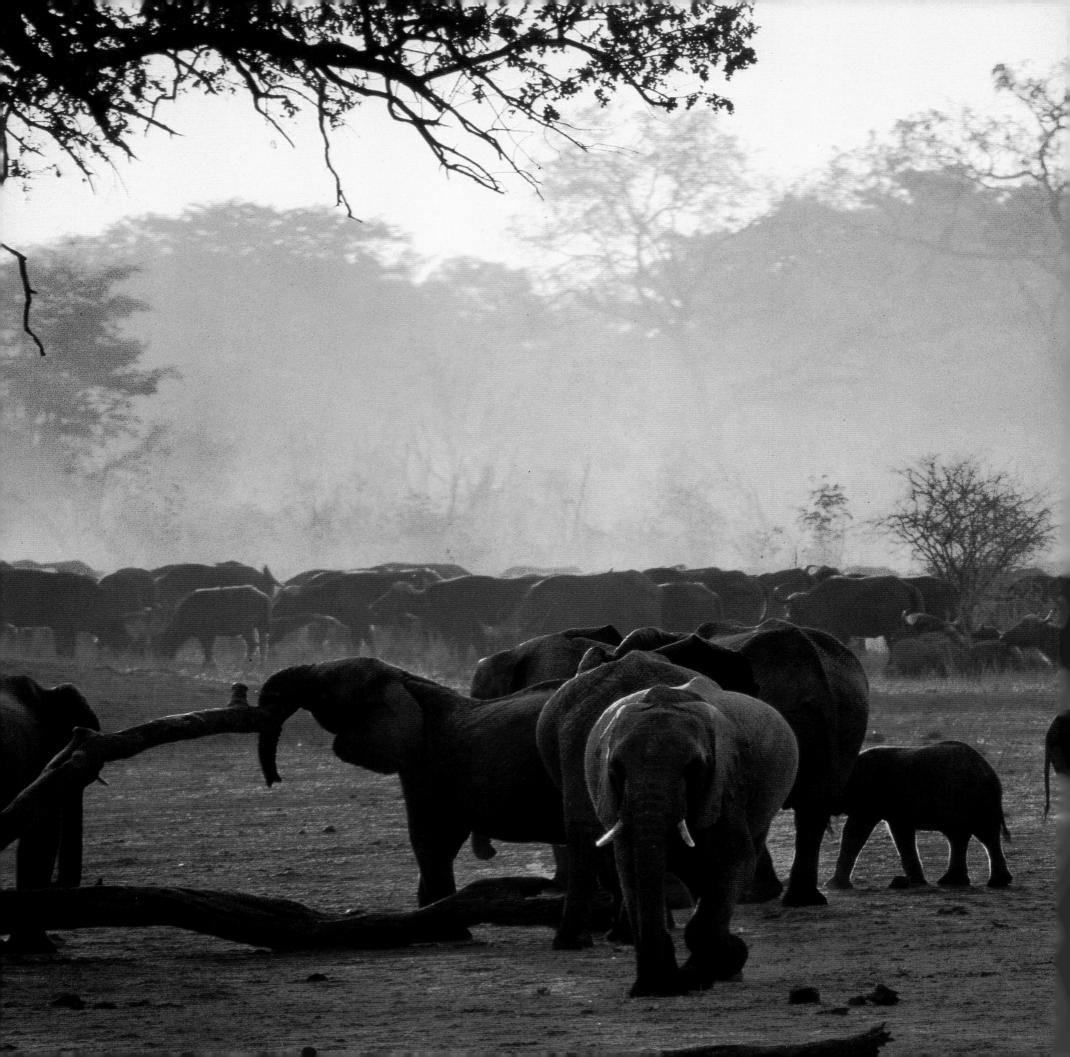

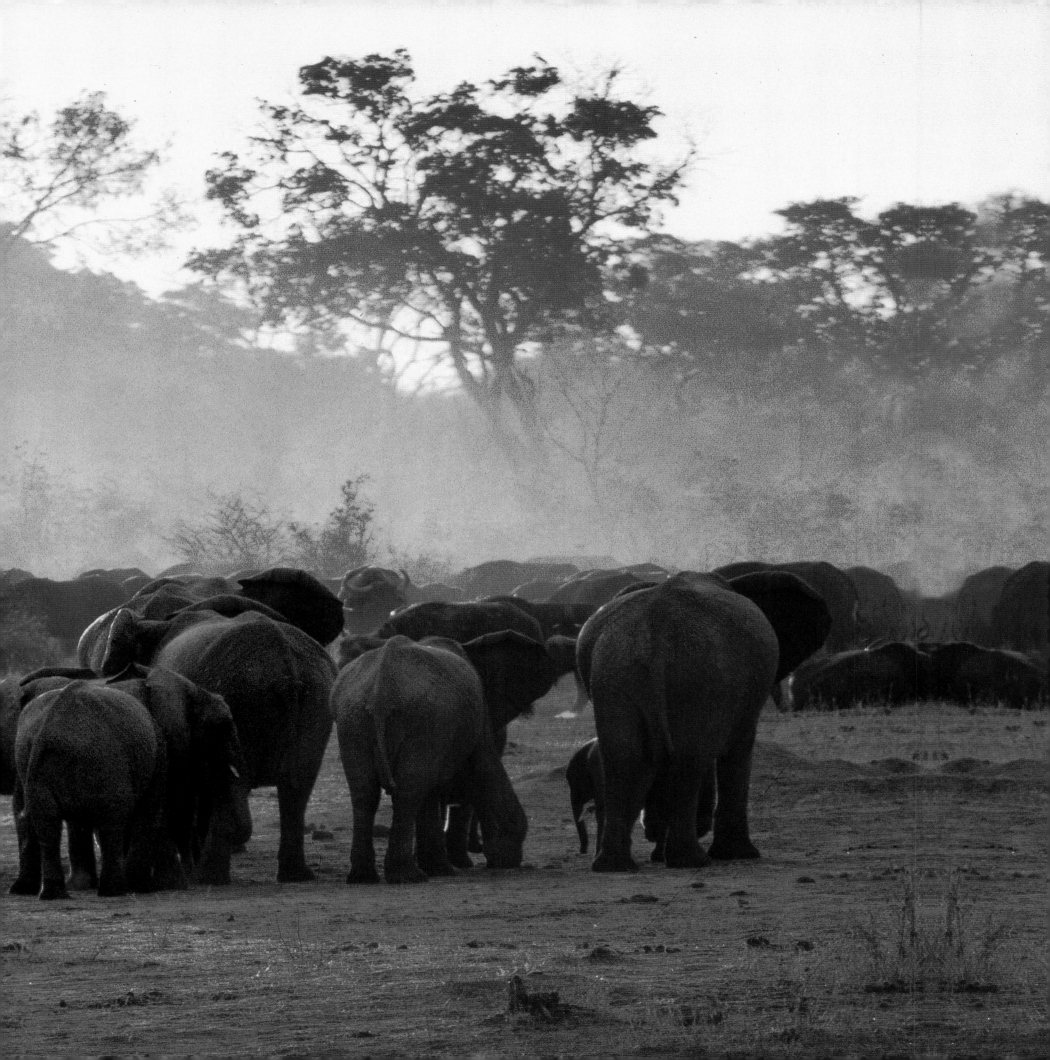

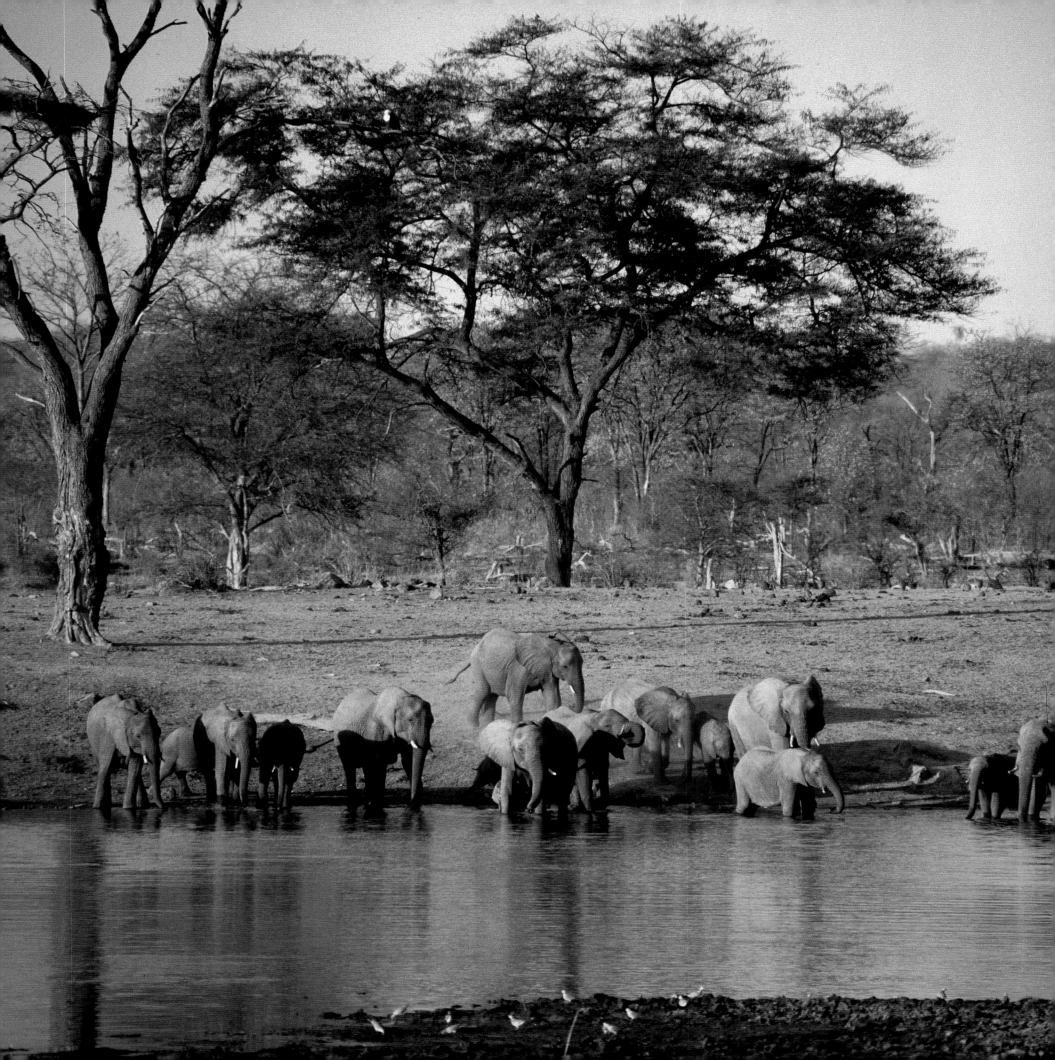

The salt pans and grassy plains of Hwange National Park support one of the largest concentrations of animals in the world.

Originally the royal hunting grounds of the Ndebele warrior-king Mzilikazi, the park was founded in 1928 by a 22-year-old game ranger, Ted Davidson. He befriended James Jones, stationmaster for the then Rhodesian Railways at Dete, close to today's Main Camp in Hwange.

The park, named after a local Nhanzwa chief, covers over 14 500 km². It hosts 105 mammal species, 19 herbivores and 8 large carnivores including a population of African wild dogs, one of the largest surviving groups on the continent. Some 400 bird species have been recorded.

Far left: 1. In a setting of autumnal mopane woodland, a herd of elephants quenches its thirst at the Detema Dam.
2. African buffaloes *Syncerus caffer* graze peacefully in a mopane clearing.
3. A herd of buffaloes thunders across the open veld.

With its bounteous wildlife, Hwange, the largest national park in Zimbabwe, has been described on many travel sites: "To travel through Hwange National Park today is to see what much of the interior of Africa might have been like more then 150 years ago."

The diversity of its habitats— miombo, mopane and teak woodland, acacia, savanna and grassland— as well as the many waterholes, dams and pans, have helped ensure the abundance of a wide variety of animals, especially the larger herbivores for which it is famous.

This was once home to nomadic San (Bushmen) who lived off the land, hunting and feasting on the great herds of migrating game. The San were in time displaced by stronger tribes, who in turn had their day.

Chief Hwange of the Nhanzwa tribe was ousted by the Ndebele chief Mzilikazi, and his lands

were taken over as a royal hunting ground in the early 19th Century,

In the same century the white man arrived and promptly set about claiming land and shooting the remaining game.

The animals were pressured further and further into the inhospitable western reaches on the Bechuanaland (Botswana) border, to an area set aside for hunting and farming. This was later proclaimed as the park we know today.

I. The serval *Felis serval* is often referred to as 'the cat of spare parts'. It is unequalled in the cat world as a predator. The serval's large ears allow it to locate small mammals moving through the grass or underground, and to successfully hunt without seeing its prey until the final pounce.

2. A pair of mating *Acraea natalica*. This species is conspicuous by its colour and zigzag flight.

3. Mopane worms (emperor moth caterpillars) *Gonimbrasia belina* are so named for their association with leaves of the mopane tree, although this is not its exclusive food source. The caterpillars are an important human food source and are hand-picked in the wild, usually by women and children.

Should a larva survive beyond its fourth moult, the caterpillar burrows underground to pupate into an adult emperor moth which lives for three to four days. Mating and egg laying occur during this short period.

4. A dung (scarab) beetle belonging to the subfamily *Scarabaeinae*, is shown here with the dung ball it is about to bury in the sandy soil. Dung beetles fall into three categories: the rollers, noted for rolling dung into spherical balls, which are used as a food source or as brood chambers; the tunnellers, which bury dung wherever they find it; and the third group, which simply live in manure.

5. Lithe and purposeful, a leopard *Panthera pardus* strides acro the wooded veld.

Right: 6. Seated atop and beside a strategic termite mound, lion cubs await the return of their mother.

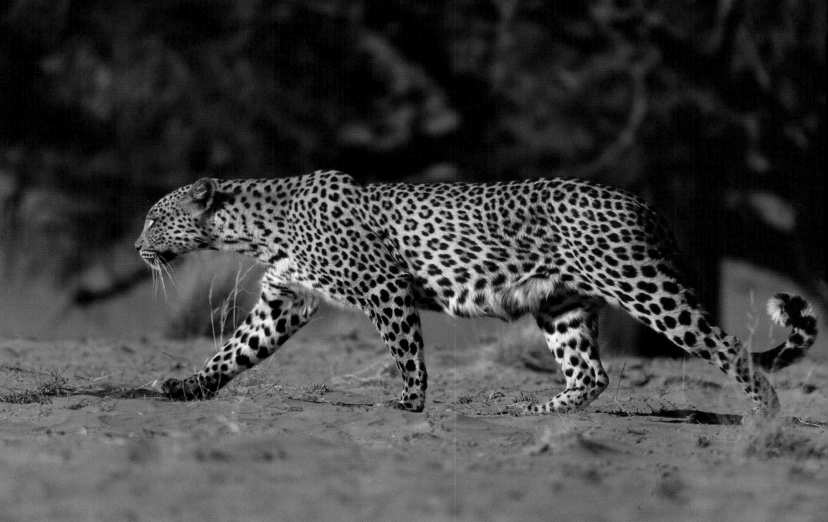

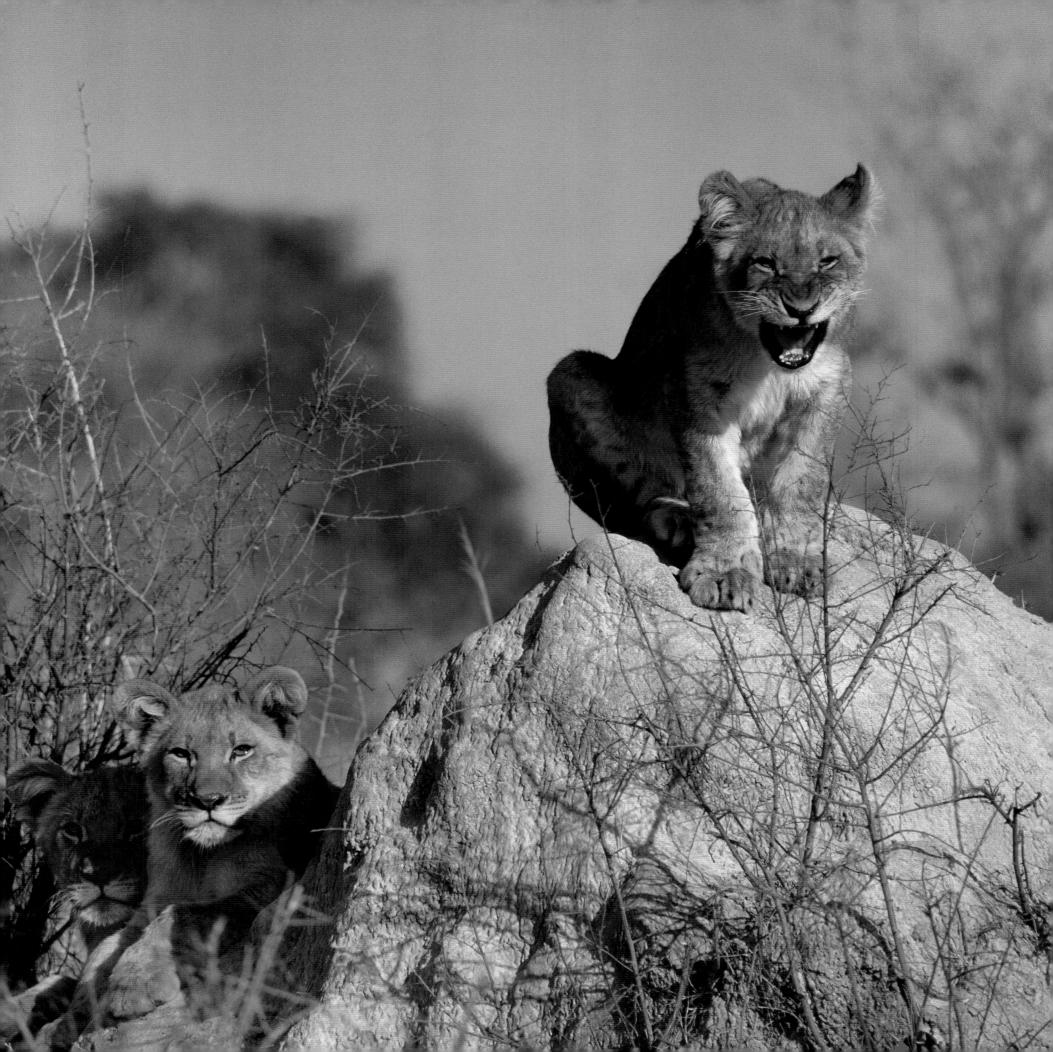

Superb false tiger moth *Heraclia superba*.

Hwange is a birdwatcher's paradise, especially during the wet season, and has recorded some 400 species.

Left: 1. A male red-headed weaver *Anaplectes rubriceps* [bre]eding plumage at at its still incomplete nest, and 4, in the [...] stages of its nest-weaving endeavour. The scarlet head, [...]tle and breast are diagnostic of the male; females and non-[bree]ding males have lemon-yellow heads and orange-red bills. [...]e weavers are common in their favoured habitats of thornveld, [...]ane and miombo woodlands. This makes Hwange an ideal [envi]ronment for them.

[...]The bateleur *Terathopius ecaudatus* is a stocky raptor with [disti]nctive black and white colouring, a bare red face and red [...], a long wingspan (177 cm), and a short tail. This raptor [capt]ures prey in one of two ways. Firstly, on the wing by stooping, [acce]lerating down with folded wings at great speed and killing [its]prey on impact with its powerful talons. Using this method it [tak]es birds such as hornbills, rollers and starlings. And secondly, [h]overing and then parachuting slowly to the ground with [win]gs held up and legs extended, capturing francolin, small [ma]mmals and reptiles. Eggs of ground-nesting birds and carrion

also form part of its diet. This striking bird favours open thornveld and semi-desert areas.

3. A female African paradise flycatcher *Terpsiphone viridis* at it's nest, typically disguised on the outside with lichen. This is a very active species, usually seen flitting through the foliage of its evergreen, riverine or mixed thornveld habitat.

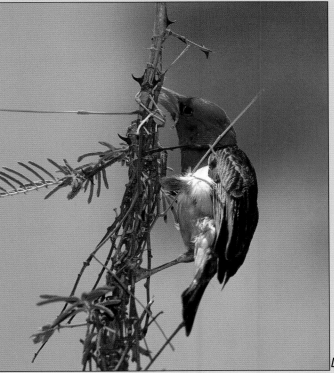

Both male and female have a metallic blue head and throat as well as a bright blue bill and eye-ring. In breeding plumage the male is a spectacular bird with its extended tail streamers doubling its length to about 41 cm.

5. Pristine leaves of a young mopane shoot *Colophospermum mopane* emerge gracefully in the veld following October rains in the Chizarira National Park.

One of the Seven Natural Wonders of the World, the breathtakingly beautiful Victoria Falls straddle the Zambezi, Africa's fourth longest river, and the largest flowing into the Indian Ocean.

The falls, known by local tribes as *Mosi-oa-Tunya* ('smoke that thunders') are surrounded by mopane woodland savanna, with smaller areas of miombo and Rhodesian teak woodland, as well as scrubland savanna. Riverine forest with palms line the banks and islands above the falls.

The rainforest around the gorge's rim receives constant nourishment from spray rising from the falls. This mist-forest nurtures plants rare elsewhere in the region including pod mahogany, ebony, ivory palm, wild date palm and a number of creepers and lianas.

Victoria Falls is neither the world's highest nor widest waterfall, yet it is the largest, with a width of 1708 m and a height of 108 m. It forms the largest sheet of falling water on the planet.

Right: At Main Falls a vast volume of water cascades into the Zambezi gorge with an unceasing thunderous roar.

I. Commonly known as the blood lily *Haemanthus multiflorus* this species proliferates around the cataracts. It is a striking plant with a large flowerhead on a bare stalk that comprises a dense umbrel of many small flowers, and contains a cardiac glycoside which can bring about cardiac irregularity and sudden death. The bulb beneath the ground contains lycorine and other alkaloids which are mildly toxic if eaten. .

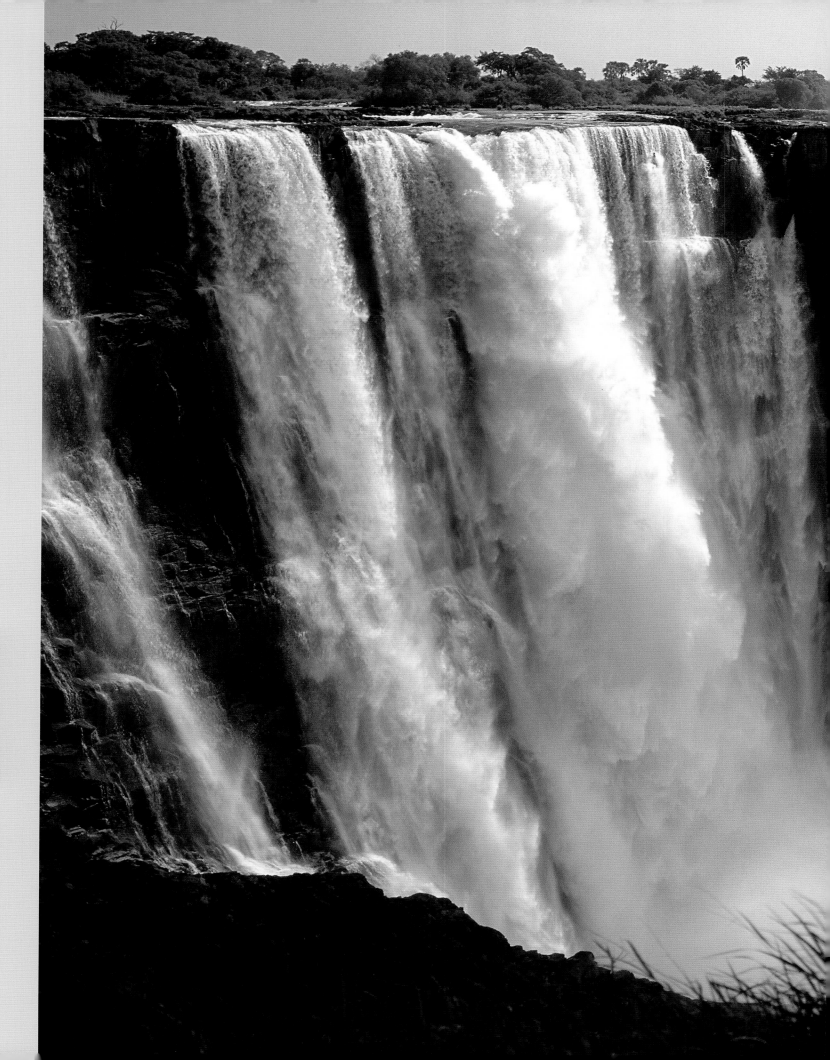

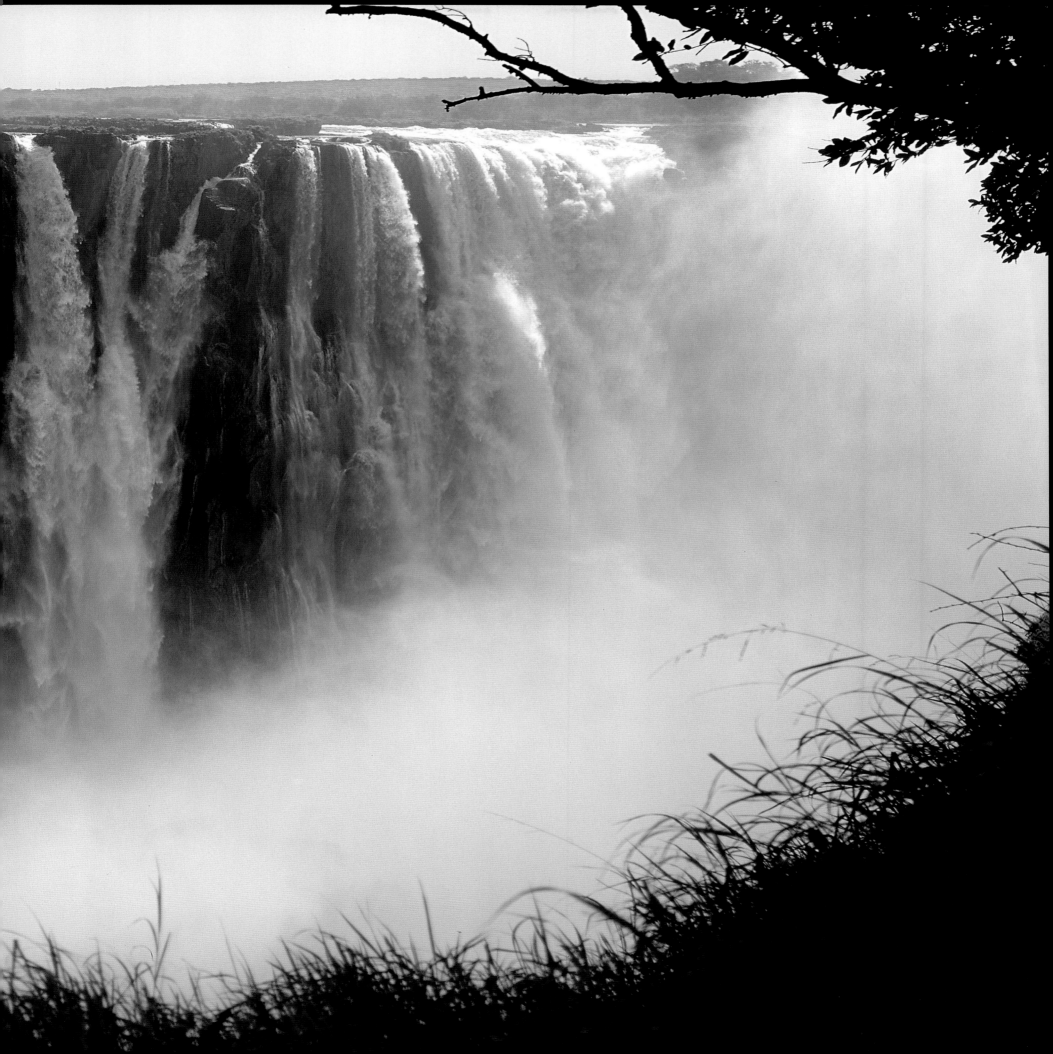

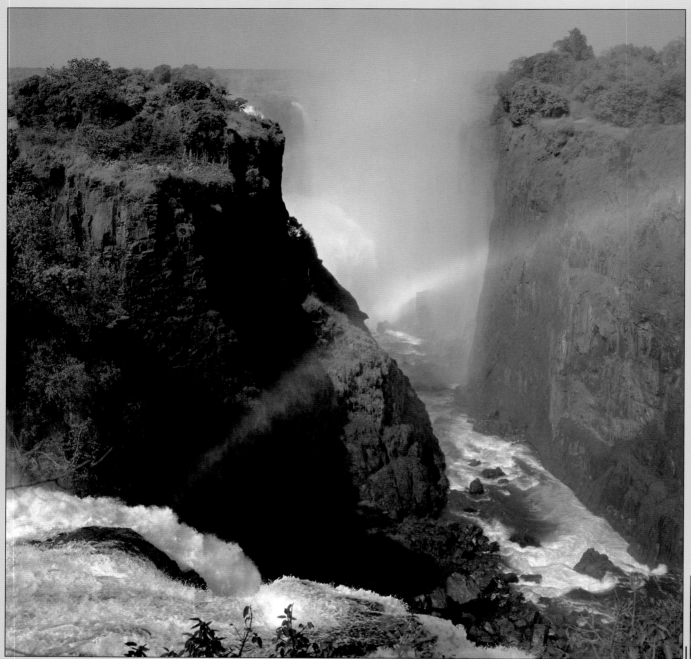

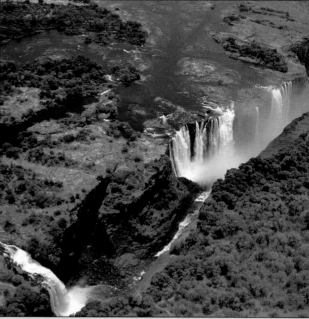

1. Where the broiling waters of the Zambezi plummet into the gorge far below, a delicate rainbow forms through the rising mi
2. An aerial view of the mighty Zambezi gorge.
3. At he Eastern Cataract the Zambezi River plunges into the swirling gorge.
4. A female Chobe bushbuck *Tragelaphus scriptus ornatus* in the mist forest. This species is one of a variable pan-African comple of *Tragelaphus scriptus*, collectively known as bushbuck, the mo widely distributed ungulate on the African continent. Distribut ranges from Senegal in the west to Kenya in the east, south through Zambia and Zimbabwe to South Africa and back north west through Botswana and the Caprivi Strip to eastern Angol Extensive variation occurs across this wide distribution with ov 40 subspecies described. Bushbuck are found in dense thick bu in low elevations as well as in mountains near a permanent sup of water.

The Chobe bushbuck, a medium-sized animal weighing 40–60 kg, is the smallest of the spiral-horned antelope species.

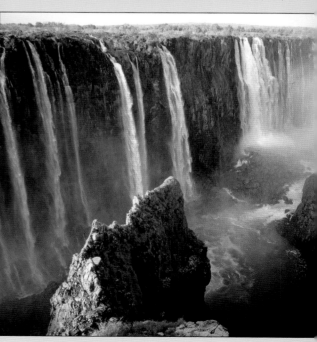

The gently flowing Zambezi River is spectacularly interrupted from its meander through the African landscape. It plummets over a knife-edge cliff into a transverse chasm 1708 wide, carved by its waters along a fracture zone in the basalt plateau. The depth of the chasm, the First Gorge, varies from 80 m at its western end to 108 m in the centre – but this is becoming ever deeper as the base is eroded away.

Two islands on the crest of the falls are large enough to divide the curtain of water even when at full flood: Boaruka Island (Cataract Island) near the western bank, and Livingstone Island near the middle. When the river is low, additional islets divide the curtain of water into separate parallel streams. The main streams from west to east are the Devil's Cataract (also known as Leaping Water), Main Falls, Rainbow Falls (the highest) and the Eastern Cataract.

Over the past 100 000 years, Victoria Falls have steadily been receding upstream. The original falls were 8 km downstream from the current position. The basalt plateau over which the Zambezi flows, as well as the gorges below, are fragmented with large cracks filled with weaker sandstone. The falls have eroded these, causing the sandstone-filled cracks to form zigzag chasms known as the Batoka gorges. The waterfall system thus moves progressively upstream over time.

Peak flood waters occur around mid-April when approximately 625 million litres of water per minute thunder over the rim. This huge volume of water, as it makes contact with the gorge below, produces a dense spray that rises over 400 m into the air. When water levels in the river are high enough to cause heavy spray, from January to September, a lunar rainbow occurs three times in each month. This lunar rainbow is observed when the spray blends with moon rays, exactly as during a daytime occurrence and with the same colours and arc.

As a result of the fine mist unceasingly dispersed from the falls, the rainforest that embraces the rim is the only place on earth where it rains 24 hours a day, seven days a week.

The ram's horns are short, spiralled and sharply pointed, whereas the ewe is hornless. The species is a territorial, shy, and nocturnal browser, seen singly or in pairs.

5. Senegal date palms *Phoenix reclinata* (referring to the curving fronds), are commonly known simply as 'date palms'. Shown here in the Victoria Falls mist forest. These palms are native to tropical Africa, Madagascar and the Comoro Islands, where they occur from sea level to 3000 m, in rainforest clearings, monsoonal forests and rocky mountainsides.

The palm produces edible fruits in large hanging clusters, and the palm heart is eaten as a delicacy.

The fibres of young, unopened leaves are used to make carpets, skirts and brooms. Palm wine is made from the sap, tapped shortly before flowering. The roots, which contain tannin, produce a brown dye as well as an edible gum.

6. The tranquility of the Zambezi River just above Victoria Falls.

7. The trumpeter hornbill *Bycanistes bucinator* some 60 cm in length, is characterised by a large grey casque on the bill.

Pairs of this species choose a nesting hole above the forest floor. From the inside the female uses mud, food and faeces to plaster the opening nearly shut. The male regularly feeds her and the chicks through this narrow space with fruits and large insects until they finally emerge after about three months.

These hornbills are gregarious, living in groups of between two to five individuals in tropical evergreen forests.

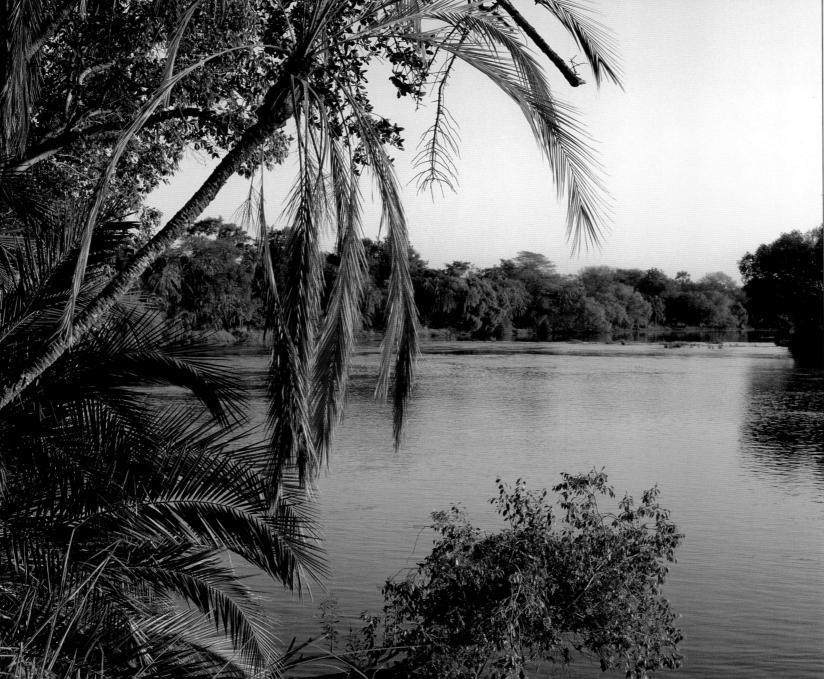

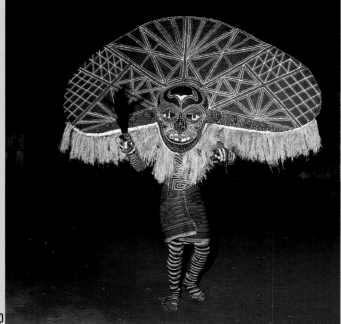

With magnificent costumes of woven natural fibre and masks painted in red, black and white, the Makishi enact traditional dances that originate in age-old tribal customs of the Lovale people.

A masquerade is performed using intricate masks, each representing a specific character. This marks the end of the 'kumu-kanda', an initiation ceremony, that takes place every five years for young boys. Initiates leave their homes and live for about a month in an isolated bush camp, marking their symbolic death as children. Here they experience circumcision, tests of courage and lessons on their future role as men and husbands.

For centuries Makishi dancers, shrouded in secrecy, have intrigued and intimidated audiences. Their entrance creates an eerie but fascinating atmosphere. Appearing during the 'mukanda', elders who represent the ancestors' spirits, command utmost respect.

At the end of each dry season, the graduation phase and ceremony of the 'mukanda' takes place amidst song and dance. Food and millet beer are prepared. The boys then perform for the village with celebrations extending well into the night Finally the Makishi, return to the graveyard to sleep allowing the spirits to return to the ground.

1. **Far left:** Makishi dancers perform at Victoria Falls.

2 & 3. The dancers wear huge fearsome masks.

4. Shangaan dancers pound the earth in a traditional dance.

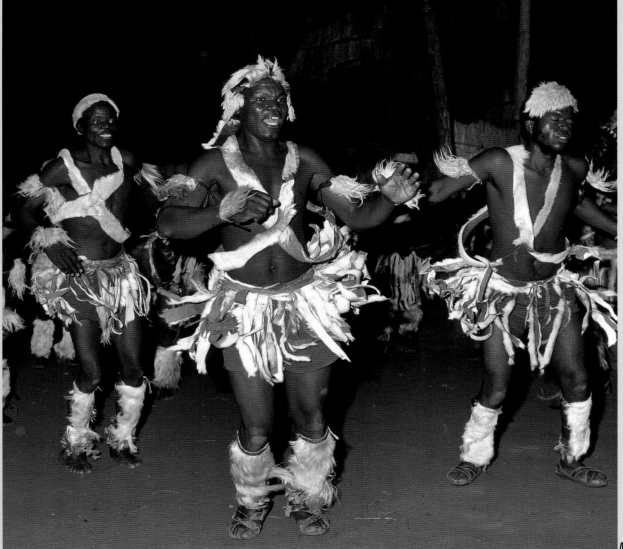

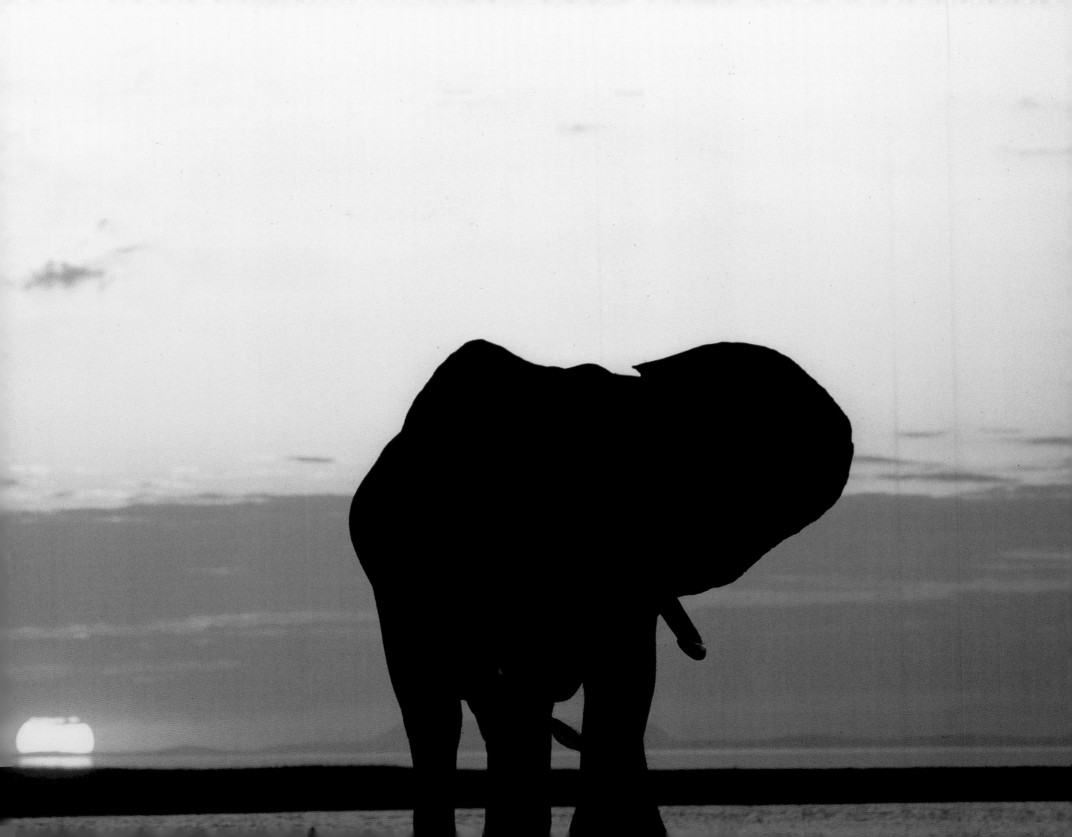

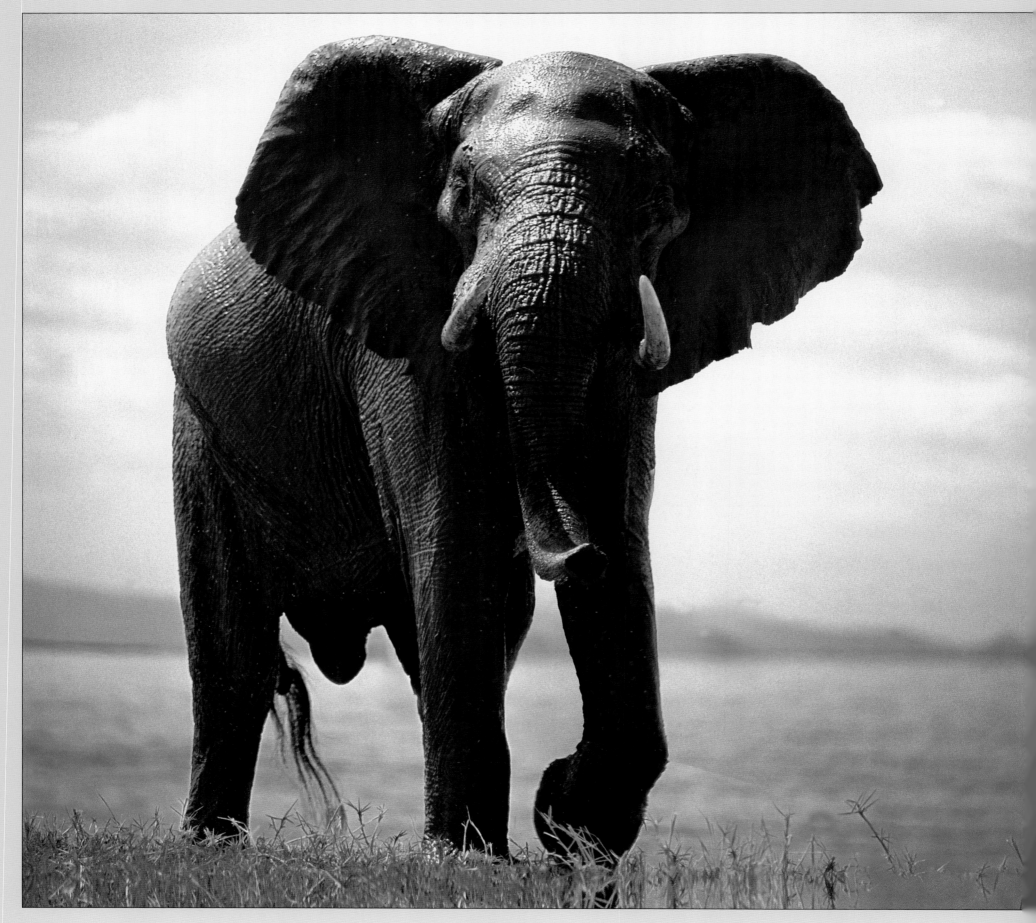

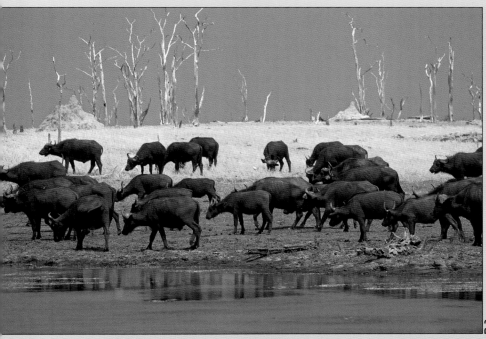

Kariba is a place of outstanding beauty, a great inland sea nestled between mountains, guarded by enormous game reserves and made beautiful and savage by the elements. The shoreline has created a beautiful 1000 km stretch of untamed Africa with placid backwaters dotted with islands and sun-bleached branches of dead trees, ghostly remnants of pre-dam forests, all surrounded by a rising wall of mountains that serves as a majestic backdrop.

Elephants and lions roam freely; and hippos, buffaloes, impalas and crocodiles thrive by the shores of this great lake. Elephants can sometimes be seen swimming between the shore and the islands that survived the flooding of the Zambezi Valley.

Far left: 1. A bull elephant emerges from bathing in the cooling waters of Lake Kariba.
2. With a backdrop of bleached tree skeletons, a herd of African buffaloes patrols the shores of Lake Kariba.
3. A water monitor lizard *Varanus ornatus* peers from its nesting hole in a lofty termite mound. Though generally considered a terrestrial species, this large lizard is both an adept climber and an excellent swimmer.
4. A herd of Impala *Aepyceros melampos* graze peacefully at sunrise alongside the water's edge of Lake Kariba in the Matusadona National Park.

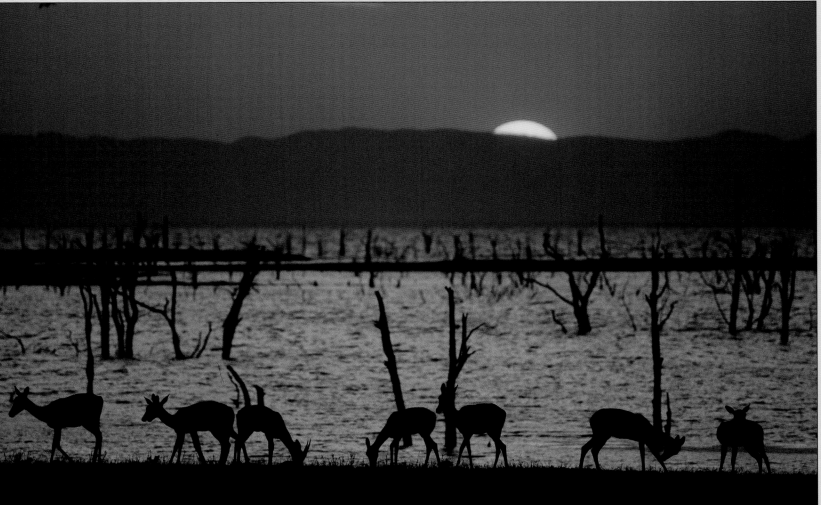

Previous page: A solitary bull elephant at sunset beside Lake Kariba in the Bumi Hills region.

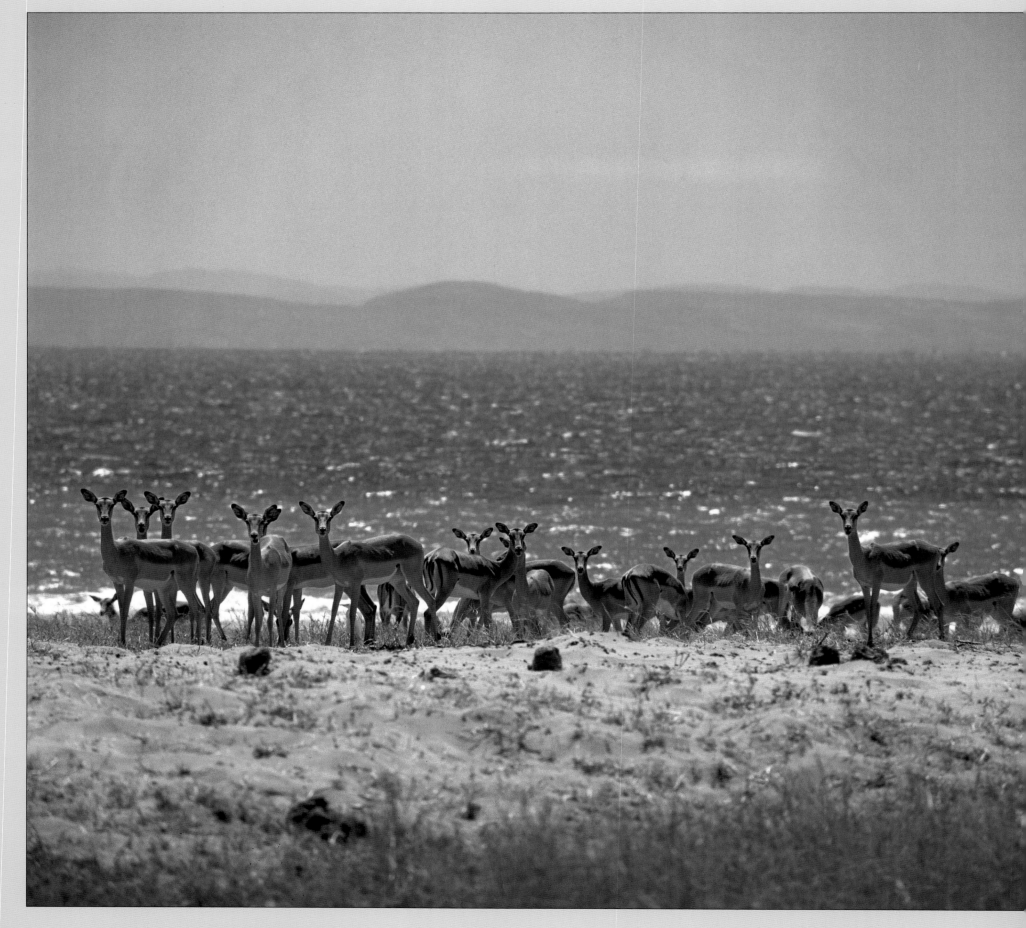

up to 6000 wild animals were dramatically rescued from the rising Zambezi waters in a project known as Operation Noah. The lake now features many islands, remnants of former hilltops.

1. A herd of impala graze on fresh grasses beside the ocean-like blue waters of the lake.

2. Carmine bee-eaters *Merops nubicoides* nest in large colonies in cliffs, usually near river banks. They use their bills to excavate long horizontal nesting tunnels sometimes 5 m or more in length.

Watching for bees and other flying insects from a strategic perch, they deftly snatch prey in mid-air.

3. A pair of saddle-billed storks *Ephippiorhynchus senegalensis* feed by the shores of Lake Kariba. These waders are the largest of African storks, attaining an impressive height of 1.5 m with a 2.7 m wingspan. Generally seen singly or in pairs near open water, they are easily recognised from their brightly coloured bills with a yellow 'saddle' at the base.

4. The impala lily *Adenium obesum* flowers through winter into early spring. It is a small,

succulent tree native to central and eastern southern Africa. The stem contains a milky latex with toxic alkaloids like other members of the succulent Apocynaceae family. This is used both as an arrow and fish-stunning poison.

5. An aerial view of the Zambezi River showing the extensive floodplain below Mana Pools.

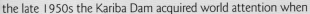

ke Kariba, by volume the largest man-made lake and reservoir n the world, is located about halfway between the source and th of the mighty Zambezi. Here in the Zambezi Valley, follow- he completion of the Kariba dam (a project started in 1955), great lake took shape, gradually filling between 1958 and 1963. e lake today extends over 220 km in length and is up to m wide. It covers an area of 5580 km². With a mean depth of and a maximum of 97 m it has an immense storage city of 185 km³. This enormous mass of water is believed to e caused induced seismicity in an already seismically active on. Over 20 earthquakes greater than magnitude 5 on the ter scale have been recorded.

the late 1950s the Kariba Dam acquired world attention when

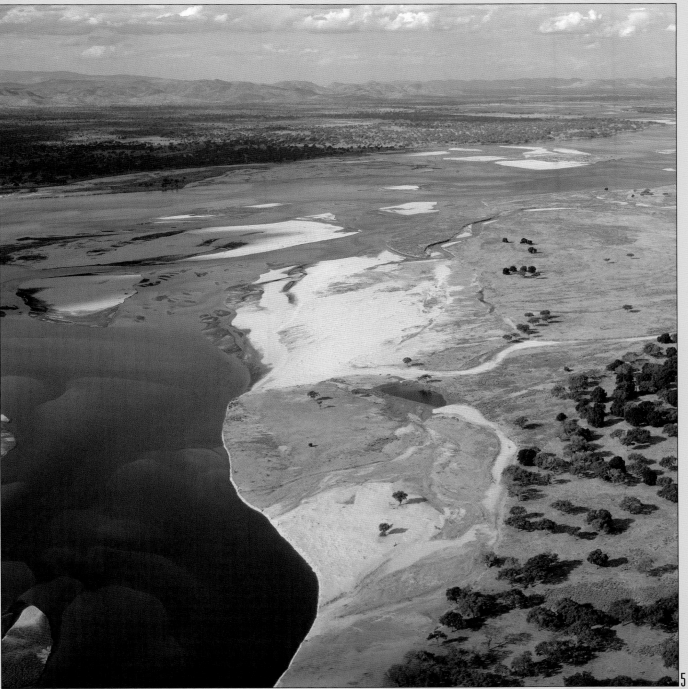

ZIMBABWE

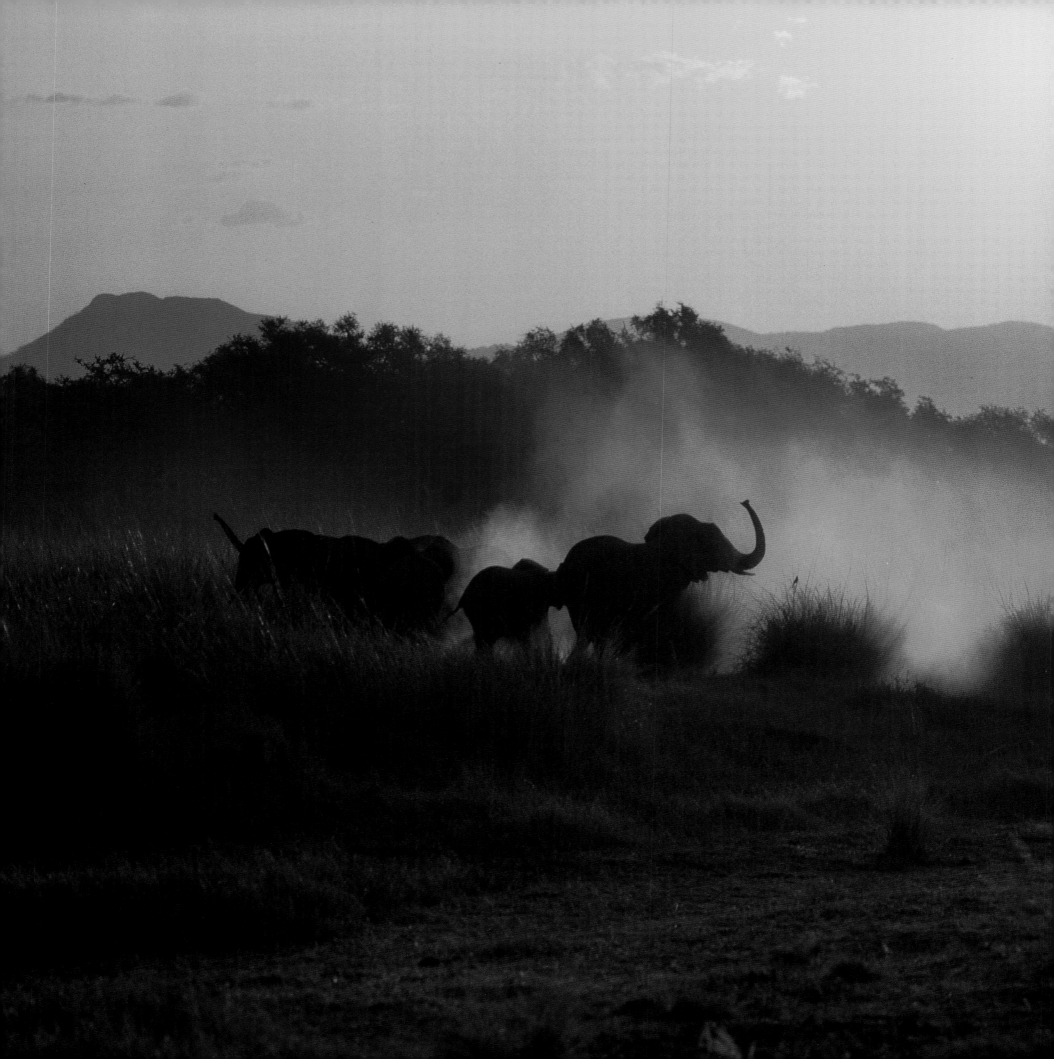

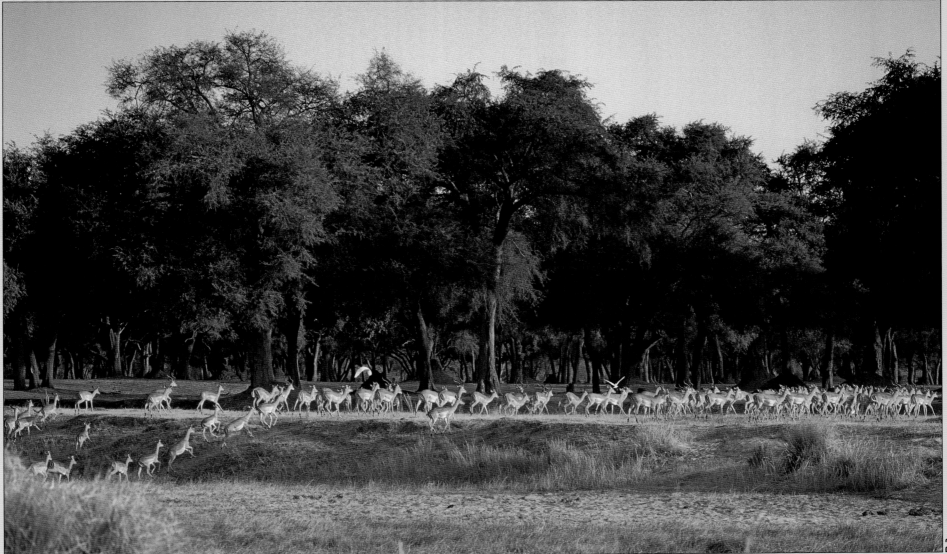

In the wide Zambezi floodplain beneath high escarpment cliffs, 110 km downstream from the Kariba Dam, previous channels of the river have formed the Mana Pools. In 1975, together with other smaller parks and safari areas on the banks of the

Zambezi, the Mana Pools were combined to form a contiguous conservation area of 676 600 ha. This region is home to a significant concentration of wild animals including elephants, hippo,

leopards, cheetahs, buffaloes and crocodiles. Birdlife on the river and in the bush is also prolific with over 450 species recorded. Chewore, one of these areas, formerly included one of the largest concentrated populations in Africa of the black rhino (some 500), but these have in recent years been poached out of existence. This region was included in the World Heritage List in 1984.

Far left: 1. Elephants stir up dust on the Zambezi floodplain below Mana Pools.

2. An impala herd moves across the floodplain in front of woodland dominated by characteristic *Acacia albida* trees.

3. A harmless striped bush snake *Limnophis bicolor* moves with great agility, preying on lizards and tree frogs in low-level bush and rocks.

4. An eland *Taurotragus oryx* the world's largest antelope, browses in miombo woodland. It uses pointed spiral horns to pull down overhanging branches.

5. A yellow billed stork *Mycteria ibis* balances momentarily on one leg. A large wading bird, it feeds mostly on fish and frogs by probing with its long bill, often with the entire head under water.

6. Crowned hornbills *Tockus alboterminatus* are a common

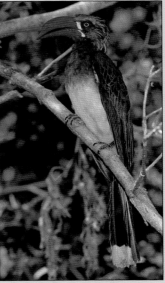

sociable species, sometimes seen in large flocks in the Zambezi Valley bushveld.

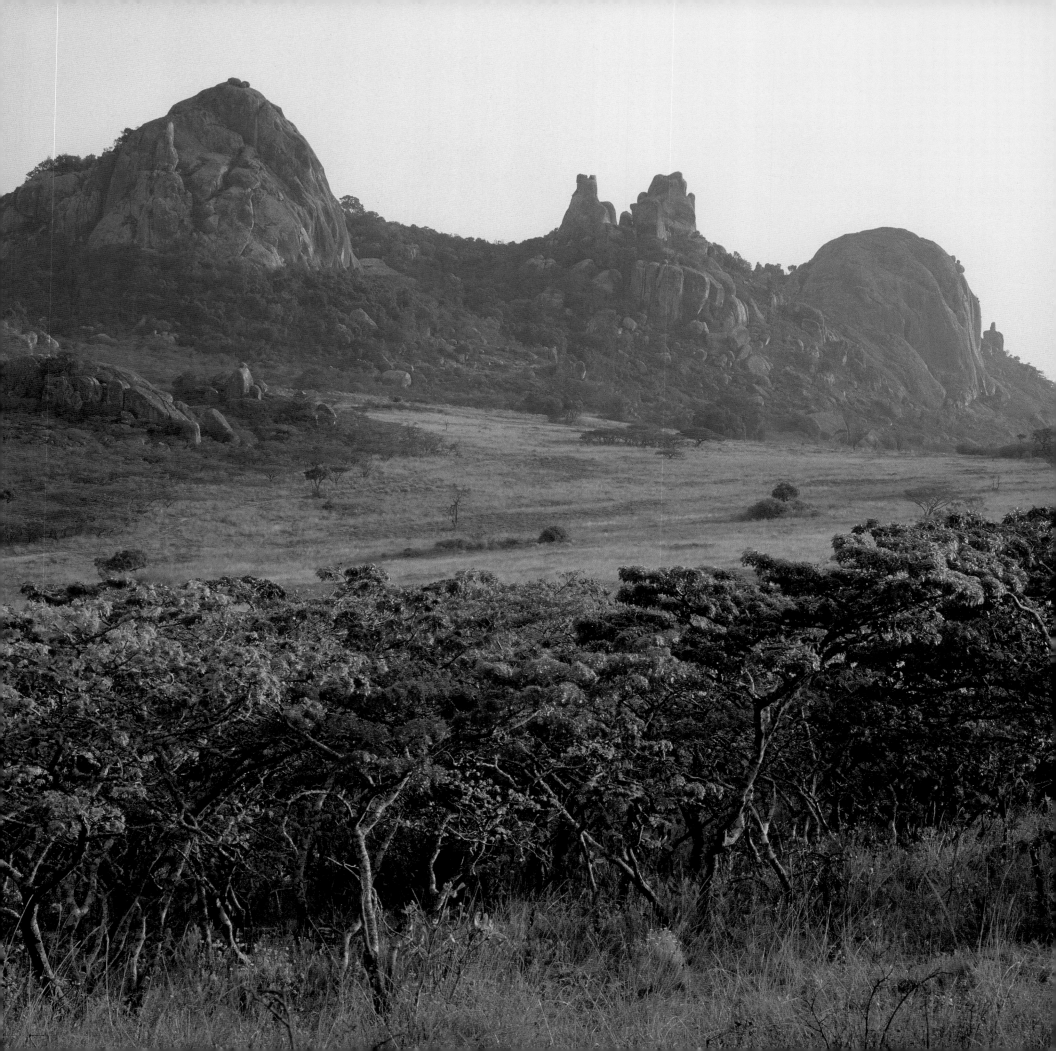

Zimbabwe's Eastern Highlands, in Manicaland province, are a mountainous region carved from a rifted ...tzite block. The highest ..., Monte Binga, just across ...order in Mozambique, ...es a height of 2436 m. ...wn as the Chimanimani ...ntains, the range ...ches for some 50 km ...n to south, forming the ...er with Mozambique. ...e Shona are Zimbabwe's ...t indigenous group. ...a population exceeding ...million they represent ...80% of the populace. ...ural Shona often live ...olated settlements

comprising one or more older men with their extended families. Decisions are generally made within the family group. Traditionally they follow an agricultural lifestyle, growing beans, peanuts, corn, pumpkins, and sweet potatoes.

Today, Shona cultural heritage extends to modern art well represented by graphic stone sculptures which are highly valued throughout the world.

Stone carving has been an integral part of Zimbabwean culture since 1200 AD when Great Zimbabwe was built by early ancestors. The carvings are made from serpentine stone which comes in a range of colours: black (the hardest and least common), brown, mauve, green and yellow. Sculptures are also fashioned from semi-precious stones such as verdite.

Far left: 1. Msasa trees *Brachystegia spiciformis* are widespread colourful deciduous trees characteristic of the Juliasdale region. Typically reaching a height of about 16 m, they are the prime constituent of miombo woodland. In spring, when new leaves shoot, these trees bring forth a splendid palette of colours

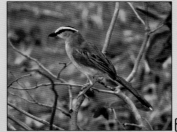

ranging from purple through bright red to a rich brownish hue. The small, green flowers are insignificant, but have a fragrant scent.

2. A fine example of a Shona verdite carving, 'Resting Farmer', by Joseph Ndandarika (1983).

3. A pair of red-billed fire finches *Lagonosticta senegala*. These are familiar and very tame birds ranging from the Kalahari to Senegal in the north.

4. Crested barbets *Trachyphonus vaillantii* inhabit riverine forests, open woodland and thornveld.

5. Shona women and children in their Sunday best.

6. The brown-crowned tchagra, *Tchagra australis* is common in thick tangles of thornveld undergrowth.

7. The Chimanimani pincushion *leucospermum saxosum* is a rare endemic multi-stemmed low

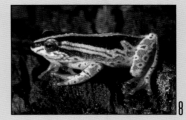

make the larvae and adults poisonous to predators. The warning is clear both from the butterfly's body coloration and the bright, coloured wings, which start out bright magenta and radiate to orange with yellow on the outside.

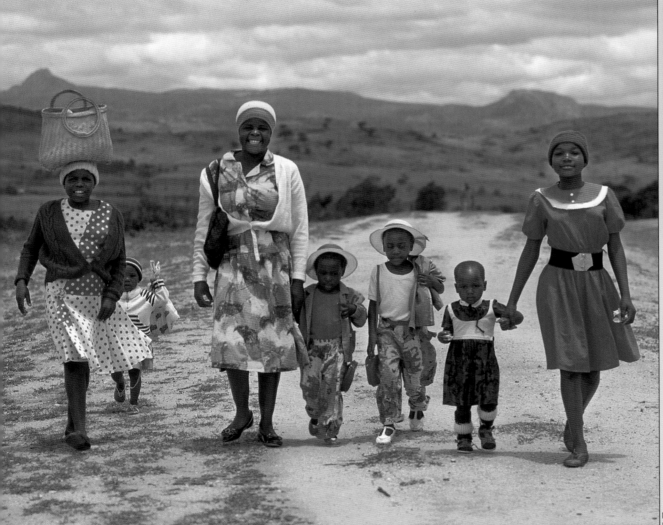

shrub which grows up to 2 m. It is one of the few members of the protea family that do not occur in the winter-rainfall area of the Western Cape.

8. The painted reed frog *Hyperolius marmoratus taeniatus* is a tiny amphibian, one of many varied patterned subspecies occurring in Africa. It is typically striped in black, red, white and yellow.

9. The brush-footed butterfly *Acraea acara acara* has been described as "the gaudiest of our Bitter Acreas" — and this for good reason. The caterpillar's foodplants, usually members of the Urticaceae and Passifloraceae families contain cyanogenic glycosides which

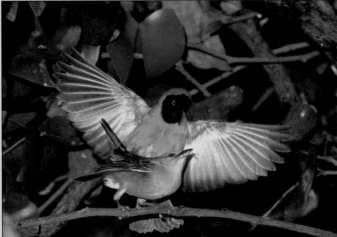

10. Lesser masked weavers *Ploceus intermedius* mating. This species breeds colonially in trees overhanging rivers and dams as well as amongst reeds.

11. The Giant African land snail, a species of the carnivorous family *Streptaxidae,* in the Chirinda forest leaf litter.

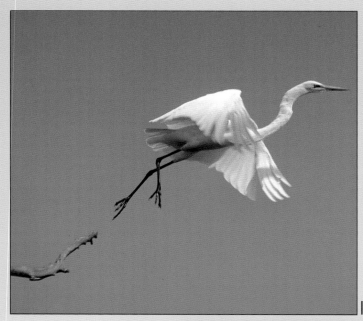

a single outlet, the Shire River, which flows into the Zambezi River.

1. A great white egret *Egretta alba* largest of the white herons, gracefully takes to the skies
2. An African fish-eagle *Haliaeetus vocifer* heads to its perch with a freshly caught fish.
3. Grey crowned cranes *Balearica regulorum* frequent swamps which today in many regions are being drained to make way for development.

Far right: 4. A tranquil vista of Lake Nyasa (Malawi) from the south-western shore.

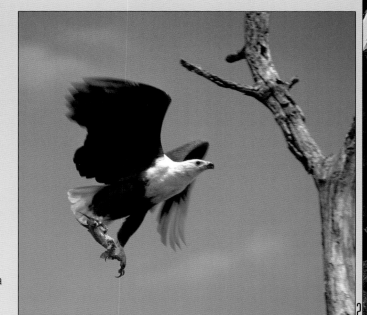

Lake Nyasa, at the southern end of the Great Rift Valley, is the world's eighth largest lake, and both Africa's third largest and second deepest. David Livingstone was the first European explorer to reach these shores in 1859, and named it Lake Nyasa. Today it is known colloquially as Lake Malawi.

With a surface area of about 29 600km², Lake Nyasa is 580 km long and 75 km at its widest. The largest portion of the Lake falls within Malawi's boundaries.

On 16 August 1914, just after World War 1 broke out, the lake was the scene of a brief naval battle. The British gunboat *Guendolen* was ordered by Britain's High Command to 'sink, burn, or destroy' the *Hermann von Wissmann,* the German Empire's sole gunboat on the lake. This was located in German East African territorial waters in a bay near Sphinxhaven. The gunboat was dramatically disabled with a single cannon shot from a range of 2000 yards. This astonishingly brief conflict was hailed by *The Times* in England as " the British Empire's first naval victory of World War 1."

The placid tropical waters of Lake Nyasa are reputed to be habitat for more species of fish – 600 – than any other lake on earth. This large body of freshwater has but

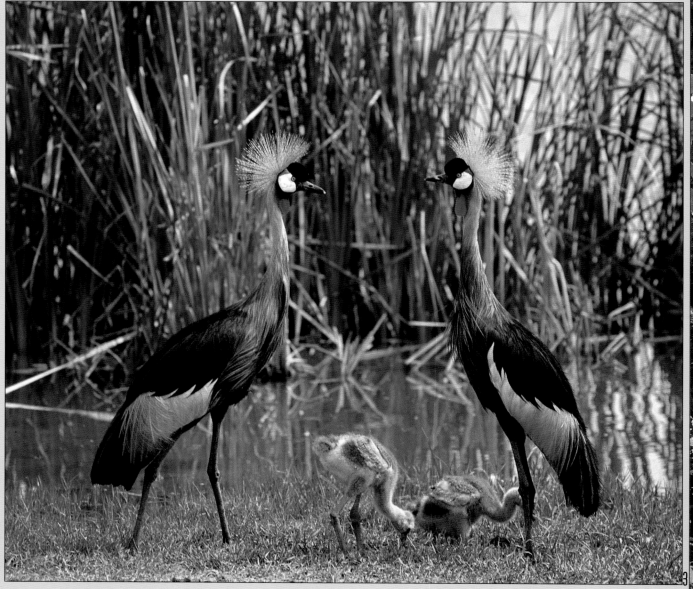

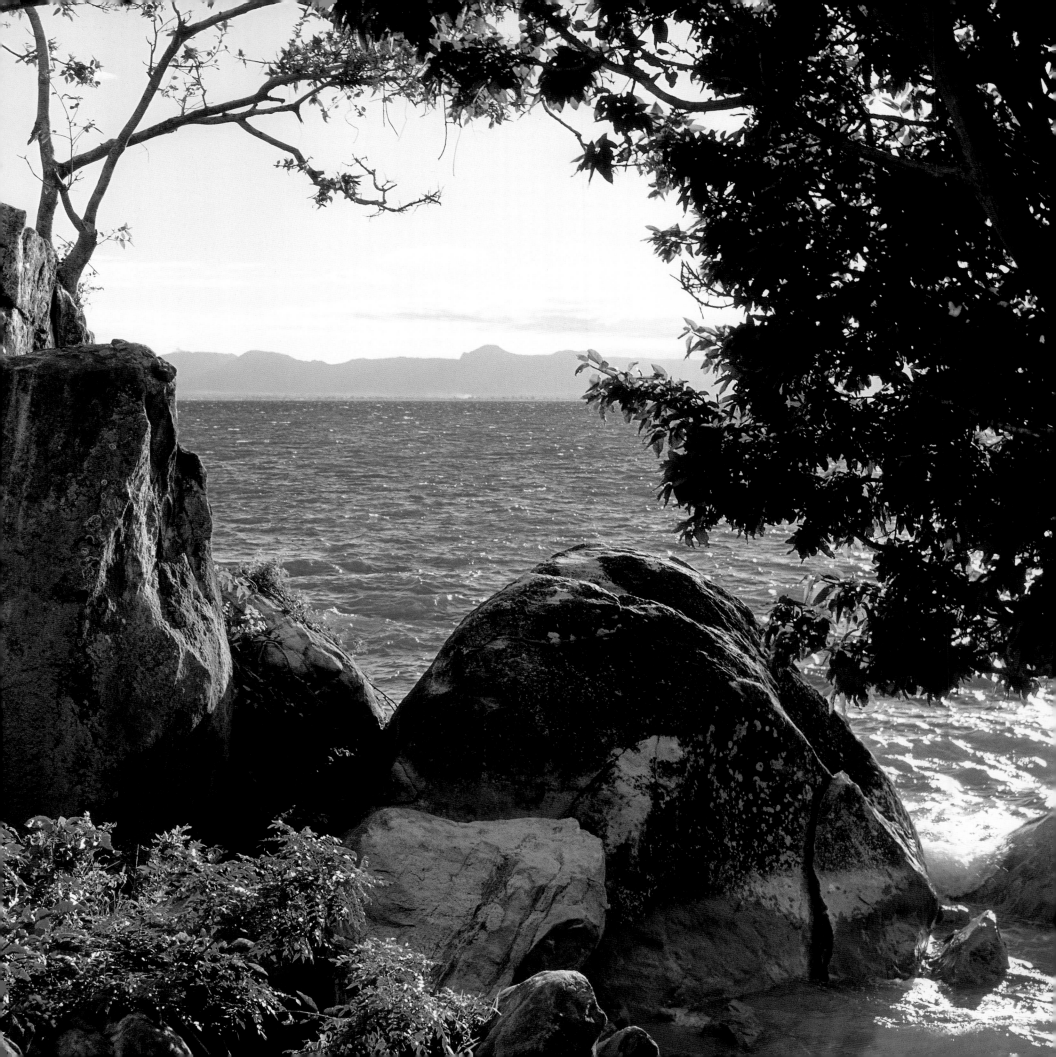

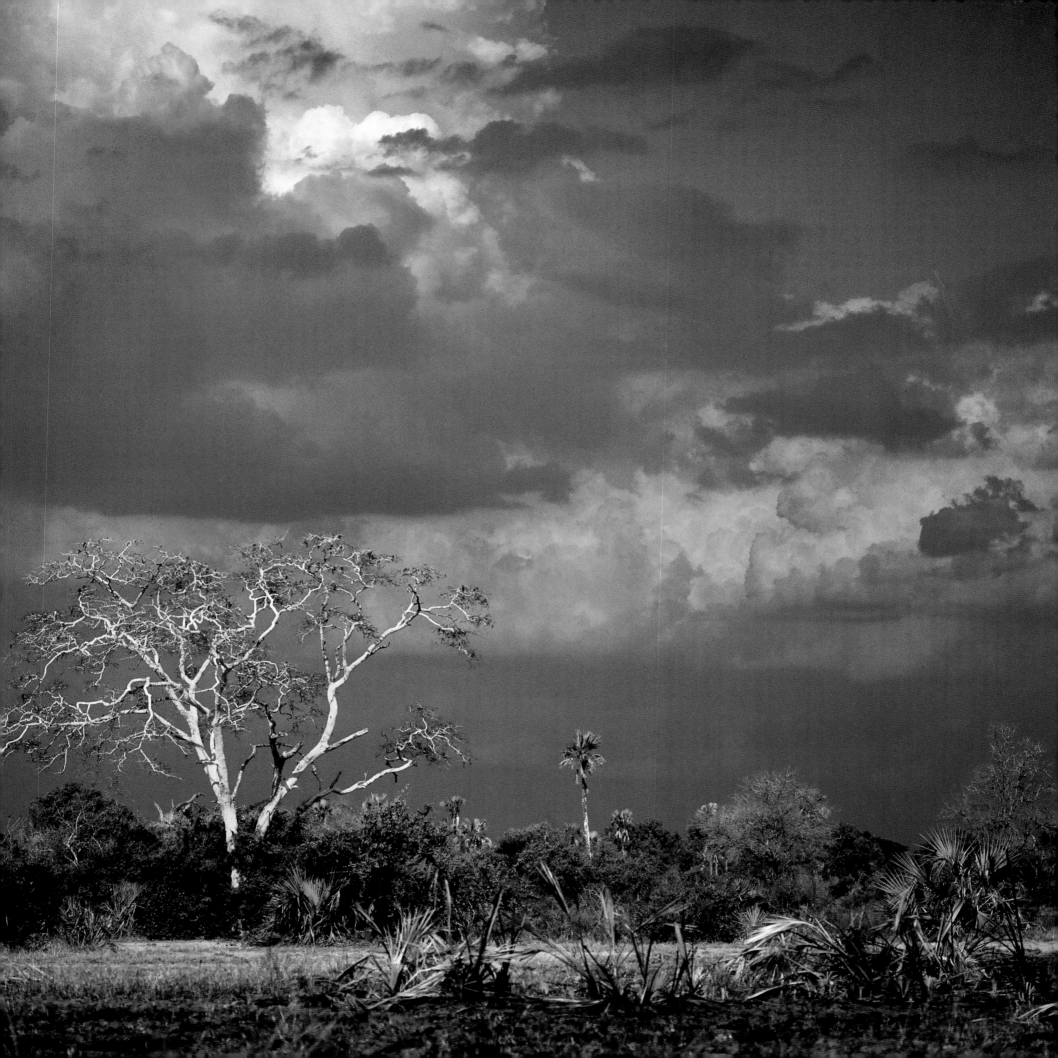

t: l. Brooding storm clouds
...r over Gorongoza National
...n Mozambique.
... dwarf mongoose *Helogale*
...ula peers out from its den
...n a termite mound. This is
...mallest African species. The
...als are sociable, generally living
...oups of 12 to 15 individuals
...y a dominant female and her
...consort. Nomadic by nature,
...s tend to be constantly on
...nove throughout their range of
...oximately 0.3 km².
...nite mounds are favoured as
...sites, lookout posts and as a
...source. They are used for a
...lays at a time before a move is
...e to a new site.

...rassus palms *Borassus*
...opum silhouetted at dusk.
... oribi pair *Ourebia ourebi* in
...ngoza National Park. Oribi are
...mallest true grazers amongst
...opes. They have slender legs
...ong necks. Only males carry
...s, which are short, slender and
...ht. These antelope are highly
...r-dependent and inhabit open
...slands or thinly bushed country
...re they can access a reliable
...ce of water. They prefer habitat
... short grasses for grazing
...spersed with tall grasses, which

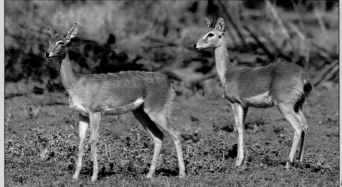

provide cover from the elements and
marauding predators.
5 The racquet-tailed roller *Coracias
spatulata* can be recognised by its pale
blue underparts and elongated tail
shafts with spatulated tips. It forages
on the ground for large insects,
especially beetles and grasshoppers,
and nests in tree holes in dense
woodland.
6 Day draws to a close as the
blazing sun sinks toward the horizon
in Gorongoza National Park.

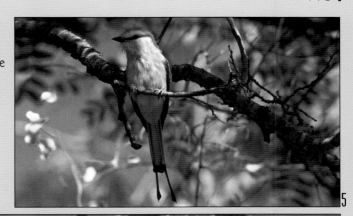

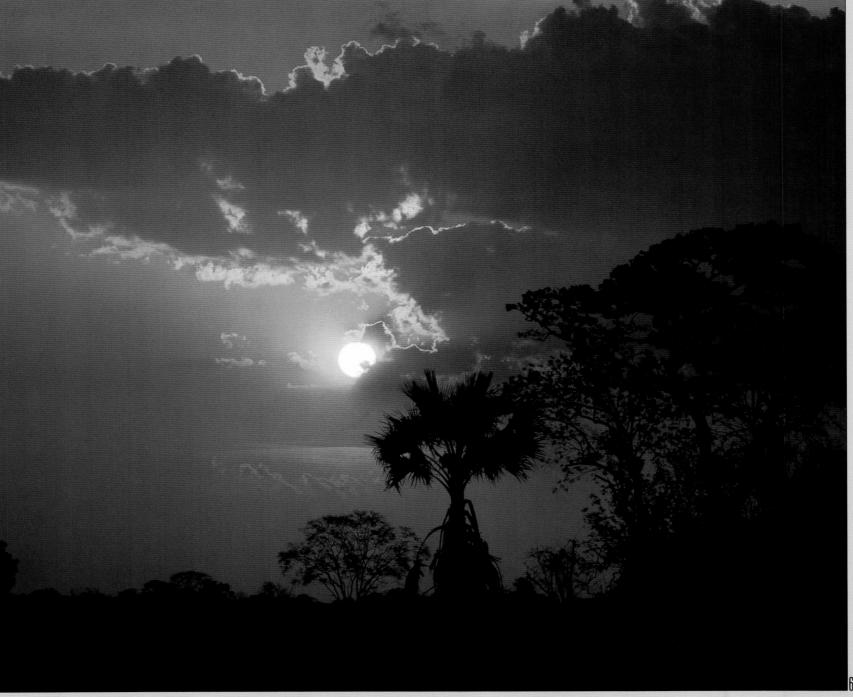

MADAGASCAR

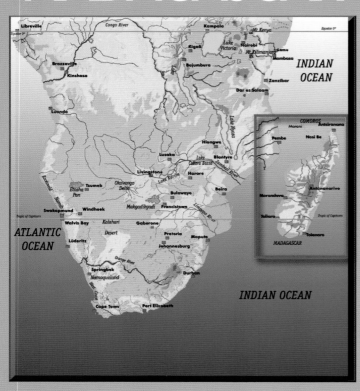

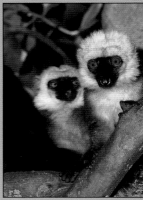

White-fronted brown lemurs Eulemur albifrons *(two males sho are found in the rainforest remnan north-eastern Madagascar.*

The panther chameleon Furcifer Pardalis *one of the most common of Madagascar's 80-plus chameleon species.*

M adagascar is an astonishing place, largely thanks to its geological history. Once part of a supercontinent which covered much of the southern hemisphere, the island, still attached to India, splintered off from Africa about 165 million years ago. Subsequently, possibly around 80 million years ago, Madagascar and India separated with the island in its present position, largely within the tropics.

A mountainous spine was created by geological forces, separating the predominantly humid east from the seasonally dry west and the sub-arid south. Diverse floral communities developed in these different climatic regions, and faunal assemblages evolved to occupy the amazingly wide variety of habitats.

It remains uncertain how many species are present in Madagascar – an enormous amount of scientific work has still to be done and numerous new discoveries are revealed to science annually.

The exceptionally high level of species endemism resulting from Madagascar's long isolation is one of the factors contributing to the country's compelling 'uniqueness'. In excess of 80% of Madagascar's wildlife is endemic, in other words found nowhere else. And much of it is strikingly different from continental fauna. Sadly, many of Madagascar's stunning natural assets face a very real threat of extinction, which makes the island one of the world's foremost conservation priorities. Some 2000 years ago, humans

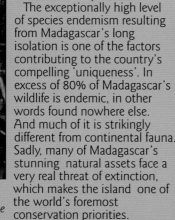

A male black lemur infant Eulemur macaco macaco *clings to his mother in the Lokobe Reserve, last stand of the Sambirano Forest on Nosy Be.*

arrived on what was then one of the last sizeable land masses people could settle on.

In the blink of an evolutionary eyelid, the remaining megafauna – which some argue was on its way to a natural extinction because of gradual climatic changes – was swiftly exterminated. This included various species of giant lemur, a few species of pygmy hippo, giant tortoises and a number of species of elephant bird including, *Aepyornis maximus,* the largest and heaviest bird ever to have walked the earth.

Today, at least 200 000 species remain extant in Madagascar, though this is only a rough estimate. In its isolation, through speciation, the founding stock of Madagascar's wildlife evolved in a gentle, 'asylum' environment, free from great predators. It is believed by some that a fair proportion of the ancestral stock made its way to the island on rafts of vegetation, possibly the result of violent storms.

Because of the extraordinarily varied landscapes created by the different geological formations and floristic domains, visiting nature enthusiasts feel as if they are exploring several very different countries packed into an island the shape of a gigantic left foot. In the western half of the country for instance, lie the famed 'tsingy' plateaux, formidable limestone fortresses topped with razor-sharp pinnacles and protecting sunken seasonally dry forest packed with large populations of rare wildlife. In the desolate, semi-arid south-western interior, the vast sandstone massif of Isalo strongly brings to mind images of the Kimberleys of northern Australia – that is, until one takes a closer look at the locally endemic flora and fauna. At the southern end of the highlands near the town of Ambalavao, in a region marked by massive granitic inselberg formations, the Andringitra Mountains hold two of the country's highest peaks.

Nature enthusiasts visiting Madagascar never fail to be impressed by the country's wildlife. Scattered around the island is a network of protected areas covering most of the habitat types, and it is a selection of these sites that are

Madame Berthe's mouse lemur Microcebus berthae *the world's smallest primate.*

responsible for attracting the vast majority of tourists to the country.

The rainforests of the humid eastern region, separated into lowland, mid-altitude montane and high-altitude montane rainforests, hold the greatest diversity of plant and animal species. They are noticeably rich in palms, bamboos and orchids – all plant groups far more diverse in Madagascar than on the nearby African mainland,

even though the island accounts for only 2% of the African land mass. The most visited protected areas include Andasibe-Mantadia National Park ('Perinet') in the Mantadia-Vohidrazana rainforest block; Ranomafana National Park much further to the south-east, and the north-eastern national parks of Masoala and Marojejy, rated by many as a veritable treasure chest for naturalists. The isolated rainforest-clad massif of Montagne d'Ambre in far northern Madagascar is not linked to the eastern rainforest band so is well worth visiting for its rather different complement of flora and fauna.

Far more fragmented and fragile are the seasonally dry decidu forests of the country's drier western half: less than 6% of this forest type remains, with accessible and rewarding examples including Kirindy Forest in the Menabe region near Morondava the 'tsingy' plateaux of Bemaraha and Ankarana; the privately managed reserve at Anjajavy; the remote northern reserve of Analamerana; and perhaps the favourite of visitors to the west region, Ankarafantsika National Park where the Durrell Wildlife Conservation Trust (DWCT) has its largest Madagascar-based project, aimed at rescuing various endemic Malagasy tortoises and freshwater turtles from extinction. Among Madagascar's best-known flora is its baobabs: six of the world's eight speci are unique to the island. They include the largest of all, the statuesque Grandidier's baobab *Adansonia grandidieri* of the Menabe region, and the smallest, the bottle baobab *A. rubrost* which has a wide distribution and is particularly impressive in unprotected and rapidly dwindling spiny bush near Ifaty to the north of Tulear.

Zebu oxcart near Morondava. Zebu are considered a symbol of wealth and are an important link with the ancestors.

The chaotic floral spectacle the sub-arid thorn thicket or spiny bush comprise a fascinating variety of often thorny and/or bloated, droug resistant plants and trees, including many endemic *Euphorbia, Aloe, Delonix, Moringa and Hildegardia* species, to name but a few. Aptly, the spiny bush was christened 'Madagascar's botanical lunatic asylum' by renowned travel writer Dervl Murphy. Protected examples this remarkable habitat can b seen at Ifotaka near Ihazofots (the spiny bush sector of Andohahela National Park), Beza Mahafaly Reserve and the are around the soda lake Tsimanampetsotsa, in the far south-west The small and famed Berenty Private Reserve holds a small par of spiny bush, along with some dry gallery tamarind woodland

A cursory glance at statistics pertaining to Malagasy flora is enough to have any plant enthusiast planning a trip to the island's wilderness areas. Of the currently estimated 11 217 vascular plant species, some 84% are endemic, and according botanists of NGOs long active in Madagascar such as the Missouri Botanical Gardens, perhaps more than 1300 plant species still await formal classification. With the enormous rat of new plant discoveries, it is now estimated that Madagascar species total might escalate to as many as 13 500 of which at 90% would be endemic.

…adagascar is perhaps best known for its wildlife, in particular …undeniably endearing lemurs, which range in size from the …oon-sized *Indri indri* to the diminutive, nocturnal mouse …urs, which include the world's smallest primate, Madame …ne's mouse lemur …*ocebus berthae*. In recent … an enormous amount of … has been conducted on …agascar's lemurs, revealing …al of about 100 taxa and …ng the island a primate …pot *nonpareil*.
…astic habitat loss …adagascar retains only about …of its original primary forest …r) has resulted in many …rs now being regarded as …ally endangered. During his …nsive travels around the …d-continent, Gerald has been one of the few people to have …ographed some of the rarest of the lemurs, in particular the …er bamboo lemur *Prolemur simus* which survives in small …bers in a few montane rainforests of central-eastern …agascar such as Ranomafana National Park and Marais de …orofotsy near Andasibe-Mantadia National Park. In …omafana and Andringitra, the species coexists harmoniously …its striking relative, the critically endangered golden bamboo …r *Hapalemur aureus* as the two lemurs eat different parts of the bamboo plant so do not compete.

The iconic ring-tailed lemur *Lemur catta* Madagascar's national mammal and most terrestrial of the lemurs, is happily still fairly common where it occurs in the southern region, with a distinct population living in the granitic mountains of the Andringitra massif. Equally well known are the sifakas, which range from the pure white silky sifaka *Propthicus candidus* of Marojejy National …(rarest of all lemurs according to primatologist Erik Patel) to …itch black (and also critically endangered) Perrier's sifaka …*hicus perrieri* of Analamerana Reserve in northern Madagascar. …r critically endangered sifakas featured in this book are the …ly-known crowned sifaka *Propthicus coronatus* and the range-…icted Tattersall's Sifaka *Propthicus tattersalli*. Unable to walk on …ground, sifakas – which can leap enormous distances between …. – have to hop as if they are participating in a sack race. …here permitted, night walks …usually extremely rewarding, …a very different cast of …acters – including a wide …ty of lemurs – emerging …dusk from daytime …outs. These include various …ies of dwarf lemur, sportive …ur, woolly lemur, mouse …ur, tenrec (a group of …itive, insectivorous …mals which mostly …nble hedgehogs, voles …rews), and perhaps some …e island's eight endemic …ivores as well as several …e relatively few endemic …nts. …s are well represented in

Rainforest canopy in the Montagne d'Ambre National Park.

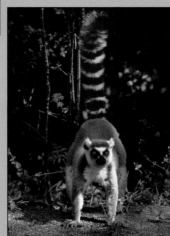
Displaying its distinctive tail, a Ring-tailed lemur Lemur catta *in the Berenty Private Reserve.*

…branches of the octopus tree, …a trollii.

Madagascar's national plant, the traveller's palm Ravenala madagascariensis *in marshland near Baie Ste Luce in the south-east.*

Madagascar, the most often seen being the flying foxes or Madagascar fruit bats, among the westernmost representatives of a predominantly Asian genus, *Pteropus*. The vast networks of caves and underground passages in the 'tsingy' plateaux of Bemaraha and Ankarana hold at least half the island's endemic bats. Night walks are also rewarding for

An orchid, Oeonia rosea, in the Ranomafana National Park

reptiles, such as chameleons, for which Madagascar is home to over half the world's species, including the two largest (Oustalet's and Parson's, which can reach 68 cm) and the smallest, the pygmy stump-tailed chameleon *Brookesia peyrierasi*. Also best sought at night are the incredibly well camouflaged leaf-tailed geckos of the genus *Uroplatus*, true masters of camouflage which in some cases resemble bark, or in other cases, dead leaves. At least 92% of the more than 370 reptile species are endemic, and 99% of the island's 400-odd species of frog are endemic, making Madagascar a paradise for reptile fanciers. Oddly enough, there are some noticeable links between certain Malagasy reptiles and those of South America. Examples include boa constrictors and iguanid lizards, both of which are well represented in Madagascar and South America but absent from nearby Africa. Unfortunately, the aesthetic appeal of many Malagasy reptiles and frogs, particularly the leaf-tailed geckos, many of the chameleons, the colourful green day geckoes and frogs such as the brightly coloured, poisonous mantellas, has led to their being exported (usually illegally) in massive numbers for the exotic pet trade.This has brought about a highly visible reduction in local populations of hallmark species such as the two-foot-long Parson's chameleon of the eastern rainforests, which is now almost impossible to see in Analamazaotra (Perinet), where two decades ago it was common. So determined are the illegal animal traders that they have even gone as far as to break into the enclosures at the captive-breeding centre of the DWCT's Project Angonoka and stolen several critically endangered ploughshare tortoises from the site.

Birders visiting Madagascar too are in for a treat. For its enormous size (the island is roughly half the size of South Africa, measuring 1,571 km in length and 570 km across at its widest point) and exceptionally varied habitats, it has a rather short species list of some 283 species, of which 109 are endemic. However, as with the country's other wildlife, it is often a case of quality as opposed to quantity that comes to the fore here. For starters,

birders can quite easily see some of the world's rarest species, such as the Madagascar fish eagle *Haliaectus vociferoides* which numbers only some 100 pairs but is almost certainly seen at Ankarafantsika and Anjajavy. Five families are of particular interest to visiting birders: the three primitive, rail-like Mesites; the nine Long-tailed, blue-masked couas; the five quietly beautiful ground-rollers; the four Asitys, of which two resemble broadbills and two look like tiny sunbirds; and last but not least, the diverse vangas,

The streaked tenrec Hemicentetes semispinosus *inhabits humid eastern Madagascar.*

which range from the turtle-dove-sized sickle-billed vanga *Falculea palliata* to the tiny and delicate coral-billed nuthatch vanga *Hypositta corallirostis*. Beak variation among the vangas – which are believed to have descended from a common ancestor possibly related to Africa's helmet-shrikes – is extraordinary. The sickle-billed fills the niche occupied in Africa by wood-hoopoes; the helmet vanga *Euryceros prevostii* has a huge, blue beak adapted for dealing with stick insects; and then there are many species such as the hook-billed vanga *Vanga curvirostris* which resemble true shrikes. The smaller species, such as Chabert's vanga *Leptopterus chabert* and the Ward's flycatcher *Pseudobias wardi* hawk insects much as true flycatchers do.

Like Madagascar's botanical wealth, the island's invertebrate diversity is simply bewildering, with probably more than 100 000 species being present. Among the best known invertebrates – and those most likely to be seen by visitors – are the enormous Malagasy comet moths *Argema mittrei* (larger than their African relatives by a third); the beautiful day-flying *Urania* moths (whose nearest relatives are in South America and Tanzania); the largest of the island's butterflies, a swallowtail, *Atropaneura anterior*, whose nearest relatives are in south-east Asia; and the endearing hissing cockroaches and pill millipedes. Perhaps the first invertebrate visitors are likely to see on arrival after leaving Antananarivo airport (because of its conspicuous webs suspended from telegraph wires), is the golden orb web spider *Nephilia madagascariensis*.

Other well-known invertebrates include the reddish-pink flattid

Wooden carvings decorate the tombs of some tribes, such as these on an Antandroy tomb in the arid south.

leaf bugs, and the delightful giraffe-necked weevil *Trachelophorus giraffa* which like so many other Malagasy life forms, epitomises that which is bizarre, a descriptive associated with many of the animal and plant oddities on this living laboratory of evolution.

Derek Schuurman.

The critically endangered Tattersall's or golden-crowned sifaka *Propithecus tattersalli has a very restricted range in the far north.*

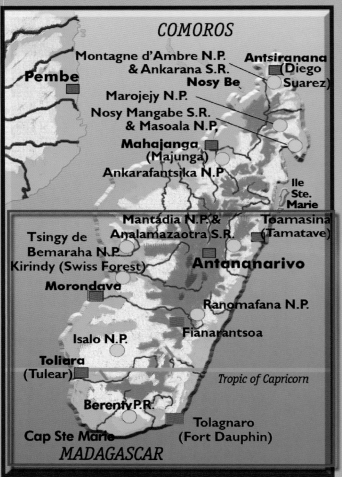

COMOROS

Pembe

Montagne d'Ambre N.P. & Ankarana S.R.

Antsiranana (Diego Suarez)

Nosy Be

Marojejy N.P.

Nosy Mangabe S.R. & Masoala N.P.

Mahajanga (Majunga)

Ankarafantsika N.P

Ile Ste. Marie

Mantádia N.P. & Analamazaotra S.R.

Toamasina (Tamatave)

Tsingy de Bemaraha N.P.

Kirindy (Swiss Forest)

Antananarivo

Morondava

Ranomafana N.P.

Isalo N.P.

Fianarantsoa

Toliara (Tulear)

Tropic of Capricorn

Berenty P.R.

Cap Ste Marie

Tolagnaro (Fort Dauphin)

MADAGASCAR

SOUTHERN REGION

The Madagascar Red Fody Foudia madagascariensis, *is one of four endemic weavers.*

In the arid south, the landscape of cactus-like Didierea trees provided the last sanctuary of the flightless elephant birds *Aepyornis* spp. before man hunted them to extinction. Skeletal remains and eggshells indicate that these herbivores were the largest birds ever to walk the earth. The remote Cap Ste Marie is the southernmost point: a lonely, very sandy region. To the north-west lies the Mahafaly plateau, renowned for its painted wooden tomb carvings.

1. The hoopoe *Upupa epops marginata* is widespread throughout the drier regions of the island and is easily recognised by its boldly striped wings and flamboyant crest, which fans out when alarmed. Larger than its African counterpart, the Madagascar hoopoe has a completely different call.

2. The crested coua *Coua cristata* is a common Madagascar endemic found in forest, bush and savanna grasslands. One of three arboreal couas, it has a penchant for eating tree gum besides feeding on chameleons, insects, snails, berries and fruits. It has a wonderful vocal repertoire.

3. *Pachypodium lamerei* is one of the many strange, drought-resistant plants found in the drier regions of the 'Great Red Island'

4. Euphorbia-Didiereaceae spiny desert forest in the Beza Mahafaly Special Reserve. Inhospitable to man, this forest is a natural sanctuary for indigenous plants and wildlife.

5. *Far right:* Of the eight existing baobab species, six are endemic to Madagascar. Here, the smallest, bottle baobabs *Adansonia rubrostipa,* reach heavenward, lending a ghostly effect to the spiny bush forest in the Ifaty region of the south-west. Their flowers are pollinated by bats, hawk moths and small nocturnal lemurs.

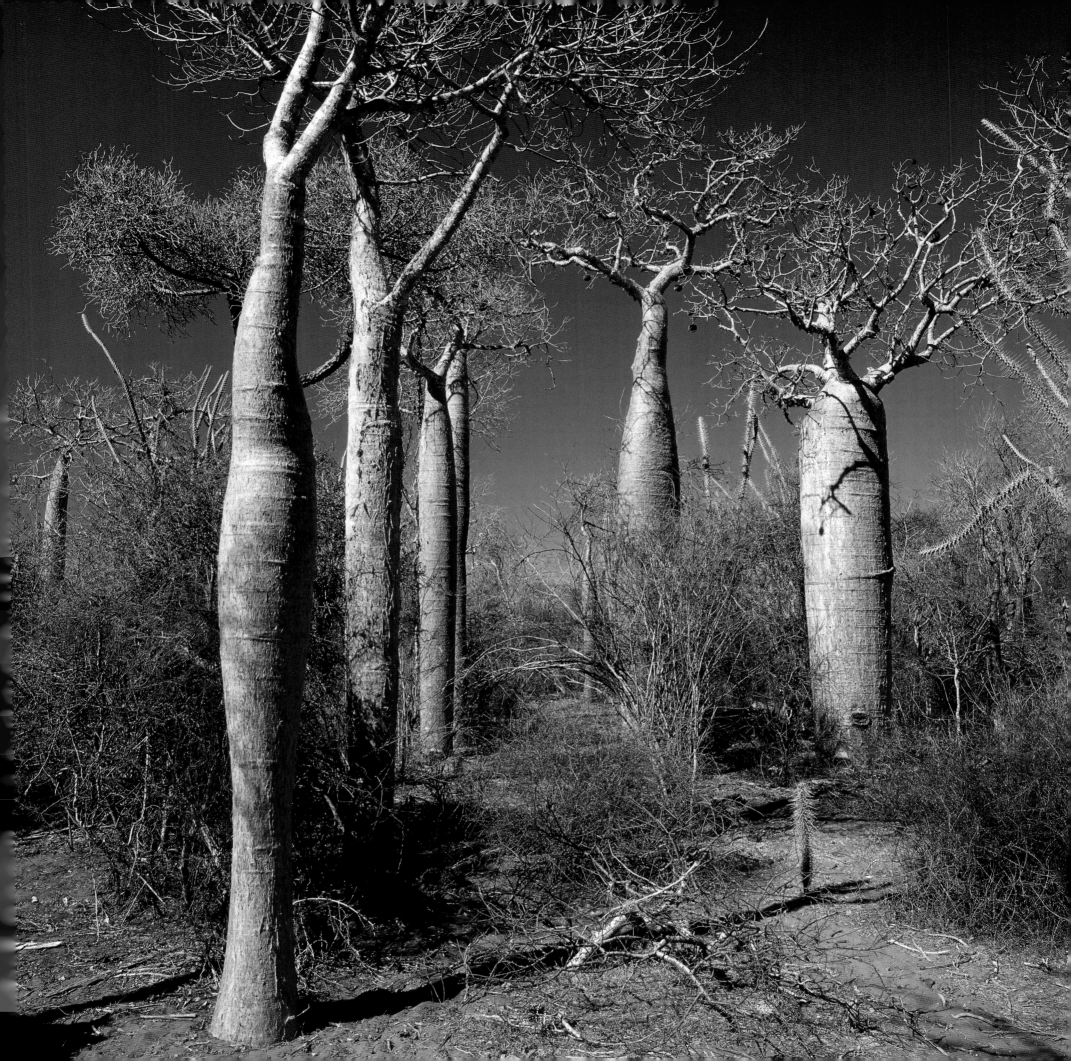

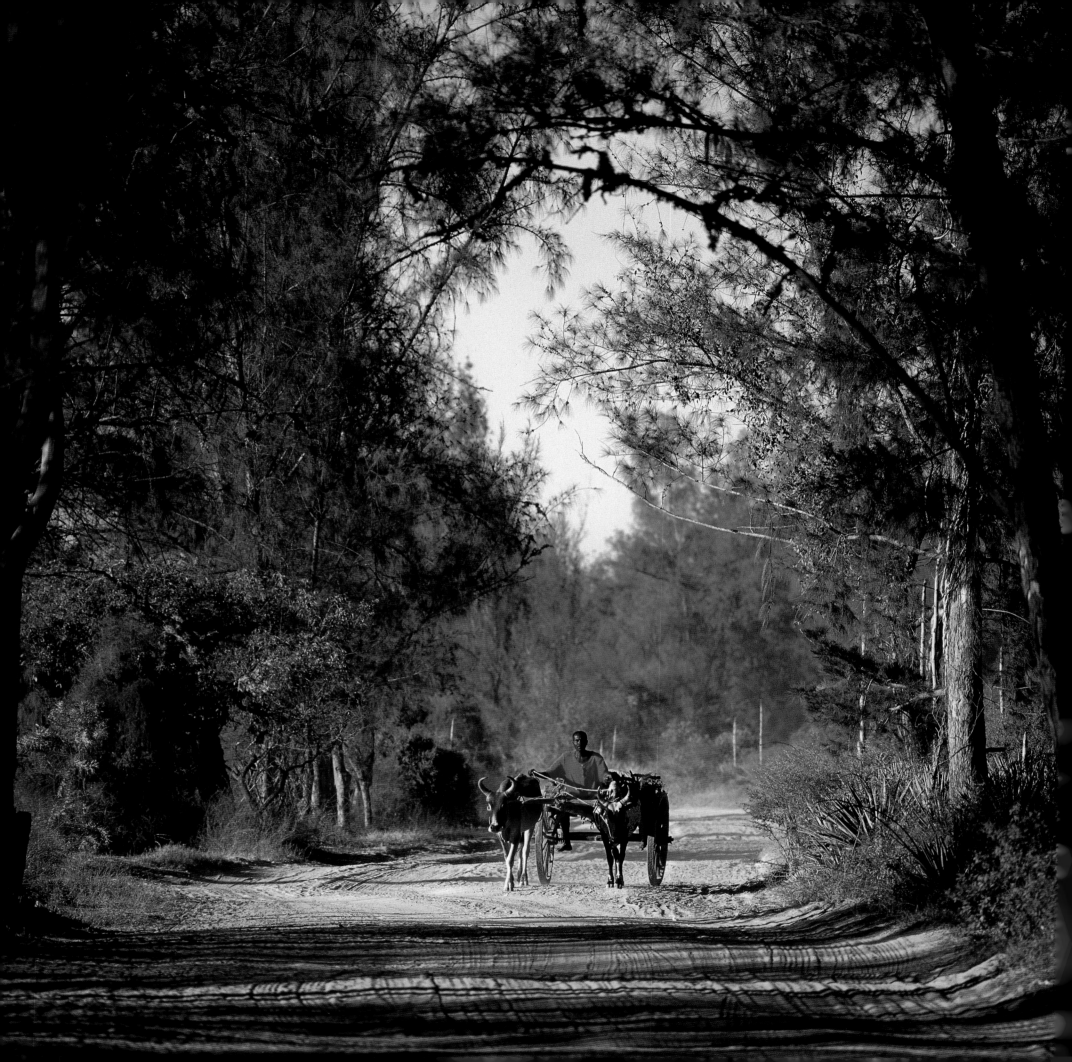

Far left: 1. Ubiquitous throughout rural Madagascar, an oxcart wends its way slowly homeward in the Ifaty region of west Madagascar. Zebu are considered a symbol of wealth and a link with the ancestors.

2. Veso fishermen in their sail-rigged dugouts (*lakana*), make their way across a lagoon north of Toliara (Tulear).

3. The Onilahy gallery forest is a prime habitat for the appealing and ever-curious ring-tailed lemur *Lemur catta*. The long, black-and-white ringed tail makes this one of the most recogniseable of all lemurs. Highly social, it lives in groups of up to 30 individuals in a strictly matriarchal society. To keep warm and reaffirm social bonds, groups will sometimes huddle together to form a 'lemur ball'.

4. Male Madagascar paradise-flycatchers *Terpsiphone mutata* come in two colour morphs: pied or red. Females are always red. Here a male is shown at its delicately woven nest in the Beza Mahafaly Forest.

5. The Madagascar flying fox, *Pteropus rufus*, is a vulnerable endemic inhabitating subtropical

or tropical moist lowland forests. It is threatened by habitat loss and an increased level of hunting as a food source, particularly since the introduction of shotguns.

6. The Sakalava weaver *Ploceus sakalava* is endemic to dry shrubland and forest. The kidney-shaped nests of this colonial

species are often suspended from baobab trees or even the thatched eaves of buildings.

7. Smallest of Madagascar's four endemic owls, a Malagasy scops owl, *Otus rutilus* is well camouflaged in the fork of a tree and keeps a watchful eye on its forested domain in Beza Mahafaly Reserve.

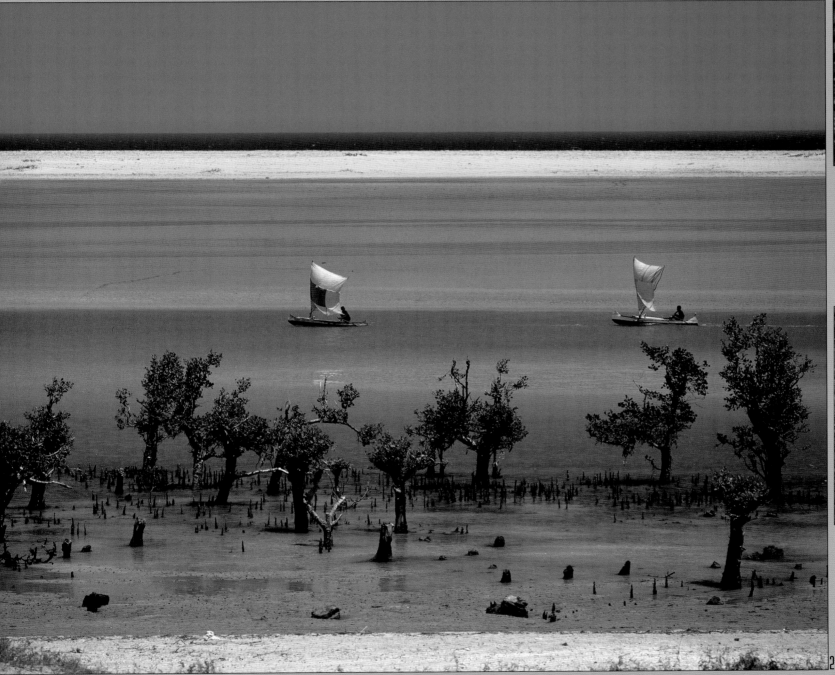

Berenty Reserve is a small private expanse of gallery forest along the Mandrare River, set in the semi-arid spiny forest ecoregion of the far south-east of Madagascar. The vegetation grows in a poor substrate with low, erratic winter rainfall. The reserve hosts many endemic bird species in the gallery forest, including owls and couas, but is renowned for the abundance of its lemurs, many accustomed to human interface.

1. An alert female red-fronted brown lemur *Eulemur fulvus rufus* and 4. male and female. The species is found in seasonally dry forests such as Kirindy and also in some eastern rainforests, particularly Ranomafana National Park.

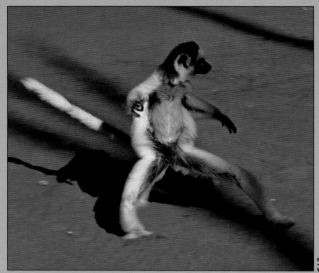

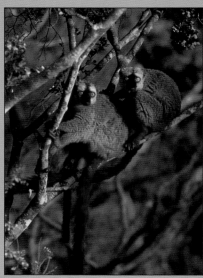

clearing in the late afternoon. This is the most terrestrial of lemurs. It is alert, omnivorous, and forages during the day.

Right: 6. The magic of twilight as the yellow veneers of day fade to the purple shades of dusk, silhouetting a grove of Grandidier's baobabs, *Adansonia grandidieri*, north of Morondava.

Grandidier's is the largest of Madagascar's six endemic species. Formerly linked with the topography of lakes and seasonal river systems, this endangered baobab is today associated more closely with degraded scrubland and open agricultural pastures.

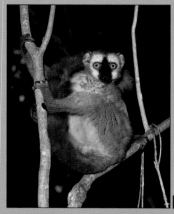

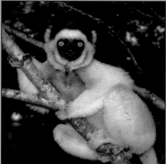

2 & 3. Verreaux's sifakas, *Propithecus verreauxi* live in small troops in a variety of dry southern and central-western Madagascar habitats ranging from spiny desert to deciduous dry forest and rainforest. These swift and sure-footed lemurs leap impressive distances as they move through the trees using their tails as an additional balancing limb. The sifaka appears somewhat ungainly when on the ground, where it hops in an upright sidewise gait. 5. A ring-tailed lemur *Lemur catta* suns itself in a forest

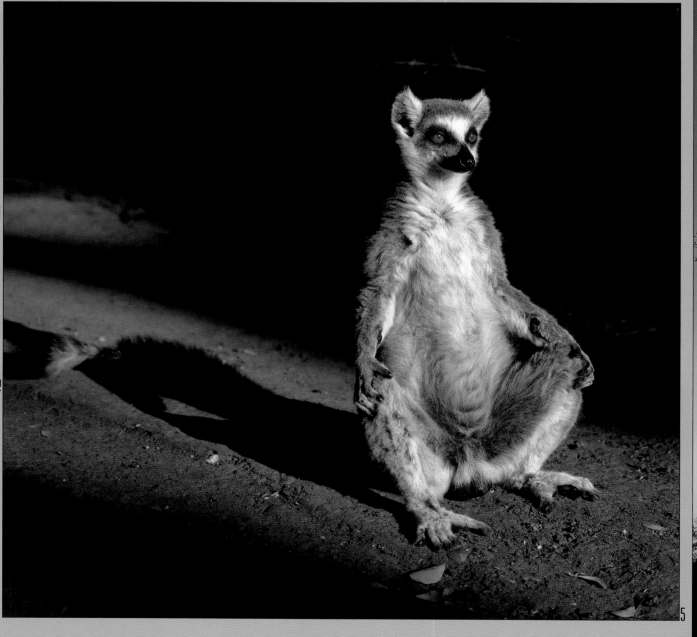

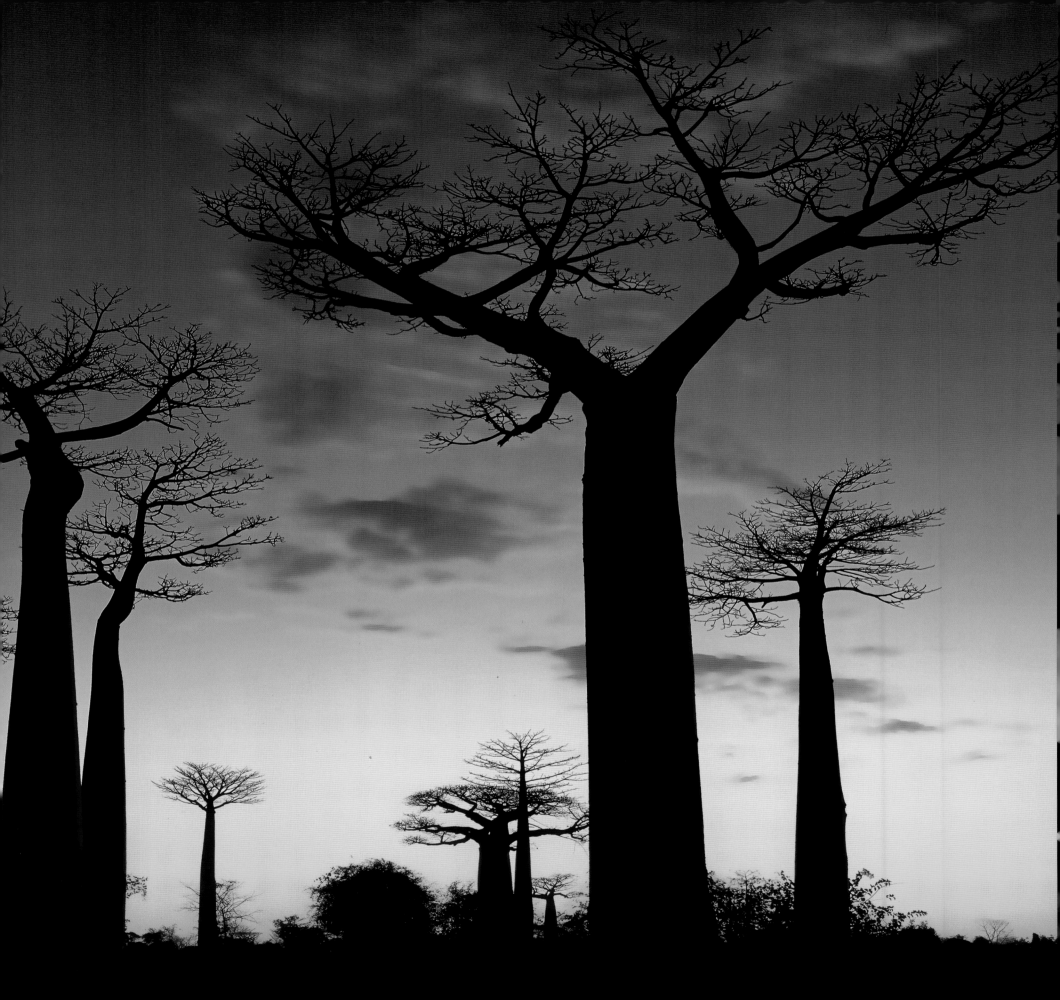

1. The fossa *Cryptoprocta ferox*, cat-like in appearance and habit, was previously believed to be in the Felidae family but recent research has brought it into the Viverridae. It is the largest of Madagascar's eight endemic carnivores and is a formidable predator of lemurs.

This mainly nocturnal animal is agile and fast moving, and preys on rodents, birds and lemurs. It is solitary, except during the

and south-western Madagascar, the radiated tortoise *Astrochelys radiata* is today a critically endangered species. Numbers have declined drastically during the last few years due to overhunting and exploitation for the trade in exotic animals.

6. *Kigelianthe grevei* is a colourful endemic.

mating season (November) when site-faithful females occupy a tall tree and mate with a number of males. This rare but widespread species occurs in fragmented woody regions throughout.

2. *Uncarina decaryi*, an endemic shrub with bright yellow flowers that attract bees, butterflies and birds.

3. A huge Grandidier's baobab in seasonally dry forest north of Morondava. This is the most utilised of all Madagascar baobabs: seeds and fruit pulp are eaten raw and provide a source of cooking oil; bark fibres are made into ropes; and the fibrous spongy wood is dried in the sun to be used as thatching material.

Regeneration has been severely impacted by habitat degradation and few young trees survive.

4. A nocturnal ground gecko, *Parodura pictus*, amongst leaf-litter in the Kirindy Forest.

5. Formerly abundant and wide-ranging but now restricted to just a few localities in southern

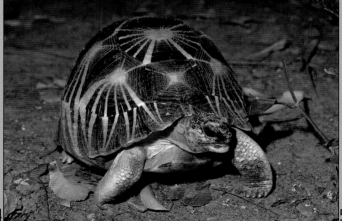

Far right: Weighing barely 30 with an average body length o only 92 mm, the nocturnal Madame Berthe's mouse lemu *Microcebus berthae* is the wor smallest primate. It was descr as a new species in 2000.

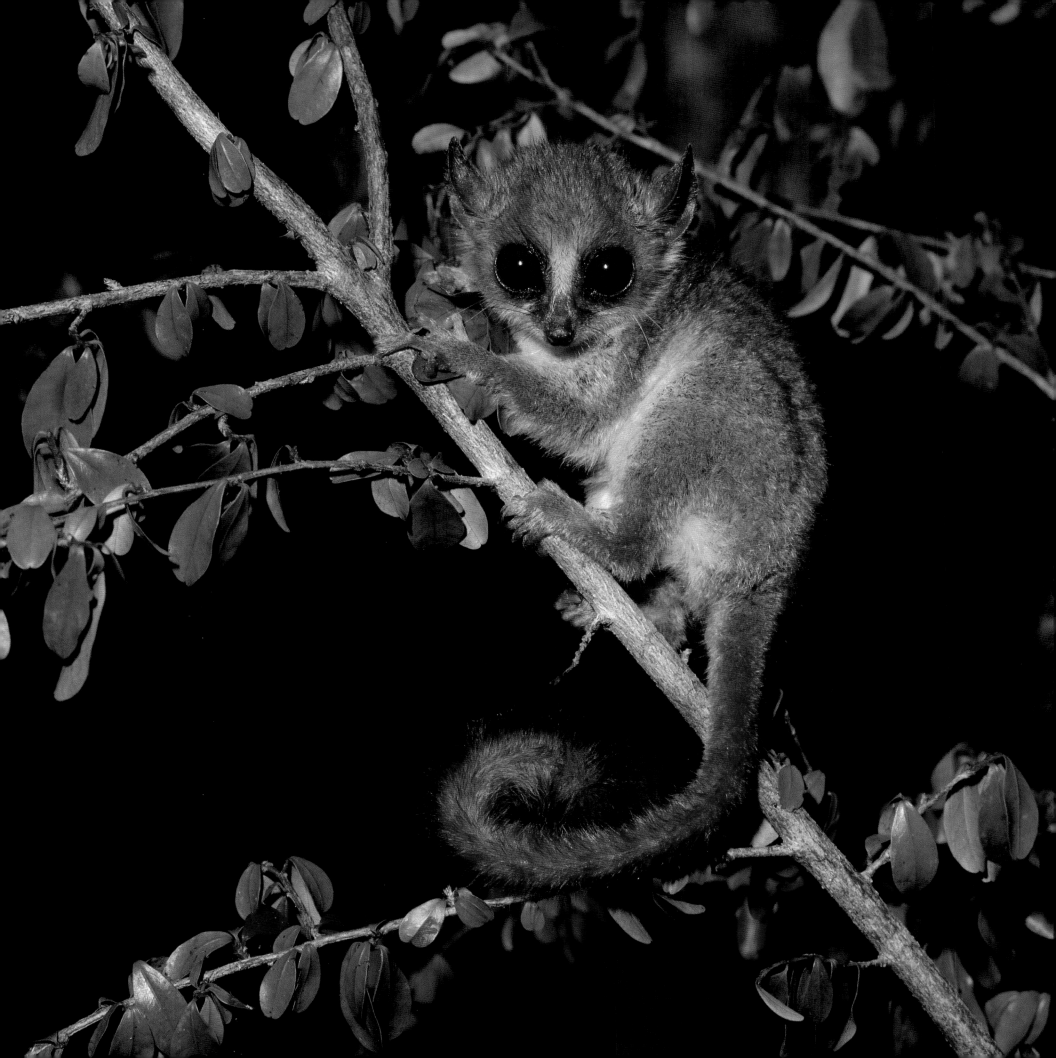

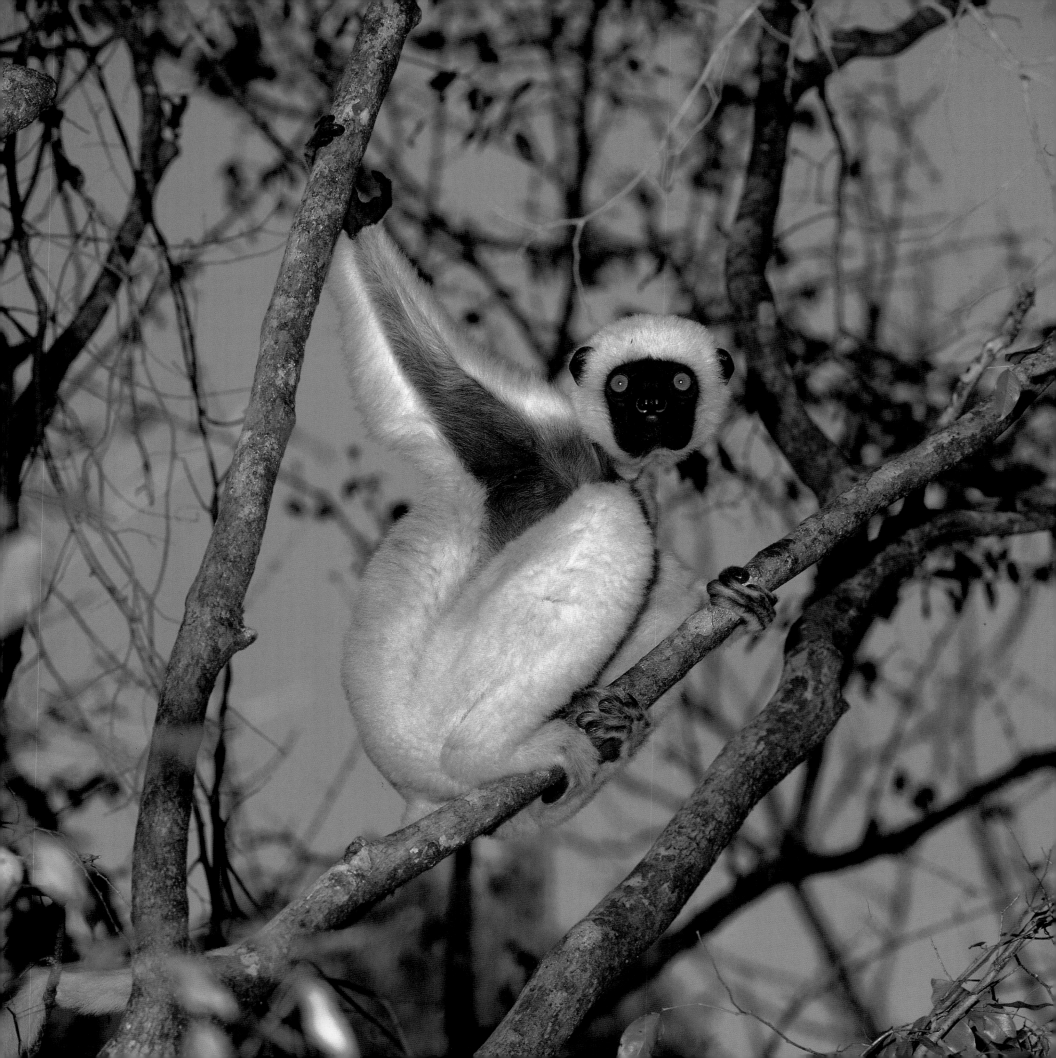

Far left: 1. A Decken's sifaka *Propithecus deckeni* in seasonally dry forest, Tsingy de Bemaraha National Park. Although this species' habitat is fragmented due to population pressures, some protection is provided by a strong taboo within local communities.

2. A female Madagascar kestrel *Falco newtoni* the most common of the island's endemic raptors, at her nest on a Tsingy rock ledge.

3. The collared iguanid lizard *plurus cuvieri* has a wide range, particularly in dry western Madagascar.

4. The grey mouse lemur *Microcebus murinus* one of the world's smallest primates, is a solitary nocturnal feeder. It coexists with the smaller Madame Berthe's mouse lemur in Kirindy Forest, where it can be seen during night walks. Kirindy claims a world record for primate density.

5. The Great Tsingy ('where one cannot walk barefoot' in Malagasy) are a feature of the Tsingy de Bemaraha National Park, a World Heritage Site since 1990. These limestone karst formations are the remains of an ancient seabed. The eroded pinnacles with thin sharp points are sheer and treacherous to climb.

6. The pied morph of a Madagascar paradise flycatcher *Terpsiphone mutata* at take-off.

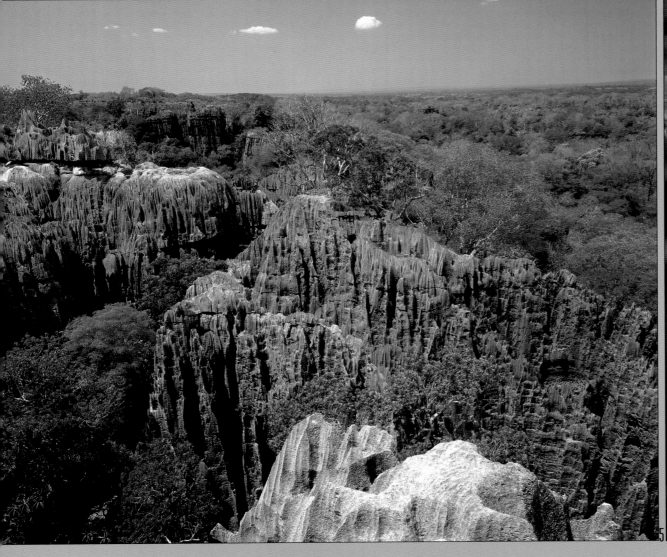

Madagascar's population is diverse, consisting of 17 different clans or groups. Origins are obscured in the mists of time but can be traced back to migrations initially from Southeast Asia some 1500 years ago. Infusions of Bantu and Arab peoples were subsequently introduced to the ethnic mix. This led to a rich folklore that flourishes to this day long after, and in spite of, the French colonial period and English missionary endeavours of the 19th and 20th centuries. Half of the population is today nominally Christian.

Ancestor worship, however, still lies at the heart of beliefs and the dead are accorded all honour and respect. The departed are regarded as if alive, sometimes even being exhumed and taken out on sight-seeing taxi rides, later to be re-wrapped in fresh shrouds.

In the south, elaborate family tombs are erected and surrounded by white washed and exotically painted walls (4).

The Antandroy are pastoralist cattle herders a(6) in the dry semi-desert regions of southern Madagascar.

Painted tombs (4) totems (1) and wooden effigy carvings (5), depicting a French colonial period soldier wearing his peaked 'kepi') are found throughout the countryside. They show the lifestyle of the deceased and are a colourful aspect of Antandroy rural culture.

2. Mahafaly tomb carvings (painted carved wooden totem poles known as *aloalo* soul perches).

The Mahafaly are famed for their fine wood carvings. These also record the life of the deceased as well as social status in the community. Zebu horns (the humped cattle of Madagascar) surmount the enclosed built-up tomb compound area, denoting the significance of cattle to these pastoral people.

3. Zebu oxen haul a cart made from the body of a dilapidated Renault van in the Ihosy region.

7. A spider cautiously explores the lip of one of the two endemic insectivorous pitcher plants

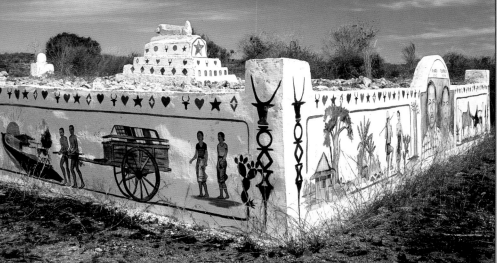

8. The crown-of-thorns or Christ plant *Euphorbia milii* woody succulent species, o of many endemic euphorbia native to Madagascar. It is thought that the species wa introduced from Madagasca to the Middle East in ancien times, and hence legend associates it with the crown

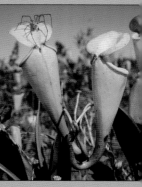

thorns worn by Jesus.

It is a climbing shrub, whi grows up to 1.8 m, with densely spiny stems and straight, slender spines up t 3 cm long, which help it scramble over other plants. Generally the plant only produces leaves on new growth. Flowers, variably re pink or white, are small (up about 12 mm wide). The sa moderately poisonous.

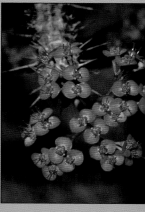

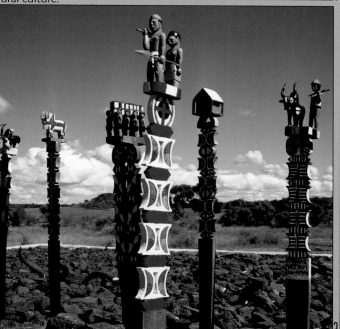

Nepenthes madagascariensis. This was the first *Nepenthes* species to be discovered, in 1658. Today it is found only in the lowland swampy, sandy regions of eastern Madagascar such as the Baie Ste Luce marshland (shown here) near Fort Dauphin.

Right: 9. The landscape in Isalo National Park covers a varied topography: sandstor mountains and ridges interspersed with deep canyons; grassland expanse and occasional oases of freshwater embraced with luxuriant vegetation and pa trees. Depicted here: a gash the *massif ruineforme* which drops to a narrow densely vegetated valley 150m belov

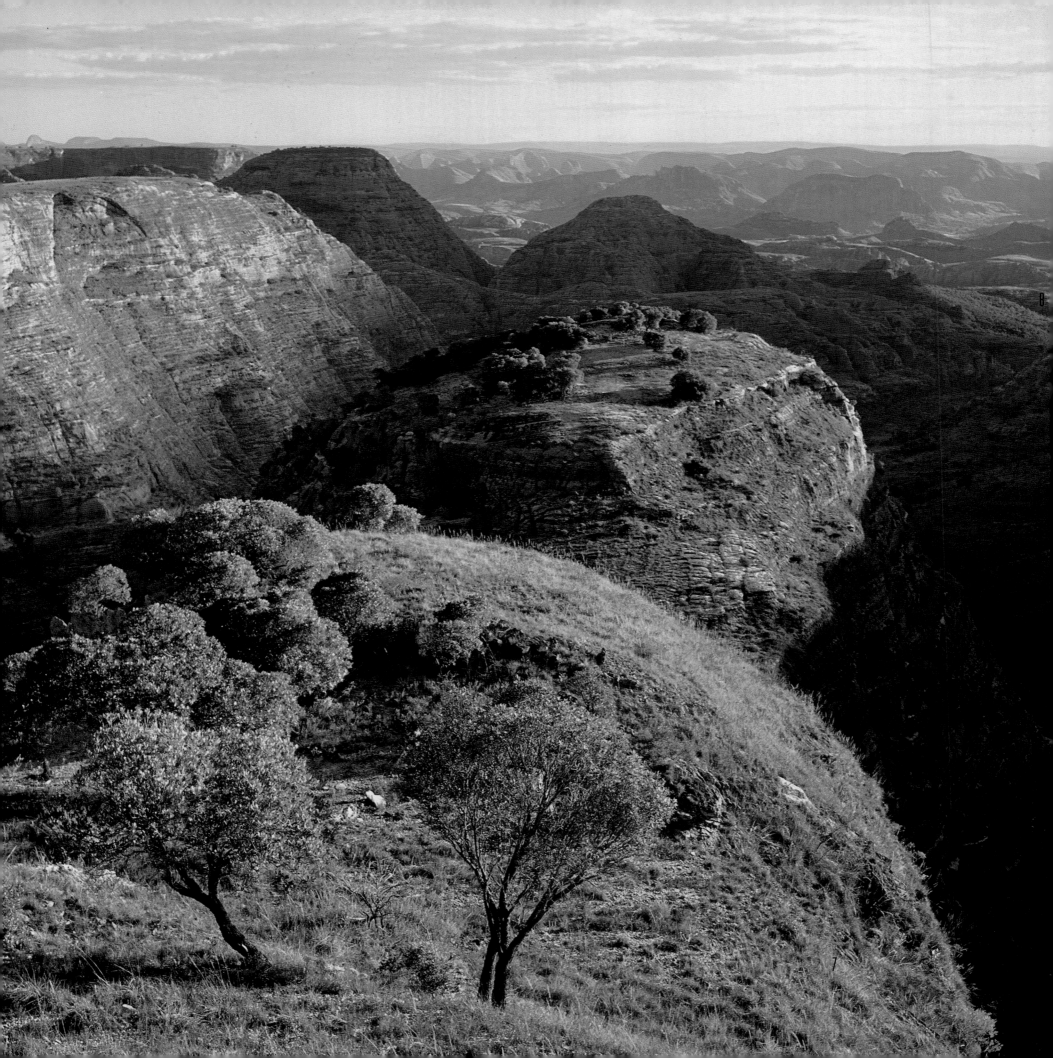

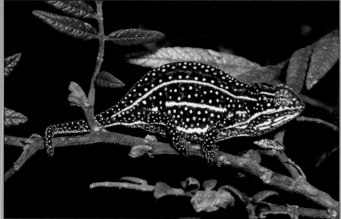

1. The Jewelled Chameleon *Furcifer campani* is found in southern and eastern Madagascar.

2. The highlands streaked tenrec *Hemicentetes nigriceps* is an insectivore from the central highland regions. It is covered in detachable quills that are erected when alarmed.

3. A granitic mountain landscape in Andringitra National Park in the south-central highlands. This park is one of the most biodiverse regions of Madagascar, abundant with flora, birdlife and mammals.

4. A Betsileo boy in the south-central highlands.

5. A Betsileo mother and child at the window of their house in Ambalavao. Most houses have windows with simple folding shutters. Glass is an expensive luxury that few can afford.

6. Rural Betsileo dwellings, complete with church tower, south of Ambositra.

7. *Far right:* A rural settlement south of Ambalavao. Overgrazing by Zebu cattle over the centuries has resulted in a characterisic topography of dry grasslands and eroded hillsides.

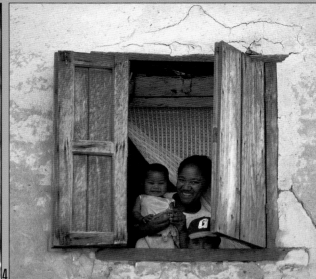

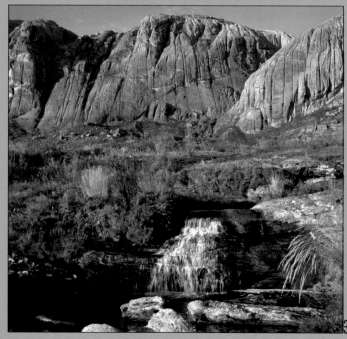

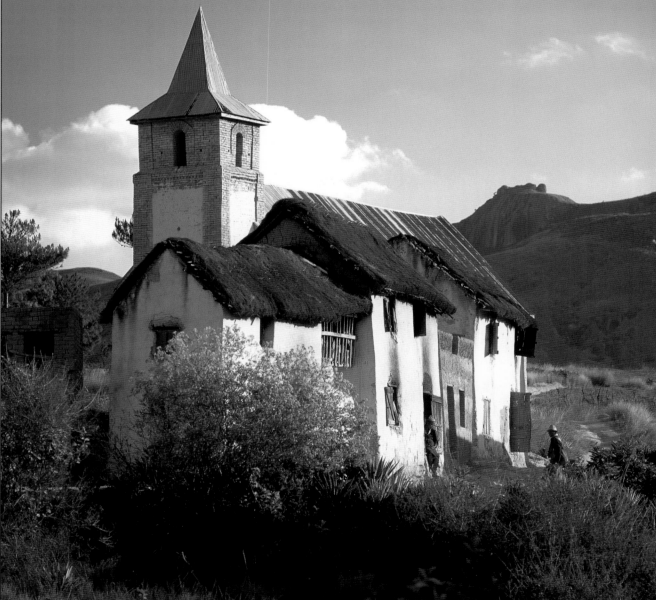

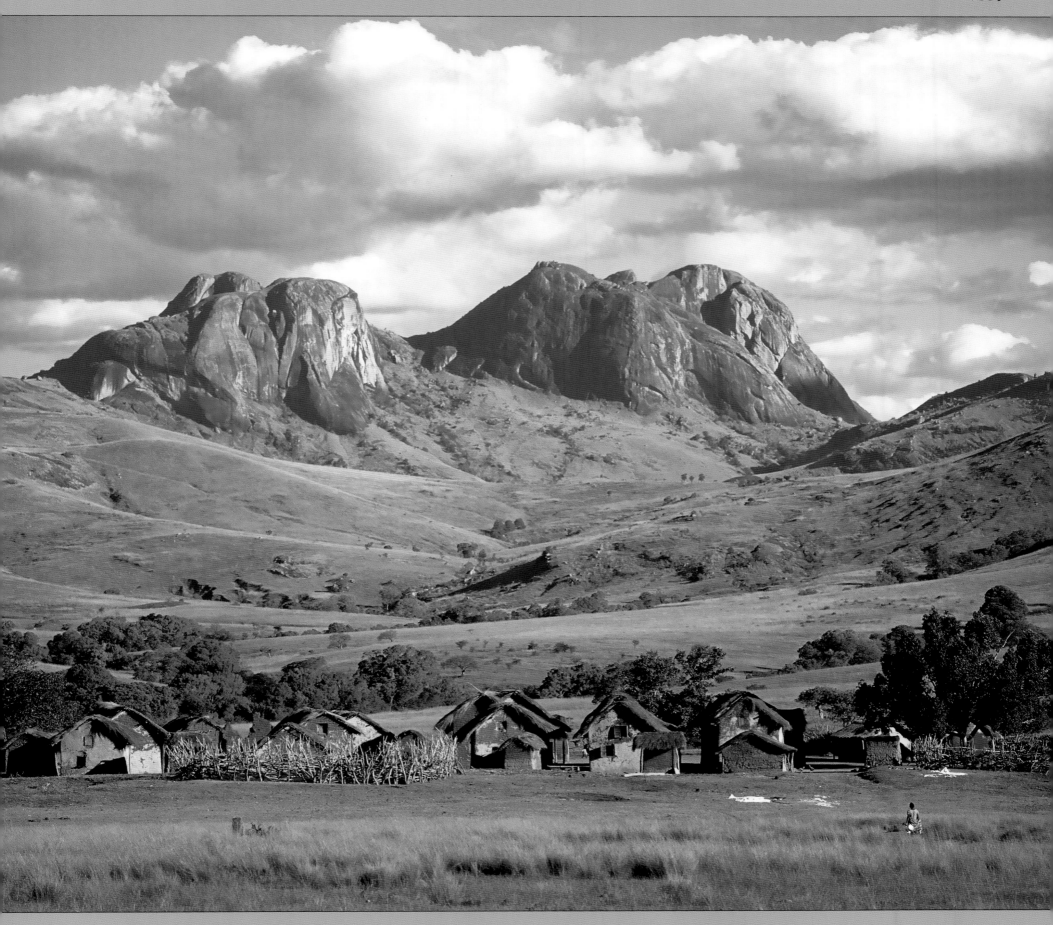

MADAGASCAR

Betsileo houses in the south-central highlands. The London Missionary Society brought protestant Christianity to Madagascar in the mid-19th century. Travelling missionaries influenced the style of architecture that now prevails throughout the region.

Houses typically lack glass windows and the entrance is always elevated from the ground in accordance with local fady (customary superstition) to impede bad spirits.

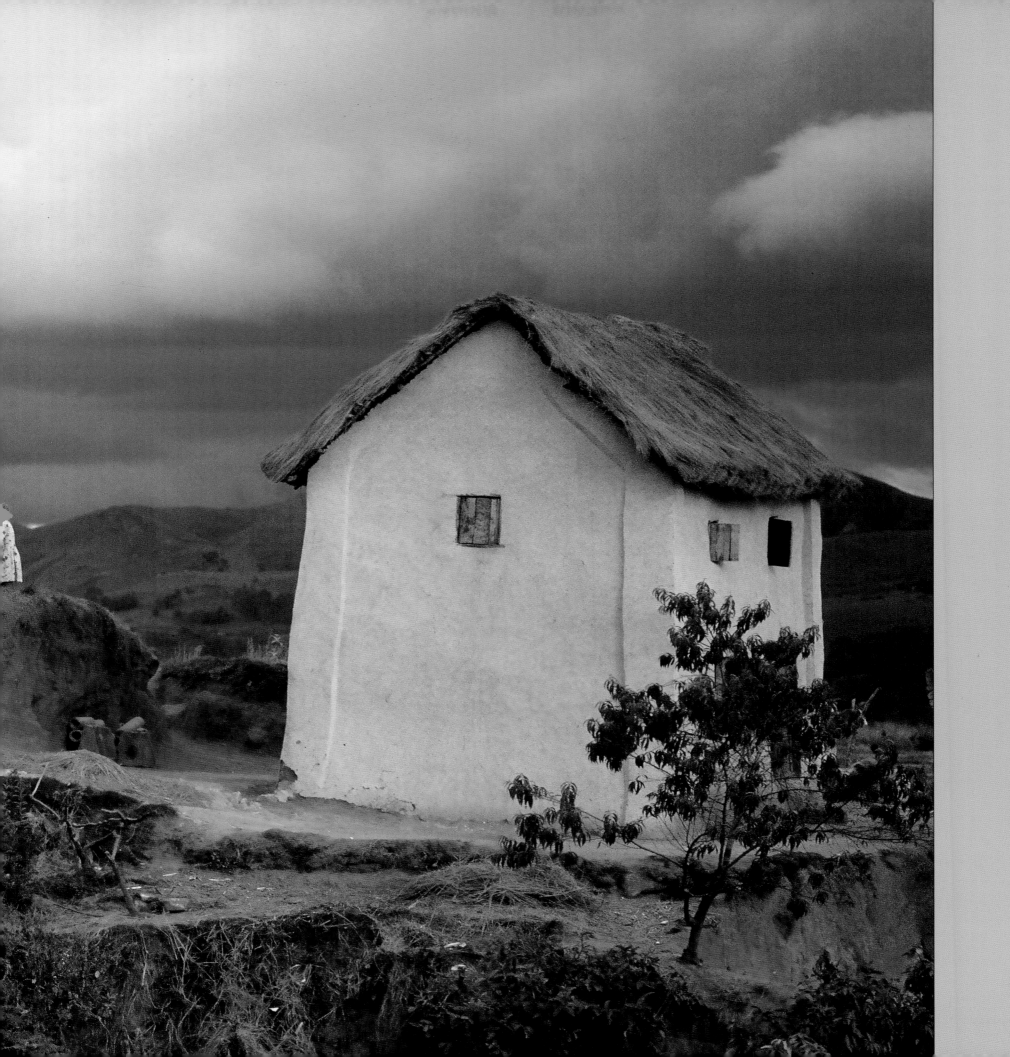

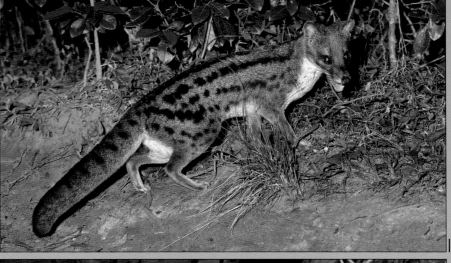

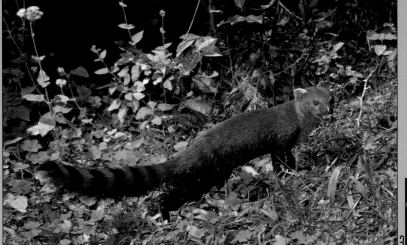

3. The ring-tailed mongoose *Galidia elegans* is a diurnal endemic carnivore. Although agile tree climber it is often se on the humid forest floor. Its varied diet includes small mammals, reptiles, fish, birds eggs and invertebrates.

4. A small-toothed sportive lemur *Lepilemur microdon* pe out from its daytime tree-hol resting place. The many speci of sportive lemurs are nocturr and largely solitary.

5. All *Bakarella* species are parasitic and used locally as treatment for syphilis.

6. *Oeonia rosea* is an epiphy orchid found in humid evergreen forests. It is one of more than 900 species ender to Madagascar.

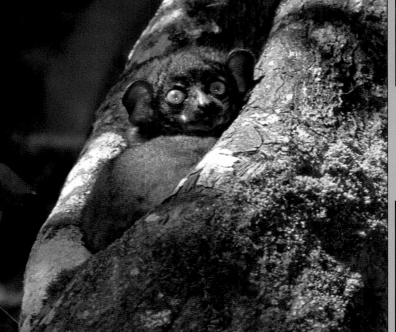

Ranomafana in south-eastern Madagascar was designated a national park in 1991 following research in the area by a team of primatologists headed by Dr Patricia Wright (Stony Brook University, New York) and the discovery in 1986 of the golden bamboo lemur *Hapalemur aureus*.

The park covers 416 km² of montane rainforest rich with tree species, ranging in altitude from 400 to 1417m. Renowned for a unique biodiversity, it protects within its borders one of the world's highest concentrations of primate species (12 in five families).

Ranomafana provides sanctuary for three species of bamboo lemurs: the golden bamboo lemur, the greater bamboo lemur and the eastern lesser bamboo lemur.

1. The Madagascar civet (*Fanaloka*) *Fossa fossana* is a nocturnal, ground-dwelling carnivore. A rare euplerid endemic to Madagascar's eastern rainforests at altitudes below 800 m, it feeds on reptiles, small mammals, frogs and birds' eggs.

2. A highly endangered Golden bamboo lemur *Hapalemur aureus*, is shown feeding on the leafy tip of a Giant bamboo,(*Volohosy*) *Cathariostachys madagascariensis*. This is a diurnal crepuscular lemur under severe threat due to habitat loss. The population is probably less than 1000 animals.

Right: 7. A greater bamboo lemur *Prolemur simus* feeds o a stem of Madagascar giant bamboo. This is stripped apa to reveal the interior juicy pit principal food source.

This critically endangered lemur lives in small groups ai is active both by day and at night.

All pictures in this and the following spread taken in Ranomafana National Park.

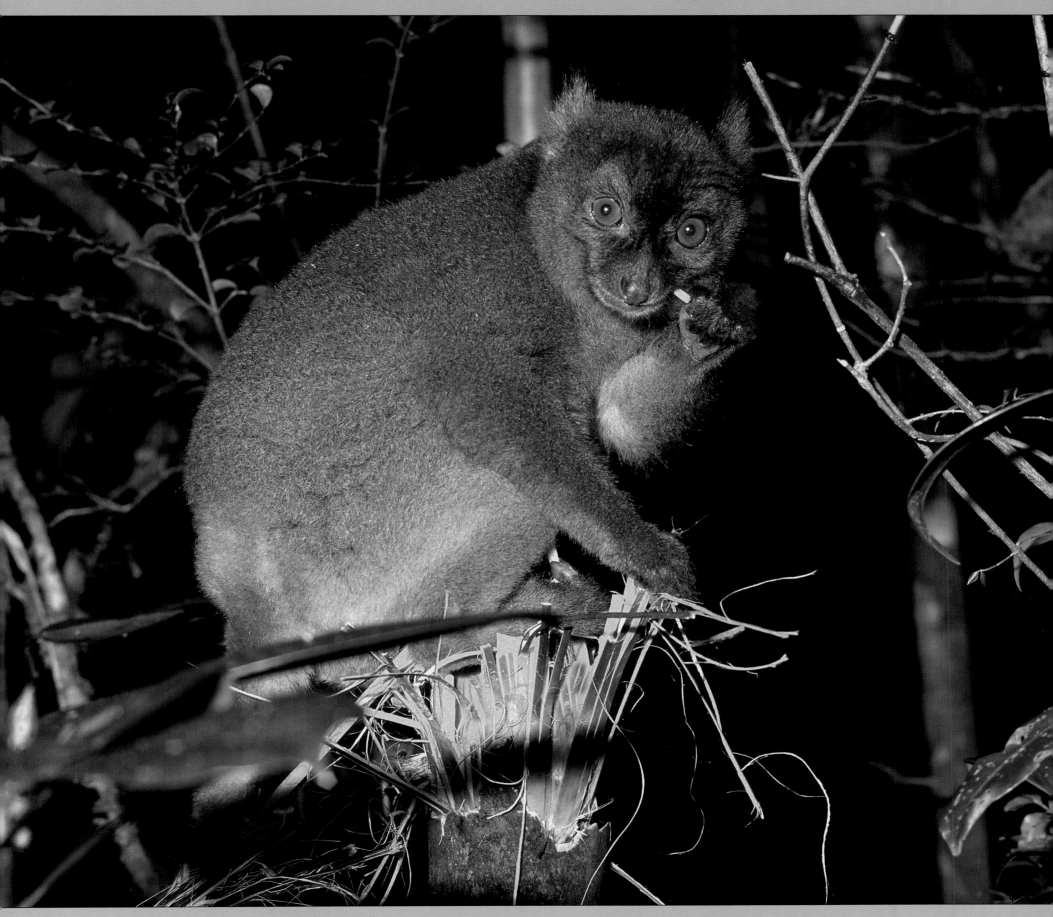

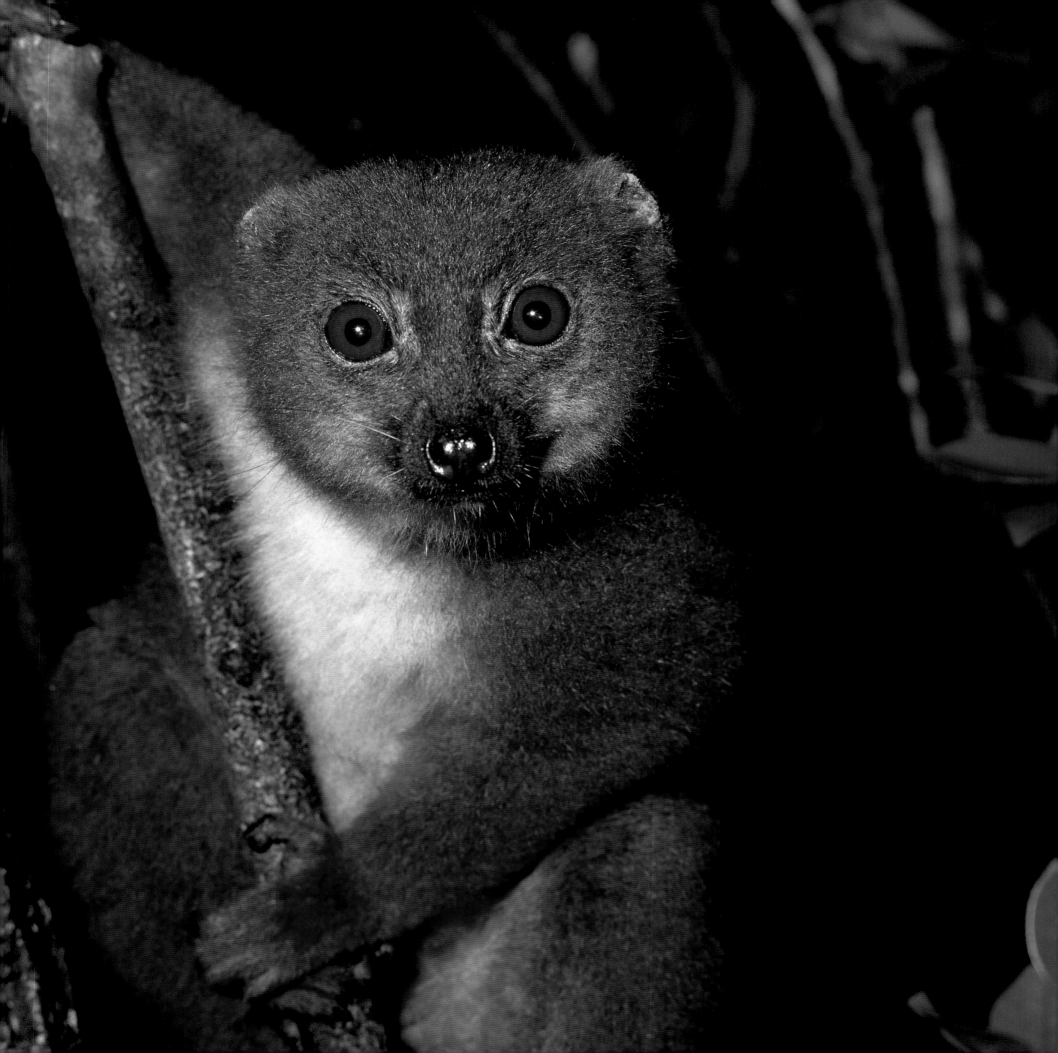

1. A female red-bellied lemur *Eulemur rubriventer* one of the 11 'typical' lemurs, stares out at the intruder.

The giraffe weevil *Trachelophorus giraffa* is a sexually dimorphic comic where the male's neck length is twice that of the female.

The montane rainforest in Ranomafana National Park is a habitat for wildlife. It is part of the Unesco World Heritage Site encompassing the Atsinanana rainforests, which have suffered to intense illegal logging, particularly between March 2009 and March 2010, when a ban was introduced on further logging

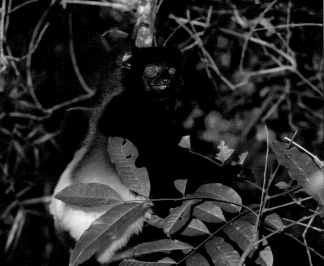

rubriventer are sexually dichromatic (like most *Eulemur* species). Here the male is on the right. The primary terrain for these lemurs lies within intact eastern rainforests, now under ever-increasing threat from forestry clearance and illegal logging. This lemur is active during the day and at night.

8. Parts of the lary tree *Psiadia altissima* have been traditionally used by local people to repel insects and relieve itching. An essential oil from the tree is excellent for the respiratory system, having a warm clean aroma. Lary products help to restore vitality to the body, are healing for the skin and are

especially useful for lungs and sinuses. They also help reduce swelling and inflammation of joint tissues and alleviate muscle pain, and they eliminate infections. The leaves produce an essential oil that is arousing international commercial interest.

9. The eastern rufous mouse lemur *Microcebus rufus* is a solitary, nocturnal omnivore.

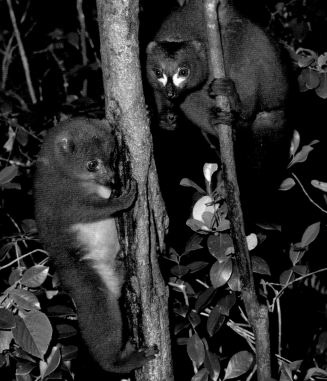

and the export of rosewood and ebony.

4. The greater dwarf lemur, *Cheirogaleus major* is widespread in the eastern lowland rainforests. Prior to hibernation it stores up to 30% of its mass as fat in its tail.

5. Eastern woolly lemurs *Avahi lanigar* live in monogamous pairs with their offspring in the eastern rainforest band.

6. The Milne-Edwards' sifaka *Propithecus edwardsi* keeps to small groups in a narrow range of the central south-eastern rainforests. It feeds on fruit, seeds and flowers.

7. Red-bellied lemurs *Eulemur*

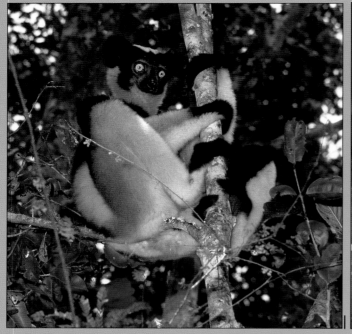

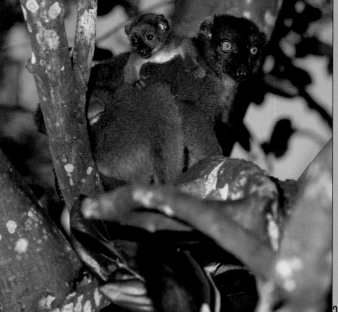

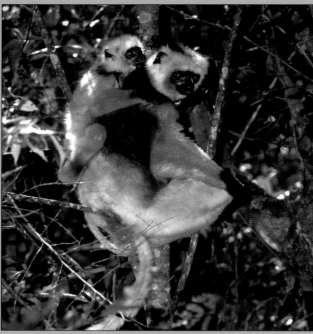

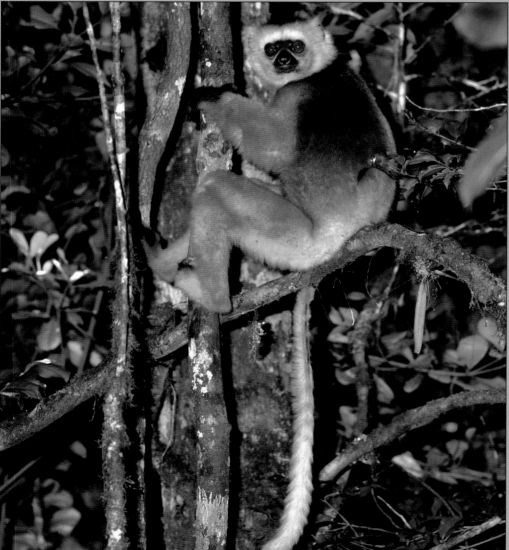

1. & 7. Indris *Indri indri* in the Analamazaotra Special Reserve forest. This is the largest of all lemurs and is widespread in undisturbed lowland and montane forests in eastern Madagascar. Indris are unmistakable in the forest with their hallmark eerie and siren-like wails that carry far and wide. They live in small groups and feed on tender young leaves, fruits, seeds and tree bark. They cannot survive in captivity and

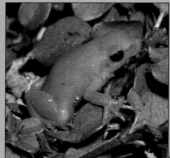

therefore depend on the conservation of their rainforest habitat. In some areas they benefit from local *fady* (customary superstition), but in others they are illegally hunted.

2. A female white-fronted brown lemur *Eulemur albifrons* with her infant. This denizen of the north-eastern rainforests is among the most heavily hunted of lemurs. It is also vulnerable to persistent slash-and-burn land clearance, the illegal logging of precious hardwoods (particularly endemic rosewoods and ebonies) and

quartz mining, which have all resulted in the degradation of the protected areas where it exists.

3. A diademed sifaka *Propithecus diadema diadema* in the Andasibe-Mantadia National Park rainforest. This sifaka, one of the two largest extant lemurs, is restricted to the central-eastern rainforests at altitudes from about 200 to 1600 m. It is diurnal living in small groups and feeding on a variety of fruits, flowers, leaves and seeds. Threats to its habitat include slash-and-burn agriculture and mining activities.

4. The poisonous golden mantella frog *Mantella aurentiaca* best known of Madagascar's frogs, is a rare species restricted to Torotorofotsy Marsh near Mantadia National Park. The illegal trade in reptiles and frogs poses a severe threat to such aesthetically pleasing species.

5. The diademed sifaka is regarded as the most beautiful of Madagascar's primates.

6. The common tenrec *Tenrec ecaudatus* is a common and widely distributed insectivore in spite of being hunted as a popular food source. The female has 17 pairs of nipples and can give birth to as many as 32 offspring, the record for mammals.

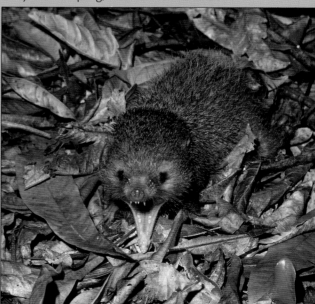

1. The male comet moth *Argema mittrei* has a wingspan of up to 20 cm and tail up to 17 cm long. This is one of the world's largest silk moths. Only fertile the first day after emerging from its cocoon, it has a life-span as a fledged moth of a mere four to five days.

2. A male panther chameleon *Furcifer pardalis*.

3. *Boophis madagascariensis*, is a tree frog that is fairly widely distributed in the central and eastern rainforests.

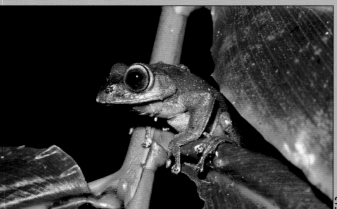

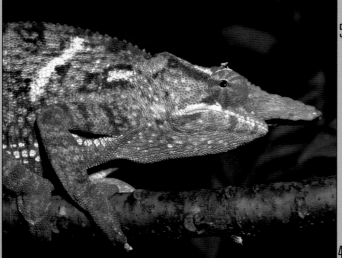

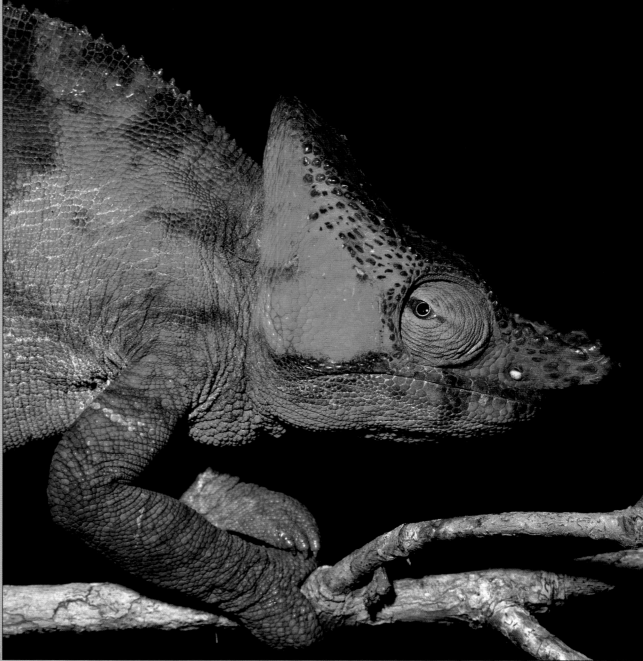

4. A male two-horned chameleon *Furcifer bifidus*.

5. A male Parson's chameleon *Calumma parsonii* displays a formidable nasal appendage. It inhabits humid rainforests in the east. Together with the enormous Oustalet's chameleon of western Madagascar, this is the largest of all chameleons.

6. This female short-horned chameleon *Calumma brevicornis* unleashes her long sticky tongue to snare an unsuspecting insect. This species is widely distributed in the eastern rainforests.

7. The forest lizard *Zonosaurus madagascariensis* is the most common of its genus in eastern Madagascar.

8. A subspecies of Parson's chameleon *Calumma parsonii parsonii* (male shown) is also huge, generally attaining up to 68 cm in length.

9. The lined leaf-tailed gecko *Uroplatus lineatus* like the 11 other leaf-tailed geckos is a strange-looking nocturnal insectivore. It mimics dead foliage and is widely regarded with superstition.

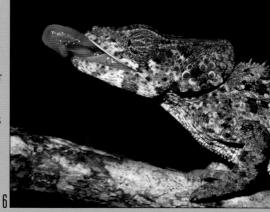

EVOCATIVE AFRICA

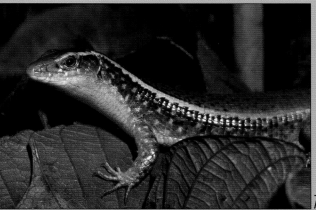

7

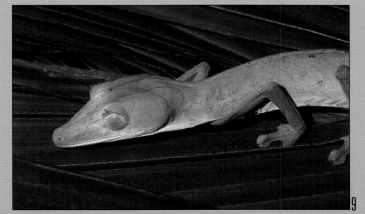

9

10. The tomato frog *Dyscophus antongilii* is a rare species from the north-eastern coastal region around Maroantsetra. If threatened it puffs itself up. If then taken, it exudes a sticky toxic substance that causes the predator's mouth and eyes to gum up. This offers the frog a chance to escape.

11. The boa *Acrantophis madagascariensis* is a large ovoviviparous ground-dwelling snake that inhabits mainly dry deciduous scrubland and forest in the north and north-west.

12. The poisonous *Mantella betsileo* is an adaptable terrestrial and diurnal frog species.

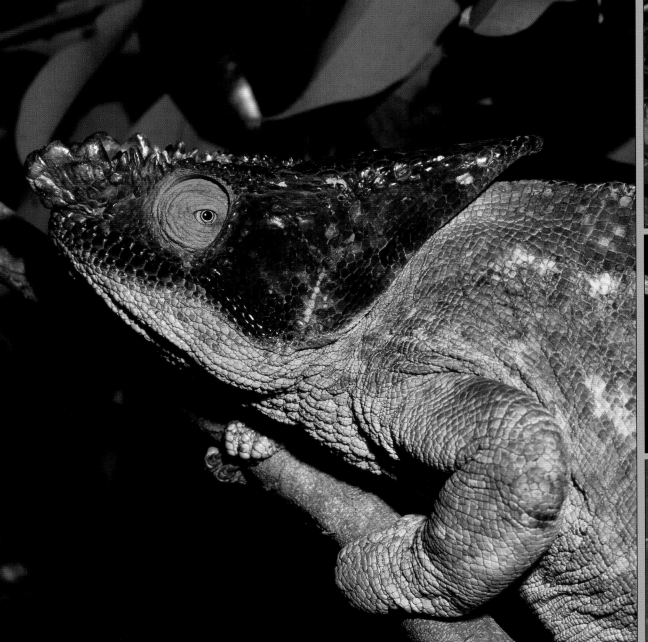

8

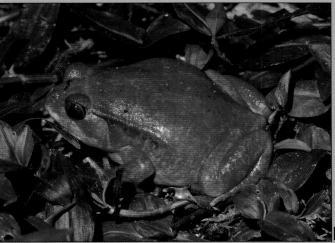

10

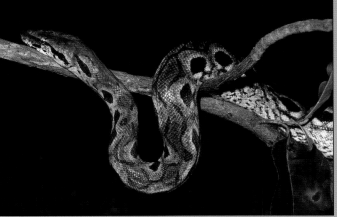

11

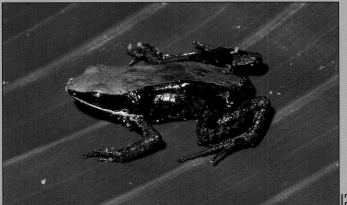

12

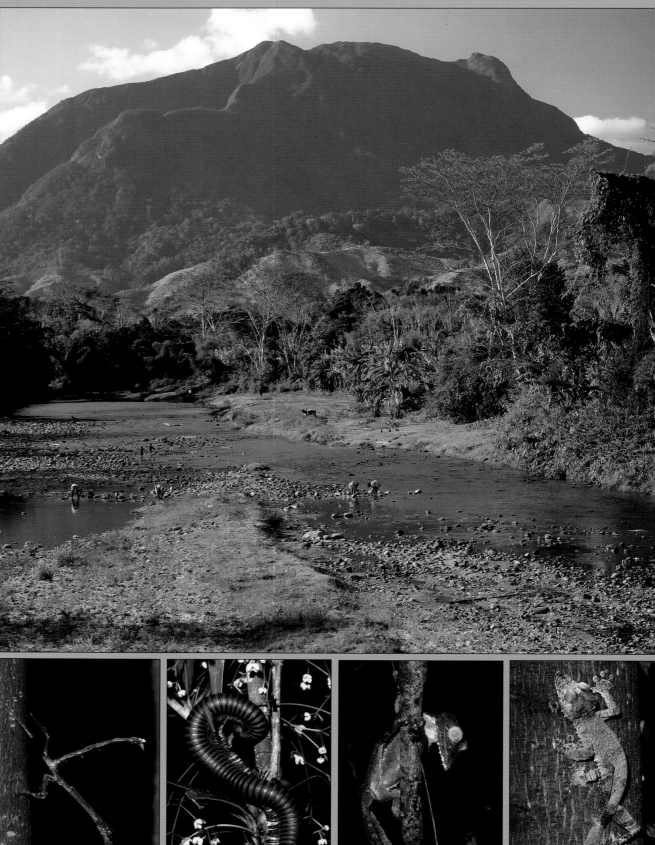

COMOROS

Pembe

Montagne d'Ambre N.P.
& Ankarana S.R.
Nosy Be

Antsiranana
(Diego Suarez)

Marojejy N.P.

Nosy Mangabe S.R.
& Masoala N.P.

Mahajanga
(Majunga)

Ile
Ste.
Marie

Ankarafantsika N.P.

Mantadia N.P. &
Analamazaotra S.R.

Toamasina
(Tamatave)

Tsingy de
Bemaraha N.P.
Kirindy (Swiss Forest)

Antananarivo

Morondava

Ranomafana N.P.

Isalo N.P.

Fianarantsoa

Toliara
(Tulear)

Tropic of Capricorn

Berenty P.R.

Cap Ste Marie

Tolagnaro
(Fort Dauphin)

MADAGASCAR

NORTHERN REGION

1. The Antongil leaf chameleon *Brookesia peyrierasi* is a tiny terrestrial species 38–43 mm in length. Together with the similar *Brookesia minima,* it is the smallest chameleon and one of the world's smallest reptiles. It lives amongst the leaf litter in the lowland rainforest of the Nosy Mangabe Reserve.

2. The 600 km² Marojejy National Park comprises lowland, montane and high-altitude rainforest and is part of the Atsinanana World Heritage Site. Like Masoala National Park, it is one of the richest biodiversity hotspots in Madagascar, though today it is suffering heavily from illegal logging activities.

3. A stick insect in Marojejy National Park.

4. A giant forest millipede.

5. & 6. Fringed leaf-tailed geckoes *Uroplatus fimbriatus* are amongst the world's largest geckoes. They have flattened tails and strange

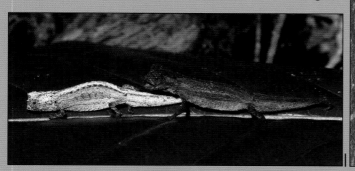

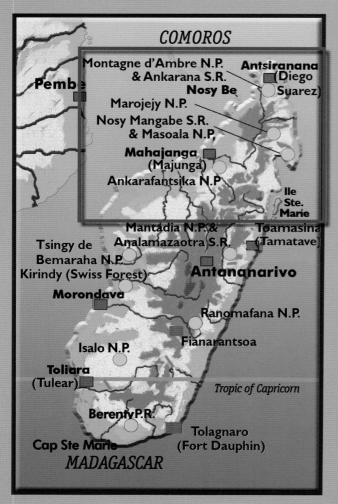

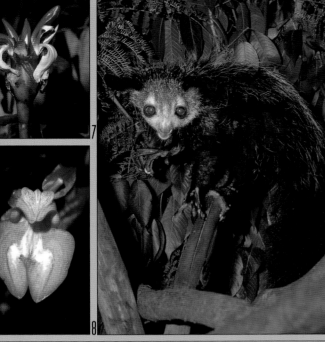

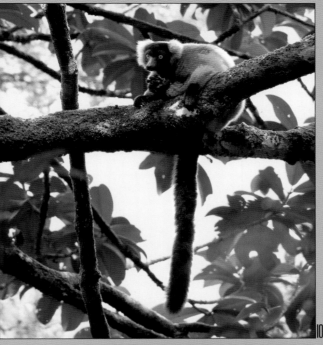

yellow-brown/beige-coloured eyes. They spend most of the day stretched vertically on a tree trunk blending in with the bark coloration: a perfect display of camouflage. These arboreal and nocturnal insectivores are found in lowland and montane rainforests in the east.

7. Wild ginger *Aframomum angustifolium*.

8. An orchid of the genus *Disperis*.

9. The aye-aye *Daubentonia madagascariensis* is the only living member of the *Daubentoniidae* family. It is a weird lemur species with large ears and strong incisors for gnawing wood and tree cavities. Using its fingers, it taps the bark and tree surfaces to locate hollow areas within. The middle finger, armed with a sharp claw, extracts insects and larvae. Formerly believed to be on the verge of extinction, this nocturnal species has now been located in a variety of habitats. It faces the usual threat of forest destruction. In some areas it is also regarded as the foreboder of evil and misfortune, and is killed on sight. The corpse is then deposited elsewhere to avoid bad *fady*.

10. The red-ruffed lemur *Varecia rubra* has a very restricted habitat confined to primary lowland rainforests on the Masoala Peninsula where it prefers tall trees, feeding on fruits, leaves and nectar. This endangered diurnal species was heavily persecuted during the frenzied illegal logging which occurred from early 2009 to April 2010.

11. A tranquil coastal scene on île Sainte Marie.

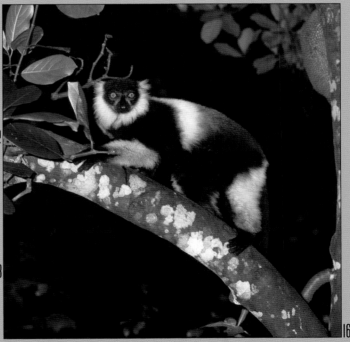

Renowned for its prolific diversity of amphibians, Madagascar is is home to more than 400 species of frogs, of which 99% are endemic. 270 have alredy been described and 130+ await formal description. Species in Nosy Mangabe Reserve include:

12. *Geophyromantis boulengeri* in the rainforest leaf litter.

13. A recently metamorphosed *Gephyromantis redimitus* .

14. A climbing mantella *Mantella laevigata*.

15. *Mantidactylus betsileanus*.

16. The critically endangered ruffed lemur *Varecia variegata* is more often heard than seen due to its explosive vocalisations.

17. *Phelsuma madagascariensis* is a colourful diurnal gecko.

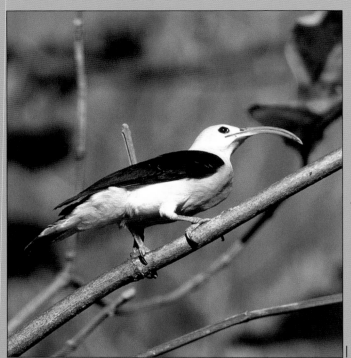

1. A sickle-billed vanga *Falculea palliata* in the Ankarafantsika deciduous forest. The largest of the vangas, the species forages and behaves like Africa's wood-hoopoes.

2. The little known crowned sifaka *Propithecus coronatus* is a critically endangered diurnal species inhabiting a few stands of western, seasonally dry, deciduous forest, none of which receives official protection. As a result of charcoal production and stock grazing this sifaka is severely threatened by habitat loss.

3. A Coquerel's sifaka *Propithecus coquereli* stretches out to feed in a mango tree. These lemurs, also critically endangered, live in matriarchal groups of three to 10 animals. They are diurnal and inhabit low-altitude dry mixed deciduous forests in the north-west of the island.

4. A female mongoose lemur *Eulemur mongoz*. This rare, crepuscular species from seasonally dry forests in the north-west is endangered. The Ankarafantsika National Park provides the only protected sanctuary for it; elsewhere, besides being hunted for food, it is threatened by slash-and-burn agriculture and forest destruction for charcoal.

5. The northern ring-tailed mongoose *Galidia elegans dambrensis* has a diet that includes small mammals, eggs, fish and reptiles.

Far right: 6. A female Coquerel's sifaka, with her infant, feeds on the fruit pods of a silk cotton tree.

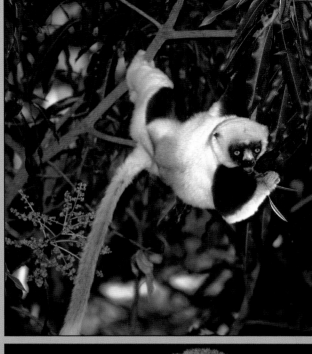

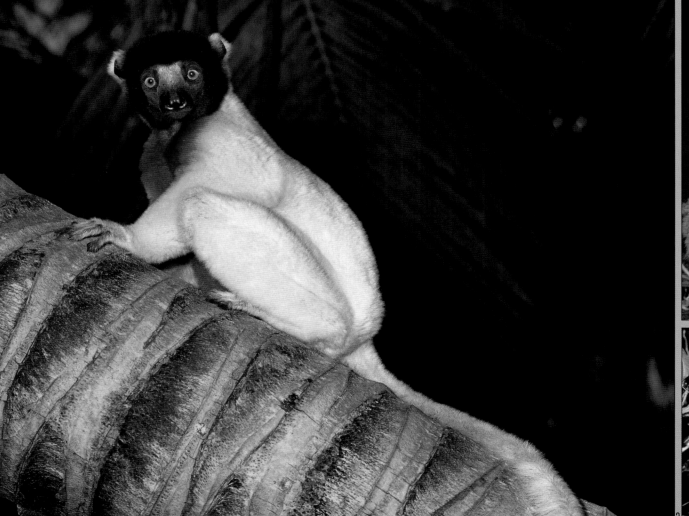

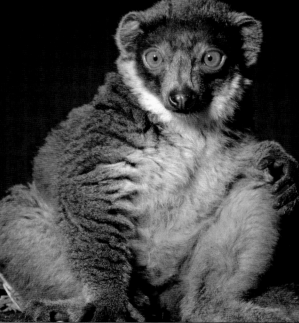

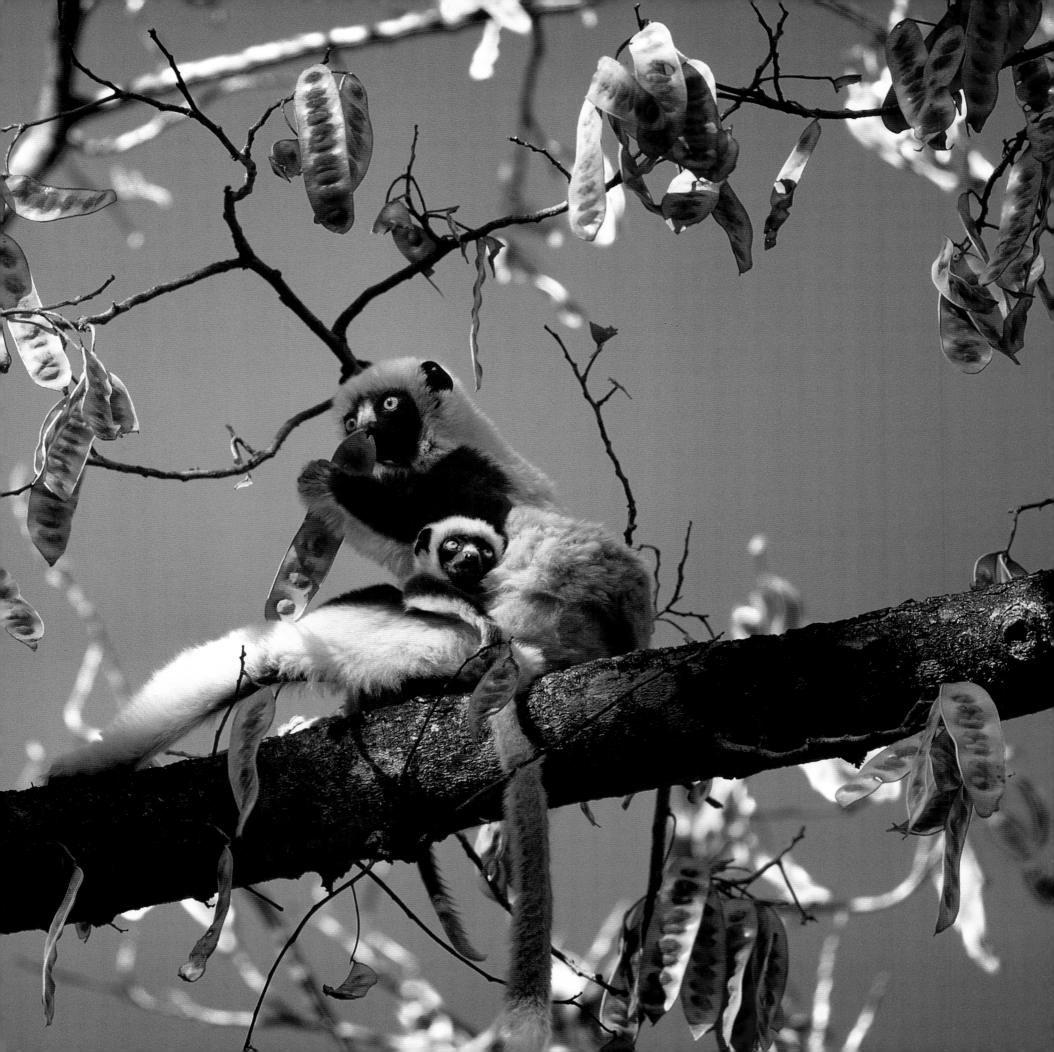

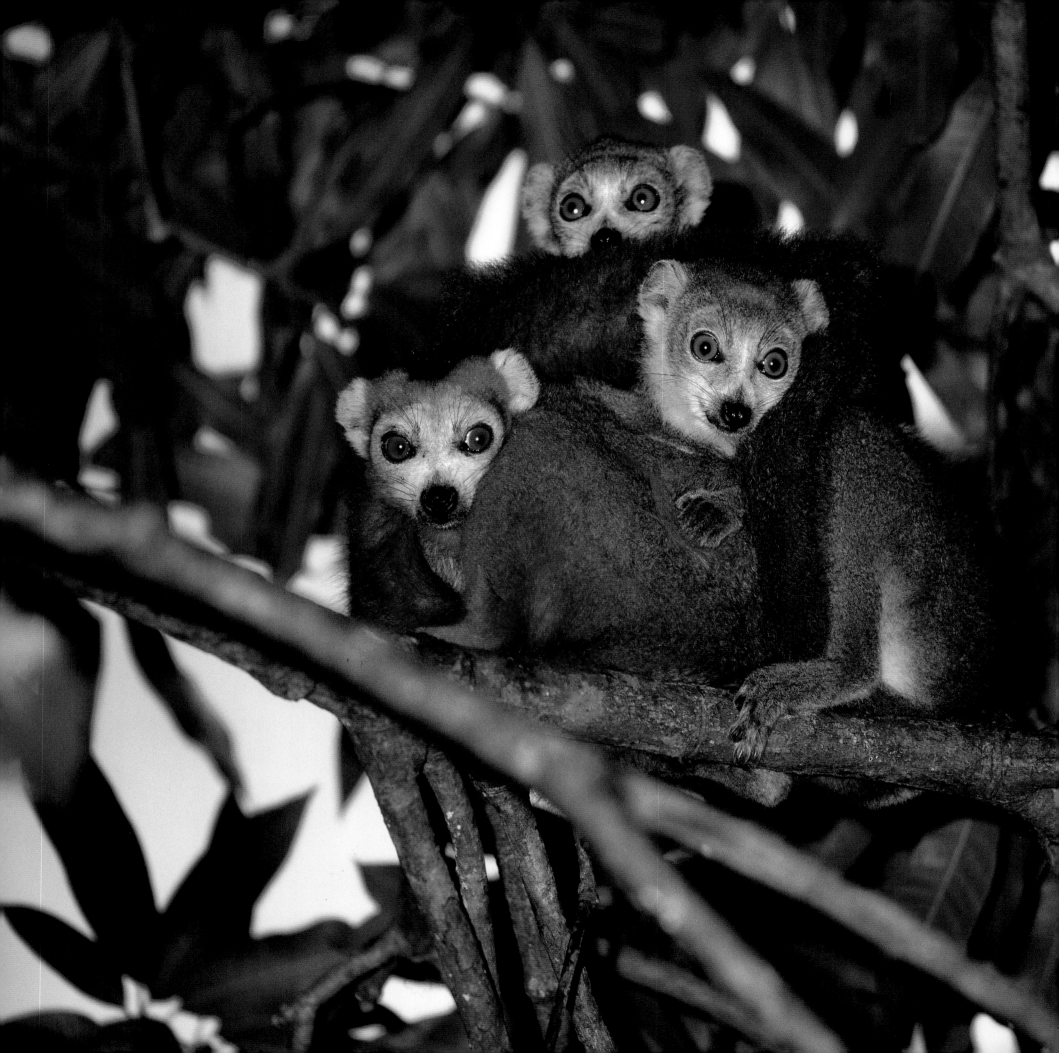

leaves and flower pollen.

2. The endemic Madagascar magpie-robin *Copsychus albospecularis* frequents both dry and moist subtropical and tropical forests.

3. Larva of a Flatidae leaf bug.

4. Fungi on a fallen log.

5. The verdant montane rainforest provides an important habitat for a large variety of flora and fauna.

6. A crowned lemur, with her infant in the forest.

7. The flower head of a bizarre plant *Hildegardia ankaranensis* that is common in the Ankarana massif.

8. The Ankarana Special Reserve covers 182 km² and comprises a rugged limestone plateau on which dry deciduous forest grows. This plateau rises to a dramatic cliff formation in the west up to 280 m high. Erosion has led to an extensive cave system and underground rivers, some of which are inhabited by crocodiles. Sharp karst pinnacles (*tsingy*) interspersed with deep treacherous caverns are a feature of the plateau summit.

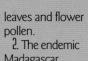

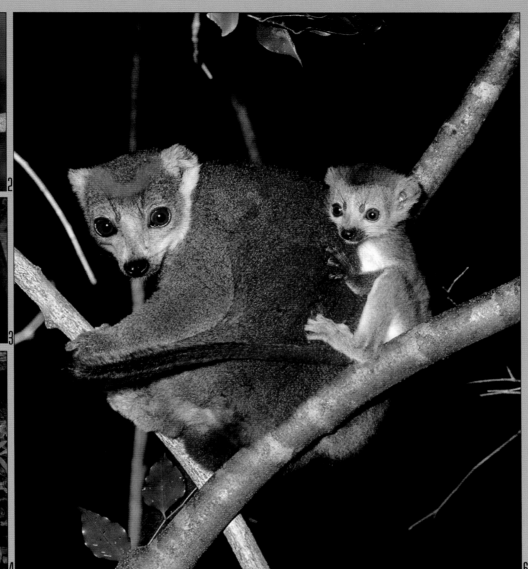

The Montagne d'Ambre National Park in the far north comprises 182 km² of montane rainforest embracing an ancient volcanic massif renowned for its lush forests, crater lakes and scenic waterfalls.

1. A male crowned lemur *Eulemur coronatus* huddles cosily with two female companions on a forest branch in the Montagne d'Ambre National Park. This species is sexually dichromatic with distinctive colour variations between male and female. It can be seen in various regions of northern Madagascar, prefering tropical and dry lowlands, as well as in montane forests up to about 1350 m. These lemurs forage on the ground but are also active in trees, where they feed on fruits,

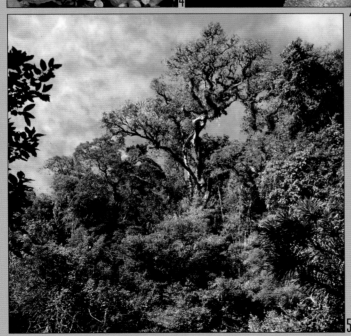

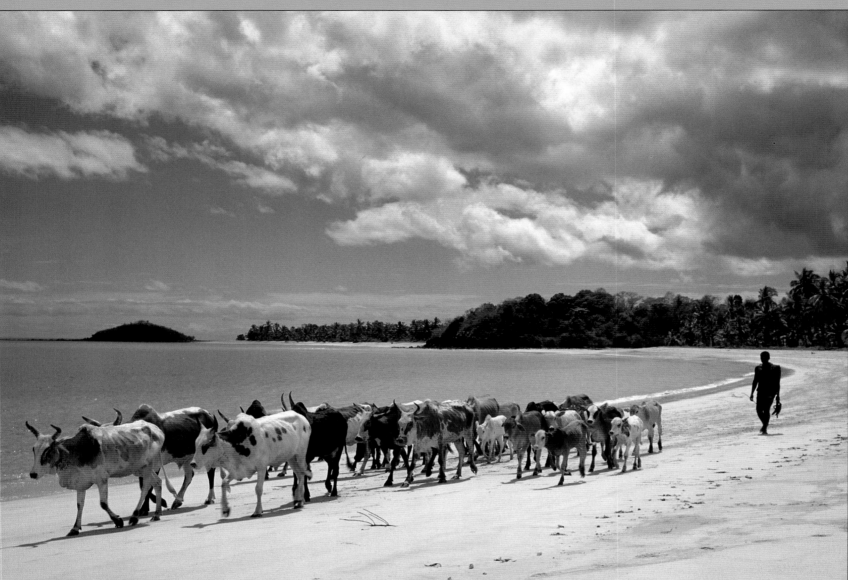

of the traveller's palm *Ravena[la] madagascariensis*.

5. A female black lemur *Eule[mur] macaco macaco* on Nosy Kor[ba]. This is another of Madagascar['s] sexually dimorphic lemurs; m[ales] are black and females a reddis[h] brown.

Living in matriarchal groups [of] about 10 animals, this is an adaptable, mainly fruit-eating species from the north-west.

Right: 6. Nosy Iranja, a sub tropical island with white powdery-sand beaches, sout[h] of Nosy Be. This island is a small but important breeding sanctuary for green and hawksbill turtles.

1. A herdsman drives his Zebu cattle along Andilana beach, Nosy Be.
2. A Sakalava girl pounds away at rice grain in the traditional manner.
3. Two cheerful youngsters on Ambatoloaka beach, Nosy Be.
4. The grey-backed sportive lemur *Lepilemur dorsalis* frequents tropical lowland moist and montane forests, as well as secondary forest growth in the north-west, where it feeds on fruit, bark and leaves. Besides being hunted for food, this lemur suffers the familiar threats of habitat loss from forest clearing and illegal logging. With its predilection for nectar, this small primate is a significant pollinator

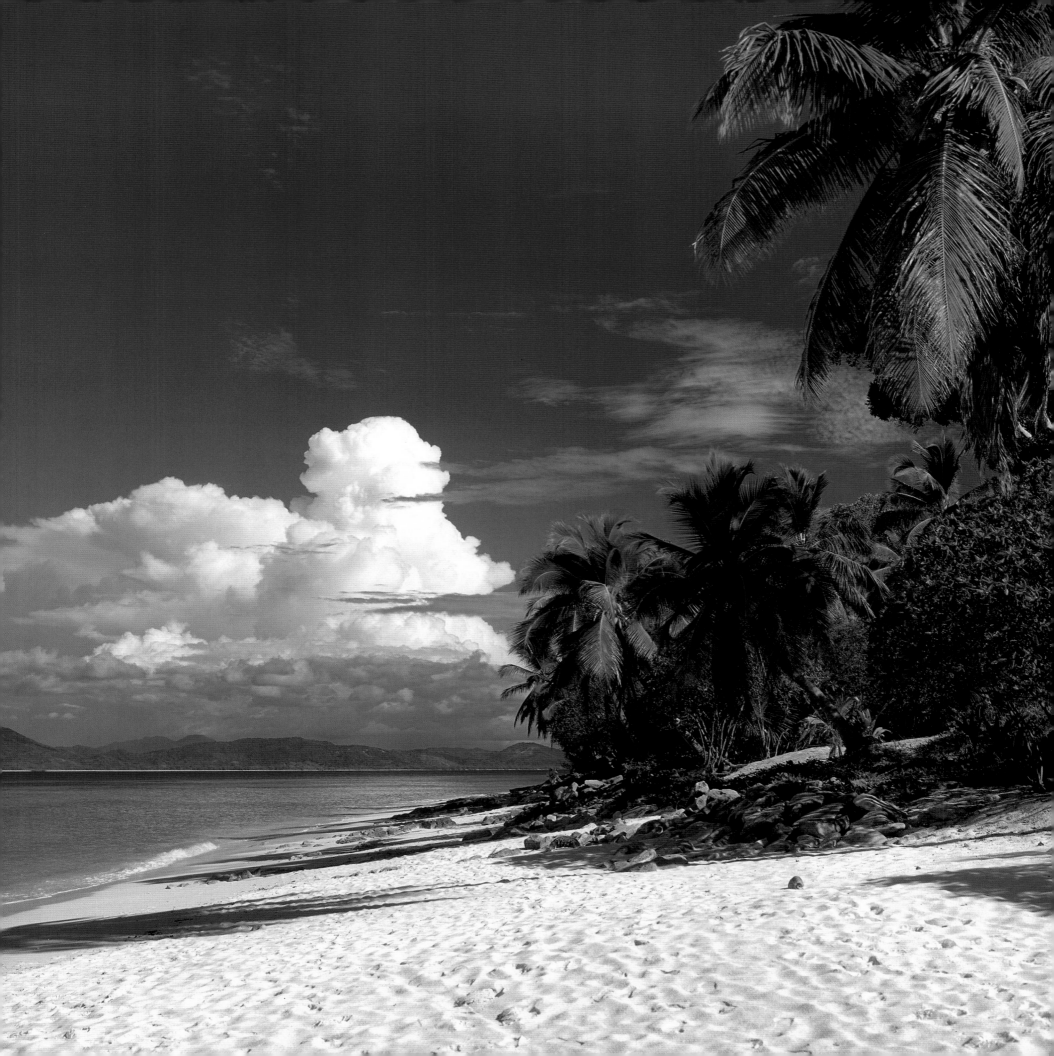

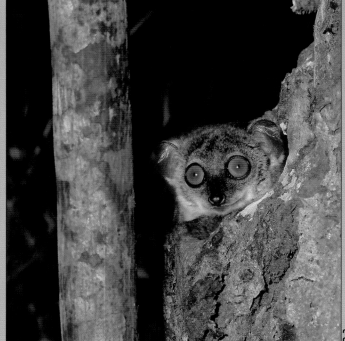

Right: 5. The golden-crowned sifaka *Propithecus tattersalli* is yet another critically endangered lemur with a very limited range. Besides the usual environmental threats to its habitat, it also has to contend with small-scale gold mining activities that scar the deciduous forest with exposed search pits, especially in the Dairana Reserve. Although protected to an extent by its endearing humanlike-

characteristics, it is sometimes hunted for food. The sifaka lives in groups of two to six animals in deciduous forests up to about 700 m, where it feeds, like most sifakas, on unripened fruits, seeds, flowers and leaves.

Overleaf: Veso fishermen at the end of another long day.

1. The critically endangered all-black Perrier's sifaka *Propithecus perrieri* has a very restricted habitat comprising dry and semi-humid forest to an altitude of about 500 m in north-east Madagascar. Here the continued survival of the species is threatened by slash-and-burn agriculture as well as livestock pasturage, tree felling for charcoal and casual mining operations. These sifakas live in small groups of two to six animals and feed on flowers, plant stems, leaves and unripened fruit.

2. A Northern sportive lemur, *Lepilemur septentrionalis,* peers out from its tree hole. It is critically endangered and referred to as one of the world's rarest primates in Dr Russell. A. Mittermeier's *Primates in Peril: The World's 25 most endangered Primates 2008–2010.*
3. The Madagascar Harrier Hawk, *Polyboroides radiatus,* is a widespread endemic raptor.
4. A landscape in the Dairana region of Northern Madagascar shows the extent of soil erosion that prevails over much of the country.

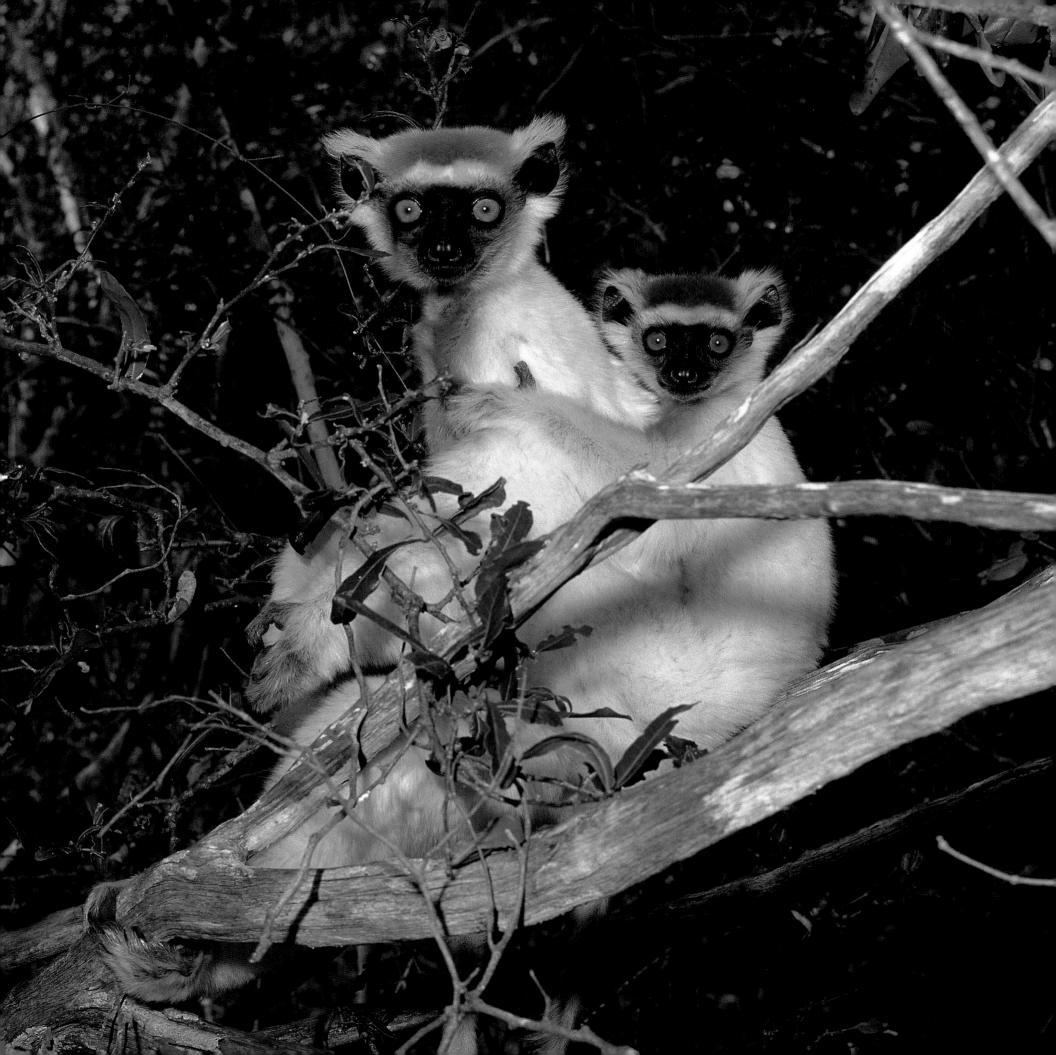

NORTHERN TANZANIA AND KENYA

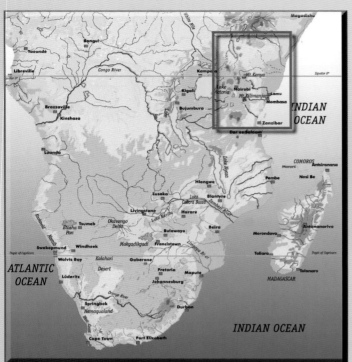

According to palaeoanthropologists, Tanzania and Kenya are regarded as one of the oldest known continuously inhabited areas on earth. Fossil remains of humans and pre-human hominids have been dated back over two million years. More recently the region is believed to have been populated by hunter-gatherer communities, probably Cushitic and Khoisan. About 2000 years ago, Bantu-speaking people began to arrive from western Africa in a series of migrations. Later, Nilotic pastoralists entered the region and slowly continued to do so into the 18 th century.

With a combination of awesome volcanic and grassland scenery, spectacular wildlife and charismatic indigenous tribespeople, northern Tanzania is arguably the greatest safari destination in all Africa. The

A Turkana woman embellished with customary bead necklaces.

north-east showcases the majestic Mount Kilimanjaro, at 5892 m Africa's highest peak, while Lake Victoria is Africa's largest lake.

A Samburu herdsman drives his cattle to fresh pastures.

Tanzania's varied wildlife habitat is exemplified in its many ecologically significant national parks, which include the famed Ngorongoro Crater and Serengeti parks in the north.

The Maasai had been grazing livestock in the great open savanna which they knew as *Serengeti* ('endless plain') for over 2000 years before the first European explorers 'discovered' the location. Here, nearly two million blue wildebeest and other herbivores participate in a vast annual migration to find forage during the dry season.

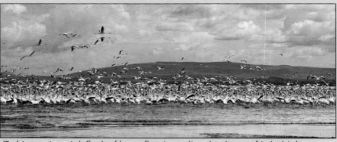

A shimmering pink flock of lesser flamingos line the shores of Lake Nakuru.

The Serengeti, today a UNESCO World Heritage Site, initially gained acclaim from the work of Bernhard Grzimek and his son Michael. In the 1950s they produced the book and film *Serengeti Shall Not Die*, which is widely recognised as one of the most important early pieces of nature conservation documentary. Besides the migration of ungulates, the park is well known for many other resident wildlife species, particularly the 'Big Five' (so-named from the most prized trophies of big-game hunters): elephant, buffalo, rhino, lion and leopard. Some 500 bird

Kenya evokes much mental imagery: the Masai Mara plains where enormous herds of herbivores gather prior to their annual migration to the Serengeti Plains; Karen Blixen's *Out of Africa*, with the film version's haunting theme music, provided enchanting images of the land; *Born Free*, the epic saga of Elsa the lioness, rescued and raised by game warden George Adamson and his wife Joy; perhaps the snow-capped peaks and glaciers of Mount Kenya, Africa's second highest mountain (5199 m), sitting astride the equator. There is also the famous safari lodge 'Treetops', in the Aberdare National Park, which had humble beginnings in 1932 as a two-room log cabin but later grew to fame. Princess Elizabeth and Prince Philip first heard the news of her father's death whilst overnighting. The following day she flew out to become queen of England.

Other-not-to be forgotten images: beautiful palm-fringed tropical beaches and islands off the coastline stretching to the north and south of Mombasa; the great semi-desert wilderness of the region formally known as the NFD (Northern Frontier District); the forested mountain ranges; the beguiling Rift Valley and its lakes; and, of course, the many magnificent national parks and game reserves.

Kenya's many evocative contrasts become immediately apparent from an astronaut's perspective. The south-western border just touches Lake Victoria, then a verdant western belt runs parallel all along this part of the Great Rift Valley right up to Lake Turkana (previously named

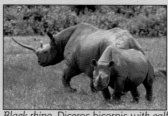

Black rhino Diceros bicornis with calf in the Aberdare National Park

Rudolf by explorer Count Teleki, after his sponsor, the Austrian crown prince). This region features volcanoes, most now extinct, though some are still dormant. Many signs of this turbulent past can be seen in the black lava flows, hot springs and alkaline lakes. Across the Valley, the renowned highlands, watched over by the

Aberdare Range and Mount Kenya with its remnants of glaciers the thick, almost impenetrable rainforests that cover its slopes. area between and around the mountains forms a fertile belt in s contrast to the arid, semi-desert regions of the east and north-Here, the grasslands of the south give way to a parched, barren terrain where the landscape appears almost biblical as nomadic trek interminablly from well to well with their camel herds and c

To the east, striking southwards: a great blue gash, as the Tana R flows down to the coast. But first, the rolling grasslands frequently subject to devastating drought, provide an environment for grazing herds of wild animals as well as human settlement. A broad swee dry thornbush country interspersed with lofty baobabs pans out t hot, humid coastal belt that stretches some 480 km from Tanzania to Somalia in the north.

'Returning to earth': this shoreline stretches like a rhapsody in tranquil white beaches, golden dunes, warm turquoise water, idyllic secluded islands and a trove of archaeological treasures, a steeped in a distinct culture that stretches back centuries. The beaches, often bordered by coastal rainforests with prolific birdli as well as protective reefs, offer calm, inviting waters, sun-filled and gentle sea breezes at night. Four marine national parks and marine national reserves along the coast afford protection to myriads of fish and their habitat – the ecologically fragile coral r

The coast features many significant settlements.Mombasa, th island town and Kenya's oldest, dates back as far as 500 BC. Th harbour here has always been a point of entry and a life-line to land-locked interior and was for centuries a key staging post for the slave trade before the British finally abolished it in 1904. Mombasa bears the distinction of possessing Africa's oldest fort, Fort Jesus, built in the 16th century by Portuguese explorers.

Mombasa became the new gateway to Africa (known in the Victorian era as the 'dark continent'). Now the continent's mysteries and intrigues could be unravelled and more fully explored.

Originally, this coast hosted communities of ironworkers, subsistence farmers, hunters and fishermen who supported

Grant's gazelle Nanger granti in the Meru National Park.

the economy with their wares. They traded with foreign lands u around the sixth to ninth centuries when the region switched to maritime economy and began to specialise in shipbuilding.

In the centuries preceding colonisation, (in the late 19th cent the Swahili coast traded with the Arab world and India, most significantly for ivory and slaves. Initially traders came mostly fro Arab states, and later also from Zanzibar island. Close to 90% c coastal population came to live under conditions of enslavemen

Malindi, to the north, is another of the older settlements. Chi porcelain has been found here dating back as far as the ninth ce conveyed in ships from the Persian Gulf, Arabia, India and China These returned home with cargoes of ivory, mangrove poles, leo skins–and slaves from the interior. In the early 15th century, dur China's Ming Dynasty, the explorer Zheng He and his fleet called Malindi. A giraffe was subsequently transported back to the Chi Emperor as an exotic gift. Vasco da Gama, the Portuguese explo visited the town in 1498 and was welcomed by the friendly rule who revictualled his ships and, most importantly, provided him a pilot/navigator for his onward journey. In modern times, Malin put Kenya on the world holiday map. Europeans were looking fo

holidays as well as safaris, with its relaxed ambience, beautiful
...es, deep-sea fishing and snorkelling, Malindi fitted the bill
...tly, complementing the inland wildlife safaris.

Still further north Lamu a town, an island and an archipelago. In the 11th century, as dhows sailed along the East African coast onwards to Arabia, Persia and India, Lamu was already known as an important trading centre. The archipelago absorbed an expanding population and a distinct Afro-Arab identity emerged. This was the birthplace of the Swahili culture.

...ashua craft is used inshore for
... transport, as well as offshore
...ing.

On Lamu's beautiful 12 km, empty sands face an ocean unprotected by a reef, in sharp ...ast to the town, crowded with houses and people, the streets ...rrow that you can shake hands with a neighbour in the house ...site. Lamu with its welcoming Swahili population conveys an ...orldly experience of being transported back through time into ...ways, lined on each side with shops and workshops—often no ...than a single room— where carpenters, herbalists, jewellers and ...rs go about their daily business At its narrowest, Lamu is ...ated from the mainland by a channel just a few metres wide.

...ween the coast and the plateau, halfway between Nairobi and ...basa, lies **Tsavo**, one of the world's largest game parks, ...ing 20 812 km². It was gazetted in 1948 as Kenya's second ...nal park. The Tsavo River, which flows west to east through the ...nal park, provided the name. The park is divided into two ...ons: Tsavo East, comprising the larger and more arid section, ...savo West, which consists of semi-arid grasslands and savanna. ...early as 700 AD, Swahili merchants traded with the inhabitants ...vo for ivory, wild cat skins—and almost certainly slaves.

...ing the building of the Mombasa—Uganda railway line, legend ...that man-eating lions terrorised the construction crews. ...ern scholarship, however, attributes, in addition, the kidnapping ...illing of Indian and British labourers to the local Waata in an ...ipt to stop the unwanted intrusion into their territory. John ... Patterson in his book *Man-eaters of Tsavo* (1907) recounts ...wn experiences while overseeing the construction of a railroad ...e. The book vividly recalls the story of a pair of lions known as ...savo man-eaters' that he eventually killed.

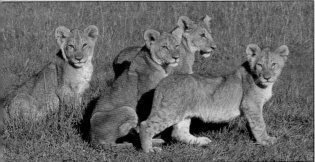

...ubs in the Masai Mara grasslands

...remained the homeland for Orma and Maasai pastoralists as ...s Waata hunter-gatherers until 1948, when it was designated ...ional park. The indigenous populations were relocated. ...ving independence in 1963, hunting was banned and ...gement was turned over to what eventually became the ...a Wildlife Service.

...ly two permanent rivers course through this vast area: the ..., which begins life on Mount Kilimanjaro to be supplemented ...huge underground river flowing from Mzima Springs; and the ...n Tsavo East with its source close to Nairobi. The Mzima ...gs are replenished daily with 220 million litres of crystal-clear ...r providing a haven in Tsavo for a rich pageant of wildlife that

includes hippos and crocodiles.

Amboseli, close to Tsavo, lies beneath the scenic slopes of Mount Kilimanjaro on the border with Tanzania. After the Masai Mara National Reserve, it is the second most popular wildlife destination in Kenya, renowned for being the best place in Africa to get close to free-ranging large-tusked elephants. It offers spectacular views of Kilimanjaro, the highest free-standing mountain in the world.

The capital, Nairobi, inland on the plateau, is situated at 1795 m and is one of the world's 'mile-high' cities.

Following the founding in 1888 of the Imperial British East Africa Company, rivalry in the region between Germany and Britain was effectively forestalled when Germany handed its coastal holdings to Britain in 1890. The construction of the Uganda railway ensured a significant inflow of Indian peoples, brought in from the subcontinent to provide the bulk of the skilled manpower that was needed. The

Mount Kenya at dawn, enshrouded in morning mist and clouds.

city's founding was, however, curiously coincidental: the area selected was essentially an uninhabited swamp, until a supply depot of the railway was built in 1899, which became the railway's headquarters.

Named from a waterhole known to the Maasai as 'Ewaso Nyirobi', meaning 'cool waters', the camp was located beside the Nairobi River, with a network of streams that could supply it with water, and with an elevation cool enough for comfortable residential settlement. The city rapidly grew around administration and tourism - initially the intrepid big game hunters. British colonialists and travellers started to explore the region and Nairobi served as a convenient base. The colonial government was prompted to build several grand hotels in the city. The renowned Muthaiga Country Club, which flourishes to this day, opened on New Year's Eve in 1913, and became a gathering place for the elite society of British East Africa.

Nairobi replaced Mombasa in prominence and became: the capital first of British East Africa in 1907 then of the colony of Kenya in 1920 and finally of the Republic of Kenya in 1963.

During the early part of the 20th century, the interior central highlands were settled by British and other European farmers who attained wealth and success farming tea, coffee, sisal, pyrethrum, corn and wheat, as well as horticultural products which flourished in these fertile soils. Today, agriculture has become the second l argest contributor (after tourism) to Kenya's gross domestic product.

The region was already home to over a million members of the Kikuyu tribe, most of whom had no land claims in European terms and lived as itinerant subsistence farmers on their productive

shambas. This eventually induced a massive exodus to the cities as the ability to provide a living from the land dwindled.

To Nairobi's north lies the heavily forested **Aberdare** range and to the west, the Great Rift Valley with a string of lakes stretching from Lake Naivasha (from the local Maasai word *Naiposha* 'rough water') to the soda lakes Elmenteita and Nakuru (dusty place), famed for their vast flamingo population, thence to Bogoria, renowned for its hot springs and geysers. Further northwards,s Lake Baringo, a freshwater lake with picturesque islands supporting a multitude of hippos and crocodiles as well as over 450 of Kenya's 1200 recorded bird species. Finally, in the far north over and beyond the knife-edge Losiolo ('World's End') Escarpment lies Lake Turkana.

In the vast regions of the north and east, which comprise two-thirds of Kenya's total area, nomadic pastoralists survive difficult and sparse living conditions in an environment of drought-prone savanna and semi-desert.

Adjacent to the coastal plains, in the lower-lying regions, coconuts, pineapples, cashew nuts, cotton, sugarcane, sisal and corn are all widely grown as commercial crops.

Although Kenya's physical geography supports an abundance of wildlife, there exist major environmental issues of concern, notably deforestation, soil erosion, desertification, habitat loss, poaching and the general effects of overpopulation.

Forestry output has declined due to resource degradation. Over the past three decades overexploitation has reduced the country's timber resources by 50%. At present only 2% of the land remains forested. An estimated 50 km² of forest are lost each year. This aggravates erosion, silting of dams, flooding, and loss of biodiversity. Kakamega Forest, Mau Forest and the Karura Forest are among the most endangered.

In response to ecological disruption, activists in recent years have pressed with some success for policies that encourage sustainable resource use. The 2004 Nobel Peace Prize went to the Kenyan environmentalist, Wangari Maathai, who founded the Green Belt Movement. She is best known for mobilising thousands of people over the years to plant 30 million trees in Kenya, and for protesting forest clearance for luxury development. In frequent conflict with the then President Moi, she was briefly imprisoned on several occasions. Maathai linked deforestation with the plight of rural women, who are forced to spend untold hours in search of scarce firewood and water.

Current issues include water pollution from urban and industrial waste, most noticeably along the coast. Water quality in the coastal and marine environments is under increasing pressure from land-and sea-based sources of pollution. Land-derived agrochemical, municipal waste and sea-based petroleum waste are major causes of pollution. Fertiliser and pesticide residues from agricultural inputs in the interior enter main drainage systems and are washed into the sea where they have a cumulative adverse effect on the marine and coastal environment.

Of the world's seven known marine turtles, five are found in Kenya and three, the green, hawksbill and olive ridley, nest within the country's borders. Trade in turtle eggs has been a source of income for many fishing communities not only along the Kenyan coast but throughout the entire Indian Ocean region. Kenya's coral reef fish are today at risk due to export for display in marine aquariums worldwide. Certain species are over-exploited, resulting in changes in population dynamics and thereby the destruction of already vulnerable coral reef habitats.

Kenya indeed shares many of the problems faced by modern Africa, yet the country is richly blessed with an astonishing variety of landscape and natural splendours, as well as a magnificent heritage of wildlife, national parks and reserves—and a welcoming and friendly people from a rich and colourful diversity of ethnic origins.

The European Roller Coracias garrulus a common migrant visitor.

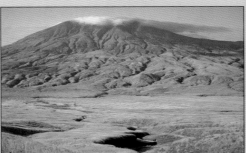

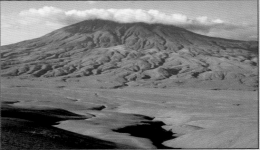

Before and after views to Mount Keramasi showing the extent of the lava dust fallout after an eruption of Ol Doinyo Lengai.

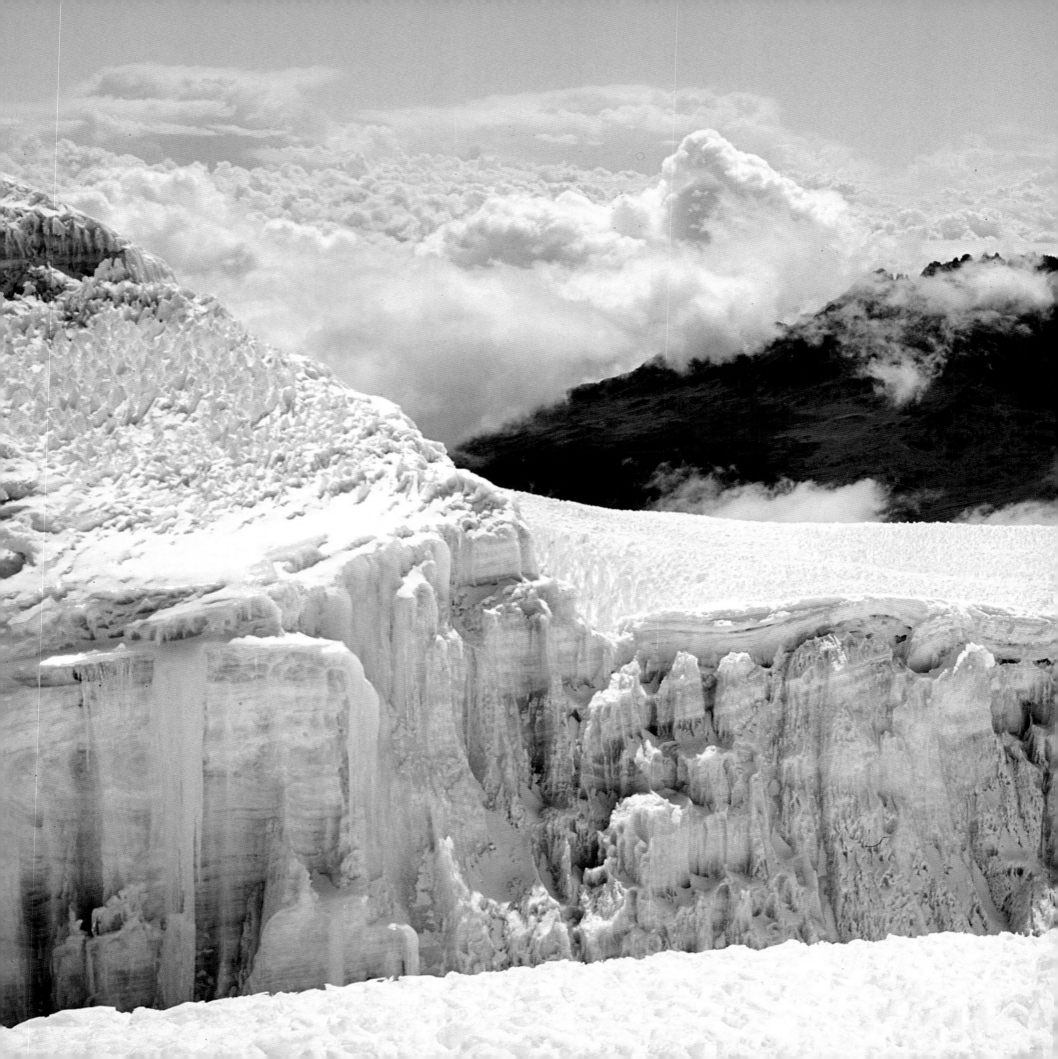

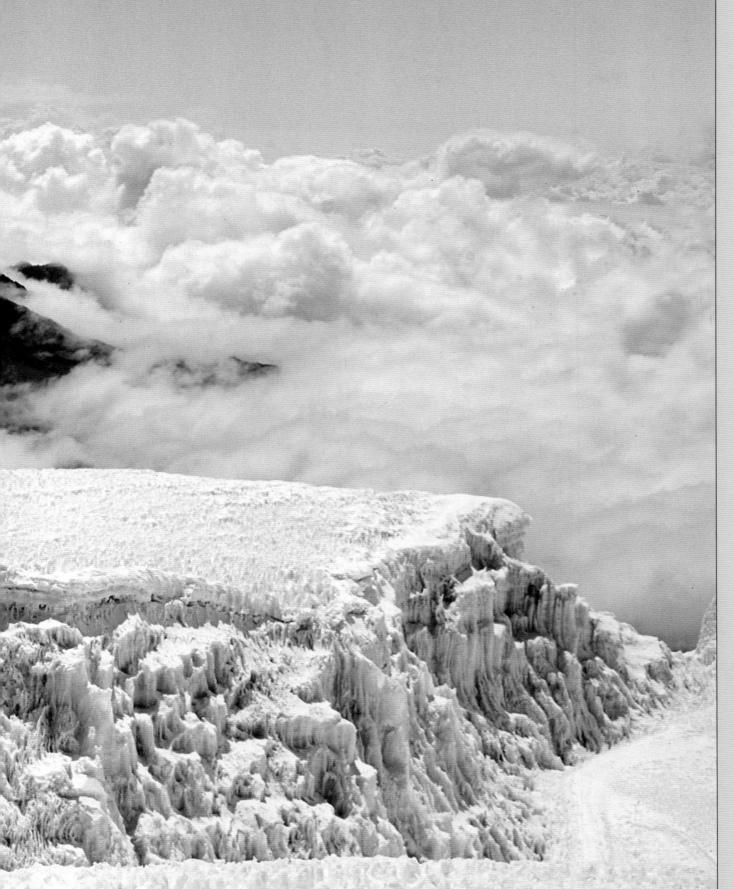

The way it was...
The 5149 m Mawenzi peak, one of the three volcanic cones of Mount Kilimanjaro, viewed from the icy crater rim of Kilimanjaro prior to the devastating effects of global warming in recent decades.

When observing Africa's highest mountain, Mount Kilimanjaro, it is hard to believe that what is seen in these images is today almost gone. The dramatic consequences of global warming have had enormous impact. The ice fields have lost 82% of their ice since 1912, the year their full extent was first measured. If current climatic conditions persist, the legendary glaciers icing the peaks of Africa's highest summit for nearly 12000 years could be gone entirely by 2020.

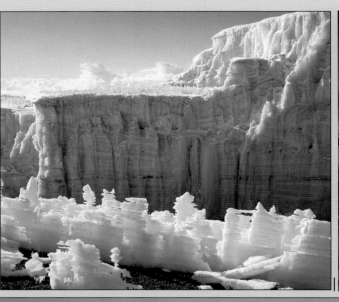

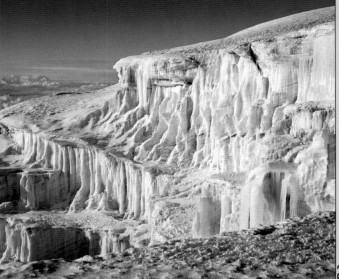

In 2003, as quoted in the *National Geographic Adventure Magazine,* Andrea Minarcek wrote: "Last January, Vince Keipper realized a long-time goal when he trekked to the top of Mount Kilimanjaro. But the view from Africa's rooftop had compared to what he saw on the way up the mountain's Western Breach. 'The sound brought our group to a stop,' Keipper recalled. 'We turned around to see the ice mass collapse with a roar. A section of the glacier crumbled in the middle, and chunks of ice as big as rooms spilled out on the crater floor.' Keipper grabbed his camera j

in time to capture a section of Kilimanjaro's massive Furtwängler Glacier spilling on the same trail his group had ascended the very night befor

1 & 2 Weathered ice formation along the crater rim of the volcano in the mid-1960s.
3. Mount Kilimanjaro viewed from the Momella lakes in the Arusha National Park.
4. *Protea kilimandscharica,* a Mount Kilimanjaro endemic in the heath moorland at about 3200 m.

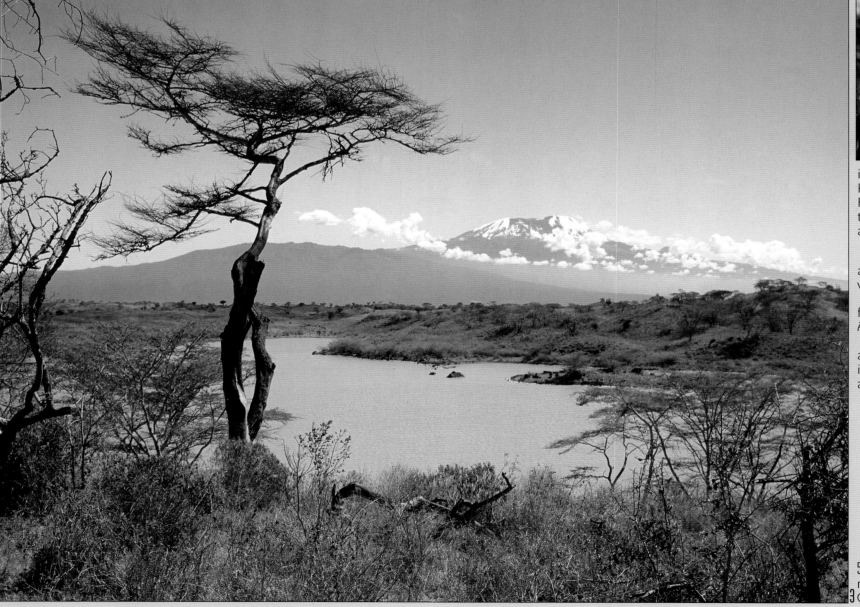

5. *Right:* The ice-covered crater rim of Mount Kilimanjaro from Gilman's Point (at 5685 m)

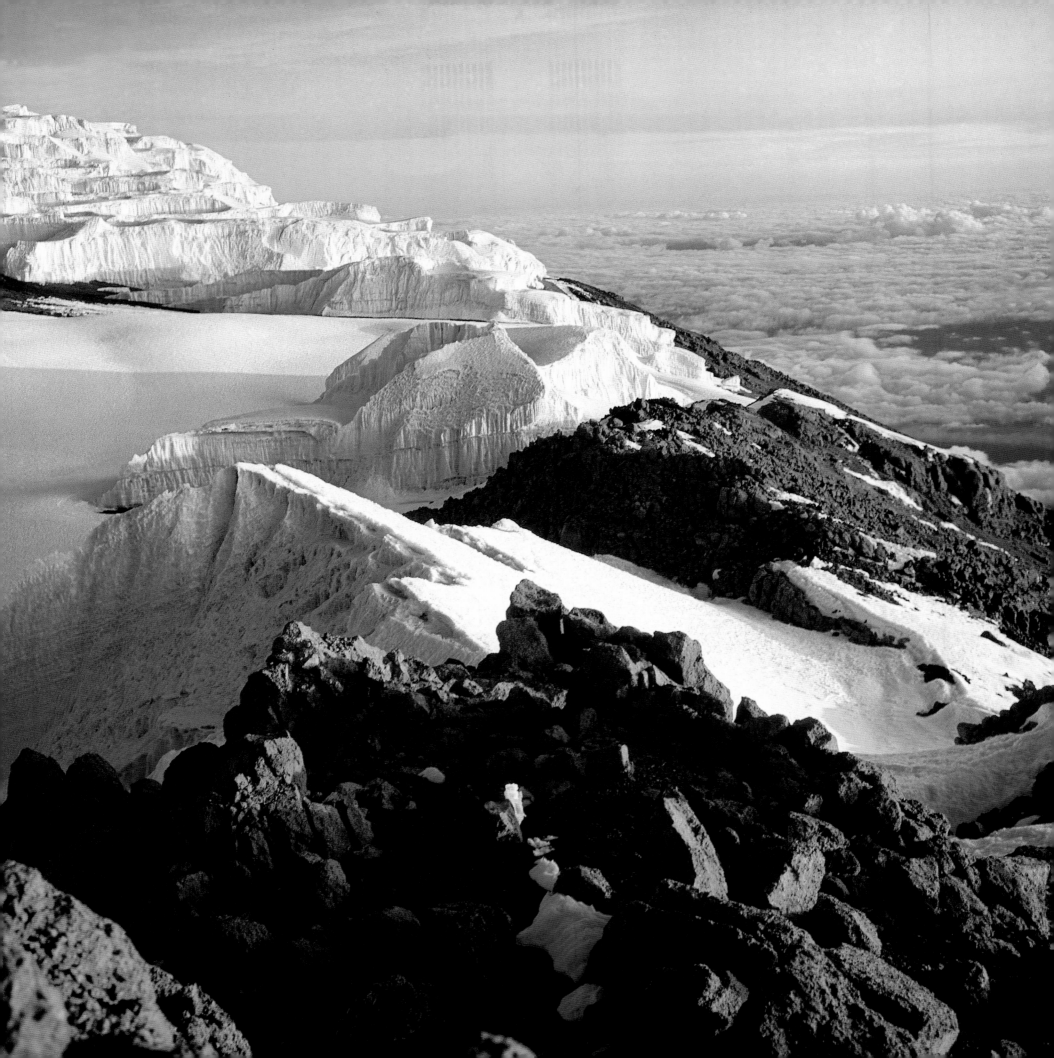

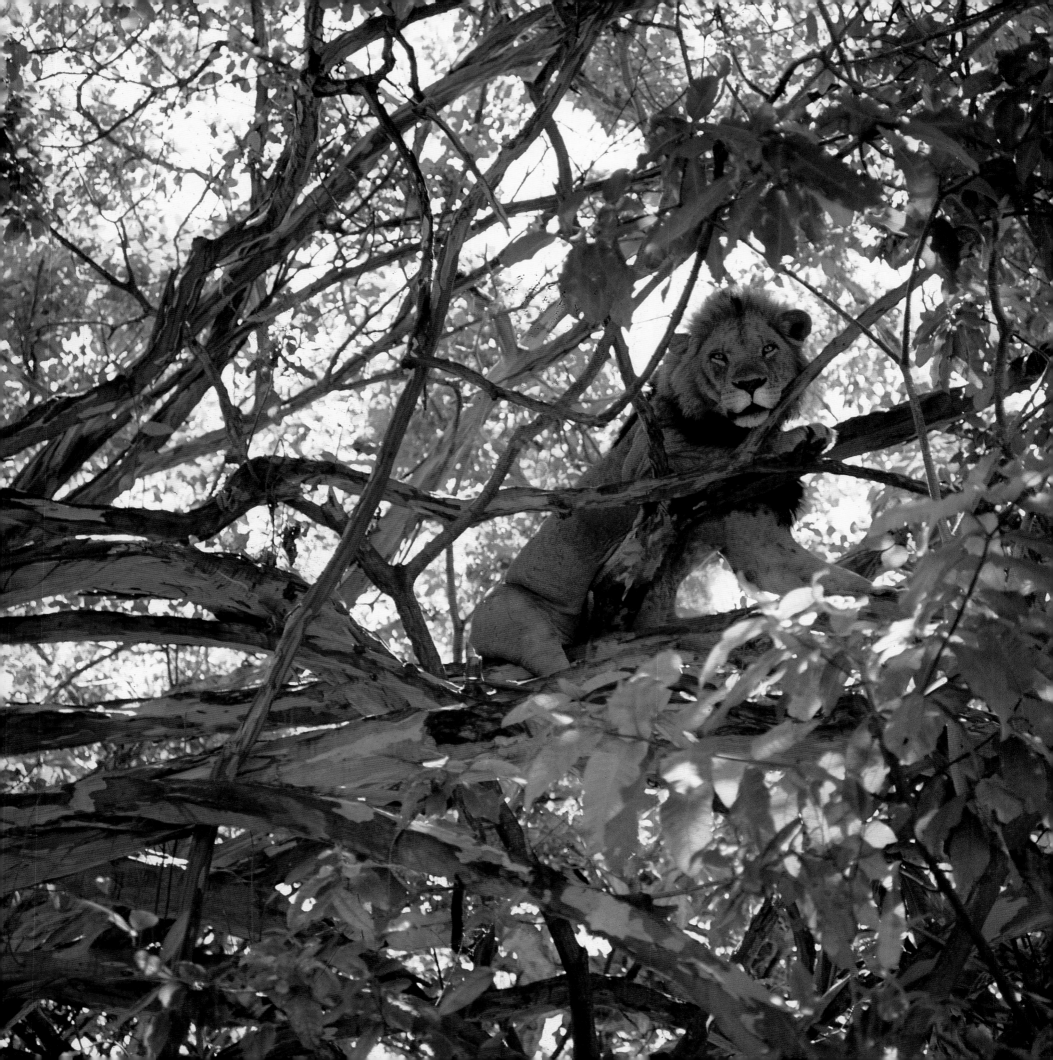

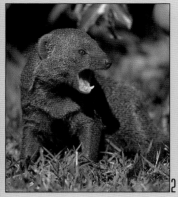

Left: 1. A lion *Panthera leo* reclines up a tree in the Lake Manyara National Park. This unusual behaviour is possibly an evasive tactic to avoid ground ticks.

2. The dwarf mongoose *Helogale parvula* is a small carnivore common in the African bush, savanna and open forest up to 2000 m. It favours termites in its diet, and is often seen in the vicinity of termite mounds. Other food sources include insects, grubs and larvae, small amphibians, reptiles, birds and their eggs, fruits and berries.

Sociable by nature, the mongoose lives in packs of up to 50 individuals, occupying warrens. The animals are very noisy, communicating with a wide variety of sounds. When threatened, they growl and spit in similar fashion to a domestic cat. Being diurnal, they prefer sunny spots during the day but retire to warrens, rock crevices, hollow trees and abandoned anthills at night.

Northern Tanzania is renowned for its magnificent national parks, abundant wildlife, the Masai grassland plains and the Great Rift Valley, where volcanic activity still shapes the landscape, in some places with dramatic effect.

3. The serval cat *Leptailurus serval hindei* favours lush grasslands and reed bed areas near a source of fresh water. Mainly nocturnal, it is active in the late afternoon and at night, when it feeds on rodents, reptiles, amphibians and insects. It sometimes catches birds in mid-flight by leaping into the air.

4. Usually found basking in the sun on a favourite rocky perch, the rock hyrax (dassie) *Procavia capensis* is a widely distributed species in habitats ranging from dry savanna grasslands to thick forest and even afromontane heathland. The animals live in colonies of up to 50 individuals.

Ever wary of marauding predators, especially raptors, they forage in the early and late hours of the day. The dassies' diet comprises grasses, leaves, fruit, lizards and birds' eggs. They can survive for long periods without water.

5. Dung beetles, also known as scarab beetles, feed exclusively on fæces. Here a ball of dung is rolled across the ground in a straight line to be buried where the ground is soft. It will be used for food storage or as a brooding ball.

6. Yellow-collared lovebirds *Agapornis personata* frequent open grasslands and woodland in northern Tanzania.

7. The red-billed hornbill *Tockus erythrorhynchus* has a wide distribution in east and southern Africa. Like the yellow-billed hornbill it feeds mainly on the ground. Outside the breeding season it forms flocks.

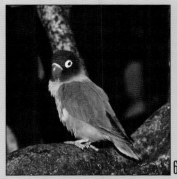

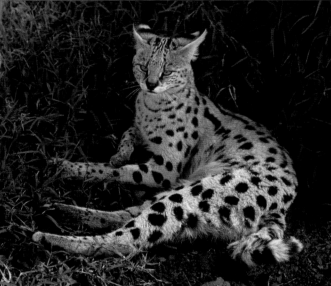

Ol Doinyo Lengai (2882 m), the Maasai 'Mountain of God', is part of the East African volcanic system in the Great Rift Valley. Intermittently active, it is geologically unique. Whereas most volcanoes produce red silicate lava, Ol Doinyo Lengai initially produces a black carbonate lava, rich in sodium and potassium carbonates, inyererite and gregoriyite. This mixture is chemically unstable and within 48 hours of contact with moisture in the air, it is converted to a fine white powder comprising crystals of sodium carbonate commonly known as washing soda. This eventually weathers away.

1. The crater a few days before a major eruption in September 1966, showing bubbling fumaroles and cones.

2 & 4. Gerald Cubitt, at the crater's summit during the eruption, describes the momentous scene: "Standing at the dust-coated crater rim, I viewed in awe the massive column of ash rising 8,000m into the clear blue sky. Huge blocks of lava, the size of small shipping containers, were emitted from the volcanic depths, only to fall back within seconds into the cauldron with a resounding crash like cannon fire. Every few minutes bolts of lightning streaked through the spiral of ash, thence to circuit the crater rim with an alarming crackling sound. Each time as it raced around the rim I flung myself to the ground. Fortunately the strong prevailing wind steered the fall of the massive lava boulders towards the opposite side of the crater, and I was unharmed."

3. A year later the surrounding countryside (here showing Mount Keramasi in the background) illustrates the devastating effect of the eruption.

5 & 6. Views of the erupting volcano from the Masai plains.

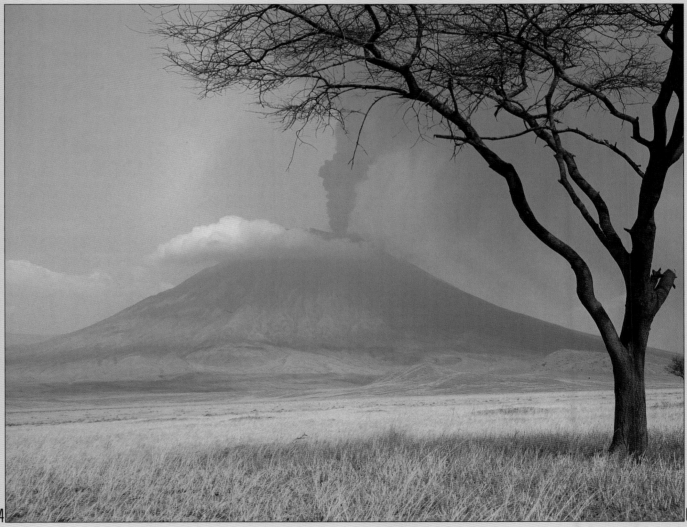

4

5

6

...ually found in pairs, Kirk's dik-dik *Madoqua kirki* (here a male) ...common species in open grasslands, a preferred habitat where ...e is good all-round visibility to watch for predators.

...A warthog *Phacochoerus africanus* with attendant red-billed ...cker, stands his ground.

...After bathing, an elephant will often 'dust' its skin with dry soil ...ud to alleviate the irritation of biting insects.

...Dusk in the Tsavo East National Park silhouettes the branches of an acacia tree filled with weavers' nests.

5. Led by the matriarch, an elephant herd moves across sparse grasslands in Amboseli National Park.

As they travel, the matriarch shows each member of the herd all the water sources she is familiar with. These will be memorised for the future. Relations among members of the herd are close: for instance, when a baby is born, all members acknowledge the new addition by touching it with the trunk; and when an old elephant dies, the rest of the herd will stay for a while 'mourning' beside the corpse.

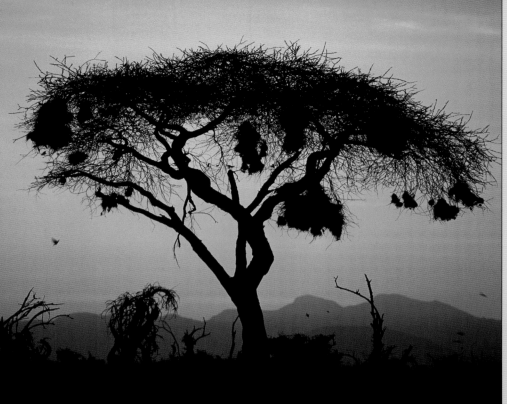

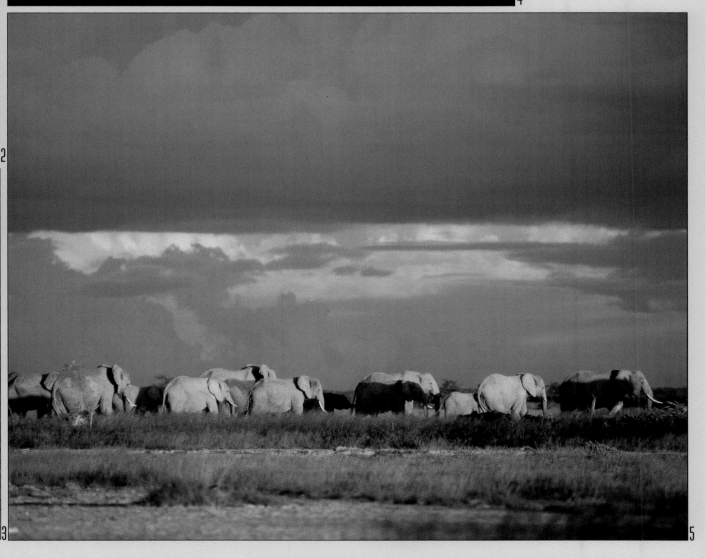

KENYA

1. Superb starling *Spreo superbus* common residents in thornbush and acacia bush.

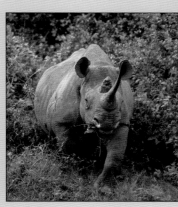

2. A striking male common waterbuck, *Kobus ellipsiprymnus* scans his surrounds on Crescent Island, Lake Naivasha. These large antelopes have coats of reddish brown which become progressively darker with age. They live in wide, separated ranges which are shared by many females as well as territorial and non-territorial males. The size of the home range depends on the quality of habitat, the population size and the fitness and age of the animals.

3. A black rhino *Diceros bicornis* emerges from thick bush in the Aberdare Salient. This species has a long pointed and prehensile upper lip which it uses whilst browsing to grasp leaves and twigs. Although referred to as 'black', it is more of a grey/brown/white colour.

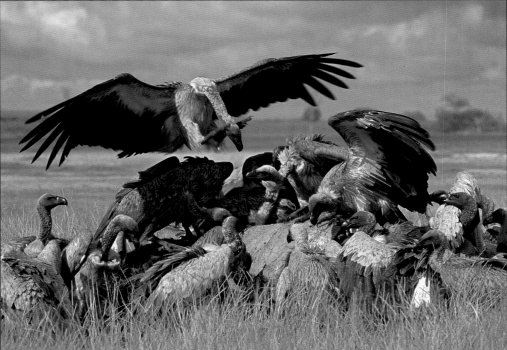

measures the population is slowly increasing in some regions.

4. Rüppell's griffon vultures *Gyps rueppellii* scavenge a lion's buffalo kill in Amboseli National Park. These raptors use sharp talons and beaks to rip apart the carcase. Sociable birds living in colonies of up to 100 pairs, they are the most common vultures seen in Kenya. Unlike some vultures, this species does not supplement its diet with living prey.

The Rüppell's vulture holds record as the highest-flying b One was recorded sucked into the engine of a passing jet at astonishing 11300 m in West Africa.

5. The Pyjama lily *Crinum kir* is an East African member of Amaryllidaceae family (here in the Loita Hills), that sends up striking candy-striped flowers each summer. The plant is so eye-catching that it was once to mark boundaries in the Afr grassland.

6. A lion and lioness relax at vantage point on a termite me in the Maasai Mara grassland

7. A bongo *Tragelaphus eury* drinks at night at a waterhole the Aberdare National Park. S populations of these antelope reside in the montane highlar forest and bamboo zone of Ke Bongos are the largest and mc colourful of African forest antelopes, and the only ones form herds. They are grazers a well as browsers. Both sexes have horns

The Aberdare National Park. stretches over the higher regic of the Aberdare mountain rar of central Kenya. Its topograp varies according to altitude, v ranges from 2100 m to 4300

Habitats range from grasslands to semi-desert and include forested regions, especially where grasslands and forests blend.
Black rhinos lead a sedentary lifestyle and remain more or less in one general area. Their status is listed as: Critically Endangered, but with effective conservation

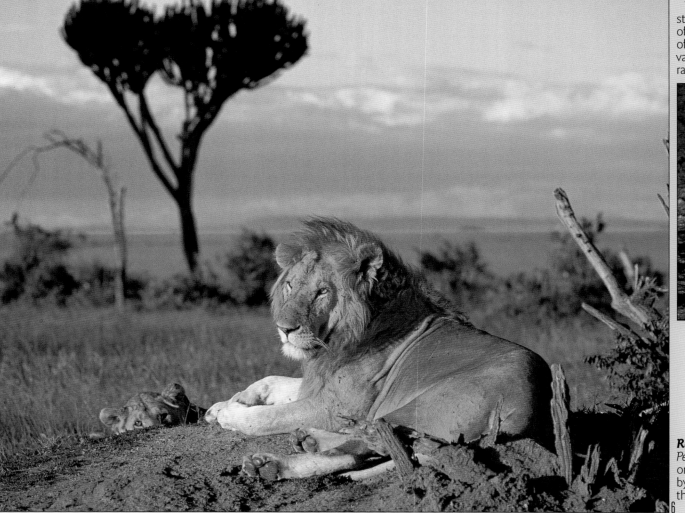

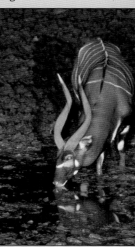
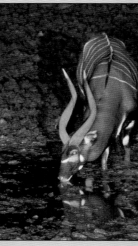

Right: 8. Pink-backed pelicans *Pelecanus rufescens* roost at su on the skeletal remains of a tr by the shores of Lake Naivash the Rift Valley.

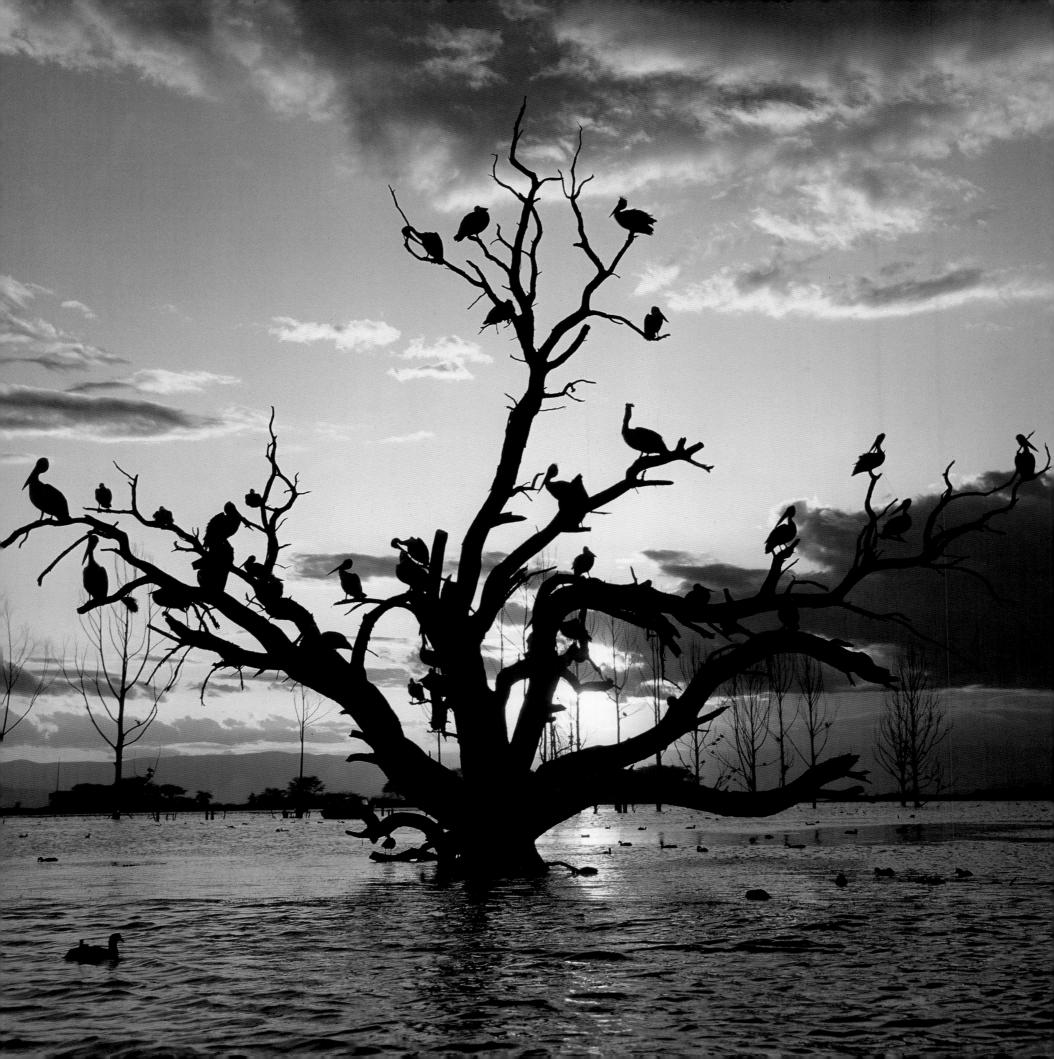

k, paints the scene gold and
n as Luo fishermen
fully fish for Nile perch in
Kendu Bay, Lake Victoria.
The Luo are Kenya's
third largest ethnic
group. Historians
believe that they and
other Kenyan Nilotic
tribes originated from
the Nile regions of
n. They are among the few
that do not practise male
ncision as an initiation to
ood. Instead Luo tradition
ves the removal of six front
, three each from the upper
ower jaws.
like in other tribes, Luo
ty was not disrupted by the
l of white Europeans. Luos
nowned for their
oyant character and sense of
as well as their polished and
ent command of the English
age. The late father of Barack
na, president of the United
s, was from this ethnic group.
e perch *Lates niloticus* were
duced to Lake Victoria in the
s. Although it has proved to
commercially viable and
rtant food source, the
es has had a devastating

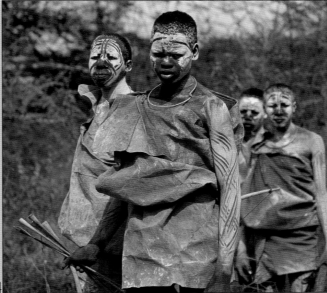

three white eggs are laid. Their diet
consists of fish and amphibians
which are usually obtained by
group fishing. Chicks feed by
plunging their heads deep into the
adult's pouch to remove
regurgitated, partially digested fish.
4. A traditional Luo settlement of
thatched dwellings.
5. Nandi boys in circumcision
paint. This widely practised African
tradition symbolises the coming of
age and is performed for both sexes.
The Nandi, once formidable
warriors, form a sub-group of the
Kalenjins, one of Kenya's largest
tribes. They are sedentary cattle-
herders and agriculturists
inhabiting the western borders of
the Great Rift Valley.
6. Luo fishermen, in a painted sail
boat, glide across the calm waters
of Lake Victoria, Africa's largest lake
at 68 800 km².

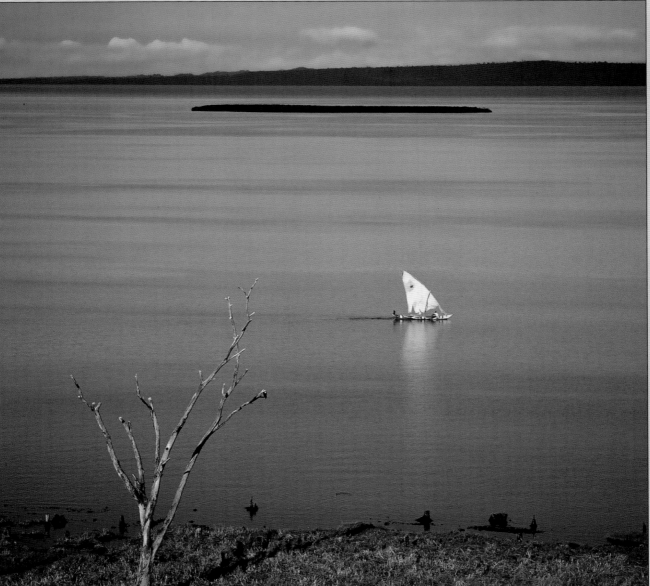

The blood lily *Haemanthus multi-
florus* is a toxic plant reputed to
contain a cardiac glycoside that
causes cardiac irregularity and
sudden death.

: on the indigenous fish,
of which have been
ght to or near extinction by
ntroduction of this non-
e species.
oss's turaco *Musophaga
e* is a brilliantly crested bird
frequents forests of different
s in western Tanzania and
a.
ink-backed pelicans
anus rufescens are large birds
pouched bills and long wings
ning up to 2.4 m. Resident
ers in Africa and southern
ia, they construct platform
s of sticks in which two or

8. Thomson's gazelle *Eudorcas
thomsonii* in lush grasslands.

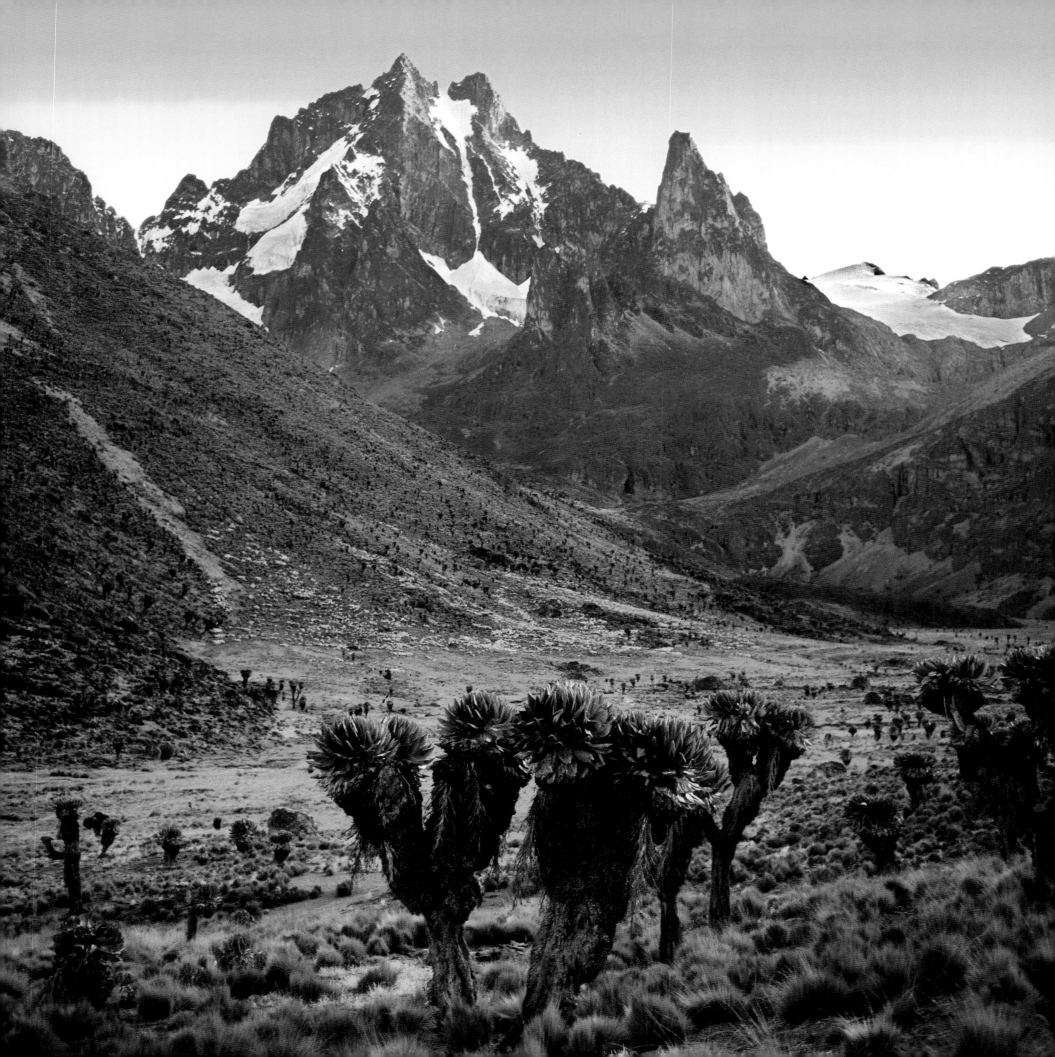

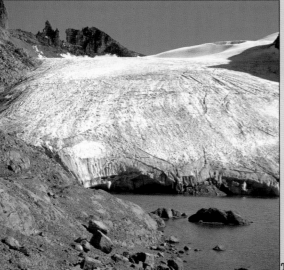

Left: 1. View to the peaks of Mount Kenya from Teleki's Valley (3962m) in the afro-alpine zone. This shows the two highest peaks on the mountain, Batian (5199 m) and Nelion (5188 m). Mount Kenya, on the equator, is an extinct volcano and Africa's second highest mountain after Mount Kilimanjaro.

The mountain can be divided into eight distinct vegetation bands from the base to the summit. The lower slopes are covered by different types of forest. Several plant species are endemic, including giant lobelias and senecios.

This giant groundsel *Dendrosenecio keniodendron*

(foreground) can grow to a height of 6m. These plants occupy the higher altitudes of Mount Kenya above the forest level, at altitudes of 2900 m to 3800 m.

The living leaves are protected at night from prevailing freezing temperatures by closing up and opening again during the relative warmth of the day. The older outer leaves freeze, whilst the younger inner ones are protected by them and remain above freezing point.

The Kikuyu people, one of the principal tribes who live around Mount Kenya, view the mountain as an important aspect of their culture. To them it is known as Kiri Nyaga 'the shining mountain'. They believe that their god, Ngai, lived on the summit peaks when he came down from the sky, and that the mountain is Ngai's throne on earth. This is the place where Kikuyu, the father of the tribe, used to meet with Ngai. By tradition, dwellings were constructed with entrances facing the sacred mountain.

The Embu tribe are also prominent around the mountain slopes, living to the south-east. As with the Kikuyu they build their houses with doorways facing toward the peaks. The Meru people occupy the east and northern regions of the mountain utilizing what is considered to be some of the most fertile land in the country. These people are all agriculturalists and livestock farmers.

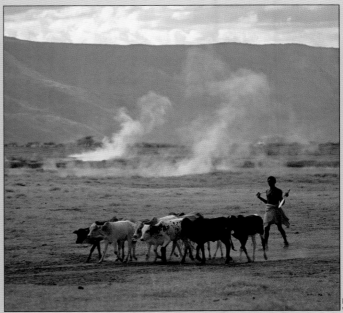

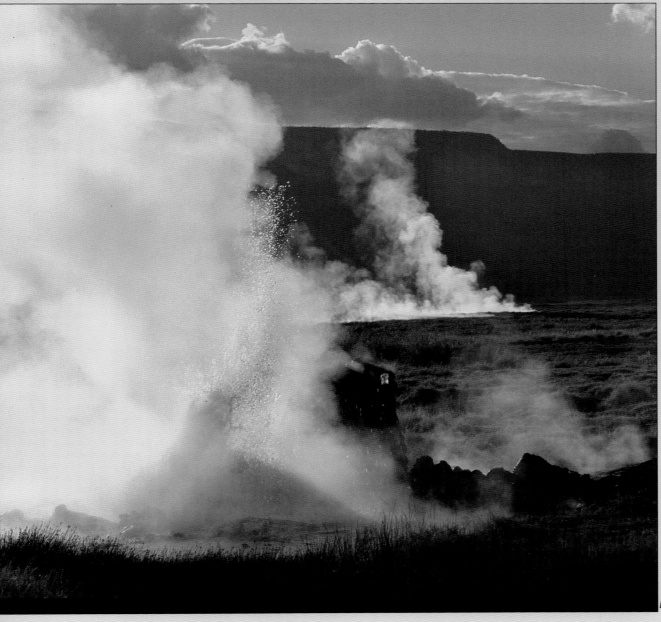

2. The appearance of the Lewis glacier at an altitude of about 4750 m on Mount Kenya has significantly altered since this image was taken in the mid 1960s. Due to global warming there has been a drastic retreat. Today no fresh snow falls in winter, so no new ice can form.

It is predicted that in less than 30 years all the ice will have completely disappeared from the mountain (Kenya Wildlife Service, 2006). Mount Kenya is the main water catchment area for two important rivers in the country: the Tana, Kenya's largest river, and the Ewaso Ngiru. This combined ecosystem provides water directly for over two million people.

3. This flowering giant groundsel *Dendrodrosenecio elgonensis* is endemic to Mount Elgon and grows at about 4300 m. It has characteristic huge leaves and spikes of bright yellow flowers that appear every few years.

4. A sign of active volcanism in the Rift Valley, hot geysers erupt from the shores of the saline, alkaline Lake Bogoria.

5. A Kalenjin herdsman drives his cattle past steaming hot springs on the shores of Lake Bogoria in the Rift Valley.

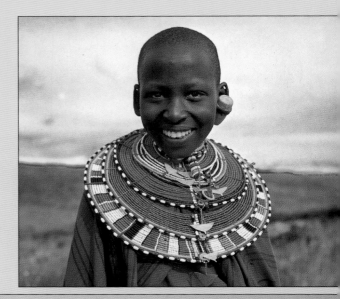

1. A Maasai moran (warrior) in the Rift Valley. The Maasai are a Nilotic semi-nomadic tribal people, traditionally cattle and goat herders. They speak 'Maa', which is part of the Nilo-Saharan language group and live in a patriarchal society. Monotheistic, their god is known as Engai and possesses two natures: a benevolent black one known as 'Engai Narok' and a vengeful red one known as 'Engai Nanyokie'.

Today, the staple diet of the Maasai comprises cow's milk and maize meal. Cattle are greatly prized and a man's status and wealth is judged by the size and quality of his herd, as well as by the number of his progeny.

2. At rest in her *manyatta* (tribal enclosure) in the Rift Valley, a Maasai Mother with her twin sons.

3. A Maasai herdsman drives his cattle up the Mau Escarpment.
4. A graceful young Maasai girl wears a traditional garland necklace of colourful beadwork.
5. Maasai cattle, attended by herdsmen, at rest by a stream in the Rift Valley's Olorgesaillie Gorge.
6. *Far right:* A young Njemps woman carries a load of reeds for hut roofing. The Njemps are a pastoral, cattle-herding tribe who also uniquely eat fish. Other pastoral groups such as the Maasai and Samburu, with whom they are linguistically and culturally related, regard fish-eating as a taboo.

These people are sedentary agriculturists rather than pure nomads. They live by the south and west shores of Lake Baringo in the Rift Valley.

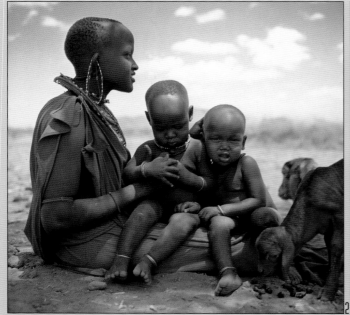

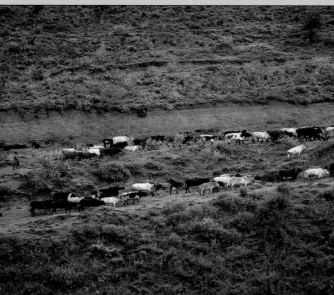

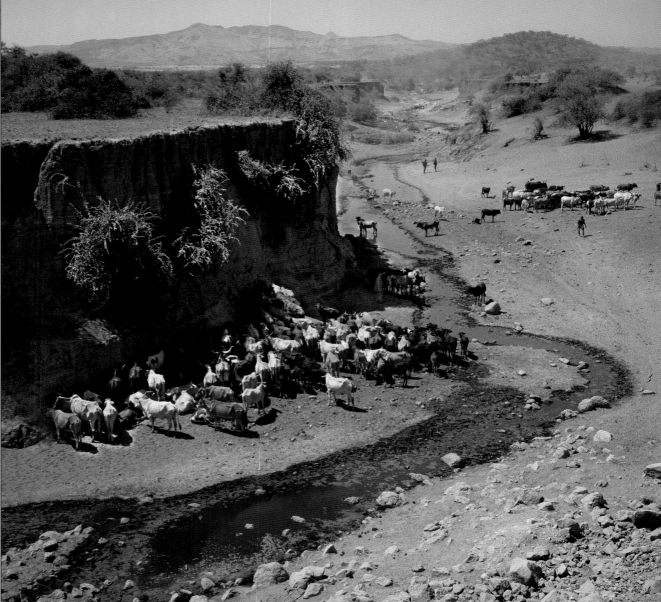

EVOCATIVE AFRICA

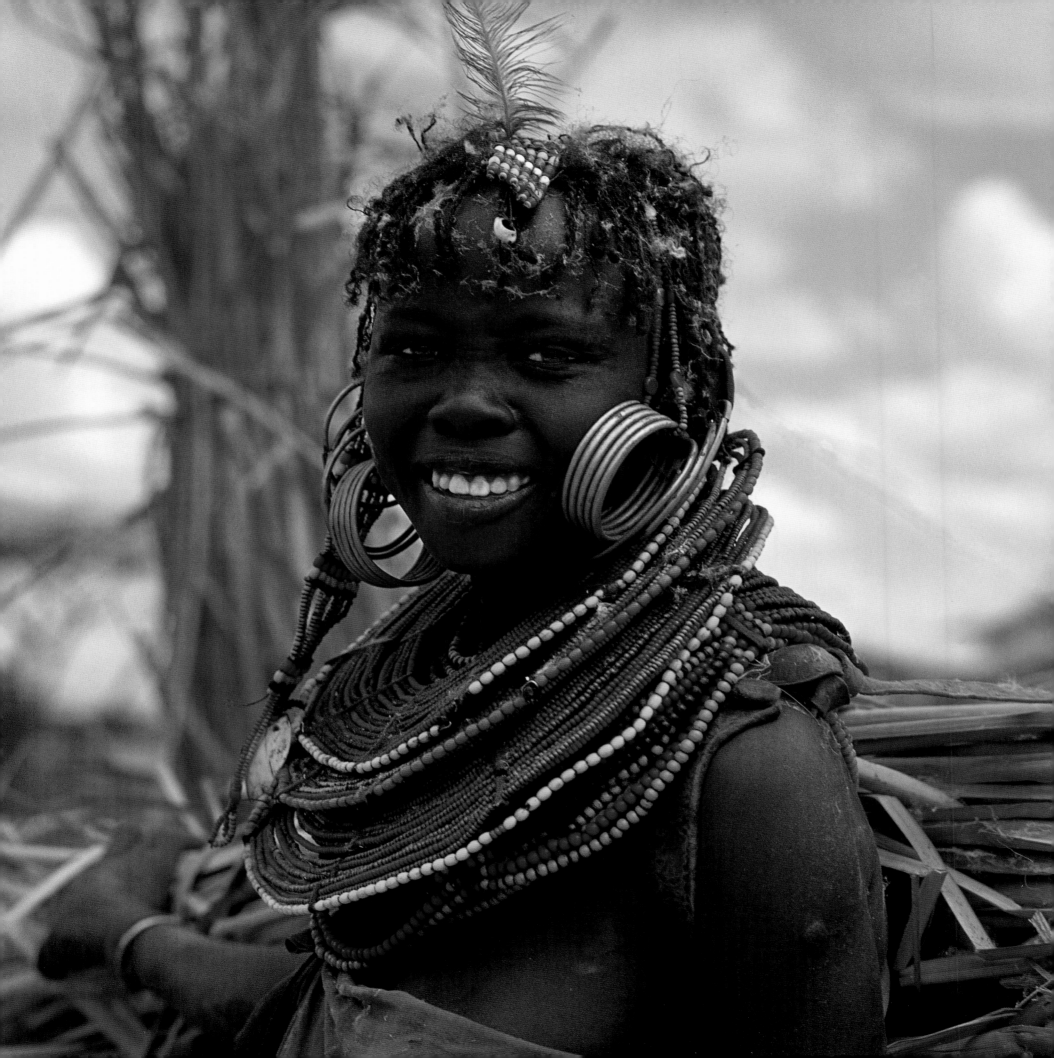

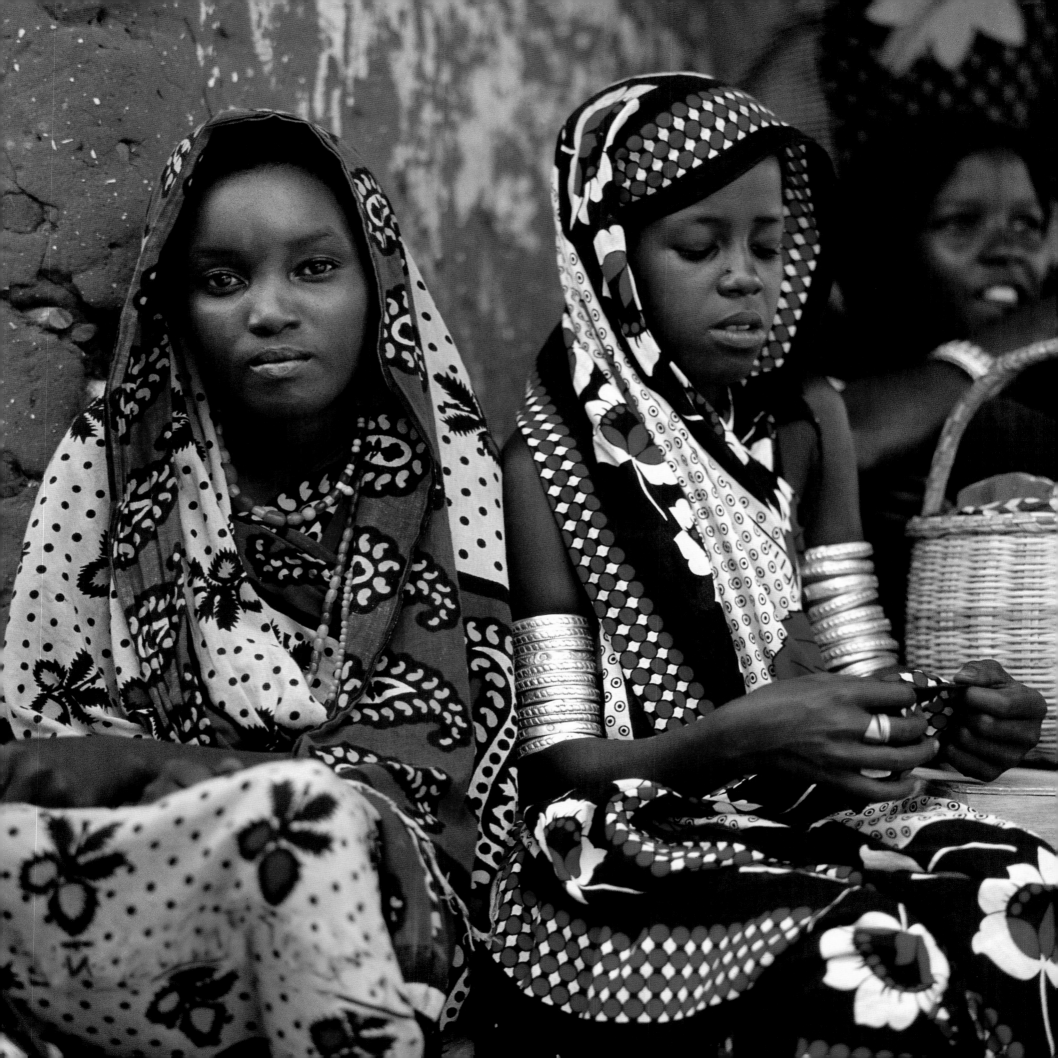

...mu, a World Heritage Site ...tuated on an island off ...a's north coast and part of ...rchipelago, is the oldest ...hili trading port and has ...ed for at least a thousand ...s. Since the 12th century ...s been a maritime trading ...re. This is Kenya's oldest ...bited town.

...e Portuguese invaded Lamu ...06, prompted by Portugal's ...essful mission to control ...e along the coast of the ...n Ocean. Export taxes were ...osed on the pre-existing

local channels of commerce. The town first rebelled against the Portuguese rulers in the 1580s. Finally in 1652, with assistance from Oman, Portuguese control was brought to an end and the island became an Omani protectorate. This marked the golden age of Lamu. During this period the town became a centre of arts and crafts, poetry and politics, as well as trade in slaves, ivory, rhino horn, turtle shells and mangrove poles. Slavery was only finally abolished in this region as late as 1907. Today the Swahili make their living from the international dhow trade and as farmers and fishermen.

The Bajun are a tribal group indigenous to the islands of the Lamu archipelago. Their history has become blurred over time with that of the Swahili to the extent that Lamu's Swahili culture has been distilled by the local Bajun people. Lamu's architecture is distinctive and characterised by mosques, narrow streets and flat-roofed stone houses, many with intricately carved wooden doorways.

Far left: 1. Orma girls at the Witu market on Kenya's northern coast. The Orma are semi-nomadic pastoralists who live mainly in the lower Tana River region. They number around 70 000 and speak their own distinctive language, also called Orma.
2. Detail of a traditionally wooden carved door with chain and padlock.
3. An alleyway in Lamu shows a passing Bajun woman in her traditonal black *buibui*.
4. A little Bajun girl peers pensively out into the street from the doorway of her home.
5. Bajun men engage in animated conversation in a Lamu street. Their dress is a mix of customary and modern, the cotton *kikoi* wrap combined with modern western-style shirts. Intricately embroidered cylindrical caps known as *kofia* are worn on the head. Flip-flop sandals complete their apparel.

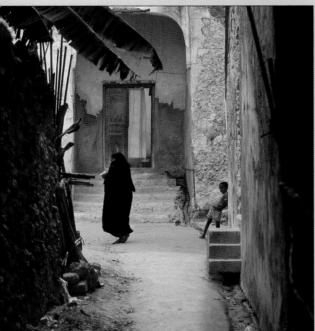
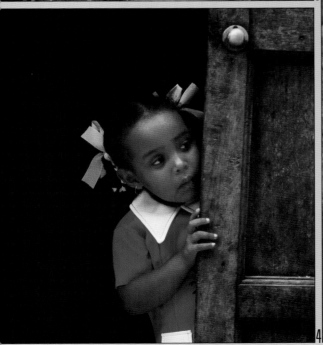
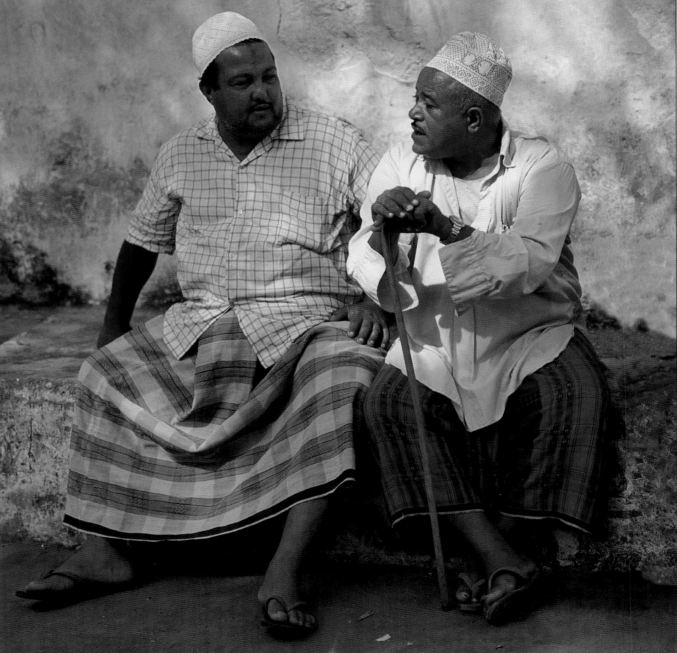

KENYA

1. A Bajun mother and daughter in Lamu.

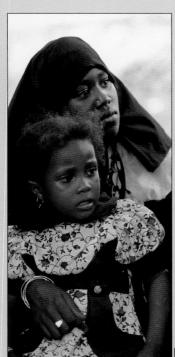

2. The building of Lamu fort commenced in 1813 following Lamu's victory over Pate and Mombasa at the Battle of Shela. It was built under the encouragement and support of the Sultan of Oman, who was endeavouring to cultivate an alliance with the town. It was completed in 1821.

Initially the fort served as a garrison for Baluchi soldiers sent by the Sultan. It provided security and protection for Lamu throughout the 19th century and helped introduce a period of development and commercial success for the town. From 1900 to 1984 it served as a prison. It is now the Lamu Museum.

3. Painting the *mehrab* of the Pate mosque.

4. Antique traditional Swahili jewellery. A silver Herizi talisman case contains the Koran text and in the past was worn by coastal Swahili women.

5. Crescent-shaped gold earrings.

6. Silver embellished cartridge cases for holding snuff, and worn on the belt.

7. A group of Bajun women wearing the traditional black *buibui* attend the annual Maulidi celebrations commemorating the birth of the Prophet Mohammed.

Far right: 8. The roof of Lamu's Riyadha mosque, built in 1900.

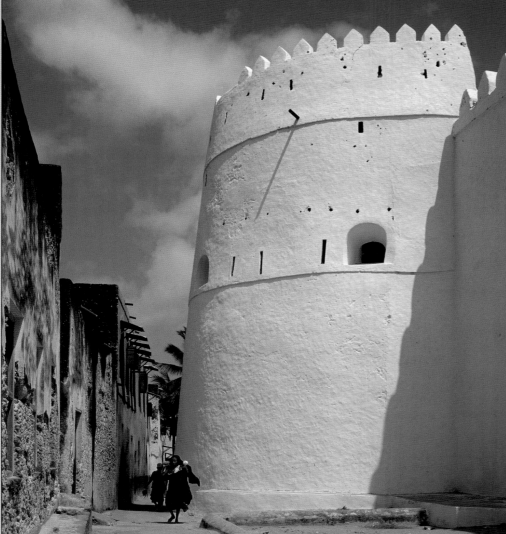
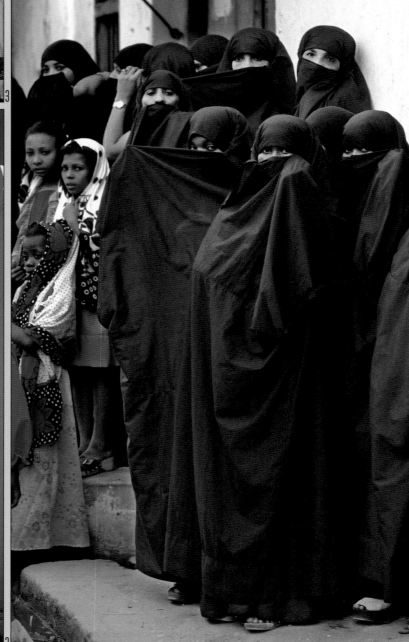

KENYA

4. A decorative stucco alcove in an 18th-century Lamu house.

5. A small coastal craft off the Shela coast, most commonly used for inshore transport and handline fishing.

6. The Aweer are a small, isolated, semi-nomadic Hamitic tribe found along the northern coast. Today, only some 8000 Aweer people survive in this region. This Kenyan tribe is best known for its unusual practice of using semi-domesticated honey-guides (birds) with their mellifluous whistling signals to find honey, the principal ingredient in their diet. They also eat wild fruit, roots and a variety of

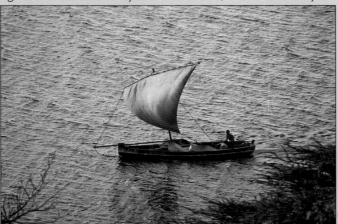

game, the last putting them at odds with wildlife officials.

Like other coastal tribes, the Aweer are mostly Muslim. Their remote territory is heavily wooded, making them forest dwellers though they also practise small-scale shifting cultivation. They are traditionally hunter-gatherers rather than typical Kenyan cattle herders.

7. The evocative ruins of Gedi lie surrounded by coastal forest. These are the haunting remains of a once-flourishing Swahili town that was most prominent in the 13th and 14th centuries. The Muslim inhabitants, some 2500 in its heyday, traded worldwide.

No written records have been preserved, but findings from excavations have included beads from Venice, scissors from Spain, an iron lamp from India, and coins and a Ming vase from

China. The town was finally abandoned in the early 16th century.

Today, crumbling ruins of a palace, a mosque, and several large stone houses can be see

Right: 8. An earthenware jar with bougainvillea brings colo to the enclosed courtyard of a 18th century Lamu house.

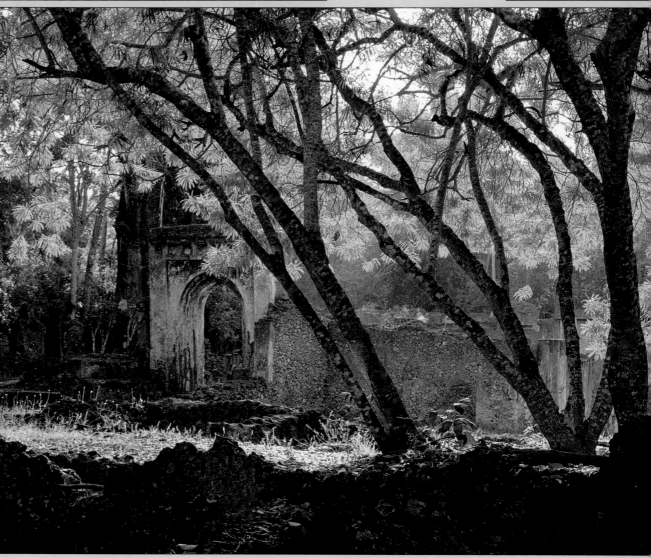

1. The common diadem *Hypolimnas misippus* (male), one of the nymphalids, is a distinctive butterfly with iridescent purple wing patches. This is a widespread species, known for the female's capacity for mimicry.

2. The Kenyan coast contains remnants of many settlements dating from the 8th to the 19th century. These can be divided into two geographical groups: a northern group based around the Lamu archipelago, and a southern group between Gedi, six km inland, and Mombasa.

This Kaburi pillar tomb dates from the 15th or 16th century and is located at Ishikani, north of Kiunga, on the far north coast of Kenya close to the Somali border.

The coastal people of Africa, from Somalia to Mozambique,

form part of the Swahili indigenous group who converted to Islam. Coastal settlements were established and a flourishing trade was built up with Arabia, India and S.E.Asia. Ishikani would have been one such settlement.

3. Dawn gently breaks across the Indian Ocean in this seascape along the far north coast.

KENYA

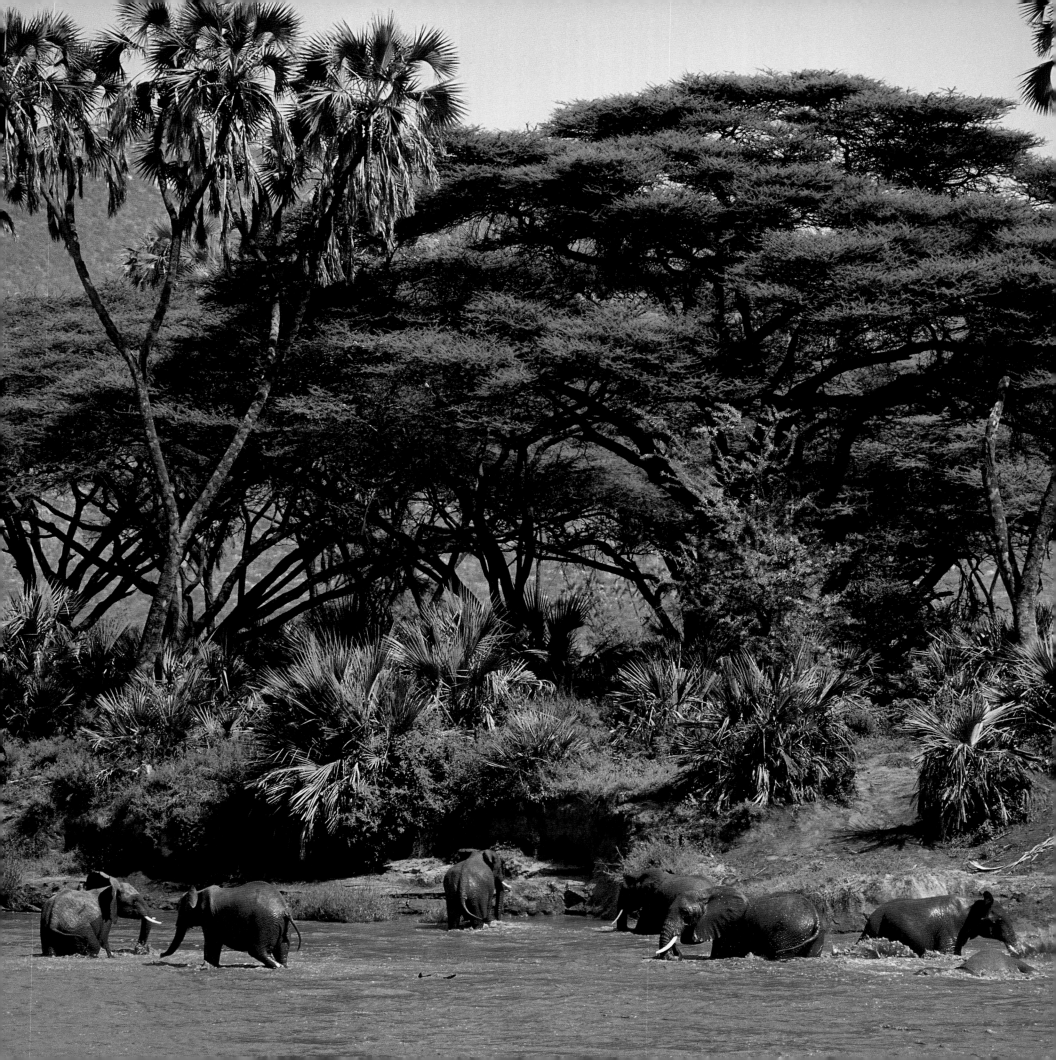

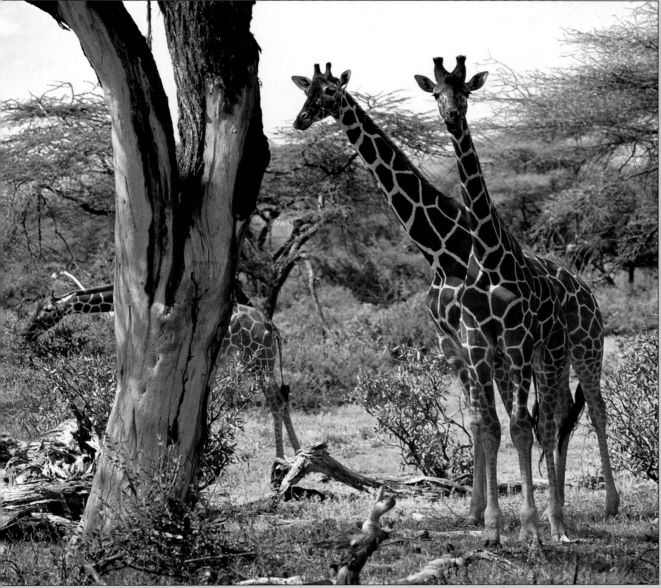

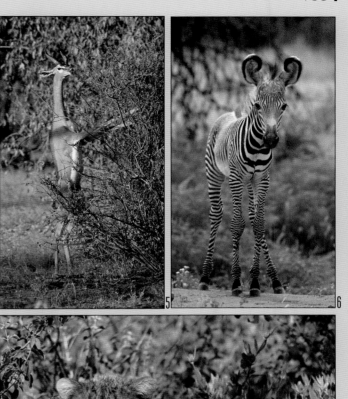

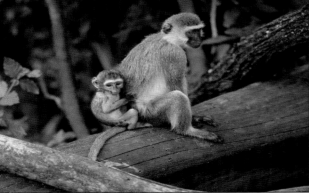

conservationists George and Joy Adamson raised Elsa the lioness.

All three big cats, lion, leopard and cheetah, are found in the reserve, as well as elephant, buffalo, and hippo. Other mammals frequently seen include Grevy's zebra, reticulated giraffe, Beisa oryx, waterbuck, gerenuk, Grant's gazelle, impala, and Kirk's dik-dik. Black rhinos, are no longer present in the park due to heavy poaching in recent years. Over 350 species of bird have been recorded in the region.

Far left: 1. Appearing almost diminutive beside tall riverine trees (including doum palms *Hyphaene thebaica*), a group of elephants bathe in the Ewaso Ng'iro during the heat of the day.

2 Reticulated giraffes *Giraffa camelopardalis reticulata* are a distinctively patterned subspecies that frequents the dry grasslands and bush of northern Kenya.

3. A vervet monkey mother

Cercopithecus aethiops with her infant, in the riverine forest.

4 A vulturine guineafowl *Acryllium vulturinum* in the Kora National Park. This is the largest and perhaps most spectacular of the guineafowl family and is named for the vulture-like appearance of the shape of its head and long bare neck. By nature it is gregarious and lives in flocks of up to 25. This species prefers open savanna grasslands with scattered bush cover.

5. A Gerenuk *Litocranius walleri* (meaning 'giraffe-necked' in the Somali language) browses on acacia bush. By standing upright on its hind legs, this slim antelope can reach high into the bush to feed on succulent leaves. It never requires water, getting all the moisture needed from the

plants it browses upon.

6. The Grevy's zebra *Equus grevyi* is the largest of the zebra species and is distinguished by its large ears and narrow stripes. Here a foal appears vulnerable in Samburu. The species is named after Jules Grévy, president of France in the 1880s, who was presented with one by the government of Abyssinia.

Today this species is endangered due to habitat loss, hunting for its skin as well as competition from grazing cattle and goats. Estimates of animals in the wild lie between 1500 and 2000.

7. At rest but always alert, a young cheetah *Acinonyx jubatus* awaits the return of its mother.

...cated on the banks of the Ewaso Ng'iro River, the Samburu ...ational Reserve comprises 165 km² of arid acacia grassland. ...iver flows through the middle of the reserve, giving rise to lofty ...m palm groves and thick riverine forests along its banks. ...ovides the crucial water supply without which game could ...survive. ...mburu attained fame from the best-selling book and award-...ning film *Born Free*. This was one of the two areas in which

The Samburu are semi-nomadic pastoralists who inhabit the dry regions of north–central Kenya. Although related to the Maasai, and sharing the same Maa language, they are distinctive from them.

During one of the later Nilotic migrations from the Sudan, the tribe developed as part of the Plains Nilotic movement. The broader grouping of the Maa-speaking people, however, continued moving southwards, possibly under pressure from the Borana expansion into their plains.

Admiring their beauty, neighbouring tribes called them *samburu* which means 'butterfly' in the Samburu language. They however refer to themselves as the Loikop.

1. A young Pokot boy strums the wire strings of his hide-covered harp.
2. A striking young Samburu girl wears customary headbands, bead necklaces and long earings.
3. Adorned in traditional finery: a young Pokot woman in the West Pokot district of northern Kenya.

The Pokot (Suk people) inhabit the West Pokot and Baringo districts. They can be divided into two groups. The Hill Pokot inhabit moist highlands in the western and central parts of the Pokot region where they are mainly farmers and pastoralists. The Plains Pokot endure a harder existence living in the dry and infertile plains where they graze cattle, sheep and goats.

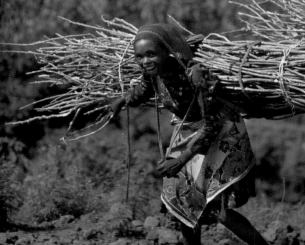

Their language, part of the southern Nilotic language group, is known as Pokoot.

Tororot is the Pokot supreme deity, and prayers and offerings are made to him during tribal ceremonies and gatherings.
4. A Meru woman cheerfully carries a heavy load of firewood for her *shamba* (farm) in the Nyambeni mountains.

The Meru are a Bantu agricultural people divided in seven sub-groups. The tribe inhabits eastern Kenya and especially the north-eastern slopes of Mount Kenya.

Traditionally governed by a council of elected leaders, the Meru were in effect the only tribal group in Kenya that practised a true form of democracy before colonisation by the British.
5. Samburu women return home with gourds filled with fresh water from the well at Ilaut.

Right: 6. A Samburu woman displays traditional head bands, brass earings, tight fitting armbands and an array of metalic and bead necklaces.

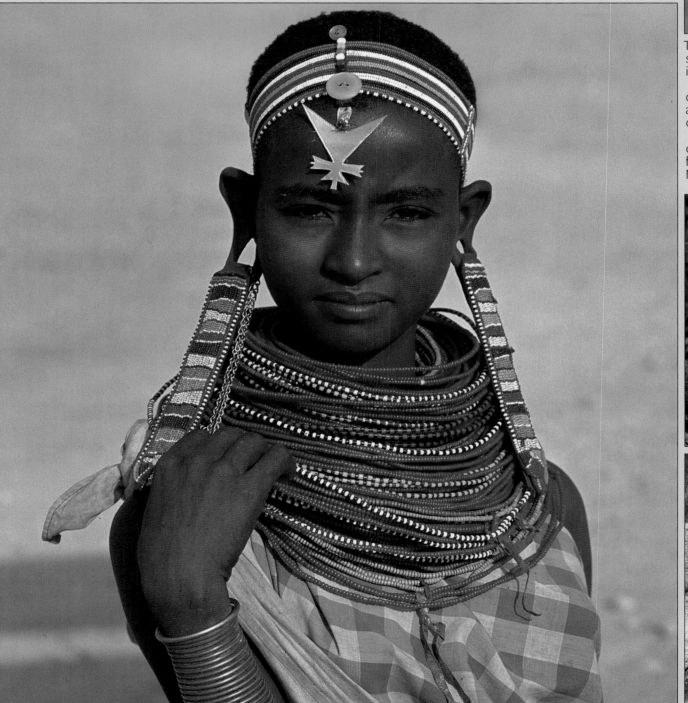

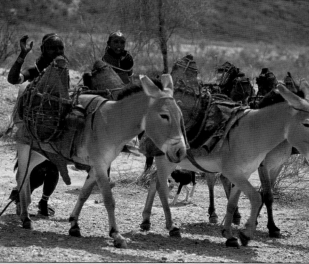

EVOCATIVE AFRICA

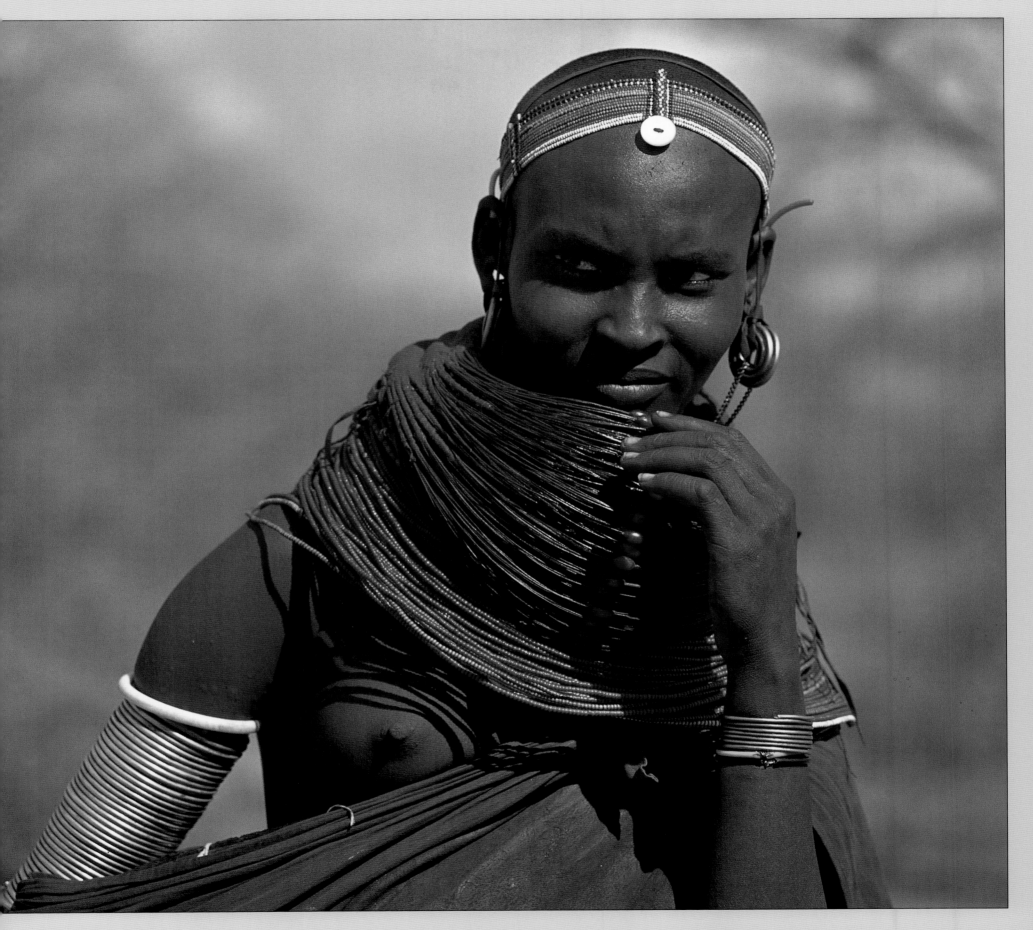

KENYA

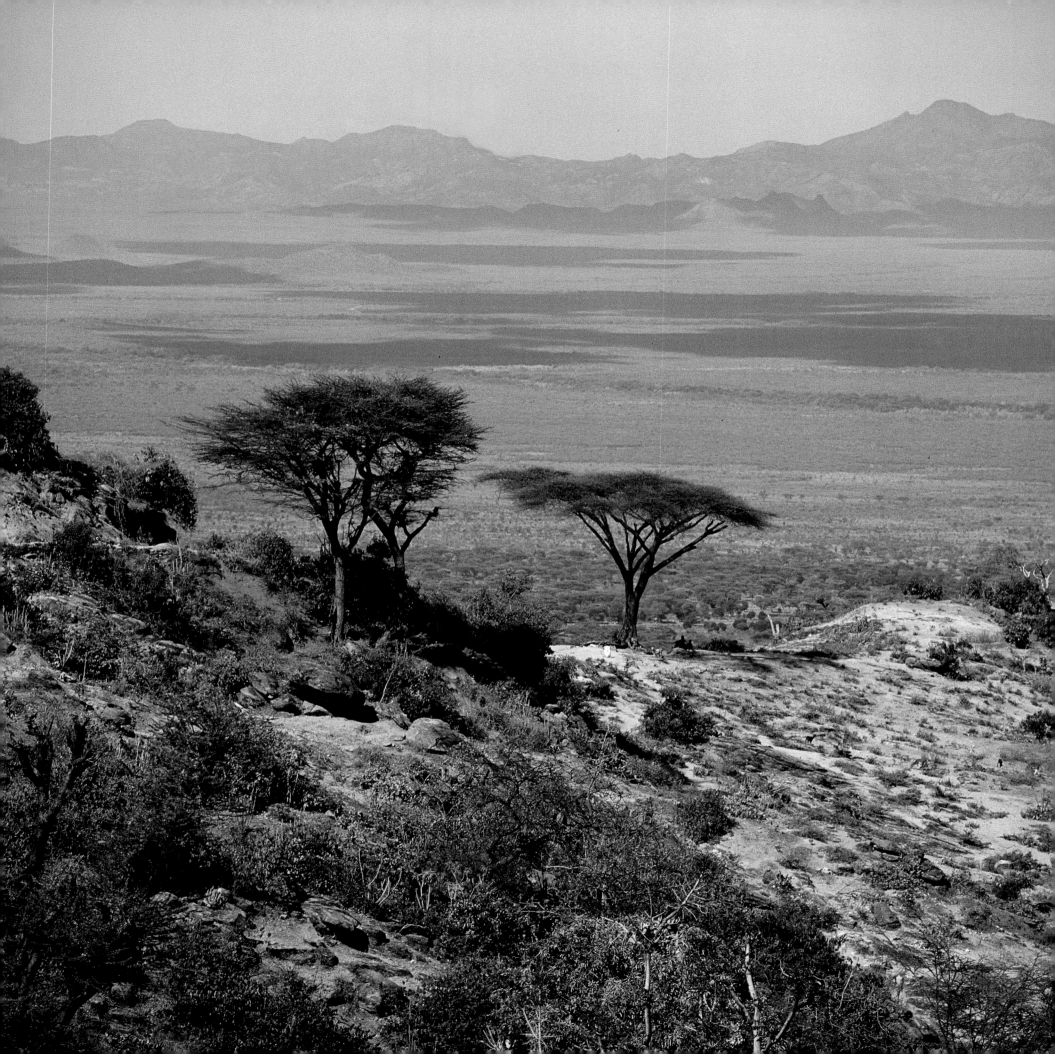

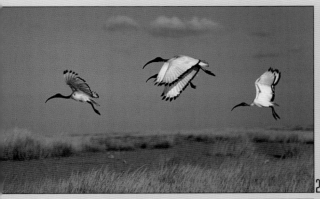

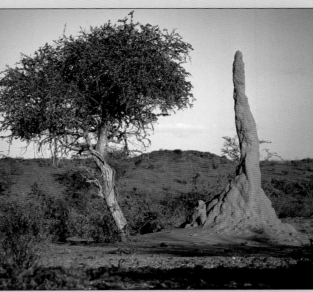

Most of its water comes from Ethiopia via the Omo River. It is drinkable but not palatable. The lake is home to some 22 000 crocodiles.

5. A termite mound with an exceptionally long and slender turret, in the arid acacia bushland of West Turkana.

6. The Somali ostrich race, *Struthio camelusmolyb-dophanes* (male shown), differs from the North African and Masai subspecies, in that it has a blue grey neck and thighs of similar shade (instead of pinkish).

7. Lake Turkana from the Loiyangalani oasis (place of the trees).

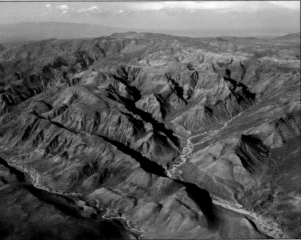

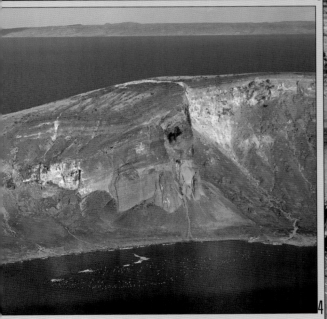

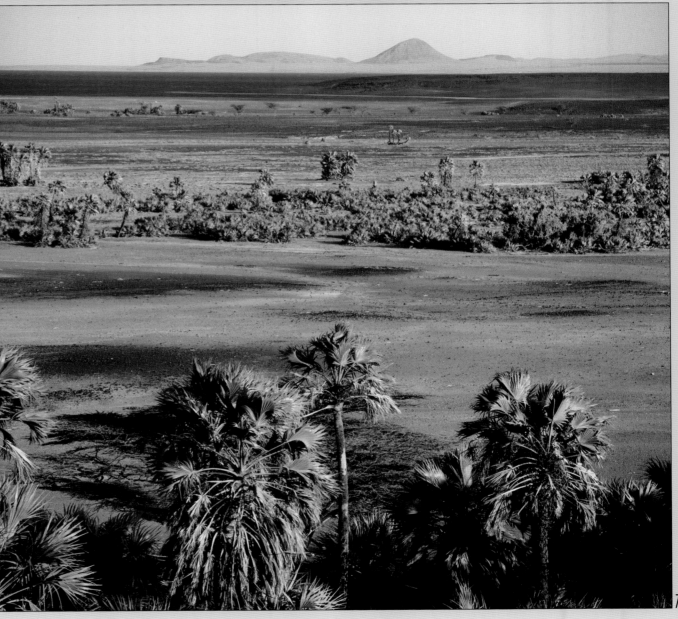

left: 1. The Great Rift Valley from the Tot Escarpment.
African sacred ibis *Threskiornis aethiopicus* in flight over seasonal lands by the shores of Lake Turkana at Ferguson's Gulf.
An aerial perspective of the eastern walls of the Great Rift Valley.
A flight of flamingos skim the surface of the caldera crater-lake Central Island. The time-worn eroded volcanic cliffs provide a matic foreground to Lake Turkana in the background.
riginally named Lake Rudolf in 1888, the lake was renamed after ependence in 1975 to Lake Turkana, to honour the major tribe g in the area. Situated in the Great Rift Valley, this is the world's est permanent desert lake, as well as the largest alkaline lake.

KENYA

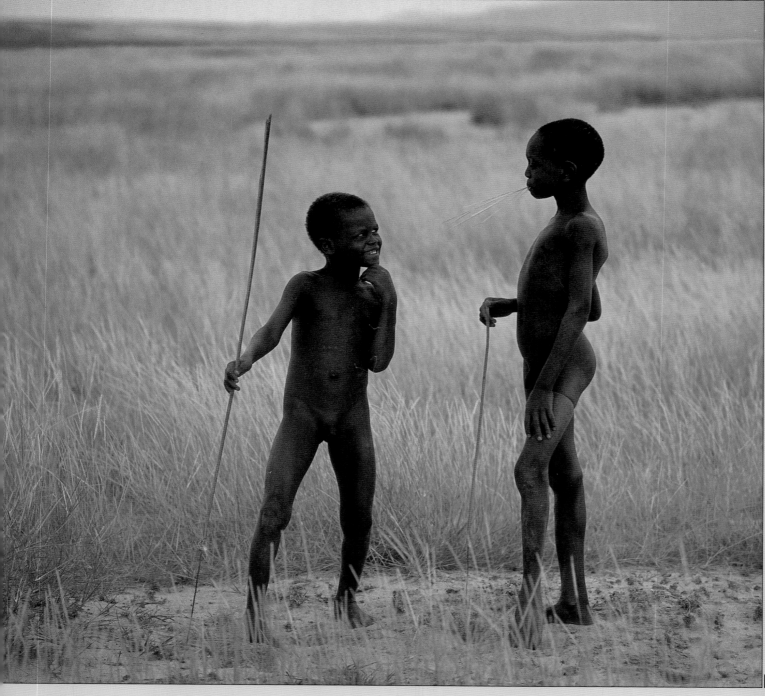

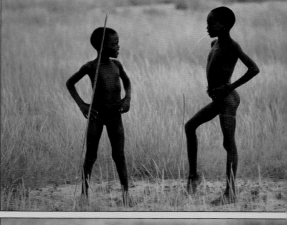

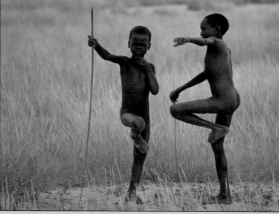

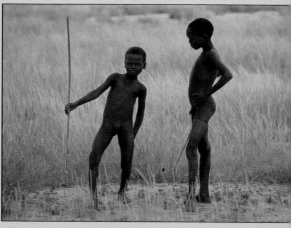

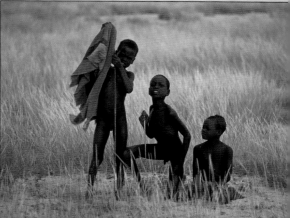

The Turkana are a Nilotic people, numbering some 340 000, who inhabit the extensive hot dry region of north-west Kenya. Livestock plays a pre-eminent role in their culture; wealth is perceived by the size of a man's herd, and this can determine the number of wives he may have.

1-5. Cameo studies of young Turkana boys in the grasslands beside Lake Turkana at Ferguson's Gulf.

6. Cistanche tubulosa known as the 'desert hyacinth' or 'desert ginseng', is a parasitic medicinal herb well-known for its restorative properties. It strengthens kidneys, enhances sexual function, and is commonly used in the treatment of male impotency and infertility in both sexes. Modern research shows that it also enhances memory, and works as an agent combating senile dementia, ageing and fatigue. It is known moreover to regulate the immune function.

7. A typical Turkana settlement by the shores of Lake Turkana.

8. A Turkana woman tends her goats inside the *manyatta* (a clan or family group compound made up of several huts enclosed by a thorn-bush fence).

9 Elaborate bead necklaces embellish and dignify the status of a Turkana headman's senior wife.

10. An El Molo child at his settlement by the south-east shores of Lake Turkana. The El Molo are Kenya's smallest ethnic group and live in igloo-like dwellings made from scrub vegetation and doum palm fronds. They are hunter-gatherers and rely on fishing for Nile perch on the lake. The name El Molo comes from a Maasai phrase meaning 'those who make their living from sources other than cattle'. The Samburu, with whom they have close geographic contact, refer

6

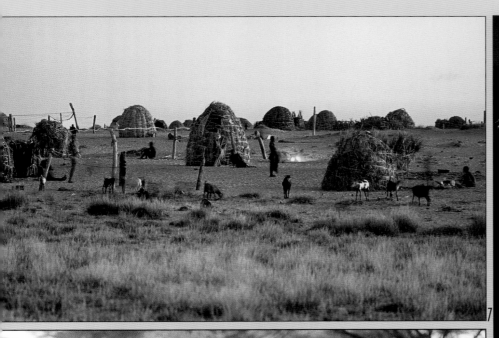

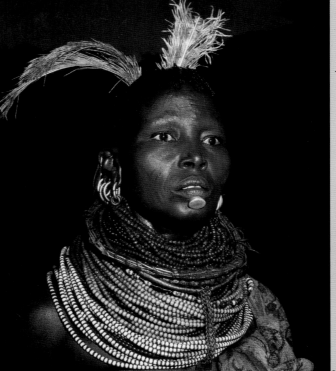

to them as *loo molo onsikirri* ('the people who eat fish'). Fishing nets are made from the fibre of doum palms, rafts are constructed from doum palm logs and harpoons from acacia roots. This tribe spoke an Afro-Asiatic language, which is today almost extinct and spoken only by a few of the older generation.

11. A Turkana tribesman watches over his goats inside the *manyatta*.

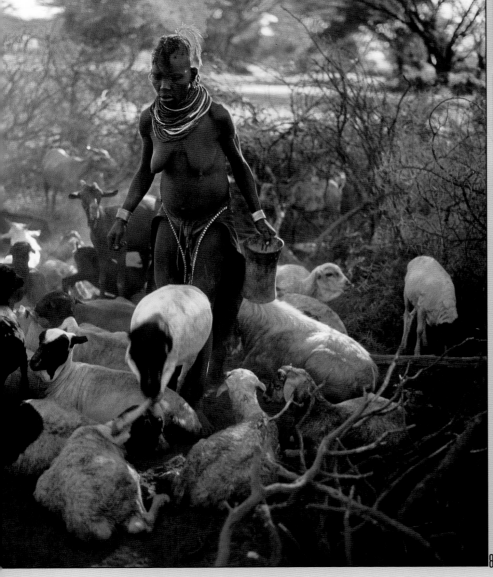

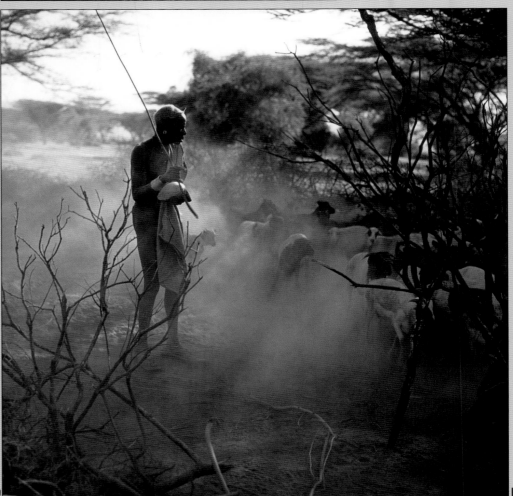

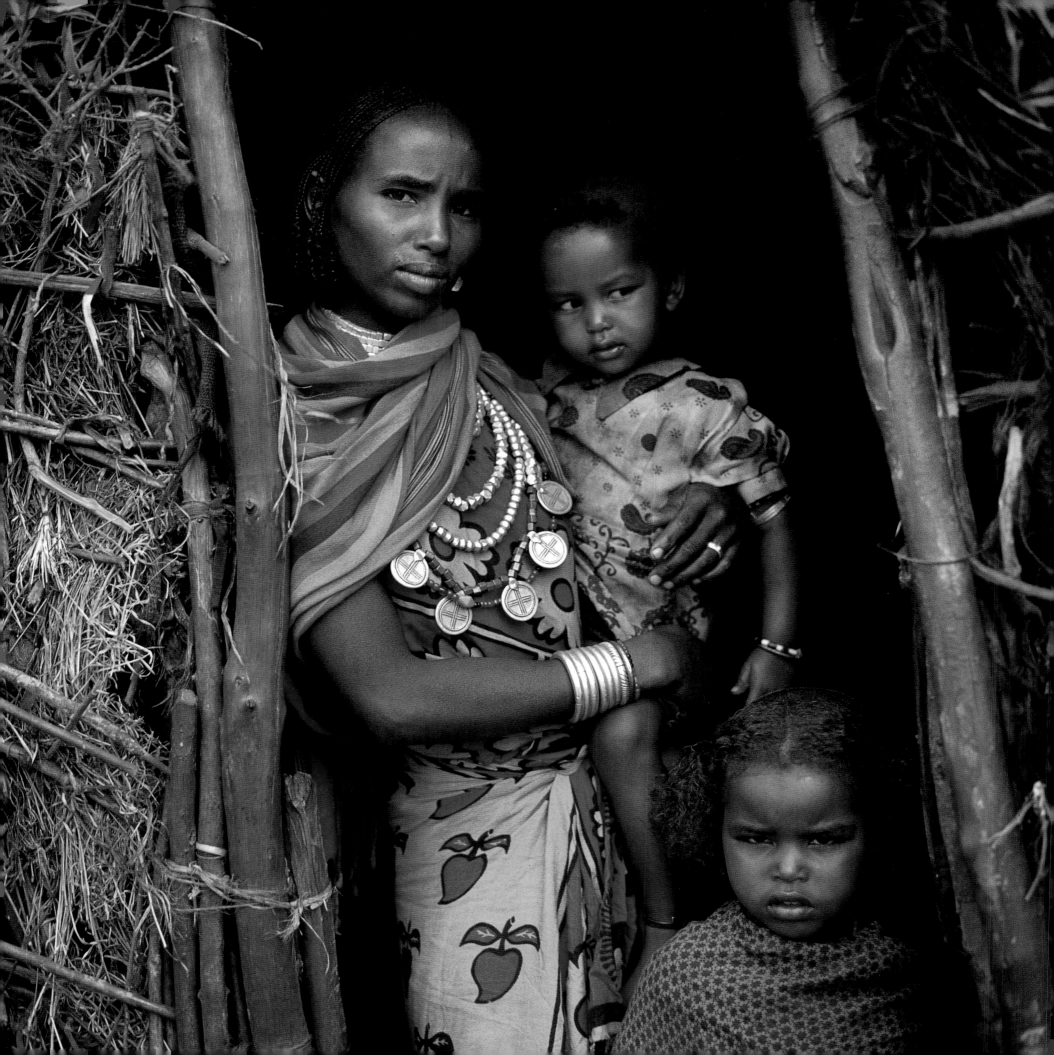

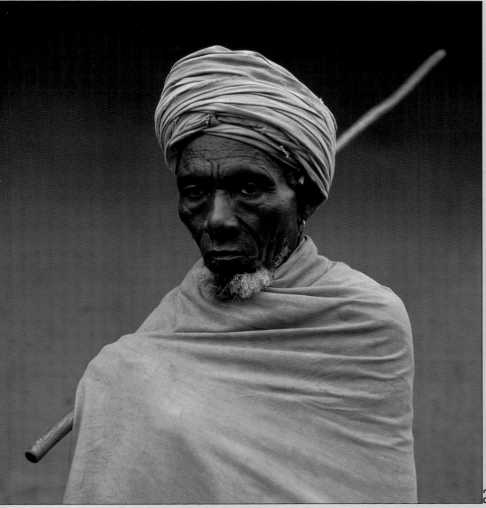

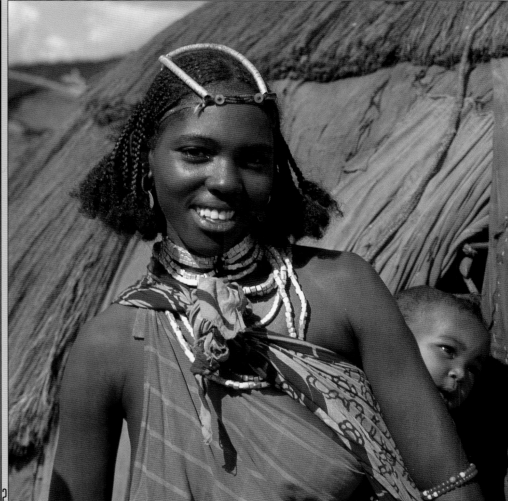

e Oromo people first entered
orthern Kenya from southern
opia during a major
ratory expansion in the
10th century. In time they
rated into the cattle-herding
na and the camel-keeping
ra and Sakuye.
e Borana mostly follow a
nadic way of life. Their
uage is part of the
nitic branch of the Afro-
tic group. In their choice
othing colours, they prefer
shades of blue, green and
n contrast to the bright reds
pinks typically worn by the
buru.
mel nomads of northern
ya, the Gabra are also
oralists, numbering today
e 30 000. Originally a
ali people and still speaking
language, they subsequently
from this ethnic group,
ed with the Borana and
e up Islam.
ost Gabra now live in
opia, but some inhabit the

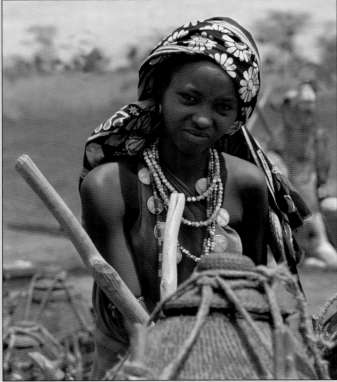

Huri Hills and Kaisut Desert
regions of northern Kenya where
they graze their camel herds.

Far left: 1. Displaying a fine
array of traditional jewellery, a
Borana mother with her two
young children stands at the
entrance to her home in the
Marsabit region.
2. Portrait of a Gabra elder
with cloak wrapped tight against
the elements.
3. About to head home, a
young Gabra woman tightens
the harness of her seated camel,
loaded with a container (*amuuju*)
of well water.
4. A Gabra mother with infant
son in her *manyatta* in the
Marsabit region.
5. A Turkana herdsman
wears the traditional
mud-caked head piece adorned
with an ostrich feather.

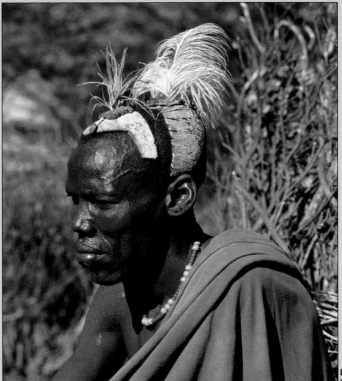

KENYA

BOTSWANA

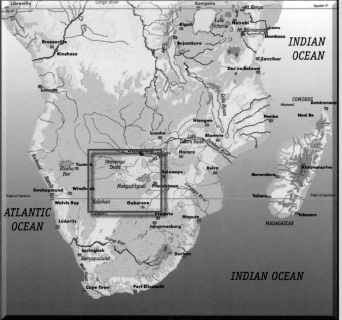

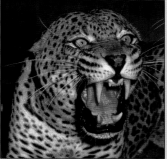

*Close encouter of a fierce kind:
a snarling leopard* Panthera pardus.

The Republic of Botswana, formerly the British protectorate of Bechuanaland, adopted its new name on gaining independence within the Commonwealth. It is one of Africa's most stable countries with the continent's longest continuous multi-party democracy. Free and fair democratic elections have been held since independence.

Botswana is landlocked, bordered by South Africa to the south and south-east, Zimbabwe to the north-east, and Namibia to the west and north, and meeting Zambia at a single point. The country is relatively flat with the Kalahari Desert in the south-east dominating the country, and forming about 70% of the landmass. The eastern regions of the country are, however, hilly.

Besides the Kalahari, the main geographical divides of the country comprise the Okavango Delta, fed by the river of the same name, the pre-eminent feature of the north-west and the world's largest inland delta; the Makgadikgadi Pan, a huge salt-pan and national

Wild Dog. Lucaon pictus.

park in the north-east; the Chobe River to the north, forming the border between Botswana and Namibia (the Caprivi Strip); and the Limpopo River which forms the border with South Africa.

The earliest inhabitants of the region were nomadic San (Bushmen), followed much later by the Tswana. About 50% of the population today is ethnic Tswana. The people of Botswana are referred to as 'Batswana' (singular: Motswana) which refers to a national rather than an ethnic origin.

In the 19th century, hostilities broke out in the region between the Tswana and Ndebele tribes who were making incursions into the

territory from the north-east. Encroachment by Zulus in the 1820s and by Boers from Transvaal in the 1870s and 1880s threatened peace in the region. After appeals by Batswana leaders Khama III, Bathoen and Sebele for assistance, the British Government put 'Bechuanaland' under its protection on 31 March 1885. This measure effectively prevented territorial encroachment of the Boers from the Transvaal as well as German expansion from South West Africa. The northern part of the territory remained under direct administration as the Bechuanaland Protectorate and subsequently became modern-day Botswana, whilst the southern region became attached to the Cape Colony and is now part of North West Province of South Africa.

The copse of 'Baines' Baobabs', immortalised on canvas by painter/ explorer Thomas Baines in 1862.

Botswana is Africa's oldest democracy and achieved independence on 30 September 1966.

The country is the world's largest producer of diamonds. This abundance ensured a transformation from former impoverishment into the status of a middle-income developing nation. Botswana however is today endeavouring to diversify its economy and reduce its economic dependence on this single high-value commodity.

Sparsely populated due to the aridity and parched conditions of its topography, most areas are just too dry to sustain any agriculture apart from cattle. Nevertheless, Botswana protects some of Africa's largest wilderness areas and has become one of the foremost wildlife-viewing destinations in the world. Some 90% of the territory, including the Kalahari Desert, has adequate vegetation to support tens of thousands of wild animals. Common trees include mopane, camel-thorn, motopi (shepherd's tree), baobab, marula, sycamore fig, African mangosteen, the curious sausage tree with its drooping pendulous fruits, wild date palm and the real fan palm *Hyphaene petersiana* which epitomises the Delta.

Botswana is a natural game reserve for most animals found in southern Africa, including elephant, rhino, hippo, buffalo, lion, leopard, cheetah, giraffe, zebra, hyena - and 22 species of antelope. Wildebeest (gnu), springbok, steenbok and duiker are all familiar sights. Over 17% of Botswana's land area has been set aside for national parks and game reserves. From the lush green of the Okavango Delta in the north to the red desert dunes in the southwest, great areas of wilderness have been preserved to offer visitors an opportunity to experience nature at its very best, to feel a sense of solitude, to view an incredible variety of wildlife species and to enjoy the prolific birdlife.

The principal parks and reserves can be overviewed, starting at Chobe and moving southwards:

Chobe National Park, is Botswana's second largest national park and covers 10 566 km². It has the greatest concentrations of game found on the African continent present throughout the year. It can be divided into four distinctly different ecosystems: Serondela with its lush plains and dense forests in the Chobe River region; the Savute Marsh in the west; the Linyanti Swamps in the north-west and the hot dry hinterland in between.

Botswana boasts Africa's, and the world's, largest population of elephants. Well above 100 000 animals are concentrated mostly in the north of the country: the greatest surviving continuous population of the species in Africa. The IUCN Global Category Survival Commission issued figures from its 2006 survey (grouped into 'definite', 'probable' and 'possible' catgories).

Total:175 487 elephants in all three categories, an increase of 32 since the previous count in 2002.

Large herds make seasonal migratory movements of up to 200 from the Chobe and Linyanti rivers, where they concentrate durin the dry season, to the pans in the south-east of the park into wh they disperse in the rains. These huge numbers do, however, bea serious habitat and ecological consequences.

Zoologist Dr Kate Evans, founder of Elephants for Africa research ways for humans to live alongside and conserve the species. " O tagline is conservation through research and education...What w look into is understanding their ecological and social requirement so the areas we deem suitable for wildlife conservation are actual providing what they need. In addition we are investigating ways may be able to mitigate human-elephant conflict. "

The rather ominous-sounding 'human–elephant conflict' immediately brings to mind poaching, but Evans says this is not the most serious problem in Botswana. " Crop raiding is a huge socio-economic problem throughout Africa and Asia and easily t biggest cause of ill-will towards elephants here. Electric fences do keep them out of farmers' crops, because they quickly learn that tusks won't conduct electricity. "

The same areas where elephants abound provide the main habitat of hippo which are common wherever suitable grazing and fresh water can be found. Hippos need fresh water deep enough for submersion as well as nearby grasslands for feeding. The animal's skin, thin and lacking sweat glands, is prone to lose moisture at a high rate. Consequently being away from water in the heat of the day risks dehydration. For this reason hippos spend their days semi-submerged and feed only at night. They can cover many kilometres during their nightly feeds before returning to the water in the early morning.

Waterlilies bring tranquility to the del waters.

To the south-west lies ***Moremi***, where early in 2002 white rhin were reintroduced at Mombo Camp as part of a joint programme between Wilderness Safaris and Botswana's Department of Wild and National Parks. As of mid-2005, there were more than 40 wild-roaming white rhinos and four calves born since the reintroduction. They are closely monitored by anti-poaching patro and each animal carries a transmitter that was inserted into its h before it was released.

Elephants in this area have the distinction of being the largest in body size of all living elephants though their ivory is brittle.

The Batawana tribe initiated the proposal to create a game rese in 1961 from previous Bushman hunting grounds. This was appr by the Batawana at a *kgotla* (traditional community council) in 1 Moremi was officially designated a game reserve in April 1965 an in 1976 was extended to include Chiefs Island. The Department o Wildlife and National Parks took the reserve over in August 1979

Moremi contains approxima 20% of the Okavango Delta a is described as one of the mos beautiful wildlife reserves in A It combines mopane woodlan and acacia forests together w floodplains and lagoons.

It is claimed that it contains some 30% of all living African dogs, whose numbers are rap dwindling elsewhere. These ca are regularly sighted and have been subject to a conservatio project operating since 1989.

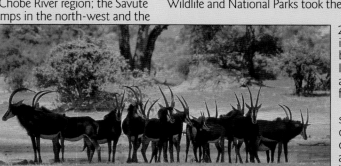

A peaceful herd of Sable antelope Hippotragus niger *shelters from the midday heat.*

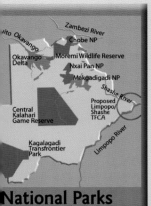

National Parks

The **Okavango Delta** is the world's largest inland water system and the only delta of its kind. It is an oasis of life at the northern stretch of the Kalahari Desert. Encompassing more than 16 000 km², the Okavango supports a staggering variety of animals, birds, fish and plantlife. The water was once thought have reached the sea, but this is no longer the case. After a series of tectonic uplifts and earthquakes running along geological fault lines, the land at the edge of the delta now lies lower than that of the surrounding area.

ce the water very rarely flows further south than Maun. e Delta is inundated by seasonal flooding. Between January and uary the floodwaters begin their 250-km journey downstream n the Angolan highlands. This surge takes place over a period of ut one month. Because of the gentle slope of the Okavango Delta (1:36 000) the floods take approximately six months to travel

nquil backwater in the Okavango Delta

heir eventual destination. The delta consists of a multitude of n channels, smaller tributaries and lagoons, as well as floodplains, nds and mainland areas. The watercourses are constantly nging due to annual flooding and a combination of sediment sport, seismic activity, the construction of termite mounds, and continual opening up of new channels by feeding hippos and closing of others by new vegetation growth. There are two fairly inct areas of the Okavango Delta: the permanent swamp, inunded with water all year round, and the seasonal swamp, which is ded annually and dries gradually with the onset of summer. The etation of the permanent mp includes groves of wild e palms, swathes of papyrus, nds fringed with forest and ons covered with floating erlillies.

e flood peaks between June August during Botswana's winter months, when the a swells to three times its vious size, attracting animals n all around and creating of Africa's most significant centrations of wildlife. About m³ of water annually flows the delta, 2% of which cones into adjacent Lake Ngami. outflow prevents the delta

flushing out the minerals carried by the river and its salinity increases, rendering it uninhabitable. This effect however is reduced and counter-balanced by the low salt content that collects around the roots of the plants. The floods do not greatly enrich the floodplain with nutrients.

Waterlily leaves: a colourful spread in a shallow Delta backwater.

were established in the early 1970s in an endeavour to protect the entire ecosystem and in the hope that their complementary natures would facilitate the migration of wildebeest and zebra herds during the wet season.

In December 1992 the Nxai Pan area was extended south to the main Gweta/Maun road to adjoin the Makgadikgadi Pans. They were at that stage renamed The Makgadikgadi Pans National Parks to form one vast conservation region now covering just under 7500 km². They are treated as one management complex although two separate parks. These i ncorporate Ntwetwe Pan, Makgadikgadi Pans, Nxai Pan, Baines' Baobabs and the Kudiakam Pan. Once the centre of a great lake, these desolate salt pans, have been dry for more than two thousand years.

Makgadikgadi, a vast wilderness of space and timelessness, comprises two huge saltpans, Sowa and Ntwetwe, as well as a number of smaller ones. Following summer rains,

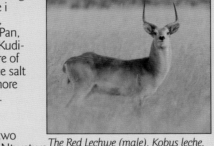

The Red Lechwe (male), Kobus leche, is a grazing species always found near water.

as these pans fill to a depth of a few centimetres, fish and aquatic shrimps that have been lying muddy and dormant suddenly come alive.

Drawn by a rich food supply, the pans are a significant breeding ground for flamingos, pelicans and, less frequently, waders. With the onset of the rainy season, these great thirstlands are transformed into vast sheets of shallow water which attract at their periphery not only a spectacular array of waterbirds, but also trigger the dramatic migrations of both wildebeest and zebra, which in turn attract an attendant range of predators: lion, cheetah and hyena. At this time of year large herds of giraffe, gemsbok and eland can also be viewed.

The northern sector of the Nxai Pan National Park consists of an extensive grassland plain covered with acacia and mopane trees.

Situated in the centre of the country, the **Central Kalahari Game Reserve,** was established in 1961. This is the second largest game reserve in the world and is characterised by vast open plains, salt-pans and ancient riverbeds. The topography varies from shrub-covered sand dunes in the north to flat bushveld in the central area. It is more heavily

The prevelant high temperature ensures rapid transpiration and evaporation, resulting in a cycle of rising and falling water levels.

To the south-east lie the **Makgadikgadi Pans** and **Nxai Pan** national parks, where both the dry and wet seasons result in a dichotomy: dramatic desert-like pans at their driest and their subsequent transformation into a water wonderland. Both parks

wooded in the south, where mopane forests predominant. Rainfall is sparse and sporadic. San, (Basarwa) Bushmen have been resident in this vast arid desert region for thousands of years. Originally nomadic hunters and gatherers, their traditional way of life has gradually changed with the times. They have come to live mainly in settlements, some, situated in the southern half of the Central Kalahari Game Reserve.

Since the 1990s, the government encouraged these people to move to areas outside the reserve so that they could be provided with modem facilities, including schools and medical clinics, as well as to integrate them into modern society. It

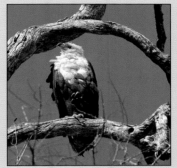

An African Fish Eagle, Haliaeetus vocifer, at a regular perch.

was moreover claimed that the Basarwa were a drain on financial resources, despite revenues increasing from tourism to the reserve.

In 1997 three-quarters of the entire San population was forcefully relocated from the reserve. In October 2005, the government resumed relocation of the remaining people into resettlement camps situated outside, leaving only some 250 permanent occupiers within its bounds. In 2006 a court ruling however proclaimed that the government had acted illegally in evicting thousands of Bushmen from their homes in the Central Kalahari and that it should allow one of Africa's most ancient peoples to return to the land their families had occupied for centuries.

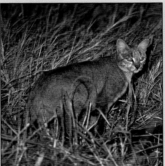

The African Wild Cat, Felis lybica, is a widespread solitary predator most active at night.

The **Kgalagadi Transfrontier Park** is situated in the south, adjacent to the border with South Africa and is Africa's first formally proclaimed trans-border conservation area. It was officially launched on 12 May, 2000 by then South African President Thabo Mbeki, and Botswanan President Festus Mogae. It incorporates a combined land area of about 38 000 km² of which 28 400 km² lies in Botswana and 9600 km² in South Africa. The absence of man-made barriers (except to the west and south) has provided a conservation area large enough to maintain examples of two eco-logical processes that were once widespread in the savannas and grasslands of Africa: the large-scale migratory movements of wild ungulates; and predation by large mammalian carnivores.

Two major concurrent environmental problems currently face Botswana: desertification and drought. Desertification predominantly stems from the severe drought that afflicts the country. Due to this condition 75% of the country's human and animal populations are dependent on groundwater. Although groundwater eases the effects of drought, it leaves a detrimental toll on the land. It is retrieved by drilling deep boreholes which give rise to land erosion. Surface water is very scarce and less than 5% of the country's agriculture is sustainable by rainfall. As a result 95% of the population raises cattle and livestock for income, and 71% of the country's land mass is given over to communal grazing. This has been a major cause for desertification.

Since raising livestock has proved so profitable, land exploitation continues unabated. Even the Okavango Delta, an ecosystem crucial to the survival of many animals, is suffering the effects and slowly drying up as a result.

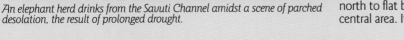

An elephant herd drinks from the Savuti Channel amidst a scene of parched desolation, the result of prolonged drought.

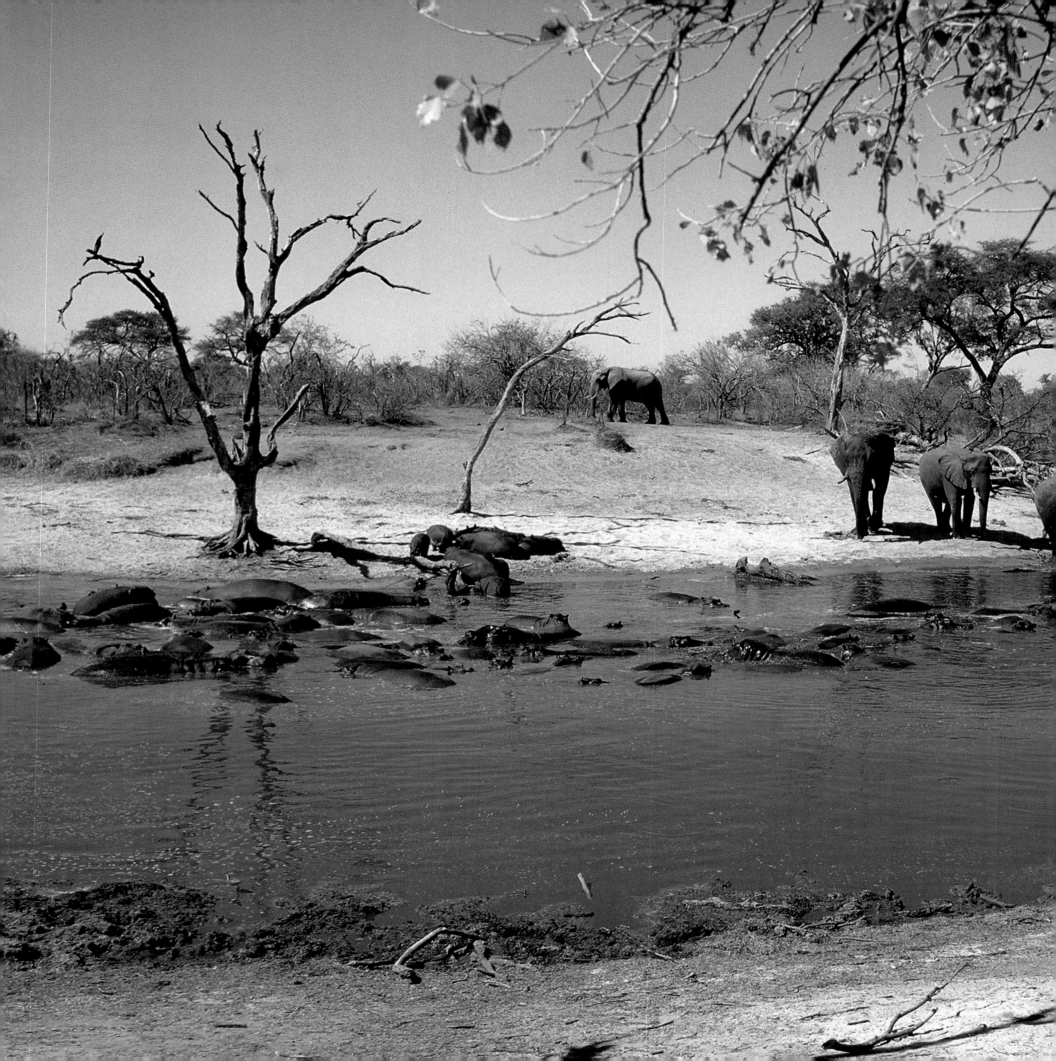

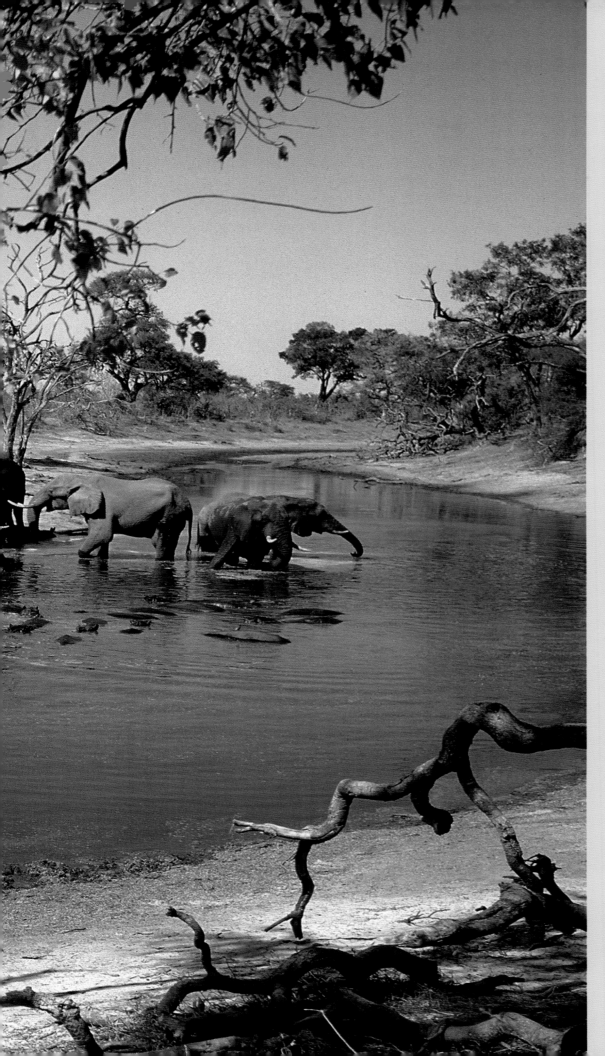

On his way to 'discover' the Victoria Falls in 1851, David Livingstone commented that the Okavango wilderness was a " dismal swamp". Sometime around 1888, however, these swamps began to dry up and they remained completely parched until 1957.

The moist highlands of central Angola are the source of two important south-flowing rivers, the Kwando and the Cubango in addition to all the northward flowing rivers that end up in the Congo. The Cubango becomes the Okavango River, which forms the Okavango Delta system in Botswana, while the Kwando flows southwards through Namibia's Caprivi Strip to eventually become the Linyanti River that forms the border between Namibia and Botswana.

In times of exceptionally high floods, the waters of the Kwando / Linyanti can even connect through to the Chobe River, which finally in turn joins the Zambezi River to find its way to the Indian Ocean.

These floods usually occur only every 30 years or so, and the waters of the Kwando will then fill the Savuti Channel and even the famed Savute Marsh in the Mababe Depression within northern Botswana's Chobe National Park.

The Savuti Channel starts at the Zibadianja Lagoon in the Linyanti Marshes and slowly meanders through Linyanti Wildlife Reserve and into Chobe National Park, finally filtering out into the Savute Marsh. Throughout its history, this channel has fluctuated from a flowing river to a dry ribbon of grassland. This fickle watercourse began to fill again in 1957 and these conditions prevailed until the early 1980s when once again it dried up.

Then, in 2006, late exceptional rains fell after years of drought and... "Life is pumping through the veins of northern Botswana's famed safari country – in the form of water" according to southern African safari pioneer, Colin Bell. For the first time since the early 1980s, "The Savuti channel made a push towards the Savute Marsh, weaving a ribbon of water through an otherwise arid region. This blast of fresh water brought to life normally harsh ecosystems, encouraging the growth of lush plantlife, which in turn spawned large populations of ungulates and the predators that hunt them. For the last 28 years the channel has been dry; but now the channel is once again flowing with water and elephants are happily frolicking, cats are swimming, wild dogs are chasing kudu through the channel, and lion and hyena are battling over kills in the shallow water."

The 2009 and 2010 seasons have again resulted in the Savuti flowing.

Chobe National Park follows the Okavango Delta as Botswana's second most renowned conservation area. The region's original inhabitants were San Bushmen, known in Botswana as the Basawara people. Like elsewhere where they roved, these nomadic hunter-gatherers left their mark in the region with characteristic rock paintings.

The proposal for a national park was first mooted in 1931. The following year 24 000 km² in the district was officially declared a non-hunting area. In 1943 heavy tsetse fly infestations however delayed further progress. Finally in 1960 Chobe National Park was proclaimed. The timber industry was gradually moved out of the park, but it was not until 1975 that the whole protected area was exempt from human activity.

The park is best known for its concentrations of elephant. It has the largest continuous surviving elephant population in Africa – over 120 000 individuals providing the highest elephant concentration on the continent, along with a healthy population of buffaloes, antelopes and predators.

These Chobe elephants moreover have the distinction of being the largest in body size of all living pachyderms. Nevertheless, few of them have large tusks, possibly due to calcium deficiency in the soils, and their ivory is brittle.

Chobe elephants are migratory, making seasonal movements of up to 200 km. Concentrating during the dry season between the Chobe and Linyanti rivers, they trek south-east towards the pans with the onset of the rainy season.

Currently the park is being considered for inclusion in the 'Five-Nation Kavango-Zambezi Transfrontier Conservation Area'.

Left: A group of elephants, and a large concentration of hippos take advantage of the cyclically diminishing waters of the Savuti Channel in Chobe National Park.
2. The hooded vulture *Necrosyrtes monachus* is an uncommon bushveld resident in the Chobe region.

BOTSWANA

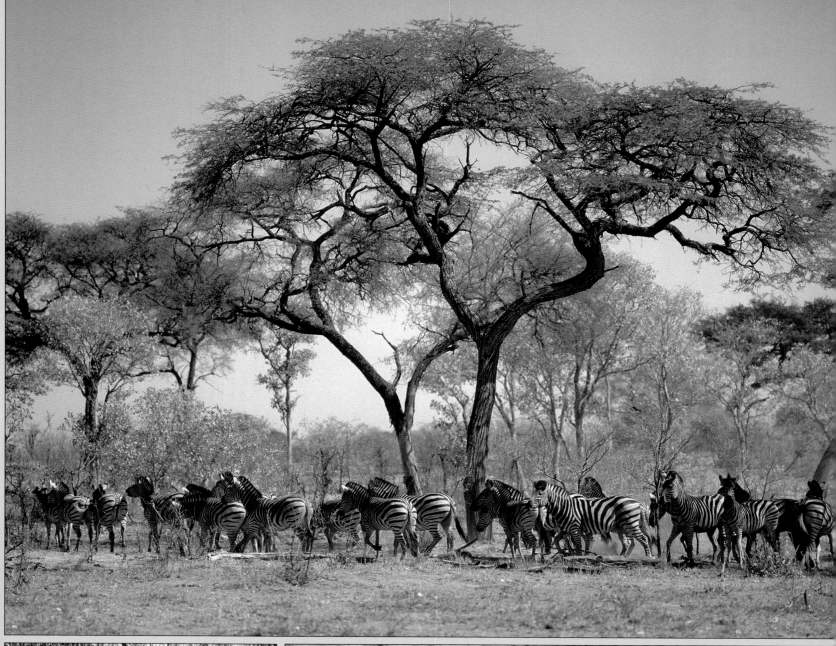

1. The aardwolf *Proteles cristatus cristatus*, is a small, insectivorous hyena whose diet consists almost entirely of termites, other insect larvae and carrion. Its name means 'earth wolf' originating from Dutch/Afrikaans.

2. A herd of Burchell's zebras *Equus quagga burchellii* pass through tall acacia woodlands in the Linyanti region.

3. Hippos *Hippopotamus amphibius* on the banks of the Okavango River at the delta panhandle.

4. A pod of hippos, attended by both yellow-billed and red-billed oxpeckers, at rest beside the Savuti Channel.

Far right: 5. A giraffe *Giraffa camelopardalis* spreads its slender forelegs to drink from the Savuti Channel. Ever wary of predators, giraffes are at their most vulnerable whilst drinking.

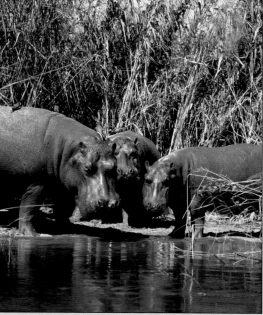

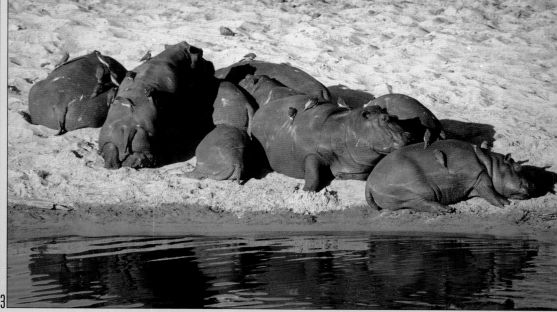

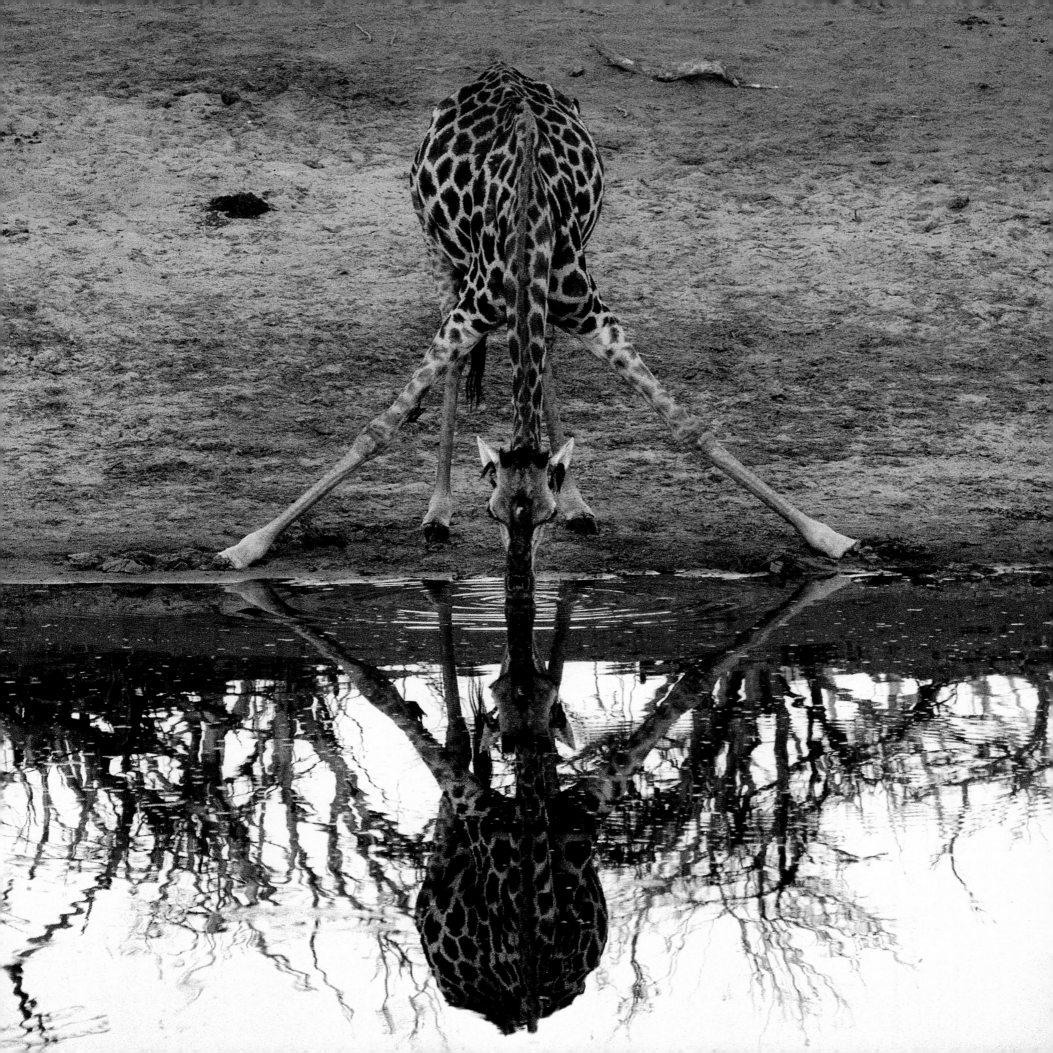

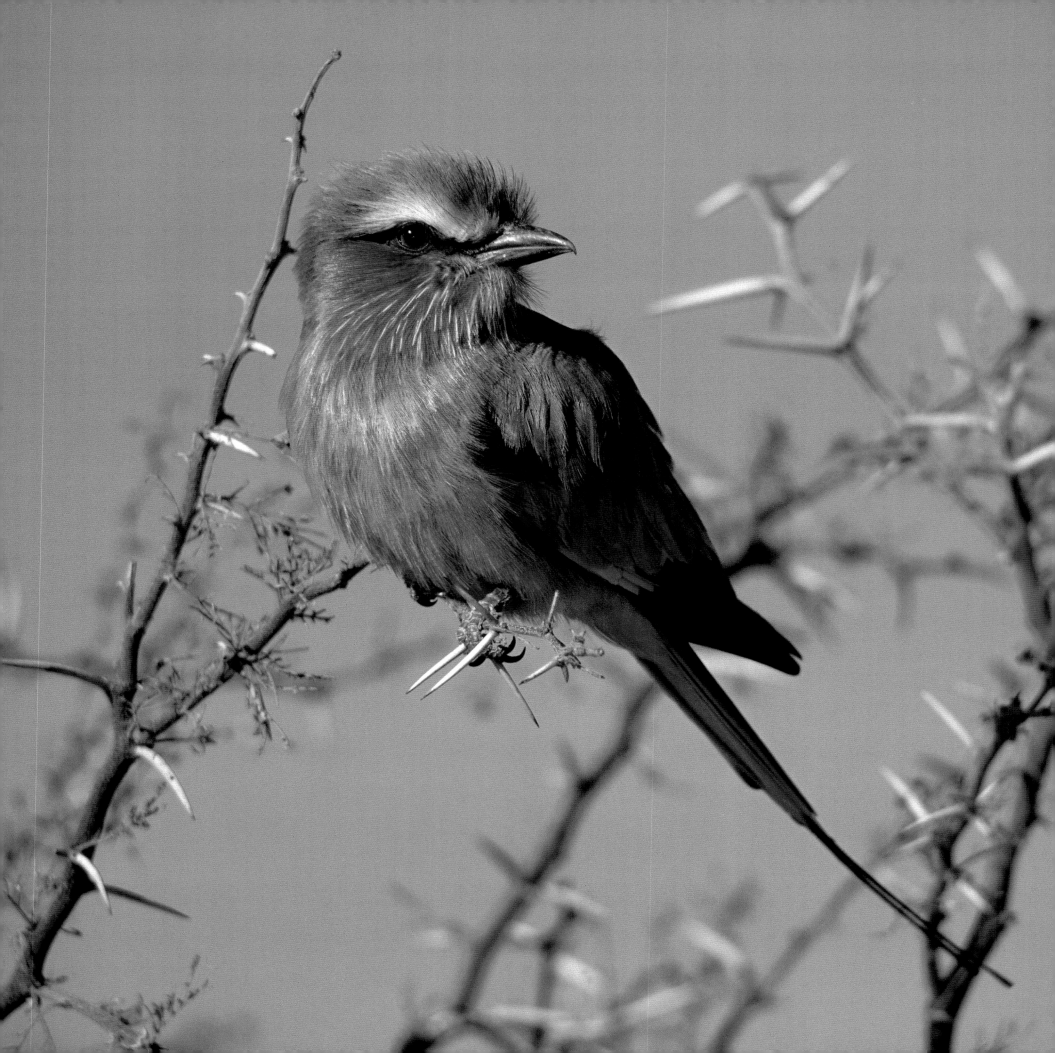

1. The scrub hare, *Lepus saxatilis*, feeds at night mainly on grasses. It has very long ears and well-developed hind legs.

2. A common resident [of the area]es, the lilac-breasted roller [Cora]*cias caudata* frequents [arid] bushveld, woodland and [grass]veld. Its blue wings, [beauti]ful in flight, led Mzilikazi, [king] of the Matabele, to reserve [the fe]athers for his exclusive use.

[T]he martial eagle *Polemaetus* [bellic]*osus* is a large raptor [with] a wingspan of up to 2.6 m. [It is a] shy elusive bird that [spen]ds most of the day on the [wing.] It soars high and has good [eyesi]ght, being able to spot prey [over] 5 km away.

[Me]dium sized mammals, [medi]um to large birds, reptiles [and c]arrion are its main food [sourc]es.

The stork's bill grows throughout its lifespan and can reach a length of 34.6 cm. This is a formidable weapon against competing scavengers, even hyenas and jackals.

The birds generally live in colonies. As scavengers, they are often seen in association with vultures, feeding on animal carcasses found in the bush. They have a rich diet ranging from aquatic animals such as frogs and fish to lizards, snakes and rats.

5. A troop of yellow baboons *Papio cynocephalus* move through the open woodland foraging for food. *Cynocephalus* literally means 'dog-head' in Greek and describes the shape of the primate's muzzle and head.

These baboons have slim bodies with long arms and legs and yellowish-brown hair. Their tails are nearly as long as their bodies. They resemble but are smaller than the Chacma baboon, and their muzzles are not as elongated. The hairless face is black and framed with white sideburns. Males grow to about 84 cm and females to 60 cm.

Yellow baboons are a terrestrial diurnal species inhabiting savannas and light forests. These primates lives in complex mixed gender social groups, from eight to 200 individuals.

They are omnivorous but have a preference for fruits. Plants and large insects also feature in their diet.

Baboons play three important roles in their natural environment: serving as food for larger predators; aiding in seed dispersal due to their messy foraging habits; and as efficient predators of smaller animals and their young, thereby keeping some animal populations in check.

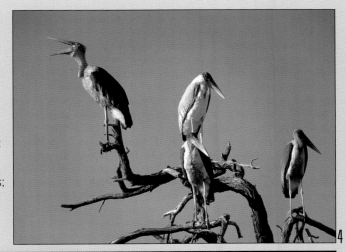

[Th]e eagle has a wide [distri]bution, preferring savanna [and b]ushveld, but is also found [in se]mi-desert.

[Th]e generic name is derived [from] the Greek *polemos* meaning ['war'] and *aetos*, 'eagle', and the [speci]es name *bellicosus* is Latin [for 'w]arlike', a combination that [is we]ll suiting this aggressive [hunt]er.

[M]arabou storks *Leptoptilos* [crum]*eniferus* are large but [usefu]l scavengers with balding [scab]by heads and pendulous [throat] air sacs. To the [unin]itiated they appear as one of [the w]orld's ugliest creatures.

[M]arabous stand up to 1.5 m [in he]ight, and with a wingspan [appr]oaching 2.9 m they are one of [the w]orld's largest flying birds.

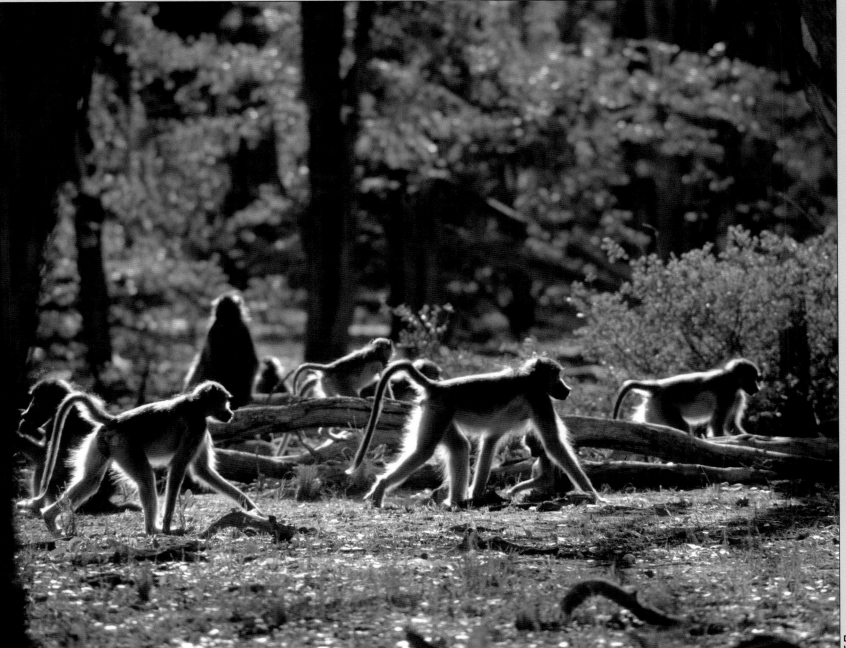

1. A summer migrant from North Africa, Abdim's stork *Ciconia abdimii* is often seen in large flocks together with White Storks. The green bill and white back distinguish this species from the Black Stork.

2. A marsh owl *Asio capensis* sits over the remains of its kill. This raptor has a round to oval face surrounded by a dark rim, and patches around its eyes that make them appear huge. This is the only gregarious owl which gathers in flocks during the non-breeding season. It hunts before sunset from a favoured perch, sometimes catching surplus prey for later consumption.

3. A pair of saddle-billed storks *Ephippiorhynchus senegalensis* on the banks of the Okavango River. With a striking black-and-red banded bill with yellow saddle at the base, this stork is unlikely to be confused with any other. Sometimes seen striding over grasslands, it is always found near water where it feeds on crabs, shrimps, fish, frogs, small mammals and young birds. This stork has the unusual habit of often tossing its prey into the air before catching and then devouring it.

4. Another summer migrant, the African openbill *Anastomus lamelligerus* feeds on water snails and fresh-water mussels as it wades through the swamps It probes beneath the water, often with its head completely submerged.

5. With talons outstretched, an African fish-eagle *Haliaeetus vocifer* swoops low to grasp an unwary fish.

6. A huge herd of African buffalo traverse the delta plains on the way to fresh grazing grounds.

Far right: 7. An aerial view of the Okavango River and flood plain at the delta panhandle. Two recent oxbow lakes, now detached from

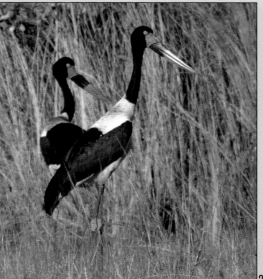

the river, are clearly visible. These crescent-shaped oxbow lakes (often temporary) form when a bend in a river is cut off from the main channel by erosion and silt build-up. As soil erodes and re-deposits, the river's original course is changed and an oxbow lake is slowly created. The bend eventually becomes isolated from the river's path. Once water stops flowing in the former river bed, sediment builds up in the lake and this becomes first a wetland and then a meadow. Finally trees take root. This process is known as 'succession', and what was once a river course eventually becomes a forest.

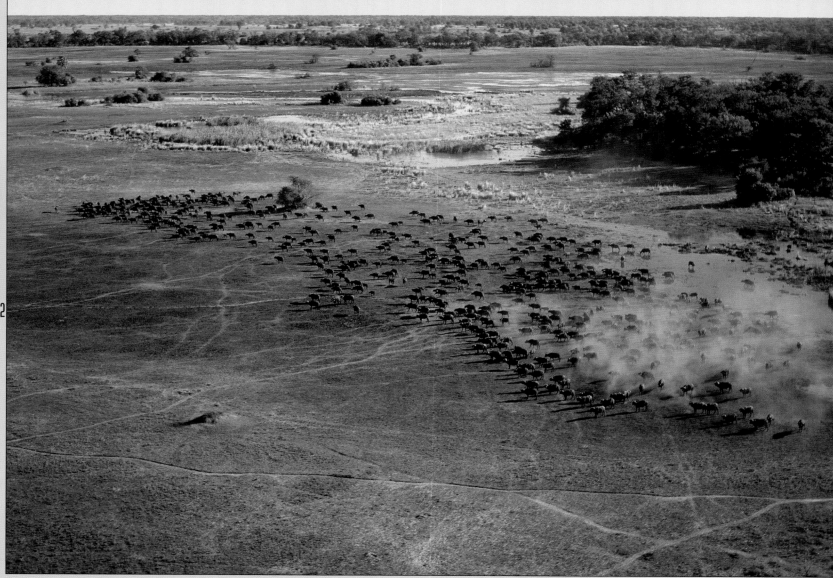

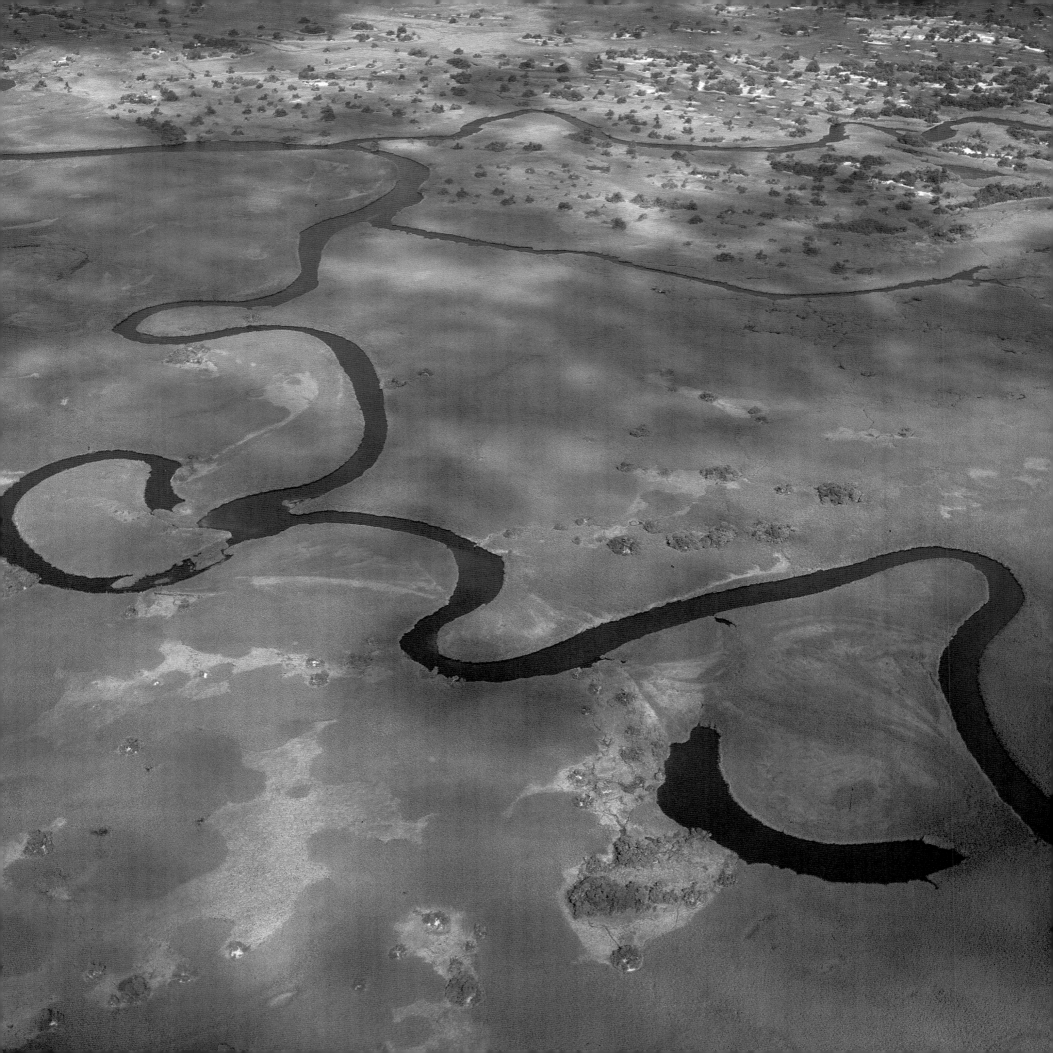

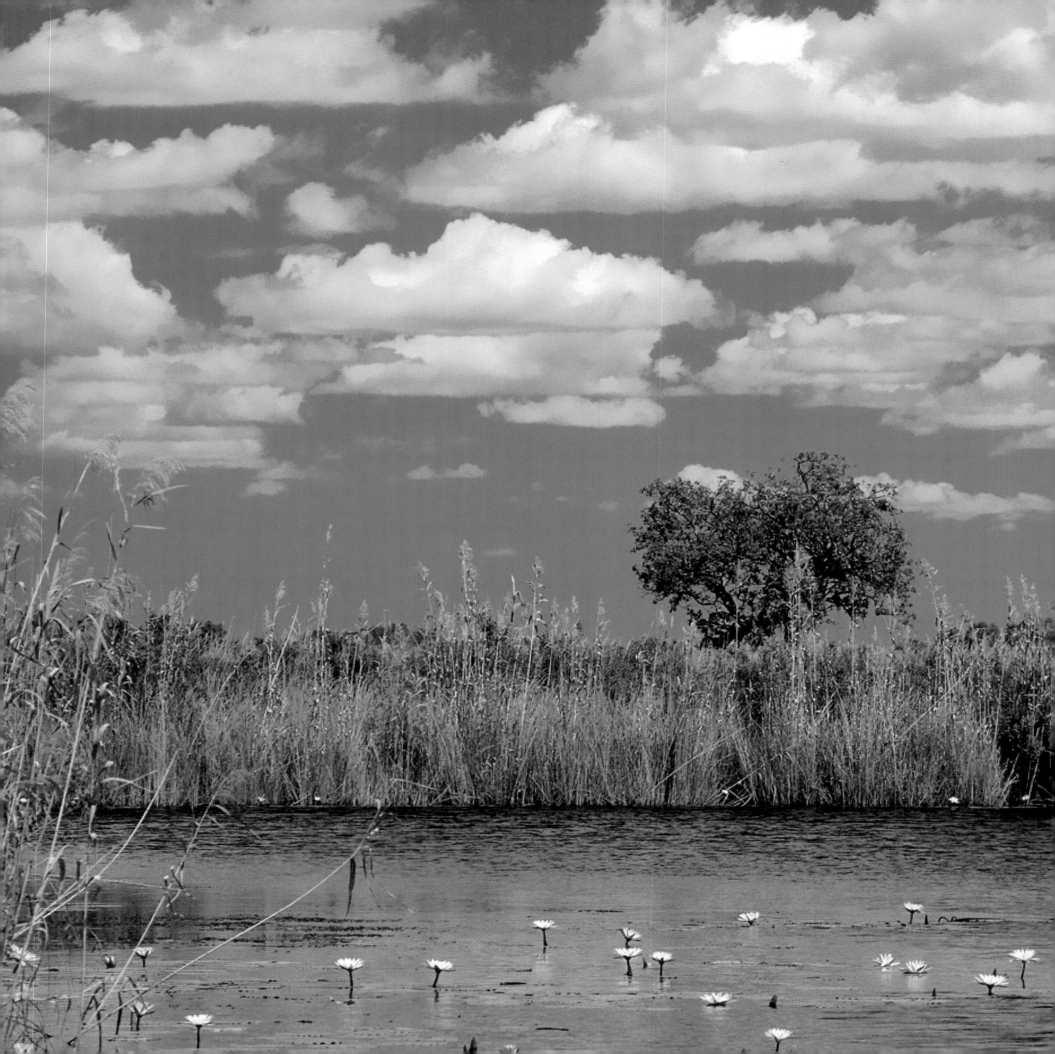

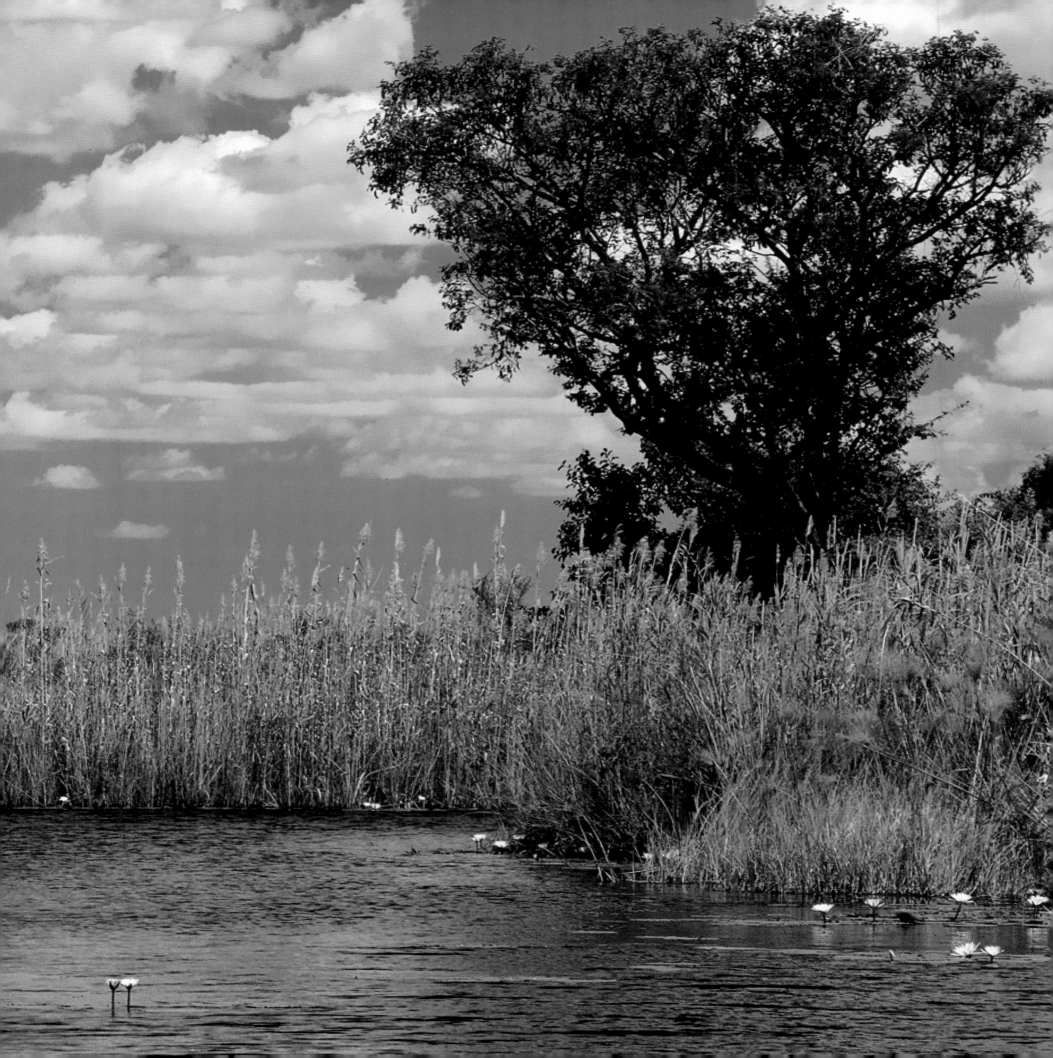

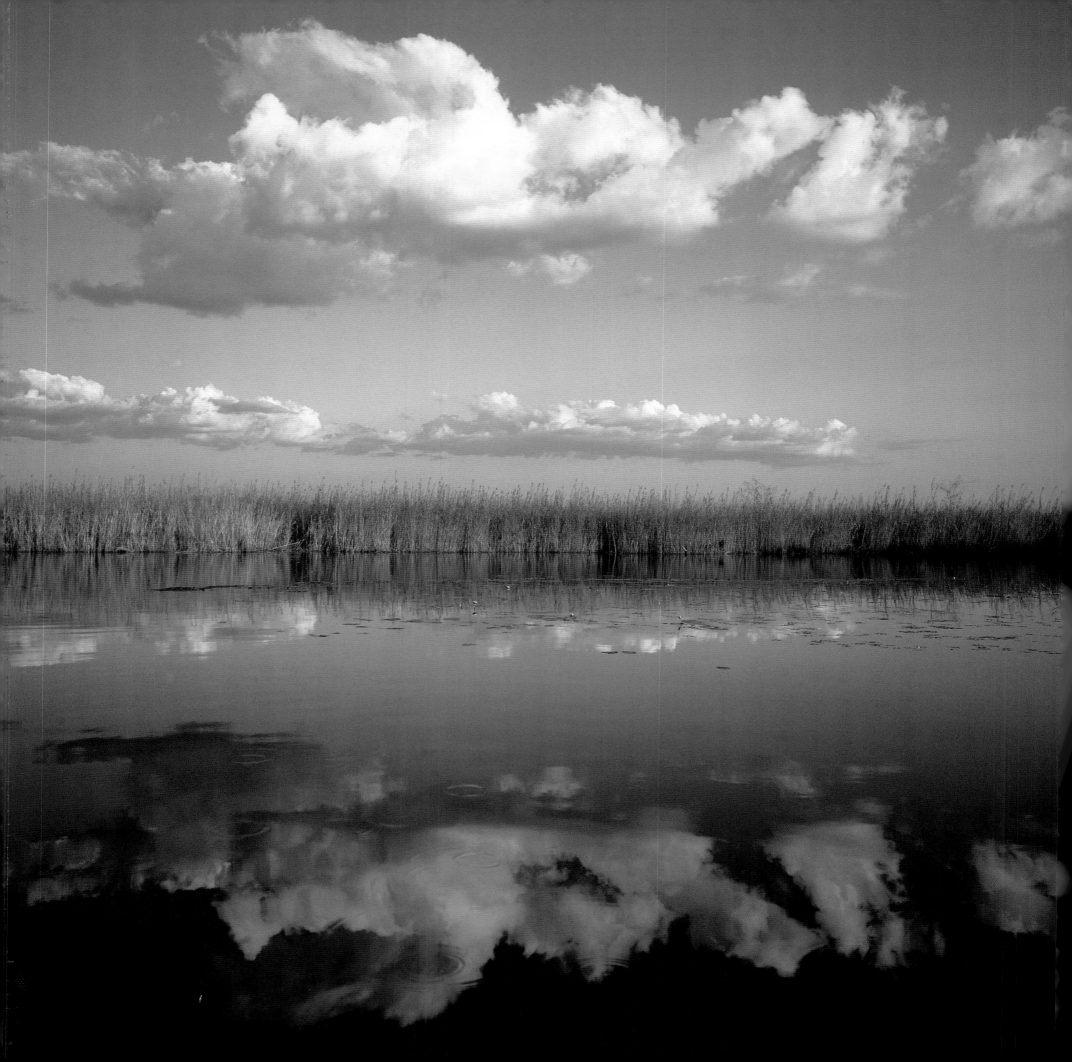

1. Little bee-eaters *Merops pusillus* are the smallest of the bee-eaters in southern Africa. Favoured hunting perches are returned to day after day.

ft: 2. Papyrus swamps ch along the banks of a quil backwater channel in Okavango Delta.

3 An Angolan reed frog *erolius angolensis*.

4 flowering *Crinum* lily.

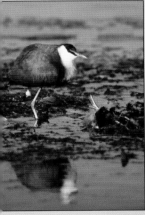

5 African jacanas *ophilornis africanus*, also wn as lily-trotters, possess extended toes that are well pted to walking across ting vegetation. In the heart of the delta.

revious page: The Kwando r, here with a scattering of erlillies, forms the border ween Botswana and mibia.

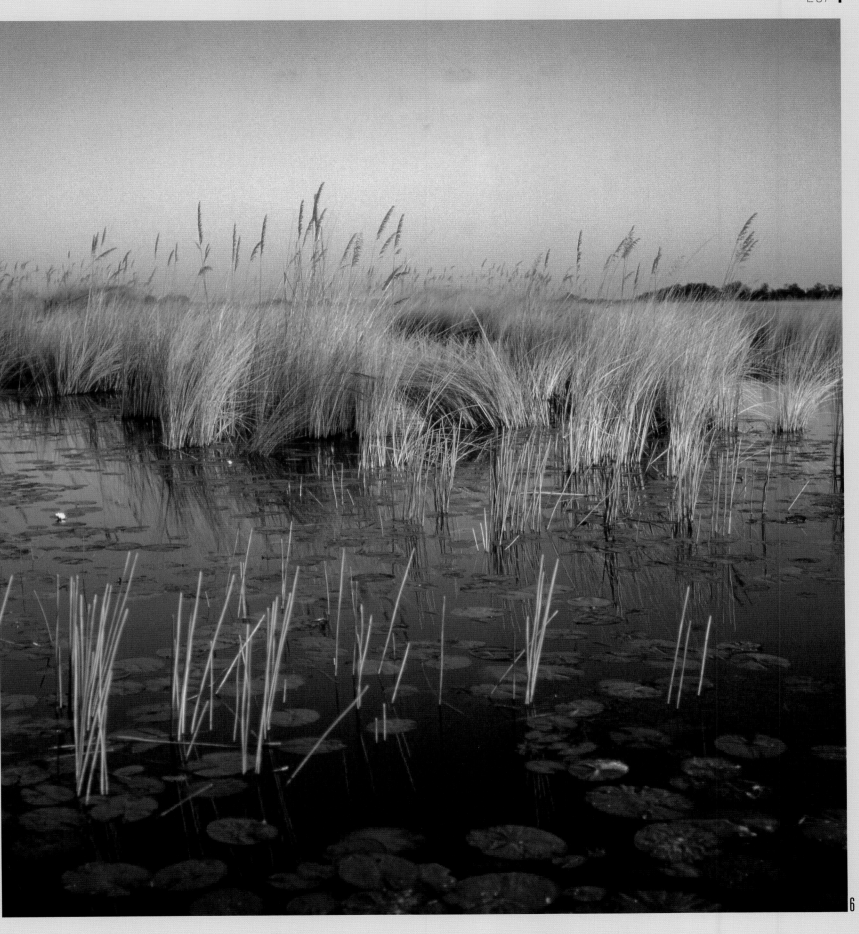

6

Mysterious, placid and beautiful, the Okavango spreads through tiny, almost unnoticeable channels that creep away behind walls of papyrus reeds into an ever-expanding network of increasingly smaller passages. These in turn link a succession of lagoons, islands and islets of various sizes, open grasslands and flooded plains in a mosaic of land and water. Towering palms and trees abound, throwing shade over crystal clear pools, forest glades and grassy gentle hillocks. More than 400 species of birds flourish in this pristine environment.

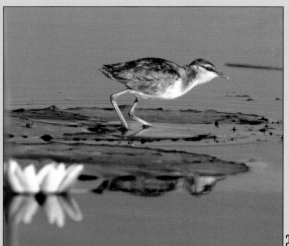

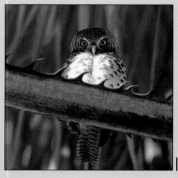

1. The African barred owlet *Glaucidium capense* is small, about 20 cm in length. As its name suggests, it has barring on its upper parts just below the head and on its back, wings and tail. These owls prefer bushveld and mature open woodland with taller trees and form territorial pairs. They feed mainly on insects.

2. The lesser jacana *Microparra capensis* is smaller and less common than the African Jacana.

3 Much feared as a man-eater throughout Africa, the nile Crocodile *crocodylus niloticus* is the best known of the four crocodile species found in Africa. This reptile's distribution extends from Egypt to South Africa, where it frequents rivers, lakes, waterholes, mangrove swamps, estuaries and freshwater marshes. Crocodiles have voracious appetites, feeding on any animal that comes to quench its thirst, including zebras, wildebeest, impala, even hippos, as well as porcupines, pangolins – and birds. They will even eat other crocodiles and carrion. Fish however comprise their principal diet.

4. A flight of African skimmers *Rynchops flavirostris* take off from a sandbank. These long-winged birds with conspicuous flattened red bills skim so low over the water that they can dip their bills below the surface when a fish is seen. Skimmers usually fly at dusk and dawn, and occasionally on moonlit nights. They rest on sandbanks when not feeding.

Far right: 5. Pel's fishing owl *Scotopelia peli,* is an uncommon localised resident in the Okavango region. In contrast to the the african barred owl, it is large and distinctive (about 63 cm in length), with a flattish face and very slight, if any, sign of ear-tufts. Large dark brown eyes dominate the face. Nocturnal, this owl usually occurs in pairs, sometimes accompanied by a single fledgling. It hunts from a perch about 2 m above the water; and much like the fish-eagle, swoops down to seize a fish.

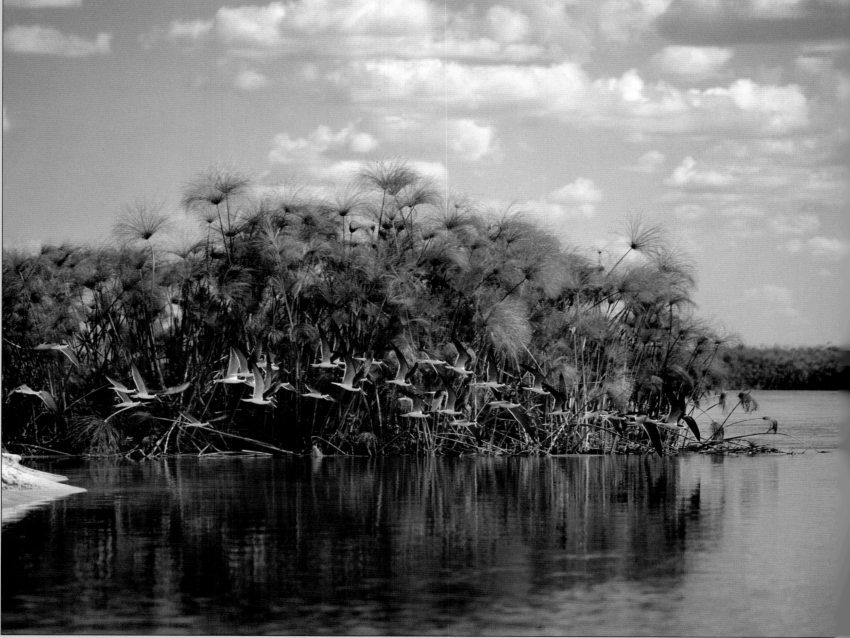

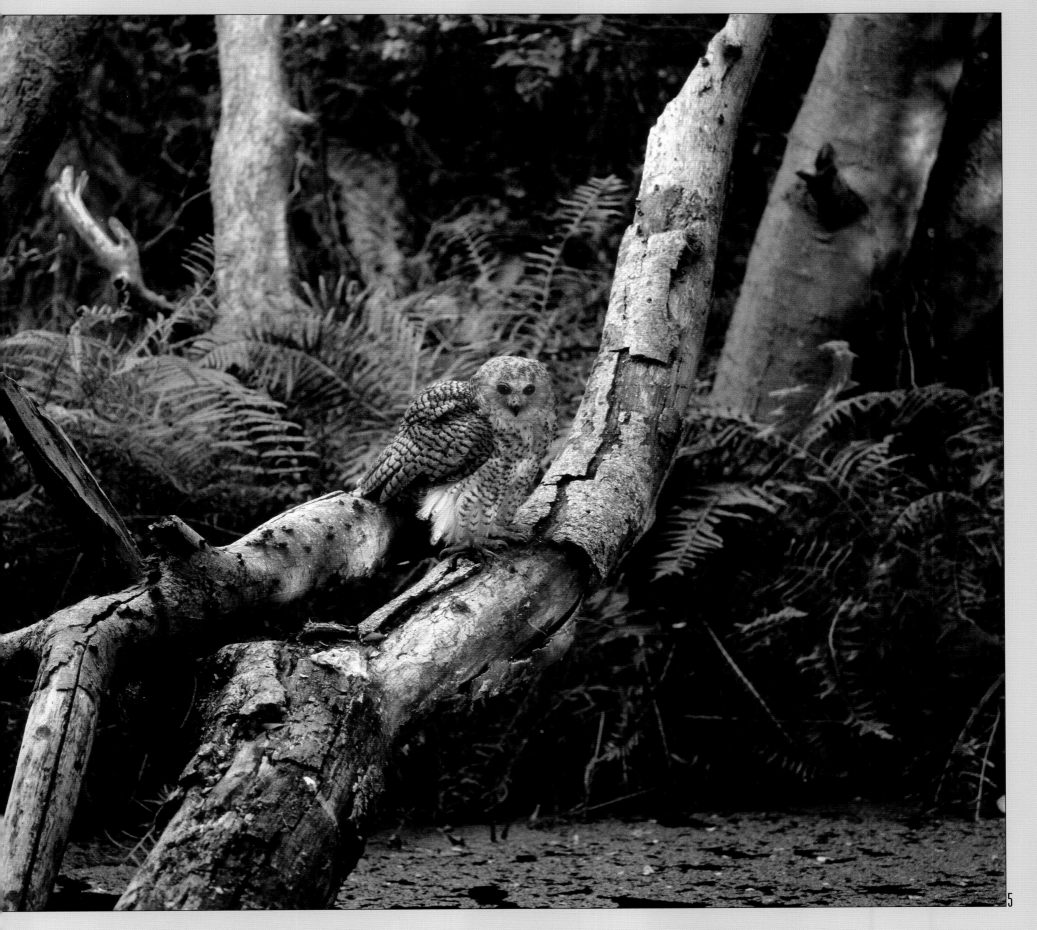

White-backed ducklings
Thalassornis leuconotus glide
effortlessly through the reeds.

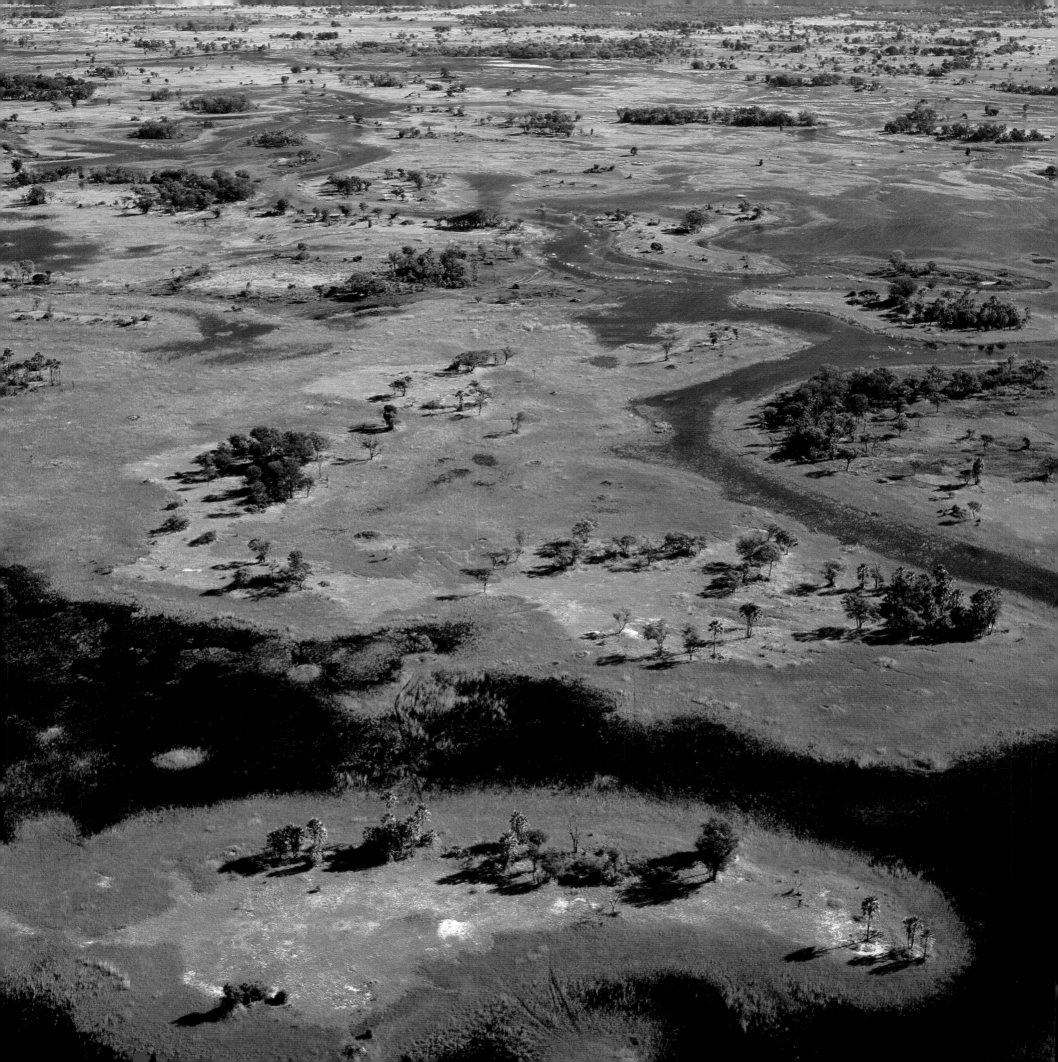

Seasonal flooding is a crucial aspect of the delta system, occurring in mid-summer in the north and ng some six months later he south. The nature of the ds is gentle, with islands and dplains disappearing under er and re-emerging at the of each season. This is ecially pronounced in the tral Okavango. The river vides a rich and varied system for wildlife, including 400 species of birds.

1. The Okavango, a vast lerness of waterways rsecting a maze of seasonal nds, stretches as far as the can see. Once part of Lake Makgadikgadi, an ancient lake that dried up some 10 000 years ago, it is today the world's largest inland delta.

2. The diminutive malachite kingfisher *Alcedo cristata* inhabits reedbeds surrounding freshwater lakes and along streams and lagoons. It feeds on small fish, frogs, tadpoles, beetles and grasshoppers.

3. A goliath heron *Ardea goliath* hunts amongst the reeds for its regular prey of fish and frogs.

4. A Tswana herdsman drives his cattle alongside the banks of the Thamalakane River.

5. An egret settles in for the night at its roost in the reeds, as dusk silhouettes a passing flight of African sacred ibis *Threskionis aethiopicus*.

3

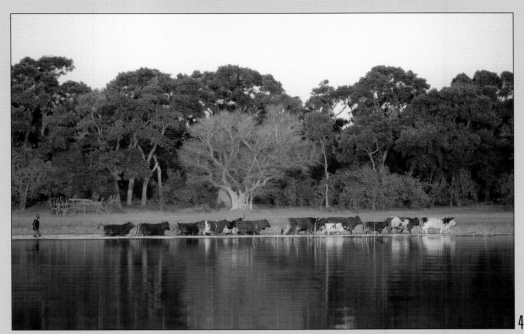

4

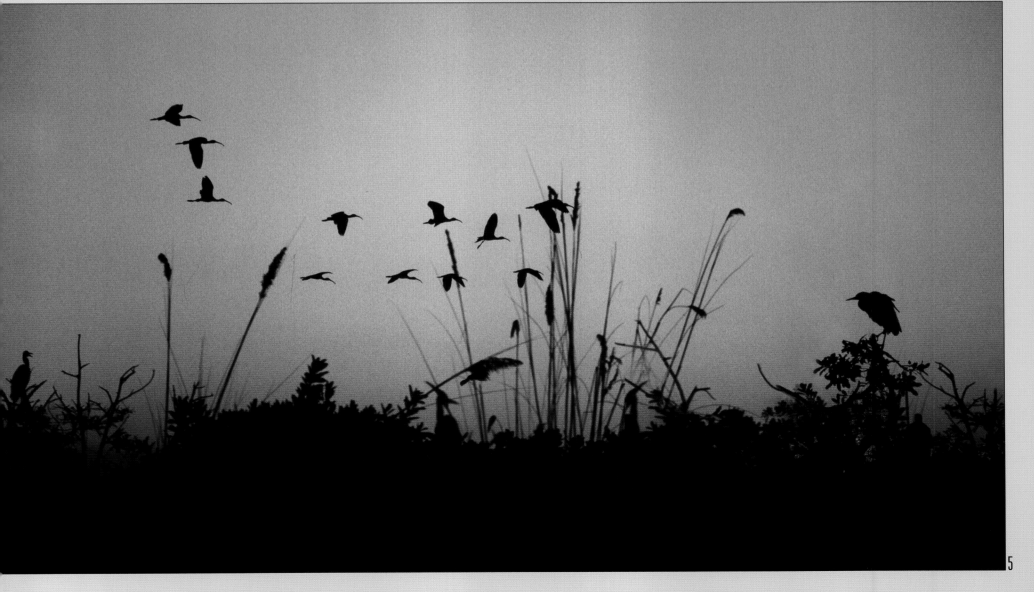

5

1. A lonely track through dry scrub grasslands leads to the distant Makgadikgadi Pans.

2. The springhare *Pedetes capensis* a nocturnal rodent with kangaroo-like appearance, is a common resident in the arid wilderness of central Botswana. It has strong hind legs which are used for hopping. During the heat of the day it shelters in burrows excavated with its short forelegs.

3. A yellow mongoose *Cynictis penicillata* (the grey northern subspecies) stands alert beside its burrow in the Makgadikgadi Pans.

4. Mopane woodland in the Nxai Pan National Park. Mopane *Colophospermum mopane* is a tree species widespread throughout the hot, low-lying regions across the northern parts of southern Africa

5. Drought and desolation: the remains of a gemsbok at the edge of a desolate salt pan in central Botswana.

6. Fallen baobab fruits.

Right: 7. Alone in the wildern a solitary baobab *Adansonia digitata* overlooks the empty expanse of the Kudiakam Pan

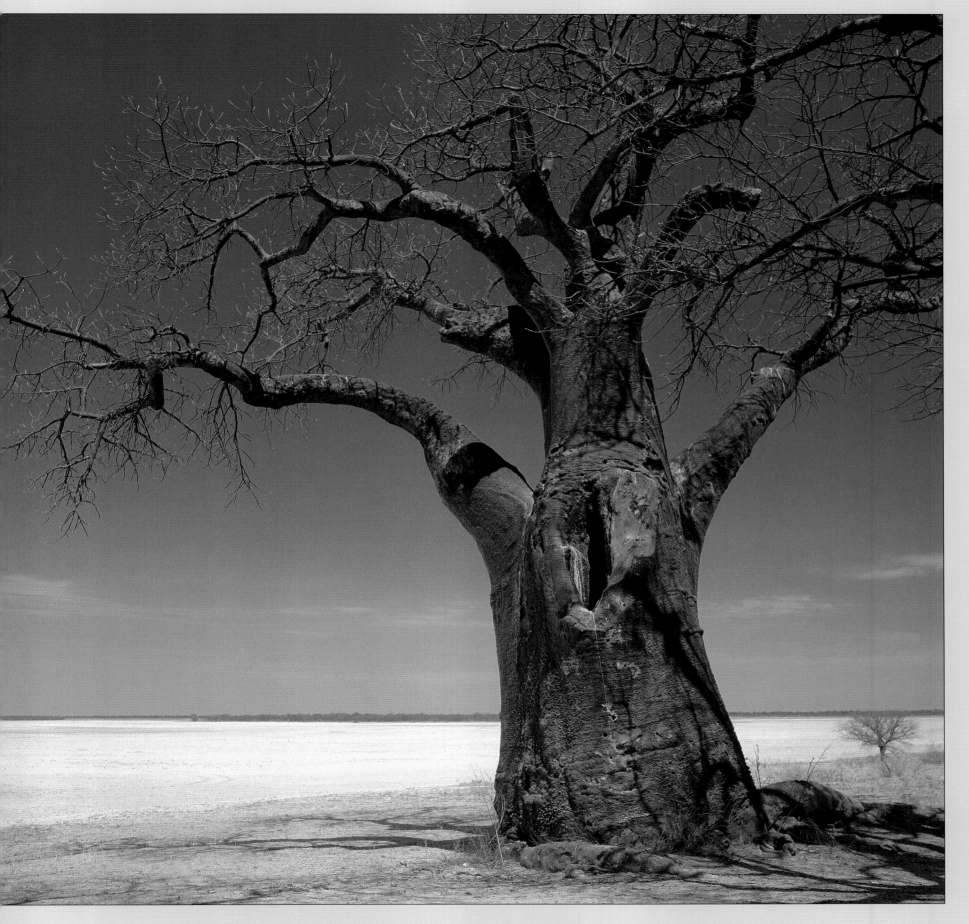

BOTSWANA

NAMIBIA

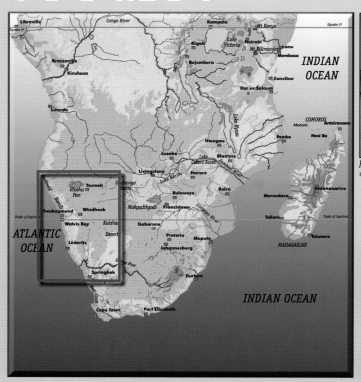

Herero women in traditional dress.

The country has a landmass of 825 418 km² and is bounded on three sides by water. Apart from the Atlantic Ocean, the northern and southern boundaries are formed by rivers: the Kunene and Cuando/Okavango in the north and the Orange in the south.

Namibia is graphically described by Johann Richter in the introduction to *"South West"* Gerald Cubitt's first book on this country, (Struik 1976) :

"There is a vast land sprawled along southern Africa's Atlantic seaboard astride the Tropic of Capricorn... In this mystic land man and beast, flora and fauna, have somehow managed to survive and multiply in precarious inter-dependance. To me this has always been an enchanting place, a place to capture the spirit, and I have returned there again and again. Now more than ever before it is also a land of contrasts, where jack-hammers shatter the desert silence and primitive rhythms mingle with the whine of jet engines."

Moving south, the Central Plateau is bordered by the Skeleton Coast in the north-west, the Namib Desert and its coastal plain in the south-west, the Orange River to the south, and the Kalahari Desert to the east. The roof of Namibia is found here at Königstein, the highest peak of the Brandberg (2606 m). The majority of Namibia's population lives in this region and it is within this wide, flat plateau that most of Namibia's economic activity takes place in and around Windhoek, the nation's capital. Almost half of the population is employed in agriculture, yet arable land accounts for only 1% of Namibia's landmass. The abiotic

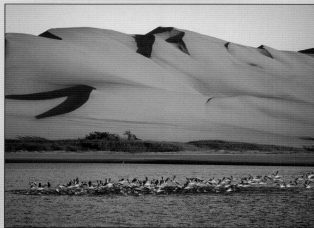

A flock of lesser flamingoes Phoenicopterus minor *takes off from the lagoon at Sandwich Harbour.*

conditions here are similar to those found along the Escarpment, the topographic complexity is reduced. Summer temperatures here can reach 40 °C, and frosts are common in winter.

The Great Escarpment divides the Central Plateau from the Coastal Desert. In this region, the average temperature and actual range of temperatures increase, being further inland and away from the cool Atlantic waters. Lingering coastal fogs slowly diminish. Although the area is rocky with poorly developed soils, it is nonetheless significantly more productive than the Namib Desert. Moisture is extracted in the form of precipitation as summer winds are forced over the Escarpment. This, along with the rapidly changing topography, is responsible for the creation of micro-habitats which give rise to a wide range of organisms, many endemic. Vegetation along the escarpment varies in both form and density, with community structure ranging from dense woodlands to more shrubby areas with scattered trees. Several acacia species are found here, as well as grasses and other shrubby vegetation.

The Namib Desert consists of a huge expanse of hyper-arid gravel plains and dunes that stretches along Namibia's entire coastline and varies between approximately 10 and 170 km in width. Divisions within the desert include the Skeleton Coast and Kaokoveld in the north and the extensive Namib Sand Sea in the central region. Interestingly, the sands that make up the 'sand sea' result from processes of erosion that take place in the Orange River valley and areas further to the south. As sand-laden waters drop their suspended loads into the Atlantic, onshore currents deposit them along the shore. Prevailing south-westerly winds then pick up and redeposit the sand to form, over time, massive dunes; at Sossusvlei they are the largest in the world. These dunes are ever-changing, ever-moving.

Prevailing winds play yet another role: whichever way they blow the slipface moves to the opposite side, as if seeking refuge. When a wind suddenly gusts from another direction the slipface changes just as suddenly, even sometimes to disappear and reappear later again under the influence of another wind. Where there is a constant wind from a single direction offshore, transverse dunes, like mimics of ocean waves, are formed and ripple symmetrically along the coast. Where the supply of sand is reduced because of the inability to cross riverbeds, the winds scour the land to form large gravel plains

Hartmann's mountain zebras Equus zebra hartmannae *gallop along a dusty gravel plain in the Namib-Skeleton Coast National Park.*

The cold Benguela current surges up from the Antarctic, past the Western Cape coast, to play a major role in shaping the ecology of Namibia. Most mornings a thick, sometimes foreboding fog moves inland over this inhospitable shoreline, often not lifting until late afternoon. But this is not a negative aspect, as the fog, which stretches inland some 50 km, brings life-giving moisture to desert creatures as it condenses. The formidable offshore current brings shoals of pelagic fish that provide the staple for many marine bird species. Man, as always the greatest predator, has however brought mechanisation to the fishing industry and this once-rich source of protein is today becoming dangerously depleted.

A young San Bushman woman.

In winter, harsh gales and dangerous currents wreak havoc along these shores. The strip that separates the plateau from the ocean in the north is aptly known as the Skeleton Coast, a shore of mainly desert sands and ever-shifting dunes on which are scattered bleached bones and skeletal shipwrecks. This region, together with the rest of the coast from the Kunene River in the north to the Orange in the south, a 1570-km-long shoreline, has recently been combined into a new National Park (the Namib-Skeleton Coast National Park). This vast wilderness embraces the Namib Desert, the world's oldest. To the east lies the Kalahari, and between these two deserts the Great Escarpment and Central Plateau that rise to over 2 000 m.

Geographers generally divide the landmass into five geographical areas, each with characteristic conditions and vegetation (though with some overlapping variations) the Namib Desert, the Great Escarpment, the Central Plateau, the Bushveld and the Kalahari Desert.

Yellow-billed hornbill Tockus flavirostris.

The Bushveld extends across the north-east of the country, along the Angolan border and into the finger-like Caprivi Strip (a narrow corridor demarcated for the German Empire to access the Zambezi River during the 'scramble for Africa'). This region receives a significantly greater amount of precipitation than the rest of the country, averaging 400 mm per year. Here, temperatures are also cooler and more moderate, with approximate seasonal variations ranging between 10 and 30 °C. The Bushveld is generally flat with sandy soils that have a limited ability to retain water.

Etosha Pan and the eponymous national park lie in the north-western Bushveld: For most of the year this is a dry, saline 'waste-land', but during the wet season a shallow lake forms covering over 6000 km². This area is ecologically important and vital to the huge numbers of animals and birds from the surrounding savanna that gather here as winter drought forces them to the many scattered waterholes that ring the pan. Namibia's northern Bushveld has been demarcated by the WWF as part of the Angolan mopane woodlands ecoregion which extends north across the Kunene River into neighbouring Angola.

Mopane trees Colophospermum mopane *surrounded by a carpet of Tribulis zeyheri flower after summer rains in Damaraland.*

tation is sparse in most areas of the Namib Desert, aside from
ns and seasonal grasses that are found in the gravel plains and
y river beds where plants access subterranean water.
dy beach comprises 54% of the shoreline, and mixed sand and
form another 28%. Only 16% of the total length consists of
shoreline.
mibia has rich coastal and marine resources many of which
emain to be explored. One resource that has been thoroughly
red: diamonds. The Namib provides one of the richest sources
e world of these precious stones.
e Kalahari Desert, shared topographically with South Africa and
wana, embraces a variety of localised environments ranging from
y desert to areas that seem to defy the common definition of
t. The relatively stable nature of precipitation lies behind high
uctivity and plant endemism. Virtually an extension of the Karoo,
Kalahari does not experience drought on a regular basis. Though
rea is technically desert, regular winter rains provide enough
ture to support the region's interesting plant community.
e Khoisan were the first people to imprint their footsteps on
and, as in most other southern African countries. There were
e who moved along the coast, leaving their middens for us to
er over. They lived on fish until the seasonal rains came, when
moved inland. Another group, pastoral invaders from north-
Africa and the equator, came southward with their longhorn
e and fat-tailed sheep. And a third group moved up across the
ge River from South Africa some 200 years ago. Today most are
loyed as farm labourers and only a very small remnant live the
tional life.

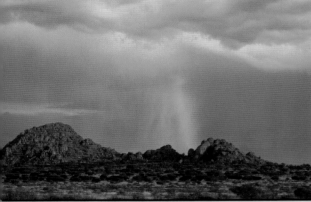

n clouds breached by a transient rainbow offer promise of welcome rain
e parched veld in southern Namibia.

Himba, an ethnic group of about 20 000 to 50 000 people, live
orthern Namibia in the Kunene region (formerly known as the
koveld). They are mostly a nomadic, pastoral people, closely
ed to the Herero. They migrated away from Egypt in the
century and speak Otjihimba, a dialect of the Herero language
originated in the Nile Valley region of Egypt.
e Nama peoples (13 clans) live in the south and midlands,
ing and preserving ancient crafts and musical traditions.

rtuguese seafarers originally
ted the wild and desolate
eline during the 15th century.
h later the Dutch and
sh took commercial interest in
vis Bay and the guano islands
he south. But it was left to
Germans and their Rhenish
sionaries and Lutheran pastors
ctually establish settlements
is hostile and forbidding land
others feared.
1884, as a result of the
gress of Berlin and the
comitant 'scramble for Africa',

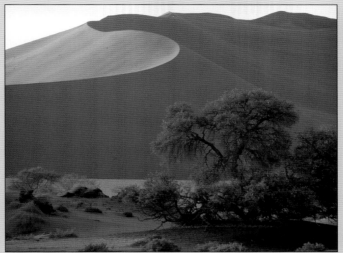

The graceful curve of a Sossusvlei dune catches the late afternoon sun.

Germany proclaimed the territory a protectorate and it remained
an Imperial German colony until 1915 when, during the First
World War, South African forces overran it. In 1920, the League
of Nations mandated the territory to South Africa and it became
known as South West Africa. South Africa thereupon imposed its
laws, including from 1948 the policy of apartheid.

In 1966, the International Court of Justice dismissed a complaint
brought by Ethiopia and Liberia against South Africa's continued
presence in the territory. However, in 1971, the court issued an
'advisory opinion' declaring South Africa's continued administration to
be illegal. This resulted in the formation of the South West Africa
People's Organisation (SWAPO), a guerrilla group that began an
armed struggle for independence. South Africa still maintained
de facto control of the administration until October 1989,
when the United Nations supervised Namibia's first-ever popular
and democratic election (one-person, one-vote). This was
overwhelmingly won by SWAPO. The territory officially gained its
independence on 21 March 1990 with Sam Nujoma sworn in as
the first elected president of Namibia.

Namibia stands apart when it comes to making the most of its
natural resources and implementation of conservation policies.
It was the first African country to incorporate protection of the
environment into its constitution. This was reinforced by giving its
diverse communities the opportunity and rights to manage wildlife
resources through communal conservancies. These communities
came to see wildlife as a valued livelihood asset, and vast tracts
have been set aside as wildlife management conservation areas.
Poaching, as a result, is no longer viewed as socially acceptable.

WWF's coordination of the 'Living in a Finite Environment' (LIFE)
programme in Namibia is part of a larger community-based natural
resources management programme designed to assist rural
communities in directly managing and benefiting from wildlife on
their lands. The translocation of buffalo, impala and sable from
Mahango National Park to community-run conservancies in Caprivi
is one such example. The Chee-
tah Conservation Fund (CCF)
also plays an important role,
allowing volunteers to work with
all stake-holders.

The government strictly
enforces conservation laws. All
major black rhino populations
are monitored. Individuals of this
endangered species are placed
on approved freehold game farms
and conservancies.

An integrated Coastal Zone
Management System for
Namibia's coast was established

The Spitzkoppe, a spectacular granitic outcrop that rises some 700 m above
the plain.

in March 2006. It is intended that this will improve awareness about
coastal biodiversity, environmental problems and the value of
the coast itself.

National parks that have to date been established in Namibia
include the Namib-Skeleton Coast National Park, which covers
107 540 km^2; and the world renowned Etosha National Park. Smaller
parks include Kaudom, a remote and relatively inaccessible reserve
bordering the Kalahari in the north-east, and Bwabwata, Mudumu
and Mamili national parks in the Caprivi region, which are currently
being considered for inclusion in the five-nation Kavango–Zambezi
Transfrontier Conservation Area. The popular Waterberg National
Park is situated on the plateau. Black rhinos were reintroduced to this
conservation region in 1989.

The |Ai-|Ais/Richtersveld Transfrontier Park, proclaimed in 2003, is
a peace park that straddles the border between Namibia and South
Africa. It combines the former IAi-IAis Hot Springs Game Park and
the South African Richtersveld National Park. The park includes the
southern sector of Fish River Canyon, the world's second largest after

Sun-baked dry mud on Etosha Pan—
beauty in abstraction.

Hoodia gordonii is a desert succulent
renowned for its medicinal uses.

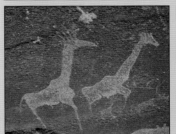

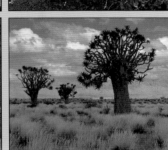

Ancient stone etchings of giraffe at
Twyfelfontein.

Kokerboom or quiver, trees
Aloe dichotoma.

the Grand Canyon in the United States. The Fish River, Namibia's
longest interior river, cuts deep into the southern plateau leaving a
dry and stony canyon. The river flows only intermittently, though it
often floods in late summer. For the rest of the year it forms a chain
of long disconnected pools.

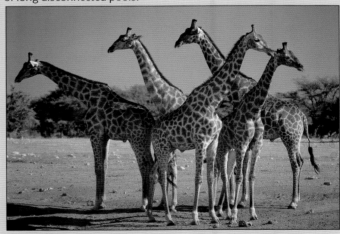

Giraffes Giraffa camelopardalis angolensis beside the Chudob waterhole in
Etosha National Park.

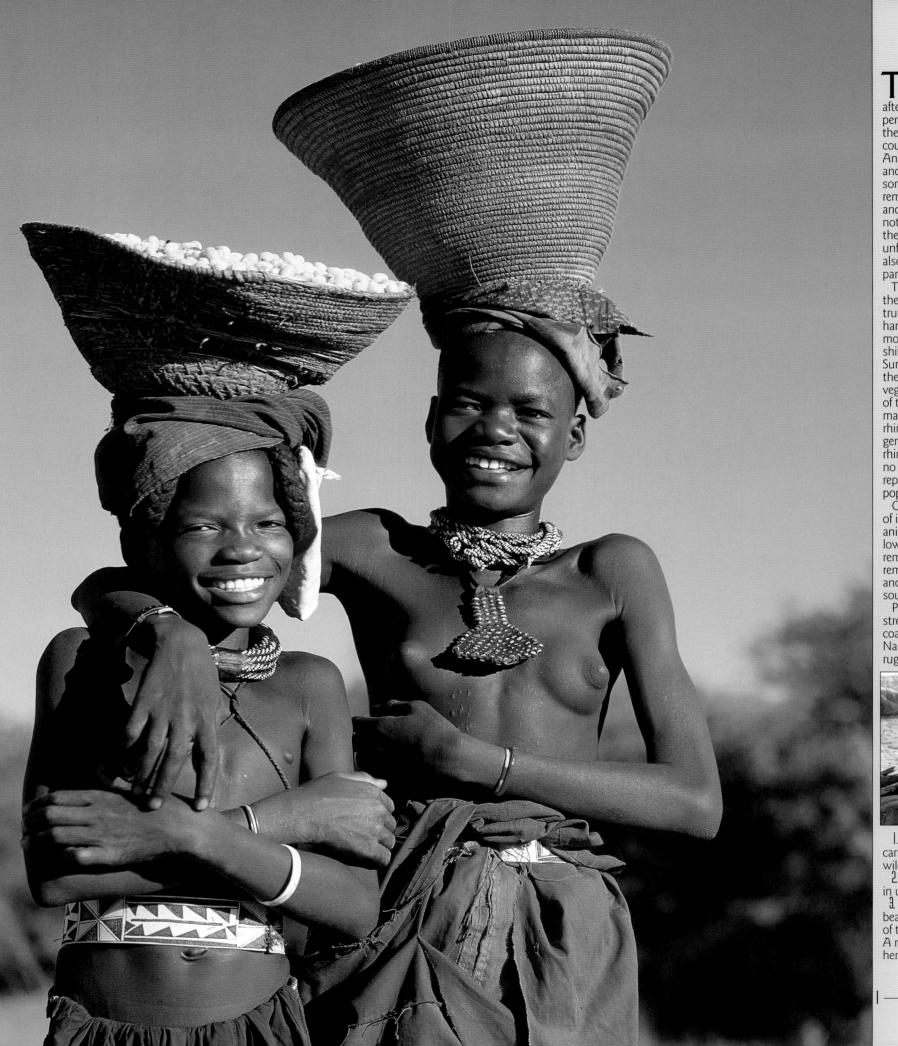

The Kunene Region in north western Namibia is named after the Kunene River, the only permanently running river in the Kaokoveld, which marks the country's northern border with Angola. The Himba, a nomadic and pastoral people numbering some 12 000, survive in this remote region, breeding cattle and goats. They are noteworthy not only for their ability to sustain themselves in this hot, arid and unforgiving environment, but also for their striking appearance, particularly their women.

This a wild land – in fact, the Kunene is one of the last truly wild regions of Africa. It is harsh. Arid landscapes of rugged mountains, gravel plains and shifting sand dunes abound. Surface water is scarce. However the dry riverbeds are often well vegetated and are thus the lifeline of the desert – home to large mammals such as elephant, black rhino, giraffe, mountain zebra, gemsbok and kudu. The black rhino here, estimated to number no more than 150 individuals, represent the only unfenced population in Africa.

Coastal fogs allow a range of interesting, desert-adapted animal species to survive in this low-rainfall environment. It is a remarkably unchanged world that remains one of the most remote and undeveloped regions of southern Africa.

Pristine desolate beaches stretching along the Atlantic coastline in the west border the Namib Desert wilderness with its rugged mountain ranges.

1. Two young Himba carry baskets of freshly picked wild plums.
2. A typical cast iron cooking pot in use at the Etenga kraal.
3. Himba women are extremely beauty conscious and spend a lot of time on their appearance. A mixture of butter fat, ochre and herbs is made, with which the

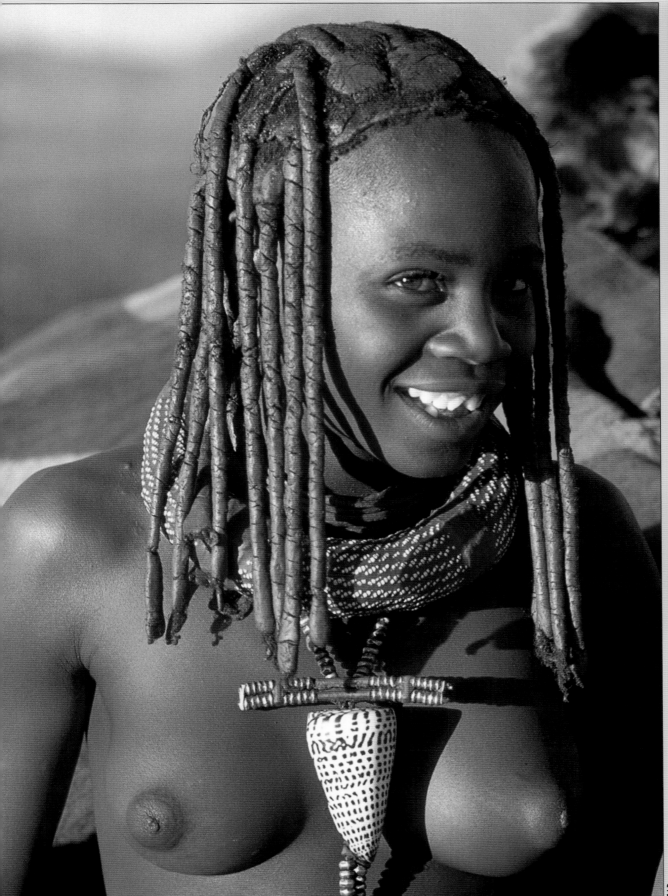

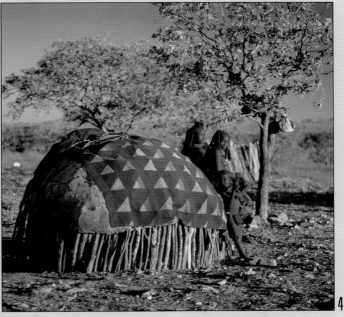

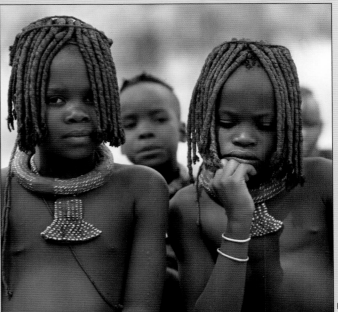

cover themselves, giving their skins a reddish appearance. They also braid each other's hair and cover it with this same mixture. The whelk shell, worn as a pendant, is a traditional and highly valued jewellery item passed on from one generation to the next.

As a tribe, the Himba are closely related to the Herero, with whom they share a common language. They are monotheists who worship the god Mukuru, but also participate in ancestor worship at sacred fire sites.

4. Himba dwellings are simple in style and easy to dismantle. They comprise folded saplings bound with fronds from the makalani palm and moulded together with animal dung. A village will consist of a group of several household kraals.

5. Two young Himba girls.

6. A flower of *Turnera oculata*, var. *paucipilosa*, a Kaokoveld endemic.

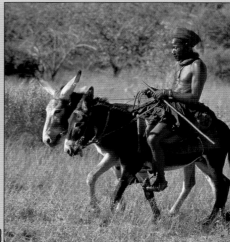

1. Pigtails denote the unmarried status of a young Himba man, here playing a tune on his simple mouth harp.

2. The Kunene River, which forms the border with Angola, flows peacefully near Epupa Falls. This is one of only five perennial rivers in Namibia.

3. Epupa Falls drop in a series of cascades spread along a distance of 1.5 km. Originally threatened by the proposed Epupa Dam, which would have adversely affected the local ecosystem as well as Himba traditional grazing grounds. The scheme has now been dropped in favour of the Baynes Dam planned further downstream, but the project continues to raise controversy and is opposed by the Himba.

4. Mules are a hardy and reliable means of transport in the Kaokoveld wilderness.

5. & 6. A study in contrast: The Kaokoveld transformed by summer rains where fresh green growth is everywhere abundant. However, in the dry season, this becomes a parched and arid wilderness.

The region is sparsely inhabited by the semi-nomadic Himba people.

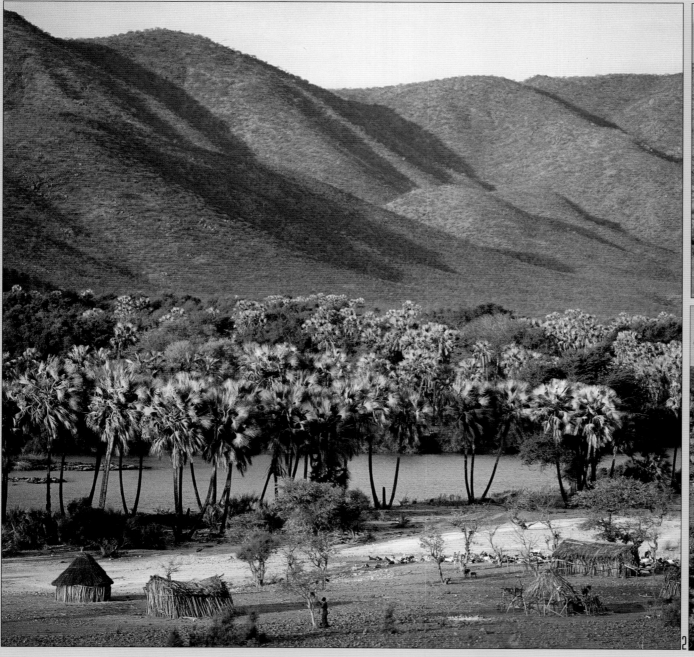

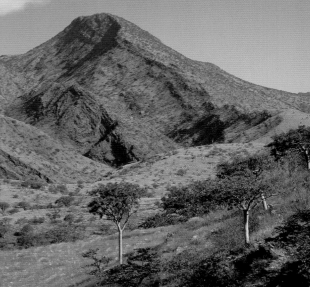

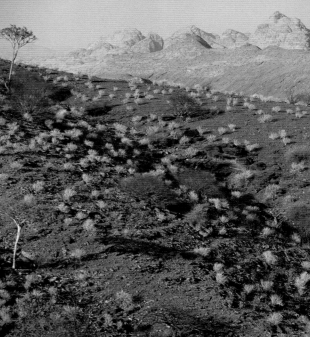

EVOCATIVE AFRICA

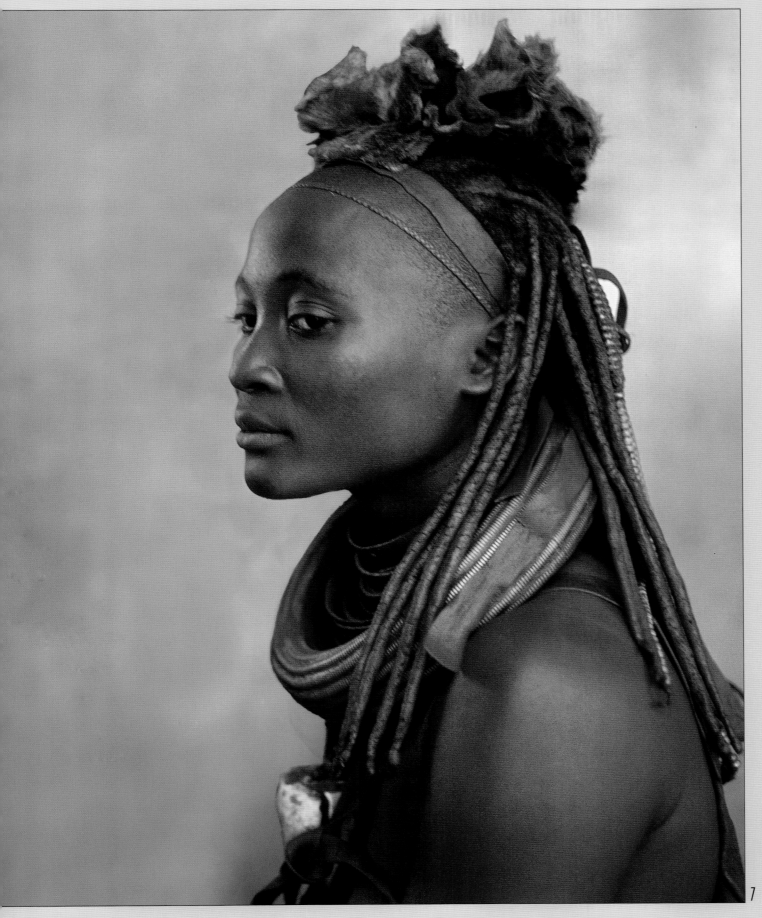

7. A dignified and beautiful Himba woman in traditional attire: goatskin headpiece, extended braids, twisted copper necklaces – and the treasured whelk pendant.

7

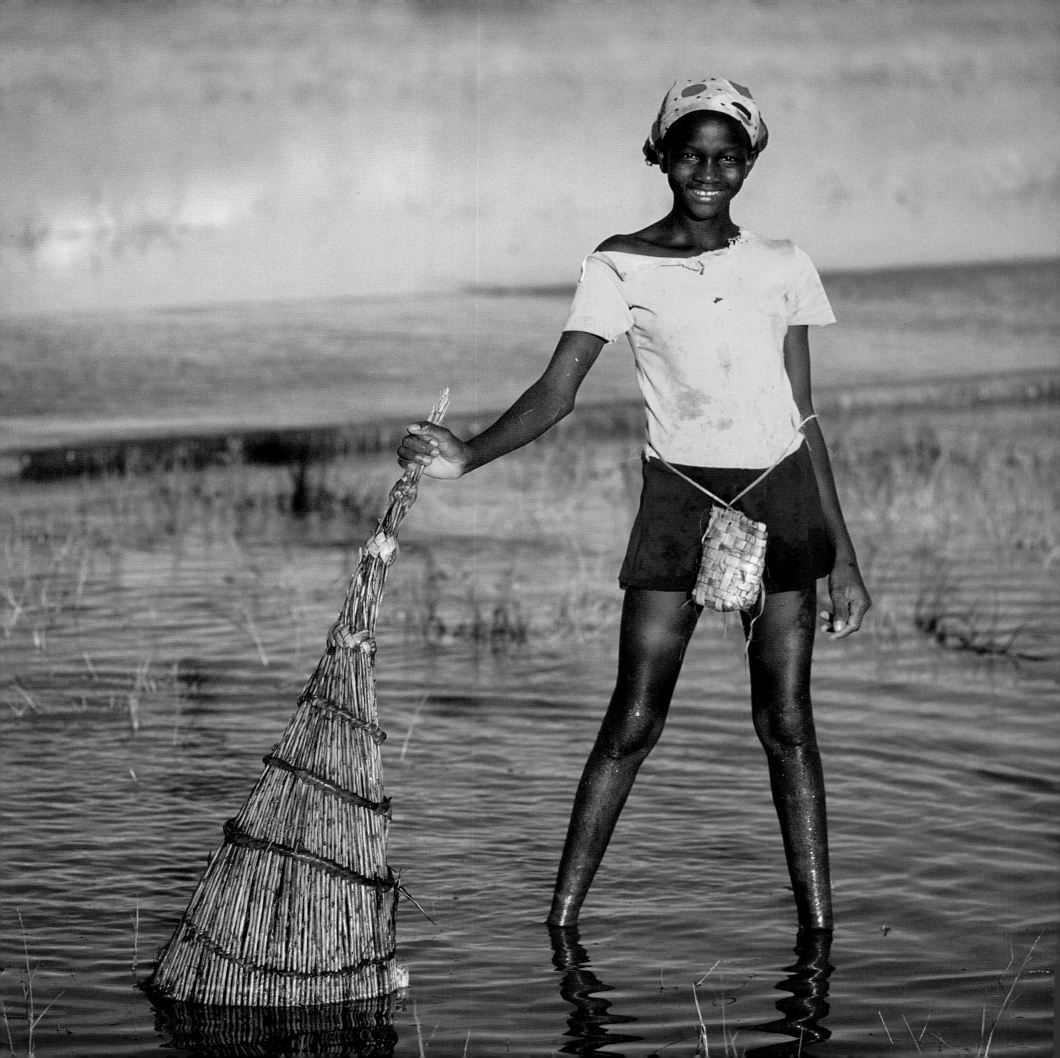

n Ovambo girl poses with
cone-shaped *shikuku* reed
et used to catch fish in a
cal *oshana* (a seasonally
led depression). Most of the
the pan is parched and dry,
after summer rains it will fill
water. Fish spawn, buried
e mud, hatch and provide a
ome source of protein.
hing is usually a social event
hich a group of participants
nce in a line, driving fish
rd the shallows and then
sting downwards time and
again to trap them. This
ly yields a good catch of
m and other species, which
xtracted from an aperture
e top of the basket.

red velvet mite
bidium sp. is known as a
beetle' due to its frequent
earance after rain. This mite
es its home in the leaf litter
oodlands and forests where
resence is important to the
ronment. It is part of a
munity of soil arthropods,
h are critical in terms of rates
composition in woodlands
in maintaining the structure
e entire ecosystem.

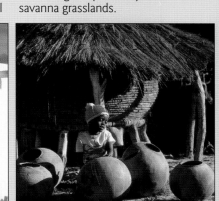

3 Wild flame lilies *Gloriosa superba* in Ovamboland.
4 A flap-necked chameleon *Chamaeleo dilepis* so
named from the large movable flap that protrudes from
either side of the upper surface of its neck. During
threat displays, these are raised at 90 degrees to deter
rivals or predators. This chameleon species has been
one of the most extensively exported for the pet trade.
5 A well-described Ovambo enterprise in the heart of
rural Ovamboland.
6 These large clay pots are made to hold the opaque
white beer so popular in African society. This powerful

brew has a strong smell and is known
for its nutritional value. In the back-
ground, a tightly woven storage basket
protects grain from insects and rats.
7 Summer rains have produced fresh
grass in the open plains of
Ovamboland. A towering termite
mound stands between lofty Makelani
palms *Hyphaene ventricosa*.
8 Cattle graze peacefully in the hot
savanna grasslands.

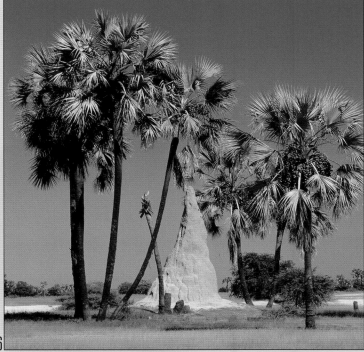

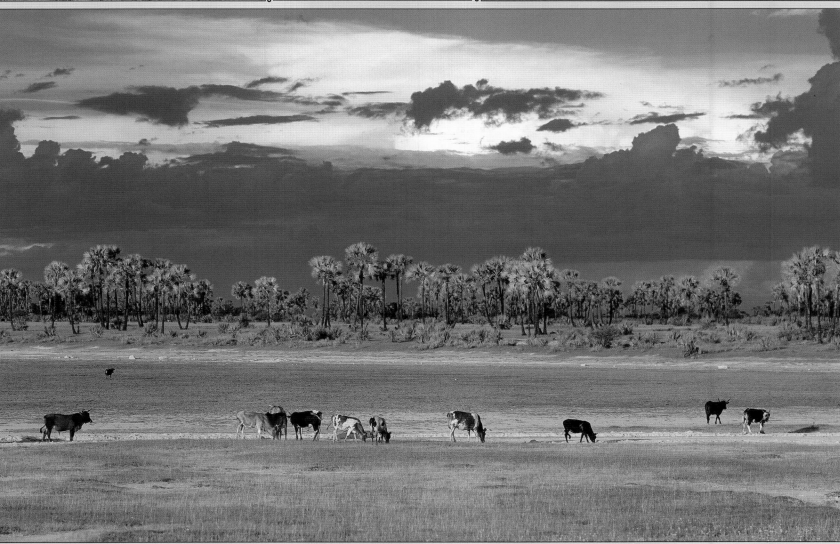

1. The southern carmine bee-eater *Merops nubicoides* like most bee-eaters, is a striking, richly coloured bird. It is a highly sociable species that gathers in large flocks both in and out of the breeding season.

2. Cattle settle in for the evening at their kraal in Kalembeza village, eastern Caprivi.

3. A typical Basubia kraal in eastern Caprivi. The Basubia (also known as Vekhuhane) are an ethnic group occupying the region between the Chobe and Zambezi rivers. What is known of their origins can only be gleaned from oral testimony.

4. A Mafwe fisherman makes his way across Lake Liambezi in his *mokoro* dugout. This traditional canoe is carved from a single tree trunk. Situated between the Linyanti and Chobe rivers, this occasional lake, when flooded, can cover over 100 km².

Long before country borders existed in Africa, the people that lived in what is today Caprivi, south-eastern Angola and the upper part of Botswana were all part of the Lozi people. When borders were arbitralily drawn during the Conference of Berlin (1884/85), the Lozi were split, with the Mafwe assigned to dwell in south-eastern Angola and along the Kwando River.

5. Homeward bound from the local market, a Mafwe woman skillfully balances a laden basket of millet on her head.

Far right: 6. At dusk, a mood of serenity casts its spell over the quietly flowing waters of the Okavango River (here near Rundu). This demarcates the border between Namibia and Angola, .

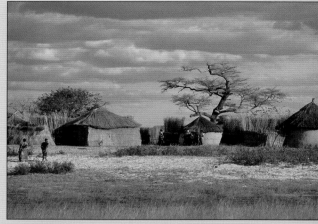

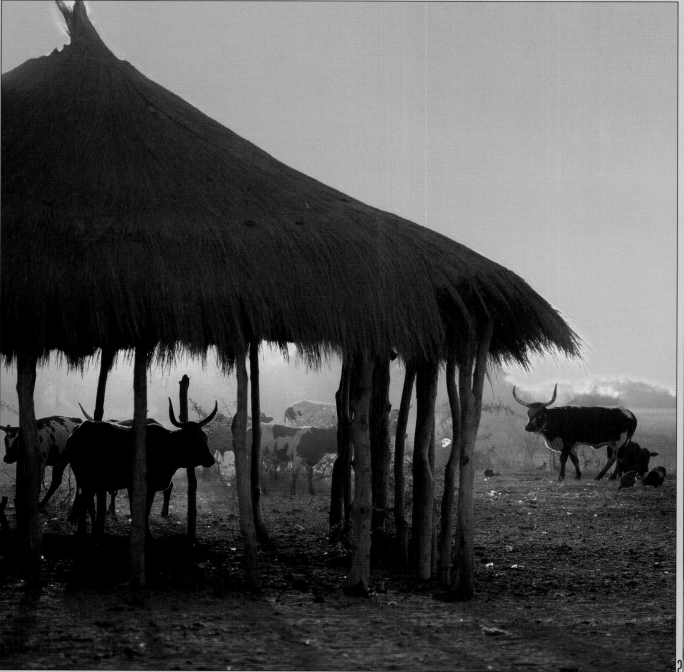

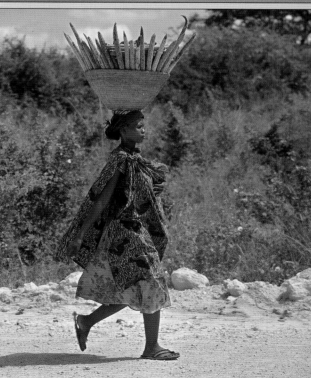

EVOCATIVE AFRICA

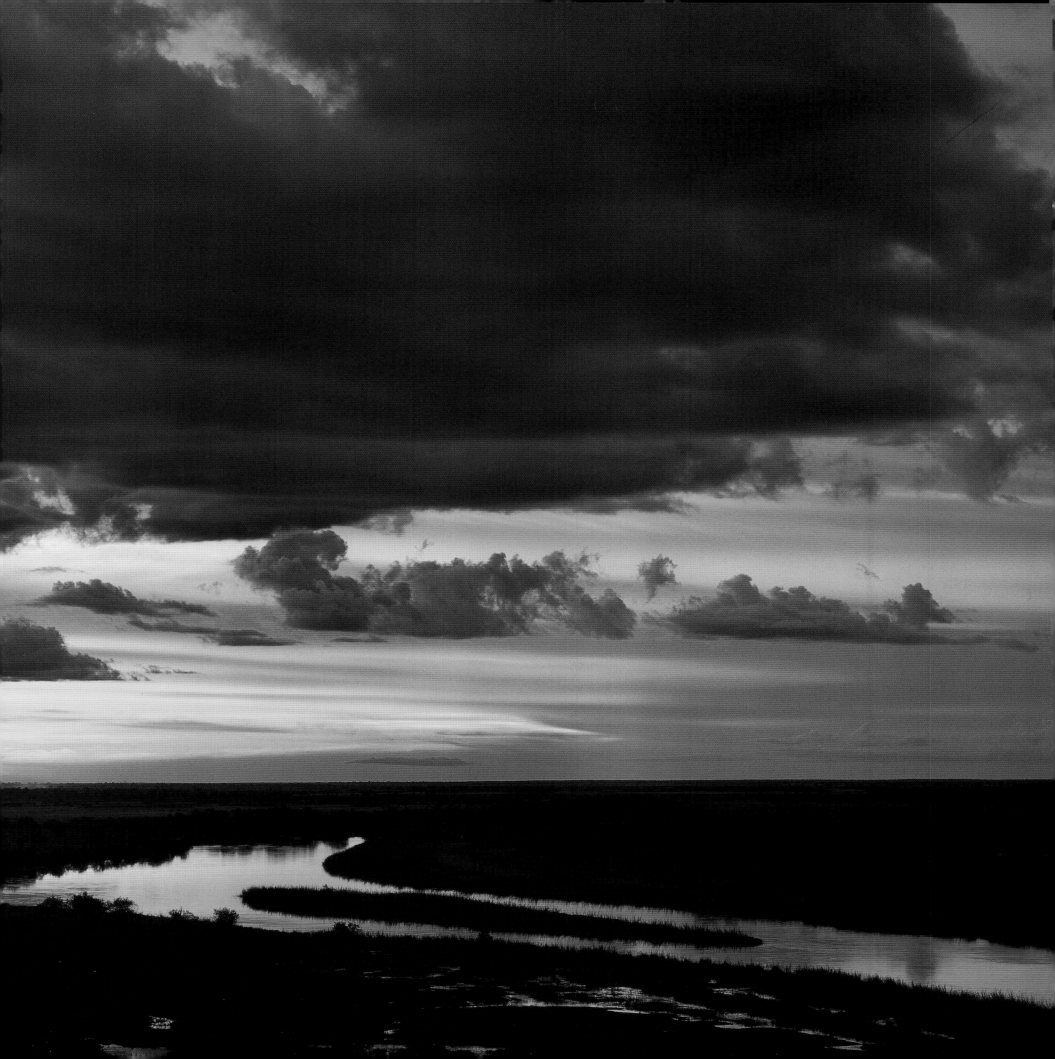

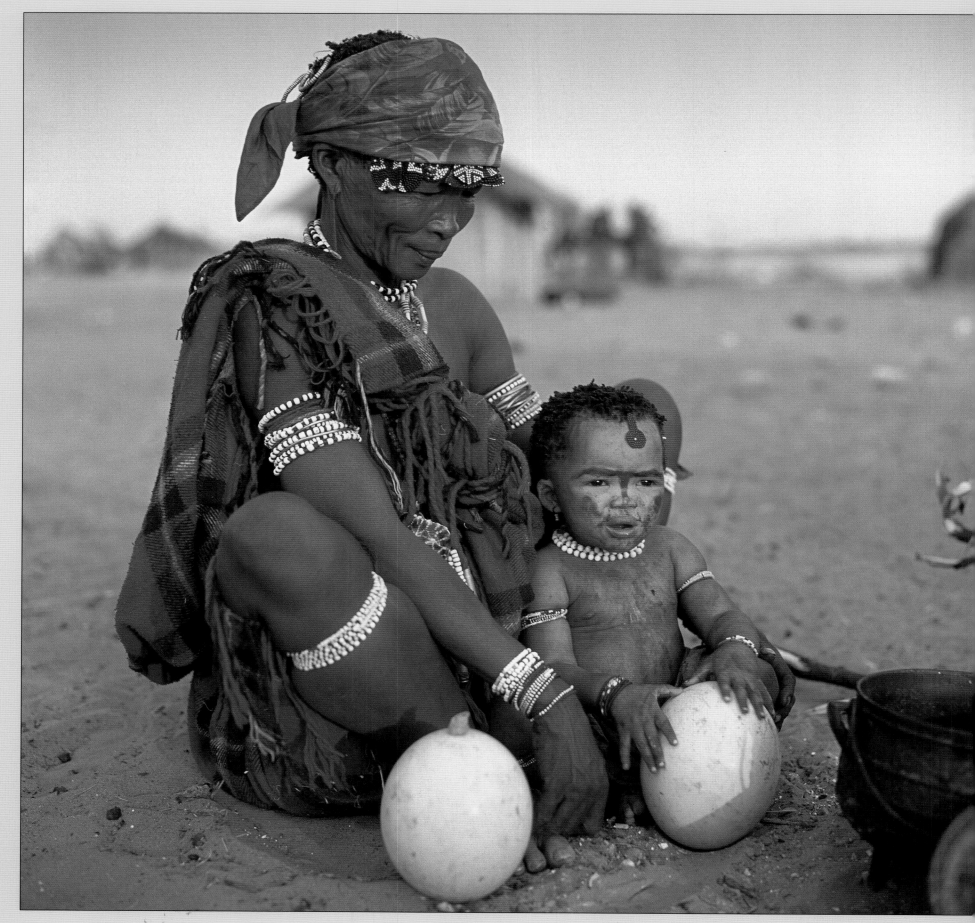

e San (Bushmen) are the
oldest ethnic group in
ibia and have inhabited
hern Africa for an estimated
00 years. South Africa's
neland' policy forced them to
e in remote Bushmanland, a
t-like area in north-
ern Namibia with Tsumkwe,
e district capital.
e San have a deep
rstanding of nature and
gy. They are able to identify
dreds of plant species, as
as being renowned as
ent animal trackers.
ninishing numbers of these
lly people still live a
ional life as hunter-
erers. The men hunt whilst

3. Two men make fire in the traditional manner by rubbing sticks together and catching the sparks on a dry tuft of grass.
4. A hunter squats beside his temporary shelter in the wilderness of the Kalahari Desert. This traditional hut is constructed from local materials: the frame from branches, and the roof thatched with long grass.

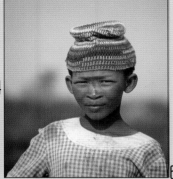

5. Two women of the Barakweno group display an eclectic mix of modern and traditional dress.
6. A San boy in the western Kalahari region.
7. A San woman in modern dress, but still wearing a customary head band, bead necklace and arm bands.

women collect wild fruits,
s and wild onions rich
arch.
the estimated 30 000
men still living in Namibia,
about 2000 still follow the
ional way of life. Land
ages as well as other
ems, especially alcoholism,
a significant threat to the
Today, as their culture has
ily eroded, the majority are
oyed as farm labourers.
ft: 1. A San mother with her
g son. Ostrich eggs are
for storing fresh water.
are sealed with beeswax
hidden in the sand at secret
t locations.
A Bushman 'love bow': a
ature of the traditional
hunting equipment. It
scribed thus due to the
ional custom that a young
would 'fire' a tiny harmless
w at the girl to whom he
attracted. If she then picked
she would indicate her
est in developing
ationship.

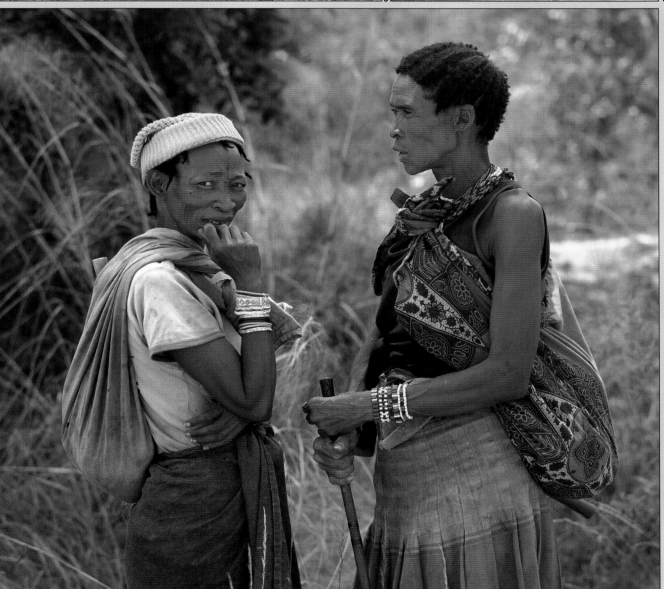

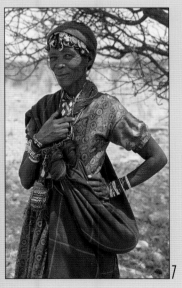

Damaraland, a huge untamed and ruggedly beautiful region, is one of the most scenic parts of Namibia.

It stretches 600 km southwards from the Kaokoveld to the main Swakopmund / Windhoek road, and extends 200 km inland from the desolate Skeleton Coast.

1. An ancient rock engraving depicting an elephant at Twyfelfontein, Damaraland.

2. Rock etchings at Twyfelfontein show a multitude of wild animals. This is the richest source of engravings in Africa. There are some 2000 figures engraved into the rocks as part of symbolic rituals enacted by hunter-gatherers who lived in this region over some 2000 years prior to 1000 AD. They depict elephants, rhinos, lions, giraffes, kudu and ostriches, as well as animal and human footprints.

3. The famed 'White Lady' Bushman painting was discovered in a rock shelter high in the Brandberg mountain in 1917. For many years its origin was the subject of much conjecture and speculation. Previous theories of a possible Phoenician link have today given way to the modern belief that it is a fine example of ancient local San (Bushman) art, at least 2000 years old. The 'Lady' is in fact a male – probably a medicine man. In one hand he holds a bow and in the other what appears to be a goblet.

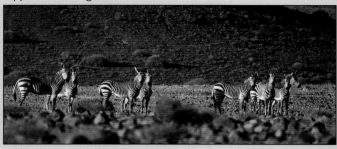

4. The mountains and wilderness of Damaraland provide an arid habitat for Hartmann's mountain Zebras, *Equus zebra hartmannae*

5. Gnarled mopane bushes, *Colophospermum mopane* beside the dry Hoanib River in the Khowarib Gorge.

6. An endangered black rhino and her calf shelter beside a milk bush succulent, *Euphorbia gregarii*.

7. The elephants in Damaraland are uniquely adapted to the harsh semi-desert conditions by having smaller bodies and larger feet than other pachyderms. Here a group of these desert elephants move slowly along the dry Uniab riverbed. They routinely move up to 70 km between feeding grounds. By living in smaller family units of only two or three animals, pressure is reduced on scarce food and water resources. Researchers have noted that these elephants destroy fewer trees than those living in higher- rainfall areas in other parts of Africa. By the 1980s poaching and hunting had accounted for most of the 3000 that had lived in this region. However, from a low of 52 animals the population has now recovered to over 600.

8. A Dassie rat *Petromus typicus* shelters from the midday sun.

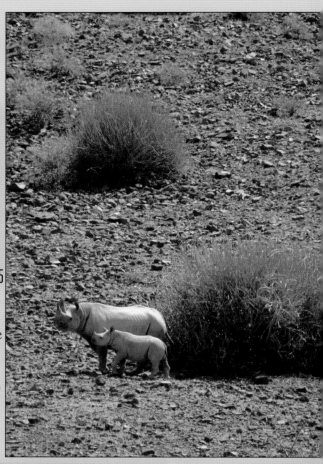

This rodent is the only living member of its genus.

9. The giraffe *Giraffa camelopardalis angolensis* has large spots with some notches around the edges, extending down the entire lower leg. It has been estimated that fewer than 20,000 of this subspecies remain in the wild.

10. Growing to a height of 1– 6 m, the bottle tree *Pachypodium lealii* owes its name

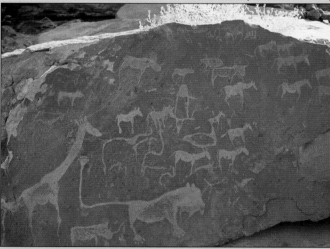

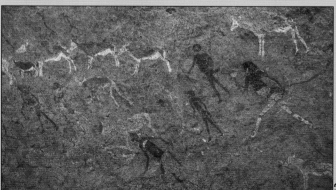

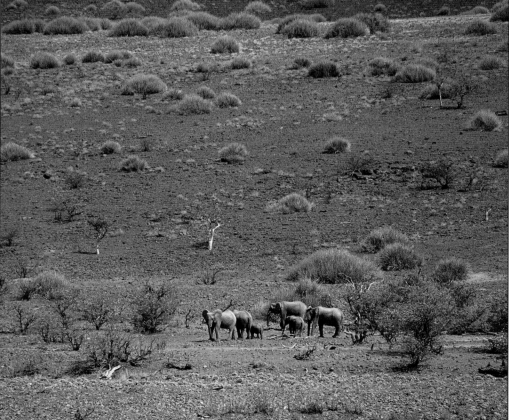

to the unusual swollen shape of its succulent trunk. This acts as a water store and enables the plant to tolerate the hot environments in which it grows. The sap is highly toxic.

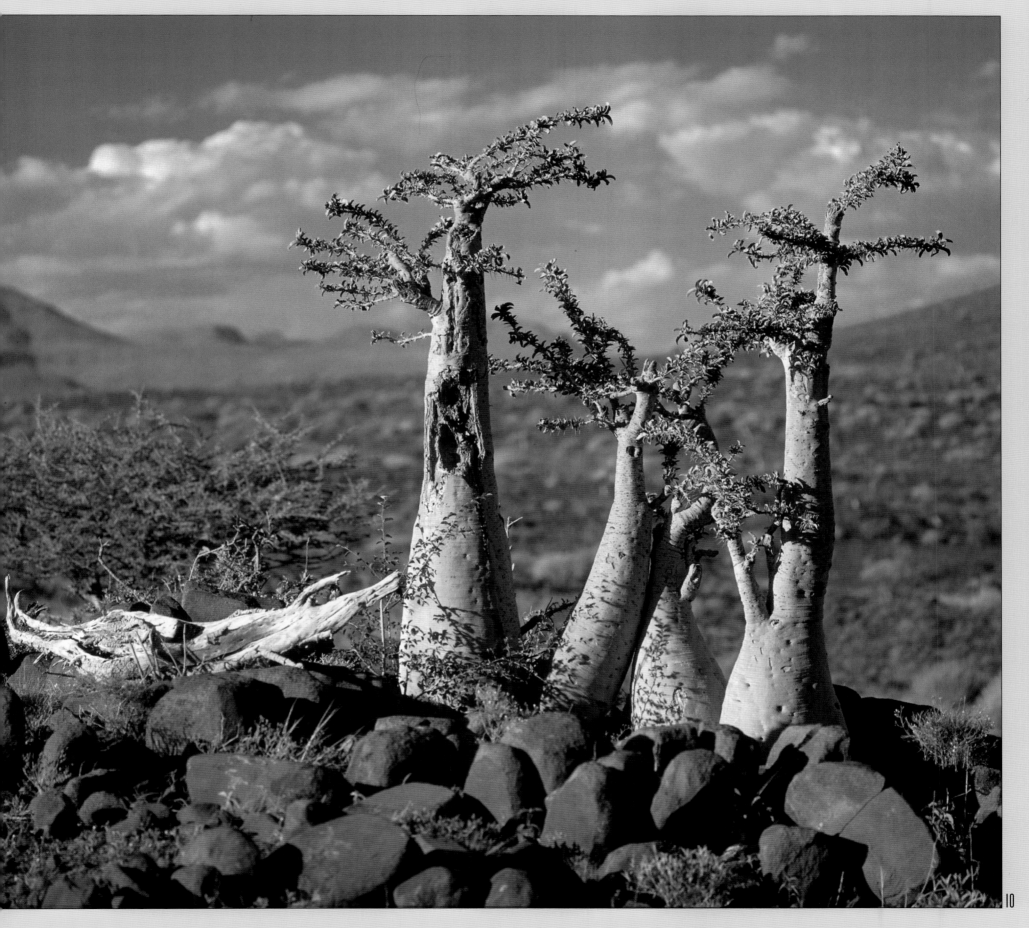

NAMIBIA

The name 'Herero' (like 'Nguni') covers a group of tribes; the Herero, the Himba (Ovahimba), the Tijimba and the Mbanderu, all of whom speak a common language. Little is known of their ethnic roots, but it is believed that these people were descendants of the large groups who migrated southward from Central Africa during the 16th century. Tribal traditions indicate that they originally came from the Great Rift Valley in East Africa. It is thought that the Herero separated from the main migration group and entered present-day Namibia from the north-east. Here they divided into two groups. One crossed the Okavango River and entered the Gobabis area, east of Windhoek, and became known as the Mbanderu (or Eastern Herero). The other group crossed the Kunene River and settled in the Kaokoveld, the rocky dry north-western part of Namibia, and became known as

the Tijimba and Himba. In about 1750, a group of the Kaokoveld population migrated southwards to central Namibia and met up again with the Mbanderu, eventually settling throughout the western Kalahari where they

became known as the Herero.

By the mid-19th century European explorers, traders, and missionaries had moved into central and southern Namibia.

During the 'scramble for

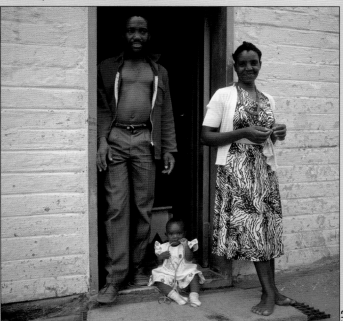

Africa', Britain made it known it was not interested in this region, and the 1884 Berlin Conference awarded the territory to Germany.

The Germans quickly established their presence on the coast before moving inland to consolidate their occupation of the whole country. From the early 1890s settlers were encouraged to occupy land taken from the local tribes. Land and the cattle that were essential to Herero and Nama lifestyles passed into the hands of immigrant Germans, inevitably causing discontent. In 1904 Herero Chief Samuel Maharero openly defied the Germans and led his people into battle. Despite a force of only 7000 warriors, the Herero were able to use the

element of surprise to score key victories early in the fighting and regained control of much of the central region. However, the tide of battle soon shifted as Germany flexed its military might, fortifying the region with seasoned, experienced soldiers. The arrival of 14 000 troops under General Lothar Von Trotha led to the infamous 'Extermination Order'.

On 11–12 August 1904 at the Battle of Waterberg the Herero were defeated. Survivors, mostly women and children, were sent to concentration camps.

Unable to achieve a conclusive victory through battle, Von Trotha ordered captured Herero males to be executed, whilst women and children were to be

driven into the Omaheke Desert (the Kalahari), where most died of thirst and starvation. Here, Von Trotha even had the existing wells poisoned.

This has been described by historians as the first genocide of the 20th century. According to the 1985 UN Whitaker Report, some 65 000 Herero (80% of the total population) were killed between 1904 and 1907.

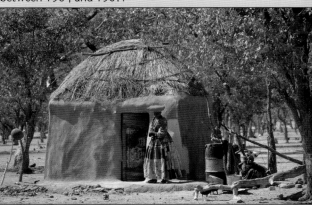

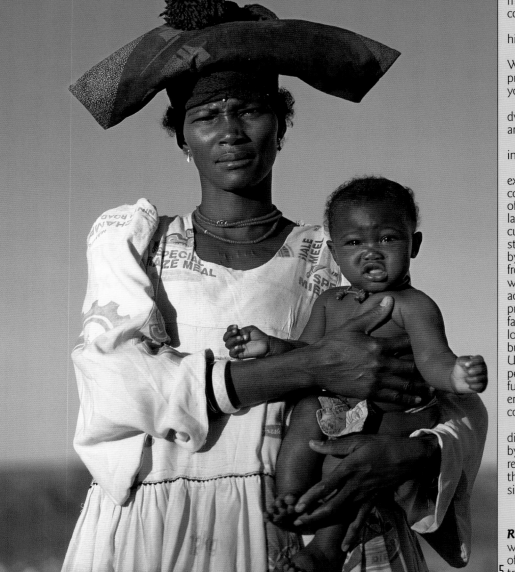

1. Donkey carts are a commo[n] means of transport in the ope[n] countryside.
2. A Herero child tenderly ho[lds] his pet goat kid.
3. At their home in Katatura[,] Windhoek, a Herero couple proudly pose with their young daughter.
4. A traditional Herero rural dwelling with walls of baked m[ud] and a roof thatched with reed[s.]
5. A Herero woman with her infant son.

German missionaries took exception to what they considered to be the immodes[ty] of traditional Herero dress, or [the] lack of dress (then similar to current Himba styles). The striking and colourful attire w[orn] by Herero women is derived from German missionaries, who encouraged them to dres[s] according to fashions then prevalent in Europe. The dress[es] falls to the ankles and include[s] long sleeves and a bodice that buttons up close to the neck. Under the dress six to eight petticoats may be worn, addi[ng] fullness to the skirts. Finely embroidered shawls often complete the colourful appare[l.]

The style and shape of the distinctive headpiece worn by Herero women is said to resemble, and pay homage to[,] the horns of cattle that are so [so] significant in their culture.

Right: 6. In Windhoek, a Here[ro] woman displays her collection of tiny dolls for sale, all garbe[d in] traditional style.

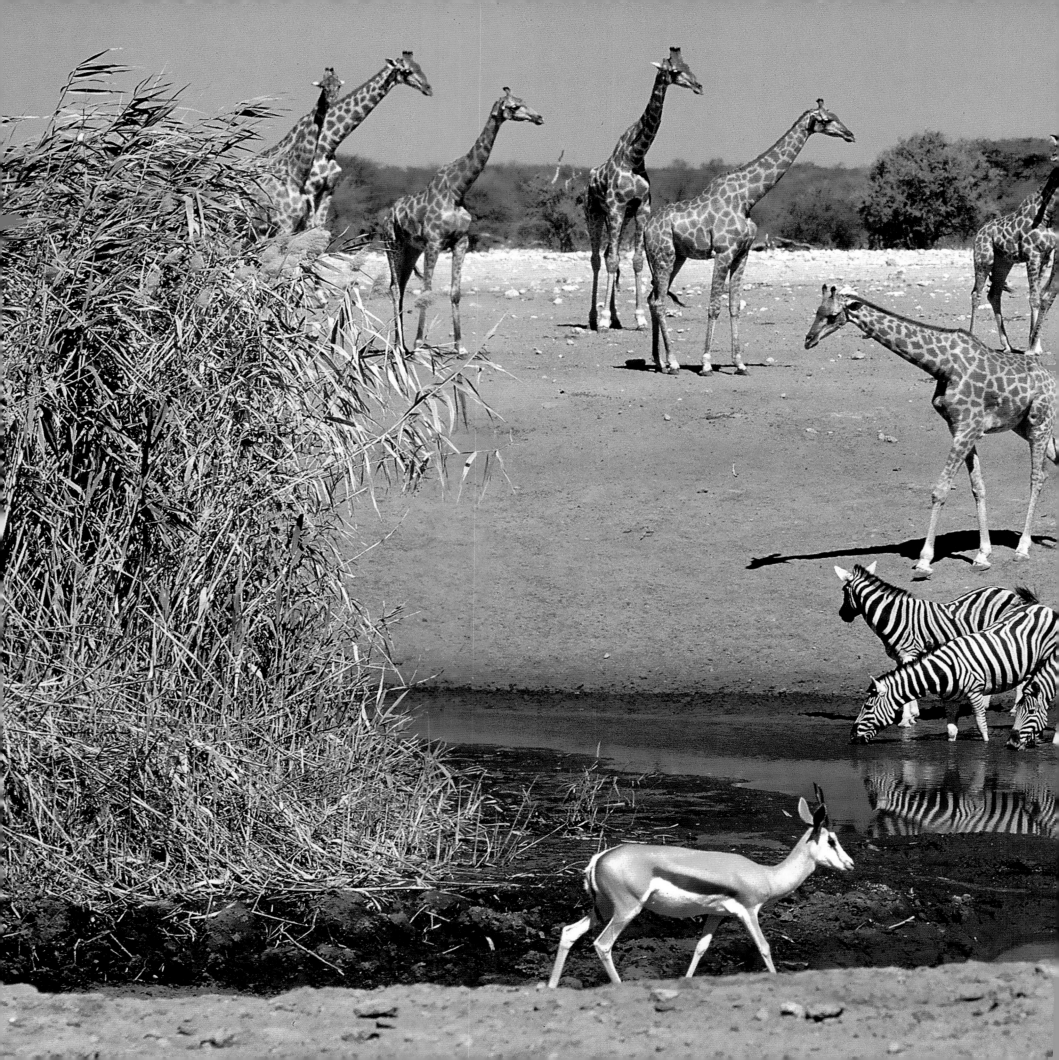

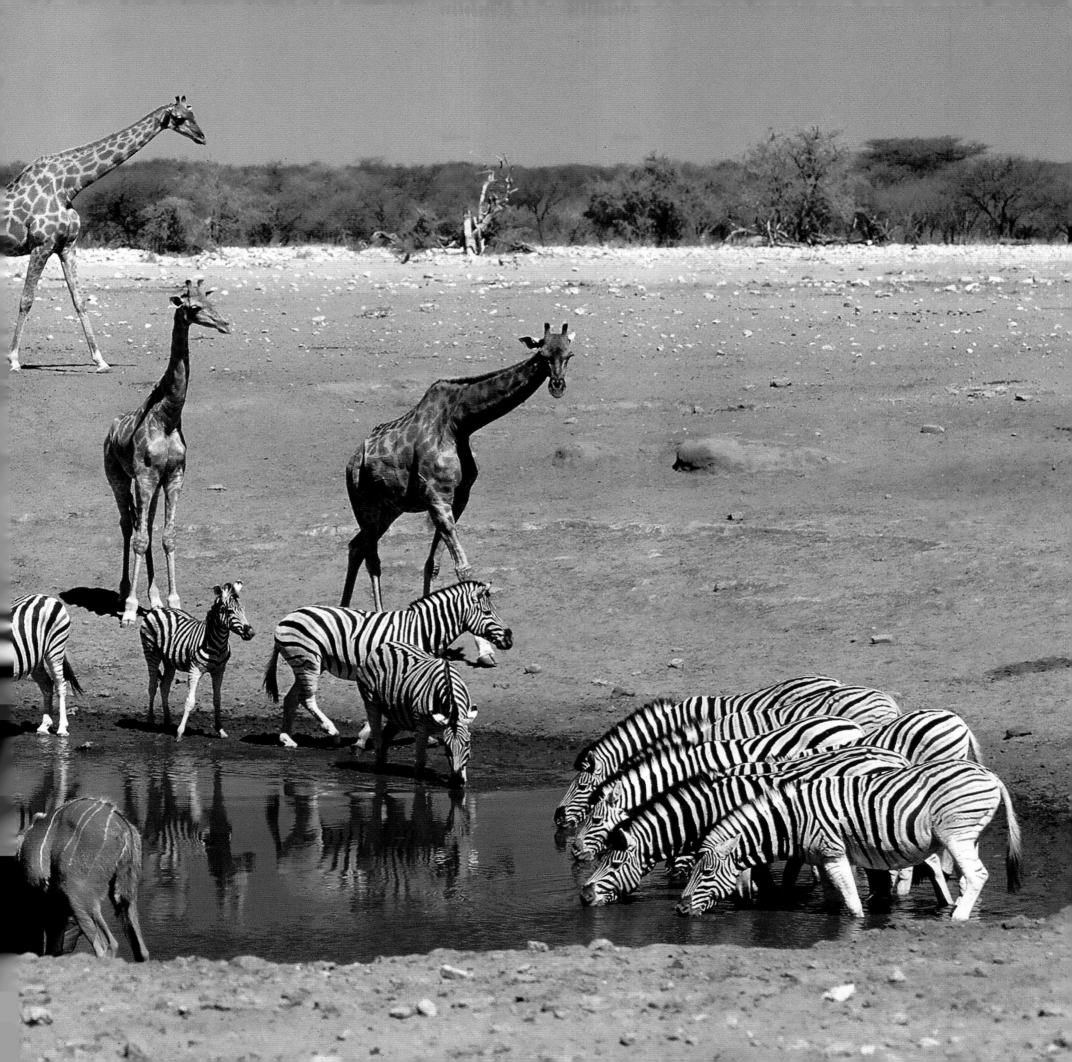

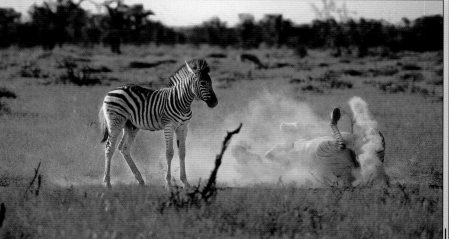

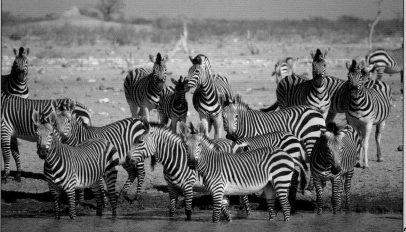

of wildlife to the Chudob waterhole, including giraffes, zebras, a kudu and a springb

1. The dry plains find a Burchell's zebra *Equus quagg burchelli* rolling in the dust w her foal looking on.

2. At a waterhole in eastern Etosha, Hartmann's mounta zebras, *Equus zebra hartman* together with Burchell's zebr gather to drink.

3. Burchell's zebra stallions spar aggressively in a dusty arena beside the Chudob waterhole.

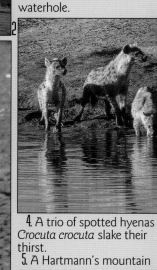

4. A trio of spotted hyenas *Crocuta crocuta* slake their thirst.

5. A Hartmann's mountain

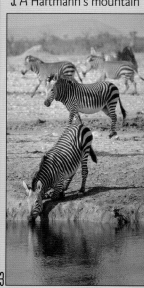

Etosha National Park, one of Africa's major wildlife sanctuaries, was proclaimed a game reserve in 1907. Initially it comprised 100 000 km² (then the largest reserve on earth), but in the 1960s political pressure resulted in the park being reduced to its current size of 22 750km².

Etosha (great white place or place of dry water in the Herero language), is centred around a huge, flat, 5 000 km² calcrete pan, part of the Kalahari Basin. This was originally a lake fed by the Kunene River and covers about 25% of the national park. It is now a large depression of salt and dusty clay that fills only

if summer rains are heavy, and even then only holds water for a short period. This temporary water attracts wading birds in their thousands, including impressive flocks of flamingos lured by the prevalent blue-green algae.

A San legend describing the formation of the Etosha Pan tells

how a village was raided and all but the women were slaughtered. One woman was so distressed at the death of her family, she cried copiously until her tears formed a great white pan.

Today Etosha provides habitat for elephants, black rhinos, lions, giraffes, wildebeest and large numbers of antelope species,

especially springbok and black-faced impala. Occasionally leopards and cheetahs can be seen. In all 114 mammal species, 340 bird, 110 reptile, 16 amphibian and, surprisingly, one species of fish have been recorded.

Previous page: The waters of life attract a kaleidoscope

zebra, an endangered species adapted to these semi-desert conditions, kneels to drink.

Right: 6. A lone Burchell's zeb stallion stands amidst dry bu nutritious grasses.

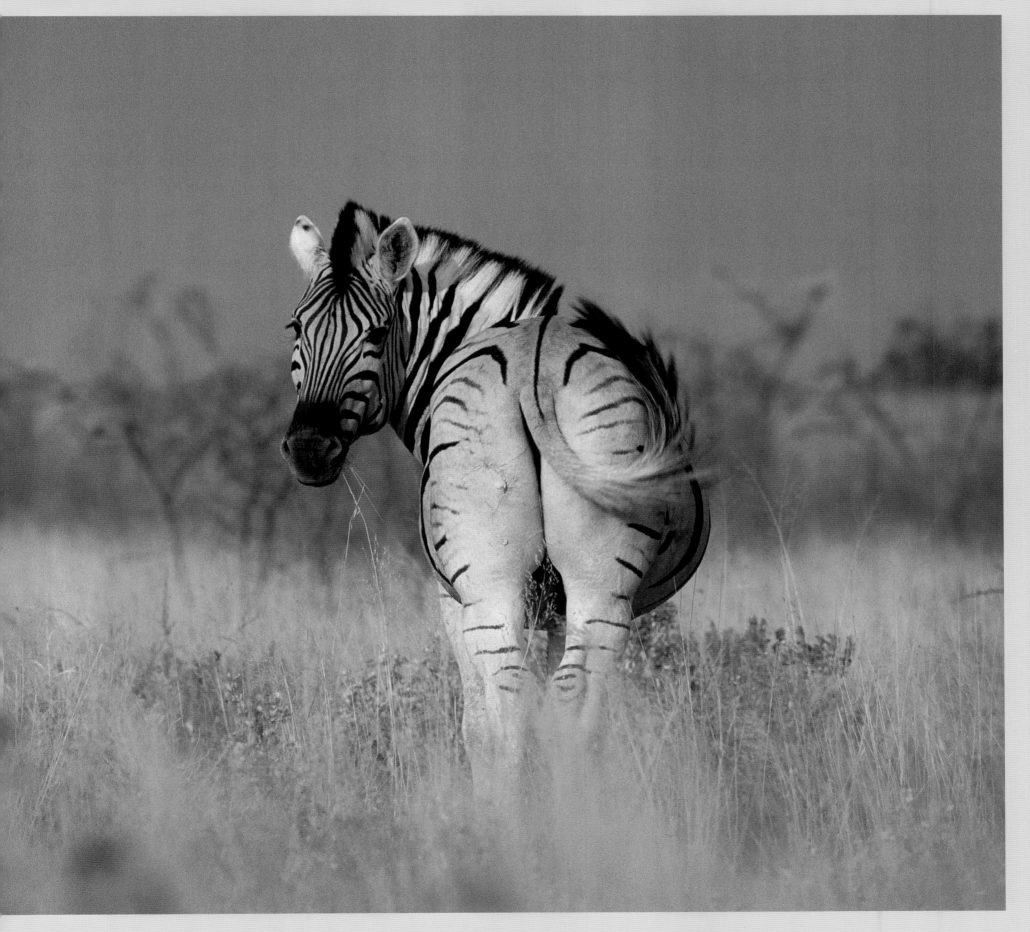

1. The Crimson-breasted shrike *Laniarius atrococcineus* has been described as "one of the most startlingly coloured birds of the dry bushveld". It tends to skulk in the undergrowth and, although it is so brightly coloured, it can be difficult to see.

2. Black-backed jackals *Canis mesomelas* scavenge the remains of a lion's kill, here a giraffe carcase.

3. A noisy flock of helmeted guineafowl *Numida meleagris* gather at the Chudob waterhole in the early morning. These familiar birds, domesticated on some farmlands, often form large groups and run around excitedly chasing one another. With grey flecked bodies, naked blue and red heads surmounted by a red casque, they are unmistakable birds of the veld.

4. Damara dik-dik *Madoqua kirkii* frequent dense woodland and thickets. Despite the name, the species is not found in Damaraland, but is common in Etosha, the Caprivi Strip and the Waterberg. Although regularly seen alone, these

diminutive antelope pair and mate for life.

5. Two lions spar aggressively. This behaviour is not intended to cause injury and rarely lasts long.

Right: 6. Ever possessive, a li gnaws away at its recent kill.

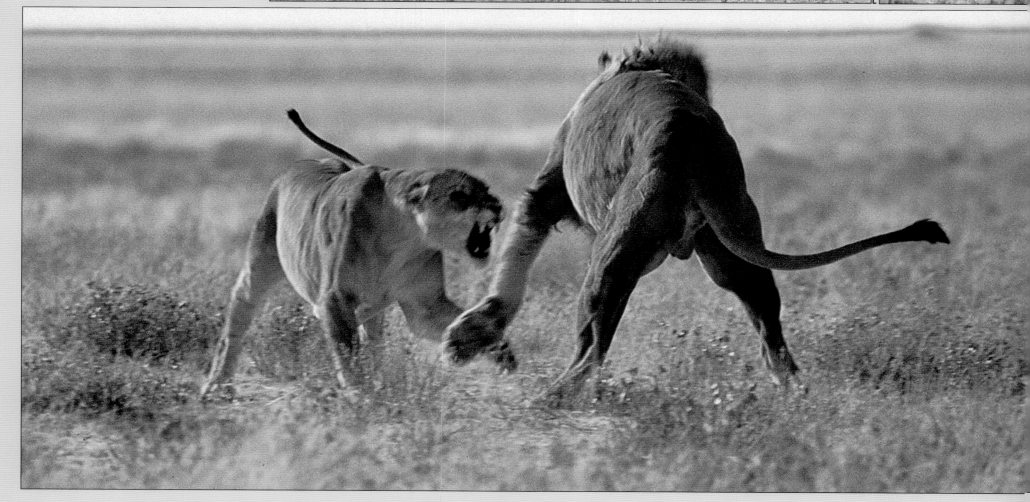

EVOCATIVE AFRICA

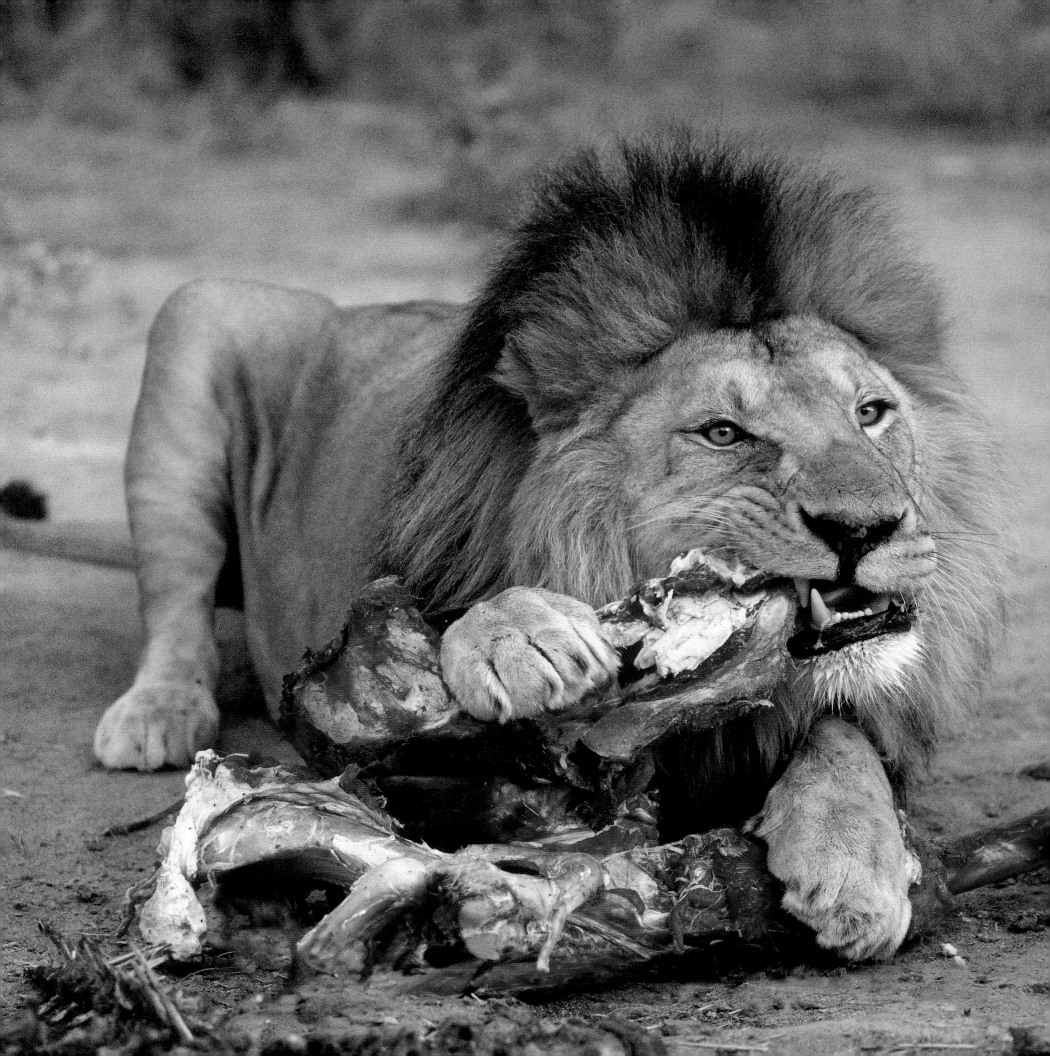

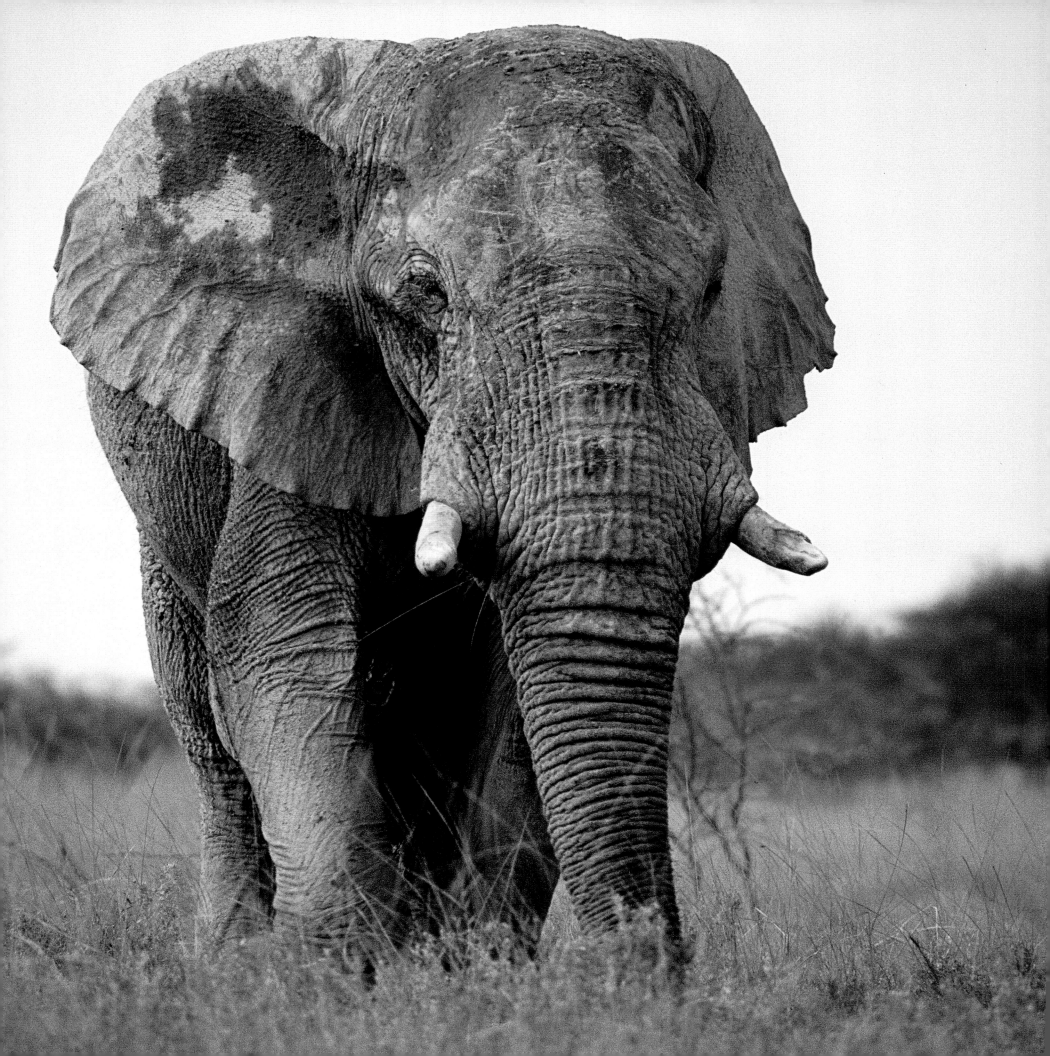

plorers Charles Andersson nd Francis Galton were the Europeans to visit Etosha in early 1850s. They recorded impressions:

..we traversed an immense ow, called Etosha, covered saline encrustations, having wooded and well-ed borders. Such places n Africa designated 'salt '... In some rainy seasons, Ovambo informed us, the ity was flooded and had all appearance of a lake; but it was quite dry, and the

soil strongly impregnated with salt. Indeed, close in shore, the commodity was to be had of a very pure quality."

They were amongst the first explorers and traders who relentlessly hunted the area's vast herds of game. In 1876 an American trader, McKierman, came through the area and wrote of his visit to Etosha: "All the menageries in the world turned loose would not compare to the sight that I saw today."

Far left: 1. A bull elephant

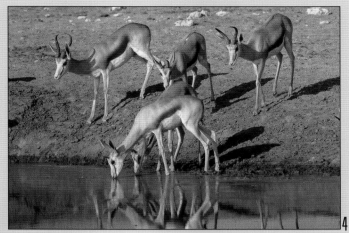

makes his way slowly across the dry savanna grasslands.

2. Fairly common and a widely distributed small antelope, the steenbok *Raphicerus campestris* is inclined to hide during the day amidst long grasses and bushes. It feeds in early morning and evening.

3. Black-faced impala ewes *Aepyceros melampus petersi* feed on the yellow buds of *Acacia nebrownii*. This sleek and graceful subspecies of the common impala is native to southern Angola and northern Namibia. Black-faced impalas are becoming rare due to

uncontrolled hunting in their limited natural range. Larger and darker than their common cousin, they have a characteristic black strip from their nostrils to the top of the head.

The common impala has been called 'a living fossil' by author Michael Mooring, and 'the quintessential antelope' by Jonathan Kingdon. The former description is based on fossil evidence showing that the species has remained almost unchanged, with only one species present in the fossil assemblage at any given time. The latter epithet refers to the impala's phenomenal

overall ecological success story. Despite ongoing environmental degradation in Africa due to human intervention, impala numbers have increased steadily and the species has broadened its range over the past century. This is attributed to its remarkable ability to adapt to a wide range of climatic and ecological scenarios. As a mixed feeder, it has a flexible diet and is dependent neither on grazing nor browsing for survival.

The concept of an endangered impala species seems inconceivable, yet the black-faced impala is today a subspecies classified as Endangered, in the IUCN Red Data Book.

The total population numbers a mere 3200 and is restricted to the drought-prone mountainous regions of south-western Angola, the Kunene River in the Kaokoveld, and the Etosha National Park.

4. In the heat of the afternoon a group of springbok *Antidorcas marsupialis* come to slake their thirst

5. A breeding herd of elephants, led by the dominant matriarch approaches the Goas waterhole.

6. A black-faced impala ram.

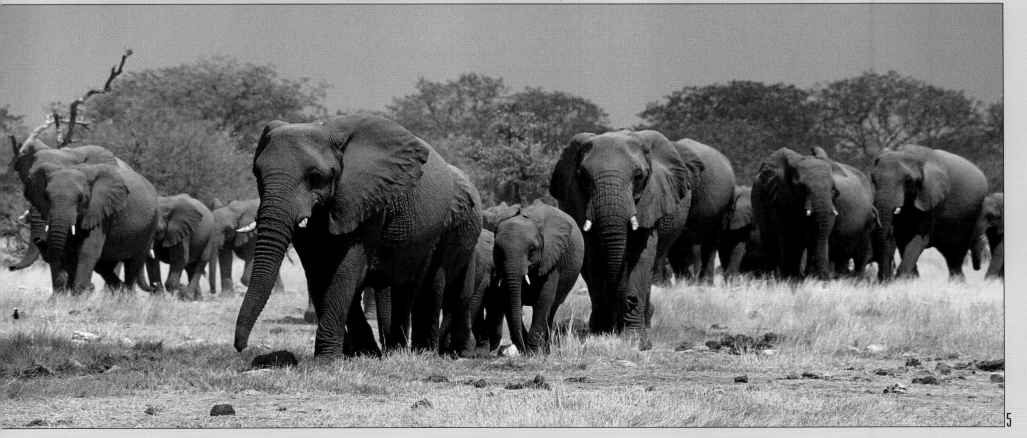

Current statistics reveal an estimated 250 lions in Etosha, 300 rhinos, 2500 giraffes, 6000 zebras and over 2000 elephants. Springbok are especially numerous, with at least 20 000 roaming through the park, sometimes in herds of several hundreds.

1. A black korhaan *Eupodotis afra* 'calling'.

2. A crowned lapwing *Vanellus coronatus* stands protectively beside its young chick. The black crown, like a hood, is encircled by a white 'halo' and distinguishes this lapwing from any other. It is usually found in pairs, but becomes gregarious following the breeding season when it sometimes gathers in flocks of up to 40 birds.

3. Lesser flamingos at Fischer's Pan, in the rainy season.

4. Grey go-away birds *Corythaixoides concolor* gather to drink at the Kalkheuwel waterhole.

5. A tree squirrel *Paraxerus cepadi* feeding on acacia buds.

6. A juvenile banded mongoose *Mungos mungo* stands beside its adult 'minder'. These are sociable creatures that forage in packs that can number up to 30 animals.

7. Ostriches *Struthio camelus* at the edge of the great Etosha Pan. These tall, flightless birds possess long flexible throats that enable them to swallow all manner of things, including the indigestible. Omnivorous, they feed on grass, seeds, vertebrates and insects.

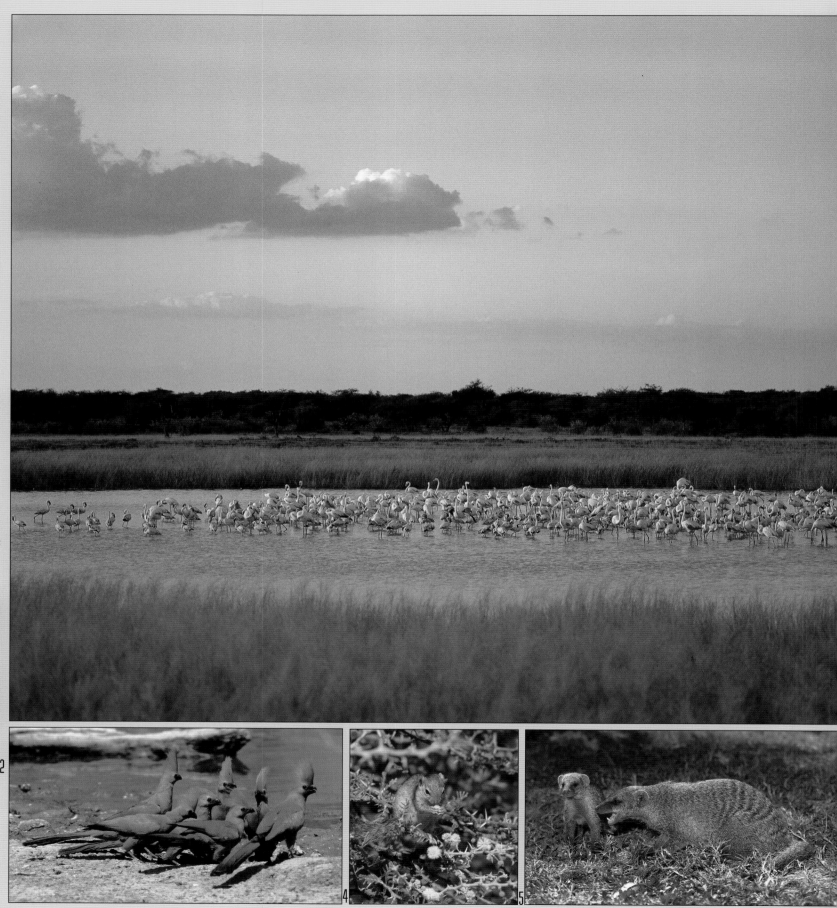

EVOCATIVE AFRICA

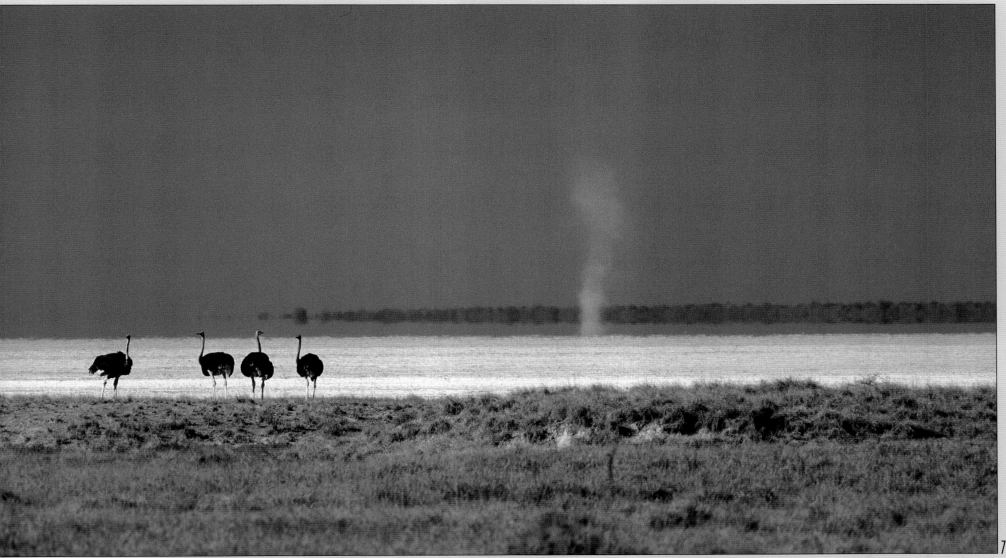

7

8

...ghing up to 130 kg.
...iches are the world's largest
...s; and the fastest, capable of
...hing speeds of 75 km/hour.
...said that 'an ostrich buries
...ead in the sand' believing
this achieves invisiblity. In fact,
it lays its head flat on the ground
making itself barely
distinguishable to predators
amidst the natural cover.

8. Although reluctant to take
wing except when threatened,
the kori bustard *Ardeotis kori* is
the world's heaviest flying bird.
It frequents dry savannas, where
there is fairly tall grass over
which it can see approaching
predators, as well as semi-desert
regions. This bustard feeds on
carrion, seeds, small reptiles and
mammals

9. After good summer rains, *a*
gemsbok *Oryx gazella* grazes
contentedly in lush Etosha
grasslands. With horns as
formidable weapons (able to
defend against a lion's attack)
and with the ability to survive
long periods without water,

9

gemsbok have no problem living
in this generally dry region.
These ungulates have a special
mechanism to release heat by
raising their body temperature
to 45 ºC.

10. Detail of the sun-baked clay
formation of the dry Etosha Pan.

11. An alert Cape ground
squirrel *Xerus inauris*. This is a
widespread and common
species, found in open dry

10

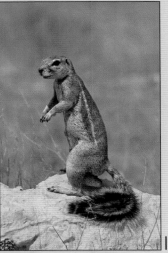

11

savanna with sparse bush and
grass cover. It feeds mainly
on flowers, bulbs, leaves and
insects, especially termites.

The 'Gates of Hell' is how Portuguese sailors once referred to the Skeleton Coast, Namibia's coastal region that stretches inland to the Kaokoveld and Damaraland, and from the Kunene River in the north to the Swakop River in the south. The Bushmen of the interior called this desert wilderness 'The Land God Made in Anger'. This is 'where ships and men come ashore to die'.

The region owes its name to the abundance of bleached whale and seal bones which covered the windswept shores during the heyday of the lucrative whaling industry, as well as to the many skeletal shipwrecks driven ashore by perilous currents. More than a thousand vessels of various sizes today litter this desolate, unforgiving coast.

The coast itself is generally flat, occasionally relieved by rocky granite outcrops. North of Terrace Bay, the landscape is dominated by shifting sand dunes that stretch over 500 km from north to south and 100 km across at the widest point. The southern section in contrast consists of bleak gravel plains.

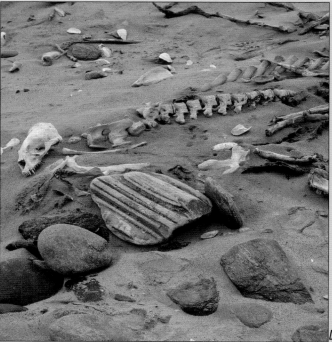

During the early and mid 19th century bird guano was in huge demand as a fertiliser in Europe and America. Many ships came to exploit this rich natural resource from the islands off Namibia's coast. Some never made it home due to treacherous sea conditions that invariably prevail in this lonely and inhospitable region.

1. An early 19th century wooden figurehead from a sailing ship that foundered on the northern Skeleton Coast.

2. The forlorn skeleton of a Cape fur seal on the beach.

3. Elegant even in death, the bleached carcass of a Cape cormorant.

4. The calcified remains of a dead Cape fur seal.

5. Wind-scarred desert showing white dunes flanking the Skeleton Coast.

6. Yellow 'bubble' succulent Zygophyllum clavatum on a shoreline dune. There are 41 species of Zygophyllum endemic to southern Africa. These dwarf shrubs typically branch out across the sand and are a common feature of this strip of wild, windswept desert.

7. Springbok scat encrusted with salt crystals from a saline spring lie scattered along the lower course of the Hoanib River.

Right: 8. A fishing trawler lies wrecked on this hazardous, dreaded coast. Cape cormorants Phalacrocorax capensis have taken abode on the rusting hull.

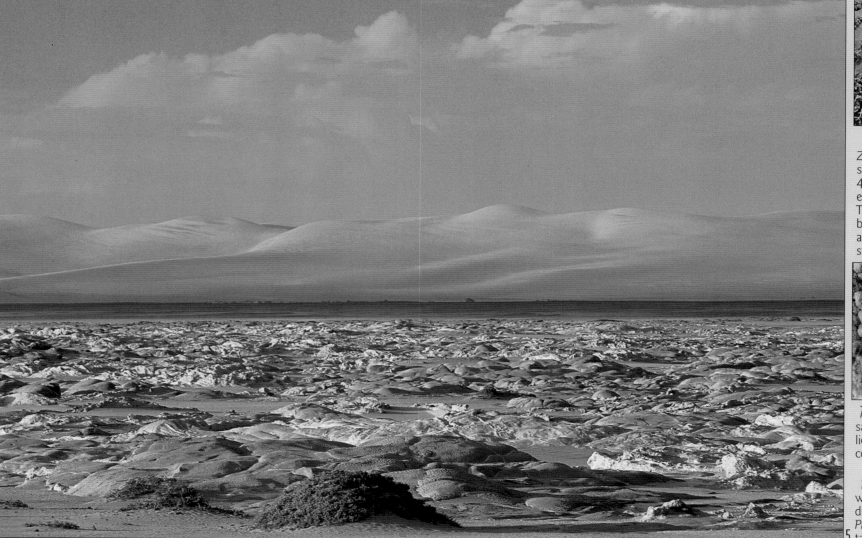

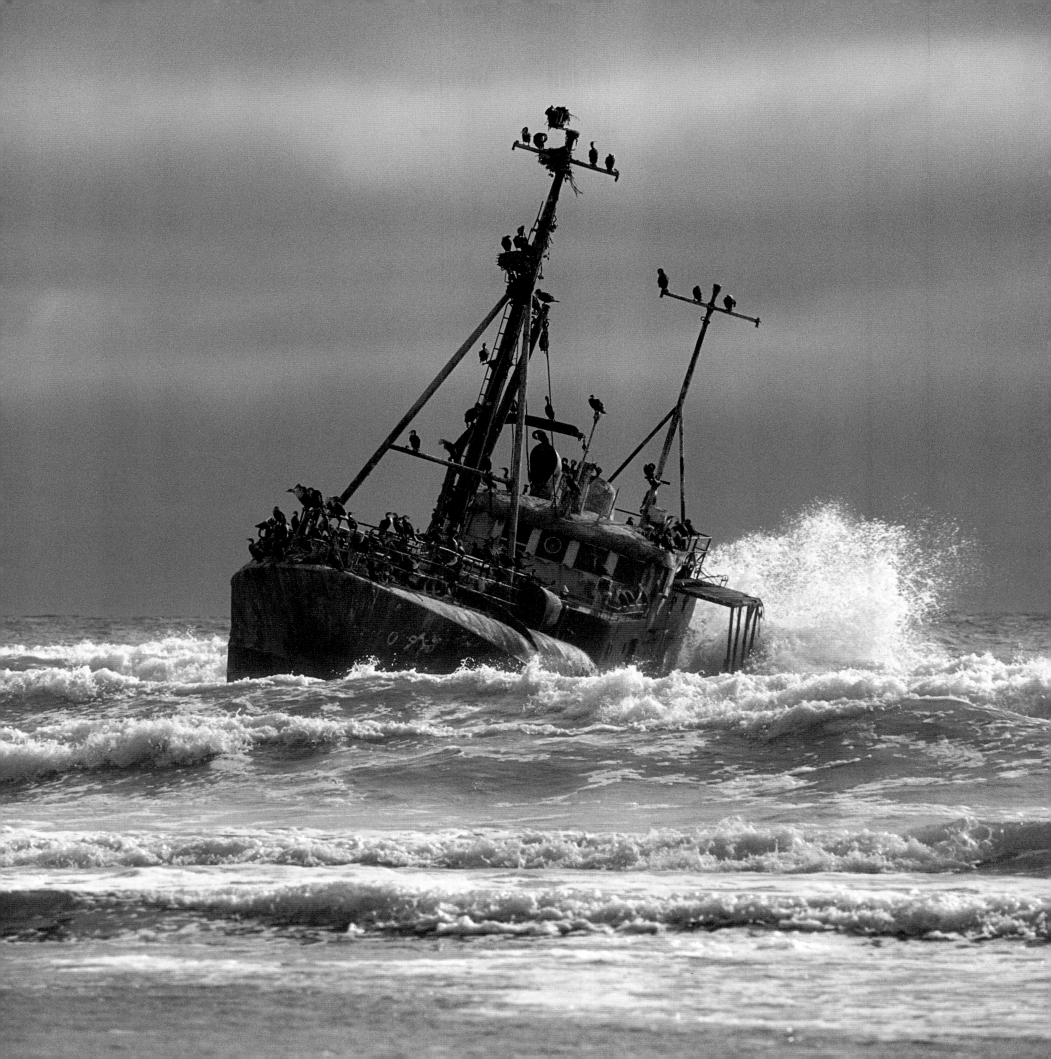

Resembling members of a *corps de ballet*,
two pairs of male ostriches, in almost perfect symmetry,
race across a white dune in the northern sector of
the Namib-Skeleton Coast National Park.

1 & 3. A male *Welwitschia mirabilis* displays a characteristically scraggy appearance in the bleak Namib.

The species is the only one in the family Welwitschiaceae and is limited to the Namib Desert and southern Angola. The plants are regarded as 'living fossils'with some believed to have survived for 2000 years or more.

Each plant grows from a thick trunk and develops just two long broad leaves during its entire lifetime. These lengthen in time and split into strap-like sections. The bunches of leaves

seen on older plants are in reality splits of the original leaf pair. The largest known welwitschia, nicknamed 'the Big Welwitschia', star a massive 1.4 m tall and is over 5 m in diameter.

Most cacti, succulents and other desert plants are xeromorphic, having spiny leaves with a small surface area. The welwitschia however, grows long, wide and relatively thin leaves similar to tho of plants found in climates that experience regular rains. These leaves have up to 22 000 stomata (small pores) per square centimetre, which are used for the exchange of gases in photosynthesis. Also, in contrast to other leafed plants, they rem open during foggy or wet conditions and absorb moisture. When hot conditions prevail, they close to reduce evaporation of plant fluids. The welwitschia's root system reaches depths of 2 – 3 m ar can grow laterally as much as 30 m across.

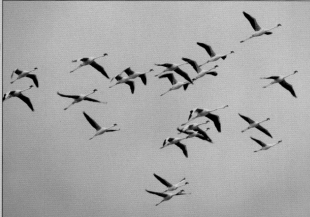

2. A close look at the cones of this female plant shows an *Odontopus sexpunctatus* bug in its red nymph stage. Contrary to popular belief, these bugs of the Pyrrhocoridae family play no part in the pollination of the welwitschia plants but merely feed by sucking the sap.

4. A flight of flamingos in formation over the desert coast.

5. Great white pelicans *Pelecanus onocrotalus* like flamingos, take advantage of whatever fresh water resources they can find along t desert coast, especially in and around rivers that seasonally flow into the Atlantic.

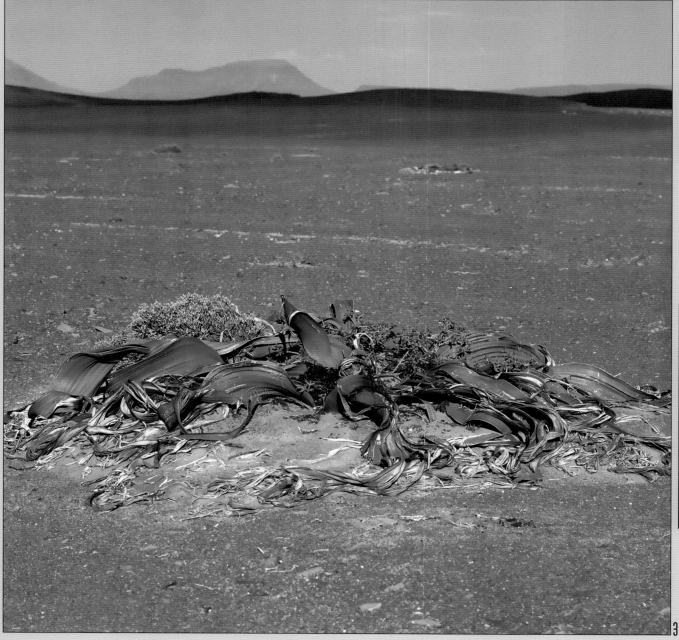

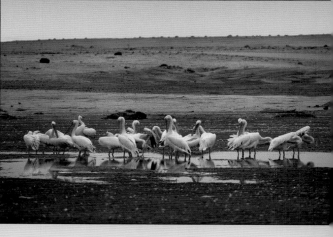

Right: 6. Stark, bare and inhospitable, Damara granites rose throug the earth's crust aeons ago to create what is now known as the 'Badlands'.The evocative-sounding Moon Valley was formed when this previously high range became worn down over time by the eroding forces of the Swakop River.

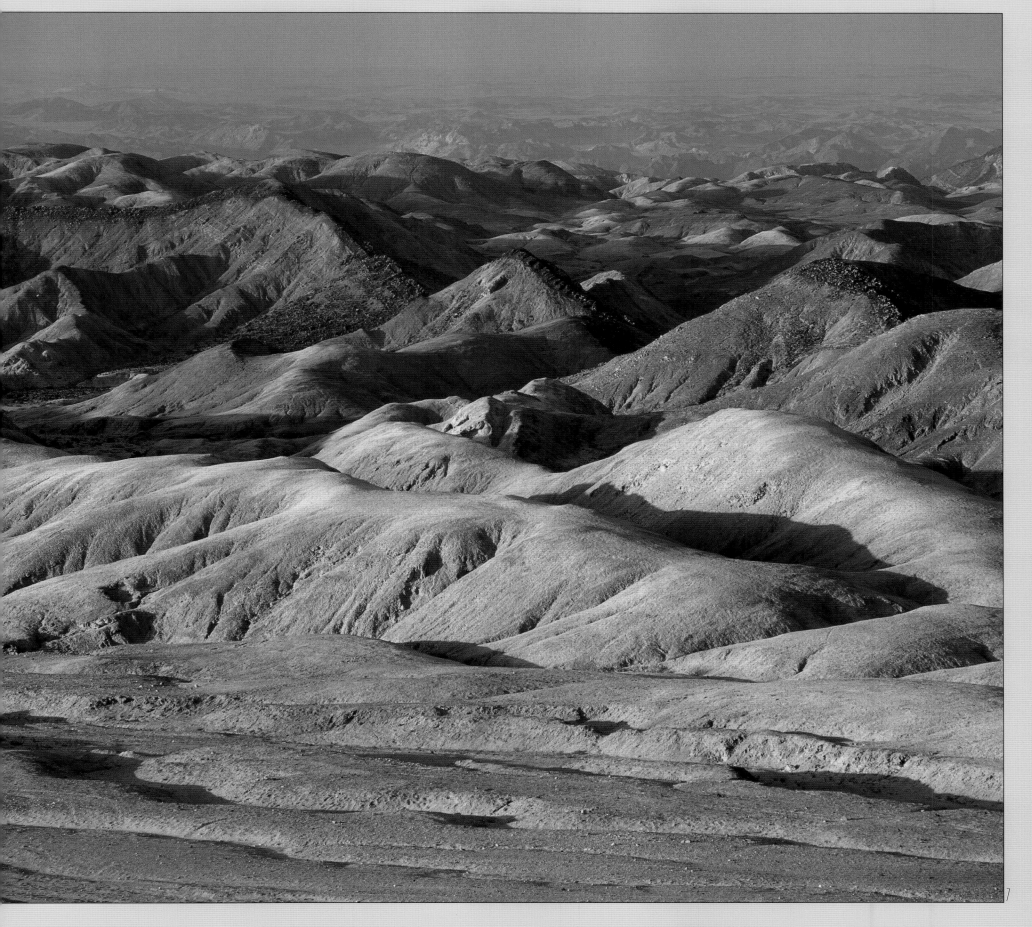

NAMIBIA

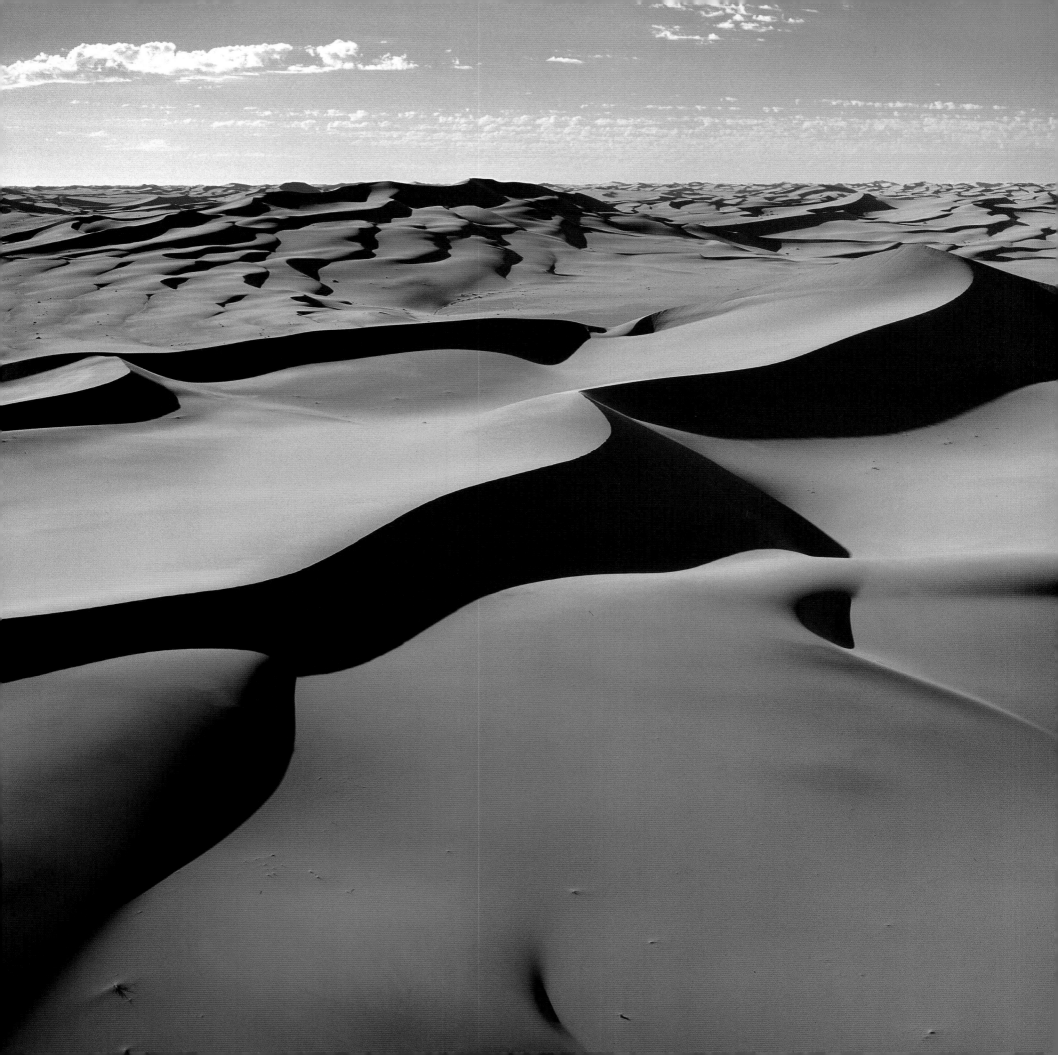

Sandwich Harbour, the country's only marine reserve, is a natural lagoon between the Namib Desert dunes and the Atlantic shore.

At one time a harbour for whalers and fish processors, it is today one of the world's most coveted birding sanctuaries, providing a haven for waterbirds and a wintering ground for migrant shorebirds from the Palearctic regions.

The lagoon supports some 50 000 birds in the summer and over 20 000 during the winter months.

Far left: | A vast sea of wind-sculpted dunes embraces the central section of the Namib Desert. This is Africa's second largest desert (80 900 km^2) and one of the world's oldest and driest, with less than 10 mm annual precipitation. It stretches over 1600 km along Namibia's Atlantic coast and into southern Angola.

2 Great white pelicans *Pelecanus onocrotalus* take off from the desert shore.

3 The Namib Desert viewed

from the Kuiseb Canyon. The Kuiseb is the largest river to traverse the desert and forms a barrier to encroaching sand dunes of the southern Namib. The recently declared Namib-Skeleton Coast National Park, is 1570 km long and covers 107 540 km^2. Its width varies between 25 km and 180 km, making it the largest park in Africa, the sixth largest terrestrial park globally and the eighth largest overall.

In this harsh land of extremes, a surprising collection of

animals survive, including gemsbok, Hartmann's mountain zebra and brown hyena. Some of the smaller creatures such as Peringuey's side-winding adder, the intriguing golden mole and certain gecko and beetle species are uniquely adapted to live in this environment

4 A Black Korhaan chick, *Eupodotis afra* lies exposed in its stony nest site in the Kuiseb Canyon.

5 Peringuey's adder *Bitis peringueyi* is a sidewinding species so called for its mode of locomotion across windswept desert sands. An ambush-hunter, it catches prey by submerging in the sand with only its head visible, where it awaits an unwary victim.

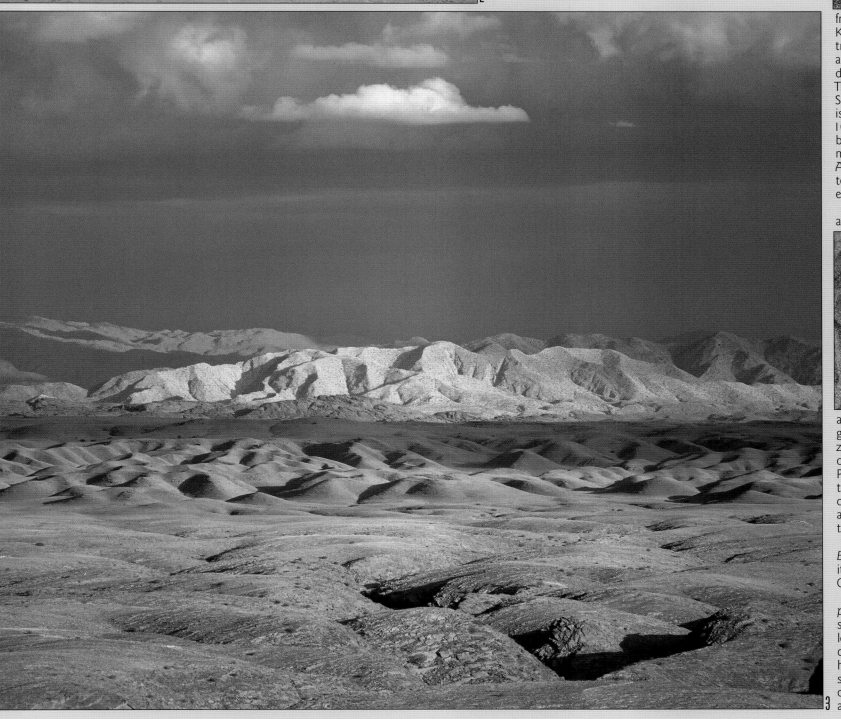

Treacherous seas and ever-shifting sands make the Namib Desert coast one of the world's most dangerous. The interaction of moist sea air meeting the dry desert causes dense fogs. Wild winter storms and the Atlantic's longshore currents all contribute to the notorious infamy of the feared Skeleton Coast.

1. Shallow inlets, sandbanks and lagoons to the south of Sandwich Harbour. Calm today, they are always subject to the relentless and violent whims of nature that will inevitably change the patterns and shapes that define the view.

2. The wreck of the *Edward Bohlen*, a 2000-ton, 100 m long cargo ship which ran aground in dense fog south of Conception Bay on 5 September 1909. It now lies almost 1km from the shoreline. This shows just how quickly the desert claims the ocean.

The sand moves inexorably into the Atlantic.

3. Great white pelicans thrive along this coastal desert, benefitting from the abundant fish life.

4. The turbulent ocean faces a long line of spectacularly wind-sculpted dunes along the central Namib Desert coast.

Right: 5. This has been the blight of countless ships that have foundered along the shores over the years; their splintered hulks buried for years, and then eventually exposed again to the restless desert sands.

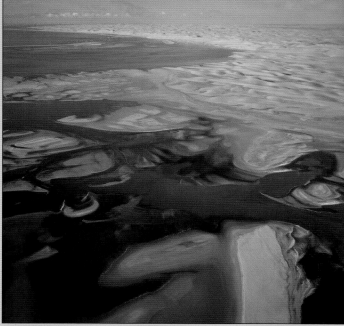

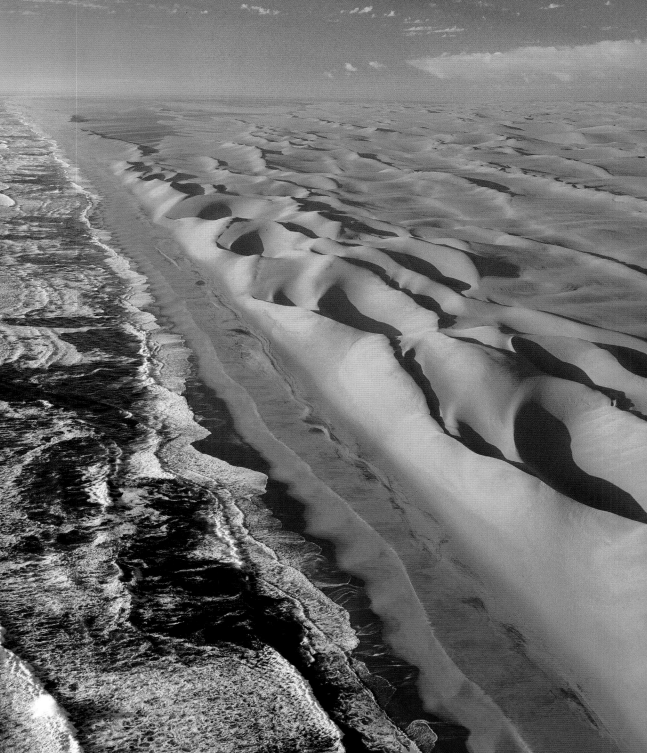

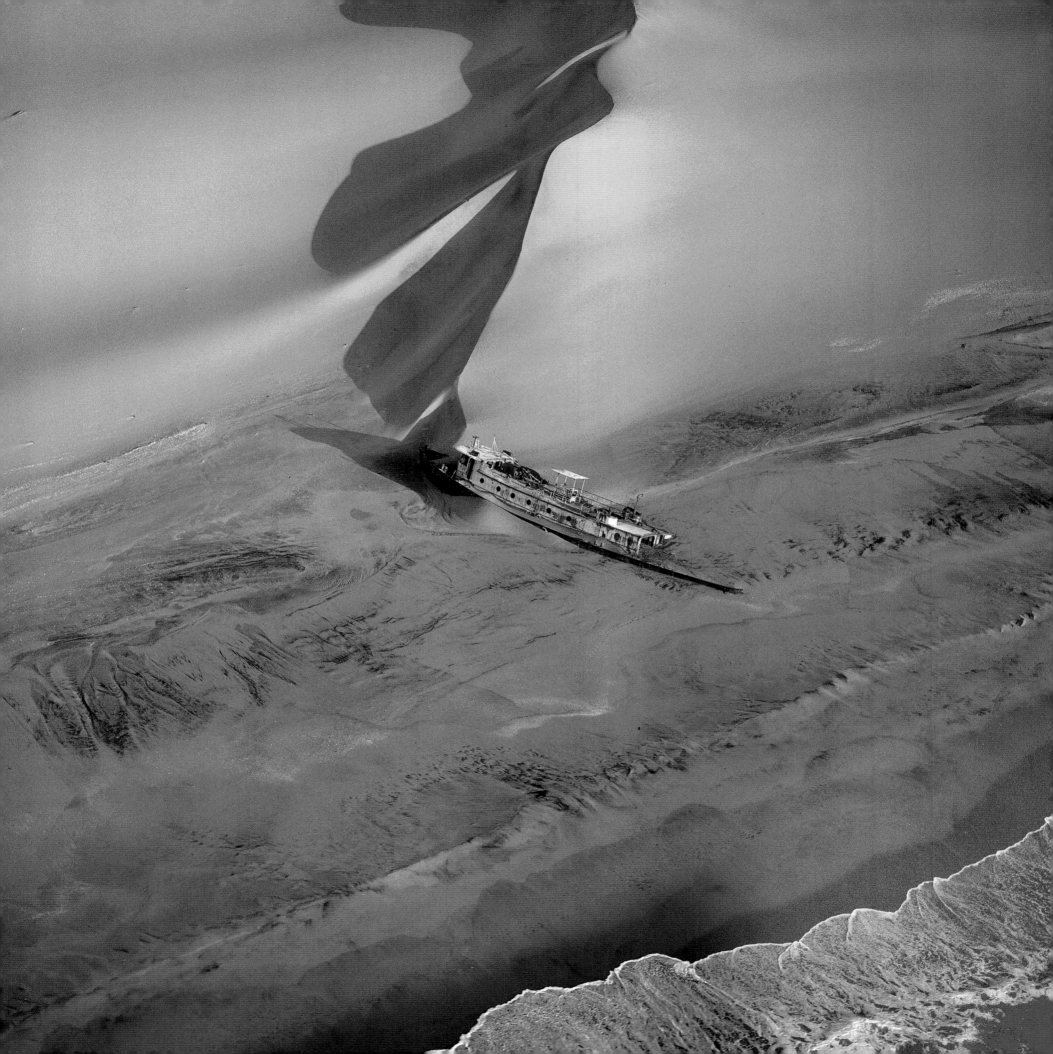

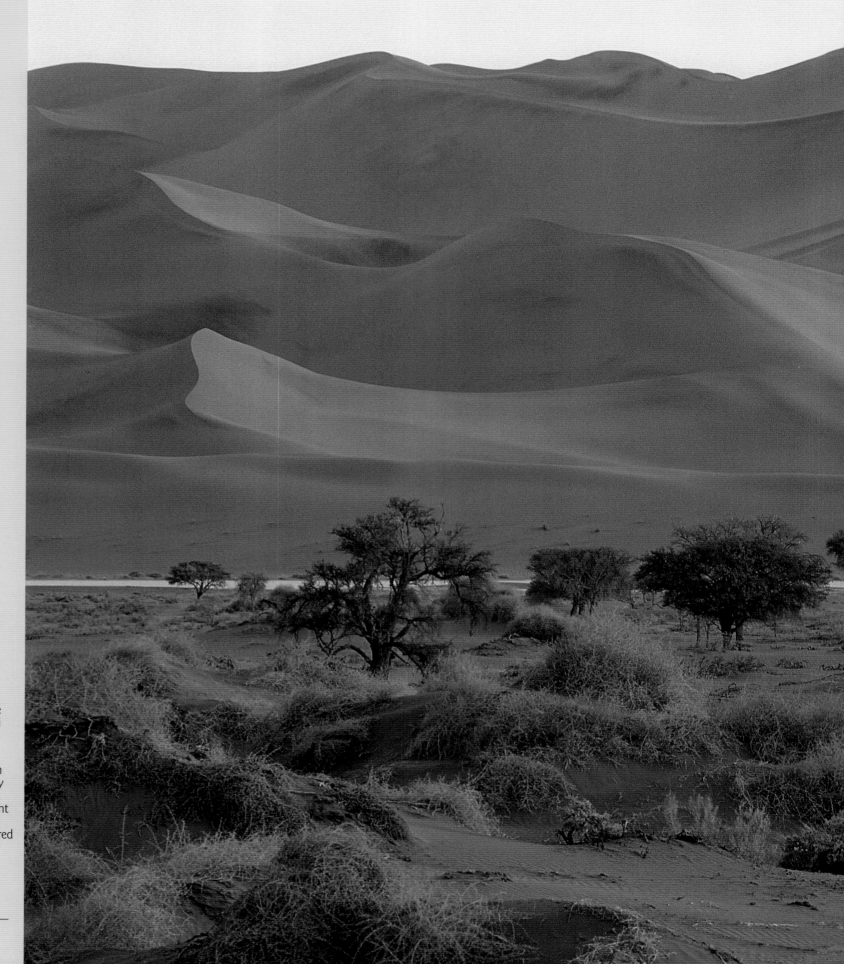

A majestic desert dune, one of the highest in the world, looms above Sossusvlei in the Namib-Skeleton Coast National Park.

Sossusvlei is a large clay pan in the central desert that is fed by the Tsauchab River. Infrequent seasonal floods ensure sufficient groundwater to sustain hardy camelthorn acacias and scattered patches of grass scrub.

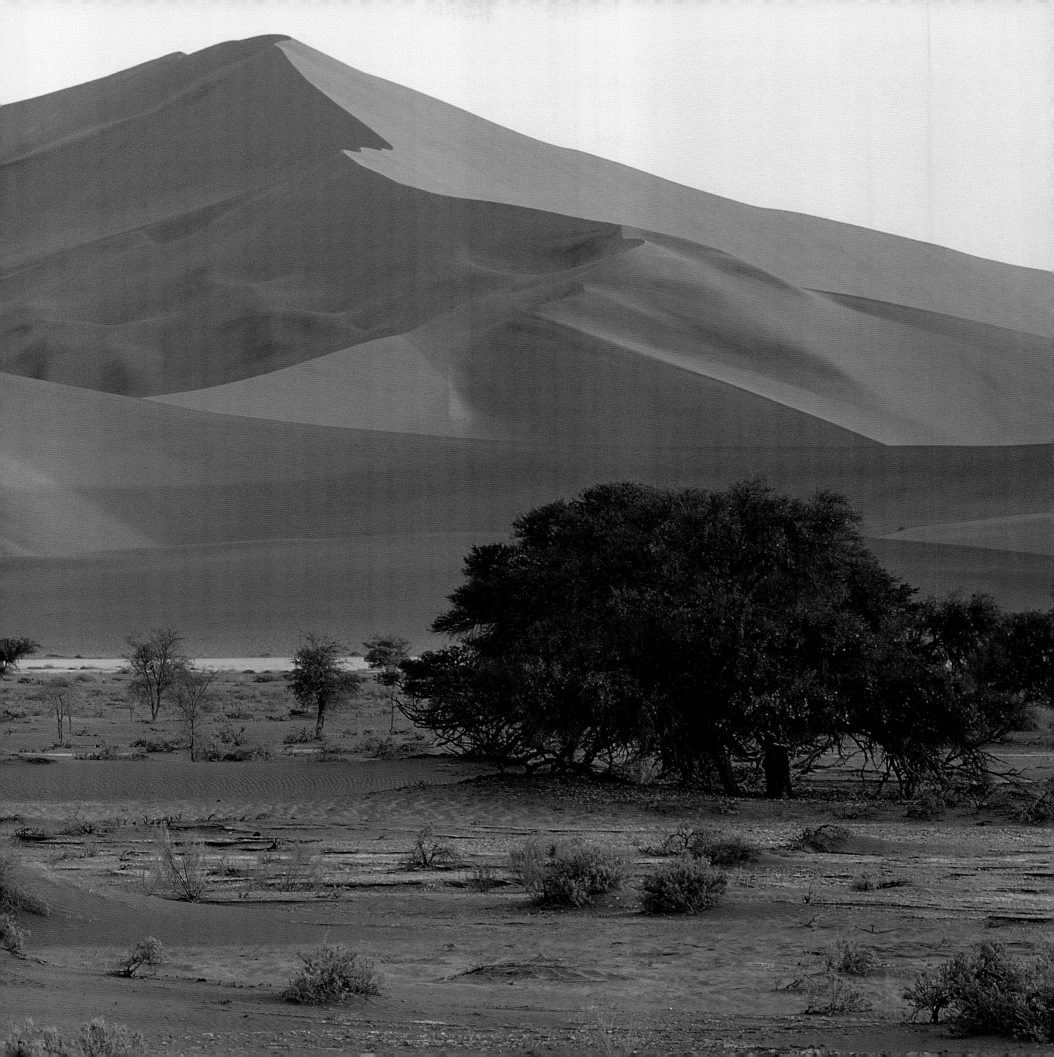

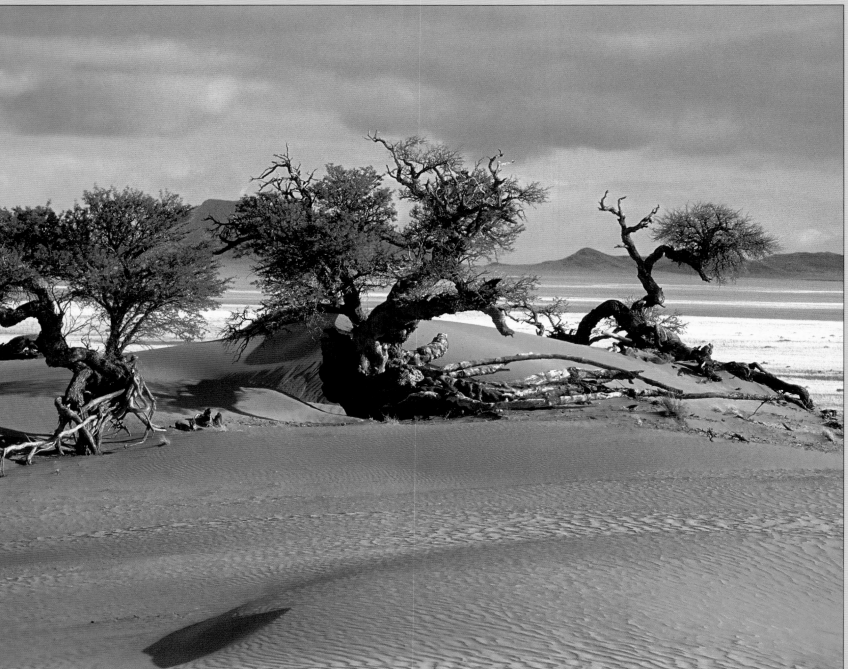

1. The Cape fox *Vulpes chama* prefers an open habitat, savanna and semi-desert to woodlands. It is mainly nocturnal, although pups pla[y] during the day.

This small, non-territorial fox is monogamous. It is an omnivore and feeds on small rodents, reptiles, invertebrate[s] and wild fruits.

2. The spiny fruits of the strange nara plant *Acanthosicyos horrida* were, i[n] years gone by, a useful food source for Bushmen and are still relished by wildlife. With deep water-seeking roots, they are finely adapted to the harsh desert habitat a[t] Sossusvlei.

3. A juvenile spotted eagle ow[l] *Bubo africanus* is well camouflaged in the shady thicket of a camelthorn acaci[a]. This is the most common ow[l] species in southern Africa.

4. Gnarled and stunted camelthorn acacias anchor th[e] sand in the Koichab dunes.

5. A male tenebrionid beetle *Onymacris bicolor* rides the female to conserve both energy and moisture, a uniqu[e] adaptation in its hot dry dese[rt] habitat.

Right: 6. A camelthorn acac[ia] *Acacia erioloba* draws sustenance from moisture de[ep] beneath the dry Tsauchab riverbed. It stands dwarfed beside a dune in the Sossusv[lei] region of the Namib-Skeleto[n] Coast National Park.

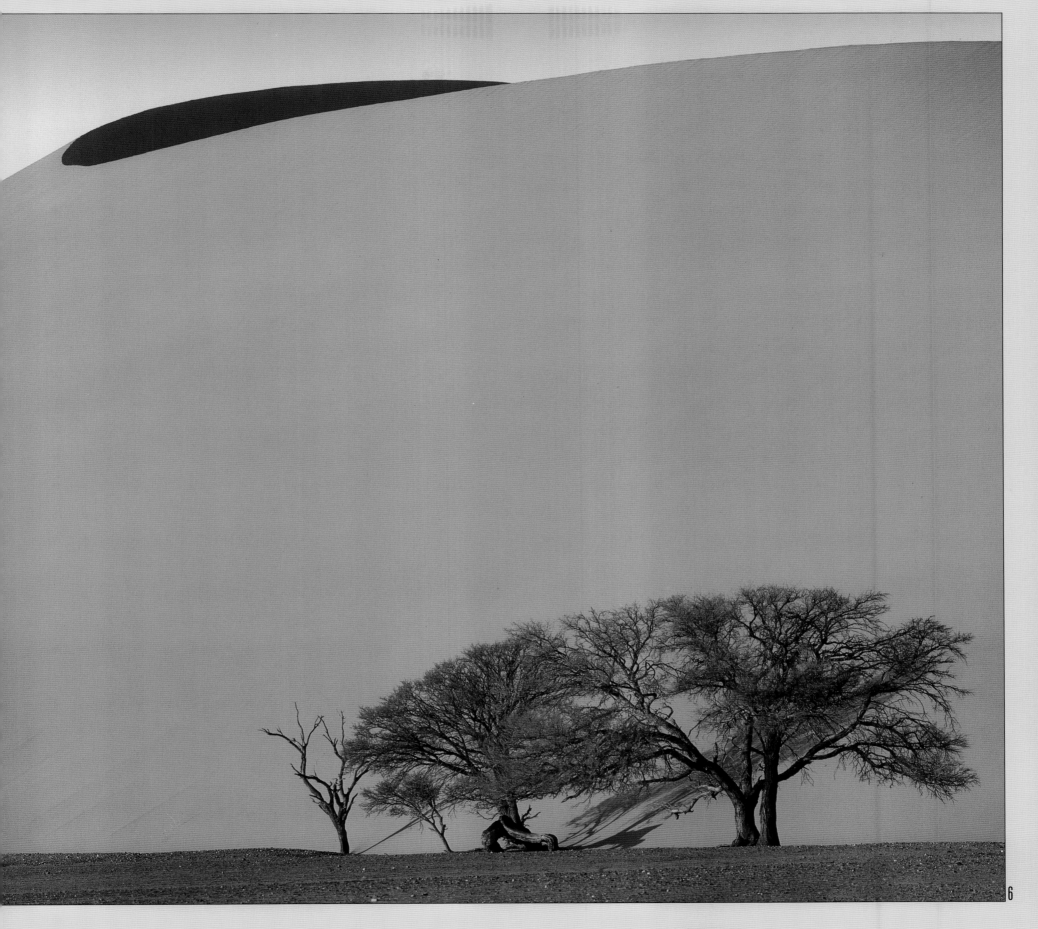

NAMIBIA

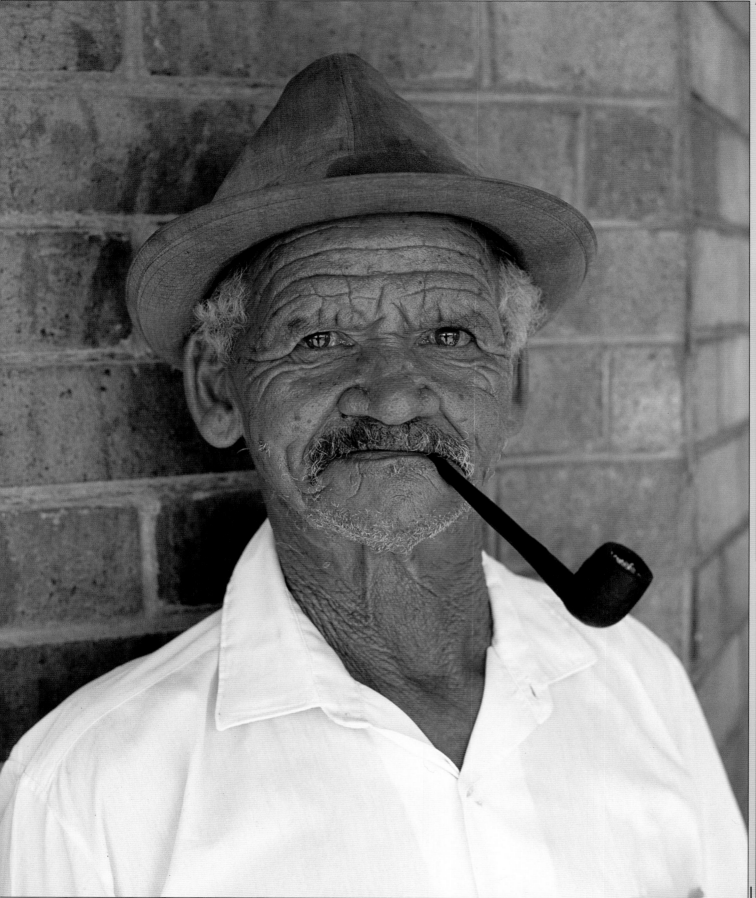

The names Namibia and Namaqualand come from the Na
people who share ancient linguistic and cultural roots w
San (Bushmen), already living on the subcontinent for
centuries, as well as Khoi herder clans from the Northern Ca
(today's Namaqualand). During the 17th and 18th centuries
these people, referred to as Hottentots, were driven across t
Orange River by advancing European settlers. In the mid-19t
century, led by Jan Jonker Afrikaner, they moved northwards
reach present-day Windhoek.

Around 13 Nama clans exist to this day, preserving a cultu
and language rich in music, poetry, oral history and a way of
life founded on communal land ownership and leadership by
elders (or Kapteins). They are known for crafts which include
leatherwork and the making of skin karosses and mats,
musical instruments (such as reed flutes), jewellery, clay pots
and tortoiseshell powder containers. Some of the older
generation of Nama women still dress in Victorian traditiona
fashion, a style of dress introduced by missionaries
in the 1800s.

In 1991 a portion of Namaqualand, home of the Nama,

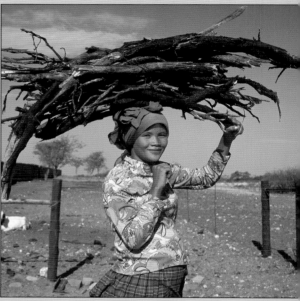

EVOCATIVE AFRICA

...came the Richtersveld ...ational Park, one of the last ...ue wilderness areas of South ...rica. In December 2002,

ancestral lands, including the park itself, were returned to community ownership. The governments of South Africa and Namibia embarked on the development of a transfrontier park along this west coastal region of southern Africa, absorbing the existing Richtersveld National Park.

Today the |Ai-|Ais/Richtersveld Transfrontier Park is one of the few places where old ways survive. Here, the Nama still move with the seasons and speak their language, Nama of the Khoe-Kwadi (Central Khoisan) language family. The traditional Nama dwelling —|haruoms (a portable-mat covered domed hut)

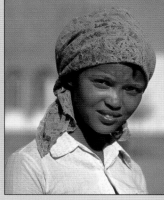

— is a reflection of their nomadic way of life, offering a cool haven against the blistering heat of the sun, yet easy to pack and move if grazing lands become scarce.

Hendrik Witbooi, the famed Nama leader (c. 1825–1905), after serving in a branch of the German army for three years fighting the Herero, led a determined revolt against German rule in October 1904. Witbooi was eventually killed at Tses in1905. His dying request: "It is enough. The children should now have rest." An educated multilinguist, Witbooi kept detailed diaries which are still extant. Today, his face is portrayed on the back of the Namibian 10-dollar note.

1. A casual Nama study on a Keetmanshoop street corner.
2. Bearing a load of freshly

gathered firewood, a young Baster woman smiles radiantly. Basters are the offspring of Nama and Dutch settlers, an Afrikaans-speaking people who migrated to South West Africa from the Cape Colony during the 1860s. After initially settling near Warmbad in the south, in 1880 they finally moved to the area of Rehoboth, which had been established as a Rhenish mission in 1845.

The Basters are proud of their name and history, even though the word *baster* means bastard. They feel different from other Coloureds due to their unique history and by the fact they have been settled in their own land for

well over 100 years.
3. A Baster couple at their home in Rehoboth.
4. The weathered features of a Nama stock-farmer.
5. A young Nama girl's Hottentot blood is reflected in her delicate heart-shaped face and warm honey-toned skin.
6. A young Baster mother with her two children at home in Rehoboth.
7. Nama children pose at the entrance of the Mission church at Gibeon. The area around this town was originally inhabited by the Bergdamara, who called it 'the place where the zebra drink'. Nama people have settled here since the second half of the 18th century.
8. The Lutheran Church at Rehoboth dates from the German colonial-period.
9. Baster children at Rehoboth.

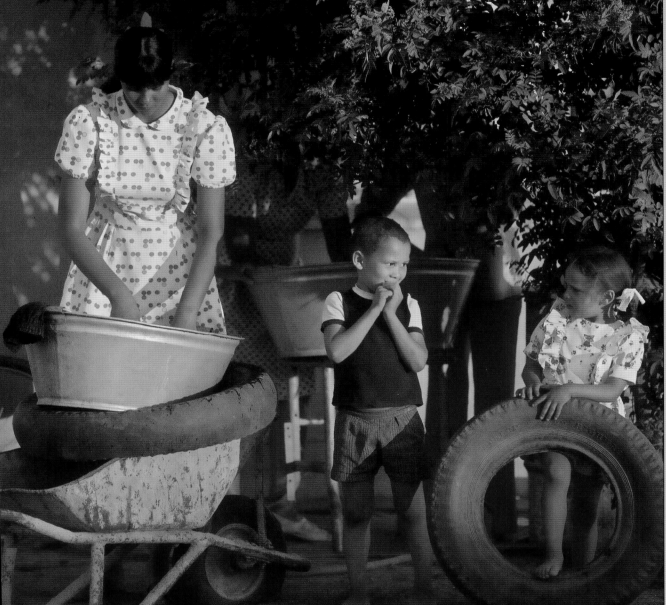

Battered by violent seas and unceasing winds, Namibia's southern desert coast remains today a barren, inhospitable region.

In the mid-19 th century however, the offshore rocky islands became world-renowned for their huge deposits of guano built up by seabirds over the millennia. This highly valued fertiliser led to a 'guano rush', with an armada of trading vessels battling the elements to exploit these riches.

Today the coast is best known for its rich diamond deposits.

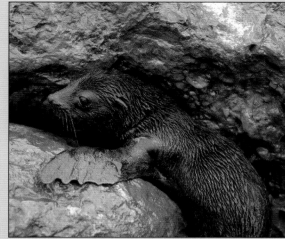

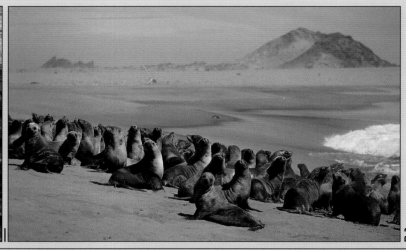

1. A Cape fur seal pup *Arctocephalus pusillus* shelters by a rocky promontory awaiting the return of its mother.

At this stage of its young life a seal is at risk from marauding black-backed jackals *Canis mesomelas* that relentlessly patrol the peripheries of the colony.

2. Cape fur seals congregate at the shore's edge along the remote Sperrgebiet coast.

3. This wild, inhospitable desert coast (here at Black Rock) supports huge colonies of fur seals – the largest with a breeding population of 180 000.

These hardy pinnipeds thrive in the barren, windswept environment of southern Namibia, taking advantage of the cold Benguela current, which ensures an abundant supply of pelagic fish.

Far right: 4. The ephemeral light of full moon is reflected in the calm waters of a tranquil inlet on the south Namib Desert coast. In the distance, a flock of lesser flamingos breaks the outline of the rocky shore.

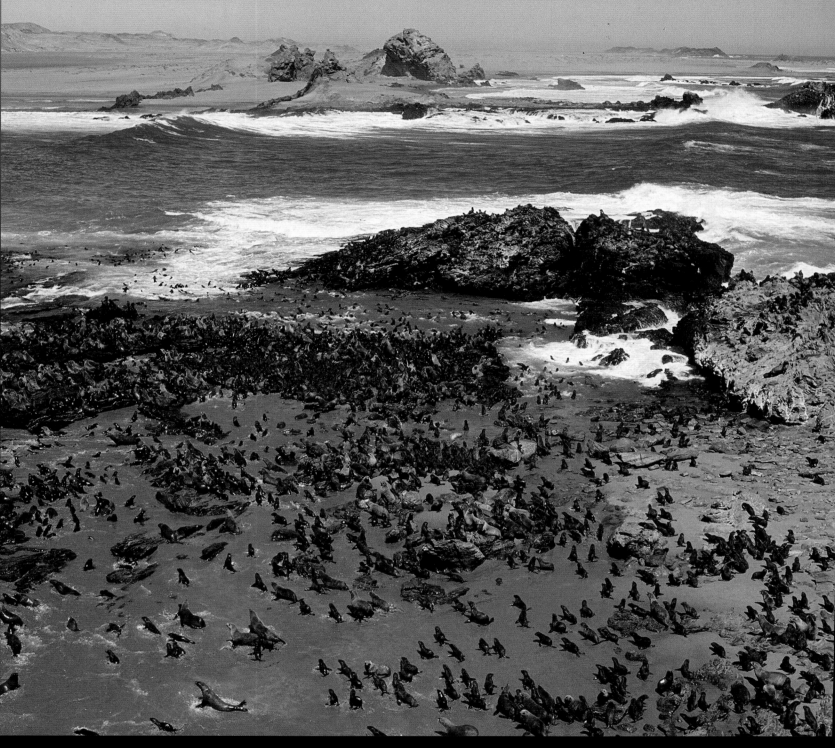

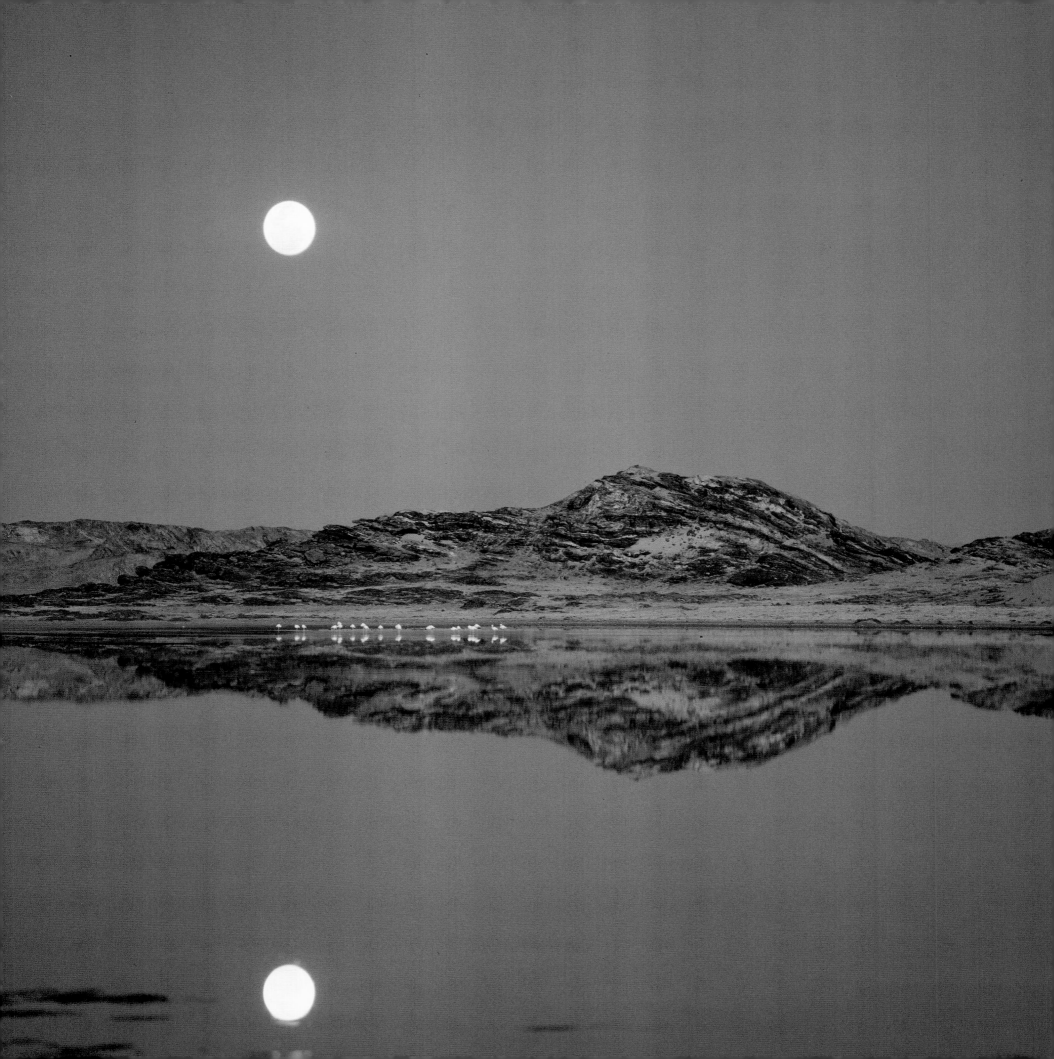

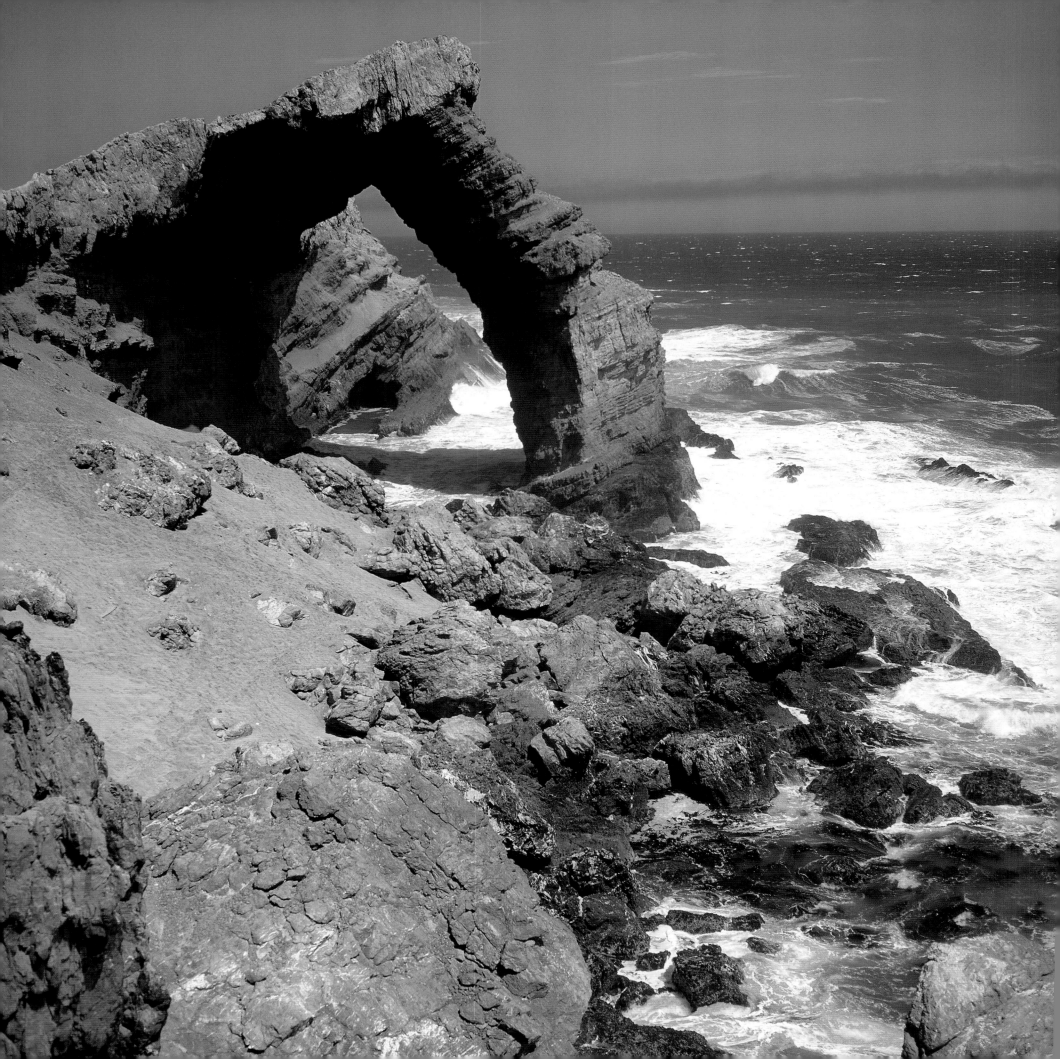

The Bogenfels Arch is a 55 m-high natural rock formation of [...]ed dolomite, a prominent feature of the southern Namib [...]rt coast, situated in a restricted diamond area. It is [...]nally subject to morning coastal fog which only clears [...]oon.

[...]ere are few sheltered bays along the coast. Most of Namibia's [...]e comprises sandy beach (54%) or mixed sand and rock [...]). Rocky shores constitute only 16% of the total length. [...]trolling the desert coast, a black-backed jackal *Canis [...]melas* searches relentlessly for food. These omnivorous [...]ators will take every opportunity to scavenge in amongst a [...]e fur seal colony.

3. A Cape fur seal bull is surrounded by young pups at the Baker's Bucht colony.
4. 'Boiled fingers' *Hydrodea sarcocalycantha* is a succulent prevalent along the southern desert shoreline.
5. *Mesembryanthemum crystallinum* in its resting stage. This is a prostrate succulent covered with large, glistening bladder cells which give rise to its familiar common names:

ice plant, crystalline iceplant or simply iceplant.
Like some other members of the Aizoaceae family, the plants' leaves are edible.
6. A rare visitor from the distant south Atlantic, this bull elephant seal *Mirounga leonina* roars its displeasure at the intrusion.

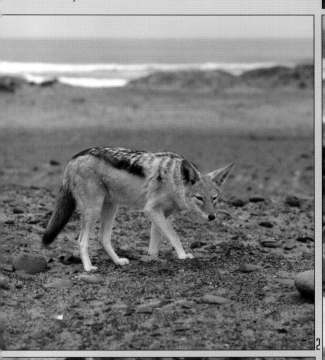

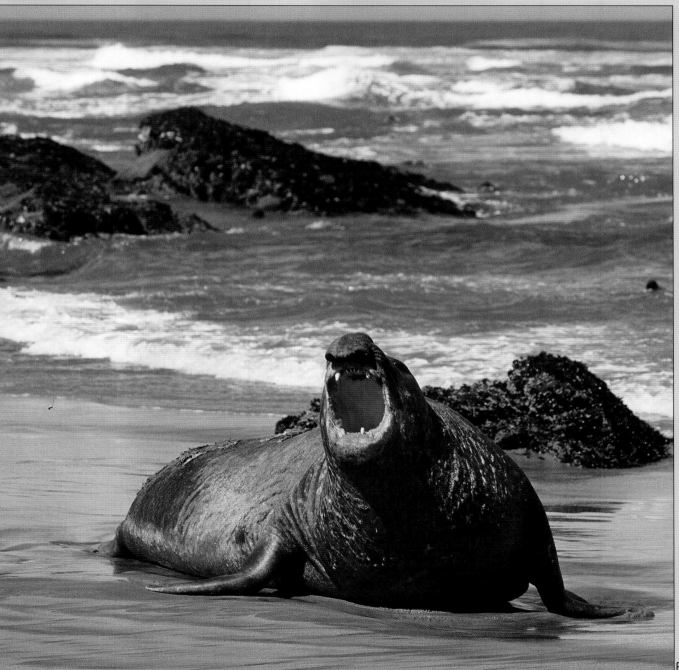

1. The rusting remains of a Second World War Sherman tank that was used to clear desert overburden in the early years following the war, in the Namdeb diamond concession in southern Namibia.

2. A derelict, long-abandoned house at the ghost town of Kolmanskop near Luderitz.

3. Ravaged by desert sands for some 80 years, the shell of an old mining house in the Bogenfels ghost town stands witness in the wilderness to the years of the great diamond discoveries.

Diamonds were first discovered in the German colony of South West Africa in 1908 when August Stauch, a young railway

supervisor told his labourers to watch out for pretty stones. Scarcely two weeks had passed before Zacharias Lewala, a Coloured man who had worked at Kimberley, discovered the first diamond. This launched a frenzied fever of search and speculation. Thousands converged on what was soon to become the Sperrgebiet (Forbidden Zone) to make their fortunes. Settlements sprang up near the new finds.

World War I temporarily halted mining, and when in the late 1920s the industry revived, it was the newly discovered marine terraces of the south that became the centre of activity. Here the industry was to develop into the giant it is today.

4. A collection of uncut coloured diamonds.

5. A diamond lies embedded in a piece of exposed bedrock.

6. Uncut diamonds, part of one day's production, at the Namib Diamond Corporation mine.

Right: 7. The Namib Desert in the southern Sperrgebiet. Fresh gemsbok tracks along the sand belie the impression of a wilderness devoid of life.

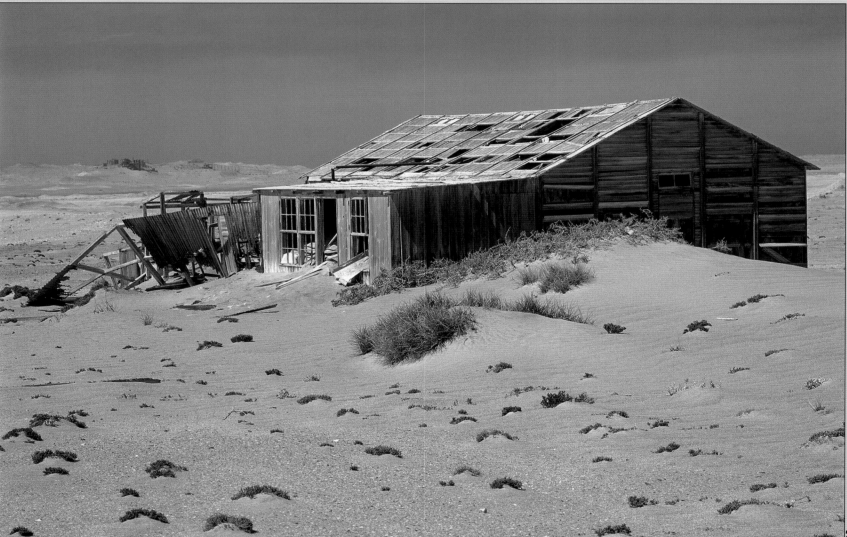

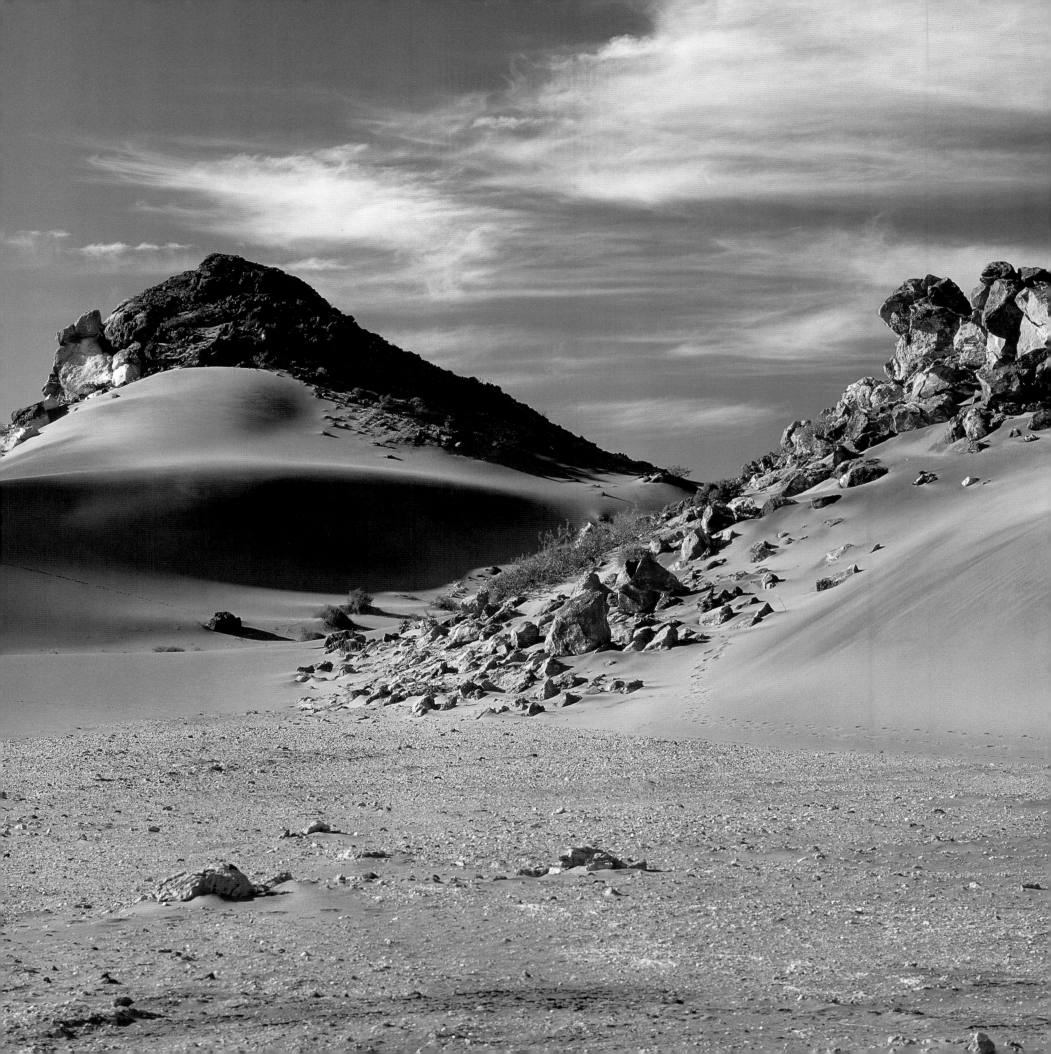

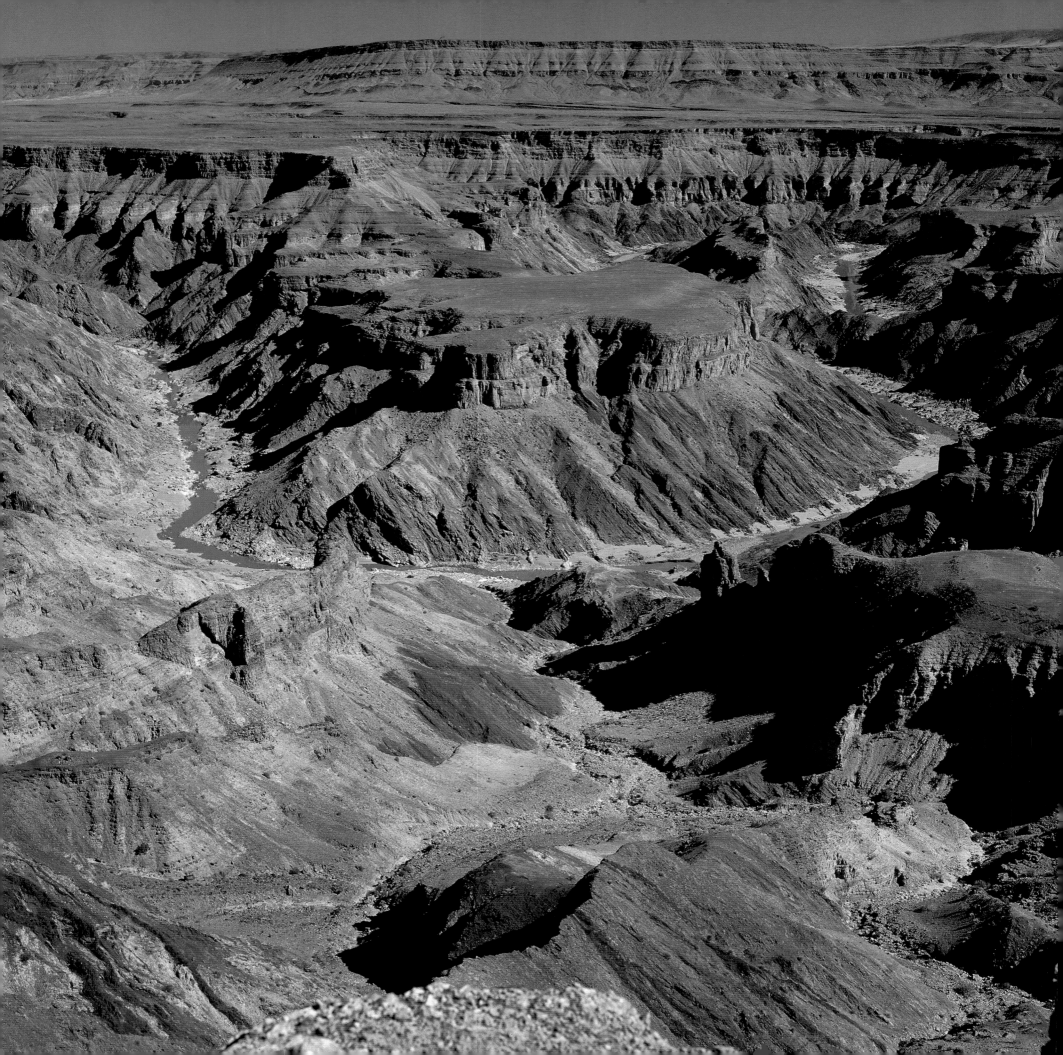

I. A vast eroded gorge, the
 River Canyon dissects the
rt plateau north of the
nge River. The lower
m is situated in the new
| Ais/Richtersveld
sfrontier Park. At 161 km
, and 27 km wide, and
m at its deepest point. It is
nd only in size to the Grand
von in Arizona.
e Fish River is the longest
ior river in Namibia, cutting
 into the dry, stony plateau.
he Mukarob or Finger of God,
eroded pillar-shaped remains
 disintegating plateau finally
psed in December 1988.
A lonely road traverses dry,
b grasslands in the
Namib of southern Namibia.

e afternoon brings
our and mood to the southern
ert wilderness.

ht: 5. Gemsbok gallop across
osed sandflats by the
nge River, which forms the
der with South Africa.

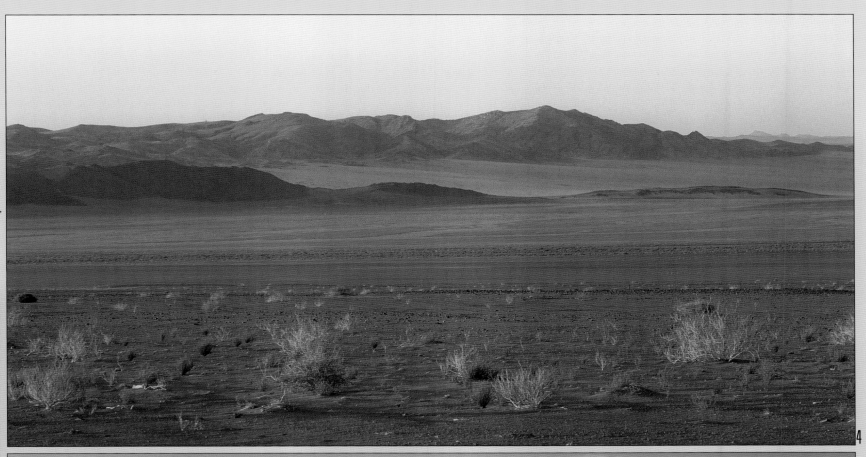

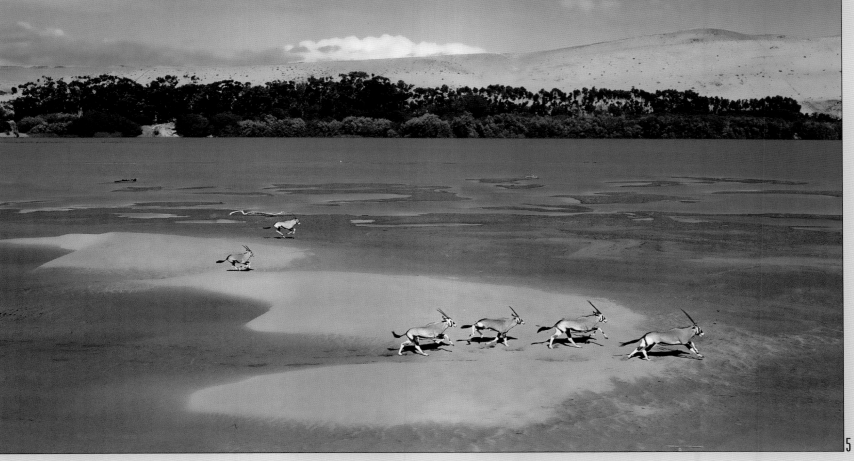

KALAHARI & THE CAPE WEST COAST

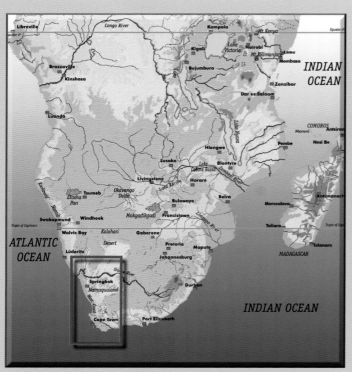

English traveller; and the famous French explorer, author, naturalist, and zoological collector, François Le Vaillant. They all travelled along the river and into its hinterland.

The eastern boundary of Namibia with South Africa adjoins the Kalahari. In this region the desert is both arid and semi-arid. Here tracts of seasonal grazing (following good rains) support a greater abundance of animals and plants than a true desert.

The yellow mongoose Cynictis penicillata *lives in colonies of up to 20 individuals in permanent underground burrow complexes.*

Desert sands are everywhere an important and forgotten storehouse of carbon dioxide taken from the world's atmosphere. Scientists heard from Dr Andrew Thomas of Manchester Metropolitan University, at the Society for General Microbiology's meeting on 2 April 2008, that: "Desert soils are unusual because the sand grains at the surface are bound together into a crust by bacteria, reducing wind erosion and adding nutrients to the soil. Deserts cover over one third of the world's land surface", Sands like those in the Kalahari Desert are full of cyanobacteria, drought- resistant bacteria that can fix atmospheric carbon dioxide. Together they add significant quantities of organic matter to the nutrient- deficient sands.

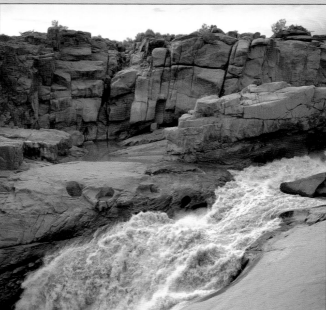

The Orange River cascades over ancient eroded granite formations at Augrabies Falls.

Dr Thomas continues "...We know that globally there is a huge exchange of carbon between the atmosphere and the soil. As average global temperatures rise, scientists are concerned that bacteria will break down organic matter in soils more rapidly, releasing more carbon dioxide into the atmosphere... We also discovered that the fluxes of carbon dioxide from the soil were

highly sensitive to temperature. Warmer air but similar soil moisture levels caused greater losses of carbon from the desert soils to the atmosphere... These desert soils are contributing significantly to the global carbon dioxide budget. Until recently they have been ignored". *ScienceDaily* (4 April 2008).

A significant part of this desert in South Africa comprises the Kgalagadi Transfrontier Park (linked with Botswana). Despite the aridity, the region supports a variety of tree species, as well as grasses, plants and herbs.

January is midsummer, and daytime temperatures often excee 40 °C in the desert. Winter nights can be bitingly cold with temperatures well below freezing.(−11°C has been recorded).

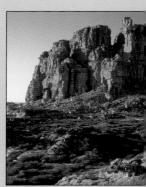

Eroded rock formations in the high Cederberg.

Rosyfaced Love birds, Agapornis roseicollis, *a common endemic species to the north-west Cape.*

Bushmen have lived here for thousands of years as hunter-gathe using bows and arrows to hunt wild game, as well as gathering edible plants, such as the tsama melon, and insects. Provision h been made in recent years to allow the Khomani San and Mier communities to continue living their traditional way of life in th park with 580 km² set aside for their use. These communitie retain commercial benefits and rights, as well as the use of land for symbolic and cultural purposes.

Namaqualand stretches from the Orange River south to Vanrhynsdorp, and from the Atlantic coast to Pofadder in the ea This is a vast and varied region: semi-arid, hilly and mountainou the north, becoming generally flatter in the south. This was the original home of the Nama people referred to by the early colonialists as Hottentots.

The Richtersveld National Pa one of the last true wilderness areas of South Africa, was crea in the northern section of Namaqualand in 1991 after 18 years of negotiation with th local Nama people. In June 200 an area of equivalent size to th south of the national park, wa named a World Heritage Site. Richtersveld Community Conservancy now forms the c

A black-footed cat Felis nigripes.

The Orange River is one of the longest on the African continent. It rises in the Lesotho Highlands, at an altitude of 3300 m, then flows toward the Atlantic Ocean in a generally westerly direction for some 2030 km. Initially it traverses the veld region of South Africa, after which it defines the southern limit of the Kalahari and bisects the southern Namib.

Some 32 km below Kakamas, flowing in several channels, the river has over millennia gouged out the Augrabies Falls. Here it descends in a series of thunderous rapids to plunge dramatically into a deep pool. Further west the Orange designates the southern boundary between Namibia and South Africa. It traverses the remote Richtersveld wilderness before finally draining into the

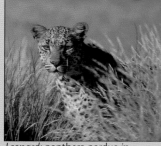

Leopard: panthera pardus *in the Kalahari grasslands.*

Atlantic Ocean at Alexander Bay.

The Orange river provides vital irrigation to cultivated areas between Upington and the Augrabies Falls where cotton, lucerne (alfalfa), export grapes, and dates are grown.

In 1760, Jacobus Coetsee, an Afrikaner elephant hunter, became the first white man known to have crossed what was then called the Groot River to the north bank, near the river's mouth. Subsequent explorers included another Afrikaner, Hendrik Hop; Robert Jacob Gordon, a Dutch officer who named the river in honour of the Dutch house of Orange; William Paterson, an

Ursinia sp. wildflowers in the Darling district.

of this heritage site and is not subject to diamond mining, and
...us the more pristine of the two areas. Later, ancestral lands
...ding the park were returned to community ownership. A
...frontier park known as the |Ai-|Ais/Richtersveld Transfrontier
...was created in 2003 by combining the Namibian IAi-IAis Hot
...gs Game Park and the South African Richtersveld National Park.
..., the Nama still move with the seasons and speak their own
...nctive language. The traditional Nama dwelling, the |haruoms,
...table rush-mat covered domed hut, is still in use and
...ts their nomadic way of life. It is easy to pack and move when
...ng becomes scarce, offering cool haven against the sun's
...ering heat.

...ving springbok Antidorcas marsupialis *in the Kgalagadi
...sfrontier Park.*

...gged mountains, sandy desert plains, strange endemic plants
...a giant blue sky characterise the Richtersveld wilderness. This is
...rded as the only Arid Biodiversity Hotspot on earth, containing
...stonishing variety of plants, including 4849 succulents species,
...hich 40% are found nowhere else. Among these are a number
...range plants, including the Halfmensboom ('half-person tree')
...ypodium namaquanum so-called from the tree's crown
...sisting of a grouping of thick, crinkled leaves, which from a
...ance resemble a human head. The tree is revered by the Nama
...ne embodiment of their ancestors mourning for their ancient
...e: half human and half plant. The rocky terrain also provides
...tat for numerous species of lithops – tiny succulents with
...uisite seasonal flowers which appear like small stones – as well
...ne most lichen species (29) of any area in the world.
...1685 Simon van der Stel, then Governor of the Cape of Good
...e, discovered the rich copper deposits of Namaqualand.
...vever, long before any ship had docked at Table Bay, the local
...na people had fine-tuned the art of smelting copper and were
...g it for domestic and decorative purposes. A copper rush took
...e in the 1850s to exploit this valuable mineral. The boom years
...now long over but copper mining still remains productive.

...ngtime wildflowers in the Biedouw Valley.

For most of the year the plants of Namaqualand's semi-desert
remain featureless and dormant. Then, following sufficient winter
rains, a wonderland of vibrant colours explodes across the

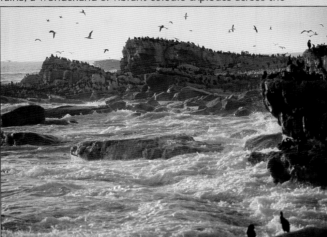

*The rocky shores of Bird Island, haven for huge numbers of breeding
Cape gannets and cormorants.*

landscape. It is as if a black and white scene has magically been
transformed by a paintbrush to bring forth a carpet of myriad
blooms: a palette of yellow, gold, purple, red, orange and white;
everywhere a tapestry of short-lived flowers following the course of
the sun's daily arc. It is a feast of colour, momentarily
overwhelming and magnificent. Soon, however, this wonderful
spectacle comes to an end and the landscape fades back to a
bland uniformity.

Ixia maculata (Darling district)

The Cederberg mountains
comprise a small but significant
range to the south of
Namaqualand extending about
50 km north to south and about
20 km east to west. The range is
noted for its sharply defined
sandstone rock formations, in
places coloured reddish or deep
orange from iron oxide. The
highest peak, the Sneeuberg,
reaches 2026 m. In places the
rocks contain bands of shale in which significant fossils of primitive
fish have been discovered in recent years. Fine examples of San rock
art lie scattered throughout the area in caves and overhangs,
evidence of the nomadic people who once inhabited the region.

The range was named after the endemic Clanwilliam cedars
Widdringtonia cedarbergensis, a high-altitude cypress. With the
onset of European settlement,
these local trees were felled for
telephone poles, furniture and
house construction. Today, as a
result of overexploitation and fire
damage, they are mainly confined
to inaccessible crags and kloofs,
and are endangered.

The Cederberg valleys also
burst into vibrant bloom each
spring. Apart from ubiquitous
vygies and gousblom, there exist
many endemics such as the
yellow *Leucospermum reflexum,*
the snow protea *protea cryophylla,*
blue *Lachanaea filamentosa,*
yellow sparaxis, and pink *Cyanella alba.*

*Kokerboom tree Aloe dichotoma in
spring in the Nieuwoudtville region.*

The verdant valley of the Olifants River lies between the Cederberg
mountains and the coast. Here large herds of elephant once roamed.
The region between Citrusdal and Clanwilliam is today renowned for

citrus farming. In Clanwilliam,
the Ramskop Nature Reserve
hosts more than 350 species of
cultivated indigenous wild flora.

The West Coast is a sparsely
populated yet productive fishing
region benefitting from the
effects of the cold Benguela
current.

At Lamberts Bay, Bird Island
provides sanctuary to large
colonies of both Cape gannets
and Cape cormorants, which
also benefit from the pelagic
shoals, ensuring a long-term and
on-going conflict with the
commercial fishing industry.

*Winter grasslands in the
Kalahari desert.*

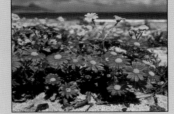

*Springtime wildflowers on the
Blaauwberg dunes: Senecio elegans
(foreground) and Senecio littoreus.*

Further south, on the way back
to Cape Town, lie the expansive
farmlands of the south-western
Cape. These provide wheat,
canola, grapes and other
deciduous fruits. Irrigation for the
region is forthcoming from the
294-km-long Berg River, which
has its lead source in the Drakenstein Mountains and outlet to the
Atlantic at Laaiplek. The river had been known to the European
settlers since 1657 when the first Dutch Governor sent the bailiff
Abraham Gabbema to trade for meat with the Khoekhoe. The river

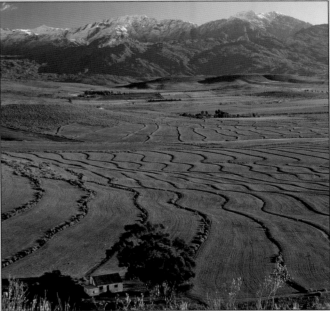

Farmlands in the Ceres Valley with the snow-capped Hex River Mountains.

was also then habitat for hippos, which were exploited for their
meat and hide. In 1869 the last known animal was shot by Martin
Melck when it attacked and killed one of his employees.

The Western Cape falls within the Cape Floral kingdom, and
just after winter rains, the countryside around Darling, Saldhana
and Langebaan explodes into colour producing a patchwork of
brilliant multi-coloured hues – springtime in all its glory.

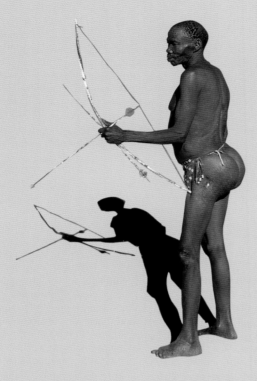

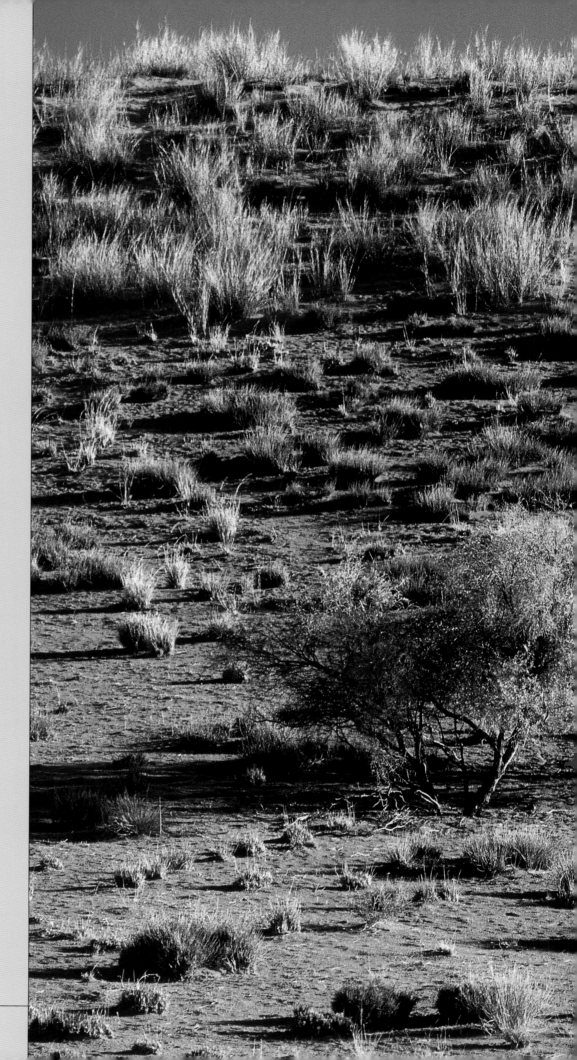

Above: A traditional San Bushman hunter in the Kalahari displays his bow and arrows. It is believed that the San have lived as hunter-gatherers in the Kalahari for at least 20 000 years – surviving by hunting wild game and gathering edible plants such as berries, melons and nuts, as well as nutritious insects. In the past Bushmen rarely drank water; they got most of their water requirements from plant roots and the desert melons found above or below ground.

Right: Grey camelthorn trees *Acacia haematoxylon* amidst scrub grasses in the Kalahari wilderness. The Kalahari (900 000 km² in extent) covers most of Botswana, the eastern parts of Namibia and a section of the north-west Cape in South Africa. Most of the region is not true desert as a result of limited summer rains which give rise to varied plantlife – and in consequence, a wide range of wildlife. The characteristic red colour of the Kalahari sand owes its origin to a thin layer of iron oxide that coats each grain.

EVOCATIVE AFRICA

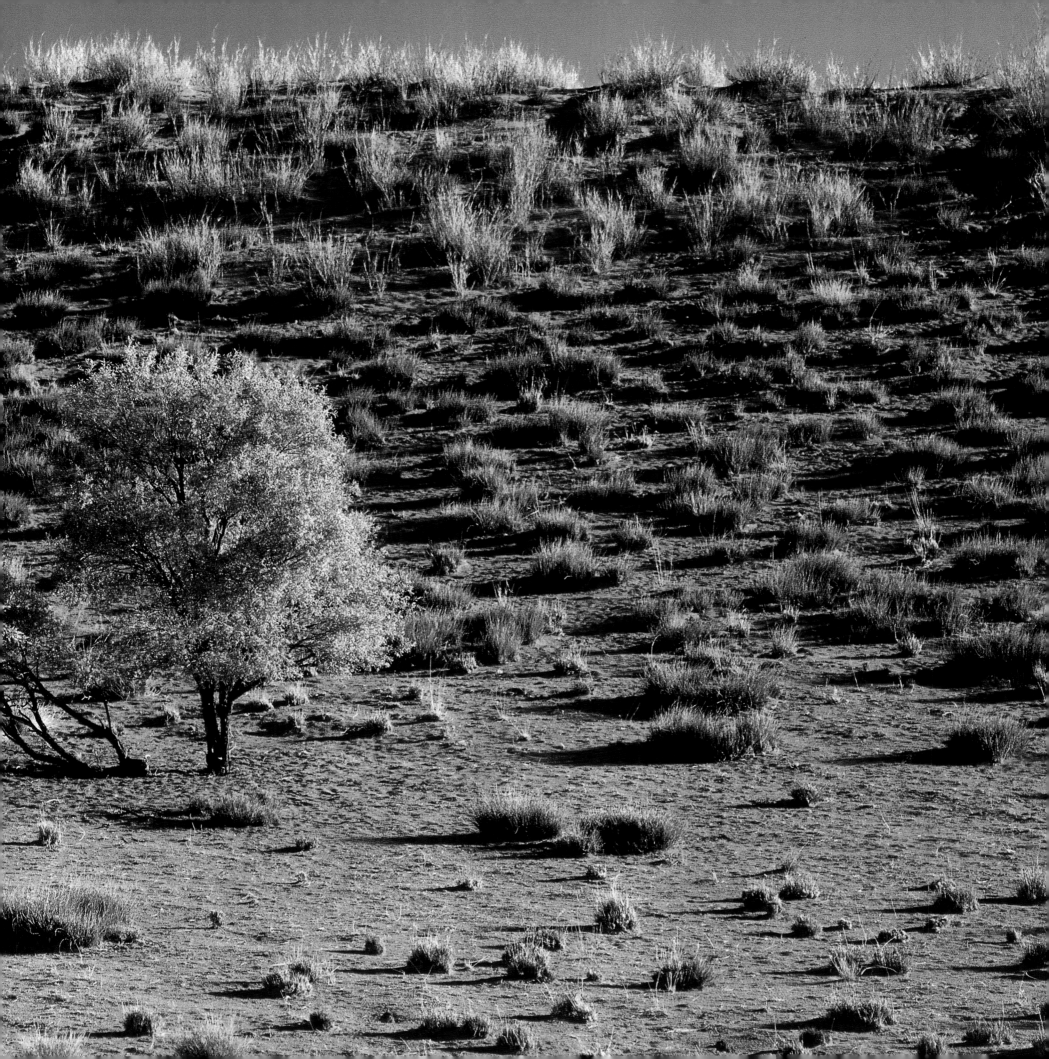

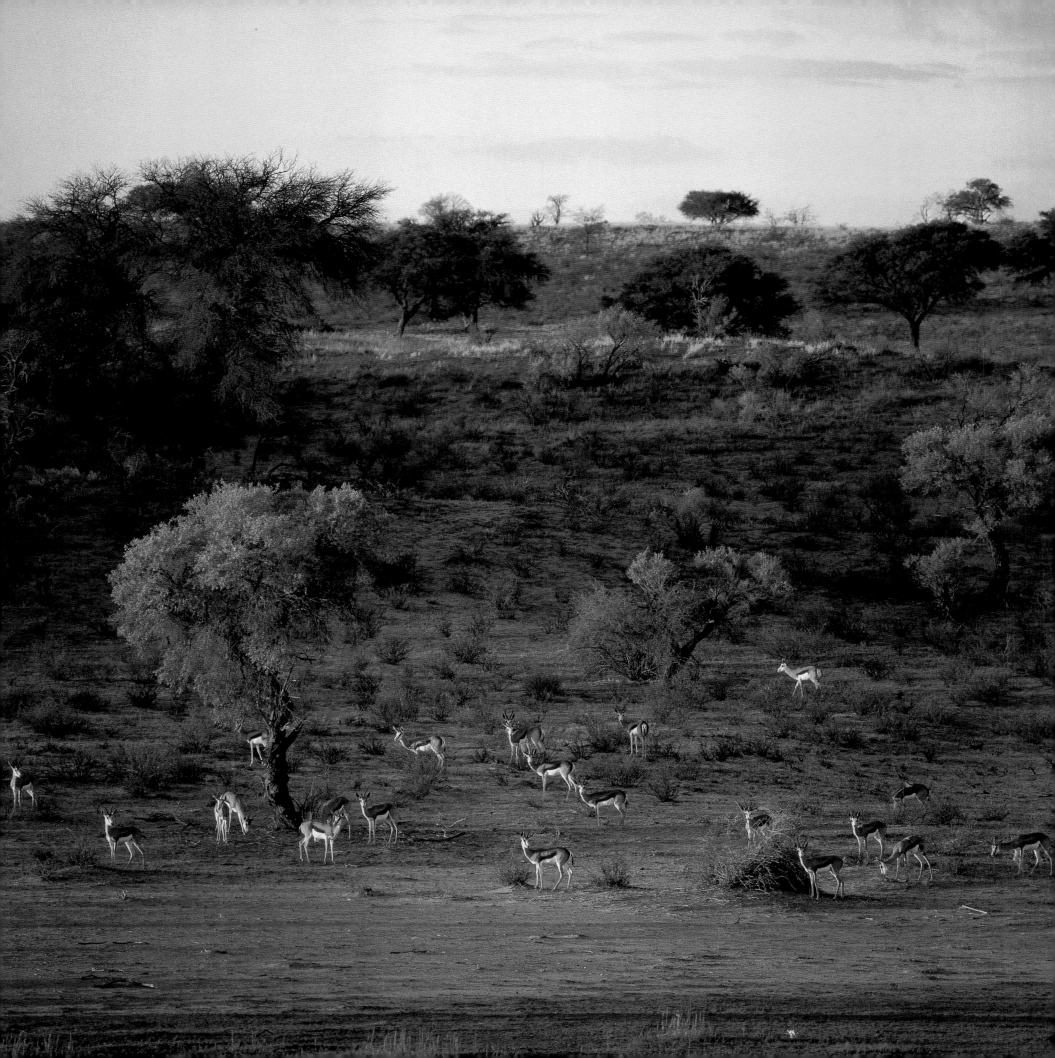

e Kgalagadi Transfrontier ark (from the Tswana word meaning 'place of thirst' aterless place') has been ibed by South African nal Parks as: "Where the unes and scrub fade into y and herds of gemsbok, gbok, eland and blue beest follow the seasons, provide shade for huge -maned lions and vantage s for leopard and many rs... This is the Kgalagadi frontier Park.

amalgamation of the hari Gemsbok National in South Africa (proclaimed 31) and the Gemsbok nal Park in Botswana, the agadi Transfrontier Park

comprises an area of over 3,6 million hectares – one of very few conservation areas of this magnitude left in the world."

This region is noted for its red sand dunes, sparse vegetation and the dry riverbeds of the Nossob and Auob. These rivers are said to flow only two to three times every hundred years.

Left: 1. Late afternoon finds a herd of springbok *Antidorcas marsupialis* browsing by the dry Auob riverbed in the Kgalagadi Transfrontier Park.

2. A pair on their own.

4. Another herd moves along the dry Nossob riverbed in search of fresh pastures.

Springbok can survive for long periods without drinking and

are thus perfectly adapted to arid conditions in the Kalahari Desert. Active both in the day and at night, these herbivorous antelope are versatile feeders. In the summer they are more typically grazers, and in winter and during drought periods, browsers. Moisture is obtained from wild melons, and minerals from the soil.

Springbok live in mixed herds that can number up to some 200. During the mating season, territorial males assert their dominance and chase away competing males from the herds, which will then be left comprising only the few dominant males, females and juveniles.

In historical times, before

farm fencing became an ubiquitous feature of the landscape, vast herds of springbok numbering several hundred thousand roamed the open veld, migrating in response to drought conditions in the Karoo and Kalahari.

3. The Brant's whistling rat *Parotomys brantsii* is a diurnal rodent of the Kalahari and Karoo regions of southern Africa. Its name derives from the high-pitched whistle it emits as an alarm call whilst sitting upright beside its burrow.

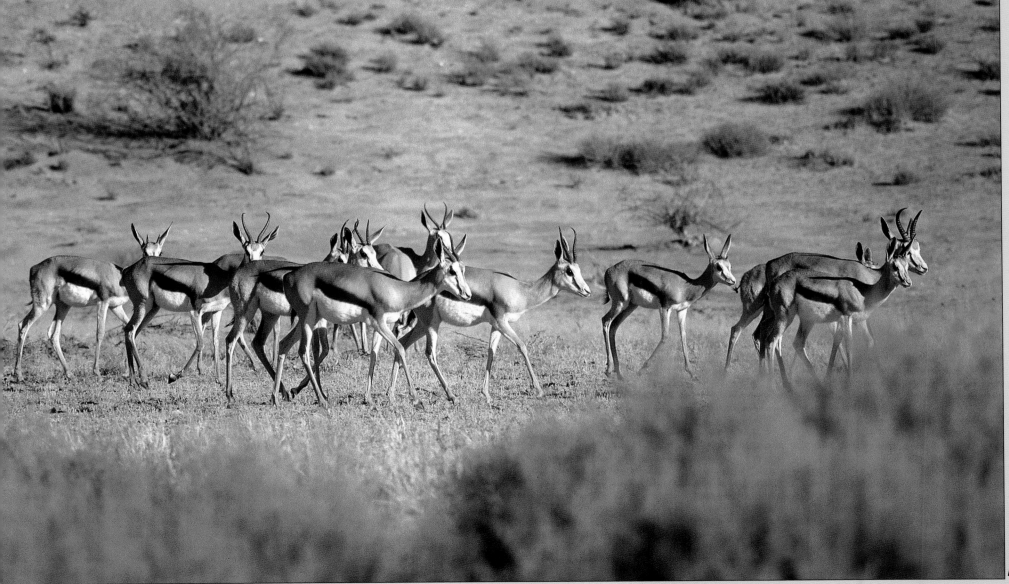

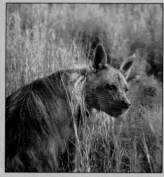

During the short wet season in the Kalahari, blankets of flowers and grasses cover the dunes to the benefit of large herds of plains game. The herds are intently followed and shadowed by resident as well as migratory predators: lion, leopard, cheetah, African wild dog, and both the brown and spotted hyenas. In their wake a number of smaller predators follow: the honey badger, black-backed jackal, black-footed wild cat, and both the bat-eared and Cape foxes.

In the long, dry season, in contrast, antelope herds, ever stalked by resident predators, tend to roam the waterless riverbeds where sparse but nutritional grasses survive.

1. A shy scavenger, the brown hyena *Hyaena brunnea* is mainly active at night. Here in the Kalahari region it feeds

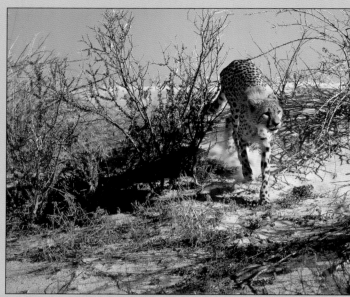

on the remains of vertebrates, ostrich and other ground bird eggs, reptiles, Kalahari 'truffles', tsama melons and any other smaller fruits of the desert it can locate.

2. A cheetah *Acinonyx jubatus* tracks across a Kalahari dune.

3. Stopped in its tracks, a lactating leopard *Panthera pardus*. This solitary carnivore is adept at facing the challenges of the desert, whatever the season.

4. Active between dawn and dusk, the omnivorous black-backed jackal *Canis mesomela* frequents most areas of southern Africa. It is common in the Kalahari where it scavenges on animal kills of the larger predators. Jackals sometimes hunt in cooperative packs to bring down prey. Up to 10 of these social feeders can often be seen grouped around a carcass.

Jackals pair for life and are very territorial, each couple guarding a permanent territory.

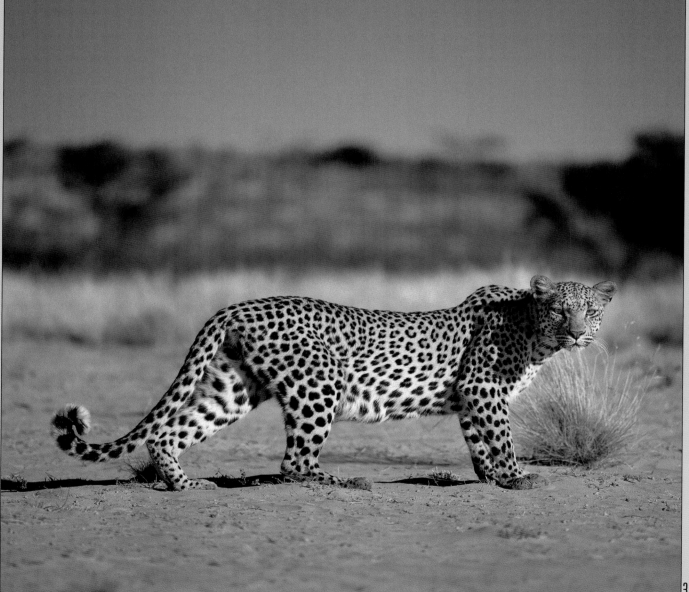

Right : 5. A lion rests amidst the Kalahari's golden winter grasses.

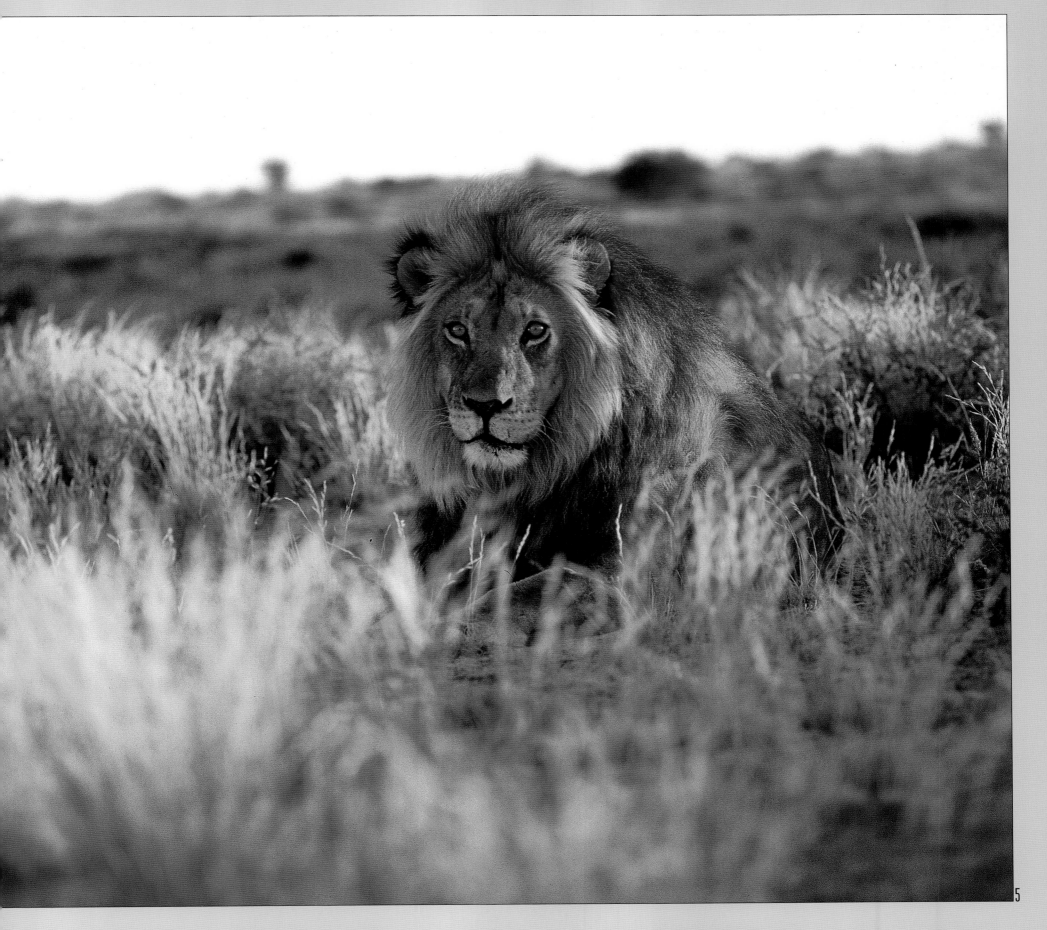

KALAHARI

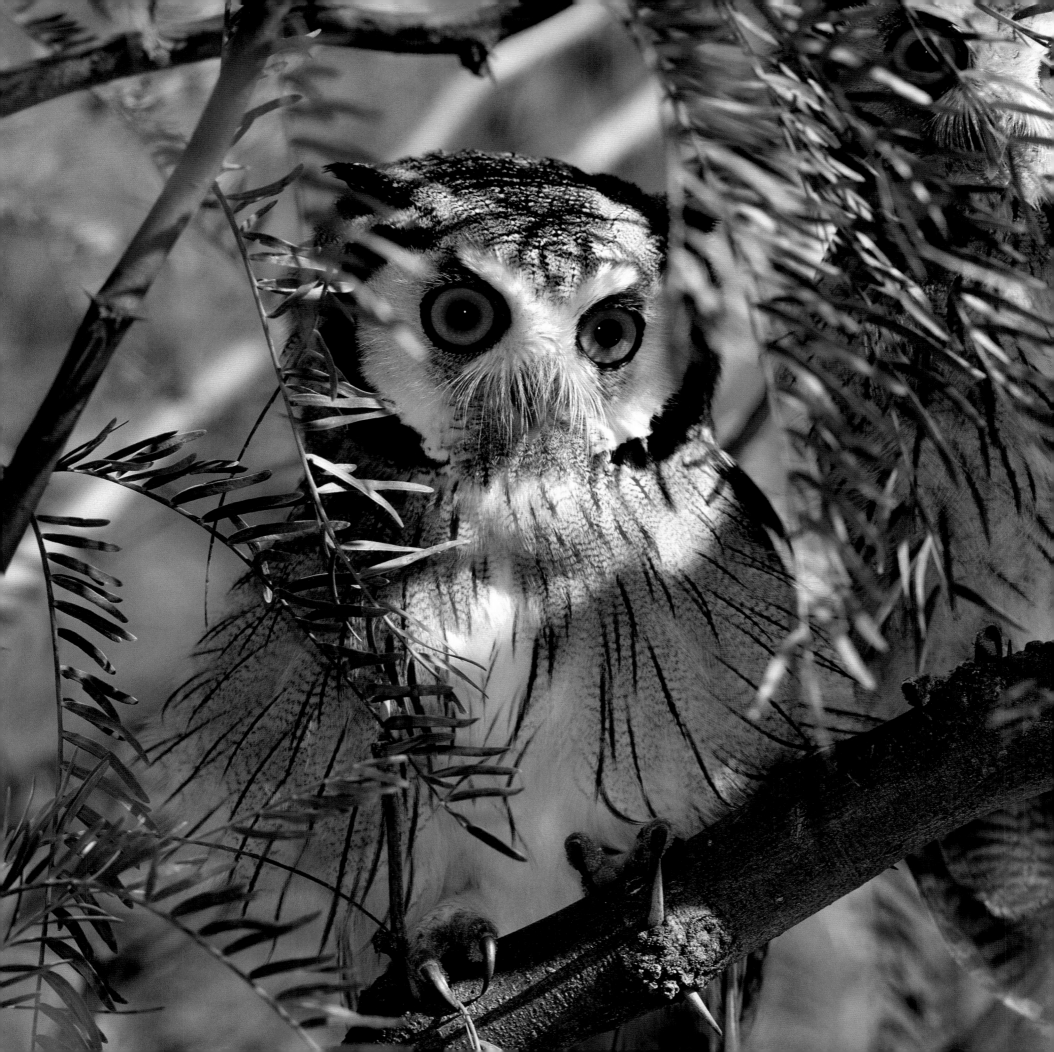

south-west Kalahari
northern Cape regions are
wned for their abundance of
rs.
ether stooping for prey,
silently through the veld,
g gracefully on thermals or
eer power, strength and
y, raptors never cease to
re and amaze.
se birds own the skies;
of the shrubland too.
I. Two immature southern
e-faced scops owls *Otus*
psis) *granti* eagerly await
eturn of a parent bird with
These nocturnal owls,
t in camouflage, roost on
ame perch day after day,
which they drop down on
specting rodent prey.
ociable weavers *Philetairus*
s return to their massive
munal nest. As their name
es, they are a gregarious
es that thrive in the dry
ns of the south-west.
y pairs breed and roost in
rate quarters inside these
grass 'tree houses'.
frican white-backed
res *Gyps africanus* are
mon residents in the
hari and bushveld regions of
hern Africa, where they feed
arrion and bone fragments.
often outnumber all other
engers at a carcass.
A greater kestrel *Falco*
oloides surveys the
ounding desert from its
inent perch on the prickly
n of a camelthorn acacia.
raptor seizes prey after a

descent to the ground,
re it closes in on its victim,
if it is hidden under stones
fts of grass.
lanner falcon *Falco*
micus a versatile hunter,
s its time on a weathered
elthorn acacia, ready in an
ant for any opportunity that
nt arise from activities in a
by sociable weavers' nest.
distinctive small raptor,
black-shouldered kite *Elanus*

caeruleus often perches for hours at a time on the same strategic branch. From time to time it will alight and hover with wings outstretched as it searches for terrestrial prey.

7. Tawny eagles *Aquila rapax* are large, mostly solitary birds of prey, feeding on carrion, small mammals, reptiles and other birds. They hunt for prey with a variety of tactics: actively diving from a perch, stooping from a soaring flight, pirating from other birds, and scavenging.

8. Secretary birds *Sagittarius serpentarius* are more commonly seen on the ground where, often in pairs, they patrol methodically for snakes and reptiles, which are despatched with their sharp beaks or by vigorous stamping.

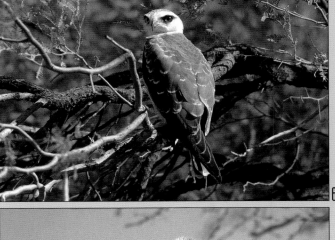

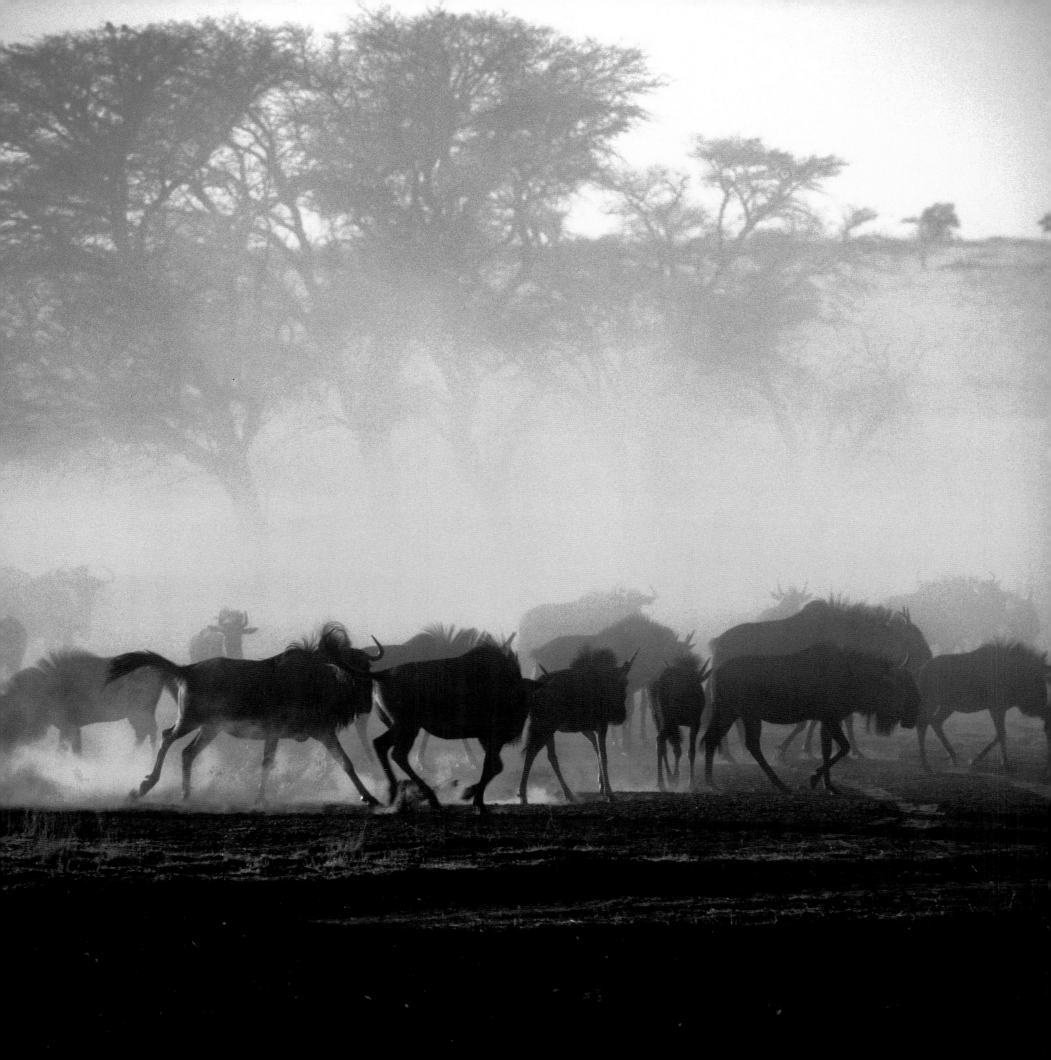

1. Namaqua sandgrouse, *Pterocles namaqua* are a familiar [s]ight in pairs or flocks at [wat]erholes in the desert where [the] birds come to drink in the [earl]y hours of morning. Water [is re]tained within their breast [feat]hers to provide nourishment [to t]heir young who could be [kilo]metres away in the desert.

[Lef]t: 2 In the Nossob riverbed a [herd] of blue wildebeest [*Con]nochaetes taurinus* kicks up [the] dust in the urgent quest [to d]rink.

3. *Nerine laticoma* in full bloom after the rains. This is a summer growing nerine, one of a genus of beautiful geophytes (underground bulbs dormant in winter) endemic to South Africa, except for one species found in Zimbabwe. The plant bears a large, spherical inflorescence of white or pale to rose pink irregular flowers on pinkish brown stalks. These are short-lived and are followed by a papery capsule, the fruit, that contains irregularly shaped, fleshy seeds.

4. A herd of red hartebeest *Alcelaphus buselaphus caama* a species that occupies a wide range in southern Africa, including these Kalahari grasslands. It is both a grazer and browser.

Diurnal, this antelope feeds mostly during the cooler daylight hours. It is one of the first game animals to lose body condition when forage quality deteriorates. It can, however, survive without water for several days.

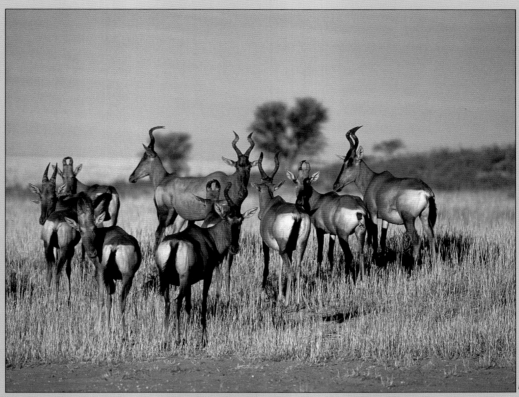

5. Splendid in breeding plumage, a male shaft-tailed whydah *Vidua regia*, displays its long, spatulate tail and buff front. In non-breeding dress it resembles the female, but slightly darker. It is found both in small parties and larger flocks in thorny scrub, open grassy areas, and broad-leafed woodland. Males are busy, aggressive birds that spend much time chasing each other as well as disturbing other small birds.

6. Superbly adapted to the often parched arid conditions in the Kalahari; a pair of Gemsbok Oryx gazella traverse an exposed desert dune.

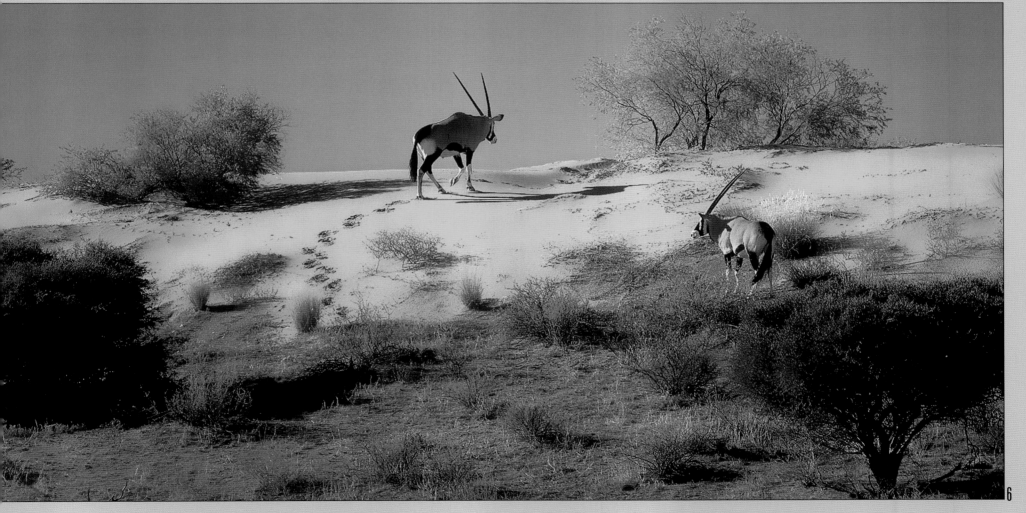

1. A suricate (meerkat) *Suricata suricatta*.

2. Just occasionally, maybe once every 40 years or so, the Nossob River comes into flood after exceptionally heavy, thunderous rainfall. This last took place in April 2005, and the effects were dramatic.

3. 'Cometh the rain, cometh the flowers'. The parched and dry desert veld suddenly springs to life in an amazing transformation. Fresh new verdant grasses appear as well as carpets of colourful wild flowers, such as mauve cat's tail *Hermbstaedtia linearis,* and yellow devil's thorn *Tribulus zeyheri.*

4. Standing upright in their characteristic alert posture, the adult meerkats survey the scene for signs of danger.

A group of meerkats is known as a 'mob', 'gang' or 'clan', and comprises about 20 animals. Since they carry no excess body fat, foraging for food is a daily requirement performed as a group with a sentry always on guard for predators.

Meerkats possess immunity to the strong venom of Kalahari scorpions, a favoured part of their diet.

5. Bat-eared foxes *Otocyon megalotis* are active during the day in winter and at night in the summer months. They are

capable diggers and live in dens that they either dig themselves or take over from other animals such as the aardvark. Dens have multiple entrances and chambers as well as several metres of tunnels.

6. Tsama melons *Citrullus lanatus,* are an important food and water source in the desert.

7. An adult ground squirrel *Xerus inauris* with two attentive juveniles.

Right: 8. Sunset in the Kalahari

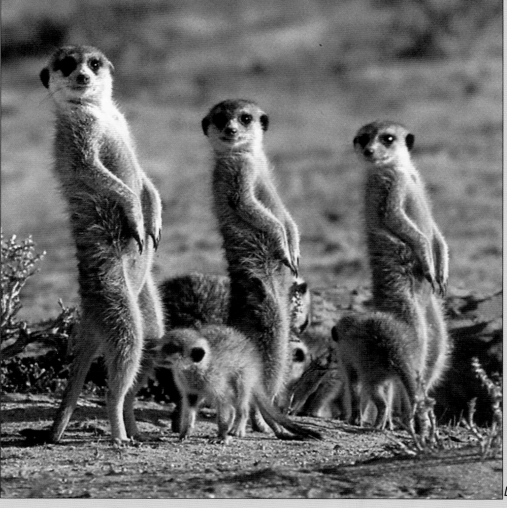

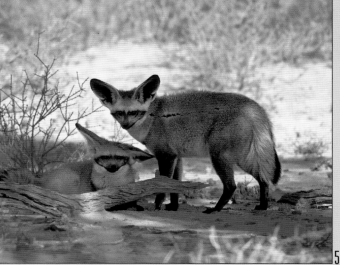

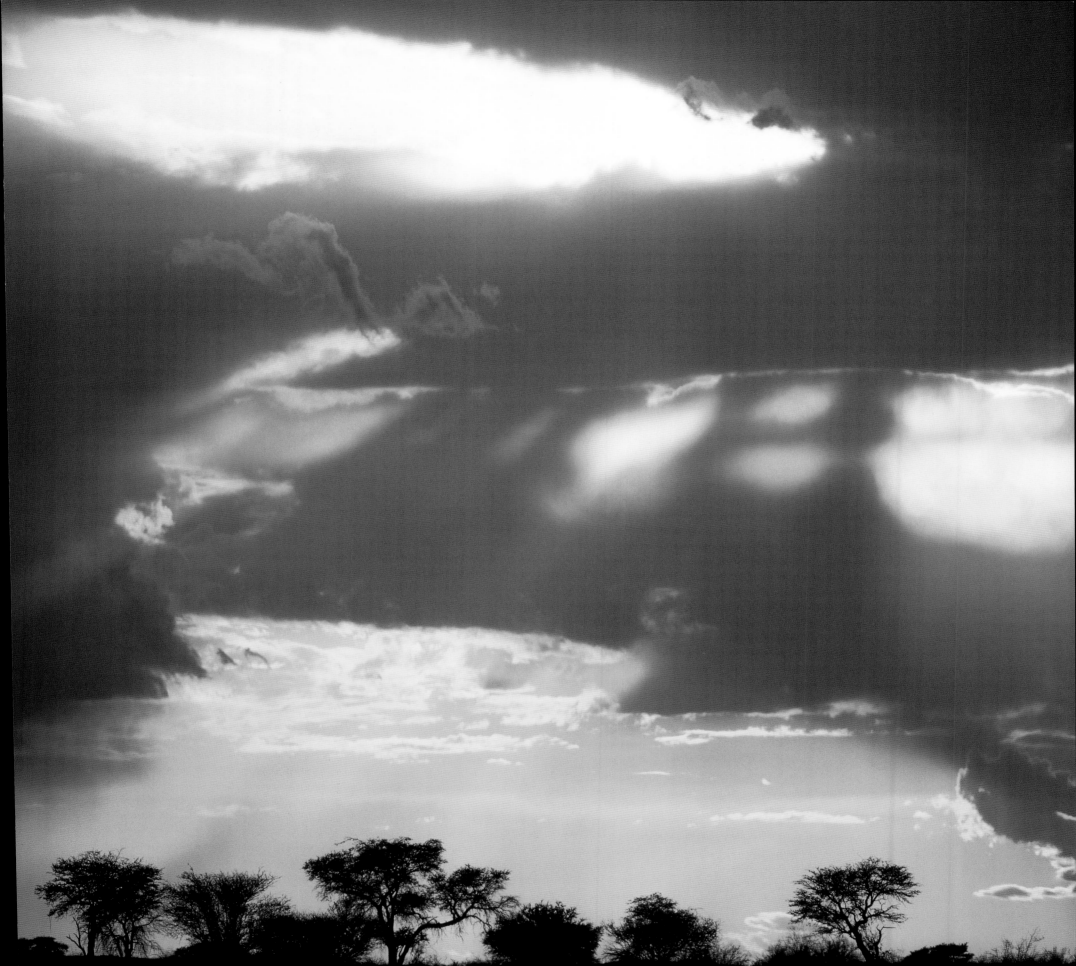

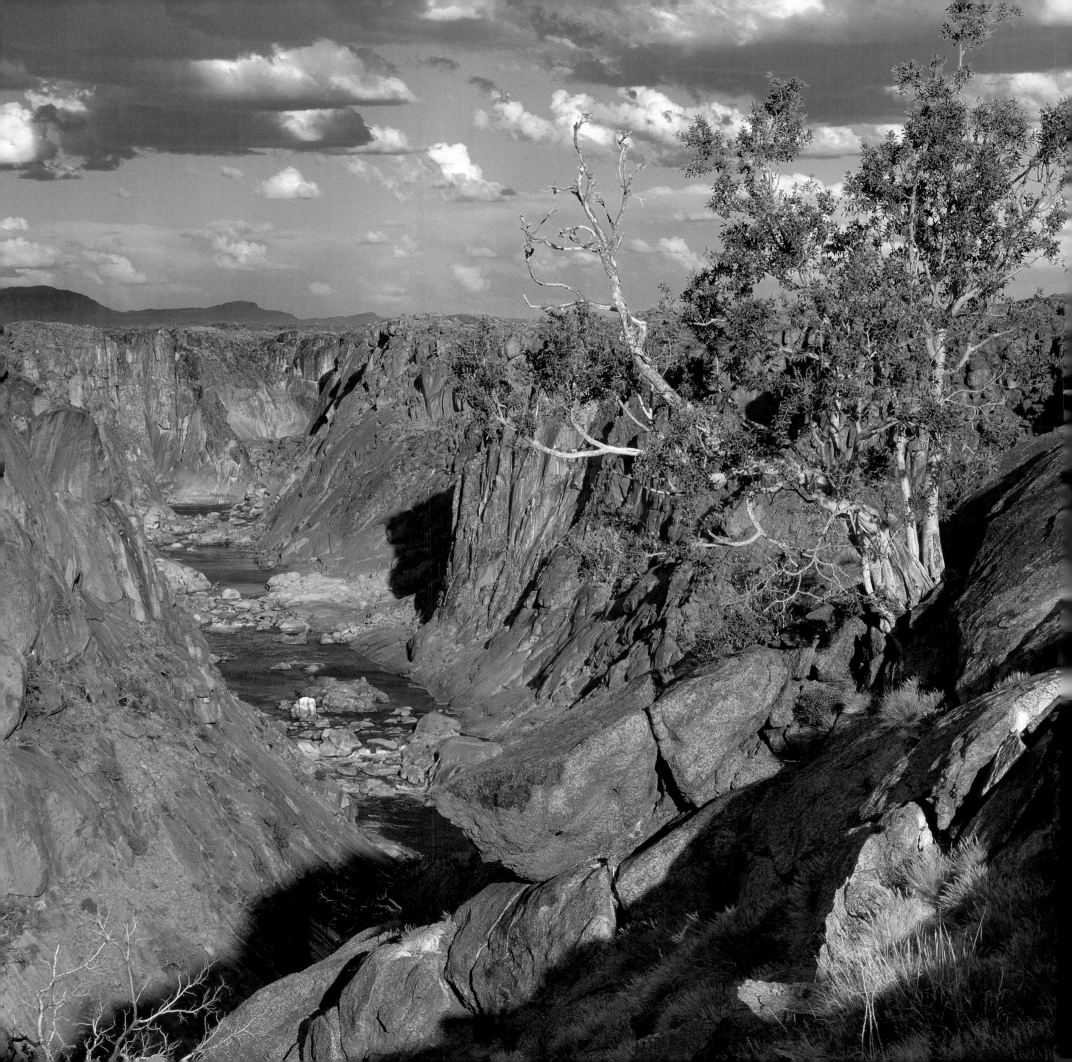

...ot many sights are as awesome or sound as deafening as when
... the raging waters of the Orange River roar in full flood. This
...dering torrent of water led the original Khoi/Hottentot
...ents to believe that evil spirits were active. They aptly named
... waterfall *Ankoerebis*, 'place of big noises', a name adapted to
...abies' by the trek boers who later settled here.
... Augrabies Falls National Park, situated on both banks of the
...ge River in the Northern Cape, provides sanctuary to a diversity
...ant and animal species, including giraffe, black rhino, gemsbok,
...gbok, klipspringer and rock hyrax (dassies). The park embraces
...km², with the spectacular river gorge carving out an 18-km
... through a parched and desolate landscape. Only the most
...st can survive in this ruggedly beautiful part of South Africa.
't: 1. The Orange River gorge, as viewed from Ararat. Further
...ream the river drops 191m at the Augrabies Falls. Here it is
...ashed from rocky surroundings to plunge in a tumultuous
...ade into the gorge. This demonstrates the dramatic effects of

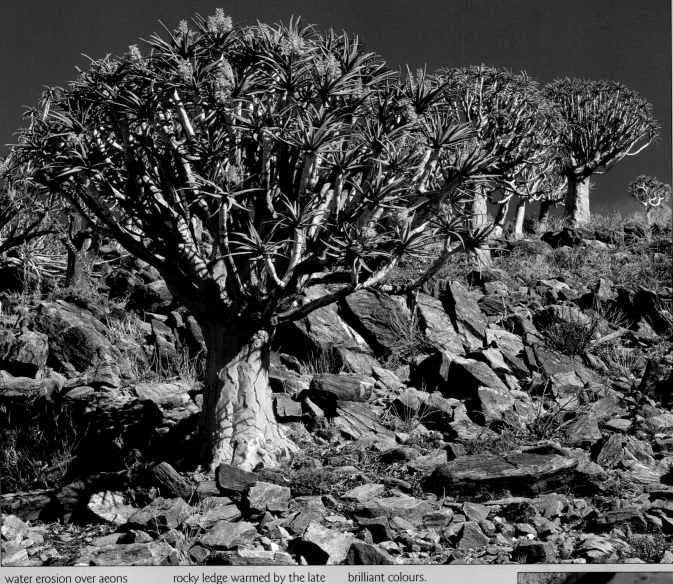

water erosion over aeons
through a granite plateau.
2. A caracal *Felis caracal* in
the Augrabies Falls National
Park. The name comes from the
Turkish karakulak, meaning
'black ear'. Widely distributed
and fiercely territorial, it is
mainly a solitary nocturnal
species, feeding on small
antelope, mammals, rodents,
reptiles and birds up to the size
of a guineafowl.
 Previously, described as
a lynx, this wild cat is an
exceptional climber and jumper,
renowned for its spectacular
skill at hunting birds; it
sometimes snatches one, or
even two or more in flight.
3. A group of rock hyrax
Procavia capensis rest on a

rocky ledge warmed by the late
afternoon sun. Hyraxes are most
active in early morning and the
afternoon, resting up in the heat
of the day. They are herbivorous,
and live in small family groups
dominated by a single male who
vigorously defends his territory
from rivals.
4. A male Broadley's flat lizard
Platysaurus broadleyi displays his

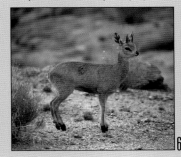

brilliant colours.
 These small reptiles are
common along the granite walls
and crevices of the gorge, where
they can be seen darting about
during the sunny hours.
5. Kokerboom trees in flower
in the Kokerboom Forest near
Kenhardt. The forest
comprises 4000–5000
kokerbome. Adapted to harsh
dry conditions and poor soils,
these huge aloes are a striking
feature of the north and
north-western Cape.
6. When it comes to the
uneven rocky terrain of the
Augrabies Falls National Park,
klipspringers ('rock jumper' in
Afrikaans) *Oreotragus oreotragus*
are truly in their element: adept,
agile and sure-footed. This small

antelope obtains food and
liquid nourishment from a wide
variety of plants and shrubs.
Territorial, it lives with a bonded
partner together with the
current season's young.
7. The striped mouse,
Rhabdomys pumilio is an
opportunistic omnivore.

Namaqualand has been described as a " Garden of the Gods", a particularly apt description as during the arid summer months it is almost impossible to imagine the phenomenon of a yearly wildflower spectacle. An amazing transformation occurs following winter rainfall: Namaqualand dons her coat of myriad colours and for a brief moment wildflowers invade the countryside. Fields are

turned into floral seas of gold and purple, red, pink and white. Carpeted valleys become works of art. Countless poems, novels, paintings and prose have been dedicated to this annual shower of the Creator's gift of colourful splendour.

The thin green agricultural belt flanking the Orange River as it nears the Atlantic Ocean provides a lush contrast to the ruggedness of the Richtersveld. Amid saw-toothed mountain peaks, wind-sculpted boulders and colourful indigenous flora give rise to a beauty found nowhere else on earth.

In the north, along the Orange River (where it forms the frontier with Namibia), the terrain is

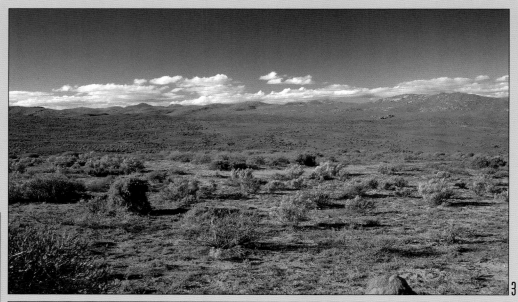

hilly to mountainous, consisting of granites and other metamor rocks. Namaqualand (48 000km²) covers the southern part of th semi-desert region and is generally flat. It extends all the way fro the coast to the Pofadder region in the north-east and southwar to Vanrhynsdorp.

1. A dense canopy of *Ursinia speciosa* daisies, among others, in full bloom.

2. A euphorbia sp. bush under stress from prevailing drought. A red pigment is produced which helps the plant ward off the harmful effects of ultra violet.

3. For much of the year Namaqualand is an arid semi-desert wilderness.

4. In springtime, Namaqualand portrays a magical tapestry of wildflowers, here shown cascading down a rocky hill slope in an astonishing array of contrasting colours. The previously parched veld is brought to life with a profusion of wildflowers.

Right: 5. During August and September, the Biedouw Valley comes alive with magnificent abundance. Shown here, amongst others, a magical mix of blue *Heliophila* species and pink *Geissorhiza* species,

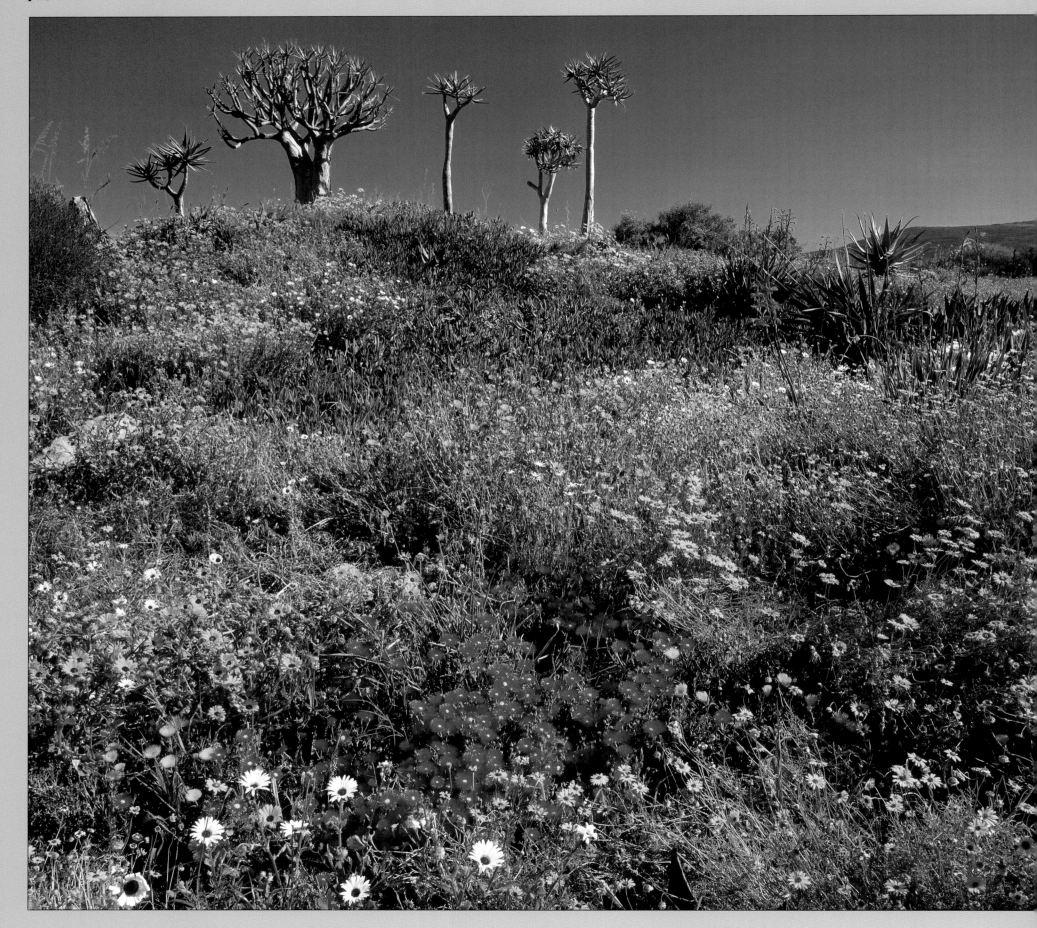

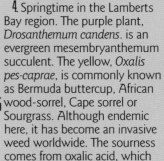

F rom its headwaters in the Kouebokkeveld Mountains, the Olifants River stretches a long way north through southern Namaqualand to enter the Atlantic west of Lutzville. Just over the Piekenierskloof Pass, it meanders through a beautiful valley, bringing life to the otherwise dry surrounds. The name, given by the first pioneers who explored the region, derives from the huge herds of elephants that roamed here over 300 years ago.

Far left: 1. Springtime wildflowers in the Ramskop Wildflower Reserve, Clanwilliam. The reserve boasts over 250 indigenous species of wildflowers. Here a spread of *Ursinia* species, amongst others, with *Aloe dichotoma* trees on the hilltop.

2. *Dorotheanthus oculatus* a Mesembryanthemum, is a dwarf annual succulent species commonly known as vygie or ice-plant.

3. Growing in the Cederberg Mountains, Wagener's resin bush *Euryops wageneri* attains a height of 1.5 m. Erect and sparsely branched, it smells strongly of resin. The species is restricted to the area from Matjiesrivier northwards into the Biedouw Valley. It inhabits rocky dry areas in river valleys and on mountain slopes at altitudes between 700–1220 m.

4. Springtime in the Lamberts Bay region. The purple plant, *Drosanthemum candens*. is an evergreen mesembryanthemum succulent. The yellow, *Oxalis pes-caprae*, is commonly known as Bermuda buttercup, African wood-sorrel, Cape sorrel or Sourgrass. Although endemic here, it has become an invasive weed worldwide. The sourness comes from oxalic acid, which can be toxic in large quantities.

5. *Cheiridopsis candidissima* is a member of a large genus of over 100 Mesembryanthemums.

6. The white-eyed duiker root *Grielum humifusum* is a prostrate annual.

7. An orange cluster of *Dimorphotheca aurantiaca* one of the seven species of this endemic daisy. When flowering *en masse* they create a sheet of colour with a shimmering brilliance.

8. Gazanias are one of the most prolific endemics that produce magnificent colour displays year after year. *Gazania lichtensteinii* is an annual that attains 200 mm in height.

9. *Hyobanche sanguinea*, is one of an endemic genus of parasitic plants. The flowering portion is above ground: the remainder consists of a fleshy underground stem that attaches to a host root. The species shown has the widest distribution; from coastal fynbos to desert karoo.

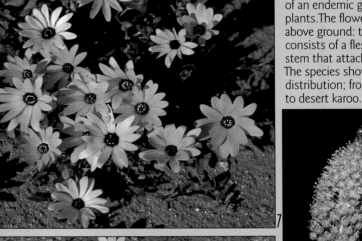

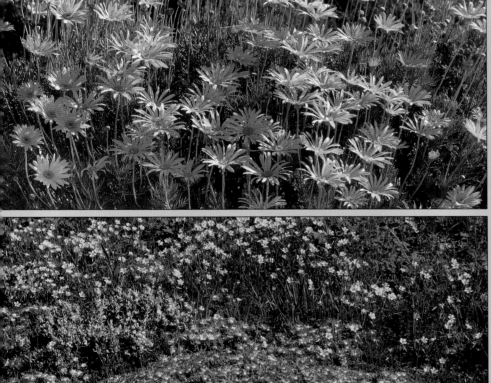

10. Cat's tails *Bulbinella latifolia* var. *doleritica* comes in three distinctive colours: yellow, orange and cream. It is only found at the top of the Bokkeveld Escarpment around Nieuwoudville.

In the late 1700s, clashes between pioneering trekkers and indigenous people led the former to move to the top of the escarpment where eventually, in 1897, the small town of Nieuwoudville was established. Today this has become known as 'the Bulb Capital of the World'.

Renowned for its dramatic landscapes and rock formations, the Cederberg was proclaimed a wilderness area in 1973. It was so named for the Clanwilliam cedar tree *Widdringtonia cedarbergensis* a species now under threat due to several centuries of exploitative harvesting, as well as frequent fires. The range extends north to south for some 50 km and is 20 km at the widest.

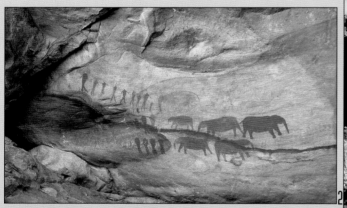

1. A southern rock agama *Agama atra* suns itself on a rocky perch in the Cederberg. This is a terrestrial, diurnal species with an extensive range thoughout this mountainous and rocky region.

2. Bushman rock paintings near the Stadsaal cave depict elephants once prevalent in the valleys. San and Khoi people inhabited the Cederberg area from earliest times. European settlers began stock farming in the early 18th century.

3. The Wolfberg Arch is a prominent natural feature of the high Cederberg wilderness. This and other spectacular rock formations owe their origin to a number of factors, including the flat nature of the geology, well-defined fracture patterns, the chemical composition of the rocks and erosion over the ages.

4. The Maltese Cross, a distinctive eroded rock feature, is some 30 m in height.

5. Strangely eroded rock formations in the high Cederberg.

6. A view from the rocky plateau at the crest of the Cederberg. Geologically, the range comprises mainly hard Table Mountain sandstone, often of a reddish hue, as well as quartzitic formations. The fertile valleys are carved from softer shale formations.

7. Late afternoon sunhine illuminates the Wolfberg Arch to reveal the rusty red of the sandstone.

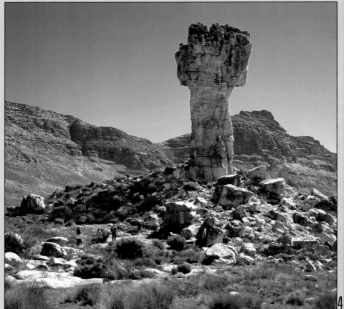

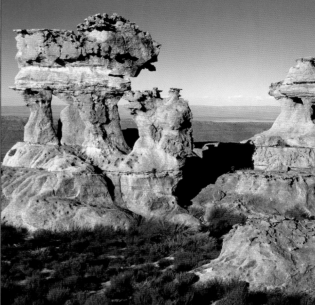

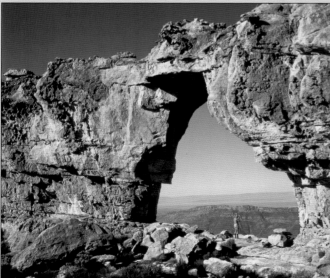

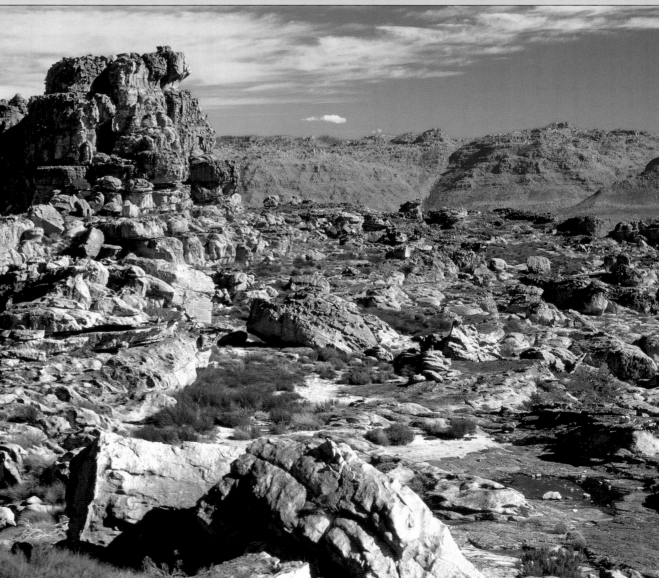

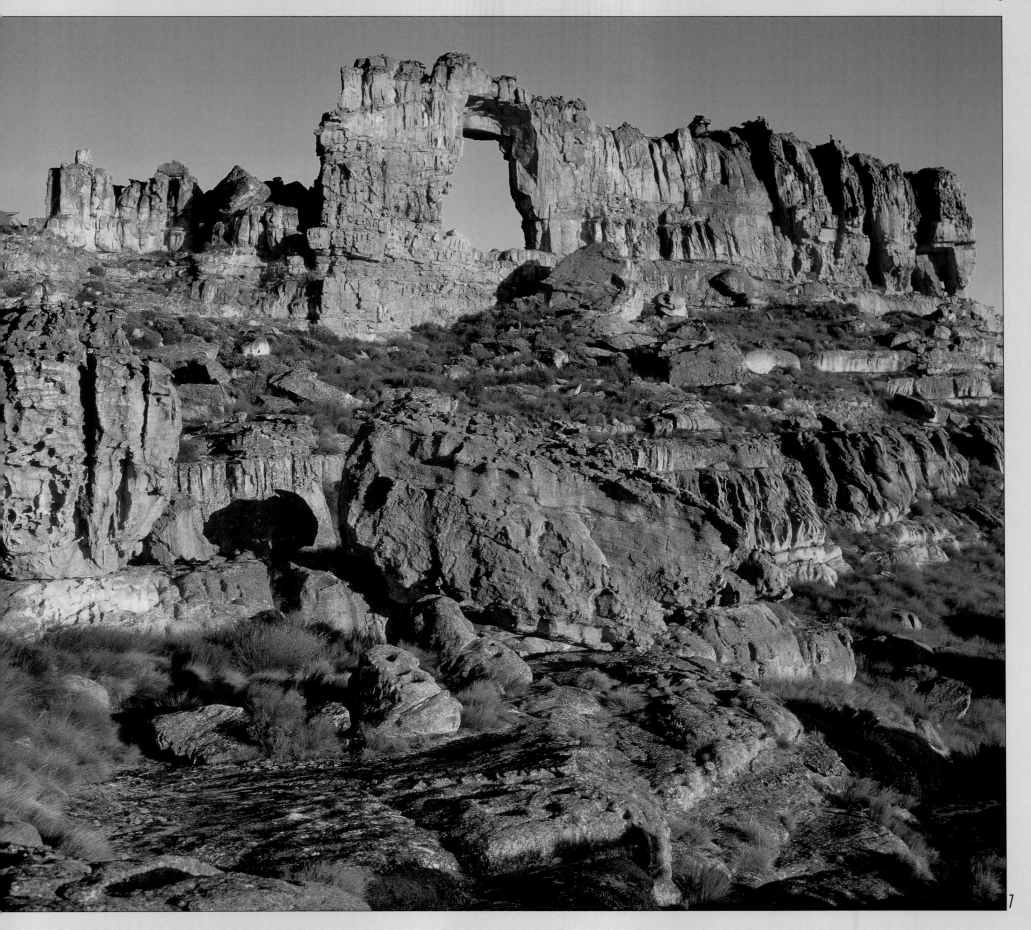

Unlike most of South Africa's coastline, the West Coast is sparsely populated. Occasional fishing villages feature along the bleak Atlantic coast, barely altered since they were founded. Boats with fishing nets put to sea into the cold, often tempestuous, yet productive Benguela Current that sweeps north from Antarctica; others carry divers and suction pipes to exploit the diamonds that lie on the seabed.

This is a harsh, unforgiving landscape not given to agriculture which makes it unique in South Africa.

1. A Cape gannet *Sula capensis* 'skypointing', an appeasement posture adopted to avoid pecking and harassment from other birds in its colony.

2. Bird Island at Lamberts Bay is sanctuary to large colonies of Cape Gannets and Cormorants. These birds benefit

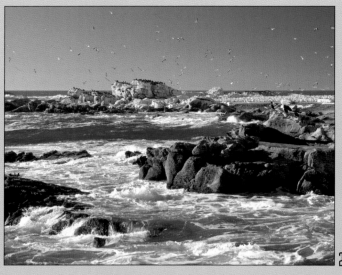

from the abundant sealife brought about by the offshore Benguela Current which enriches the ocean with oxygen and nitrates.

3. Cape gannets in their thousands gather on Bird Island during the breeding season. This lasts for several months from August. Incubation is shared by both parent birds and the solitary egg will generally hatch after 42–46 days. Strong fliers, these sky-acrobats plunge-dive with great force into the sea to catch their fish prey. Their status today is vulnerable, partly due to the commercial over-exploitation of existing fish resources.

4. The wild and windswept rocky shores of Bird Island. The air is filled with the raucous calls of gannets and cormorants that breed here in huge numbers and the ever-present pungent smell of fresh guano.

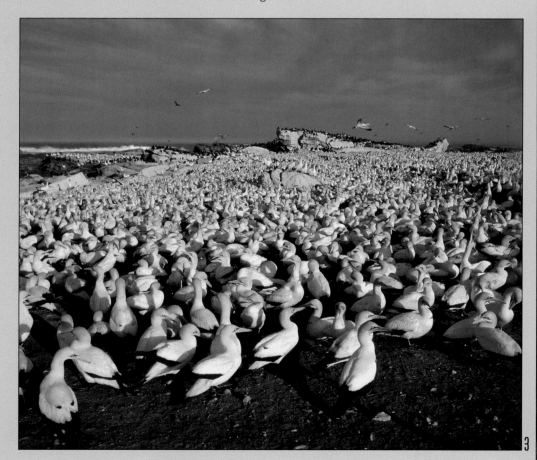

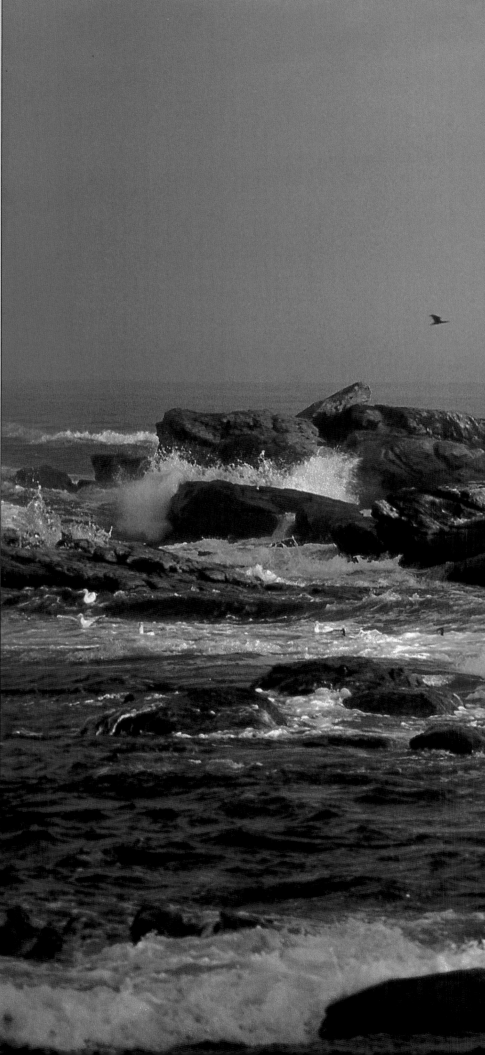

EVOCATIVE AFRICA — 4

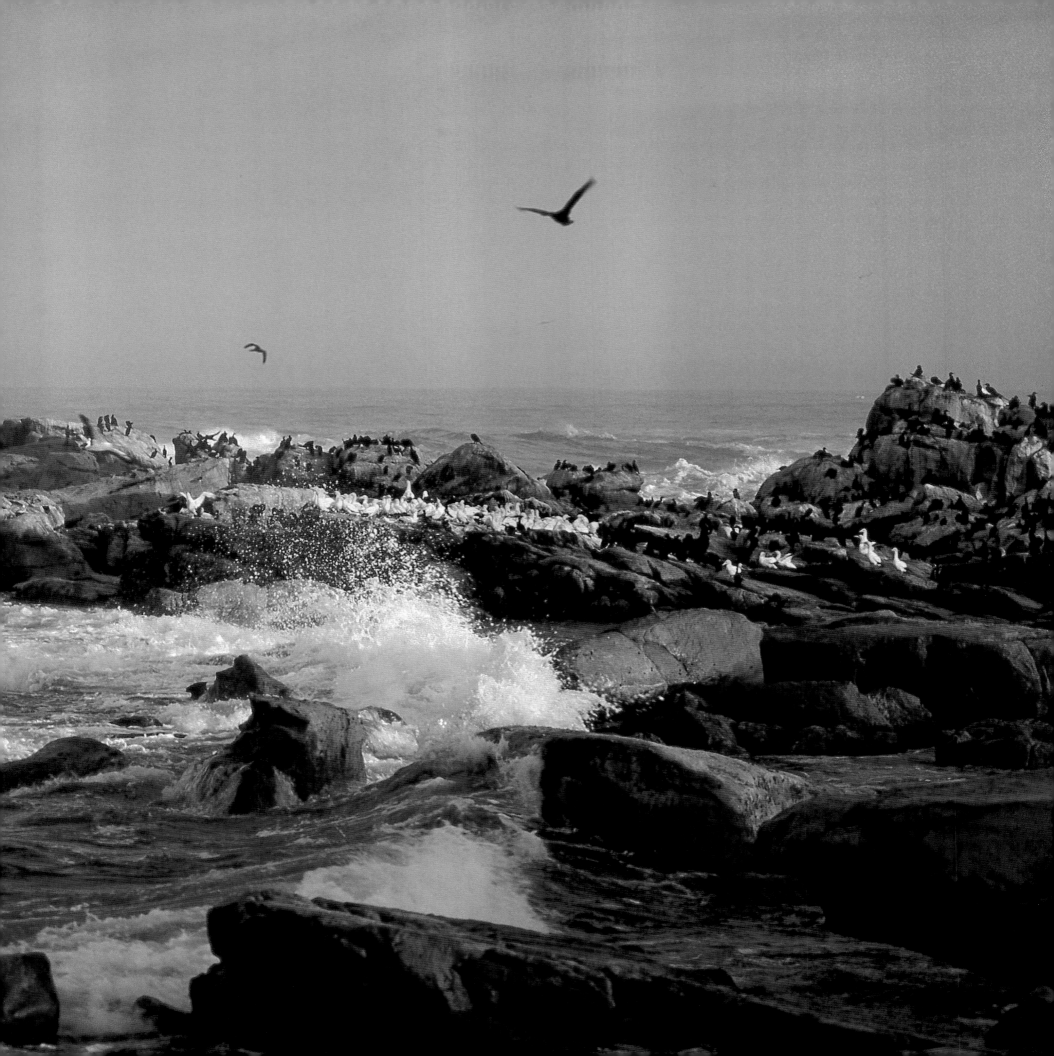

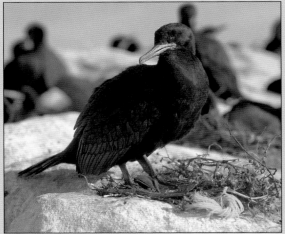

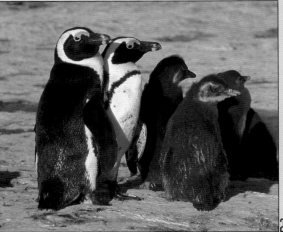

Managed by Cape Nature Conservation in collaboration with the people of Lamberts Bay as an ecotourism project, the renowned Bird Island is reach from the mainland by means a breakwater wall erected in 1959.

This is the most accessible Cape gannet colony. The islan also provides protection and breeding grounds for Cape an white-breasted cormorants, a well as the African penguin.

1. Using whatever nesting material is available, this Cap cormorant *Phalacrocorax capensis* includes a stretch of yellow nylon cord from the harbour at Lamberts Bay.
2. African penguins *Sphenisc demersus* watch over juvenile at their breeding colony on Marcus Island, Saldanha Bay.
3. The African black oystercatcher *Haematopus moquini* distinguished by its red bill, eyes and legs, is a common wader around the coast of southern Africa. A resident breeder on rocky offshore islands, the species is usually encountered in pai or small groups as it forages along the shoreline beside coastal lagoons and along river estuaries.

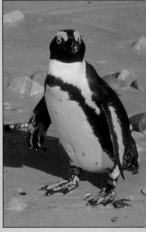

4. Amidst the crowded colo a gannet 'skypoints' in appeasement posture as it waddles through to its nest.
5. An African penguin in characteristic upright stance the beach at Lamberts Bay.
Right: 6. A Cape gannet hov momentarily before dropping to its nesting site in the densely populated colony on Bird Island.

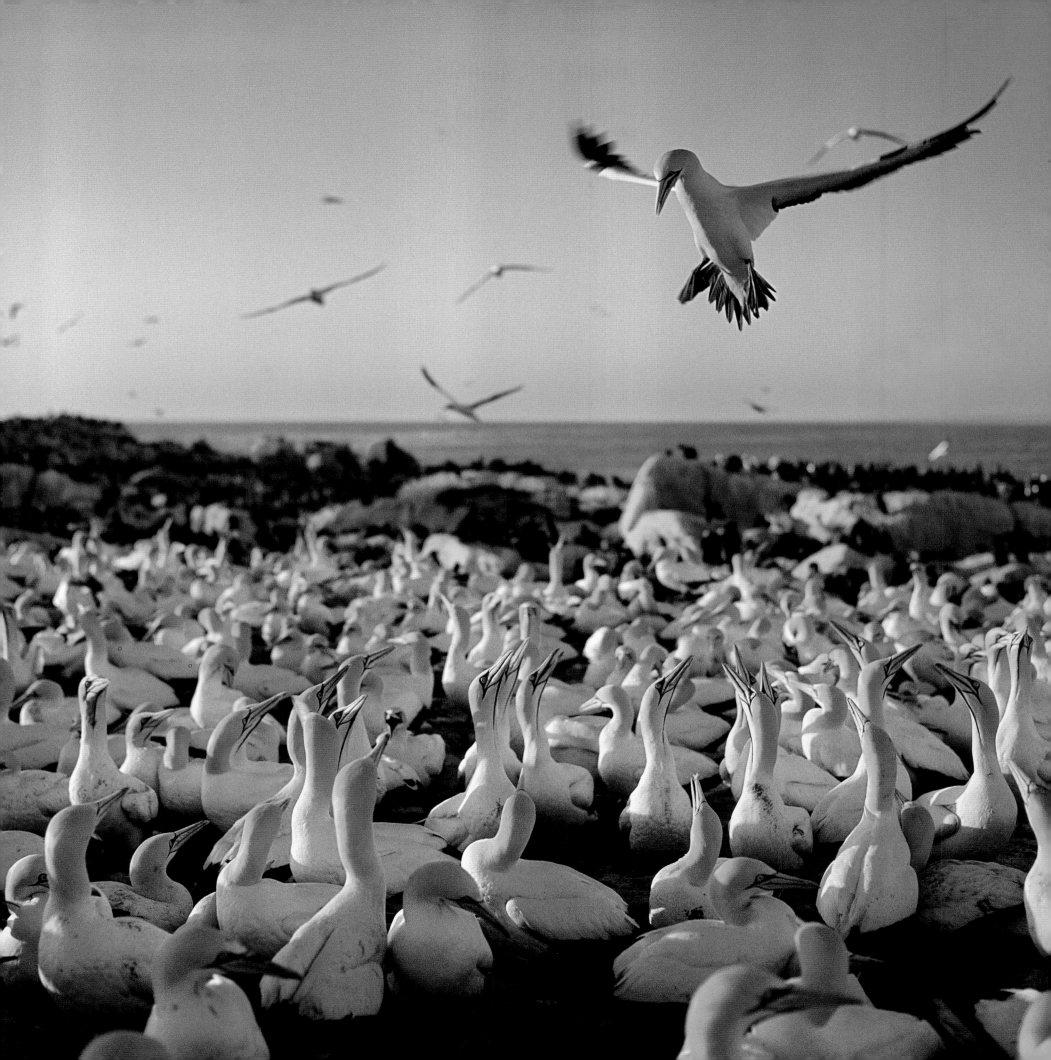

This farmland region of the south-west Cape stretches from Saldanha Bay, the largest natural bay in South Africa, to the g River Valley far inland.

he western shores of the Langebaan Lagoon are carpeted with rilliant display of multi-hued spring flowers during August and tember. Over 360 bird species frequent the protected lagoon ters and the surrounds of the West Coast National Park. The ire region and its rich abundance of flora falls within the Cape ral Kingdom.

he Berg River Valley is the largest of the Western Cape's three t and wine producing valleys. Mountains, capped with snow winter, surround this heavily cultivated region, bountiful with wheatlands, canola fields, vineyards, and fruit orchards.

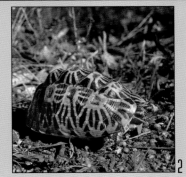

Far left: 1. The snow capped Mostertshoek Twins viewed in winter from the Breede River, .

2 The endangered geometric tortoise *Psammobates geometricus* occupies a restricted range in coastal renosterbosveld. Habitat loss due to farming encroachment is the principal threat to its existance.

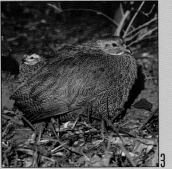

3. A Cape francolin hen *Francolinus capensis* protects her young chick in the folds of her wing feathers. This species frequents open scrubland often close to running water.

4. A winter farming landscape in the Piketberg region of the Swartland.

CAPE WEST COAST

The Western Cape, richest of the world's six floral kingdoms, supports around 9000 species with over 6000 endemics. This diversity of wild flora in the south-west stretches from Vanrhynsdorp in the north 250 km southwards to the Cape Peninsula.

In the foreword to Mary May-tham Kidd's *Cape Peninsula Wild Flower Guide* (1950), the Rt. Hon. Field-Marshal J C Smuts wrote: ' The public generally, even the botanical public, are far from fully aware of the beauty and wealth of our wonderful Cape flora... It is distinct from the flora of the African continent, even the rest of South Africa... Our Cape plants belong to a flora which is unique and to which a great deal of mystery attaches...True it is that when the European botanists came to the Cape in the 17th and 18th centuries they found here an unrecognisable plant life, quite unlike that of Europe. New names had to be invented. Everything looked new and strange. A new botanical world had been discovered, of unique and strange characters. '

1. *Lampranthus roseus.*
2. *Romulea cruciata.*
3. *Brunsvigia orientalis.*
4. *Conicosia pugioniformis.*
5. *Geissorhiza radians.*
6. *Dorotheanthus bellidiformis.*
7. *Dimorphotheca pluvialis.*
8. *Crassula columnaris.*

Right: 9. Springtime in the Darling region. A blue *Heliophila* stands out amongst a patchwork of multicoloured *Ursinia* daisies.

Overleaf:
Table Mountain and Cape Town reflect the atmospheric hues of the setting sun. In the foreground, kelp gulls *Larus dominicanus* linger on the shoreline.

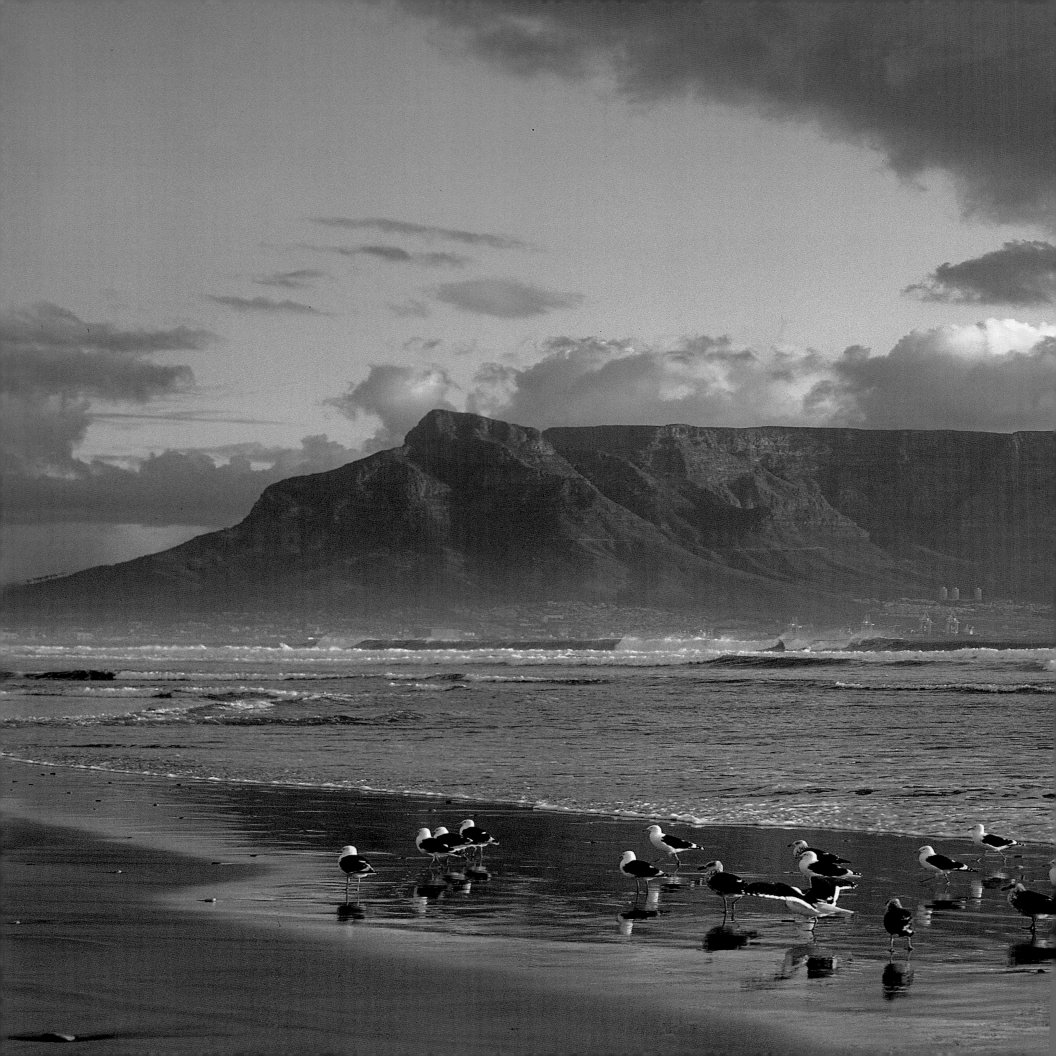

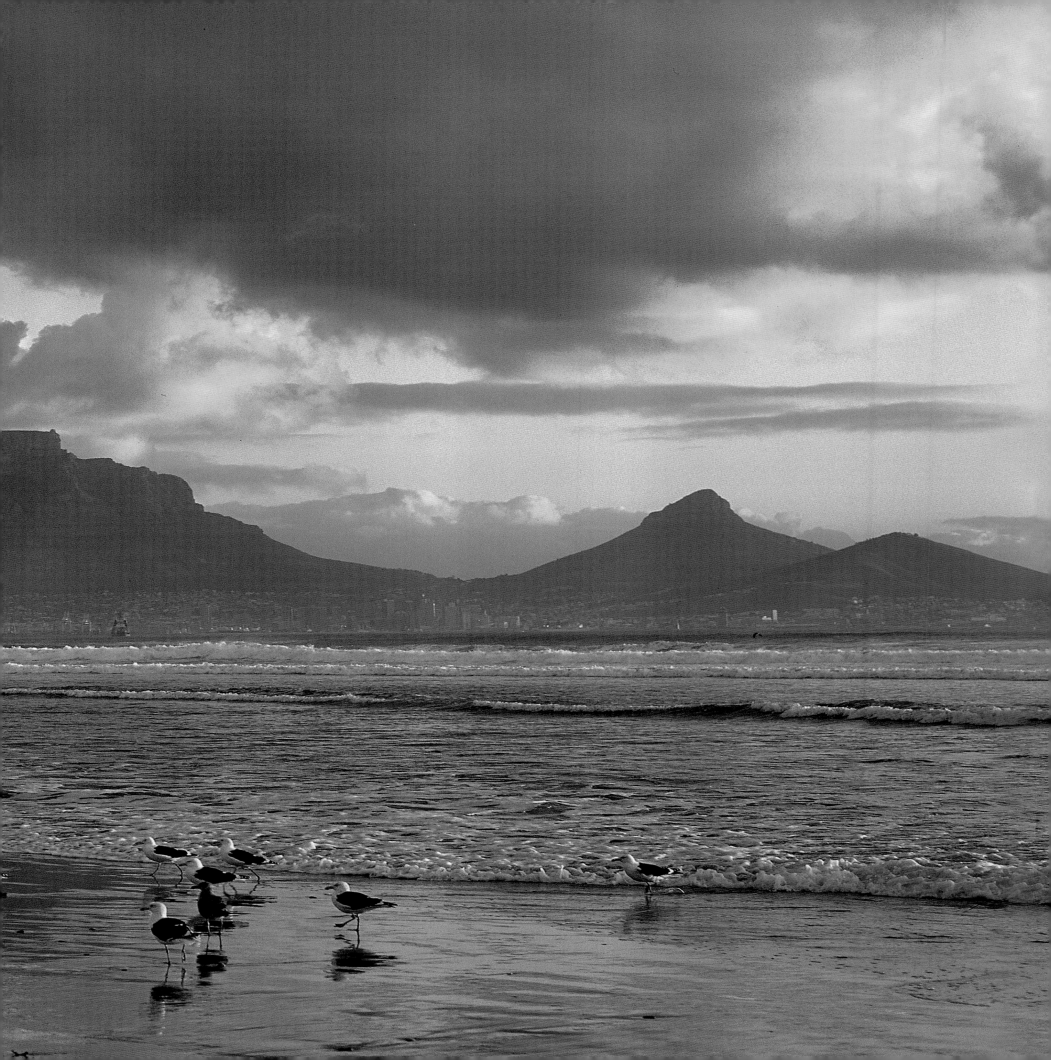

INDEX

Page numbers in *italics* refer to photograph

|Ai-|Ais/Richtersveld Transfrontier Pa
 217, 257, 265, 267
1820 Settlers 16, 40

Aardwolf *Proteles cristatus* 198, *198*
Aberdare National Park 158, 159, 170
Acacia nebrownii 239
acacia, camelthorn *Acacia erioloba* 25
 255
Acraea natalica 96
Adamson, George 158
adder, Peringuey's *Bitis peringueyi* 24
 248; rhombic night *Causus rhombea*
Afrikaner, Jan Jonker 256
agama, southern rock *Agama atra* 280
Aloe ferox 34, *34*
Amboseli National Park 159, *169*
Amphitheatre *50–51*, 51, 54
Analamerana Reserve 121
Andasibe-Mantadia National Park 120
Andersson, Charles 239
Andohahela National Park 120
Andringitra Mountains 120, 121;
 National Park *134*
Ankarafantsika National Park 120, 121
Ankarana Plateau 120, 121; Special R
 150, *150*
Antandroy culture 132, *132*
Arniston *27*
Arusha National Park *162*
Augrabies Falls 266, *266*, 281; Nationa
 280–281, 281
Auob riverbed *270*, 271
Aweer people 182, *182*
aye-aye *Daubentonia madagascariens*
 147, *147*

Baboon, Chacma *Papio ursinus* 16, *
 81, *81*; olive *P. anubis 159*;
 yellow *P. cynocephalus* 201, *201*
Baines' Baobabs *194*, 195
Bajun people 179, *179*, *180*
Bakarella sp. 138, *138*
baobab *Adansonia digitata* 86, *214*,
 215; bottle *A. rubrostipa* 120, 122, *1*
 Grandidier's *A. grandidieri* 120, 126
 126–127, 128, *128*
barbet, crested *Trachyphonus vaillanti*
Basawara people 197
Basotho pony *54*
Baster people *256*, 257, *257*
Basubia kraal *224*; people 224
Batawana people 194
bateleur *Terathopius ecaudatus* 99, *99*
BaTonga woman *84*
bats, Madagascar fruit *Pteropus* spp. 1
bee-eater, little *Merops pusillus 207*;
 southern carmine *M. nubicoides* 111,
 224, *224*; white-fronted
 M. bullockoides 82
beetle, dung Scarabaeinae 96, *96*, 165,
 tenebrionid *Onymacris bicolor* 254, *
Bemaraha Plateau 120, 121
Benguela Current 12, 16, 216, 258, 28
Berenty Private Reserve 120, 121, 126
Berg River 267; Valley 293
Betsileo houses *134*, 135, 136, *136–13*
 people *134*
Beza Mahafaly Special Reserve 120, *1*
Bhambatha 60–61
Biedouw Valley 267, *283*, 285

Lagoon 36
ve 76, 158
sland 267, *267*, 288–289, 290,
–291
oot *Dilatris pillansii* 28
River 74; Canyon 74
rivierpoort Dam 74, *74–75*
crantophis madagascariensis* 145, *145*
ean, weeping *see* tree fuchsia
nfels Arch 260, 261; ghost town *262*
l fingers *Hydrodea sarcocalycantha*
261
Tragelaphus eurycerus 170, *170*
bok *Damaliscus pygargus pygargus*
34
bok National Park 34
sla people 12, *192*, 193, *193*
vana, environmental challenges 195
tree *Pachypodium lealii* 228, *229*
ters Beach *21*
e's Luck Potholes 74, *74*
lberg 216, 228
e River *292*
South Africa Company 84, 90
vigia orientalis* 294
o, African *Syncerus caffer* 79, *92–93*,
109, 202
Hills *106–107*
aby, thick-tailed *Otolemur*
sicaudatus* 70, *71*
uck *Tragelaphus scriptus* 40, 80, *80*,
Chobe 14, 102–103, *103*
man 268, *268*; paintings 46, *52*, 86,
, *286*; *see also* San rock art
mans River *54–55*
nen 46, 242, 254, 266, 286; *see also*
people
rd, kori *Ardeotis kori* 241, *241*
fly, brush-footed *Acraea acara acara*
, *115*; swallowtail *Atropaneur*
erior* 121; swallowtail *Papilio*
nodocus* 28, *28*; *Acraea natalica*
96; common diadem *Hypolimnas*
sipus* 182, *182*
wata National Park 217

nelthorn, grey *Acacia haematoxylon*
–269
elabra, lesser *Euphorbia cooperi* 62
Agulhas 16
Dutch 24, *24*
Floral Kingdom 16, 267, 293
Town *14–15*, 16, *296–297*
vi Strip 12, 194, 197, 216, 217, *224*
al *Felis caracal* 281, *281*
lack-footed *Felis nigripes* 266
tail *Bulbinella latifolia* 285, *285*
mbstaedtia linearis* 278
pillar Pan (Hwange) *92–93*
pillar, lily borer *Brithys pancratii* 48
dral Rock *45*
Clanwilliam *Widdringtonia*
arbergensis* 267, 286
rberg 266, 267, 286, *286–287*
al Kalahari Game Reserve 195
Valley 267
vayo 46
eleon, Antongil leaf *Brookesia*
rieriasi* 146, *146*; Cape dwarf
dypodion pumilum* 18; flap-necked
maeleo dilepis* 223, *223*; jewelled
cifer campani* 134; Oustalet's
staleti* 121; panther *F. pardalis* 120,
Parson's *Calumma parsonii*
, 144, *144*, *145*; pygmy stump-tailed
okesia peyrierasi* 121; short-horned

Calumma brevicornis 144; two-horned
Furcifer bifidus 144
cheetah *Acinonyx jubatus* 79, *185*, 272
Cheetah Conservation Fund (CCF) 217
Cheiridopsis candidissima 285
Chilojo Cliffs *84*, 86
Chimanimani 85; Mountains 115
Chizarira National Park 85
Chobe National Park 194, 197; River 194,
197
Chudob waterhole *232–233*
Chuka dancers *2*
civet, Madagascar *Fossa fossana* 138, *138*
Clanwilliam 267
Cloete, Hendrik 24
Coetsee, Jacobus 266
Conicosia pugioniformis 294
copper mining 267
cormorant, Cape *Phalacrocorax capensis*
243, 267, 290, *290*; reed *P. africanus* *6–7*
coua, crested *Coua cristata* 122, *122*
crane, blue *Anthropoides paradisea* 27;
grey crowned *Balearica regulorum* 116;
wattled *Grus carunculatus* 66, *66*
Crassula columnaris 294
Crinum sp. *84*
crocodile, Nile *Crocodylus niloticus* 66, *66*,
208, *208*
crown-of-thorns *Euphorbia milii* 132, *132*
Cubango River 197
cycad, Zululand *Encephalartos ferox* 65, *65*

Da Gama, Vasco 46, 159
Dairana, Madagascar *154*
daisy, Barberton *Gerbera jamesonii* 73, *73*
Damaraland 228, *228–229*, 242
Darling 266, 267
dassie *see* hyrax, rock
dassie rat *Petromus typicus* 228, *228*
date palm, Senegal *Phoenix reclinata*
103, *103*
De Hoop Nature Reserve 22, 23, *23*
devil's thorn *Tribulus zeyheri* 278
diadem, common *Hypolimnas misippus*
182, *182*
diamonds 217, *262*; discovery of 262
Dias, Bartholomeu 16
dik-dik, Damara (Kirk's) *Madoqua kirkii*
168, 169, 236, *236*
Dimorphotheca aurantiaca 285;
D. pluvialis 294
Dinuzulu 60
disa, red *Disa uniflora* 18
Disperis sp. 147
Dorotheanthus bellidiformis 294;
D. oculatus 285
dragonfly 57
Drosanthemum bicolor 32; *D. candens* 285
duck, white-backed *Thalassornis*
leuconotus *210–211*
duiker, blue *Philantomba monticola* 66, *66*;
red *Cephalophus natalensis* 66, *66*
duiker root, white-eyed *Grielum*
humifusum 285
Durrell Wildlife Conservation Trust
(DWCT) 120, 121

Eagle, martial *Polemaetus bellicosus*
201, *201*; tawny *Aquila rapax* 275, *275*;
Verreaux's *A. verreauxi* 31, 32, 85
eagle-owl, spotted *Bubo africanus* 39, *254*
Eastern Buttress 51, *51*
Eastern Cape 16, 40
Eastern Highlands (Zimbabwe) *114–115*,
115
egret, great white *Egretta alba* 116

El Molo people 190–191, *191*
eland *Taurotragus oryx* 46, *52*, 80, *113*
elephant, African *Loxodonta africana* 79,
79, 80, *92–93*, *94–95*, *106–107*, 108,
112, 158, 169, *184*, 194, *195*,
196–197, 197, 228, *228*, *238*, *239*
elephant birds *Aepyornis* spp. 120, 122;
A. maximus 120
elephant seal *Mirounga leonina* 261
elephant shrew, eastern rock *Elephantulus*
myurus 90, *90*
Embu people 175
Epupa Falls 220
Erica versicolor 18
Etosha National Park 12, 216, 217,
232–233, 234, *234–241*, 236, 239,
240–241; Pan 216
Eugaster longipes 34
euphorbia *Euphorbia* spp. 282, *282*;
E. cooperi *see* candelabra, lesser;
E. gregarii 228
Ewaso Ng'iro River *184*, 185

Falcon, lanner *Falco biarmicus* 275, *275*
fanaloka *see* civet, Madagascar
fig tree *Ficus sycomorus* 66
Finger of God *see* Mukarob
firefinch, red-billed *Lagonosticta senegala*
115
Fischer's Pan *240*
Fish River 42, 217; Canyon 217, *264*, 265
fish-eagle, African *Haliaeetus vocifer* 116,
195, 202; Madagascar *H. vociferoides* 121
fishing-owl, Pel's *Scotopelia peli* 208, *209*
flame lily *Gloriosa superba* 85
flamingo, lesser *Phoeniconterus minor* 20,
49, 158, *158*, 159, 216, 240, 259
flamingos *246*
flycatcher-vanga, Ward's *Pseudobias*
wardi 121
flying fox, Madagascar *Pteropus rufus*
125, *125*
fody, Madagascar red *Foudia*
madagascariensis 122
fossa *Cryptoprocta ferox* 128, *128*
fox, bat-eared *Otocyon megalotis* 278,
278; Cape *Vulpes chama* 254, *254*
francolin, Cape *Francolinus capensis*
293, *293*
Franschhoek *24*
frog, Angolan reed *Hyperolius angolensis*
207; Cape rain *Breviceps gibbosus* 17;
Cape river *Rana fuscigula* 23; climbing
mantella *Mantella laevigata* 147;
dusky-throated river *see* frog, Cape
river; golden mantella *Mantella*
aurentiaca 142, *142*; painted reed
Hyperolius marmoratus taeniatus 115,
115; tomato *Dyscophus antongilii* 145,
145; tree *Boophis madagascariensis*
144 frogs, mantella *Mantella* spp. 121
fur seal, Cape *Arctocephalus pusillus* 258,
258, *261*
fynbos 23

Gabbema, Abraham 267
Gabra people 12, 193, *193*
Galton, Francis 239
gannet, Cape *Sula capensis* 267, 288, *288*,
290, *290–291*
Garden Route 16, *36–39*, 40
Gazania lichtensteinii 285, *285*
gazelle, Grant's *Nanger granti* 158;
Thomson's *Eudorcas thomsonii* 173
gecko, fringed leaf-tailed *Uroplatus*

fimbriatus 146, 147; ground *Parodura*
pictus 128; lined leaf-tailed *Uroplatus*
lineatus 145, *145* geckos, leaf-tailed
Uroplatus spp. 121
Gedi ruins 182, *182*
geelbos *see* kraalbos
Geissorhiza spp. *283*; *G. radians* *294*
gemsbok *Oryx gazella* 241, *241*, 248,
265, *277*
genet, large-spotted *Genetta tigrina* 86
Gephyromantis boulengeri 147;
G. redimitus 147
gerenuk *Litocranius walleri* 185, *185*
Giant's Castle 52, *54–55*
ginger, wild *Aframomum angustifolium* 147
ginseng, desert *see* hyacinth, desert
giraffe *Giraffa camelopardalis* 80, *84*, 86,
199, 217, 228, *232–233*; southern
G. c. giraffa 70, *70*; reticulated
G. c. reticulata 185, *185*.
go-away-bird, grey *Corythaixoides*
concolor 240
Golden Gate Highlands National Park
46, *46*
Gonarezhou 85
Gordon, Robert Jacob 266
Gorongoza National Park 118, *119*
grasshopper, short-horned *Zonocerus*
elegans 48
Great Karoo 16, *30*, 31–32, *31*, *32*, 34
Great Limpopo Transfrontier Park 85
Great Rift Valley 158, 159, 165, 167, *175*,
176, *188*, *189*
Great Tsingy 131, *131*
Great Zimbabwe 11, 84, 88, 89, *89*, 115
Greyia sutherlandii 51
Griqua people 46
Groot Rivier Pass 38
groundsel, giant *Dendrosenecio*
elgonensis 175; *D. keniodendron* 174,
175
grysbok, Sharpe's *Raphicerus sharpei* 85
Grzimek, Bernhard 158
guano harvesting 242, 258
guineafowl, helmeted *Numida meleagris*
236, *236*; vulturine *Acryllium*
vulturinum 185, *185*
gull, kelp *Larus dominicanus* *296–297*

Halfmens *Pachypodium namaquanum*
267
Harare 84, 85
hare, scrub *Lepus saxatilis* 201, *201*
harrier-hawk, Madagascar *Polyboroides*
radiatus 154
hartebeest, red *Alcelaphus caama* 277, *277*
heath, Albertinia *see* heath, bridal
heath, bridal *Erica bauera* 28; Prince of
Wales *E. perspicua* 28
Helichrysum adenocarpum 51;
H. ecklonis 51; *H. squarrosum* 51;
H. vestitum *28–29*
Heliophila sp. *283*, *294–295*
Herero dress 230, *230*, *231*; dwelling *230*;
people *216*, 219, 230, *230–231*
heron, goliath *Ardea goliath* 213;
grey *A. cinerea* 65, *65*;
purple *A. purpurea* 170, *170*
Hesperantha schelpeana 51
Hex River Mountains 267; valley *25*
Hildegardia ankaranensis 150
Himba dwelling *219*; people 12, 217,
218–220, *218–221*, 230
hippo *Hippopotamus amphibius* 68, 78,
80, 194, *196–197*, 198, 267
Hluhluwe-Umfolozi Game Reserve 46,
62, *65*

honey badger *Mellivora capensis* 70, *70*
Honnet Nature Reserve 68
Hoodia gordonii 217
hoopoe, Madagascar *Upupa epops*
marginata 122, *122*
Hop, Hendrik 266
hornbill, crowned *Tockus alboterminatus*
113; red-billed *T. erythrorhynchus* 165;
southern ground *Bucorvus*
leadbeateri 82, *82*; southern yellow-
billed *Tockus leucomelas* 82, *216*;
trumpeter *Bycanistes bucinator* 103, *103*
Hout Bay *17*
human–elephant conflict 194
Hwange National Park 84, 85, *92–99*,
95–96, 99
hyaena, brown *Hyaena brunnea* 248, 271,
272; spotted *Crocuta crocuta* 80, *80*,
81, *234*
Hyobanche sanguinea 285, *285*
hyrax, rock *Procavia capensis* 36, 165,
165, 281, *281*

Ibis, African sacred *Threskiornis*
aethiopicus 189, *213*; southern bald
Geronticus calvus 46, *70*
ice plant *Dorotheanthus oculatus* 285;
Mesembryanthemum crystallinum 261,
261
Île Sainte Marie 147
impala *Aepyceros melampus* 62, 70, 80,
109, 110, *113*; black-faced *A. m. petersi*
239, *239*
Impatiens sylvicola 73, *73*
indri *Indri indri* 120, 142, *142*, *143*
Isalo National Park 132, *133*
Ishikani 182, *182*
Ixia maculata 267

Jacana, African *Actophilornis africanus*
207, *207*, 208; lesser *Microparra*
capensis 208
jackal, black-backed *Canis mesomelas* 236,
258, *261*, 272, *272*

Kalahari Desert 12, 194, 216, 217, 230,
266, 267, 268, *268–273*, 271–272, 275,
276–279, *277–278*
Kamfers Dam 21
Kaokoveld 216, 217, 218, 220, 228, 230, 242
Karanga people 89
Kariba Dam 111, 113
Karoo National Park 31
Kaudom National Park 217
Keate's Drift *60–61*
Kenya, environmental challenges 159
kestrel, greater *Falco rupicoloides* 275,
275; Madagascar *Falco newtoni* 131
Kgalagadi Transfrontier Park 195, 266,
270–279, 271–272, 275, 277, 278
Khoisan people 217
Kigelianthe grevei 128
Kikuyu people 159, 175
kingfisher, malachite *Alcedo cristata*
213, *213*
Kirindy Forest 120, 131
kite, black-shouldered *Elanus caeruleus*
275, *275*
Klein Swartberg 32
klipspringer *Oreotragus oreotragus*
32, 281, *281*
kokerboom *Aloe dichotoma* 217, 267, 281,
284; Forest 281, *281*
Kolmanskop *262*

korhaan, black *Eupodotis afra* 240, 248
kraalbos *Galenia africana* 30
Kruger National Park 11, 68, 70, 76, 80, 85
Kruger, Paul 68
Kudiakam Pan *215*
kudu, greater *Tragelaphus strepsiceros* 62,
80, 82, *82*, *82–83*
Kuiseb Canyon 248; River 248
Kunene Region 218; River 216, 218, *220*,
230, 234, 239, 242
Kwando River 197, *204–205*, 207, 224
KwaZulu-Natal 40, 46, 54

Lake Baringo 159, 176
Lake Bogoria 159, *175*
Lake Elmentaita 159
Lake Kariba *6–7*, 84, 85, *106–111*, 109, 111
Lake Liambezi 224
Lake Malawi *see* Lake Nyasa
Lake Manyara National Park 165
Lake Naivasha 159, *171*
Lake Nakuru *158*, 159
Lake Natron 158
Lake Ngami 195
Lake Nyasa 116, *117*
Lake Turkana 158, 159, 189, *189*
Lake Victoria 158, *172*, *173*
Lamberts Bay 267, 288, 290
Lampranthus roseus 28, *294*
Lamu 12, 159, 179, *179–183*; fort 180
Langebaan 267; Lagoon 293
Langeberg 34
Langjan Nature Reserve 74
Langkloof Mountains 40, 40; Valley 40
lapwing, crowned *Vanellus coronatus* 40,
240, *240*
lary tree *Psiadia altissima* 141, *141*
Le Vaillant, François 266
lechwe, red *Kobus leche* 195
Lemba people 89
lemur, black *Eulemur macaco macaco* 120,
152, *152*; crowned *E. coronatus* 150, *150*,
150–151; eastern lesser bamboo
Hapalemur griseus 138; eastern rufous
mouse *Microcebus rufus* 141, *141*;
eastern woolly *Avahi lanigar* 141, *141*;
golden bamboo *Hapalemur aureus* 11,
121, 138, *138*; greater bamboo *Prolemur*
simus 11, 121, 138, *139*; greater dwarf
Cheirogaleus major 141, *141*;
grey mouse *Microcebus murinus* 131,
131; grey-backed sportive *Lepilemur*
dorsalis 152, *152*; Madame Berthe's
mouse *Microcebus berthae* 120, 121,
128, *129*;
mongoose *Eulemur mongoz* 148, *148*;
northern sportive *Lepilemur*
septentrionalis 154, *154*; red-bellied
Eulemur rubiventer 140, 141, *141*;
red-fronted brown *E. fulvus rufus* 126,
126; red-ruffed *Varecia rubra* 147, *147*;
ring-tailed *Lemur catta* 121, 121, 125,
125, 126, *126*; ruffed *Varecia variegata*
147; small-toothed sportive *Lepilemur*
microdon 138; white-fronted brown
Eulemur albifrons 120, 142, *142*
leopard *Panthera pardus* 32, 80, 96, 194,
266, 272, *272*
Lesotho, Highlands 266; Kingdom of 46, 54
lily *Crinum* sp. 207; blood *Haemanthus*
multiflorus 100, *100*, 173, *173*; flame
Gloriosa superba 223; ground
Ammocharis coranica 65, *65*; impala
Adenium multiflorum 111, *111*; pyjama
Crinum kirkii 170, *170*
Limpopo National Park 85; Province 68,
73; River 84, 194

Linyanti Marshes 197; River 197; Swamps 194
lion *Panthera leo 1*, 76–77, 85, 97, *159*, *164–165*, 170, 236, 237, *272–273*; white 76, 80
lithops 267
Little Karoo 16, 34, 40
Livingstone, David 116, 197
lizard, Broadley's flat *Platysaurus broadleyi* 281, *281*; collared iguanid *Plurus cuvieri 131*; Drakensberg girdled *Pseudocordylus subviridis 54*; flat *Platysaurus intermedius rhodesianus* 90, *90*; forest *Zonosaurus madagascariensis* 144, *145*
Lobengula 84
locust, bush *Phymateus leprosus 58*
Lone Creek Falls 74, *74*
Long Beach *16*
Loskop Dam Nature Reserve *8–9*
lourie, Knysna *Tauraco corythaix 39*
lovebird, rosy-faced *Agapornis roseicollis 266*; yellow-collared *A. personata* 165
Lowveld 70; Zimbabwe *86–87*
Lozi people 224
Luo people *172*, 173; settlement *173*
Lusaka 85

Maasai people 158, 159, 176, *176*, 186
Maathai, Wangari 159
Mafwe people 224, *224*
magpie-robin, Madagascar *Copsychus albospecularis* 150, *150*
Mahafaly culture 132, *132*
Maharero, Samuel 230
Makgadikgadi Pan 194, 214; National Park 195
Makishi dancers *104–105*, 105, *105*
Malati Park Nature Reserve *70*
Malindi 158–159
Maltese Cross *286*
Mamili National Park 217
Mana Pools 85, 113, *113*
Mandela, Nelson 11, 42
Mantella betsileo 145, *145*
Mapungubwe 84
Marojejy National Park 120, 121, 146, *146*
marsh rose *Orothamnus zeyheri 28*
Masai Mara 159; National Reserve 159
Masoala National Park 120
Matabeleland 84, 85
Matopo Hills 90, *90*, *91*
Matopos National Park 85, 90
Matusadona 85; National Park *109*
Mbanderu people 230
Mbeki, Thabo 195
meerkat *Suricata suricatta* 278, *278*; *see also* suricate
melon, tsama *Citrullus lanatus* 266, 278
Meru people 175, 186, *186*
mesembryanthemum *Ruschia* sp. *31*
millipede, giant forest *146*
mite, red velvet *Trombidium* sp. 223, *223*
Mkambathi Nature Reserve 45
Mkuze Game Reserve *64*
Mogae, Festus 195
Mombasa 158, 159
mongoose, banded *Mungos mungo* 240, *240*; dwarf *Helogale parvula* 119, *119*, 165, *165*; ring-tailed *Galidia elegans* 138, *138*; northern ring-tailed *G. e. dambrensis* 148, *148*; yellow *Cynictis penicillata* 214, 266, *266*
monitor, water *Varanus ornatus* 109, *109*
monkey, samango *Cercopithecus mitis* 85; vervet *C. (Chlorocebus) aethiops* 80, *80*, 85, *185*

Montagne d'Ambre National Park 120, 150, *150*
Mont-aux-Sources 51
Moon Valley *247*
mopane *Colophospermum mopane* 99, 214, *214*, 216, 228; worm *Gonimbrasia belina* 96, *96*
Moremi 194
Mostertshoek Twins *292*
moth *Urania* spp. 121; Cape lappet *Pachypasa capensis*, caterpillars of *18*; comet *Argema mittrei* 121, 144, *144*; superb false tiger *Heraclia superba* 99
Motlatse 74
Mount Kenya 158, *159*, *174*, 175, *175*
Mount Keramasi *159*, *166*
Mount Kilimanjaro 12, 158, 159, *160–161*, 162, *162*, *163*
Mountain Zebra National Park 23
mouse, striped *Rhabdomys pumilio* 281, *281*
Mpumalanga 70; mining in 70
msasa tree *Brachystegia spiciformis* 114
Mudumu National Park 217
Mugabe, Robert 84, 85
Mukarob 265, *265*
Mzilikazi 85, 95, 96
Mzima Springs 159

Nairobi 159
Nama culture *256–257*; dwellings 257, 267; people 217, 230, 256–257, *256–257*, 266–267
Namaqualand 256, 266, 267, 282, *282–283*, 285; wildflowers 267, 282, *282–283*
Namib Desert 79, 216, 246, 248, *248–251*, 263, 266
Namibia, conservation in 217; German colonisation of 217, 230
Namib-Skeleton Coast National Park 216, 217, *244–245*, 248, *252–253*, 254
Nandi people 173, *173*
nara plant *Acanthosicyos horrida* 254, *254*
Natal Midlands 46
Ndebele homestead *68*; people 68, *68*, *69*, 84, 85, 194
Ndumo Game Reserve 66, *66*, 67
Nerine laticoma 277, *277*
Ngorongoro Crater 158
Nguni people 42, 57
Nieuwoudtville 267, 285
Njemps people 176, *177*
Nongqawuse 11
Nossob River *278*; riverbed 271, *271*, 276
Nosy Be 152
Nosy Iranja 152, *153*
Nxai Pan National Park 195
nyala *Tragelaphus angasii 62*, 85
Nyamandlovu waterhole *84*
Nyamasakana River *86–87*
Nyanga 85
Nyangani, Mt 84, 85
Nzimane River *65*

Octopus tree *Didiera trollii* 121
Odontopus sexpunctatus 246, *246*
Oeonia rosea 138
Okavango Delta 12, 194–195, *194*, *195*, 197, 202–*213*, 207, 213; River 197, *203*, 216, 225
Ol Doinyo Lengai 11, 159, *166*, 167, *167*
Olifants River (Limpopo) 79, *79*, *80*
Olifants River (Western Cape) 267, 285
olive-pigeon, African *Columba arquatrix* 18
Olorgesaillie Gorge *176*
openbill, African *Anastomus lamelligerus* 202, *202*

Orange River 216, 217, 256, 265, 266, *266*, *280*, 281, 282
orchid *Oeonia rosea* 121
oribi *Ourebia ourebi* 46, 119, *119*
Orma people 159, *178*, 179
Oromo people *192–193*, 193
ostrich *Struthio camelus 8–9*, 240–241, *241*, *244–245*; Somali *Struthio camelus molybdophanes* 189, *189*
otter, Cape clawless *Aonyx capensis* 45
Outeniqua Forest 34; Mountains *34–35*, 40
Ovambo people 222, 223, 239
Ovamboland *223*
Overberg 27
owl, marsh *Asio capensis* 202, *202*
owlet, African barred *Glaucidium capense* 208, *208*
Oxalis hirta 28; *O. pes-caprae* 285, *285*
oxpecker, red-billed *Buphagus erythrorhynchus* 169, *198*; yellow-billed *B. africanus* 198
oystercatcher, African black *Haematopus moquini* 290, *290*

Paarl Valley *26*
Pachypodium lamerei 122
palm, borassus *Borassus aethiopum 119*; doum *Hyphaene thebaica 184*; makelani *H. ventricosa* 223; real fan *H. petersiana* 194; traveller's *Ravenala madagascariensis* 121, 152
paradise-flycatcher, African *Terpsiphone viridis* 99, *99*; Madagascar *T. mutata* 125, *125*, *131*
Paterson, William 266
Paton, Alan 57
Pavonia burchelli 74, *74*
pelican, great white *Pelecanus onocrotalus* 246, 248, *251*; pink-backed *P. rufescens* 171, 173, *173*
penguin, African *Spheniscus demersus* 21, *21*, *290*
perch, Nile *Lates niloticus* 173
perdebos *see* kraalbos
Phelsuma madagascariensis 147
Phymateus morbilosus 31
Piketberg 293
pincushion *Leucospermum cordifolium 19*; Chimanimani *L. saxosum* 115, *115*
pineapple, wild *Eucomis autumnalis* 73
pitcher plant *Nepenthes madagascariensis* 132, *132*
Plettenberg Bay *37*, 40
Pokot people 12, 186, *186*
Polygala bracteolata 16
porcupine, Cape *Hystrix africaeaustralis 32*
praying mantis *Cilnia humeralis 31*
protea, giant *see* protea, king
protea, king *Protea cynaroides 18*; *P. kilimandscharica 162*; *P. simplex* 73, *73*; *P. subvestita 51*
pyjama flower *Androcymbium striatum* 73, *73*
python, African rock *Python sebae* 66

Quiver tree *see* kokerboom

Ramskop Wildflower Reserve *284*, 285
Ranomafana National Park 120, 121, 138, *138–141*, 141
rat, Brant's whistling *Parotomys brantsii* 271, *271*
red Afrikaner *Homoglossum priorii 28*
red-hot poker *Kniphofia uvaria 40*
Reed Dance 60
Rehoboth 257

Rendille people 12
resin bush, Wagener's *Euryops wageneri* 285, *285*
rhino, black *Diceros bicornis* 62, *63*, 85, *158*, 170, *170*, 217, 218, 228; white *Ceratotherium simum 8–9*, *46*, 48, 62, *62*, 85, 194
Rhodes, Cecil John 84, 85, 90
Richtersveld 266; Community Conservancy 266; National Park 257, 266–267
roan *Hippotragus equinus* 80, *80*
robin-chat, Cape *Cossypha caffra 18*
roller, European *Coracias garrulus* 159; lilac-breasted *C. caudata* 200, *201*; racket-tailed *C. spatulata* 119, *119*
Romulea cruciata 294
Rondevlei 20
Rooiberg 46
Royal Natal National Park 51, 54
Rozwi 84

Sabie River 74, *79*
sable *Hippotragus niger* 194
Sakalava people 152
Saldanha 267; Bay 290, 293
Samburu National Reserve 185; people 12, *158*, 186, *186*, *187*
San people 96, 194, 195, 197, *216*, *226–227*, 227, 234, 256, 267, 268, *268*; *see also* Bushmen
San rock art 267; *see also* Bushman paintings
sandgrouse, Namaqua *Pterocles namaqua* 277, *277*
Sandwich Harbour *216*, 248, *248*, 251
Savute Marsh 194, 197
Savuti Channel *195*, *196–197*, 197
Scheepers, Commandant 40
Schryver, Izaak 40
scops-owl, Malagasy *Otus rutilus* 125; southern white-faced *O. leucotis* 274, 275
sculptures, Zimbabwean 115, *115*
secretarybird *Sagittarius serpentarius* 275, *275*
Sehlabathebe National Park 54
Senecio elegans 267; *S. littoralis* 267
Sentinel Peak *17*, 51
Serengeti National Park 158
serval *Felis (Leptailurus) serval* 96, *96*, 165, *165*
Shaka, Zulu king 57
Shangaan dancers *105*
Shire River 116
Shona dwellings 85; people 84, 85, 89, 115, *115*
shrike, crimson-breasted *Laniarius atrococcineus* 236, *236*
sifaka, Coquerel's *Propithecus coquereli 4–5*, 148, *148*, *149*; crowned *P. coronatus* 121, 148, *148*; Decken's *P. deckeni 130*; diademed *P. diadema diadema* 142, *142*; golden-crowned *see* sifaka, Tattersall's; Milne-Edwards' *P. edwardsi* 141, *141*; Perrier's *P. perrieri* 121, 154, *154*; silky *P. candidus* 121; Tattersall's *P. tattersalli* 121, *121*, 154, *154–155*; Verreaux's *P. verreauxi* 126, *126*
Skeleton Coast 12, 216, 228, 242, *242*, 243, 250, 251, *251*
skimmer, African *Rynchops flavirostris* 208, *208*
Smuts, Field-Marshal J.C. 294
snail, giant African land Strepaxidae 115
snake, striped bush *Limnophis bicolor* 113, *113*
Somali ostrich *see* ostrich

Sossusvlei *10*, 216, *217*, 252, *252–253*, 254
Sotho house *46*; people 46, *54*
Sperrgebiet 258, 262, *263*
spider, golden orb web *Nephilia madagascariensis* 121; hunting *Palystes* sp. *18*; orb *Argiope* sp. *31*
Spitzkoppe 217
spoonbill, African *Platalea alba* 64, 65
springbok *Antidorcas marsupialis* 46, *232–233*, 239, 267, *270–271*, 271; migration 31
springhare *Pedetes capensis* 214, *214*
squirrel, Cape ground *Xerus inauris* 241, *241*, *278*; tree *Paraxerus cepadi* 240
starling, superb *Spreo superbus* 170
steenbok *Raphicerus campestris* 239, *239*
Stevenson-Hamilton, James 68
stick insect *146*; Thunberg's *Macynia labiata* 16
stink-horn *Anthurus archeri* 40
stork, Abdim's *Ciconia abdimii* 202, *202*; black *C. nigra* 202; marabou *Leptoptilos crumeniferus* 201, *201*; saddle-billed *Ephippiorhynchus senegalensis* 111, *111*, 202, *202*; white *Ciconia ciconia* 202; woolly-necked *C. episcopus* 65, *65*; yellow-billed *Mycteria ibis* 113, *113*
sugarbird, Cape *Promerops cafer* 19
sunbird, malachite *Nectarinia famosa* 18, *23*; orange-breasted *Anthobaphes violacea* 18; scarlet-chested *Nectarinia senegalensis* 66, *66*
suricate *Suricata suricatta* 278; *see also* meerkat
Swahili coast 158–159; culture 12, 159, 179, 180, 182; *180*, 182
Swakop River 242, 246
Swartberg 16, 34
Swartland *293*
Swartvlei Beach *36*
Swazi kraal *72*

Table Mountain *14–15*, 16, *16*, *296–297*
Tana River 158
tchagra, brown-crowned *Tchagra australis 115*
tenrec, common *Tenrec ecaudatus* 142, *142*; highlands streaked *Hemicentetes nigriceps* 134, *134*; streaked *H. semispinosus* 121
Terrace Bay 242
Thamalakane River *213*
Thembu people 42
thick-knee, spotted *Burhinus capensis* 42
Thomas, Dr Andrew 266
Tijimba people 230
Timbavati Private Nature Reserve 76
tortoise, geometric *Psammobates geometricus* 293, *293*; leopard *Geochelone pardalis* 42; radiated *Astrochelys radiata* 128, *128*
Transkei 11, 40, 42
tree fern *Cyathea dregei* 73
tree fuchsia *Schotia brachypetala* 74, *74*
trekboers 46
trogon, Narina *Apaloderma narina* 82, *82*
Tsauchab River 252, *255*
Tsavo National Park 159, *169*
Tsitsikamma Forest 36, 39; Mountains 40
Tswana people 46, 194
Tugela Falls 51; River *50–51*, 54, 59
turaco, Ross's *Musophaga rossae* 173
Turkana people 12, *158*, 190, *190–191*, *193*; settlement *191*
Turnera oculata var. *paucipilosa* 219
Twyfelfontein *217*, 228

UKhahlamba 52; World Heritage Si[te]
Uncarina decaryi 128
Ursinia sp. *28–29*, 266, 284, *294–295*; *U. speciosa* 282

Valley of Desolation *33*
Van der Stel, Simon 24, 267
Van Riebeek, Jan 24
vanga, Chabert's *Leptopterus chabert[i]* helmet *Euryceros prevostii* 121; hook-billed *Vanga curvirostris* 12[1]; nuthatch *Hypositta corallirostris* 12[1]; sickle-billed *Falculea palliata* 121, [...]
Veso fishermen 125, *156–157*
Victoria Falls 84, *84*, 100, *100–101*, 1[...] *102*, 197; & Zambezi National Park
Von Trotha, General Lothar 230
vulture, African white-backed *Gyps africanus* 275, *275*; bearded 46; hooded *Necrosyrtes monachus* 197 Rüppell's griffon *Gyps ruepellii* 17[...]

Waata people 159
walnut, African *see* tree fuchsia
Walvis Bay 217
warthog *Phacochoerus aethiopicus* 6[...]
Waterberg National Park 217
waterbuck, common *Kobus ellipsipry[mnus]* 80, *84*, 170, *170*
Waterfall Bluff *45*
weaver, Cape *Ploceus capensis* 18; le[sser] masked- *P. intermedius* 115, *115*; re[d-] headed *Anaplectes rubriceps* 98, *99* *99*; Sakalava *Ploceus sakalava* 125 sociable *Philetairus socius* 275, *27[5]*
weevil, giraffe-necked *Trachelophorus giraffa* 121, 141, *1[...]*
Welwitschia mirabilis 246, *246*
West Coast 267, 288, *288–291*, 290; National Park 293
whale, southern right *Eubalaena austr[...]*
whydah, shaft-tailed *Vidua regia* 277, [...]
wild cat, African *Felis lybica* 195
Wild Coast *44*, 45, *45*
wild dog, African *Lycaon pictus* 80, 8[...] 95, 194, *194*
wildebeest, blue *Connochaetes taurin[us]* 80, 158, *276*
Windhoek 216, 230, 256
wine-growing 24, *24*, *25*
Witbooi, Hendrik 257
Wolfberg Arch 286, *286*, *287*
Wolkberg 73, *73*
woodpecker, ground *Geocolaptes olivaceus* 24

Xhosa people 16, 40, *40–41*, 42, *42*, 4[...]

Zambezi River 84, 85, 100, 102, *103* *111*, 116, 216, 298; Valley 85, 111
zebra, Burchell's *Equus quagga burchellii* 46, 48, 79, 80, *84*, 198, *232–235*; Cape mountain *E. zebra z[...]* 22, 23, *23*, 31; Grevy's *E. grevyi* 18[...] *185*; Hartmann's mountain *E. zebra[...]* *hartmannae* 216, 228, 234, 248
Zebu cattle *120*, 124, 125, *132*, 152
Zimbabwe Conservation Task Force 8[...]
Zulu culture 58, 60; kingdom 46; kraa[...] 57; migration 57; military campaign[...] people *56–61*, 57–58, 60–61, 194; primary school *58*
Zululand 46, 56; southern 56
Zwelitini, King Goodwill 60
Zygophyllum clavatum 242, *242*

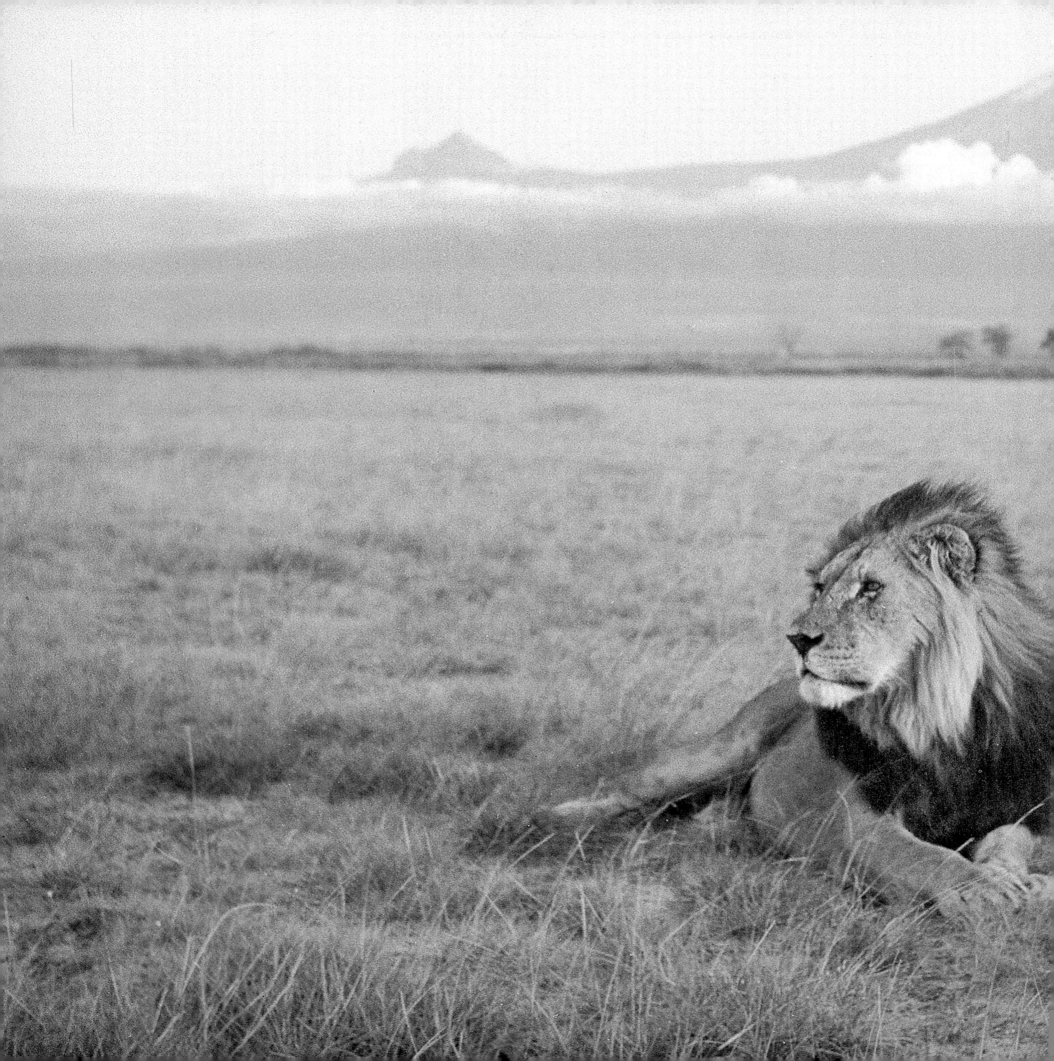